Graphic Communications Today

By William Ryan and
Theodore Conover

Graphic Communications Today

Fourth Edition

THOMSON

DELMAR LEARNING ™

Australia Canada Mexico Singapore Spain United Kingdom United States

THOMSON

DELMAR LEARNING

Graphic Communications Today, 4E
William Ryan and Theodore Conover

Vice President, Technology and Trades SBU:
Alar Elken

Editorial Director:
Sandy Clark

Acquisitions Editor:
James Gish

Development Editor:
Jaimie Wetzel

Marketing Director:
Cyndi Eichelman

Channel Manager:
William Lawrensen

Marketing Coordinator:
Mark Pierro

Production Director:
Mary Ellen Black

Production Manager:
Larry Main

Production Editor:
Thomas Stover

Art & Design Specialist:
Rachel Baker

Editorial Assistant:
Marissa Maiella

Cover & Interior Design:
Pentagram

Library of Congress Cataloging-in-Publication Data:
Card Number: [Number]

ISBN:0-7668-2075-0

Contents

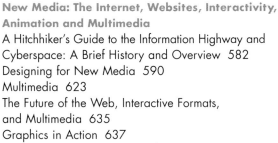

Dr. Mario R. Garcia is founder and CEO of Garcia Media. He has more than 30 years of graphics experience and has worked with more than 450 organizations worldwide redesigning

Visual storytelling is an ancient art form, as anyone who has enjoyed reading Aesop's Fables can testify. The average reader first examines the beautiful, hand-drawn images used to teach life's lessons—illustrations that have helped make the fables beloved for more than seventeen centuries. Only after delighting in the artwork does the reader delve into the succinct narratives. For the most part, imagery and words are processed similarly today.

However, the task for contemporary visual journalists is considerably more challenging than it was for Aesop and his artists. Because of the onslaught of media, today's communicators must cater to an audience that's bombarded with messages: branding and advertising, video games, bus tails, television, print materials, cereal boxes, billboards. We are pummeled with a non-stop graphic barrage of information and hype. Nothing seems to remain stationary. Messages flash at us simultaneously, competing for our attention from just about everywhere on the globe. So, a newspaper reader surfing a website of a newspaper in Argentina, Singapore, or Germany gazes through a window into that country's news, graphic styling, and its cultural milieu. The fact is we live in the world that is always visually on—everywhere.

The challenge for you, then, is to tell stories simply, clearly, and visually and to engage the audience with inviting, uncluttered pages and messages with pure design. The idea behind this strategy is clear—just as your messages should be. Communicate quickly, efficiently, and explicitly.

This edition of *Graphic Communication Today* addresses all of the important issues facing visual journalists. Subjects covered run the gamut: from the tremendous importance of legible typography (nothing could be more important to the overall success of the design of anything), to using photography and illustration effectively (it is no secret that most readers enter a page through an image). The text also examines specific peculiarities of designing newspapers, magazines, and other printed matter—as well as moving imagery, websites, and interactive media. After all, today's readers get their information from the Internet, print, television, and a smorgasbord of media, so it's crucial to reach your important "customers" through a wide range of channels.

Each chapter works as a sort of mini-book of reference by itself, using research and practical information to ground and initiate newcomers, aspiring visual journalists, while also satisfying the needs of those already exposed to graphic communication who are studied or experienced in the field.

One particular asset of this book is that it features interviews and statements from many

newspapers, magazines, corporate publications and websites. Mario Garcia and his firm worked with The Wall Street Journal *on their noted new look in 2002, The Wall Street Journal Europe, Die Zeit (Germany), El Mercurio (Chile), Staten Island Advance and many publications in Europe and South America. He is the author of a dozen books including his most recent,* Pure Design. *He has served as professor at Syracuse University (New York), the University of South Florida and since 1984 has been a faculty member at the Poynter Institute for Media Studies, where he founded the Visual Journalism department and completed an in-depth eye-tracking study for the Internet. Garcia has received numerous awards from the Society for News Design (SND) and he was recently honored with SND's first Lifetime Achievement Award for his stellar work in newspaper design.*

accomplished and established visual journalists. They are interactive designers, animators, documentary photographers, graphics editors, filmmakers, designers, illustrators, and creative directors. Their backgrounds and experience are international and multi-cultural: people such as Bill Allen, Mary Ellen Mark, Rodrigo Sanchez, Gail Anderson, Saxone Woon, Connie Phelps, Dave Gray, Kit Hinrichs, Pat Samata, Pete Docter, Tracy Wong, Robert Slimbach, Pegie Stark Adam, Steve McCurry, and D. J. Stout—to name just a few. Some offer sage advice and candid stories about how they broke into visual communication. Others provide research, problem-solving strategies, and unique case studies—or connect you to the legacy of graphic design history. Truly, they are some of the finest practitioners in graphic communications from around the world.

The variety of professionals profiled speaks to another critical aspect of visual journalism today: convergence. Our media continue to merge, and we can no longer afford to categorize ourselves as print, broadcast, or Internet people. First and foremost, we are all storytellers. Newspapers, for example, embrace a cross-section of media: newspaper (of course), magazine, Web, newsletters, advertising, and other formats. Truly, the greatest opportunities belong to skilled visual storytellers who understand the intricacies of effective graphic communication and apply their vision across media formats.

The author himself, Bill Ryan, is such a person. He brings a rich and varied professional background as a visual journalist to each page of this book. He's worked as a designer, photographer, author, painter, educator, and graphic consultant. He is also an award-winning teacher and scholar who's received Kellogg, Mellon, and Fulbright fellowships and taught and worked in many cultures. His words, insights, and experiences speak to a wide array of media and graphic strategies—and—his work walks the talk. But Ryan knows both sides of the fence. His undergraduate degree is in writing, and he has worked extensively as a writer and editor, so he understands firsthand the intricate dance between word and image.

Many challenges lie ahead for those in our field: the challenge to simplify the message of the story, select appropriate media for specific messages may be targeted at a range of different audiences, and to attract and retain the attention of those in the "always on" culture.

Much has changed in the past 25 years: technology has snowballed; computers and digitization have revolutionized our tools and media; and the Internet has truly transformed the world into a "global village." However, one thing that has remained constant is the importance of visual presentation. In fact, our media and audiences are more graphically oriented. Today your charge is to learn and spread the gospel of visual literacy, to convince all of the so called "word" people that their best efforts at reporting, writing, and editing efforts will be ignored if their stories' presentations aren't visually compelling. For years, I have embraced the WED concept (the marriage of words and images through Writing-Editing-Design). For two decades, I've have conducted workshops and taught at the Poynter Institute for Media Studies and numerous universities; and, I've worked with reporters and editors around the world. The lesson has been the same everywhere: to understand the heart of the story and to lead the reader there—visually. As we begin a new century, it is important that we explode the myth that "word" people need not be concerned with visuals.

Dr. Ryan's book is mandatory reading for anyone considering a career in design or graphic communication, as well as for those working on the "word" side of communication—reporters, writers, editors, copywriters. *Graphic Communication Today* will set both audiences on the right path. In fact, this book serves as an excellent map for the visual journalist's journey—the very same one that began centuries ago for Aesop, who understood that you could tell a compelling story in 25 lines, so long as you left enough room for the illustration.

Dr. Mario R. Garcia
President/CEO
Garcia Media
www.garcia-media.com

Simply stated, the goal of the fourth edition of this book is to change the way you see. Its mission is to help you acquire a new visual language and to shape how you think about and use design principles, composition, typography, photography, color, and the other vital components of visual literacy. To really become visually literate, however, it is important that you understand the theory, history, and culture of graphic communication; rub elbows with some of its heroes; and become facile in at least one medium with which you can communicate visually.

This book is a primer. The real world, particularly its libraries, galleries, museums, and all the media you encounter each day, is an extended classroom rife with examples to further enlighten you. If you can combine the two, you'll not only become visually literate, you will extend your knowledge and understanding of graphic messages and the strategies behind them, improve your critical thinking skills, and hopefully begin forging a vision of your own.

Intended Audience

Graphic Communications Today is targeted at you and anyone else aspiring to work in some facet of graphic communication. It presents well-organized chapters and fundamental concepts in a logical sequence to help you create arresting messages that communicate quickly, efficiently, and clearly. In brief, the book will provide you with a solid visual grounding.

But this publication is directed at writers, too. Today, the division between the "word" and "art" sides of media continues to erode. Smaller newspaper editors often require new reporters to have solid photography skills, and some seek writers who can execute page layouts as well. Photography is invaluable to magazine freelance writers, too, for obvious reasons; it may even mean the difference between securing an assignment or not. In addition, writers and graphic communicators work in tandem across various media. In advertising, for example, art directors and copywriters are paired up on all creative assignments. "Maestro" teams (editor, photographer, writer, and designer) produce features and news packages for newspapers and magazines. Screenwriters, directors, producers, animators, and a host of others team up to create films, TV spots, animation, and documentary projects together. If you're planning on a writing career, it's crucial that you at least share a common vocabulary with your graphic counterparts.

In addition, this book may prove valuable to professionals testing the waters of interactive

design or other media new to them or to those looking to break out of their routines. Although experienced art directors, designers, and photographers are technically sound, it's easy to become complacent or to get in a rut. *Graphic Communications Today* can work as a catalyst to spark your enthusiasm, perspective, or creative muse. It's always good to step back and reassess your work and methods of thinking; after all, that's the basis or premise of most workshops. In fact, some of the text's exercises are borrowed from professional workshop sessions I've conducted.

Finally, this book should also be useful to the average consumer of visual messages and communication because it will provide valuable insights about graphic communications: their planning and use of color and design, as well as the theories, graphic applications, and strategies that shape our messages. It also will help deconstruct not only the graphic messages in media but their intent and real meaning.

However, to be truly visually literate, it is crucial that you apply the concepts and visual strategies presented throughout the text. To that end, the Graphics in Action section at the close of each chapter offers assignments that include identifying, collecting, and deconstructing materials; creative problem-solving and production; and weightier projects that may involve teamwork. Most of the assignments are tied to specific situations and demand critical thinking, strategy, analysis, audience assessment, and applying graphic concepts learned in the chapter within a problem-solution context.

It is important to remember, too, that effective visual communication is a process of analysis; it necessitates devising a plan based on your research and understanding of a problem, and ultimately creating order through function. That plan takes the following into consideration: audience, content, voice, context, and the intent of the message being created. The most effective and memorable visual communication is user-friendly and strikes a positive chord with the audience. After all, trust and loyalty are as important to newspapers, websites, documentaries, and magazines as they are to branding, public relations, advertising, collateral materials, and other persuasive messages. Finally, when applying the concepts of this text to the exercises, it's important to remember that graphic communication is not about decoration or window dressing; it's about engaging your audience and conveying messages—period.

Emerging Media Directions

As I write this preface, Kodak has just announced its decision to pull all of its resources out of film and redirect them toward the "digital side of the business." To be sure, we live in a digital age. Media convergence and technology are transforming all of communication but particularly graphic communication in significant ways. Marshall McLuhan's manifesto of a "global village" nearly 40 years ago was much more than a clever pronouncement. Media and the opening of world markets continue to shrink the planet. Globalization and branding, for better or worse, have bridged cultures and language, and they're here to stay. The signs of those cross-cultural influences may be blatant or subtle. For example, Japanese calligraphy and ceramics are often cited as inspirations from the past, but today Japan's product technology and computer game culture are changing how you perceive and relate to the world. These changes are not trends or permutations; they are part of a larger graphic evolution that continues to snowball with ever-changing technology. Among other things, these transformations underscore how technology and media are constantly shifting and merging cultures, communication and how we engage the future, our "permanent address."

Background and Features of This Text

Truly, I have an on-going connection to this book; I've used earlier editions of it in many of my classes, and in the past I served as a reviewer of and contributor to *Graphic Communications Today*. However, when my friend Ted Conover asked me to take over as author, I was as humbled as I was surprised. At the same time, the task of bringing the book up to date was challenging; indeed, the world of graphic communication has changed dramatically over the past ten years. Digitization and technology have revolutionized how we make images; design pages; and how we construct, convey, and perceive our

messages. Technology has always stretched our ability to communicate and spawned interesting symbiotic relationships between media. Today media convergence is a major concern in both the academic and professional worlds. Meanwhile, media boundaries continue to blur. In the process, all of our media have become more graphic in nature. Moreover, the flow of our communications is a nonstop churn, and its relentless onslaught has had a numbing effect upon us. Because we are bombarded with messages daily, we have become jaded and very selective about what we read or process. Consequently, it is more important than ever that visual presentation in media be compelling and functional and communicate quickly and lucidly.

To be sure, this text is not just an updated edition of *Graphic Communications Today*. It is an entirely new publication. My vision of the book you hold in your hands was an ambitious one. It meant expanding, rewriting, and restructuring Theodore Conover's fine work. The third edition's art has been all but completely replaced. In addition, the fourth edition offers five new chapters: fine and graphic art history (and its push and pull effect and influence on media); illustration; photography; identity and branding; and websites, interactivity, and multimedia. In most ways the entire book is brand new; you'll find interviews, case studies, profiles, sidebars, and other surprises in each chapter. There are also several graphic puzzles that test your knowledge of logo fragments, typography, color, and other design-related topics. Some of the new content includes animation, the physiology of sight, storyboarding, creative strategy, usability, website coding, multimedia, packaging and hospitality design, visual communication theory, documentary photography, visual ethics, and presentation.

One of the highlights of the book features interviews with the most brilliant and gifted designers, photographers, editors, creative directors, and other visual communicators from around the world. Bill Allen, editor-in-chief at *National Geographic* magazine, introduces the first chapter with an insightful discussion on the importance of visual communication. Rodrigo Sanchez, art director and designer of *Metropoli*, *La Revista*, *La Luna* and other magazines of *El Mundo* (Spain), opens the fifth chapter with a discussion about engaging your audience and how content should drive design; his striking artwork, layouts, and visual strategies reinforce his points. Mary Ellen Mark, an extraordinary documentary photographer (*Twins*, *Ward 81*, *Mother Teresa's Mission of Charity in Calcutta*, and *Streetwise*), speaks about her work and the challenges of making photographs today.

Gail Anderson, former assistant art director at *Rolling Stone* and currently an art director at SPOT Design NYC, is a guru of design and typography; she addresses the differences between designing magazines and posters. Charlie Robertson, branding genius and founder of Red Spider (Scotland), explains how brands differentiate products through a competitive set of choices and simplify the decision-making process. Pegie Stark Adam, who is renowned for her research in visual communication, newspaper design and redesign, and her connection to the graphics area at The Poynter Institute for Media Studies, demonstrates how to use color as "punctuation" when designing newspaper pages.

Tracy Wong, the founder, creative director, and partner at WONGDOODY advertising in Seattle, who is heralded by many as the most creative art director in advertising today, explains in a compelling manifesto why he hates most advertising. Kit Hinrichs, art director, designer, and principal at Pentagram-San Francisco, is a true visionary; he offers aspiring graphic communicators advice about editorial design. Saxone Woon, co-founder and designer at Immortal Design (Singapore) has worked across all of Southeast Asia. He addresses the importance of multicultural sensibility in packaging, hospitality design, and graphic design. Pat Samata is a designer and has taught at the Illinois Institute of Technology's Institute of Design. She and her partners—Greg Samata and Dave Mason (principals of Samata-Mason, Chicago)—reflect on the image of corporations today, investor confidence, and the role graphic design plays in marketing communication.

Pete Docter, the writer and director of *Toy Story, Monsters, Inc.*, and other animated films, provides insights on storyboarding and his

approach to directing animation. Chris Curry, the illustration editor of *The New Yorker*, talks about the importance of illustration and what it's like to work with the finest illustrators on the planet. Dave Gray, who serves as executive director of the Society for News Design, examines contemporary newspaper design and speculates on its future. Kevyn Smith, an incredibly artistic and distinguished website and interactive designer at Peel Interactive, shares his approach to user-centric design as demonstrated with his clients: Starbucks, The New York Philharmonic, Warner Brothers, Amnesty International, the Smithsonian Institute, and others.

The contributors mentioned above are just several of nearly 200 graphic communicators who speak to a variety of subjects and issues from their respective fields. Many of them are friends and former students; all of them have made precious contributions to this book. Their diverse backgrounds are in newspaper, interactive media, advertising, magazines, identity, newsletters, public relations, film, documentary photography, branding, presentation, illustration, photojournalism, packaging design, visual communication theory, typography, storyboarding, multimedia, outdoor media, printing production, documentary film, websites, animation, hospitality design, brochures, annual reports, information-graphics, logos, TV spots, Internet coding, type and nameplate design, visual ethics, film and entertainment reviews, and more. What they have in common is that they're all amazing visual storytellers and graphic communicators. Their candor, experience, insights, wisdom, and advice are invaluable; they add a special dimension to this book that you will find not only useful but inspiring.

The artwork I selected for this edition illustrates and fleshes out the chapters' concepts; it connects to the text's content in perceptive and often unusual ways. The captions for the artwork are equally revealing and address background, creative strategy, context, audience, design principles, typography, and other graphic details. Truly, the art and its discussion are intrinsic to understanding the concepts of graphic communication. Again, the artwork and other examples were created by many of the most accomplished talent

anywhere. Much of it has appeared in *Communication Arts*, *Print*, *Graphis*, and *Design* annuals, showcasing the best in graphic arts across the media. Earlier, I mentioned globalization and its imprint on our messages. Because of the global nature of today's communication, the artwork chosen comes from across the world and across all media.

Acknowledgments

It is impossible to cite everyone who has significant ownership in some piece or another of this book. There are, however, a number of people to whom I am deeply indebted in addition to those singled out earlier. First, I want to thank Ted Conover, again, for passing the torch to me, and for entrusting me to create the fourth edition of his fine textbook. I treasure his patience, friendship, encouragement, and sage advice. D.J. Stout, former *Texas Monthly* art director and current Pentagram Design principal and art director, is as gifted as he is generous and kind; his camaraderie, timeliness, and design work have always astonished me. Connie Phelps is the design editor at *National Geographic* and my patron saint of magazine design; she is also a dear friend whose help and contributions go well beyond her work and thoughtful remarks in the fourteenth chapter. Jim Parkinson and Robert Slimbach are two legends in typography and type design whose work graces the pages of this book. Like D.J. Stout, this is Thomas Ryan's third adventure contributing work to my various book projects; for that and his design prowess, resolve, and sense of humor I am, again, grateful.

I have long admired the photography, words, and courage of Steve McCurry and Cary Wolinsky; their imagery in *National Geographic* has likely awed you as often as it has astonished me. Kris Viesselman, a senior art director at *The Orange County Register*, provided significant insights on the recent redesign of the newspaper; she also teaches newspaper design at California State University, Fullerton. Tom Wheeler, a former magazine editor of *Guitar Player*, is also a professor, talented musician, colleague, and a close friend. I thank him, again, for his sidebar on visual ethics—and for many past favors and enlightening conversations. I'm especially

delighted to introduce you to Paul Carter and his incredible photography; his intuitive sense of composition and visual storytelling is second to none. He is also one of the most articulate, sensitive, and honorable men I have ever known, and I am blessed to have him as a friend.

Along with probably having the best portrait in *Graphic Communications Today*, Angela Hill works as graphics editor for *The Times-Picayune* in New Orleans; she is also an inspiring artist who could teach all of us a thing or two about the power of teamwork. Former student Dirk Barnett is art director at *Popular Science*; his typographic treatments and page designs have received a wallfull of awards; his layouts shine. Barnett's online counterpart at *Popular Science* is Peter Noah, whose candid observations and advice help make this edition a better book. Robb Montgomery teaches graduate visual editing courses at Northwestern University; he is also the art director at the *Chicago Sun-Times* and *Red Streak*. Montgomery assembled and oriented a graphics staff and was instrumental in creating *Red Streak* from scratch — all in a matter of weeks. He is deft at matching voice and design to audience, and he's a friend who made releases happen in a pinch.

Danny Lyon is a documentary photographer whose work is gritty, poignant, and beautifully composed; he has long championed the alienated, disenfranchised, and disinherited of society. I'm honored to share his images from *Conversations with the Dead* with you. Jon Sievert is another astute photographer whose work really shines on these pages; his imagery is magical. Sarah Aichinger Mangerson and Kipp Wettstein are former students and good friends who work at *The New Yorker*; Sarah as assistant art director and Kipp as assistant photo editor. Their contributions—past and present—are sizeable ones. I also offer my gratitude to Caroline Mailhot and David Remnick, *The New Yorker's* art director and editor-in-chief, respectively, for their help as well. Rob Siltanen is another University of Oregon student who has blazed a most remarkable trail; he is executive creative director and cofounder of Siltanen-Keehn. His work for Nissan, Apple, Levis, and Infiniti is legendary, and several of his TV spots have been added to the permanent collection at the Museum of Modern Art.

I would also like to thank my dean, Dr. Tim Gleason, for his encouragement and support throughout the evolution of this book. The kindness lent me by Hornall Anderson Design Works' Jack Anderson (co-founder, partner and senior art director) and Christina Arbini (media relations manager) has been overwhelming. Jack's candid discussion of presentation applies to marketing design and communication— and all media, for that matter. Patrick Coyne is the editor of *Communication Arts* (*CA*), perhaps the most widely read and most respected publication covering visual arts; he discusses the evolution of *CA* and how it has integrated Web and interactive media into its magazine and annuals. Matthew Bates is art director at *Backpacker* magazine; he has also worked at *Saveur, Civilization, Mirabella*, numerous Time-Life projects and several other magazines. He's another former student and friend whose graphic contributions make me proud.

Marc Ulriksen is a former designer turned illustrator; his sense of humor and love of dogs recur thematically in his work. I treasure his friendship, whimsy, and unique illustrative style. Several other illustrators whose works appear in this book are Anita Kunz, Al Hirschfeld, Ed Sorel, and Ralph Steadman; all of them have been heroes of mine since the first time I saw their work. Fred Hammerquist is the executive creative director at DDB-Seattle, a true creative mentor and rock climber who I am still attempting to convert to kayaking. Eric Evans is a friend who's worked on more projects with me than he probably wants to remember; he's a gifted photographer and one of my regular kayaking partners. His golden lab, Ollie the wonder dog, posed for the sixteenth chapter's opener.

Curtis Clarkson (editor) and Genevieve Astrelli (art director) invented *CMYK* magazine to offer students studying visual communication a forum for their work; almost ten years later, the publication has been through a major redesign and its circulation continues to bloom. Clarkson offers portfolio tips and Astrelli discusses their publication's redesign and offers pre-production advice. Gail Dolgin is another University of Oregon

alum; she and Vicente Franco have a tireless talent for making documentary films; their film frames from *Daughter from Danang* are appreciated more than words could ever express. The film received the grand award at the Sundance Film Festival (2003) and was nominated for an Oscar (documentary) the same year. Rick Williams is a professor, philosopher, theorist, writer, and documentary photographer. His book, *Working Hands*, is a stunning documentary that studies culture, place, and work; it is a visual highlight of this book. Like many others whose work is shared in this text, Rob Elder is former student of mine whose work sparkles; he is a film and entertainment reviewer at the *Chicago Tribune* and he affirms why this book is for "word" people, too. Dennis Dunleavy is a documentary photographer, professor, and friend; he runs the photojournalism program at San Jose State University. They are fortunate to have him.

I first met Mario Garcia in 1987 at The Poynter Institute of Media Studies, where he proved to be a most remarkable mentor; his name is synonymous with great newspaper design and redesign. His friendship and my learning from him have continued over those many years. Mark Clemens is a British friend, former student, and associate art director at *Scientific American*. He's a great designer and has a remarkable knack for conceiving efficient information-graphics and for working with illustrators and young designers. Fred Woodward has been a hero of mine since he was an art director at *Texas Monthly*; his chameleon-like designs from *Rolling Stone* are clearly some of the most profound work to ever appear on magazine pages — anywhere, anytime. Carlos Puma represents a new, multicultural flank of young, gifted photographers who continue the social tradition of documentary and photojournalism. When I first saw his work covering the Mexican rodeo, I knew I wanted him in the book; thankfully, he obliged me. The Coulter brothers, Dylan, Jesse, and Cyrus, prove convincingly that there is a DNA helix connection to talent and creativity.

I would also like to express my appreciation for the camaraderie of my colleagues Al Stavitsky, Julianne Newton, Steve Ponder, Kathy Campbell, Jim Upshaw, John Russial, Ann Maxwell, Charlie Frazer, and Todd Kesterson; all of them offered humor, compassion, and commiseration at critical moments. Todd Kesterson also shared his talents as an artist, video editor, and multimedia artist. David Funk is another friend and designer whose work I've long admired and am delighted to share with you.

To all my former students, who've taught me so much, I offer my gratitude and admiration. It would truly take pages to list them all. To be sure, there are many, many others—hundreds, in fact—who were willing to share their remarkable work in this book. I am amazed by their talent, generosity, and help in making *Graphic Communications Today* a reality.

I would also like to thank the following reviewers for their valuable suggestions, insights, and their expertise:

Meredith Davis
Graphic Design Department
North Carolina State University
Raleigh, North Carolina

Nicole Ferentz
Fine Arts Department
Loyola University - Chicago
Chicago, Illinois

Lorrie Frear
Graphic Design Department
Rochester Institute of Technology
Rochester, New York

William Padget
Chair, Visual Communications Department
Syracuse University
Syracuse, New York

Philip Ruderman
Commercial Art Department
Springfield Technical Community College
Springfield, Massachusetts

Joseph Schickel
Applied Engineering and Technology Department
California University of Pennsylvania
California, Pennsylvania

Sarah Shirley
Visual Communications Department
Katherine Gibbs School - New York
New York, New York

This preface is not complete without sharing a mini-history of the fourth edition of this book and giving proper acknowledgement to the Delmar editorial team and production staff. Being a designer, I had high expectations for the content and the design of this book. From the start, I wanted to provide readers a window into the worlds and work of artists and communicators I've long admired. Additionally, I wanted a highly textured body of artwork from across all media from those same gifted artists, designers, photographers, and other visual communicators. From the onset of this project, I carried a design blueprint for *Graphic Communications Today* in my head, which I shared with my acquisitions editor, Jim Gish. He shared my vision for this book from the beginning and guarded its integrity to the very end. That included defending its ever-increasing page count, expanded content and art, additional chapters, and special features. Jim Gish was also instrumental in helping the other editors and the publisher realize the visual potential and message of this book.

All design is a problem-solving process. It embraces change and often demands a willingness to take risks. I told Jim Gish I wanted Kit Hinrichs of Pentagram to design this book, something unheard of in "textbookdom." After several conversations with Kit, it was clear we shared similar design concerns and agreed about the function and graphic mission of the book. More importantly, we shared educational philosophies. Two weeks later, Kit Hinrichs formally agreed to design this book, despite his already slammed schedule and many clients. You are poring over the result of that vision. For that, his friendship, and for so many more things, I am eternally grateful to him. I would be remiss not to mention the countless times that Charlene O'Grady came to our aid; along with being Kit's executive assistant, she is a friend and an angel.

But there are other protagonists. Jaimie Wetzel served as my developmental editor; she kept me on task and supported our mission throughout the project, and she accomplished all of the above cheerfully, many times when I probably did not deserve her upbeat affirmation. Rachel Baker was the art and design specialist; she was responsible for keeping track of the seemingly endless stream of art that was delivered to New York. In addition, Rachel was in charge of logging and tracking each piece, along with scanning, updating third edition illustrations, and facilitating anything else dealing with the art. Another worthy Delmar team member was Marissa Maiella, who attended to details large and small, from working with biographical and website information to ironing out all the details in my travel schedule and assisting with the page proofs. Thomas Stover served as the production coordinator and orchestrated the pre-production and final edit checks. In addition, he arranged the page proof process and the printing schedule. Two tireless permission coordinators were assigned to this marathon undertaking, another reason Jim Gish walks on water. I thank Robin Sterling and Laura Molmud for handling the releases. Deborah Kantor worked as copy editor; her suggestions were wonderful. Last, but certainly not least, it was Susan Mathews of Stillwater Studio who applied Kit Hinrichs' brilliant design and stylebook to the pages of this book.

Finally, you should know that this book never would have happened were it not for Jan Ryan, my wife and soul mate of nearly 30 years. Over those decades, in addition to conceiving and raising four wonderful children, we've created books, advertising, newspaper designs, websites, magazine and newsletter prototypes, brochures, and many other materials together. Without a doubt, she's an ingenious talent, a gifted and dedicated university teacher and graphic designer. She provided constant feedback, editing, and encouragement; and, at darker moments, her reassurance drove me forward. My children have also proved resilient and encouraging over the nearly three years that it took to give birth to this book. They will be happy to see the heaps of books and research, sagging piles of correspondence, edited manuscripts, and hundreds of annuals, source books and other resources finally disappear. In reclaiming the house, they are

planning a bonfire celebration that'll likely draw the wrath of the local fire marshal.

Finally, it is my hope that the words, ideas, artists, and work in this book fuel your motivation, ignite your curiosity, kindle your aspirations, and leave you with a burning passion to create compelling graphic messages.

William E. Ryan

December, 2003

About the Authors

Dr. William Ryan has worked as an associate professor in the School of Journalism and Communication (SOJC) at the University of Oregon (UO) since 1987. He teaches visually oriented classes across the curriculum at the SOJC and has helped create the multimedia curriculum for the UO School of Architecture and Applied Arts. He holds a doctorate in media systems from the University of South Dakota. In addition, he has held the following fellowships and appointments: NDEA fellow, University of Wisconsin (Milwaukee); Kellogg fellow, Briar Cliff University; Mellon fellow, Kansas University (Lawrence); Fulbright fellow and senior lecturer, Nanyang Technological University (Singapore). He has also received numerous teaching awards, including national honors from The Poynter Institute for Media Studies, Chiat/Day, Nissan Automotive, Whittle Communications, Citibank, the American Academy of Advertising, and the Inter-

national Newspaper Advertising and Marketing Executives' Association. Ryan has worked as a writer, designer, and photographer for several newspapers; he served as the director of information and publications for South Dakota Governor's Office; and he continues to work as a consultant, photographer, and designer. His clients have included National Public Radio; Hinman Vineyards; Apple Computers; Earth Resource Observation Satellite (EROS) program; Asian Media Information and Communication Centre; Veterans of Foreign Wars; Primax Writing Instruments; Advanstar Publications; Red Robin Restaurants, International; and Silvan Ridge Wineries. Ryan has also conducted many design seminars and workshops nationally—and even internationally, in Singapore and Malaysia. His research and reviews have been published widely in a number of journals, including *Journalism Educator, Visual Resources Journal, Visual Communication Quarterly, The Asian Journal of Communication,* and *Independent Publisher.* With Tom Bivins, Ryan also authored *How to Produce Creative Publications* and *Desktop Publishing.* He's also contributed to other books.

Theodore Conover, author of the third edition, received his undergraduate degree in journalism from Ohio State University and his Master of Arts from Ohio State University. He did additional study at the Massachusetts Institute of Technology and the University of Rhode Island. Since then, he has received felllowships from the Public Relations Society of America and the American Business Press. He taught journalism and graphics courses at the University of Nevada, Reno, for 22 years and served as chairman of its journalism department for ten years. He brought much practical experience to his courses as the former owner/publisher of five community newspapers and former managing editor of a small city daily.

"Off to Lake Creek," early winter, 2003. Bill Ryan and his scarred but faithful Necky kayak. Photo by Amy Ryan.

About the E.Resource

This CD was developed to assist instructors in planning and implementing their instructional programs. It includes a sample syllabus, PowerPoint slides, quiz questions and answers, a complete bibliography, a list of additional resources, and more.

ISBN: 0766820769

Feedback

Delmar Learning and the authors welcome your questions and feedback. If you have suggestions that you think others would benefit from, please let us know and we will try to include them in the next edition.

To send us your questions and/or feedback, you can contact the publisher at

Delmar Learning
Executive Woods
5 Maxwell Drive
Clifton Park, NY 12065
Att: Graphic Arts Team
800.998.7498

This book is dedicated to Jan Ryan, who helped shape, prune, nurture, and create the book you hold. And to our four children—Beth, Bill, Catherine, and Amy—all of whom were shaped and nurtured in the same loving way.

The Power and Magic
of Graphic Communication

Visual Communication:
An Introduction

Vision: Shining Some Light
on the Physiology of Sight

Communication Models:
The Communication Process

Visual Communication Theory

Graphics in Action

*If you wait, people will forget
your camera and the soul will
drift up into view.*
—Steve McCurry

◄ *Afghan Girl*, 1985, Steve McCurry

Is it so important in this age of nuclear threat, AIDS, terrorism, and polyester shirts that magazine covers, building entrances, corporate logos, lipstick ads, or abstract collages be beautiful?

Was it important that Haydn played beautifully at Prince Esterhazy's musical soirées for 80 people? That Dürer signed his etchings in much more elegant lettering than is available from all of today's computer typesetting marvels? That Stradivari treated the wood of the violins he built for a handful of clients in Cremona in a way that hasn't been duplicated in four centuries? Yes. The answer is yes, it is important.

—Henry Wolf, Visual Thinking

The Power and Magic of Graphic Communication

This book, and specifically this chapter, will address Wolf's questions. Beauty, art, media, and graphic communication are central to our lives. They shape our images, message, identities, media, and entertainment. Compelling visual images—such as Steve McCurry's stunning photographs of Sharbat Gula—leave an indelible impression in our minds (see Figure 1–1). Words and images map the details and evolution of civilization to preserve our collective history—from

Figure 1-1
Sometimes, the more things change, the more they remain the same. The cover notes of June 1985 *National Geographic* read: "Haunting eyes and a tattered garment tell the plight of a girl who fled her native Afghanistan for a refugee camp in Pakistan." In 2002, in the aftermath of the fall of the Taliban, photographer Steve McCurry found her again, and made this powerful comparative image for the magazine's article, "A Life Revealed." Photography (both images), Steve McCurry; design editor, Connie Phelps; story by Cathy Newman. Reprinted with permission of *National Geographic*.

Previous Page
After nearly two years of freelancing photography in the Philadelphia area, McCurry quit his job and moved to Asia. In 1979, he disguised himself by donning native garb and crossed into Afghanistan to photograph the ravages of war there. To get the images out of the country, he literally had to sew the rolls of film into his clothing. The following year Steve McCurry received the Robert Capa Medal for "Best Photographic Reporting from Abroad" for work that appeared in *Time* magazine. Courtesy of Steve McCurry and *National Geographic*.

A LIFE REVEALED

Seventeen years after she stared out a former Afghan refugee comes face-to- from the cover of National Geographic, face with the world once more.

cave walls to printing, moving imagery, URLs, and digital codes. Visual images truly pervade our lives. Media also employ imagery to attract our attention and to persuade us. This chapter will provide an introduction and overview of visual communication: the physiology of sight, perception, communication models, and visual communication theory. It will also introduce you to a magazine editor, a photojournalist, a film critic, and a documentary photographer and theorist.

Bill Allen, editor-in-chief at *National Geographic*, has dedicated his life to telling stories visually. The magazine continues to set the bar for quality through its photography, writing, and graphic communication. Indeed, compelling page design and breath-taking photography are synonymous with *National Geographic* magazine. Given his long tenure there and the publication's rich, visual legacy, Bill Allen seemed the ideal person to speak to the power and magic of graphic communication. He opens the book with this poignant overview of the visual realm.

Back in the dim light of history, say 10,000 years or so ago, a nameless artist took a shard of charcoal and sketched out a bison on a stone wall in a cave in France. Elsewhere in the cave, the image-maker added a deer with a lacework of antlers and a line of shaggy ponies in flight. The world portrayed by this human hand has vanished. The images on the cave walls of Lascaux remain (see Figure 1–3). The procession of animals

moves in silence, yet resonates with unanswered questions. Did the artist intend to show a ritual? Was this a statement of survival? An expression of the sheer joy of creation itself? Perhaps the answer is even simpler, and the picture stands as a testimony of existence. I was here. I created this that you might know, admire, and fear what I have known, admired, and feared.

Might we then add to our definition of humans as the species that creates images? And what powerful pictures there are to see. Consider an image of more recent origin, and surely one of the most famous photographs we have ever published in National Geographic: *the portrait of a young Afghan refugee with haunting green eyes that appeared on the cover of the magazine in 1985 (see chapter opening art). Not only did it touch readers and evoke emotion; it moved them to action, provoking thousands of letters from readers offering help, inspiring those who saw the photograph to volunteer in refuge camps or*

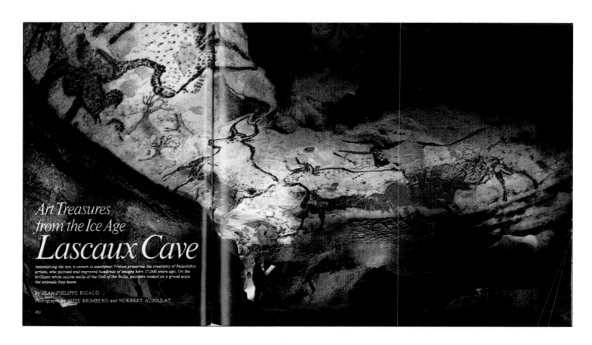

do aid work in Afghanistan. Though anchored in a specific moment in time (the Soviet occupation of Afghanistan), it is as timeless and —in its own way—as mysterious as the bison on the walls of Lascaux.

The ability to transcend place and time, to take an instant and broaden it to eternity—that is the power of the picture. When, after a last-ditch effort, we found our mysterious Afghan girl and learned her name, Sharbat Gula, a reader instinctively articulated the potency of the picture. "We are all connected through her eyes," he wrote. Like the portrait of Sharbat Gula, the most powerful images are those that reach into the cave of the heart and allow us to contemplate the world's joys and sorrows while reflecting on our own.

What else can an image do? The best ones bear witness, confirming the reality of what was. Look! An image says: Here is the face of joy. This is what pain looks like. This is what happened. A picture is a historical record. It can carry us 20 feet down under the Pacific Ocean with Luis Marden, the legendary National Geographic *pho-*

tographer who found the bones of The Bounty— *or even deeper—13,000 feet under the Atlantic to the remains of the Titanic, unseen for 73 years until photographed by Emory Kristof. Pictures allow access to worlds otherwise inaccessible. Consider Doc Edgerton's blink-in-time photograph of a bullet in mid-flight or his picture of the spiky corona of the meteor-like impact of a drop of milk. Marvel at the technical tour de force of Bruce Dale's photograph of a Tri-Star jet landing taken by a remote-controlled camera attached to the aircraft's tail, and an AIDS virus as seen through Lennart Nilsson's electron microscope (see Figure 1–4). The gift of an image is the gift of uncommon vision. It is a glimpse of a world full of wonder, both terrible and gorgeous.*

Most significantly, pictures can change the world and there are those picture-makers satisfied with nothing less. Think of the opinion-changing images of the Vietnam War broadcast into our living rooms, the scalpel-like pen of a political cartoonist puncturing the folly of government, the heart-breaking pictures of a starving African child. To search out and lay bare such

Figure 1-4

For Lennart Nilsson, photography often takes place in "inner space" via a sophisticated technology and electronic microscopes. His work includes *The Body Victorious* (with Jan Lindberg), *The Incredible Machine, A Child is Born,* and *Behold Man.* This *National Geographic* spread shows a T-cell "under attack by the AIDS virus (blue)." Reprinted with permission of *National Geographic.*

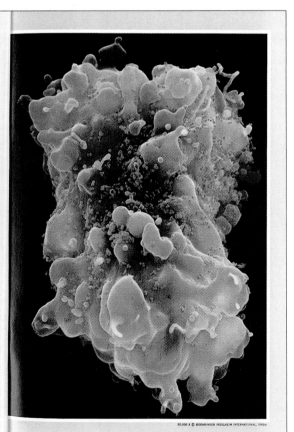

images is a particular passion, and the word that comes to mind is urgency. "I'm not just here to hold up the mirror to the world. I think we're supposed to improve the reflection," Lynn Johnson, one of our most thoughtful photographers, says. "My motive as a photographer is to make people care," adds her colleague Michael Nichols. Nichols wants people to care specifically about nature, and in single-minded pursuit of that goal spent more than a year in an epic 2,000-mile trek across central Africa. Megatransect, the three-part visual record of that journey inspired President Omar Bongo of Gabon to set aside ten percent of that nation for 13 new national parks (see Figure 1–5). Can there be any better affirmation of a life's mission than that?

I leave it to the scientists to dissect the progress of an image from the page to the eye and through the circuitry of neurons to the brain. Instead, let me suggest you think about the realm of the visual in this way: there is a direct line from the eye to the heart. We see a photograph, a segment of film, a painting. We laugh. We smile. Sometimes, we weep. It is that excitement, the expectation of finding images that touch us in some deep, meaningful way, that compels editors to weed through countless frames of film, endlessly searching for those incandescent moments that are genuine and life-inspiring. Such images can come from the raw, primitive power of a slash of charcoal on a cave wall, or by way of the sophisticated wizardry of high-tech photography. It is the message, not the medium, that matters.

Seeing is not just believing. It is learning. It is understanding. It is how we connect with each other and how we take our measure of ourselves and others. The more we see, the more generous our embrace of the world becomes. In the struggle against ignorance, which is what makes any form of visual communication matter, insight—both into ourselves and others—may be our saving grace.

Later in this chapter, Dr. Paul Lester and Aldous Huxley underscore Allen's point. Namely, the more we see and know, the better we understand one another and the world that surrounds

BY DAVID QUAMMEN

PHOTOGRAPHS BY MICHAEL NICHOLS
NATIONAL GEOGRAPHIC PHOTOGRAPHER

MEGATRANSECT
ACROSS 1,200 MILES OF UNTAMED AFRICA ON FOOT

At 11:22 on the morning of September 20, 1999, J. Michael | Fay strode away from a small outpost and into the forest in ▸

Plunging into the wild for science, J. Michael Fay of the Wildlife Conservation Society, at right, leads his survey party of Bambendjellé Pygmies through the Goualougo swamp of central Africa during his yearlong trek across the heart of the continent. His goal: to chronicle the region's still pristine forests. This is the first of three articles about the grueling journey.

Figure 1-5
National Geographic photographer Michael Nichols put his safety and well-being on the line documenting Africa's remaining pristine forests. "Megatransect" was a three-part series the publication ran of Nichols' yearlong trek through the heart of Africa. Among other things, he encountered poachers, political turmoil, gorillas, mountains, dense jungle, and disease to tell this story. Photography, Michael Nichols; design, Connie Phelps; story by David Quammen. Reprinted with permission of *National Geographic*.

us. Indeed, seeing and perception are at the heart of learning and therein lies the power. To be sure, visual communication and imagery pervade our culture.

Visual Communication: An Introduction

Although the term *visual communication* and the emphasis on visual education are relatively new curricular components, our predisposition to pictorial information goes back to our earliest messages. The evidence is as fascinating as it is beautiful: scratches and mineral pigments etched into cave walls, petroglyphs, totems, and crude ideographs that evolved from pictorial to abstract symbols.

Today it's important for you as a visual journalist or designer to be grounded in graphic communication—no matter your emphasis or career aspirations. You need to learn and apply its basic grammar and syntax. Learn the parts of sight, so to speak. Donis A. Dondis first preached this gospel almost thirty years ago.

In fact, Dondis opened her book, *A Primer of Visual Literacy*, with an insightful and important statement. One well worth repeating. She said: "If the invention of movable type created a mandate for universal verbal literacy, surely the invention of the camera and all its collateral and continually developing forms makes the achievement of universal visual literacy an educational necessity long overdue. Film, television, visual computers are modern extensions of the designing and making that has historically been a natural capability of all human beings and now seems to have been isolated from human experience."

That you are "isolated" from that visual "experience" is not surprising, nor is it anything to feel guilty about. In the vernacular, "it ain't your fault." From the time you start kindergarten until you graduate from college, you're taught the value, structure, and meaning of words—and how to put them together to compose thoughts, letters, essays, papers, and treatises. Writing is central to education. However, somewhere around the third grade, your crayons and brushes are taken away from you, and unless you happen to be studying art or design, your visual education is basically terminated.

Figure 1-6
"Empires Across the Andes," a *National Geographic* feature on the culture of the Incas, demonstrates the importance of visual literacy and the power of simple design. Parallel structure—between the stacked type in "Empires" and Wari fox whistle—hinge the pages. What else has been done to make this layout stop and hold our attention? Design director, Connie Phelps; design editor, Robert Gray; photographer, Kenneth Garrett. Reprinted with permission of *National Geographic*.

But what you missed in the way of visual education has never been more important—particularly if you plan on working in journalism, design, interactive media, or communication. To be sure, understanding through vision only appears to be an intuitive and inherent process. Because sight is effortless and fluid, we tend to take it for granted. In fact, visual communication has its own *code* and *constructions*. It possesses its own grammar, syntax, idioms, styles, and history—as well as its own language, applications, and skills to be learned. What's more, *visual literacy* demands the same study, experience, and understanding as any form of literacy. It's one thing to be able to speak a language. Another to be able to read or write it—as well as know its past and most celebrated writers. The same holds true for visual literacy (see Figure 1–6).

Visual communication and graphic and fine arts have a rich history and legacy. Just as libraries are storage complexes for the written word, museums, galleries, and our media showcase visual treasures. These resources, along with an understanding of the interrelationship between fine and applied arts, can prove invaluable to you. At the same time, it's important to you as a graphic communicator to be in touch with popular culture (see Figure 1–7).

There are a number of reasons why visual communication and design seem foreign or perhaps even mysterious to you. For one thing, few of us have had much visual education. That looms especially ironic when you consider how much our learning and survival depend upon sight. With very few exceptions, our *verbal literacy* is learned, assimilated, applied, and advanced through vision, that is, through reading and writing skills. We study letters, words, spelling, vocabulary, grammar, style, composition, writing, and literature. Grammar is central to language studies for most of our entire education. Writing begins before we start our formal schooling, first by learning to recognize a set of abstract symbols, and then to form them. Meanwhile, our visual background atrophies.

Another reason we underestimate the impact of visual communication is the effortless nature of sight itself. Our eyes process line, texture, color, shape, intricate spatial relationships, distance, and other complex visual information almost instantly. As long as we keep our eyes open, we don't run red lights, walk into telephone poles, trample people, or try to open the wrong end of a beer can.

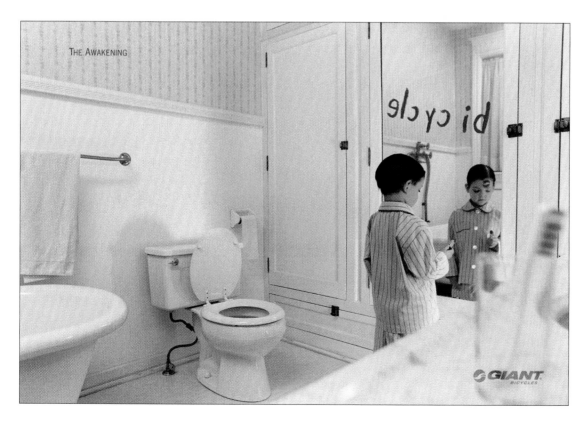

Figure 1-7
Film, music, and advertising are important facets of today's culture. In this case, Fred Hammerquist borrows directly from film for this "monster" campaign for GIANT bicycles. This DDB-Seattle ad (called "The Awakening") uses Stanley Kubrick's *The Shining* as its visual reference. The award-winning ad is as unusual as it is humorous and creative. Fred Hammerquist, executive creative director; Andy Nordfors, art direction; Matt McCain, copy; Bob Peterson, photographer. Courtesy of Hammerquist & Saffel.

However, it is both a blessing and curse that sight is so streamlined and easy. A blessing in that our visual sense operates smoothly and seamlessly; a curse in that it's often taken for granted and that sight itself is often equated with visual literacy.

Visual communication has its own vocabulary, grammar, syntax, composition, and meaning. Moreover, it possesses a unique history, literature, and heritage that precede written language. After all, it was the pictorial renditions of hieroglyphics that evolved into what we know today as an alphabet (see Figure 1–8). Happily, though, acquiring this " visual language" is considerably less painful than the average root canal. While this text is not equivalent to sixteen years of visual education nor a complete treatise on art history and aesthetics, it can immerse you in the rudiments of design, typography, composition, graphics strategy, and color. In addition, it will familiarize you with how these visual components are applied across our media.

Before embarking on that quest, however, it's necessary for you to understand several aspects of visual communication:

1. how we see;

2. how communication works via basic communication models; and

3. how theories of visual communication apply to a variety of audiences, messages, and situations.

Vision: Shining Some Light on the Physiology of Sight

Visual perception is a marvel. Perhaps Richard Gregory said it best in his book, *Eye and Brain*. "We are so familiar with seeing, that it takes a leap of imagination to realize that there are problems to be solved. But consider it. We are given tiny, distorted upside-down images in the eyes, and we see separate solid objects in surrounding space. From the patterns of stimulation on the retinas we perceive the world of objects, and this is nothing short of a miracle." That said, to be an effective visual communicator, it's important you appreciate *how* we see. Light, of course, is essential to sight, and our eyes are specifically configured to sense and receive light and color.

Light has always fascinated us. It is associated with life, death, creativity, learning, and intuition. It also plays a large part in a diverse array of subjects: mythology, theology, astronomy, physics, biology, photography, architecture, and fine arts—to cite a few. For our humble purposes, *light* is an electromagnetic radiation within a fairly narrow wavelength. Waves of light energy are emitted at various frequencies and—in addition to the visible light we see—consist of energy we cannot discern, including infrared, ultraviolet, radio, x-rays, and gamma rays. The sun is our greatest natural source of light and is perceived as colorless. In fact, it projects white light that carries all colors. Indeed, using a simple prism, light may be fractured into a complete rainbow of color.

Our eyes are amazing light detectors. Their physical construction is a wonder. The eye consists of a cornea, iris, pupil, retina, fovea, cones, rods, and optic nerve (see Figure 1–9). Though interrelated, the eye's functions are very specific.

The *cornea* is an outer, transparent sheath that covers the eyeball. Beneath the cornea lies the *iris*; it consists of an opaque diaphragm perforat-

Figure 1-8
National Geographic uses a tight shot of an Egyptian funeral ceremony for the article, "Death on the Nile." The hieroglyphics mirror the type content—death—in much the way that the understated page design reflects the story's content. Design director, Connie Phelps; design editor, David Whitmore; photographer, Kenneth Garrett. Reprinted with permission of *National Geographic*.

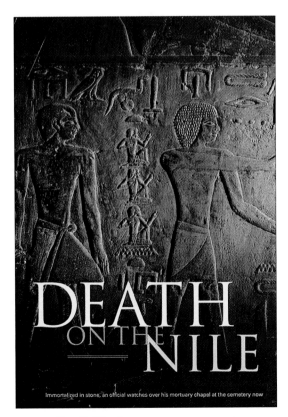

DEATH ON THE NILE

Immortalized in stone, an official watches over his mortuary chapel at the cemetery now

ed by the pupil. It is the iris that gives your eyes their pigment, a colorful mosaic imprint that—like our fingerprints—is unique to each of us. The *pupil* is the black contractile within the iris, and it controls the amount of light that passes through the eye's lens—a transparent, nearly spherical body that's responsible for focusing. The *retina* is a wall of sensory receptors—rods and cones—on the backside of the eye. *Rods*, as their name implies, are long, thin photoreceptors. Their extreme sensitivity makes them ideal for picking up sudden movement—direct or peripheral—and for seeing in the dark. You have more than 110 million rods within your retina. By comparison, your *cones* (which are cone-shaped and used almost exclusively for processing color) number around 7 million. Cones are used primarily for day vision. Rods are used more for seeing at night or in dimly lit situations. The *fovea*, though small, is the most sensitive area of the retina. It's a miniscule area positioned dead center within your visual field, and because it consists only of cones, it is excellent at discerning colors and their subtle variations, sensing

SCLERA

CORNEA

RETINA

FOVEAL AREA

IRIS

LENS

PUPIL

VITREOUS HUMOR

AQUEOUS HUMOR

OPTIC NERVE

patterns of light and dark, and for noting meticulous detail. Examine this riveting image, shot for the *Riverside Press-Enterprise* by Carlos Puma to work your fovea (see Figure 1–10).

So, how does vision work? Physiologically, light passes through the eye via the pupil and lens to the retina. The chemical interaction of the rods and cones stimulates the optic nerve, which

Figure 1-9

The human eye, a most complex and sophisticated human sensory organ, is much more than a simple lens. Its many parts and logistics are diagrammed here.

Figure 1-10

Carlos Puma captured this *decisive moment*. Look closely at his photograph; in fact, stare at the charging bull. What do you notice? You should notice your fovea working. You can't *clearly* fix on Juan Carlos Valdez's face and the bull at the same time.

What is the perspective of this image? Puma's perspective was very close. He used a 17-25 mm, wide-angle lens, so he was atop the action when he tripped the shutter on his digital camera (Nikon D-1). The bull and Juan Carlos Valdez have similar expressions. Valdez, however, appears to be moving just a tad faster than the bull—luckily for him. This image has received numerous awards, including honors from National News Photographers Association and *World Press Photo*. In fact, *News Photographer* magazine ran the image on its cover recently. Carlos Puma, a photojournalism graduate of California State University at Long Beach, has freelanced for the *Los Angeles Times* and is currently a senior photographer for the *Riverside Press-Enterprise*. © Carlos Puma.

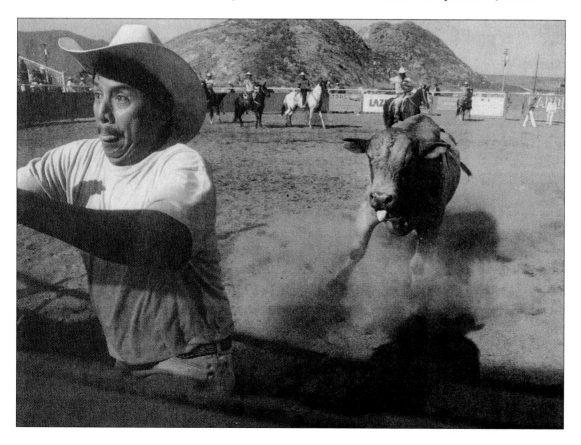

Figure 1-11

Carlos Puma is a native of East Los Angeles, CA, a United States Navy veteran, and a graduate of the United Naval School of Photography (1985) in Pensacola, FL. In 1993, Puma earned his BA in journalism with a concentration in photography from California State University, Long Beach. Freelancing and internships at the *San Gabriel Valley Tribune*, *The Idaho Statesman* and the *Los Angeles Times* helped land him a position as a photojournalist at *The Press-Enterprise* in 1994. In a relatively short time, Puma has established an enviable shooter's reputation. His work has been recognized by the Society of Professional Journalists, Greater Los Angeles Press Photographers Association, California Press Photographers Association, California Chicano News Media Association, National Press Photographers Association, and World Press Photo. In 2001, the Inland Empire Hispanic Image Awards honored him as "Journalist of the Year." Currently, Puma is the president of the California Press Photographers Association. Carlos, his wife Heidy Puma, and their two children—David Cuauhtemoc and Diego Meyyotl—reside in Riverside, CA. Carlos Puma portrait by Kurt Miller.

Carlos Puma

Photographer Carlos Puma's vision, heart, and social sensibility have served him well. He has managed to integrate his Latino background and cultural acumen into much of his work. He represents a new, multi-cultural flank of young, gifted shooters who will continue the social tradition of documentary and photojournalism established by the masters.

I believe I am a storyteller. It just happens that photography is the medium in which I communicate. A storyteller draws on past experiences to understand the world and to come up with story ideas. Being Latino—specifically, of Mexican descent—themes of Mexican culture run through what and whom I choose to photograph. For example, the photograph of the Mexican rodeo with the bull chasing Mr. Valdez was part of a feature package highlighting Mexican culture for September 16, Mexican Independence Day. While growing up in East LA my entire family—parents, brother, aunts, uncles, cousins, and friends—would go to Pico Rivera on Sundays and enjoy the Mexican rodeo. I have fond memories of those days when I was eight years old and hypnotized by the excitement and pageantry of the Mexican rodeo. In this photograph and the others for this feature, I tried to recapture that excitement and to share that drama with a new audience. The photographs provide them a window into that rich culture that I know and love so much.

More of Carlos Puma's photographs are displayed in chapter eight.

transmits those image sensations to the brain. That's the abbreviated version.

Sight is one of our most precious gifts. However, sight (or any sensation, for that matter) is an incomplete dynamic. The other half of our vision involves perception—or how we understand and filter what has been sensed visually, so that we can identify the sensation. Seeing something blankly is one thing; understanding or perceiving its meaning is entirely different. This point also makes a strong case for how important words are in conjunction with strong art. Examine this compelling Paul Carter image (see Figure 1–12). Has there been a fight? An explosion? An accident?

Our brains utilize a number of things to make sense of the world and what we see, including size, shape, figure-ground relationship, form, texture, patterns, and color. Think of how your brain would identify a lemon or bicycle using some of these tactics.

From birth onward, our visual perceptions are intricately tied to learned information: social imprinting, experience, culture, education, media, environment, and other "learned" associations. Perception's mission, simply stated, is to order the flood of sensual information we receive and filter it through our learned knowledge and experience.

Mind you, vision is a sophisticated and very complex dynamic that happens nearly instantaneously—and unconsciously. While sight is closely braided to how we recognize and understand reality (or at least our version of it), it is but one piece of a very complex process.

Communication Models: The Communication Process

There are wonderful readings and research on how we communicate. Some of the pioneers and more celebrated scholars in the area of communication models and theory include Wilber Schramm, Marshall McLuhan, Thomas Bohn, Harold Lasswell, Paul Messaris, Claude Shannon, and Warren Weaver. Bohn's model is

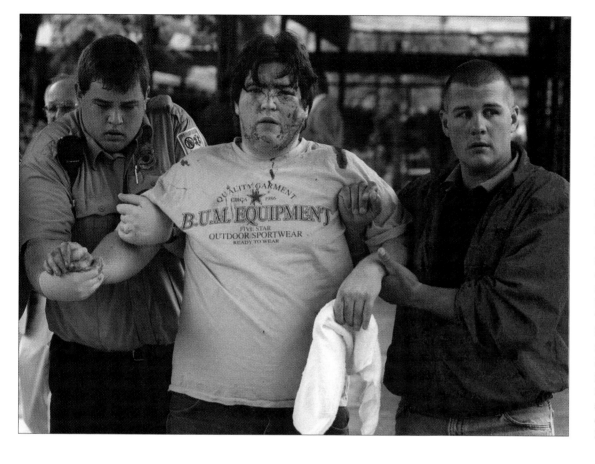

Figure 1-12
This photograph is one of several compelling images that Paul Carter shot while covering the Thurston tragedy. Ryan Atteberry was one of many students that Kipp Kinkel had shot during his rampage at Thurston High School. Carter reflects, "Bloody from a gunshot wound to the face, Thurston High School student Ryan Atteberry was led to an ambulance in the aftermath of the shootings at the school in 1998 that left two students dead. The good news is that Ryan made a full recovery." Carter, *The Register-Guard,* and its photography staff were runners-up for a Pulitzer award for their coverage of this story. Courtesy of Paul Carter.

Figure 1-13
Diagram of the Shannon-Weaver model.

perhaps the most sophisticated of them all, while the Shannon-Weaver model is more common (see Figure 1–13). For our purposes here, however, suffice to say that a complete communication consists of five parts: sender, message, medium, receiver, and feedback—or some way to indicate that the message was understood (see Figure 1–14). Omit any of these components and the communication will likely be misinterpreted or fail completely.

Sender and Message: Speaking Clearly
As the sender of a message, what do you need to understand to cobble together a clear, effective communication? Actually, several things. For starters, what's your point? Is it to design packaging for KAZI—a malt-based fruit beverage—for a young, upscale audience? Are you documenting the unique, nomadic but nearly invisible lives of acrobats in a Mexican circus? Is your mission to sell the power and clarity of

Figure 1-14
Communication model.

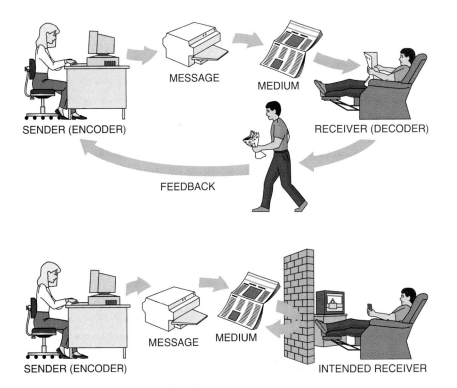

Alpine auto stereo systems? Or might it be to establish an interactive website to impart the image and provide the schedule and itinerary of the New York Philharmonic?

Your first step is to figure out what you want to say, how you want to present it, and how best to say it. Brainstorm. Research the topic. Conduct interviews. Build outlines, scripts, scenarios, and word association lists to help you organize and articulate your message. Establish what you want to say and devise a compelling and appropriate way to communicate it. Understand, too, what's expected of the receiver. Does the packaging look distinctive, hip, colorful, and appropriately alluring? Will the audience have a better sense of what it's like to be part of a traveling circus? Do you want them to own an Alpine receiver/CD changer? Are they motivated to save and use the Philharmonic schedule or take in a concert at Carnegie Hall?

Next, you need to establish how the words, type, artwork, graphics, and color can best stop and motivate that *particular* audience. No matter what your mission, medium or target is, the work needs to be simple, clear, and credible. Finally, it's crucial to make certain all these components are pulling in the same direction.

Hornell Anderson Design Works utilized hot neon color, edgy type, and peripheral materials to launch KAZI; they wanted the product to have its own glow (see Figure 1–15). Mary Ellen Mark traveled and lived with the humble Mexican circus performers whose lifestyle she documented (see Figure 1–16). Tracy Wong—partner, art director, and creative directory of WongDoody, Seattle—articulated a clear mission statement in his creative strategy for Alpine: "Our challenge was to take Alpine's heritage of product excellence and use it to create awareness of the breadth of the company's product lines." The other challenge was to communicate something about the power of Alpine's car sound systems (see Figure 1–17). Kevyn Smith, partner and creative director at Peel Interactive, captured the attention and imaginations of the media people of the New York Philharmonic by distilling the essence of the Philharmonic with spec work for them. Smith notes, "The Andre Kostelanetz: A New York Philharmonic original website was designed very formally to mirror the New York Philharmonic's existing brand without straying too far from the tone of their primary Web presence. The color scheme is based upon the

Figure 1-17

Composition plays a subtle but very effective role in selling the power of Alpine's auto stereo system. How? What are the visual cues? Why do you think creative director Tracy Wong used space the way he did in this award-winning ad? Work created by WongDoody, Seattle. Creative direction, Tracy Wong; art direction, Eric Goldstein; copy, Tor Myhren; production manager, Melary Bennett. Courtesy of WONGDOODY, INC.

Figure 1-18

Web and interactive design boast a mix of media tools: art, sound, text, links to other media, video, and email. But even isolating a single frame or page of a website design can tell you a great deal about it. After all, media succeed or fail based upon how well they use design, color, and type. Kevyn Smith, creative director of Peel Interactive, uses a number of interesting strategies to properly project the image of the New York Philharmonic on this website panel. How? Does it speak in the right voice to its audience? Why? Break down the components of this design: color, type, style, and use of space. Courtesy of New York Philharmonic/Peel Interactive.

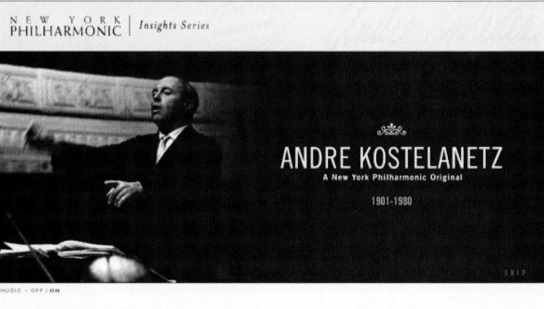

Philharmonic's existing brand palette, however, the project's final color scheme was augmented to make the site more distinct and give it an independent flare. This new online series is meant to be an intuitive, engaging, and memorable experience for visitors. Another, equally important, reason for the site's more formal design is the necessity to appeal to the Philharmonic's sophisticated audience, who we felt would enjoy a clean and simple interface that provides an ease of usability by presenting the content in an organized, elegant fashion" (see Figure 1–18). Suffice it to say that Smith and Peel Interactive nailed the contract.

Of course, there is a lot more to understand as the sender of any message. But the point is clear: know your mission, audience, purpose, and intended reaction—and communicate that message effectively and efficiently.

The Medium is the Message and The Medium is the Massage

Marshall McLuhan was the anointed media guru, socio-cultural theorist, and spokesman of the postliterate electronics age—along with being a professor and director of the Centre for Culture and Technology at the University of Toronto. He is also a widely published author whose works include *The Gutenberg Galaxy, Culture Is Our Business*, and *The Mechanical Bride*. He asserted that the medium is the *message*. The medium literally shapes the message by its channel, audience, and inherent nuances. McLuhan on radio, from *Understanding Media*: "Radio affects most people intimately, person-to-person, offering a world of unspoken communication between writer-speaker and listener. That is the immediate aspect of radio. A private experience." Contrast that to film, which also happens to be very private: "The movie is not only a supreme expression of mechanism, but paradoxically it offers as product the most magical of consumer commodities, namely dreams." McLuhan also considered the medium to be the *massage*—the kneading, manipulation, and literal shaping of the culture and our relationship to it.

Not too long ago, messages and media employed the "common denominator" tactic,

directing advertising, magazines, newspaper, and other publications at the largest number of people through mass communication. However, as McLuhan, Charlie Robertson and others might suggest, targeting the largest audience is not necessarily a good plan. Indeed, today our media options are enormous, and media have become more specialized—and sophisticated. What's more, consumers have become more selective.

Media tailored to specialized audiences are on the rise. *The Wall Street Journal*, aimed at business-oriented readers, continues its circulation success. A quick stroll through any magazine shop or bookstore reveals tightly niched marketing strategies to attract very unique audiences. Consider these titles: *Transworld Skateboarding, Paddler, Climbing, Architectural Lighting, Guitar Player*, or *Vegetarian Times*. Trade magazines are typically even more arcane: *Medical Device Technology, Salon*, or *Urology Times*. But neither the content nor the audience need be obscure; media can be very specialized yet have considerable appeal—examples that come to mind are *TV Guide, Smithsonian, The New Yorker, National Geographic, Wired*, or *DoubleTake*. Films, the Internet, annual reports,

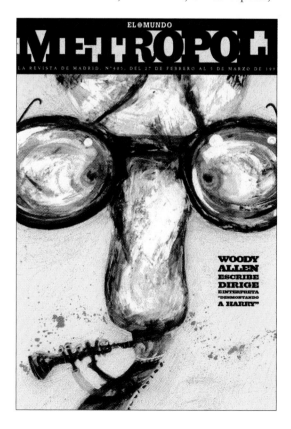

Figure 1-19
Metropoli is a specialized arts and entertainment magazine published by *El Mundo* in Madrid. *Metropoli* and its art director, Rodrigo Sanchez, push the envelope weekly with one new astonishing graphic solution after another, such as this one featuring Woody Allen, which received gold medals from the Society for News Design (SND) for best cover and best illustration. Rodrigo Sanchez, art director; Carmelo Caderot, design director; Maria Gonzalez and Raul Arias, illustrators. Reprinted with permission of *El Mundo*/Unidad Editorial, S.A.

and other media are increasingly honing their target points. Even newspapers—a medium with a broader array of information—are narrowing part of their audience appeal via special sections and weekly supplements that feature computer technology, gardening, interior decorating, "extreme" sports, entertainment, and other specialized topics or activities (see Figure 1–19).

Simply put, the medium or channel is the carrier or means of communicating the message—brochure, film, website, newspaper, advertising, annual report, magazine, outdoor billboard, photograph, package design, or newsletter. Each medium is unique, and has its own nuances, strengths, weaknesses, and applications. The American Heart Association of Chicago, for example, used a two-color brochure targeted at young people to warn them of the addictive properties of tobacco, and health implications related to smoking—heart disease, cancer, and lung diseases (see Figure 1–20). For starters, it's important that you know which medium (or

media) will best communicate your message, and, specifically, which one in particular is a logical choice for your audience.

Advertising has an entire area committed to sorting out which channel or medium to best communicate the message (ad campaign) to the target audience. It's called media planning. Advertising media planners have refined this activity down to a science. Actually, much of this information is beautifully designed and assembled in a *plans book*, which typically contains a situation analysis, research, interview results, marketing plans, creative strategies, finished ads and more information for a specific client. The book is often used by advertising agencies to address a specific problem and the agency's solution to it. The plans book is commonly part of the agency's presentation to the client when pitching new business or conceiving new campaigns, branding, or marketing proposals (see Figure 1–21).

Figure 1-20
The copy opens: "Every day, 3,000 American children become smokers." Samata Associates created this brochure for the American Heart Foundation. What have they done with color and type presentation to make this a well-targeted brochure? Pat Samata, art direction and design; Marc Norberg, photography; Liz Horan, copy. Courtesy of SamataMason/ American Heart Association.

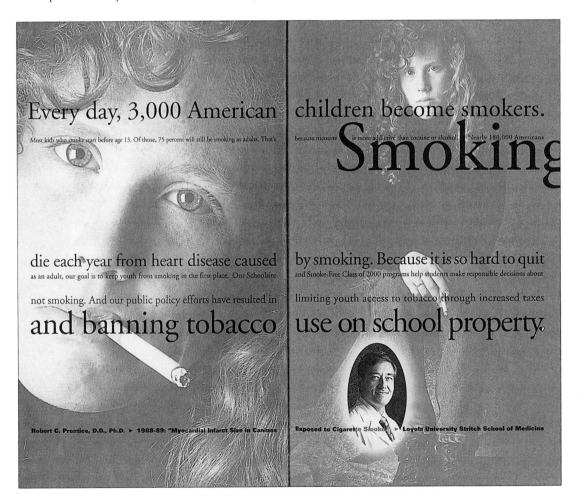

Figure 1-21
Advertising agencies
sometimes create a plans
book when pitching a
client. The typical book
consists of a campaign
overview, executive
summary, situation
analysis, research, strategy
highlights, media or
integrated marketing plan,
creative strategy, and a
campaign summary.
Upstream Advertising
created these media plans
pages for Banc of
America's Investment
Services division. Art
direction, Trevor Kuhn
and Emily Cooke;
copywriting, Ben Jenkins
and Jeremy DeForge;
CEO, David Koranda.
Courtesy of David
Koranda and Upstream
Advertising.

Media planners research the audience—its demographics, psychographics, culture, likes, and dislikes. In particular, they learn what magazines and newspapers are read by the target and which television shows and films they prefer. Media planners also research the audience's media, leisure, and purchasing habits. Through focus groups, they hope to discover audience beliefs, attitudes, and preferences—and get a sense of how they think. Specifically, they track the "prime prospects'" media usage over time. In addition, they find and establish respective costs for each of the media—and—ultimately arrive at a plan or strategy that maximizes their media budget while concurrently utilizing media channels "significantly appropriate" for that audience. It's important to note that many other media use focus groups: television, newspapers, and magazines.

For example, let's say you decide to target young males, ages 18-to-23, to launch a new steak fajita for Taco Bell. Assume, too, that the client wants to use both newspaper and television advertising. Now you've identified the audience and selected the general media avenues to drive home the sales, but which newspaper and television network will you use? Perhaps your media research suggests that college-age students don't read the local city paper but do read the campus newspaper and that it costs 70 percent less to advertise in the university publication. Bingo—a good media match. Then you conduct more research and learn that Fox-TV has high numbers of your target audience watching *Seinfeld* reruns. Maybe you also discover that *Seinfeld* reruns are available to you at a modest cost. So you order those media buys.

Advertising agencies, via their media planners, usually devise a communication mix or media mix that uses a combination of media to sell and reinforce the advertising message. *Repetition* and *recall* are crucial to the success of any advertising campaign, so recurring messages in various media help increase consumer awareness and recall. Dave Koranda, president of Koranda Communications, oversees the media planning for 7-UP and Pepsi-Cola products in the Northwest. In one instance, his charge was to widen the audience and increase market share via insightful media planning and an appropriate combination of media for the campaign.

Koranda reflected and summed up the case:

Basically, the marketing problem was simple. Although 7-UP had loyalty with a female 18-49-year-old market, they weren't seeing any growth. 7-UP wanted to capture more of the youth market and—hopefully—secure future loyalty.

The 7-UP big idea of the "Uncola" developed years before had established an irreverent attitude for the product, almost a counterculture sort of appeal. So, our concept was to build upon that irreverence to engage to a younger market. The creative strategy was to use a character well known to the audience—Orlando Jones, who was synonymous with MTV. Ad creatives unveiled the phrase "Make 7-UP Yours." T-shirts were designed with "Make 7" printed on the front of the shirt, and "UP Yours" on the back. The shirts were featured in the TV spots (see Figure 1–22).

My job as a media director was to determine which media to use and where to place the advertising. Television was a given since the spot was

going to be used to launch the campaign, so it had to be used initially. The best television vehicles were selected by examining a 'media audit' cross tabulation along with some data from MRI. This information was compared with audience data from Nielsen as well as some personal interviews we conducted with people who would be considered the core of the target market. Radio was also chosen based on formats that reflected the attitude 7-UP was trying to get across—that and the ratings information we gleaned from Arbitron.

As a result of this research, we placed a strong schedule of radio spots during the week and Saturdays with heavy airing on afternoons— when school was out. During summer months, the schedule ran more evenly during the day. Television spots were placed during access and prime times—in programs such as Real World *on MTV—programs 7-UP had never used for advertising previously.*

I also developed promotions with radio stations in several markets. Contests were tied to places where our target market were likely to hang out—such as video game parlors. Winners received "Make 7 — UP Yours" T-shirts.

The campaign not only resulted in increased sales to a new and younger market, but the same market embraced the campaign enough that the T-shirts sold well in stores and online.

Even the best conceived, researched, and produced message can get waylaid, though. There are a number of ways messages can be ambushed or short-circuited.

Figure 1-22
Attitude was the motive for this campaign for 7-UP to increase female loyalty and increase market share. "Make 7-UP Yours." T-shirts were designed with "Make 7" printed on the front of the shirt, and "UP Yours" on the back. The shirts were featured in television spots. Photography by Jan Ryan.

Technically, *any* message interference is referred to as *noise* in communication models.

Semantic and Channel Noise: Static in the Message

Essentially, there are two kinds of message interference: *semantic noise* and *channel noise*. Semantic noise deals with misunderstanding the words or their context. In England, what Americans refer to as an "elevator" is called a "lift." But semantic noise can be deadly in advertising and other media. For example, several years ago Chevrolet launched a large advertising campaign in Mexico for their new compact model, the Nova. The name Nova is derived from the French *novus* and means "new." While most Americans made that association, the Mexican and Latino audiences did not necessarily. So Chevrolet marketers were disappointed at the car's poor sales in Hispanic markets. In fact, the car's name, *Nova*, is very similar to the Spanish, *no va*, which translates as "does not go"—not a good association for an automobile. Consequently, the message and the car were misperceived by many Spanish-speaking consumers. In fact, the name was a standing joke in the Hispanic community.

Channel noise is a more common problem in the communication process. It is a noise problem inherent within or around the medium used. All of these are examples of channel noise: static on the radio, smeared ink on a page, colors or photos out of registration in a newspaper or magazine, an interactive site whose links don't work, film that slips on the projector sprockets, snowy or poor reception on a television channel, a continually crashing Web page, and serious typographical errors. Obviously, to ensure good communication, you want to avoid "noise" of any kind in your messages.

Receivers: One-on-One Coverage

As we noted in the previous section, it's important to know your audience intimately. What good are all the focus groups, research, media planning, and creative strategy if you're speaking in the wrong voice or using a visual approach that doesn't connect with your audience. Your message will fail if it misses its target, no matter how well-crafted and designed.

Good communication comes down to one-to-one interaction, so make sure you keep your message personal. It's easy to forget that all communications are one-to-one propositions, especially when you're steeped in statistics, focus groups, demographics, and other research information. Again, make sure you know the receiver. You can't speak convincingly if you don't have a common understanding and frame of reference between yourself and the audience.

In addition to secondhand research, you should interact with your audience firsthand. Hang out with them, talk to them, get a real sense of who they are and what their motivations are. To help maintain the one-to-one interchange, advertising copywriters often write in second person. Be a ruthless editor. If the words you're using aren't contributing anything to the message, purge them. Good writers aspire to whittle messages down to as few words as possible. Mike Cushman tried to make his film festival poster as minimal as he could, actually integrating words into the art (see Figure 1–23). Masafumi Sakai also wanted to keep his design stripped down, but he borrowed icon cinema frames (*Psycho* and *2001: A Space Odyssey*) to suggest or communicate the idea of film quickly and simply (see Figure 1–24).

It's no surprise that artwork—usually photography—dominates most communications. The fact is we are visually predisposed, and photography carries the weight and power of most communications—in everything from websites to magazines, identity materials to advertising. Perhaps photography's greatest strength is its inherent credibility. We tend to believe what we see, even in this jaded, digital age. But make no mistake, effective art must also possess a great idea, appropriate camera angle, and arresting composition. For a magazine section opener, photographer Kim Nguyen uses symmetry and the triangular alignment of two hands (inferring strength, balance, and equality) to speak to "Race on Campus" (see Figure 1–25).

You can increase the success of your messages by making the imagery arresting, memorable, attention-getting. Stir the curiosity of your audience. Ads Against AIDS was looking to explode notions and myths that AIDS could only

be contracted via intravenous drug use or homosexual contact. Research revealed that AIDS was being passed on through heterosexual activity as well, and that prostitution was a common source. This public service ad campaign alerted the audience of that danger though riveting art, sensible copy explaining the problem, and headlines that borrowed from film titles—

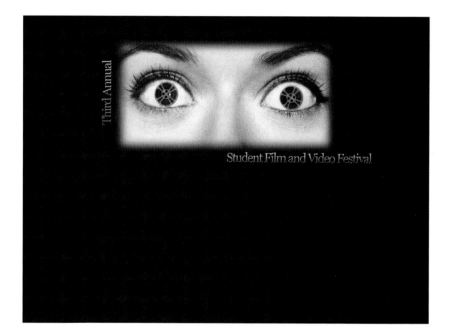

Figure 1-23
Mike Cushman chose a strong black background to set his layout apart from the rest and to integrate the typography within his artwork. Eyes dominate the art. Cushman integrated film reels into the subject's eyes. Courtesy of University of Oregon/Film Festival.

Figure 1-24
Compare this Masafumi Sakai film festival poster to the previous one. Both fulfill the directive to keep the materials visual, efficient and Spartan in design. Which do you prefer? Why? Courtesy of University of Oregon/Film Festival.

Figure 1-25
The type in this magazine section opener, "Race on Campus," is run several points larger than the rule it sits upon to allow the white space to flow through it. Triangular photographic composition (strength), symmetrical balance (equality), and touching hands (cooperation and power). Art direction, Matt Lowery; photography, Kim Nguyen. Courtesy of *FLUX* magazine.

Figure 1-26
Parallel structure is the unity ploy in this AIDS awareness ad campaign. Its mission is to explode the myths that only gay or intravenous-drug users get AIDS. Specifically, they note that AIDS may be contracted through heterogeneous sex and prostitution. The ads plot space using a matrix establishing the same amount of space for the art, headline, copy, and logo. Type specifications are also locked in place. Even the photo style, scale, and composition are unified. Finally, the film titles—*Fatal Attraction* and *Dressed to Kill*— further unify the campaign. Art direction, Kristin Holder; photography, Dustin Welch; creative direction, William Ryan.

Dangerous Liaisons, Dressed to Kill, and *Fatal Attraction* (see Figure 1–26). The result? Arresting public service ads and communication that works.

Keep the art simple. Most photography fails because it's too busy. Generally, keep subjects to a minimum, and try to neutralize backgrounds with selective focus, tight crops, blocking,

framing, or by using knockout imagery (see Figure 1–27).

Clearly, art may be used for numerous purposes, but use it not only to attract and hold attention, but to fulfill another important function for your receivers: let it flesh out what words cannot.

Artwork can also reinforce a headline designed to flag the audience. This strategy is especially critical for outdoor advertising and at newsstands, where time and situation demand immediate communication.

Feedback: "Let Me Get Back to You on That"

It's important that the communication go full circle. Ideally, the receiver should connect with the sender in some way. In a normal informal communication—two people talking—feedback is immediate and ongoing. That sort of instantaneous feedback is a bit more problematic with mediated messages, and is harder to assess at a distance.

A newspaper publisher or magazine editor may obtain feedback information in a variety of ways: letters to the editor, circulation figures, comparisons to competitors' readership, through its advertisers, and via scientific research. Websites can actually keep track of traffic from noting the

number of "hits" on a site, and get feedback from E-mail or chat rooms. A photographic exhibition or film may assess audience feedback from word of mouth, reviewers, newspaper or magazine articles, and sometimes websites—as well by noting how well the film or show pulls, that is, from its actual traffic and gate receipts. Advertising has an arsenal of tracking methods to test the effectiveness of ads—sales or promotions being two of them. In the case of direct marketing, the feedback is often even more measurable.

How's this for effective feedback? When Tracy Wong of WongDoody conceived the K2 Skis' "Rose Skull" campaign, he incorporated the Grateful Dead skull in the product design, targeting an "alternative" audience—skiers who were more concerned about the exhilarating experience of downhill than color-coordinated, Lycra outfits. The copy is borrowed from the actual fable from which the Grateful Dead acquired their name. The ad ran in January. The skis sold out in February. Effective communication was achieved through meticulous audience research, brilliant creative work, and rifle-shot targeting (see Figure 1–28).

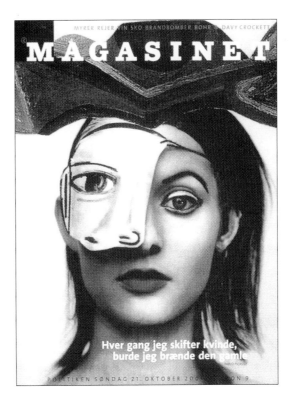

Figure 1-27

Photo illustration and brilliant design make for a unique artistic wedding in this cover for *Magasinet*, *Politiken's* magazine section. The Danish publication uses a knock-out photograph, but the mask —which adds a Picasso-like touch to the photo— blends with the painted background at the top of the page. The painted area also provides an interesting background for the nameplate. In awarding a silver medal to this publication, Society for News Design judges remarked: "This entry applies white space sophisticatedly.... The judges appreciate the fresh style of this design's illustration." Søren Nyeland, design editor; Katinka Bukh, designer; Henrik Kjerrumgaard, editor; and Henriette Lind, copy editor.Reprinted with permission of *Politiken Magasinet*.

Figure 1-28

To create an effective message or communication, several things have to happen. You need to know the audience, have a clear idea, choose the right channel or medium, and shape the message in an interesting way. This is particularly crucial in advertising, where research suggests that fewer than 10 percent of all print ads even get read. Tracy Wong and staff covered all the bases for this K2 ad, hawking their new Rose Skull skis. Tracy Wong, creative director; art direction, Tracy Wong/ Gwenne Wilcox/Debbie White; copy, Tracy Wong, production manager, Kathy Blakely Hughes. Courtesy of WONGDOODY, INC.

Signage is a medium or facet of visual communication where feedback or understanding must be inherent. It is stripped-down, hard-working visual communication, and its success depends entirely upon the receiver seeing and comprehending the meaning of the sign and acting accordingly. How many of the signs in the Hinrichs' layout can you identify? (See Figure 1–29.)

Most of the design theory, techniques, and suggestions in this book are based on years and years of feedback concerning the most attractive and effective ways of communicating messages. To build smart, effective messages, you also need to know the nuances of color, design principles, creative strategy, typography, printing, fine and graphic art history, composition, photography, and illustration, as well as possess a knowledge of the graphic side of all media. Each of these components is examined in subsequent chapters. By studying and putting the ideas to work you will learn how to create effective messages for newspapers, brochures, media kits, magazines, advertising, outdoor media, annual reports, newsletters, identity materials, film, television spots, websites

and interactive media. Materials that will make people, stop, read, look, learn, and act.

Visual Communication Theory

Understanding the basics of visual communication theory may prove to be invaluable to you. Rick Williams' omniphasic approach to visual communication is but one of a number of hypotheses of visual communication theory. His explanation of *omniphasism* refers to learning to balance the two primary cognitive systems—*rational* and *intuitive*—that the human brain uses to understand everything we encounter (see Figure 1–31).

Visual communication theory, however, has a long history of speculation and interesting ideologies about how sight works and how we make sense of visual stimuli. Many have presented treatises on vision and how we make sense of what we see. They include such luminaries, philosophers, researchers and artists as Rudolf Arnheim, Pegie Stark-Adam, Roland Barthes, Donis A. Dondis, Anton Ehrenzweig, M. C. Escher, Mario Garcia, James Gibson, Richard Gregory, Julian Hochberg, Aldous Huxley, Wolfgang Köhler, Paul

Figure 1-29

Signage is an important facet and area of design. These messages have to be read and understood almost immediately to be effective; missing the mark could even prove fatal in some instances. In a recent *@issue:* magazine, Kit Hinrichs art directed and assembled the signs for the article, "Communicating on Sight." How many do you recognize? Miss more than five and you're towed, ticketed, zapped, run over by a train, or have 15 minutes to get to the hospital before the poison kicks in. Artwork courtesy of Kit Hinrichs, Pentagram, and *@issue:*.

CMYK Magazine: The Next Generation of Visual Communicators

Visual communication is *the* mission of *CMYK* magazine. It is a publication that not only preaches and teaches the "Graphic Gospel" via articles, columns and critiques, it showcases the best student design, illustration, photography, advertising, and interactive work in the world.

Curtis Clarkson, editor-in-chief of *CMYK,* invented the magazine to demonstrate the talents of young creatives and students of graphic communications across the media. *CMYK* was first published in May of 1996 to fill a void in the world of visual art publications. The quarterly magazine is widely read in creative circles. Many students have used *CMYK* to launch their careers across the communications industry—through both internships and junior positions.

Clarkson notes, "*CMYK* allows aspiring creatives the opportunity to showcase their talents to hiring professionals—via magazine format, and in the process, gain vital industry-related insights through content written by, and about, top creative professionals."

For students, *CMYK* is a vital source of inspiration and education, and affords them a window into their generation's visual world. They see what their peers are up to, and in the process, gain vital insights from their mentors and teachers. For hiring professionals, *CMYK* is a one-stop recruitment tool—the ultimate portfolio featuring outstanding work samples from students working in a variety of media: photography, posters, advertising, magazines, illustration, and other areas.

Every piece featured in *CMYK* is hand-picked by a panel of judges that includes such industry luminaries as Cliff Freeman, Nick Cohen, Lana Rigsby, Paula Scher, Michael Schwab, Stefan Sagmeister, John English, Anita Kunz, Diane Dillon, Ryszard Horowitz, Geof Kern, Barbara Bordnick and Stephen Wilkes—to name a just a few.

Along with the artwork, *CMYK* features editorial insights on the current hottest agencies, design firms, top schools and students, plus inspirational articles written by the biggest names in the business. *CMYK* is an invaluable publication for anyone involved with the creative or design sides of graphic communication today (see Figure 1–30).

Figure 1-30
CMYK is the only publication of its kind. Along with being a vital source of inspiration and education, it showcases student work in illustration, design, advertising, collateral materials, magazine, photography, logo design and other graphic areas. Artwork here includes a *CMYK* cover and its table of contents page. Art direction, Genevieve Astrelli; editor, Curtis Clarkson. Reprinted with permission of *CMYK* magazine.

Figure 1-31
Omniphasism suggests we make sense of what we see through cognition, experience, intuition, and association. Test that theory on Rodrigo Sanchez's classic *Metropoli* magazine cover. Simplicity and attention to detail are central to its power as a wonderful visual metaphor. Notice how Sanchez uses color, type, illustration, and other graphic cues. What is your interpretation of the cover? How did cognition, experience, intuition, and association figure into your comprehension of it? Art direction, design, typography, and illustration, Rodrigo Sanchez.

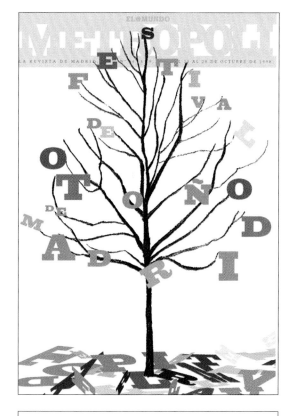

Figure 1-32
Consider these components: a field of white space, a squiggly line, a fingerprint. What do they add up to? The "thumbs up" advertising campaign that Goldsmith/Jeffrey, New York did for Identigene, a smashing campaign that improved market share and gleaned a lot of advertising awards, including a first place CLIO for Health Care Services-print. So how does Gestalt work here? Simple: "The whole is different from the sum of its parts." Gary Goldsmith, creative director; Dean Hacohen, copywriter; Noam Murro, art director; Noam Murro and Dean Hacohen, illustrators. Courtesy of IDENTIGENE.

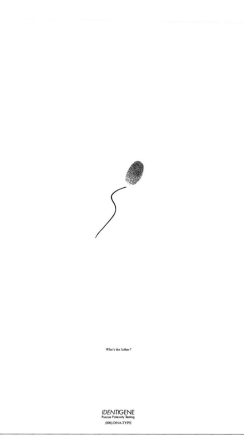

Lester, Paul Messaris, Sandra Moriarity, Julianne Newton, Robert Ornstein, Charles Peirce, Edgar Rubin, Ferdinand de Saussure, Max Wertheimer, and Rick Williams.

Theories of Visual Communication

There are different opinions about how many basic visual theories there are. Indeed, the literature and research in visual communication is enormous. For our purposes, however, we'll examine seven basic approaches to visual communication theory: Gestalt, semiotics, constructivism, ecological theory, cognitive theory, the Huxley/Lester model, and omniphasism.

Gestalt: Organizing the Parts into Meaningful Wholes

Gestalt (from the German "shape" or "configuration") philosophy is based upon the analysis of visual stimuli, observation, and response. Central to this philosophy is Max Wertheimer's notion that "the whole is different from the sum of its parts." This theory of perception emphasizes that we "see" or make sense of the world around us through the interaction of sensations from our eyes, brain, and memory. Gestalt speaks to the conundrum of how we can assemble completely different parts, pieces, or lines and comprehend the stridently different components to make a seemingly logical new whole. That is precisely what Goldsmith/Jeffrey, New York did for their client, IDENTIGENE (see Figure 1–32).

In effect, we collectively organize parts of what we see—via shape, line, similarity, association, their order (including sorting out foreground from background), proximity to one another, and their collective direction—into a new whole.

Visually, the brain is predisposed to making sense of what we see by reducing it to its most intelligible or simplest *form*. So, when presented with a bicycle tire, for example, Wertheimer might suggest our eyes would focus initially on the circular shapes—tire and axle, then see the lines (spokes) and think "bicycle tire." Or take the case of spectacles set atop a table, the Gestaltists might submit that we see the two circular rims and glass shapes, and because of their close proximity—and curved lines of the

nose bridge and temples—our brain assembles the parts and reads, "glasses."

The basic tenets of Gestalt have obvious connections to various strategies used in design, layout, photography, and cinematography compositions. For instance, juxtaposition, repetition (that is, employing repetitious shapes, motifs, and patterns), circular form, and framing are commonly used to attract or hold our vision in all our media—particularly in design, photography, and cinematography (see Figure 1–33).

Semiotics: What's Your Sign?

Semiotics—the science of signs—is an older theory of visual communication and for all practical purposes dates back to pictographs, but, like Gestalt, it has many contemporary applications. The word is derived from the Greek words *sema* (or semeion), meaning "sign," and *semelotikos* (observer of signs). From a semiotic point of view, a sign is anything that stands for something else.

Most anoint American philosopher Charles Peirce as the modern founder of semiotic theory. He suggested that there are three kinds of signs: *iconic*, *indexical*, and *symbolic*. Icons resemble what they signify. Pictures, illustrations, photographs, and film are iconic. An indexical sign suggests a causal or other connection to something that we can figure out. Ashes, for example, are a sign of fire; layers of brilliant colors in the sky suggest sunset. Symbolic signs have to be learned: a crucifix, Star of David, or crescent and star signify Christianity, Judaism, and Islam, respectively. The three-pointed star and "swoosh" are corporate logotypes and branding devices for Mercedes-Benz and Nike. The sheriff's badge is also symbolic of something beyond a simple star.

Because our vision is fluid and user-friendly, few of us think much about how we decipher or interpret what we see, but the science and deciphering of signs is a complex proposition.

Figure 1-33

These two newspaper layouts apply a variety of Gestalt tenets: shape, line, similarity, association, and proximity. Gestalt is largely about how we make sense of parts, particularly as they help us make sense of a larger picture. Which ones can you identify? Visual communication theories aren't just abstract concepts, they have real world design applications. (Left) *The Best of Newspaper Design #23* jurors said it best: "These well-edited photographs re-create the rhythm of one man's music at different points of his life. The presentation is an elegant narrative. It avoids the tricks of technology with the application of basic design skills." The Dylan layout was published by *The Hartford Courant*; Josue Evilla, designer; Jo Ellen Black, photo editor. Reprinted with permission of *The Hartford Courant*. (Right) Color implies something special here in this simple but compelling *Temas* (Cordoba, Argentina) layout. "Una década sin bipolaridad" (Ten years without bipolarity) is an overview of the political, economic, and far-reaching changes in the former USSR. Javier Candellero, designer/illustrator. Reprinted with permission of *La Voz* (*Temas*).

Figure 1-34
All of these signs are variations of the basic star, but what are their literal, implied, and deeper meanings? Mercedes-Benz logo (2nd from left) © courtesy of DaimlerChrysler AG.

astro
étoile
star
stella
stern

Figure 1-35
Different languages make a different case for symbolic signs. Specifically, there is no intrinsic connection between the word and the object for which it stands; *star, stern, étoile, astro,* and *stella* all mean exactly the same thing, but if you've not learned the code to interpret the respective alignment of letters, you won't understand their respective meanings.

Consider some of the examples mentioned in the previous paragraph and how you interpret each of them (see Figures 1–34).

Clearly, there are some *visual* connections with the configuration of the Star of David, logo, badge, and the flag. Take the six-pointed star. To school children and many others, it's simply a star. However, it stands for something completely different to many people. It's equated with the Jewish people, the state of Israel, and an entire religion. Similarly, the three-pointed star—a logo or trademark for Mercedes-Benz—represents far more than just a car. Its association also suggests something about those who drive that automobile. It's also a status symbol. Likewise, the sheriff's badge is more than a simple shield; it stands for law and order. The flag is an icon, and at the same time it's a symbol of a nation that is capable of conjuring up emotional feelings, patriotism, pride, and a sense of place. In some cultures, though, that flag may produce the opposite feelings. In all of these instances, we have to *learn* the association of the sign.

However, there is still another way to represent the concept of star (see Figure 1–35). The letters and word *star* have no inherent connection. That is, if you didn't understand the abstract symbols we know as the alphabet or read English, you'd have no idea of what it meant. There is no intrinsic connection between the word and the object for which it stands. For example, what if you saw the word *stern, étoile, astro,* or *stella*? Actually, all those words mean "star," in German, French, Spanish, and Italian, respectively. In each instance you have an example of a sign learned through language and an alphabet—more signs. So the word *star* is also symbolic.

Sometimes, though, as underscored in research conducted by Sandra Moriarity, Peirce's semiotic borders overlap (see Figure 1–36).

Another proponent of semiotic theory was Ferdinand de Saussure. He suggested that signs were integral in our day-to-day social interactions. Saussure and Roland Barthes posited that a sign has two aspects: the *signifier* (presentation or expression of an image, sound, or word) and the *signified* (its meaning: the idea or intrinsic emotion conveyed). Briefly, the signifier expresses or presents the sign, while the signified is the idea, the meaning itself.

Leo Burnett Advertising employed semiotics in their ads for Marlboro cigarettes in a powerful and memorable way—and—for the most part, it was accomplished without the use of words. The signage equated the Phillip Morris product with masculinity. Ironically, the cigarette brand initially was to be targeted at women. The imagery consisted of two main elements: the handsome, rugged cowboy (usually atop a horse), and a pictorial backdrop of remote, equally rugged landscape. In these instances, the association is simple, direct, and suggests masculinity, freedom, individualism—the embodiment of Jeffersonian spirit. Although this ad campaign was a total fiction, the image and romanticism sold not only cigarettes, but suggested that those who smoked them were virile, independent, and free.

Chiat/Day also used semiotics adroitly in their "Think Different" advertising campaign for Apple Macintosh. The words were minimal and the message simple. Each ad featured a genius who thought quite differently from mainstream culture; some of the people featured were Pablo Picasso, Amelia Erhart, Bob Dylan, Mohammed Ali, Jim Henson, Albert Einstein, Buckminster Fuller, and John Lennon. Apple, long thought of as a renegade computer maker, equated the company with societal renegades and freethinkers. What are the signifier and signified in

modeling, shadows, and textures within a field, are the two most important components of Gibson's theory. Carlos Puma's image of children playing in the river uses spatial cues like scale, lighting, textures, and shadows (see Figure 1–39).

To Gibson, light and scale helped define space and our perception of it. He felt our perceptions were more a result of how light affects what we see. According to Gibson ("Purple Pearls" musings and *The Psychology of Perception*), the literal view we have of the world changes as we move through our environment. Subtle shifts in lighting, size, juxtaposition, color, depth, and detail help us make sense of what we see and where we are. The gradient detail helps us assess scale, size, distance, and ultimately our relationship to all that's around us.

Cognitive Theory: We're All Mental

In no small part, *cognitive theory* is often associated with robotics, artificial intelligence, interactive technology, and computers. Indeed, the latter are often compared to our brains and even structured or circuited similarly.

Cognitive theorists moved beyond feeling that perception was simply a result of visual stimuli. Instead, they maintained that perception involves myriad mental processes—interpretation, memory, comparison, salience, association, inventory, analysis, and recognition.

One of the more interesting theorists among this group is Dr. Richard Gregory, a professor of neuropsychology from the University of Bristol. His experiments and writing (*Grand Illusion* and *Eye and Brain*) suggest that we understand what we see through a mental process whereby the brain is constantly "on the lookout" for things with which it is familiar.

Our brains seek objects, patterns, past associations, and congruity among objects or persons within a scene to help us perceive the world. Gregory explains: "We can see in ourselves the groping towards organizing the sensory data into objects. If the brain were not continually on the lookout for objects, the cartoonist would have a hard time. But, in fact, all he or she has to do is present a few lines to the eye and we see a face, complete with an expression. These few lines are all this is required for the eye—the brain does the rest: seeking objects and finding them whenever possible. Sometimes we see objects that are not there: faces in the fire, or the Man in the Moon."

Gregory maintains that perception isn't resolved by mere stimulus. It involves memory, deduction, and a sorting-out process. He underscores, however, that this method goes well

Figure 1–39
Most of us can identify with the freedom, fun, and terror of a kid's leap from a rock into the river on a blistering hot August day. Note the environmental and perceptual cues. Courtesy of Carlos Puma and the *Riverside Press-Enterprise*.

beyond simple identification. "It seems clear that perception involves going beyond the immediately given evidence of the senses; this evidence is assessed on many grounds and generally we make the best bet, and see things more or less correctly. But the senses don't give us a picture of the world directly; rather they provide evidence for the checking of hypotheses about what lies before us. The Necker cube is a pattern which contains no clue as to which of the two alternative hypotheses is correct: the perceptual system entertains first one then the other… and never comes to a conclusion (see Figure 1–40). Perceiving and thinking are not independent, 'I see what you mean' is not a puerile pun, but indicates a connection that is very real."

Seeing, perception, and meaning are important to Gregory, but not quite as important as they are to the Huxley-Lester model.

Huxley-Lester Model:
"The More You Know; The More You See"
Aldous Huxley, along with being an important novelist and writer, was an ethicist, philosopher, and scientist. He came from a lineage of scientists, and had his vision been better, he'd have likely pursued a career in experimental science. Although later in life he suffered several attacks of *keratitis punctata* (an acute inflammation of the cornea), Huxley first experienced blindness from a streptococcus infection in 1910 and learned Braille soon thereafter. His problems with sight led him on a quest to better understand how we see, which included writing the book-

length essay, *The Art of Seeing*, in 1942. However, blindness manifested itself in his fiction, too—*Eyeless in Gaza*.

Huxley's theory suggests that sight and thought are inseparable. As Paul Lester notes in his fine book, *Visual Communication: Images with Messages*, the stages of Huxley's theory included *sensation*—the physical dynamic of your eyes taking in light; *selection*—consciously concentrating and isolating the focus of your vision; and *perception*—grasping or understanding the significance of what you see. Simple but lucid, Huxley's formula was "sensing + selecting + perceiving = seeing." When we put all these components together, we can make sense of what's in front of us. Often words are an invaluable part of how we make sense of visuals. Weegee (real name Arthur Felig) was a quirky but talented photojournalist who made New York City his personal turf. An inordinate number of his photographs were shot at night, and their content often consisted of suicides, fires, murders, arrests, and street photography. One of his more celebrated images shows a crowd of people seemingly struggling to get closer to the camera—or to get away from it. The expressions of those in the photograph—children, teenagers, adults—run the gamut: excitement, torpor, horror, ecstasy, hilarity, sadness, and indifference. What do you make of this image? Don't read the caption until you've spent a minute or two trying to decipher the image. How do the words affect your interpretation and perception of the image? (See Figure 1–41).

Perhaps Paul Lester's interpretation and discussion of Huxley's essay and visual theory best illustrate and resolve *The Art of Seeing*. Lester places more emphasis on memory and how association helps make visual messages understandable. In fact, he affirms and improves Huxley's theory. In Lester's text, a circle of words demonstrates Lester's refined theory: "sense • select • perceive • remember • learn • know • sense"— and so on. The cycle is an on-going one (see Figure 1–42). Lester concludes, "Images have no use if the viewer's mind doesn't use them. As future image consumers and producers, you will want to see images that you remember and make images that others remember." Amen.

Figure 1–40
The Necker Cube is a visual conundrum that Dr. Richard Gregory uses to make his point about how we perceive the world around us—namely, that "perceiving and thinking are not independent." Gregory has written hundreds of essays and papers on perception and more than a dozen books, including *The Artful Eye, Eye and Brain: The Psychology of Seeing, Oxford Companion to the Mind*, and *Illusion: The Phenomenal Brain*.

Figure 1-41
This is one of Weegee's most renowned photographs; the power of the image lies in its ambiguity. It presents a visual riddle. For each emotion that seems to be captured in the photograph, there seems to be an opposite feeling—and therein lies the conundrum. Your eyes retrace their pattern back over each face and gesture and try to add up what the photograph means. It's a vicious circle, until you learn its title—*Their First Murder*. Courtesy of Weegee/Getty Images.

Figure 1-42
Using the Huxley-Lester model of "the more you know, the more you see," deconstruct and interpret these *Metropoli* covers. Rodrigo Sanchez, art director, designer and illustrator; Maria Gonzalez, designer; Carmelo Caderot, design director. Reprinted with permission of *El Mundo*/Unidad Editorial, S.A.

Figure 1-43

Rick Williams has worked as a commercial and documentary photographer for over thirty years. His award-winning photographs have been displayed internationally, and are in the permanent collections of major museums. Williams' photography has also been used in advertising campaigns and annual reports for multinational companies. He has published two books of photographs, *Contemporary Texas: A Photographic Portrait* and *Working Hands*, a personal, twenty-year documentary examining transitions in Texas culture. His theories on visual communication have been widely published. He has taught and lectured at universities across the country. His book with Dr. Julianne Newton on visual communication was published in 2004. Photograph by Kate Williams.

Omniphasism: Rick Williams

In many ways, Rick Williams takes the best pieces of the earlier theories discussed here, shakes them up along with some of his ideas, and reassembles a most compelling case for omniphasism (see Figure 1–43).

For me, the real power of visual communication is to create—that is, to stimulate new thoughts and meanings in the imaginations of others. How imagery works in the mind's eye to evoke new perceptions of reality and to motivate new acts, and new ways of being is just beginning to be understood. Through media convergence, cognitive neuroscience and related areas of study, we are beginning to understand the powerful influence imagery has on individu-

als and upon culture—through our imaginations and through the media that pervade our lives. No matter if it's created through words or a lens.

If we think of the twentieth century as the visual century, then now is the time we must begin to understand how visual intelligence affects our perceptions of reality and guides our behavior. Neurobiologists are discovering that visual intelligence is our primary intuitive intelligence. It shapes who we are and what we do. Reason is a secondary response. Extensive research has revealed that visual images are processed in the brain differently than how our rational thoughts are processed. Vision occurs initially on unconscious levels. The brain uses visual, intuitive intelligence to learn and to create or connect to unconscious memory that helps us make decisions and guide our behavior—before the rational mind is even aware that we have seen anything.

As visual communicators and consumers of visual messages, we must realize that visual intelligence is as critical as reason to our understanding of ourselves and the world around us, as well as to the sustainability of our communities and our earth.

To address this issue, I developed a theory of visual communication and cognitive balance that I call "omniphasism," which means "all in balance." Cognitive invokes knowing, while omniphasism refers to learning to balance the two primary cognitive systems that the human brain uses to understand everything we encounter. I call these two ways of knowing or thinking rational and intuitive. Our rational intelligence employs logic to know and understand the world and ourselves. Linguistic and mathematical intelligences, for example, are highly rational. On the other hand, intuitive intelligence gleans knowledge without having to employ reason. Visual and musical intelligences are excellent examples of primary intuitive mentality. In these instances, we see, know, and feel without having to think or deliberate over the stimulus. That is intuitive.

Of course, you may bring vision into the rational mind and think about what you're seeing or hearing in logical ways. This integration of intuitive and rational processes is the balance that creates whole-mind processes that are used by scientists and artists to solve problems and create new ideas, art, designs, and products. For instance, a poet uses language that is rational in structure but that creates visual images in the mind's eye. Physicists and mathematicians explore the existence of black holes and fourth and fifth dimensions by integrating math with intuitive vision. But, we can (and often do) understand things through our vision without ever thinking logically about what we have seen or learned. In fact, our vision is often used unconsciously.

Although we have always lived in a vivid, colorful world, understanding visual communication is especially important today because so much of what we come to know through our eyes has been specifically designed by advertis-

ing and media creators to carry persuasive messages. Everything—from the newspapers and magazines that we read, to packaging, advertising, film, television, the Internet, and other graphic communications that inundate us—affects our lives and our thinking. These messages attempt to define what is real and normal in terms of how we live and act. This is particularly significant because our unconscious cognitive processing system often does not distinguish between real and mediated events as it logs the unconscious memories and meanings that help us make decisions based on our intuitive cognitive understanding.

This suggests that the images that we create as designers—or process as consumers—are just as real to our unconscious, visual memory as the ones we see that are not mediated. This visual mosaic is stored in our memory system and later used to help us define what is real or fabricated—normal or unusual.

That is why the media are such powerful tools; they shape the norms and thinking of our culture. Think about it. The average American sees between 4,000 and 5,000 "mediated" images each day. For example, if those images

regularly portray women as 5´ 10˝ and 110 pounds, like the average supermodel, then this image becomes the norm by which we judge all women. If lifestyles of the rich and famous are what we most often see, then those are the lifestyles that we are most likely to define as normal and real even though they are mostly imaginary, existing primarily in the minds of media artists and in the media.

That is why media design and creativity are especially important. Because we, as media creators, understand how our messages shape cultural norms, simply knowing how to communicate effectively is not enough. We must integrate honesty into our design and create with integrity and a concern for how our messages affect others and the world we inhabit.

To try to better understand the messages in my own work I developed omniphasic processes to explore the idea of balance in some of my own photographs. I discovered a theme that permeates nearly all of my images. That theme is the balance of grace and power and can be seen in both the front and back cover images from my book (see Figure 1-44 and Figure 1-45).

Figure 1-44
Rick Williams practices what he preaches, applying his theory to his work. The cover photograph of *Working Hands, Hand on the Saddle.* © Rick Williams Photography.

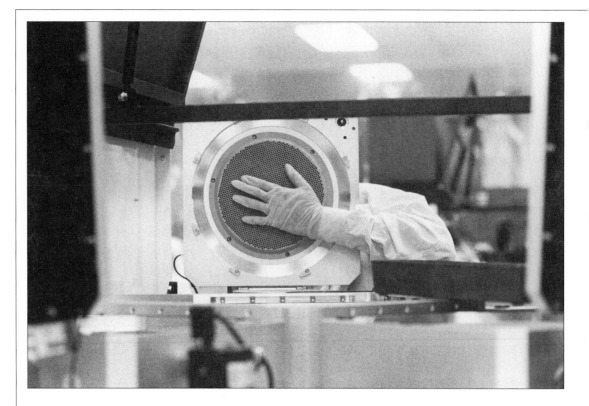

In the cover image, Hand on the Saddle, *the rugged hands of a cowboy, an American icon of strength and power, are juxtaposed with his black hat that is tilted down, covering his face. Symbolically, this suggests hesitation or inward reflection. This inward glance and the circular balance of the composition and the softness of the leather and rope next to his weathered skin, both contrasts with and complements the sense of power inherent in the iconic image and the intent to mount and to ride. In the image,* Hand on the Circle, *the power is inherent in the cold chrome and steel of the machine while the grace is apparent in both the circle and human hand upon it.*

In another set of images the metaphor of balancing grace and power is transferred to other sets of contrasting complements that suggest a cultural theme. In these images this symbolic balance is seen in the juxtaposition of rope and steel, human and animal, mud and chrome. From a cultural perspective these visual, metaphorical contrasts might suggest the concepts of balancing industry and environment, human and machine, technology and human touch (see Figure 1–46, Figure 1–47, and Figure 1–48).

I have discovered many such complementary contrasts in my photographs that reflect the same sort of balance that is suggested by omniphasism. Most of these pictures were taken long before I had rationally thought of the concept of balancing grace and power or of the omniphasic theory. Thus, this is a working example of the idea that our unconscious, intuitive minds guide our thoughts and behavior long before our rational understanding evolves.

It is the effect of visual communication on the unconscious mind that makes it so provocative and powerful. It is this very power that places the burden of visual integrity in the hands of the visual communicator.

Figure 1-46, Figure 1-47, and Figure 1-48
Both Rick Williams and D.J. Stout had a vision for *Working Hands*. The title of the book, of course, is the first clue. For Rick Williams, it was documenting three distinct groups of workers who labored in the same area of Texas: cowboys and ranchers; roughnecks and oil men; and technicians and the microchip industry executives.

When D. J. Stout designed Williams' poignant photo documentary, he immediately had a vision. He elected to build the sequencing of the photography in a triptych page architecture: to present a parallel structure to the design, and the content and context of the imagery. That is the outward structure upon which the images are chinked into place within the book's logistics and design. Williams' compositional savvy and intuition provided still another structure for the book: an inward one that subtly interrelated most of the imagery through composition. Look at these three images closely—*Bennie Roping*, *Unloading Drilling Pipe*, and *Loading Chamber Lid, Applied Materials*. Along with providing interesting cultural and ethnographic comparisons, the imagery suggests other important relationships. What are they? © Rick Williams Photography.

Visual theories help us sort out how it is we see. Vision itself is almost magic. We tend to take our sight for granted because it's effortless, seamless, and instantaneous. However, the acts of seeing and perceiving (two different things) are incredibly enigmatic. Scientists, philosophers, educators, neurobiologists, and psychologists have been trying to understand this process that few of us even consider. Indeed, the dynamic is a complex one we may never fully understand, but all of these theories have contributed important research and information to help us become better visual communicators.

At the beginning of this chapter, Bill Allen noted that imagery has powerful effects upon meaning, emotion, information, and understanding. He suggested we "think about the realm of the visual in this way: there is a direct line from the eye to the heart. We see a photograph, a segment of film, a painting. We laugh. We smile. Sometimes, we weep." At the same time, it is important to remember how we see, perceive, and understand the world around us and to further filter that visual information through our comprehension of communication models and theory. We must also understand the intent and agendas of those who originate the stream of messages that we process daily.

Graphics in Action

1. Read a newspaper and look for an article, advertisement, photograph, or page design that you feel has failed to clearly communicate its message. Bring it to class—along with your assessment of it—and analyze what went wrong and why.

2. Take the aborted communication (above) and attempt to fix or redesign it, or, develop a visual strategy to remedy the problem.

3. Look through an edition of *Communication Arts*, *Print*, *Graphis*, or *CMYK* to examine some of the showcased or award-winning design, photography, illustration, advertising, or other work. Apply what you've learned about visual communication theory to dissect 3–5 examples which you feel really utilize one or more of those theories.

4. Carefully examine a communication you receive from an organization to which you belong. It could be a sorority, club, intramural sport, or some campus group. Do you think the communication is effective? What are its shortcomings, and how do you think you could improve it?

5. Find an instance of what you feel is the most demonstrative example of *channel noise* that you've encountered in the last 2–3 weeks. If possible, bring it to class and discuss your concerns.

Be sure to consider the intended target audience. You may wish to save it as a problem/solution case to redesign later.

6. Turn back to Figure 1–32, the ad Goldsmith/Jeffrey did for IDENTIGENE. Using the concept and minimal design of the print ad, create thumbnail sketches for another 2–3 ads for this campaign. Remember, you must leave a large field of white space and come up with 2–3 *different* ideas that are related to the existing Identigene, yet completely different treatments.

7. Instructor first divides the class into 4–7 groups, and assigns a visual theory to each one. Given what you've learned about visual communication theories, look through newspapers, magazines, websites, and other media. Using some of these materials, espouse your group's theory to the rest of the class. After you've rotated through each presentation, collectively select the theory of visual communication that you most support.

8. Select a collection of layouts, photographs, magazine covers, newspapers, websites, and other media that employ Gestalt strategies. See if you can find instances of each law of Gestalt in the grouping arrangements within your examples: *continuance, proximity, common fate,* and *similarity.*

9. Working in groups of 2–3 students, revisit number six and choose the best idea each person created; then execute a fairly finished version of each "best ad" using real artwork and your computers. If the art includes photography, try to shoot your own imagery.

Answers to the frags in Figure 1.38:

Coca-Cola
Shell
Apple
U.S. Postal Service
Volkswagon
Cingular
YMCA
AT&T
NBC
Nike
McDonald's
CBS
Xerox
FedEX
Playboy
General Electric
IBM
Texaco

Graphic Communication Today:
Connecting Past Legacies

Design and Visualizing
Language through the Ages

Graphics in Action

*The painted caves were as near
the heart of Paleolithic life as
were the cathedrals and the
white churches to other ages of
humankind.*

—Wilbur Schram,
*The Story of Human
Communication*

◀ *Petroglyphs, Dinosaur National Park, Utah, 2001,
Catherine Ryan*

There is culture all around us. Pay attention.

—Hal Curtis, Wieden + Kennedy, from "A Note to Student Art Directors," Communication Arts, September/October, 2002.

Figure 2-1
D. J. Stout, sixth generation Texan, became one of the most respected designers in the world while serving as art director at *Texas Monthly* (1987-1999). Along with three national awards for "Best Photography" and "General Excellence," and graphic acclaim for everything from posters to magazine design, Stout has received recognition for his book designs, including *Mojo* and *Harvest of Animals*, the latter designed for Keith Carter. Today Stout is working his design magic as a senior designer and principal at Pentagram Design.

Previous Page
This cave painting was discovered recently on a kayaking trip on the Green River in Dinosaur National Park in north-western Utah. Photograph by Catherine Ryan.

Graphic Communication Today: Connecting Past Legacies

The earliest known art, prehistoric cave paintings, are beautiful and functional, probably serving ritual, magical, and social purposes. Schramm reflects, "The pictures were not simply art for art's sake... There is more to them than that. The cave paintings still bear evidence of group planning or social purpose. For whatever reason, they were part of the social intent of the cave dwellers." They are also the earliest examples of human communication available to us and perhaps mark the first merging of fine and applied art.

In any case, the tumultuous but long-lived association between fine and applied or graphic arts is a fascinating one. Understanding the history, culture, and movements of fine and graphic arts and their push-pull effect on each other will make you a better consumer and producer of visual messages. Hal Curtis' wisdom about embracing culture (opening chapter quote) is shared by D. J. Stout, principal and senior designer at Pentagram (see Figure 2–1).

From the very beginning of my career I have always considered myself to be an artist and to be a part of a rich artistic profession. As a matter of fact I am still kind of partial to the completely out of style term "commercial artist." I prefer it rather than the politically correct, "graphic designer," because it includes the word "artist."

As a kid I drew cartoons all the time and those cartoons became neighborhood newspapers, and that's when I got interested in journalism. When I went to college I worked for the campus newspapers drawing cartoons and creating the ads; that's when I became interested in advertising. I never saw myself as a cartoonist or a journalist, or, heaven forbid, a commercial artist. I was always

just an artist. I loved paging through art books and going to museums—and I still do. Every time I walk into a bookstore or a museum I'm inspired and influenced by the artwork and I find or rediscover art and styles that influence my art and design (see Figure 2–2).

That art legacy is the foundation of all artistic endeavors—especially graphic design.

Several years ago I served on the board of the American Institute of Graphic Arts (AIGA) in Texas, and I traveled to Chicago with a group of the board members to attend their national conference. One evening while sitting at a table talking with some of the board members, I realized that something was amiss. We had been talking for quite some time when it dawned on me that the subject matter of our discussion had mostly been some kind of high-tech gibberish about problems with computers and hard-drives and the like. It seemed to me that a bystander overhearing this discussion might easily mistake us to be a table full of computer company employees or software engineers instead of a band of high-minded artists. I had always had this romantic vision that people in my profession, graphic arts, got together at conferences to share ideas and talk about painting and photography and their experiences in the art world.

Finally, at one point during this mind-numbing, techno-babble I asked a young designer in the group, who happened to work in Houston, if he had seen one of the latest exhibitions that I had witnessed recently at the Museum of Fine Arts. It was located a block from his office. I was astounded to learn that not only had he not seen the exhibit that I had mentioned, but he'd never even set foot into any of the many rich and varied art museums in the downtown area during the entire eight years that he had worked in Houston.

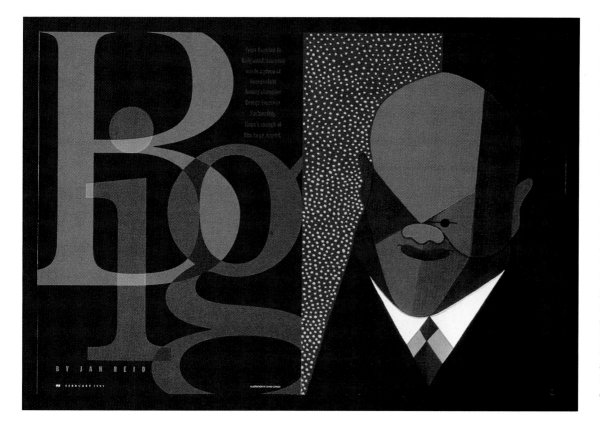

Later, when I saw his soulless, mechanical graphic design work, I realized where it had come from.

D. J. Stout's comments are as important as they are discouraging. Today, too many graphic artists, designers, and art directors have a tendency to be preoccupied with the gimmicks and nuances of computer software programs and forget their rich, on-going legacies in fine and graphic arts. Being connected to culture—both our past and present variations—is crucial to your insight, understanding, and growth. Our visual world truly is dynamic, particularly with the revolutionary changes impacting all media today. No matter if the influence comes from classic sources, such as surrealism, or popular culture and *MAD* magazine. Great, engaging design doesn't happen in a vacuum; it's influenced by all that preceded it and by what's currently happening (see Figure 2–3 and Figure 2–4).

However, some things remain constant. For example, an effective designer, creative director, filmmaker, webmaster, or graphics editor should still possess the following:

Figure 2-4

In this case, D. J. Stout and *Texas Monthly* borrow from another format—*MAD* magazine. Presidential candidate Ross Perot is portrayed as Alfred E. Newman for the cover story, "What, Me President?" In this case, Steve Pietzsch's caricature says it all: it suggests *MAD* to us via the illustration, and it presents a serious political contender in a humorous way. Art direction and design, D. J. Stout; story by Paul Burka; illustration by Steve Pietzsch. Reprinted with permission of *Texas Monthly*.

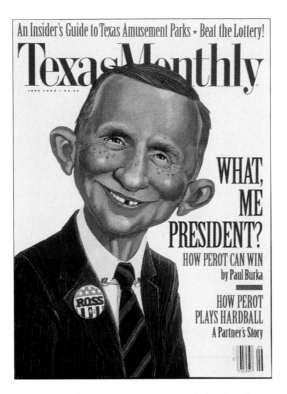

- a knowledge and appreciation of the development of visual design
- a grounding in design
- an understanding of the creative process
- an on-going curiosity and involvement with fine art
- well-developed skills in graphic tools and software

Although *visual communication* and the emphasis on graphic education in journalism and communication programs are relatively new developments, our predisposition to pictorial information goes back to our earliest messages. Indeed, we are all visually predisposed.

Design and Visualizing Language through the Ages

This chapter doesn't pretend to be a treatise on the history of design, language, and visual communication. That is a course of study in and of itself. On the other hand, it is vital that you have some background in this fascinating visual realm. Therefore, the intent of this chapter is a humble one: to offer you an overview of several of the more notable developments in the evolution of art and graphic communication. Hopefully, too, this section will stir your curiosity, open doors to that rich legacy, and compel you to study further (see

Figure 2–5). Build an art library. Make regular trips to art galleries and museums, and learn how art movements have influenced graphic design—and vice versa. Finally, study the work of today's brilliant artists and designers, such as D. J. Stout, Fred Woodward, Steve McCurry, Kit Hinrichs, Gail Anderson, Mary Ellen Mark, Mario Garcia, Connie Phelps, Mark Ulriksen, or Rodrigo Sanchez.

Evolution of Written Language: From Pictorial to Abstract Symbols

As long ago as 25,000 BC, nomadic hunters of the Paleolithic Age and the gatherers of the Neolithic Age who succeeded them, adorned cave walls and other surfaces with primitive renderings of animals, events, and mysterious shapes and patterns (see chapter opening art). These crude but moving images are found throughout the world.

Later, around 1500 BC, the Egyptians evolved *hieroglyphics*, a writing system that used pictographs to represent words and sounds. The word *hieroglyphics* is derived from the Greek words *hieros* (sacred) and *gluphien* (to inscribe or engrave). To complement their new language and visual leap in communication, the Egyptians developed papyrus, a form of paper. Indeed, many suggest that they are the first people to produce manuscripts in which words and images were combined to document and communicate information with such sophistication and detail.

Equally remarkable, the Egyptians used both pictorial symbols in their hieroglyphic language as well as sound cues, or phonograms. It is also fascinating that their sequence or line arrangement cues were intuitive and personal. For example, one Egyptian writer might inscribe a communication left to right, another right to left, or top to bottom or vice versa. In no small part, this is one of the reasons the language remained largely enigmatic until Jean-Francois Champollion's brilliant translation of the Rosetta stone in the early 1800s.

Today, the Metropolitan Museum of Art provides one of the most complete and breathtaking assemblies of Egyptian antiquity (see Figure 2–6). The complex visual language of

Figure 2-5

"Brush with Fame"—a *Texas Monthly* feature on Texas artist, art historian, and critic Jerry Bywaters, echoes 1930s-40s Works Progress Administration design. D.J. Stout used one of Bywaters' paintings, *Oil Field Girls*, to open the article. Notice how Stout applied sans serif type and minimal design to create this Swiss-inspired layout. Art by Jerry Bywaters. Story by Anne Dingus. Reprinted with permission of *Texas Monthly*.

Figure 2-6

Progress in visual communication, from cave drawings to symbols that represent events or thoughts, is illustrated by these ancient Egyptian hieroglyphs, from *The Book of the Dead*. Courtesy of Scala/Art Resource, New York.

hieroglyphics graces Egyptian art, jewelry, architecture, religion, business records, papyrus manuscripts, tools, funerary materials, and other artifacts. If you've never seen this collection, check it out the next time you visit New York City. You will need to allow at least a half-day for the Egyptian exhibit alone.

About the same period, the Chinese developed their writing system—logogram. Although less graphic than Egyptian hieroglyphics, it was also pictorial in nature. Both languages are amazingly complex. At one point, the Chinese used more than 40,000 separate characters. Today, the ideographs have been reduced to approximately 1,000. Comparatively speaking, the Egyptians worked with roughly five times as many characters. However, the Chinese did not use sound cues as did the Egyptians.

Over time, scholars and writers of Phoenicia (a middle-eastern civilization in what is now comprised roughly of Syria, Jordan, Israel, Palestine, and Lebanon) did a most remarkable thing. They reduced Assyrian *cuneiform* writing, composed of wedge-shaped characters, and Egyptian script to an abstract collection of 22

characters. Cuneiform, while not nearly as cumbersome as its Chinese and Egyptian counterparts, still used more than 500 characters. Most importantly, though, this advancement was monumental because it reduced written language to a non-pictorial, phonetic alphabet consisting of abstract symbols—characters that are the precursors to our own alphabet (see Figure 3–17).

Later, around 800 or 900 BC, the Greeks adopted the Phoenician system—with a few important adaptations. First, they converted five consonants to vowel sounds; then, for good measure, the Greeks added two other letters to their alphabet. Our word, *alphabet*, is derived from the first two Greek characters—*alpha* and *beta*.

Eventually, the Romans, who borrowed the alphabet from the Greeks, along with much of their mythology, philosophy, religion, and literature, stripped the Grecian alphabet to 21 characters and exchanged the letter *z* for what is now the *g*. Eventually, however, the *g* was restored along with the letter *y*.

Later, in medieval Europe—roughly during the tenth to the fifteenth centuries—scribes in monasteries meticulously created illuminated manuscripts (see Figure 2–7). The term, *illuminated*, is quite appropriate. These illustrations project a vivid luminescence and aura from the page; the embellished letters and backgrounds were produced from bright pigments and precious metals (typically gold leaf) and hand-rubbed and fixed to pages which were then hand-bound into books. The pages were vellum, a very thin, pressed sheet of refined calf or sheep skin. These costly books were assembled for the nobility and wealthy merchants, as well as for the monasteries themselves.

Fortunately, word of the Chinese system of producing paper from rags arrived in Spain around the mid-twelfth century. Paper, a much cheaper substitute for vellum, became widely used in books. What's more, its quality was better and the paper surface more reflective. Soon thereafter, crude picture books and playing cards were printed from hand-carved wooden blocks that were inked and pressed upon stiffened paper. These games and largely pictographic books were

Figure 2-7
This page from the *Lindisfarne Gospels* illustrates an early effort of incorporating visuals with words in the Western world. Books of the times were written and illustrated by hand. The *Lindisfarne Gospels*, it is estimated, were written in the seventh century. They were discovered on Lindisfarne Island (now Holy Island) in Great Britain. Courtesy of Art Resource, New York.

produced for the common people of Europe—most of whom were illiterate (see Figure 2–8).

As Europe slowly emerged from the Middle Ages into the Renaissance period, Johann Gutenberg had begun refining a printing process that used movable type. His press would revolutionize communication in much the same way the computer did in the late twentieth century. Gutenberg's press allowed the growing and better-educated middle class to purchase books. This technological revolution spawned a period of enlightenment that likely will never be surpassed.

But Gutenberg was more than a humble printer and inventor. He was a true designer. His two-column, 42–line Bible, published about 1455, was printed from metal-cast type. Its simple and economical design is still difficult to surpass. Within fifty years, the printing and type-setting industry had spread across the continent. Mass media was born (see Figure 2–9).

Art's Effect on Graphic Design

During the *Renaissance* (literally "rebirth") of the late fifteenth and early sixteenth centuries, painters such as da Vinci, Michelangelo, and Raphael perfected and applied the same principles of design we use today. Of course these concepts were nothing new; their origins lay in classical Greek and Roman art and architecture (see Figure 2–10). But the genius and experimentation of these Renaissance artists resulted in a flood of unparalleled creativity and art that continues to inspire designers and other artists today.

Baroque, a more flamboyant design form, characterizes the style of the seventeenth and early eighteenth century Europe. It features curvilinear forms, dramatic lighting and rich color. This lush style put its mark on just about everything: theater set design, architecture, painting, interior design, sculpture, and printed materials. Baroque exudes a rather heavy-handed and luxurious elegance. *Rococo*, a French derivation of baroque style, was even more dramatic, elaborate, and ornamental. Once again, printed materials adopted these embellished styles.

Figure 2-8
Before the invention of movable type, books and playing cards were produced in the Western world from woodcuts. This example was printed in the early 1400s.

Figure 2-9
This is the first page of the book of Genesis from the famous Gutenberg 42-line *Bible*, printed about 1455. Gutenberg designed his typeface after a manuscript style that was popular in Germany. As printing spread across Europe, many new typefaces were designed, based on the preferred styles of France, Italy, or England. Courtesy of Library of Congress.

Figure 2-10
Leonardo da Vinci's *Study of Human Proportions*, according to Vitruvius—1485-90, ink. Courtesy of Cameraphoto Arte, Venice/Art Resource, New York.

Towards the end of the eighteenth century and well into the next, life sped up. Cities were developing and technology was starting to industrialize Western civilization. Along with these changes came a rapid expansion of printing and the birth of advertising. Posters—perhaps the second mass medium—became a popular and very common form of communication.

In the latter half of the nineteenth century *Victorian* design—a more stripped down version of its immediate predecessors—became popular. The term was coined from Queen Victoria, who reigned as queen of England from 1837 to 1901. Like baroque, Victorian stylistic affectations were found in painting, architecture, print design, furniture, and many other areas—including typography. Along with being leaner and cleaner, Victorian style was rather eclectic. Indeed, everything from Gothic to baroque to geometric designs embody Victorian art and artifacts, so in that sense it was somewhat derivative. However, its simplicity and grace are timeless; Victorian design is still popular today. Notice how D. J. Stout's "El Circo" uses a Victorian-style type to anchor this *Texas Monthly's* opening spread for Mary Ellen Mark's documentary photography on the Mexican circus (see Figure 2–11 and Figure 2-12).

Then, on the heels of Victorianism, a new medium emerged that literally changed the world—and our perception of it—forever. Photography was born. To be sure, there were many photographic experiments and pioneers, but by most accounts it was "officially" placed on the visual map in 1839, when Daguerre perfected his photo process—the daguerreotype. Later, in 1880, the *New York Graphic* printed the first reproduction of a photograph with full tonal detail; the *halftone process* could transform continuous tone black and white images through the use of a screen process to *printed* images. This technique is addressed in detail in chapter eight.

Photography, along with revolutionizing all of communication, changed the world of fine art forever. Because photography, literally "light writing," was a much more detailed and graphic medium than painting and other art genres, it relieved the arts of many of their representational charges. In so doing, photography was responsible for opening the gates for modern art. It is after the arrival of the photograph that a lively array of experimental styles exploded upon the art scene: modern movements such as cubism, impressionism, futurism, art nouveau, constructivism, art deco, and expressionism—to name a handful. These new visions and philosophies dramatically affected design, as well as its possibilities and applications. Photographers—notably the photo-secessionists and Pictorial Photographers of America who wanted their medium to be accepted as a legitimate art form—sometimes adopted impressionism to make their images less graphic (see Figure 2–13).

The *impressionists* were probably the first group of artists who grew up with photography. All of them were affected by it. In fact, one of the most celebrated impressionist painters, Edgar Degas, was an accomplished photographer himself. The impressionist's experimentation with color and texture produced vibrant, even breathtaking results. As the moniker suggests, rather than fixing upon how realistic their imagery could be, the impressionists sought to capture impressions of ordinary life.

Among the many changes in visual design that occurred in the nineteenth century was the arrival of a style known as *art nouveau* (new art). Its

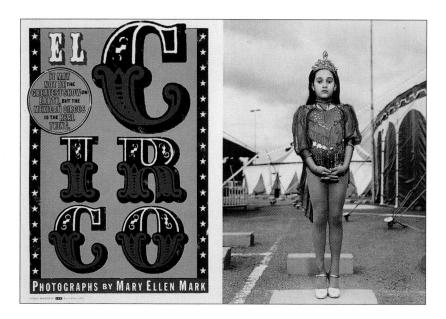

Figure 2-11
"El Circo" is doubly-influenced. The Victorian typeface is accompanied by a circus poster layout, created by D.J. Stout for this *Texas Monthly* photo essay on the Mexican Circus. The layout's deck—inserted in the playful blue circle of the opening page's type—states, "it may not be the greatest show on earth, but the Mexican Circus is the real thing." Stout's design intuition and choice of type give Mary Ellen Mark's photographs a powerful entrance. © Mary Ellen Mark. Reprinted with permission of *Texas Monthly*.

Figure 2-12
Among other things, Victorian type mixed the flamboyance of baroque styling with gingerbread edging, outline patterns, and shadowing. This type sampler page from KacKellar, Smiths, and Jordan's *Book of Specimens*, 1881, is an excellent example of type choices from this period. Compare it to the type used in D.J. Stout's "El Circo" layout, Figure 2-11.

Figure 2-13
Gullah Baptism,
Doris Ulmann.
Photography freed
the arts of their
representational mandate.
However, photographers
felt their medium was also
an art, despite the
rejection of critics and the
academy. Many adopted
"soft focus" techniques to
make their images more
painterly. Doris Ulmann
blended diffused imagery
with portraiture to
capture the quiet beauty
and mysterious moment
of not just this baptism—
but all baptisms. Her soft-
focus technique gives the
image an impressionistic
and warm feeling.
Courtesy of University of
Oregon, Knight Library
Special Collections, Doris
Ulmann.

roots were in France and Japan. It probably reached its peak of influence from roughly 1890 to 1910. Some refer to art nouveau as the bridge from the past to the future in design. Until this time, designers tended to rely heavily on old approaches to composition and style in constructing layouts.

However, art nouveau wasn't a completely original idea. Actually, it borrowed from the curvilinear affectations of baroque art, but converted them into organic patterns and nature. Art nouveau also incorporates features of Japanese art and often depicts scenes from everyday life. Notice the Japanese influence in this contemporary Rodrigo Sanchez design (see Figure 2–14). Art nouveau style was revisited and became hot among designers in the 1960's and early 1970's, particularly those working in the poster genre. Actually, the application to posters

was appropriate since much of the best original art nouveau flourished in that medium. The poster work of three of the most famous of these artists—Henri de Tolousse-Lautrec, Alphonse Mucha, and Audrey Beardsley—grace the walls of many museums today. In fact, poster work at the time was referred to as "the galleries of the streets," a very fitting description. The music scene and psychedelic movement of the 1960s and 1970s also adopted art nouveau in its posters, album covers, books and graphic design. The flowing, yet intricate outlining and interplay with subtle, often understated color, had discovered a new counterculture audience—one that would be inspired by the street work, and one which would also embrace the personalized poster format.

Will Bradley, a young graphic artist who worked as an engraver at Rand-McNally and

later as a type designer for Knight & Leonard and co. printing in Chicago, produced remarkable illustrations for *Harper's* and *The Inland Printer* magazines. Though obviously influenced by Beardsley, his illustrations are excellent manifestations of art nouveau. Like William Morris and Frederick Goudy, Bradley worked in type design, too, and had a gift for weaving type within his illustrations. Art nouveau's graceful integration of type and art is clearly one of its most memorable qualities.

Both impressionism and art nouveau had a sizeable and long-lasting impact on design. Henri de Toulouse Lautrec , for example, is difficult to label; his work is often associated with not just impressionism but also art nouveau (see Figure 2–15).

The first twenty years of the twentieth century was a time of incredible ferment and change. Politically—in Europe at least—monarchy was largely replaced by democracy and socialism. Revolutions and World War I rattled the foundations and status quo of Western civilization. Machines and technology changed everything. Airplanes, motion pictures, radio, the skyscraper, and automobiles radically transformed the face and pace of the world.

In the midst of all this evolution, chaos, and violence, it's no wonder that visual artists and designers questioned their aesthetic role and values. The emerging European avant-garde toppled art's traditional mission of representation. The visual arts teemed with new ideas, and a series of creative revolutions—many of them concurrent—emerged. Truly, the transformation of visual communication and graphic design closely parallels similar changes in twentieth-century painting, sculpture, and architecture. In many cases, the changes were as jolting as the times that spawned them.

Expressionism accounted for one of those aesthetic jolts. Erich Heckel, Ernst Ludwig, Kirchner, and Karl Schmidt-Rotluff pioneered the personal style of expressionism. These German artists had earlier been closely associated with another art movement *Die Brücke* (the bridge). Later Swiss artist Paul Klee joined them. Expressionism was unique, distinguished by its raw, almost crude, primitivism. The style was deliber-

Figure 2-14
Divan Japonis (1893) is a wonderful example of the style, media, and content of both Toulouse Lautrec and the wonderful poster work that flourished in the "galleries of the streets." Perhaps more that any other art movement, with the possible exception of Bauhaus, art nouveau married fine and graphic arts. The posters of Lautrec and others were mass-produced as lithographs. Courtesy of Digital Image © The Museum of Modern Art/Licensed by SCALA/Art Resource, New York.

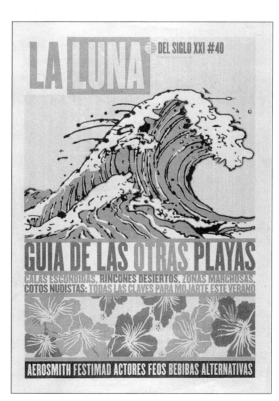

Figure 2-15
When is a newspaper entertainment section not an entertainment section? When it's a poster! This front page layout for *La Luna, El Mundo* newspaper, mixes art noveau poster style and its Japanese influences. Its fresh design turned judges' heads at the Society of News Design. Rodrigo Sanchez, art director and designer; Fredrico Dorado, designer; Carmelo Caderof, design director. Reprinted with permission of *El Mundo*/Unidad Editorial, S.A.

Figure 2-16

Expressionism espoused that life should be stripped bare and reduced to its essentials and raw truths through the artist or designer's emotions and intuition. This woodcut *Prophet*, by Emil Nolde is very representational of German Expressionism. As the *MoMA Highlights* noted: "This brooding face confronts the viewer with an immediacy and deep emotion that leave no doubt about the prophet's spirituality." © Nolde-Stiftung Seebull, Digital Image. © The Museum of Modern Art/Licensed by SCALA/Art Resource, New York.

Figure 2-17

One common tactic of expressionism was to remove the subject from its context, environment, or background, often using bold color to help express or capture emotion. Here, illustrator Andrea Ventura teams with art director Steven Heller in this compelling cover of *The New York Times Book Review*. The deck tells us, "A biography of Primo Levi explores the paradoxes of an analytical mind exposed to the dehumanizing irrationality of Nazi death camps." A fitting design style strategy for a dark biography. This illustration and design were created in 1999, but, content aside, it could easily pass for early 1900s expressionism. Copyright © 1999 by The New York Times Co. Reprinted with permission.

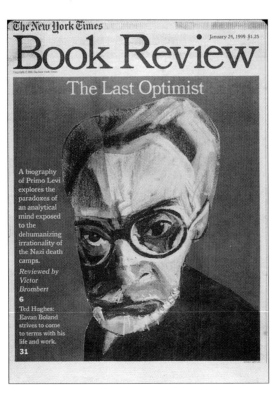

ate and suggested what many of its followers believed: that life needed to be stripped bare and reduced to its essentials through the artist or designer's emotion and intuition. It stressed the importance of the individual and a subjective perspective of the world. Compare Emil Nolde's expressionistic style (see Figure 2–16). with *The New York Times* "Book Review" cover illustration of Primo Levi (see Figure 2–17). Expressionist art was also very subtractive in the sense that the objects or people being portrayed were often removed from their context, environment, or background, sometimes via strong contour lines, tight framing, or bold interplay of colors and their complements. Expressionism—the simple but rough and sometimes colorful style—influenced design in many circles.

About the same time, roughly 1907, *cubism* emerged. It went through two basic phases: *analytical cubism*—abstractions from real things, which analyzed the planes of the subject and *synthetic cubism*—work from semi-abstract forms which only suggested an essence rather than represented it. Synthetic cubism tended to be the more metaphorical of the two. It was introduced by the development of the collage, which employs a diverse mix of media within a single work, such as newspapers, textiles, and other materials.

Cubism fractured the world's aesthetic perspective and largely dismissed representation. Primitivism, expressionism, and Paul Cézanne had a significant effect on cubist painters. Georges Braque, Pablo Picasso, and Fernand Léger relied more on *subjective experience* than realism in their art. The cubists used multiple angles of vision and simultaneous presentation of disjointed planes. These techniques rejected the Renaissance concept of a single viewpoint and stretched the notion of space in painting. Another facet of cubism that strongly influenced graphic arts and even future art movements was the use of the collage. Experimentation with collage by cubists popularized it as a "mixed medium," particularly in the genre of posters. It was an early form of mixed media, and later would influence Robert Rauschenberg.

Though technically considered a *post*-cubist, the commercial artist A. M. Cassandre really

captures the feel, dislocation, and sense of fragmentation found in cubism. Perhaps his most honored successes—though there were many—are the sequential panels he executed for Dubonnet.

Several other design movements followed closely on the heels of cubism—notably: dadaism, futurism, constructivism, Bauhaus, de Stijl, and surrealism.

The *dadaists* included poetry as well as the visual arts as philosophical territory. Borrowing from cubism's random collage assemblages, their work emphasized the absurdity of life. They railed against a world that had perpetrated the cruelest and most devastating war to date, as well as against materialism, logic, reason, and beauty itself. Some of the more celebrated dadaists include Hans Arp, Marcel Duchamp, Kurt Schwitters, Max Ernst, and Man Ray.

Among other things, the dadaists are generally credited for inventing photomontage. Indeed, they experimented with photography in a wide variety of applications that ranged from photograms (using objects as negatives) to multiple-exposure prints, to solarization—a process Man Ray invented. One of the founders of the German dada group (1919), John Heartfield, created some amazingly graphic posters and postcards that utilized artwork (mostly photography clipped from magazines and newspapers) to attack Hilter and the then emerging Nazi party. His work angered them and he had to flee Germany. His stripped-down montages communicate in raw, disturbing visual metaphors.

Much of the dadaist work bristles with outrage and often is characterized by chaotic assemblages, irony, and contradiction. This movement was more an experimentation and reaction to the establishment as much as anything else. Many of the more serious dadaists

later merged with the surrealists in the mid-1920s. An example of dadaist influence on contemporary design can be found in student Greg Desmond's unconventional Christmas message (see Figure 2-18).

Like the dadaists, *futurist* artists were closely networked with the writing community. Indeed, it was Italian poet Filippo Marinetti who published the "Manifesto of Futurism" in 1909 in the French newspaper, *La Figaro*. Ironically, some of the most interesting graphic experimentation came not at the hands of painters and graphic artists, but from futurist poets who rejected typographic conventions, harmony, and grammar. The results were remarkable: an interesting marriage of words, type, and graphic design. The futurists' typographical anarchy serves as a starting place and inspiration for much of the beach culture and David Carson school of design.

The futurists endorsed a wide and often contradictory array of beliefs: the destruction of museums, morality, and harmony. They also supported war, the machine age, and were fascinated with speed. They bought into the cubist idea that painting could examine both space and time, rejected traditional form and perspective, and tried to visually capture the energy and speed of industrialism. Some critics have suggested, too, that part of the futurists' blurred motion style was strongly influenced by photography, which

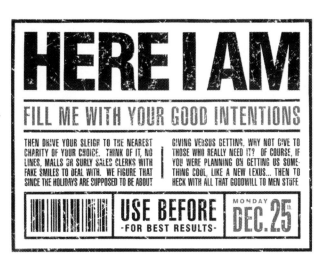

Figure 2-18
Dadaism rejected all aesthetic conventions, rationality, and traditional societal assumptions about art. Here Greg Desmond—while a student at Virginia Commonwealth University's (VCU) Ad Center—creates an anti-ad, generally rejecting our cultural and economic notions of Christmas. The medium is a silk screen message printed on laundry bags. He explains: "I sent the screened canvas bags to my friends and family at the holidays to curb our habit of overspending and consumption." The bag is a puzzle and seems quite irrational and odd as a holiday gift. The copy nails it: "Here I am … Fill me with your good intentions … Then drive your sleigh to the nearest charity of your choice. Think of it: no lines, malls or surly sales clerks with fake smiles to deal with. We figure that since the holidays are supposed to be about giving versus getting, why not give to those who really need it? Of course, if you were planning on getting us something cool, like a new Lexus … then to heck with all that goodwill to men stuff... Use before Monday Dec. 25th for best results." Art direction and copy, Greg Desmond. Courtesy of Greg Desmond.

would fit with their recognition and fascination with the Machine Age. Creative use of shutter speed could blur or stop motion, capturing movement in new and interesting ways. Balla's *Dynamism of a Dog on a Leash* is an excellent example of the futurist's preoccupation with motion (see Figure 2–19).

All of the above styles contributed to the visual shake-up of design during this period. However, perhaps constructivism, the Bauhaus School, and de Stijl most influenced graphic communication.

Constructivism, spawned in Russia, had both political and ideological motives. Inspired by the Bolshevik Revolution and the Machine Age, the constructivists espoused a classless society based upon a marriage of humanity and industry. This philosophy also rejected the notion of private galleries and museums and encouraged public art of all kinds—particularly posters, murals, and sculpture. It was often characterized by intersecting geometric shapes and typography (see Figure 2–20). Ironically, the very government it supported soon rejected the abstract agenda of constructivism in favor of more traditional styles that idealized political leaders and the working class.

Without commissions and support, constructivists Naum Gabo, Wassily Kandinsky, El Lissitzky, and many other avant-garde Russian artists left for Germany and other European countries. Two of them, Kandinsky and Gabo, were welcomed by the Bauhaus. In fact, the former taught at the Bauhaus School from 1923–1933. Constructivist influences are still common today (see Figure 2–21).

The *Bauhaus* aesthetic credo was a radical departure from the traditional structuring of the arts. The Bauhaus school was established in Weimar, Germany in 1919 by Walter Gropius. It offered a curriculum for all the arts (sculpture, photography, painting, design, architecture) based on the systematic study of visual elements and their application. Proponents of the Bauhaus movement believed that form follows function, and perhaps even more revolutionary was their canon that art, craft, design, photography, sculpture, architecture, and other facets of fine art should be grouped as one. In fact, they maintained that craft was the basis for all art and

that functionality was the means by which to judge it.

The Bauhaus espoused that artists were too isolated and elitist and that they shrugged their "responsibility" to apply their art. Consequently, Bauhaus style in architecture, furniture, and graphic design was simple, unadorned, and very pragmatic. Graphic arts flourished under the Bauhaus movement.

The *de Stijl*, literally "the style," movement adopted the very close association between fine and applied arts that the Bauhaus preached. Like many of the other art movements of this period, their idealism was a horrified and outraged reaction to World War I and all of its annihilation and inhumanity. Founded in Holland by Piet Mondrian and Theo van Doesburg, *de Stijl* strove for a "universal" graphic language grounded in shape and geometric form. This focus on geometry shaped all of its genres—painting, architecture, sculpture, and graphic design.

In many respects, they took on the beliefs of the cubists, who suggested that all natural forms were reducible to geometric shapes. However, perhaps more than any other movement, the *de Stijl* imprint on graphic communication has lasted longest. Indeed, from their philosophy and work, the *grid* became the adopted underpinning for nearly all modern print design. This, in no small part, was unknowingly promoted through the paintings of Piet Mondrian.

Today, the term *Mondrian design* is used interchangably with *modular design*, the *grid*, and *Swiss design*. Its characteristics include the following:

- Use of a grid for layouts of all kinds—from newspaper to advertising design.
- Asymmetrical placement of layouts. (Look closely at the opening and section pages of the newspaper you read).
- Clean, organized arrangement of layout parts.
- Straightforward, no-nonsense presentation.
- Use of rules, boxes, lines, and tint blocks to demarcate space.

Closely related to the *de Stijl* movement and graphic work were a group of artists from Switzerland. They were referred to as the *Swiss School* or *Swiss Movement*. Essentially, they adopted the *de Stijl* modular approach to visual

Figure 2-19
Giacomo Balla's *Dynamism of a Dog on a Leash* (1912) is considerably less fractured than most of his futurist work, especially when compared to his *Speeding Automobile* (1913). The painting almost looks like a *photo* of a dog shot at a very slow shutter speed and demonstrates the futurists' preoccupation with movement and speed. ©2003 Artists Rights Society (ARS), New York/SIAE, Rome.

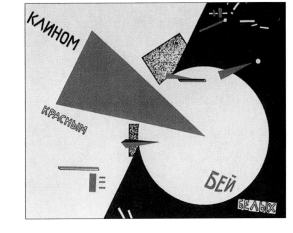

Figure 2-20
This constructivist El Lissitzky poster uses the red wedge as a metaphor for the Bolshevik (Red) Army in its battle with the "White Russians." *Beat the Whites with the Red Wedge* was created in 1919. Its political agenda is obvious. ©2003 Artists Rights Society (ARS), New York/VG Bild-Kunst, Bonn.

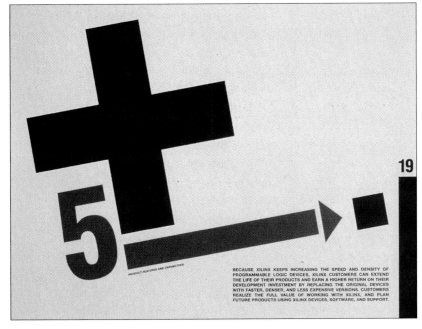

Figure 2-21
This Xilinx annual report cover's use of sans serif type, red and black, diagonal angles, and geometric shapes is reminiscent of constructivist design structure. This page addresses the five steps of a micro-chip's life cycle. Bill Cahan, art director; Michael Braely, designer/illustrator. Courtesy of Cahan & Associates.

design. Their goal, however, was to further refine it and in the process to reduce it to its most minimal components: notably, layouts employing smaller rectangles (or modules) blocked within a larger rectangle—*without* the use of rules or boxes to demarcate the space. Typographically, they achieved a similar effect by using sans serif type exclusively. Their approach is commonly referred to as *Swiss* design, or the International Typographic Style (ITS). Visionaries of the Swiss School include Ernst Keller (who taught at the School of Applied Art in Zurich), Théo Ballmer, and Max Bill. It was Bill who created the curriculum for Gestaltung (Institute of Design) in Ulm, Germany. The Ulm School, along with the methodological "problem/solution" approach to graphic arts, offered the first formal curriculum on semiotics—the study of symbols and signage.

The Swiss style emphasized presentation over the personal expression of the creator of the message. Both *de Stijl* and Swiss design incorporated many of the design techniques that we've come to think of as "modern." One long-

standing legacy left by the Swiss was their clean, minimal sans serif typography (see Figure 2–22).

Do you see how closely the notion of working with the grid affected Bauhaus, *de Stijl*, and Swiss design? (See Figure 2–23).

Art deco emerged in the 1920s and dominated graphic design and architecture between the two world wars. It was characterized graphically by streamlined objects and diagonal lines (a large Swiss influence), as well as decorative geometric elements.

You can likely sense the push-pull effects many of these different groups had upon one another. Art deco designers also drew from cubism, art nouveau, *de Stijl*, baroque, and even in some cases, the Egyptians. Because of the current fascination among some designers to capture the elegance and sophistication of this style, you can see many art deco influences in contemporary design. Erté is generally considered the patron saint of art deco, and perhaps more than anything in the world, the Chrysler Building in New York City epitomizes its grandeur and finesse. It is an art deco masterpiece from top to bottom, from its stunning, sculpted architecture to the art deco styles throughout the building's interior, including the intricate inlaid woodwork in its elevators (see Figure 2–24).

Design trends come and go, but the urbane, elegant, and sophisticated look of art deco is still popular. Although its look is dated and suggests the 1920s and 1930s, its integrity and beauty are timeless. Sometimes a designer will borrow directly from an icon or famous piece of art, as is evidenced by Rodrigo Sanchez in his aping of the Schulz-Neudamm poster for Metropoli (see Figure 2–25).

The Great Depression and President Roosevelt's New Deal programs turned to graphic arts to promote their causes. Painters and other artists produced murals, publication materials, and posters to rally the public and to advance numerous government programs, ranging from public works to conservation, from resettlement agencies to reforestation.

Figure 2-22
The look of Bauhaus/ Swiss style is timeless; so, too, is its functionality—as this modern-day *HELSINGBORGS DAGBLAD* front page demonstrates with its bold use of sans serif type, large photo play and clean design. These opening layouts "pop" off the page. Reprinted with permission of *Helsingborgs Dagblad.*

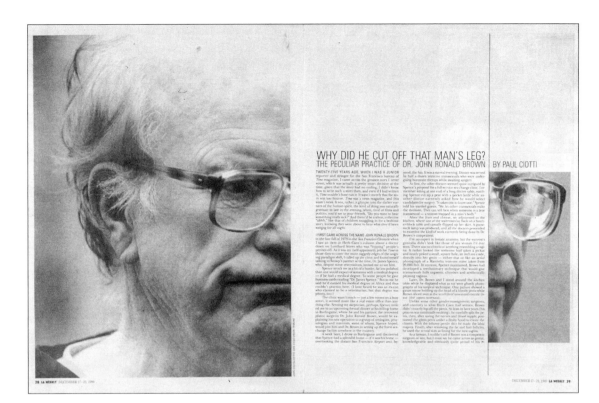

Figure 2-23
This *Los Angeles Weekly* magazine layout is a great example of the *de Stijl* grid and Bauhaus function. The crop on the photograph of a doctor who performed questionable amputations is interesting and fitting. Bill Smith served as art director and designer. Again, smart, insightful designers choose appropriate graphic strategies to tell the story visually—as Smith did here. Reprinted with permission of *Los Angeles Weekly*.

Figure 2-24
Truly, the Chrysler Building in New York City rises as a soaring monument to art deco. Its scalloped top and tower make it one of the most unique skyscrapers on the planet, and perhaps the most beautiful. William Van Alen, architect. Photograph by William Ryan.

Figure 2-25
Art influencing art department #1: one of the strengths of *Metropoli* (and mind you, there are many) emanates from the wry whimsy of its art director and designer, Rodrigo Sanchez. The *Metropoli* cover (on the right) is a hilarious borrowing of the Schulz-Neudamm poster for the 1926 film, *Metropolis* (left). The geometry, symmetry, type, and use of color perfectly capture the original and its classic art deco affectations. *Metropolis* poster reprinted with permission of Schulz-Neudamm. *El Mundo Metropoli* cover reprinted with permission of *El Mundo*/Unidad Editorial, S.A.

About the same time, *surrealism* provided a strong contrast to the slick, racy style of art deco and highly graphic posters and other government-supported work of the Depression. However, nothing comes out of a vacuum, although the eerie landscapes and haunting imagery of the surrealists might have you think that way. Actually, much of the initial impetus for surrealism came from the dadaists and their notion that art should shun logic and rationality and from the psychoanalytic influences of Sigmund Freud. The term comes from the French prefix *sur* which means "higher" or "super," thus suggesting a higher level or threshold of realism. Bruno Rinaldi and Tim Ray use surrealism as a starting point in their wonderful print ad: a Weber grill hovers over a fleeing herd of cattle, beaming one up for dinner (see Figure 2–26).

André Breton officially put surrealism on the map in 1924 with his *Manifesto*. That same year Hans Arp, Rene Magritte, Man Ray, and Max Ernst adopted that philosophy. They were later joined by Yves Tanguy (1927) and Salvador Dali (1929). Dali, of course, is synonymous with surrealism. Although their styles varied tremendously, all of the surrealists mined the unconscious mind for content, often presenting a surprising mix of common objects thrust into an alien world. Indeed, some of the half-human/half-animal creatures are reminiscent of the landscapes and horrifying creatures from the work of Hieryonimos Bosch.

Figure 2-26
Tim Ray conceived this ad for Weber Grills, using their resemblance to a UFO as his main strategy. The cattle are stampeding as one of them is about to be beamed up. The copy reinforces the ad concept: "First clear picture of the unidentified object that's been shocking cattle-owners since the 50s. Government officials will only say 'it's a satalite.'" Weird light, film scratches, and oddly shaped format add to the sci-fi hovering Webercraft effect. Kipp Wettstein, photography; Bruno Rinaldi, art direction; Tim Ray, copy. Courtesy of Tim Ray/Weber Grills.

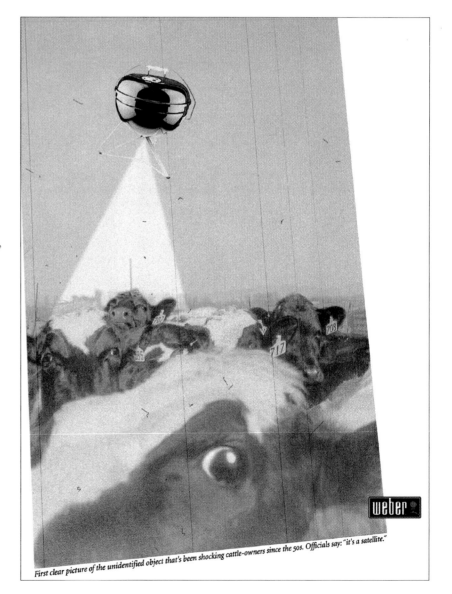

First clear picture of the unidentified object that's been shocking cattle-owners since the 50s. Officials say: "it's a satellite."

Even more horrifying was the onset and evolution of World War II. Although the war slowed some of the experimentation within the art scene, it fueled a flurry of important poster work. Ben Shahn, an important American painter and lithographer who had also worked for several New Deal agencies creating murals and posters, was one of many artists who put their visual talents to work decrying Nazi barbarity and supporting the American and Allied war effort. The poster became one of the most important and hard-working media, because it communicated efficiently and powerfully, was easily mass-produced, and could be posted just about anywhere.

Both the depression and war established a precedent for government-commissioned graphic art, and artists employed their visual talent and skill to create advertising campaigns, publications, and posters. Walter Paepcke, as well as his company, Container Corporation of America (CCA), also proved to be an important supporter of graphic arts. CCA had revolutionized the packaging industry, through its paper products and cardboard packaging. Paepcke's interest in the Bauhaus secured the notion that fine art and advertising could be combined to produce beautiful but utilitarian messages. He and CCA's advertising agency, N.W. Ayers, set the bar for advertising excellence. Willem de Kooning was one of hundreds of artists commissioned to produce art for CCA/Ayer ad campaigns.

About the same time, a little-known group, the American Abstract Artists (1936-1945) fractured off into one of the more important modern art movements, *abstract expressionism*. Founded and studied primarily in New York City, it took cues from most all movements, except realism. The dramatically different styles of Jackson Pollock, Willem de Kooning, Mark Rothko, Franz Kline, and Robert Motherwell exuded action, color, and experimentation (see Figure 2–27). As the name implies, the abstract expressionists endorsed a highly intuitive and emotive approach to non-representation—where the art and act of painting itself superceded content.

Abstract expressionism was significant for a number of reasons:

- It was the first serious American departure from existing schools or approaches to art.
- The techniques applied were many and varied—drip painting, mixed media, montage, traditional paint applications, and even throwing paint.
- New York replaced Paris as the crucible and capital of art because of the impact of abstract expressionism.
- Like many of the other movements, this one had a huge influence on graphic art and design.
- Its experimentation and tolerance for a wide variety of styles opened the gate for modern art, in much the same way that photography had done roughly 100 years earlier.

At the opposite end of the spectrum, *new realism* represented a strong counterpoint to all abstract art. Its main techniques involved experimentation in montage, multimedia, and assemblage. Robert Rauschenberg is perhaps the most celebrated artist of this genre (see Figure 2–28). His paintings and assemblages employed oils, photography, montage, and silkscreen, among other things. It wasn't unusual for some artists to incorporate objects from real life into their work. Daniel Spoerri, for example, poured resin over his half-eaten breakfast and other things from

Figure 2-27
Willem de Kooning may best represent the heart and soul of abstract expressionism. *Woman, I* is one of a series of important paintings de Kooning completed on the theme of women. © 2003 The Willem de Kooning Foundation/Artists Rights Society (ARS), New York, Digital Image © The Museum of Modern Art/Licensed by SCALA/Art Resource, NY.

Figure 2-28

Robert Rauschenberg used transfer drawings and borrowed from multimedia (magazines, logs, photography) to create *Canto XXXI*, from his series on Dante's *Inferno*. His work was as visionary as it was controversial. © Robert Rauschenberg/Licensed by VAGA, New York, NY, Digital Image © The Museum of Modern Art/Licensed by SCALA/Art Resource, NY.

Figure 2-29

"We wanted to raise awareness for the Friends of Boston's Homeless on a very small budget. Each piece was made to look like an official form of personal identification that had been lost on the street. The IDs were brought to busy shopping areas, and dropped on the ground to be discovered. We knew that the more the pieces looked like actual drivers' licenses, the more likely it was that people would bend over, pick them up, and read them—playing on people's natural instincts to return an ID to its rightful owner. There's also something fitting about discovering this message about homelessness on the street, much as you would find the victims themselves." Molly Elbadawi and Trey Phillips, art directors; Sean McBride, writer; Group 3 (Belmont, MA) ad agency. Courtesy of Friends of Boston's Homeless.

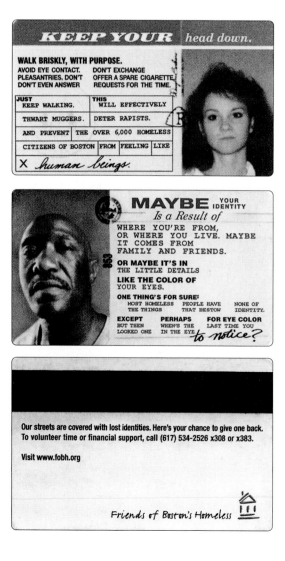

real life and presented them as art. New realism, which rejected anything abstract or amorphous, was the catalyst that helped launch *superrealism* and *photorealism* (see Figure 2–29). New realism's multimedia and assemblage approaches impacted graphic design, especially book jacket, record album, and poster design.

The much earlier Swiss and International Type movements slowly but surely began influencing New York art directors and graphic artists. By the 1960s, that influence was snowballing and revealed itself in myriad ways, most notably in poster design, but also in magazine, book jacket, logotype, and jazz album design.

Eventually, the *New York School of Design* (1950-1990s) emerged with graphic design heroes the likes of Paul Rand, Alexey Brodovitch, Milton Glaser, Seymour Chwast, Bradbury Thompson, Henry Wolf, and Saul Bass. Graphic artists trained in New York exported the vision across the country and the world. Their influence was immense. Illustration merged with type in new, exciting ways, creating a kind of new graphic fusion. Photography became more powerful than ever before, especially in magazines. Big was "in." Typography became more dominant—headlines, for example, might take up the space of an entire page. Designers used large geometric forms and color blocks across the graphic arts; even formats were expanded. Larger page sizes and posters and billboards used knockout photography or imagery with neutral backgrounds. Knockout photography strips away backgrounds by shooting the subject on seamless paper, or by removing backgrounds electronically or physically (see Figure 2–30).

The style also attracted some of the most powerful and creative minds in advertising. Bill Bernbach, George Lois, and other ad pioneers applied the direct, stripped down style to print advertising. Glaser and Chwast founded Push Pin Studios and produced timeless design for magazines, outdoor media, and advertising. Doyle Dane Bernbach launched their now famous Volkswagen (VW) "Think Small" campaign. Among other things, it featured knockout photography, sans serif type, minimal design, and seas of white space. The straightfor-

ward, inviting layout was understated and honest. The type reflected the ad's concept: "think small." Like the advertisement's honesty, its humor was equally refreshing.

Another jolt on the graphic arts scene came from Pop art. New realism influences were obvious, and, like new realism, Pop art was a bristled reaction against abstract expressionism. Ironically, Pop art not only affected graphic design, it actually borrowed from it. Warhol's Campbell Soup Cans and David Hockney's milk cartons are good examples. Claes Oldenburg's gigantic sculptures of mundane objects (baseball bats, umbrellas) later influenced the super realistic sculpture of Duane Hansen. However, Roy Lichtenstein's paintings might have had the biggest rub on graphic arts and advertising. His larger-than-life paintings directly aped comic book style and were rendered in moire dot patterns. That style is still found in graphic artwork to this day. There were few pretensions in Pop art and its mission of spanning the mundane of daily life to art was widely adopted. Lee Remias and Trevlin Utz used the Lichtensteinesque comic book format and Pop to sell GLADWARE (see Figure 2–31).

Although short-lived, *op-art* made an impressive entrance into the art scene through an immensely popular exhibition at the Museum of Modern Art. Inspired in no small part by psychedelic drugs, music, and the counter culture, op-art mushroomed into mainstream culture from a humble beginning in the Haight-Ashbury area of San Francisco in the 1960s (see Figure 2–32). Victor Moscoso and other designers created vibrant psychedelic posters for bands such as the Grateful Dead, Jefferson Airplane, Bob Dylan, Cream, Jimi Hendrix, the Rolling Stones, Jim Morrison and The Doors, and The Beatles. It was a time of renaissance in poster design and music. It is interesting to note, too, that its content was fueled largely by causes like anti-war (Vietnam) protests, feminism, civil rights, and other social issues. Poster work reflected the issues and culture of a young and agitated anti-establishment America.

Indeed, here's an instance where the graphic arts were the impetus for a new fine arts movement. Initially, posters dominated, but the

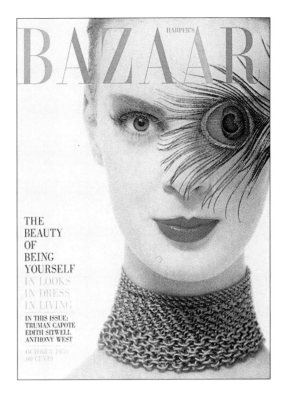

Figure 2-30
Henry Wolf's editorial design work for the likes of *SHOW, Esquire* and *Harper's Bazaar* still hold up today. His forte was simplicity: using stripped-down, bare-bones design to create immortal covers and layouts, such as this cover. Notice how all the elements in the design say elegance—from the modern roman typeface to the knockout photograph by Richard Avedon, the interplay of color (peacock feather and unusual color type treatment), and the minimal composition of the photography itself.
© Richard Avedon.

Figure 2-31
Trevlin Utz reaches back to 1960s Pop art and the comic book genre for this GLADWARE print ad. Clever copy ("Would she ever recover from the shock and heartbreak of finding out it was her own cousin who had stolen... her covered dish?") and fleshed-out comic book details made this ad as hard-working as it is kitschy. Lee Remias, copywriter; Trevlin Utz, art director. GLADWARE® is a registered trademark of The Glad Products Company. Used with permission. © 2003 The Glad Products Company. Reprinted with permission.

Figure 2-32
Op art mushroomed into the music scene in the mid-1960s. Born in San Francisco and fueled by the psychedelic period, its renaissance ran from roughly 1966 to 1968. Richard Griffin, Stanley Mouse, Victor Moscoso, Alton Kelly, and Wes Wilson were probably its most celebrated artists. This poster, *Trip or Freak*, is a classic. It advertises a special Halloween concert at Winterland, featuring Quicksilver Messenger Service, The Grateful Dead, Big Brother and the Holding Company, and Janis Joplin. It is unique, too, in that Stanley Mouse, Alton Kelly and Rick Griffin created the art collectively. *Trip or Freak*, San Francisco, 1967. © Stanley Mouse Studios.

short-lived style soon found its way from rock and social causes to more commercial applications. Literally everything, from book covers to fashion and album covers to package design, was suddenly adorned with op designs. Although artists such as Victor Vasarely and Mark Rothko had experimented with optical art and vibrant color fields much earlier, op-art didn't really take off until the late 1960s.

However, there were even more rebellions and graphic surprises.

In the 1960s, phototypesetting revolutionized an industry that basically had changed very little since Gutenberg. Although phototype's advantages pale in comparison to today's computerized and digital typographic possibilities, its elasticity and new opportunities were mind-boggling at the time. Phototypesetting was cleaner, sharper, and offered much more flexibility to designers. It was also cheaper and required less time and space. Phototypesetting houses began popping up on street corners everywhere.

Visual Graphics Corporation and CompuServe began building huge libraries of type. CompuServe's Edit-Writer phototypesetting machines became the standard typesetting technology for small shop and huge print houses alike. These phototypesetting corporations not only provided the hardware (phototypesetting machines nearly the size of a Buick), they began transferring existing faces and inventing new ones for their type's plastic strips. Briefly, phototypesetting worked like this: light was fired through the plastic type strips onto a photographic paper, which was eventually run through a photoprocessor loaded with chemicals for film development. Galleys—long strips of photographic or "cold" type—were literally developed in chemicals similar to those used in black-and-white film processing and sent to editors and publishers to be read and used for paste-up.

Herb Lubalin, who began as a designer helping to shape magazines, the likes of *Fact, Saturday Evening Post, Eros,* and *Avant Garde,* turned to type design. Eventually, he became the design director for International Typeface Corporation (ITC), which became a large supplier of type for phototypesetting and eventually a provider of digital type. Lubalin designed and oversaw the design of many families of type, including, of course, Lubalin.

However, the times, culture, and politics were "a-changing." In the midst of Marshall McLuhan's encroaching global village, feminism, civil rights, major cultural shifts, social upheaval, the Vietnam conflict, the *me* and *x-* generations, and new technology, *postmodernism* was born.

Perhaps no other art movement or philosophical positioning is more amorphous than postmodernism. No one seems to be able to agree upon exactly what it is or means. Suffice to say that it's probably easier to provide visual examples of postmodernism than to define it. One thing that is fairly clear is that it marks a clear break and rejection of the international style, Bauhaus order, traditional use of typography, and the grid. It also tends to reject the tenet of arranging design elements and type at right angles. Some of its influences may be traced back to the futurists and the dada movement. Postmodernist design reflects that kind of rejection of order of the established design status quo. Indeed, some of the initial futurist typography experiments could easily pass as postmodern designs.

A brief who's-who among postmodern designers would include Wolfgang Weingart, Robert Venturi, Dan Friedman, and Will Kunz. Some of these people, though, might even reject that inference or designation. Perhaps *Emigre* most consistently summarizes postmodern magazine design. It pushed the envelope with Zuzana Licko's early (1988) digitized low-resolution type (72 dpi) and provided an early and respected forum for this design niche. Along with *Design Quarterly, Emigre* not only applied postmodern design to its pages, it espoused and used early computer design when the rest of the magazine world remained skeptical of "desktop" technology. *Emigre* continues to function as both a magazine and a type design house.

Later, some postmodernist splinter groups mellowed and morphed into *retro* and *vernacular* design. *Retro* revived older design styles and then applied them using postmodern treatment of type, spatial arrangement, color, and slashing line angles. Although related to retro, *vernacular* design adopted old (preexisting) commercial and clip art and used it to fit content and context. In

addition, the vernacular approach also borrowed formats from days gone by—no matter their origin. Consequently, everything from cigar boxes to baseball cards, label and package design to matchbooks and classified ads were fair game

for inspiration (see Figure 2-33). In fact, these formats are often recycled directly and incorporated into anything from book jackets to corporate identity materials. This style is also found in magazine layouts, packaging design, and annual reports. Art nouveau, futurism, and art deco were the main influences for both retro and vernacular designs (see Figure 2–34).

While retro and vernacular provided graphic design work that was more comfortable to the public eye and those who preferred the order and familiarity of modernism, *extreme postmodernism* took the personal and playful approach to the max. David Carson—who was a surfer himself and personally involved with southern California alternative culture—art directed *Beach Culture*, *Surfer*, and *Raygun*. These three publications (and much of his peripheral design work) eliminated just about every conventional typographic and layout format imaginable—sometimes to the point of illegibility. To be sure, he challenged readers, but the playful and sometimes anarchistic layouts were usually respectful of the magazine content. Although Carson's work won't likely eliminate the stylebooks of *Time*, *Rolling Stone*, or *The Washing-*

Figure 2-33
BIG KONG WRITING TABLET isn't actually a 32-sheet writing tablet. Instead, it's a cover for the Briar Cliff University literary magazine, *Prologues*. The retro cover is an aping of a jungle-theme tablet, complete with simple art and vernacular type. Art direction and design, William Ryan. Courtesy of Briar Cliff University.

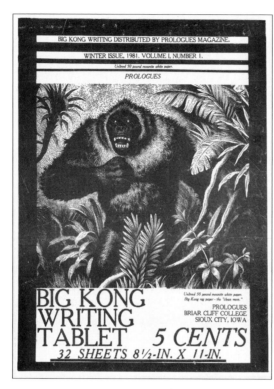

Figure 2-34
Fine and graphic arts have a push-pull relationship. Compare A.M. Cassandre's poster (left) for trans-Atlantic cruises (1931) to Joseph Binder's recruitment poster (right) for the United States Navy (1953). Similarities? Without a doubt. Or, for that matter, replace "JOIN" with a lithe, all uppercase Helvetica at the top of the layout. Do you see the *LIFE* magazine connections?

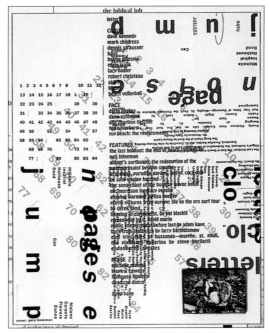

Figure 2-35
David Carson's edgy designs seem to thumb their noses at any semblance of convention. Most renowned for his work with *Transworld Skateboarding, Surfer, Beach Culture* and *Raygun*, Carson's layered and jumbled approach to typography and design have earned him the dubious title of "King of Non-communication." He also reigns as the czar of extreme post-modernism. Here are *Raygun*, Issue 6, 1993, featuring calligraphy and P.J. Harvey; *Raygun* table of contents, 1991; and "My Beach," a feature layout, *Raygun*, 1992. All three images from *The End of Print: The Graphic Design of David Carson* by Blackwell and Carson, ©1998 John Wiley & Sons.

ton Post, his impact on design was influential and far-reaching (see Figure 2–35).

Today, design is in an exciting state of flux. Designers often work from an arsenal of different styles, using them to fit content, image, audience, and situation. Eclecticism rules, and digitization has provided new possibilities for type, design, and mixing media that most people couldn't have dreamed of, even five years ago.

But graphic communication is affected by more than the histories and philosophies of design. It's also shaped by media and technology. Just as Gutenberg and the printing press transformed design and communication, so too have many technological and digital advances.

Computers, software development, and digitization have unified what once was a fragmented process into a nearly seamless one. Until fairly recently, producing a publication involved a long list of professionals: writers, editors, designers, typesetters, strippers, graphic artists, paste-up specialists, pre-production staff, platemakers, press operators, and others. Then, in the mid-1980s, "desktop publishing" began to merge many of those separate tasks. The break was largely the result of three companies: Apple Computer, Aldus, and Adobe.

Apple's first computer employed bit-mapped graphics with a resolution of 72 dots per inch (dpi) on a screen a tad larger than a postcard. Clearly,

the biggest advantages of the Apple computers were their simplicity, user-friendly nature, and intuitive navigational tool, the *mouse*. In addition, Apple offered an array of features no other computers provided, including drawing and painting programs and a humble assortment of typefaces.

Meanwhile, Adobe was developing sophisticated PostScript technology. Briefly, this programming language provided a much cleaner version

of type than bit-maps. PostScript type was sharper because of its hard-edged outline, which was stored as electronic data.

About the same time, Paul Brainerd, a newspaperman familiar with the A-text newspaper typesetting system, developed PageMaker, a high-powered layout and design program. It was revolutionary because it made pagination a reality. Indeed, it was Brainerd who coined the term "desktop publishing." Within a short time, Aldus had evolved PageMaker versions for both Apple and PC computers. Around this time Aldus created a sophisticated illustration program—Freehand, and other graphic software. The pieces for starting the digital revolution were basically in place. Of course, Adobe has long since acquired PageMaker, and also offers Illustrator, Acrobat, InDesign, Photoshop and other graphically oriented software programs.

Today digitization provides designers an amazing freedom, elasticity, and endless creative options. It also allows them to fuse media. Digitization has affected words, type, graphics, illustration, photography, film, video, on-line media, and multimedia. Computers and software can create and converge all media. The same photograph can be downloaded, manipulated in

Photoshop, placed in a design program such as PageMaker, Quark, or InDesign as a poster, newspaper, or magazine document, and even imported to a website or integrated into a video or within multimedia (see Figure 2–36).

Razor-sharp laser printers, high-speed computer processors, ever-evolving technology, the Internet, and other interactive media (hypermedia) continue to increase our ability to create brilliant and complex graphic communications and to fuse media. The Museum of Modern Art (MoMA) assembled a comprehensive online exhibition of its German expressionist show. Its organization, design, and usability is exemplary. See the MoMA online site of "Die Brücke" at *www.moma.org/brucke/* (see Figure 2–37 and Figure 2–38). As a visual communicator and designer it is important that you become skilled in the software programs and understand the inherent possibilities of the evolving technology. But that's only half the equation. How you opt to create and shape graphic messages remains to be seen. One thing is certain, though, understanding the history of design and its rich visual legacy will endow you with an invaluable resource from which to draw. In addition, it will help you contribute to the future of design—and to its magic and power.

Figure 2-36

The typographical anarchy common to *Beach Culture* and *Raygun* is often near impossible to read. However, *digitization* and the extreme of postmodern design have freed up design conventions as exhibited in these *El Mundo Metropoli* covers. Compare the effects of these two covers. Since 1992, Rodrigo Sanchez's inventive *El Mundo* designs have been dazzling Spanish readers and designers from all over the world. Art direction and design, Rodrigo Sanchez. Both covers reprinted with permission of *El Mundo*/Unidad Editorial, S.A.

Figure 2-37 and Figure 2-38
MoMA decided to put an exhibition on the expressionist movement *Die Brücke* on-line. Here are the opening frame and a sample woodcut by Emil Nolde, *Doctoren* (Doctors), 1922. The site's black and charcoal backgrounds, type, and other nuances mesh neatly with expressionist sensibility. *Communication Arts*, in featuring MoMA's "Artists of Brücke: Themes in German Expressionist Prints" in its recent awards annual for interactive design said, "With more than 125 works in over 50 comparative groupings, this site presents an unparalleled collection of German Expressionist prints and illustrated books. The restrained simplicity of the visual design enables visitors to connect with the work as if it were physically in front of them." All of the nuances and extras added to this site are too numerous to list, but the music is from the period, some of the movement and "swipes" between frames use strong, wide, diagonal brush strokes. It is a delight. Its organization is thorough: broken into themes, artists, prints, and more. The site is truly brilliant and sensitive work for the prestigious MoMA exhibition. Brad Johnson, creative director; K. Mita, MoMA technology director; Wendy Weitman, MoMA curator; Sam Ward, animator; Martin Linde, sound. URL: www.moma.org/brucke02 Both frames: design by Allegra Burnette, programming by Tanya Beeharrilall and George Hunka, May 2002. ©2003 The Museum of Modern Art.

Graphics in Action

1. Select several upscale magazines and examine the advertising within them. Try to find 5 or 6 print ads that truly are influenced by different art styles. Bring them to class along with your respective style designations. Write and present a brief list of reasons why you have aligned with each style.

2. The Bauhaus perhaps had one of the most profound influences on contemporary design. In fact, they still do, despite the effects of postmodernism. Look for contemporary work that follows the Bauhaus tenet that form, indeed, follows function and select examples of functional design in the following:

a. newspaper front section
b. magazine table of contents
c. print ad
d. brochure
e. website

Explain how the *form* and *structure* of each example follows function. That is, *deconstruct* the layouts of the different examples, noting how their design details help structure each layout, contribute to their order, and help the reader process the content of each page or web frame.

3. Find a good example of modular formatting. It really doesn't make any difference which medium you choose—print ad, magazine or newspaper page, or brochure panel. Then, using your

computer, reconfigure the modular design into a postmodern one.

4. Select 2 or 3 CD or album covers from different musical genres—jazz, hip-hop, blues, country, rock, new age. Redesign one or more of them on your computer, using one of the design styles discussed in this chapter. *Don't* choose the style arbitrarily; make sure it meshes well with the genre or portrays the artist appropriately.

5. Design a magazine opener, CD cover, print ad, or opening web page using a nontraditional print format for the basis of your design, such as a road sign, cigar box, license plate, comic book, or candy bar wrapper. Feel free to add your own formats to this list. Be sure to pay attention to

detail and imitate all the nuances of that format: color, type, design specifics, rules, angle, and so forth. Again, make the format choice and finished product smart and appropriate for the chosen media. For example, perhaps using a speed limit sign to create a poster advertisement reminding people to not drink and drive.

6. Your editor has asked you to design a new look for a newspaper sports section. The newspaper is planning on running special Friday and Saturday editions dedicated to extreme sports. The editor wants the type, color, angles, and photo crops to be real edgy and say "adrenaline sports." At the same time, the editor wants some of the paper's traditional identification to also come through.

Select your local or state paper for the page model. Bring your creation and the original page to class, display them, and discuss them. Some of the sports the editor suggested that might be covered include roller-blading, rock climbing, mountain biking, kayaking, surfing, and snowboarding.

7. Create CD covers and liner notes for 2 completely different genres of music, for example, jazz and classical. Be sure to focus on and use one of the art styles discussed in this chapter as your adopted graphic style for each genre. Again, your style selections should not be arbitrary ones.

8. The Museum of Modern Art has asked your design firm to create a poster and brief brochure for its upcoming show on Pop art. Create one or both of the materials listed above. Each team (2–3 students) should act as a competing agency trying to win the account. Make your presentations in class and select the best 3 or 4 concepts and graphic executions. *Note*: be sure to do your homework and study the Pop art scene before even considering brainstorming sessions or design plans for these materials.

9. Create a website or series of Web pages for the MoMA, given the scenario that is outlined for you above. Remember your audience and try to cleverly braid what you do with a Pop motif.

3

*The invention of typography
ranks near the creation of
writing as one of the most
important advances in
civilization.*

—*Phillip B. Meggs,
The History of Graphic Design*

◄Wooden block type.
Photograph by William Ryan

As a craft, typography shares a long common boundary and many common concerns with writing and editing on the one side and with graphic design on the other; yet typography itself belongs to neither.

—Robert Bringhurst,
The Elements of Typographic Style

Figure 3-1
Robert Slimbach trained and worked as type designer and calligrapher at Autologic Incorporation. After several years of freelance design work, including faces designed for International Typeface Corporation, he joined Adobe Systems where he works as a senior type designer. Slimbach has received a great deal of acclaim for his work, including the Charlies Peignot Award.

Previous Page
Although its applications are quite limited, wood block type is still used by art students and others today. It has changed little since its inception in the early fifteenth century, and is a reminder that typography is still a craft. Photograph by William Ryan.

Typography: An Overview

Robert Bringhurst's opening quotation speaks to the complex nature of typography. It is at once content and form, providing words and ideas with a voice and at the same time allowing our messages to be tangible, collectible, and retrievable. Type is a manifestation of thought and language. But Bringhurst put it much more poetically: "Good typography is like bread: ready to be admired, appraised, and dissected before it is consumed."

Another person who understands the history, craft, and importance of typography is Robert Slimbach (see Figure 3–1). He has basically dedicated his life to researching classic roman typefaces—traveling to the Plantin-Moretus Museum in Antwerp, Belgium, to study Garamond's earliest examples—and bringing them to life for us digitally (see Figure 3–2).

The craft of typography is about making the complex clear and the uncomplicated interesting, all with an apparent effortlessness that is democratic in its presentation. The experienced typographer knows that his primary purpose is to be a facilitator, to organize content in a lucid manner to best impart to the reader the intent, mood, and content of the work displayed. The best typographers know there is a fine line between expressing one's personality through the work for enhanced effect and being overly intrusive with one's style. Setting type and graphics is a process of weighing and balancing elements until a harmony between content and display is achieved. By respecting both the author and the reader, typographers strive for a purity of expression that can be achieved by bringing intelligence and experience to a work that rarely highlights the designer's cleverness (see Figure 3–3).

Figure 3-2
The origins of Garamond are somewhat mysterious, but credited to Claude Garamont. Garamond's architecture influenced many type designers—notably, Jean de Tournes (1504-1564) and Robert Granjon (d. 1579). Garamond is a simple, yet graceful, typeface. The italic versions Robert Slimbach designed were based upon faces created by Robert Granjon—a contemporary of Garamont. Courtesy of Robert Slimbach.

ITC Slimbach
Book *Book Italic* **Medium** *Medium Italic* **Bold** ***Bold Italic*** **Black** ***Black Italic***

The Libyrinth: Modern Word Collection
Samuel Beckett: *Apmonia*
Jorge Luis Borges: *The Garden of Forking Paths*
Tracy Flannery: *Cold Mountain 6*

When I became interested in type in the early 1980s, I was instantly drawn to classical letter-forms and their calligraphic lineage. Since then, I've immersed myself in the practice of calligra-phy and type design and the study of Latin-based letterforms. It's been clear to me that in order to build on the past, one must understand the past, for typography has innate utilitarian aspects that can only evolve slowly over time. For the past twenty years, I've focused my energies primarily on the design of composition families. For me, text forms are the purest repre-sentation of our alphabet because they represent a dual connection between the fundamental nature of the alphabet as a tool for reading and as a barometer of the aesthetics of modernity. It is an exciting time to be working in the field of typography because the digital medium is allowing designers to explore new possibilities for making and using type (see Figure 3–4).

Slimbach's research, attention to detail, and meticulous nature allow him to recreate classic typefaces. His gift is twofold because he is not only a "font designer;" he's a calligrapher. After all, typography is the visual embodiment and separate reality of language, and calligraphy is at its very core. Although typography is in a constant state of flux, with new faces and face variations being created daily, its basic architec-ture and principles have changed very little since the monastic clerics first inscribed—letter by letter—the incredible libraries of antiquity that have survived to this day. In fact, most of the typographical conventions that we take for granted were invented or refined by the scribes: lowercase letters, paragraph indentations, justifi-cation, dropped initial letters, and endmarks—just to name a few.

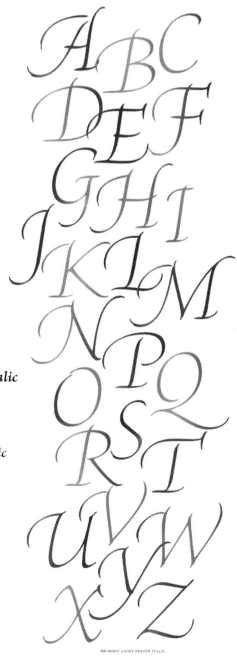

Brioso Pro Typeface Sets

Light Caption
Light Caption Italic
Light Text
Light Text Italic
Light Subhead
Light Subhead Italic
Light Display
Light Display Italic
Light Poster
Light Poster Italic
Regular Caption
Italic Caption
Regular Text
Italic Text
Regular Subhead
Italic Subhead
Regular Display
Italic Display
Semibold Caption
Semibold Caption Italic
Semibold Text
Semibold Text Italic
Semibold Subhead
Semibold Subhead Italic
Semibold Display
Semibold Display Italic
Bold Caption
Bold Caption Italic
Bold Text
Bold Text Italic
Bold Subhead
Bold Subhead Italic
Bold Display
Bold Display Italic

10 POINT LIGHT POSTER ITALIC

Typography literally fleshes out our ideas and puts those thoughts and writing to page (or other media); it gives ideas and words a voice. It might be loud—in the case of the Gail Anderson's poster for "Harlem Song," This example not only has a voice, it has projection and even implied movement from the use of color and the slightly skewed letters (see Figure 3–5). It could speak in other voices via a colorful outdoor advertisement for a BMW Z-3, a powerful magazine nameplate, or the gritty and very edgy credits at the beginning of the film *Seven*. Or it might be playful and loud in a website for children (www.smartmuseum. uchicago.edu/smartkids), or speak of ice, fire and transformation in a magazine article on Mount Saint Helens (see Figure 3–6).

For a moment—think about the wide range of content, audiences and media involved in the array of messages just listed. Would you use the same typeface and typographical strategies for each of those examples? Not likely.

Typography, like communication itself, is a living entity. Among other things, messages vary in terms of their voice, formality, intention, mood and motive. Audiences differ dramatically, too. In addition, the tone and presentation of media often have little in common. For example, Gail Anderson's "Harlem Song" poster has little in common with the BMW board. The disturbing assemblage of letters constructed by hand, with razor blades and stripped type in the film *Seven* impart quite a different effect and mood than the pages of the Smart Kids website, or the magazine article on Mount Saint Helens.

The message here is a simple and invaluable one. Content does—and should—affect the typographical direction. Perhaps Robert Bringhurst said it best in his wonderful book, *The Elements of Typographic Style*. The first principle of typography is that "type exists to honor content" and to that end, "well-chosen words deserve well-chosen letters." So the first guideline is clear: respect and reflect content, research, know your audience, and understand what you're designing before you begin selecting and arranging your typography.

Figure 3-5
Gail Anderson's gift for working magic on typography is legendary. This stunning subway poster for George C. Wolfe's "Harlem Song" captures the musical's playful character. A photograph of the Apollo Theater is screened in yellow behind the typography—that, and the embossed effect of the type give the poster a 3-D look. Courtesy of SpotCo.

But where do you begin? There are literally thousands of different types, and the litany of new faces, styles, weights, and other typographical variations are mushrooming constantly. In addition, typography makes up the lion's share of space in our publications. In fact, type is truly at the heart of most communication.

Type Function

Clearly, the main function of typography is that it be read. Remember, too, that typographical conventions, principles, and guidelines are not there to get in your way and stifle your creativity. On the contrary, they exist to provide you a simple but essential blueprint for building an effective and efficient printed communication—one that invites and holds a read, one that knits content and form together neatly and appropriately. Although typographic creativity involves bending the rules, it is important that you understand type basics first, before you begin experimenting.

Many argue that the primary element of that blueprint is type. No matter what the medium—advertising, newspaper, magazine, outdoor advertisement, annual report, Web page, film subtitles,

or brochure—type should be used to accomplish these five objectives:

1. To attract and hold the audience. Think of using type in a way that is appropriate to the audience, as well as to the mood or feel of the message.

2. To be reader-friendly and easy to read.

3. To prioritize and emphasize important information. One of the secrets of effective communication is to ensure that the arrangement of type on the page and its size, style, weight, and other specifications make the message easy to recognize and absorb. That means making sure the structure and hierarchy of the message parts are simple and clear.

4. To establish a coherent harmony among the elements in the communication. Everything—the art, typography, design, color, style—should work together as a unified whole to reinforce the message. The reader should never be confused by any element within the design, or wonder why it's there.

5. To create and establish recognition. Indeed, type is used to help create identity and maintain continuity in our messages. After all, typography is the main component of corporate logos, news-

Figure 3-6
"Born of Fire" uses classic serif type, color, and Photoshop to contrast ice, fire, and change. The story about disturbance ecology examines the renewal of life in the flora and fauna on Mt. St. Helens twenty years after its eruption. Design by Cassie Keller, photography by Aaron Deetz and Kipp Wettstein, story by Chris Bryant. Courtesy of *FLUX* magazine.

paper and magazine nameplates, and advertising messages. Publications shape their visual identities through stylebooks and interior logos, and in so doing, they bring both order and unity to their audiences. You may extend that identity by using the same type treatment on their letterhead, business cards, and websites, or T-shirts.

Typography is both a basic ingredient and logical starting place for any visual communication (see Figure 3–7). Notice how this magazine ad for *influx*—the online version of *FLUX* magazine—uses a Web menu line, sans serif type for its address (top), and a close type match for a popular hot sauce: a clever concept and typographic solution. Proper choice and use of type streamlines the communication; incorrect selection and use impedes it. When the latter occurs, channel noise strikes again.

A Confusion of Terms

The universal acceptance of the computer as our basic tool of typography and visual communication has clouded the meaning of some typographical terminology. Many people in communication have not been grounded in the tradition, history and use of type; consequently they may confuse terms.

Typographic terminology evolved over centuries. The confusion of terms is a comparatively recent problem, spawned from the development of new technologies. In any case, until some consensus emerges, it's important to be aware of some of these variations.

First of all, the term *font* in computer programs means typeface. In fact, font is a misnomer. Actually, a font is the complete assortment of a given typeface's letters, numerals, punctuation marks and other characters set at a *specific point size* (see Figure 3–8). Today, however, printers, designers, art directors, and others commonly use the term font interchangeably with typeface. *Oblique*, which refers to type that is pitched forward, is sometimes confused with *italic*. Along with being sloped to the right, true italics are also smaller in stature and slightly cursive.

You need to understand type anatomy, terminology, specification, and design strategies. It is important that you know how to tailor typography to create a wide variety of messages to fit their respective media and audiences. It is also important to know how type is measured, set, spaced, and "specced." The latter refers to type *specification*. Basic typographic principles have been established through practice over the years and refined from research studies in readability.

This chapter will provide you with a basic understanding of type and offer you important strategies and direction on how to use typography effectively.

Anatomy of Type

When you look at a letter, what do you see?

Is it an *a* or a *b*? Most of us see a squiggle that will suggest a sound that—when combined with other letters—will create an idea or image in our mind. A designer or typographer also notes weight, style, leading and many other typographic nuances. Are the ascenders and descenders long or short? Is the kerning in a headline tight enough? Is the serif typeface appropriate to the audience? Do the thick and thin strokes create an interesting contrast or bring good texture to a copy-heavy page? Are the letters large enough in the body copy for good readability to a very

Figure 3-7

Something as simple as typeface and style can help us make important graphic associations. Color and sans serifs typography mimic the real packaging of Tabasco Sauce. The inference? That *influx* is hot "spicy multimedia." Why is this background appropriate? Art direction/design Lisa Kleffner and Justin Kistner. Courtesy of *inFlux* online magazine/Tabasco Sauce.

ABCDEFGHIJKLMNOPQRSTUVWXYZ
abcdefghijklmnopqrstuvwxyz
1234567890
`~!@#$%^&*()-_—=+,.<>/?
¡™£¢∞§¶•ªº–≠/€‹›fifl‡º·±

Figure 3-8
Font is commonly used interchangeably with *typeface*. In fact, a font is the complete collection of a given typeface's letters, numerals, punctuation marks and other characters set *at a specific point size*. This is a sample of the font Georgia, at 18 point.

young audience? Is the *leading* (the spacing between the lines of type) deep enough to ensure reader-friendly copy?

In order to understand type, be able to talk about it intelligently, distinguish between typefaces, and use type correctly, you need to be able to dissect it and perceive its basic anatomy (see Figure 3–9).

The basic anatomical elements of a letter are its *strokes*, or the lines that form its design. They may be *monotonal*, or uniformly stroked. For example, most all *sans serif* faces are monotonal. On the other hand, serif letters can vary in stroke from hairline to quite thick lines (see Figure 3–10).

Letters' finishing strokes are called *serifs*. Their origins come from the early Romans, who—with brushes and chisels—painted or carved over the imperfections of their initial letter strokes. Much later, when type designers first cast roman type, they cut those lines into the type's architecture.

Ironically, the vestiges of early letter configuration have survived to this day. Serifs come in a wide variety: bracketed, hairline, rounded, slab, flat and curved. *Counters* are also important. They are the enclosed areas within a letter's arrangement: for example, the inside area of the letter *o* or lowercase *e, a, b*, and so forth.

The alphabet of a specific typeface is consistently designed. Uppercase letters will be the same height, and the lowercase heights will be consistent as well. The height of a lowercase letter is referred to as its *x-height*, from the lowercase *x* (see Figure 3–11). Incidentally, lowercase letters, which get their name from old-time printers' type cases, were originally referred to as *miniscules*. They were basically shortcut derivations of uppercase letters, which were created and perfected by the scribes, who used them to make their job easier. For example, it took them four strokes to make a *majiscule*

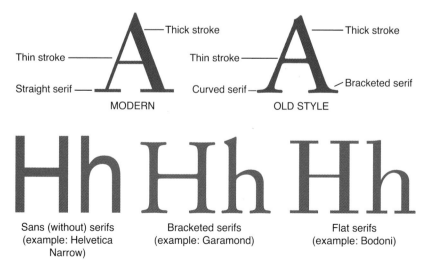

MODERN OLD STYLE

Thin stroke — Thick stroke — Straight serif

Thin stroke — Thick stroke — Curved serif — Bracketed serif

Sans (without) serifs
(example: Helvetica Narrow)

Bracketed serifs
(example: Garamond)

Flat serifs
(example: Bodoni)

Figure 3-9
Characteristics that differentiate modern and old style roman types.

Figure 3-10
Serif treatments vary with type styles. Sans serif typefaces have no serifs; old-style romans have bracketed serifs; modern romans have flat, straight, hairline serifs.

Figure 3-11
The *x-height* (the height of the lowercase letter x) is a critical basic measurement in the design of letters. Generally, the larger the x-height, the better the readability.

(uppercase) *E*, but only one stroke to write a miniscule *e*. Cover the right side of the lowercase *e* and notice how similar its structure is to its uppercase version. That may not seem like much, but when you're copying a book the size of the *Iliad* or the *Bible*, shorter strokes make a huge difference.

Some letters have a stroke, or *stem*, which extends above the x-height line or below the *baseline*. An *ascender* is any lowercase letter stroke which runs above the x-height line.

Any lowercase stroke running below the baseline is called a descender (see Figure 3–12). The letters *b, t, d, l, f, l, h* and *k*, for example, all

Figure 3-12
Any lowercase letter stroke that extends above the x-height line is called an *ascender*; if the stroke extends below the baseline, it is referred to as a *descender*.

have ascenders, while *p, q, j, y,* and *g* have descenders. In the uppercase or capital alphabet only the *Q* and sometimes the *J* have descending strokes. No capital letters have ascenders. Sometimes, old style roman numerals will have ascending and descending strokes.

There are thousands of type styles. In the days of "hot type," when metal type was literally melted and cast, typeface choices were more limited but their structures were beautiful. Caslon type, for example, which was first cut by William Caslon in England in 1734, was and still is considered one of the most beautiful typefaces around. Designer Kit Hinrichs used Sabon for the text typeface in this book.

With the advent of photocompositon, and more recently digital composition, variations of many typefaces have proliferated. Many of these types, although they resemble long-established and recognized faces, have been altered slightly by each manufacturer. A good example is Robert Slimbach's digitized Adobe Garamond (see Figure

3–2). Over the past three decades of the technological revolution, new digital faces have been created by companies such as Adobe, Poynter, and Emigre. This has made type selection more confusing to some due to the staggering number of faces available—many of which appear to be fairly similar.

A logical place to begin the discussion is by examining the various races or groups of typography. To create a meaningful communication, you also need to take stock of which typeface offers good readability while concurrently imparting an appropriate "image" or feeling for that message. To that end, it's important to understand type races and the codes and other baggage they carry.

Type Classification and Type Groups
Type is classified in a way that makes differentiation among the faces comparatively easy. It is sorted rather like anthropologists have organized humans. Just as there are various races of people, there are different groups or races of type. Briefly, races of type are collections of typefaces that have a number of graphic characteristics in common; for example, Universe, Gil Sans, Futura, Arial and Helvetica are all members of the sans serif group.

Within these groups are *families* of types. Each family shares the basic architecture of its race, but not uniformly; they differ from one another in terms of x-height, width, stroke, and overall configuration. The Goudy and Bodoni families are both members of the roman group (see Figure 3–13).

A close inspection of Goudy and Bodoni types reveals similarities, as well as differences. They both have serifs, thick and thin strokes, and similar configuration, but they also have subtle and not so subtle differences. Goudy serifs are bracketed and pinched, while most Bodoni serifs are hairline and straight. There is less differentiation between thick and thin strokes in Goudy, while its counterpart has an exaggerated contrast between the strokes. The counters of Goudy type lean to one side, but the Bodoni counters are precise, geometric and perpendicular to the baseline. Noting such differences and under-

standing their effects on printability, readability, and suitability (for a given client, audience, or job) will help you master type.

While there isn't complete agreement on type categorization, most typographers and designers classify type into six different groups. They are: black letter (or text), roman (or serifs), square serifs (also known as Egyptians or slab serifs), sans serifs (or Gothic or grotesque), scripts and cursives, and a catchall category for those designs that defy specific identification called miscellaneous (or novelty) type (see Figure 3–14).

No matter how the type is produced—whether cast from hot lead, photo-composed, or electronically digitized—all will exhibit characteristics of their respective type group. Each typeface can be categorized and discussed within the framework of this group and family system of classification.

Blackletter	Roman (Old Style)	Sans serif
Square serif	Script	Novelty

Figure 3-13
Goudy (upper figure) and Bodoni (lower figure) are both members of the roman race, but their letter architecture is quite different. Goudy is an old style roman and Bodoni a modern. Can you see the differences?

Figure 3-14
The six races of type displayed in lowercase letters for comparison.

Black Letter or Text

Contrary to popular opinion, Johan Gutenberg was not the first printer to use movable type. According to archeologists, the use of movable type may date as far back as 1500 BC. Early Greek printers used changeable clay tablet insets. There are also records of the Chinese employing a variation of transferable, fired clay ideographs as early as the ninth century. Around 1300, Marco Polo and other explorers brought back evidence of this printing method in the form of printed Chinese currency.

However, the influences that led to the development of movable type and the technology that was adapted for it, didn't end with the Chinese. Gutenberg's system was a hodgepodge of begged, borrowed, and stolen ideas. His press was based upon relief printing. Artists had already been using wooden blocks, ceramics, and other materials for printing. Some of the earliest forms of advertising, which preceded Gutenberg, were simple posters that employed the relief method.

Inks were nothing new either, and the ink base that Gutenberg used closely resembled a tried and proven formula the Dutch painter Van Eyck had concocted years earlier. Finally, the press itself was pilfered; it was an adaptation of a conventional wine press.

Nonetheless, Gutenberg's invention had a huge impact on communication. His timeless, exquisitely printed pages opened up the door to a communication revolution, and within the space of roughly fifty years, printing had spread across Europe and beyond.

Black letter type is very angular, complex, and dark (see Figure 3–15). Although seldom used, black letter faces are common today and do have a respected place in graphic design. What better way to say "medieval" or "madrigal"? While these faces resemble the ponderous, stiff architecture of Gothic cathedrals, don't call them "Gothic." That term is sometimes used for sans serif type.

Figure 3-15
This black letter typeface is called Castle, designed by Image Club Graphics.

In addition, black letter types are extremely ornate and their structures are wildly different from one another. In fact, among the type groups, black letter has the most structural variation. However, one thing that all of the families of this classification have in common is that they're difficult to read.

The name *text* was attached to these faces because black letter faces were the text or reading matter of the northern medieval Europeans. However, today text refers to body copy itself.

Black letter carries some coding baggage. Because the most prevalent book employing black letter was the *Bible*, many attach the ideas of truth, tradition, and solemnity to it. Today, where is black letter most commonly found? On diplomas, newspaper nameplates, wedding certificates, and heavy metal CD covers (see Figure 3–16). Beyond these situations, though, there aren't many uses for this type race. If you do use black letter, avoid running the type in all uppercase. Black letter faces are difficult to read in the first place, but nearly impossible to decipher when set in all-CAPS.

Figure 3-16
The Society for News Design hired Jim Parkinson to design a new nameplate for their quarterly journal, *Design*. Notice how Parkinson uses the angles of the black letter type to form diagonal alignments from the bottoms of the letter configurations. This strategy gives the letters of the *Design* nameplate a wonderful continuity.

Romans

The birthplace of printing in the Western world was northern Europe. From there it spread south and west, with Venice becoming the hub for printing and typographic design in the late fifteenth and sixteenth centuries. The people in the warmer climate in the south did not like the cool, angular nature of black letter type. They preferred the stripped down, simpler form: the classic letter structure of ancient Rome. So typefaces that were developed in Venice and Paris (and later England and the Netherlands) adopted the cleaner more readable faces we have come to designate as "romans."

Just as they borrowed many other things from various enemies—weaponry, painting, sculpture, and architecture—the Romans developed their alphabet and letter form from the Greeks and other early civilizations of the Mediterranean. In fact, some letters of the Roman alphabet can be traced to the picture writing, or hieroglyphics, of the Phoenicians and Egyptians. Historians believe the Phoenicians adopted and modified Egyptian letters. The Greeks then altered the letter structure of the Phoenicians, reconfigured their constructions, and used them to form the Greek alphabet, which the Romans later refined (see Figure 3–17).

The tools most commonly used by the Romans to inscribe their buildings and monuments were the brush and chisel. Typically, they first painted inscriptions on the masonry and then stonemasons carved over the painted outlines. The painters could turn a brush and flex the bristles to make curves and continuous lines, and so they developed open letter strokes with varying widths. To finish off the broad and imperfect strokes, they used the edge of the brush to create finer, straight lines, or chiseled over uneven carvings. These adjusted letter endings became the serifs on our letters, which is one of the more distinguishing features of roman typefaces. All romans have serifs and letter strokes that vary in width from thick to hairline.

Roman typefaces have three main sub-categories: old style, transitional, and modern (see Figure 3–18).

Old Style Romans

Old style romans are, as you might suspect, the oldest members of this group. Many typographers feel these faces are the most beautiful and useful of all the romans. The Venetian type cutters eliminated the dark, somber quality of black letter by smoothing out the hard angles, flattening the bottom of walking serifs, and widening the counters of the type. They kept the numerals, miniscule letters, and sloping counters of the earlier letterform (see Figure 3–19). Some of the old style romans, such as Goudy and Centaur, also copied the diamond and triangular

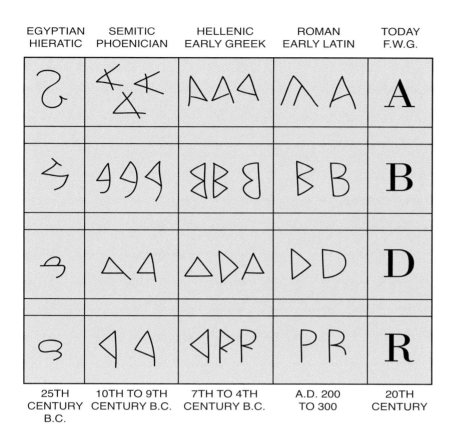

EGYPTIAN HIERATIC	SEMITIC PHOENICIAN	HELLENIC EARLY GREEK	ROMAN EARLY LATIN	TODAY F.W.G.
25TH CENTURY B.C.	10TH TO 9TH CENTURY B.C.	7TH TO 4TH CENTURY B.C.	A.D. 200 TO 300	20TH CENTURY

Figure 3-17
The development of some modern letterform can be traced back to the hieroglyphics of the Egyptians. Type was spawned from pictorial symbols and remains a visual component in graphic communication.

Goudy (old style)
ABCDEFGHIJKLMNOPQRSTUVWXYZ
abcdefghijklmnopqrstuvwxyz

ITC New Baskerville (transitional)
ABCDEFGHIJKLMNOPQRSTUVWXYZ
abcdefghijklmnopqrstuvwxyz

Bodoni (modern)
ABCDEFGHIJKLMNOPQRSTUVWXYZ
abcdefghijklmnopqrstuvwxyz

Figure 3-18
Here are examples from the three roman subgroups: Goudy (old style), ITC New Baskerville (transitional), and Bodoni (modern).

There is some contrast between thick and thin strokes.

There is a slight tilt to the angle of the swells of the round letters.

Tops of acenders have a distinctly oblique serif.

The serif angles out from the stem and terminates in a crisp point (called a bracketed serif).

Figure 3-19
Old style romans are more personal faces because they adopted little nuances and imperfections from the ancient roman chiseled and painted letters.

shapes of black letter punctuation marks. If you note these geometric oddities in a roman type's design, you know it's an old style.

Unlike their predecessors, old style romans have good readability. They are also elegant and classic in appearance. The strokes of the letters tend to be a bit quirky and of all the romans, old styles have the least amount of contrast between thick and thin strokes, and their serifs tend to be bracketed or pinched. Another distinct feature of this subgroup is the sloping counters. Part of the charm of these typefaces is that when their type designers created them, they adopted many of the imperfections from the ancient Roman structure. This gives the old styles great personality and informality.

Not all the old styles were created in the fourteenth or fifteenth centuries. Caslon, for example, was cut by William Caslon in the eighteenth century. Frederic Goudy designed Goudy in 1915, and Robert Slimbach created Brioso in 2002. Today, variations of Garamond, Caslon, Goudy, and other old styles continue to be re-created in digital form, while new families of old style type are being designed.

Transitional Romans

The moniker *transitional roman* appropriately suggests that this type is a serif face in flux. Because transitionals possess design characteristics of both of their old style and modern counterparts, they are the most difficult roman to identify. Transitional design is a unique mix of grace and pragmatism. For this reason, transitional faces are popular choices for poetry books, novels, and anything else that exudes quality.

Two dominant transitional features are their larger x-height and girth. Their letters tend to be wider than the other subgroups. Their width

makes them reader-friendly, as well as slightly larger and more formal than old style typefaces (see Figure 3–20). In fact, New Century Schoolbook is a transitional roman that was specifically designed for high readability. Indeed, designers of many primers and children's books use New Century Schoolbook face.

Incidentally, *readability* refers to the readout of the type, or how easily the face can be read. *Legibility*, on the other hand, refers to the visibility of the type, or how seeable it is. Readability is an especially important consideration with body copy. Legibility is a crucial factor when designing outdoor boards, traffic signage, and blurbs and teases on magazine covers because the audience is moving past the message quickly.

Transitional faces began the curious evolution toward the more precise and streamlined modern romans. Sometimes these faces result in a most graceful blend of new and old design affectations. Most of their counters still slope, though not at so pronounced an angle as do the old style romans. Also, there is more contrast between the thick and thin strokes of transitionals. Some of the more popular faces of this subgroup include Times-Roman, Century, Baskerville, Palatino, and California.

Modern Romans

In 1773, the Italian type designer Giambattista Bodoni, a contemporary and friend of Benjamin Franklin, introduced the so-called *modern* roman types. In direct contrast to their old style cousins, the counters of this subgroup run perpendicular to the baseline and parallel to the vertical stems of the letters. Other distinctions of moderns include a more exaggerated contrast between thick and thin strokes and straight, unbracketed hairline serifs (see Figure 3–21).

Figure 3-20
Transitional roman types are the most difficult of this race to identify. Their architecture is basically old style, but they tend to have larger x-heights and are more geometric than their predecessors. This sample is New Baskerville.

There is greater contrast between thick and thin strokes.

There is almost no tilt to the angle of the swells of the round letters.

Ascenders have slightly less oblique angles on the serifs.

Serif feet are bracketed, but they terminate in a squared-off point.

There is strong
and abrupt
contrast between
thick and thin
strokes.

The overall stress
is clearly vertical.

All serifs are
horizontal and
end in squared-off
points.

Serifs are usually
unbracketed, but
they can be slightly
bracketed.

Figure 3-21

Characteristics of modern
roman types feature more
contrast between thick
and thin strokes, counters
that are perpendicular to
the baseline, hairline ser-
ifs, and there is an imper-
sonal, geometric precision
to them, as exemplified
with this face, Bodoni.

Hairlines are a mixed blessing. When printed at very small sizes, the razor-sharp serifs may disappear, and when bolded, their narrow counters may clot. The thin serifs also tend to break up when printed on coarse, low grade paper—like newsprint. For these reasons, *modern* romans do not make an especially good body type in newspapers. However, newspapers have run a lot of modern type as headline or display type. Today, Bodoni is enjoying a resurgence in popularity as a newspaper display face. It imparts a contemporary and elegant feeling.

A close examination of modern roman anatomy reveals that the letter configuration is very precise, stiff and geometric. So, although they are quite beautiful, modern romans' rigid architecture evokes a cool, formal feeling. This precision lacks the warmth and calligraphic looseness of old style romans. However, with their delicate thin strokes and stridently contrast-ing thick strokes, moderns make a very dramatic and stylish statement in posters, nameplates, headlines, titles, and logotypes.

Romans, in general, are considered basic types. Because of their inherent texture, they are preferred as body type for most publications. Indeed, many researchers believe romans have the best readability of any type group. They come in all weights and sizes. There are romans available to help communicate virtually any message.

Sans Serif

Although this group is generally considered more contemporary, it also has an ancient derivation, probably from the flat, even-bodied lines of the Greek and early Roman letter formations. Sans serifs are called "Gothics" by some typographers, and in Europe they are often referred to as "Grotesque" types or "moderns." Sans serifs are much more popular in Europe where they are used commonly as body faces.

As the name implies (*sans* is the French word for "without"), sans serif faces have no serifs (see Figure 3–22). Their structure is geometric, clean, and open. They also are uniformly stroked for the most part. This feature tends to give them a flat, untextured look on a page, which is the main reason that many designers don't use them as body faces. However, several families of sans serifs, such as Optima, Stone Sans, and Textura, do have slight variations in their letter strokes. Most, however, are monotonal.

Like their roman counterparts, sans serifs are excellent all-purpose types. San serifs are suitable for nearly every purpose. Because of their heavier stems and uniform stroking, they have excellent legibility. Consequently, nearly all traffic signage—stop signs, street names, and interstate signs—and many outdoor boards use sans serifs. Helvetica is probably the most common sans serif (see Figure 3–23). Their legibility is crucial in these applications because they have to communi-

Avant Garde
ABCDEFGHIJKLMNOPQRSTUVWXYZ
abcdefghijklmnopqrstuvwxyz

Figure 3-22

Avant Garde is a typical
example of a sans serif
face. It is evenly stroked
and without serifs.

Figure 3-23
Helvetica is standard on interstate traffic and other signage, because of its strong legibility.

cate to a moving target, or in the case of bus tails or taxi signs, messages are moving quickly past the audience.

Sans serifs became especially popular in the 1920s when the Bauhaus and Swiss movements made their influence felt in the world of typography. The Bauhaus preached—as you recall—that *"form follows function,"* especially good advice for working with type.

San serifs are becoming more widely used today in newsletters, annual reports, magazines, newspapers, posters, packaging, and especially on websites.

Square Serif

Square serifs have the same basic characteristics of the sans serifs—uniformly stroked for the most part and monotonal—except that they have finishing strokes—squared off serifs. In fact, some typographers refer to them as *slab serifs* or *Egyptians.* Actually, they were called Egyptians when they first appeared on the scene, and for good reason.

In the early nineteenth century, British anthropologists were opening tombs and pyramids in Egypt, in no small part due to the discovery of the Rosetta stone in 1799. At this time, there was a preoccupation with the pyramids, mummies, and just about anything Egyptian. The Rosetta Stone contained an inscription in three languages—one for the rulers, another for the common people, and one in Greek. Our understanding of the Greek letters helped break the code of the other two languages, and later helped unlock the mysteries of Egyptian hieroglyphics and ancient Egyptian history and culture.

About the same time, Vincent Figgins, an English type designer, created a typeface characterized by thick, uniform square serifs. The capital letters of this face were somewhat reminiscent of Egyptian architecture and were said to be inspired by that culture's rigid building structure and the stiff hieroglyphics within; thus, the "Egyptian" moniker.

Today there are hundreds of versions of the square serif faces, many with Egyptian family names: Memphis, Cairo, Karnak, and Luxor, to name a few. Some of the others that are quite popular are Stymie, Lubalin, Girders, Towers,

and Clarendon. Of course, today, square serifs are more logically associated with modern buildings than ancient pyramids. They are also often associated with the old American West. Indeed, slab serifs were very popular in the mid-to-late 1800s, when everything from newspapers to WANTED posters were set with square serifs.

The strong right angles of square serifs give them a sturdy feeling (see Figure 3–24). Uppercase versions impart a sense of strength, stability, and ruggedness. When redesigning *Newsweek's* nameplate, Jim Parkinson wanted a type to impart a powerful, "authoritative" feeling; he designed the logo in square serif. Do you feel that strength when you see it? However, this rugged characteristic may make for a clunky read when slab serifs are employed as body text. Some designers feel square serifs are great for headlines, posters, and as a display face, but they tend not to be reader-friendly as text.

Scripts and Cursives

The two variations of the fifth type group, scripts and cursives, have one main thing in common. They both mimic handwriting. Typographers may refer to them by either term. Because scripts or cursives are similar in many ways, they are grouped together. Technically, the distinction is a simple one. Although both try to imitate calligraphy, cursive letters are not joined, while script letters are connected to one another (see Figure 3–25).

Still another confusing problem associated with this race is that a type novice might be inclined to throw italic letters into this category. Italics aren't part of this group, but a type *style.* A technical and important clarification should be mentioned here. Many type designers copied and applied some italic features to other faces of type, notably sans serifs, but these are not true italics; they are obliques. What further complicates this matter is that often computers and software design programs don't make that distinction. But now you know better.

Scripts and cursives come with a few inherent problems. The first is readability. They simply do not read well. Consequently, they have little use as body type. If you do opt to use them, don't run them all as uppercase. You wouldn't write

anything that way, so you shouldn't set type in that fashion either. The second problem is the mistaken perception that they impart a personal feel. Frankly, you are best served not to use scripts or cursives on material requiring a personal look. The fact is—unlike real handwriting—their structure is completely predictable and uniform. Each *s* is constructed exactly like every other *s*, and so forth. The result is that rather than giving a unique and personal touch to the message, the type tends to look impersonal or contrived. Designers often turn to a calligrapher to create special handwritten affectations when they're looking to strike a more sensitive chord in a nameplate, an introductory letter, or advertising copy that calls for the personal touch.

Although scripts and cursives have limited professional use, they can play an important role in good design. Typically, they are most commonly used for nameplates, announcements, and invitations (see Figure 3–26). They can also add interest, contrast, and an interesting twist to the printed page when used appropriately as a dropped initial letter, title, deck, or for some other display application. Again, because of their inherent affectation and low readability rating, they tend to be used sparingly.

Miscellaneous or Novelty

Last—and well, yes, probably least—is the catchall category for all unusual type designs, miscellaneous or novelty. The faces in this group are misfits without any real typographic family. In fact, miscellaneous or novelty types are not a true group in the sense that they share specific features or a common architecture with one another. This group sometimes wears the moniker of "decorative" type.

Many of the miscellaneous or novelty faces are simplistic visual metaphors for their respective titles: Balloon, Dracula, Stars and Bars, Icicle, and the like. Actually, most of the faces in this classification are designed for special purposes and used primarily in newspaper display advertising. For example, the Icicle face sells air conditioners in the dog days of August, or Stars and Bars hawks a special Independence Day tire sale. You get the idea (see Figure 3–27). Typically, because they adopt obvious graphic nuances,

Lubalin Graph
ABCDEFGHIJKLMNOPQRSTUVWXYZ
abcdefghijklmnopqrstuvwxyz

Figure 3-24
Lubalin Graph (a member of the square serif Lubalin Graphic family created by Herb Lubalin and ITC) is an example of a strong family from this race.

Edwardian Script

Apple Chancery

Figure 3-25
Script type is designed so its letters are joined. Cursive type has a structure that mimics handwriting, but its letters are not joined. Which is which of these two faces?

Edwardian Script
ABCDEFGHIJKLMNOPQRS TUVWXYZ
abcdefghijklmnopqrstuvwxyz

Figure 3-26
Script and cursive types have few professional graphic applications. This is Edwardian Script. The readability of any script or cursive face should be questioned; note the tiny x-height here.

Figure 3-27
Miscellaneous or novelty types can be effective if used sparingly for display purposes. Normally, they are found in newspaper retail advertising.

they have little use beyond their affectation. These are not typefaces you'd want to find on your diploma or your grandmother's tombstone.

That said, it is important to point out that there are some important novelty faces that have a variety of useful applications. A handful or so of the families in this category imitate typewriter faces; three popular ones that come to mind are Courier, Elite, and American Typewriter. These types have good credibility. Ironically, even though few of us still use typewriters, we tend to think of typewritten words (real or simulated) as very personal messages. Research has proven that point (see Figure 3–28). It is not by accident that most of the direct mail and the cover letters in

ITC American Typewriter (medium)
ABCDEFGHIJKLMNOPQRSTUVWXYZ
abcdefghijklmnopqrstuvwxyz

Figure 3-28
A handful of faces from the miscellaneous category imitate typewriter faces. This one is ITC's American Typewriter.

direct marketing use these faces. Think of the junk mail letters you've received. It's likely that most of them used a typewriter face.

However, in this mostly illegitimate grouping, there are other legitimate faces—types with a definite high-tech look. In a recent issue of *Communication Arts*, Mark Eastman discussed "futuristic" type design. Clearly, many of the new futuristic type designs are heavily influenced by computers, electronic circuitry, bit-mapping, wireframes, and even LED readouts, resulting in experimental faces that have a cool, high-tech look. *Emigre* magazine pioneered the bit-map approach; later, *Emigre* blossomed into a type design house.

The look of the futuristic faces varies considerably; they may simulate anything from graffiti to wireframe models. Today there is also a growing number of stressed types. Some of the edgier faces emulate graffiti or flaunt ragged or tattered edges, while others are blurred or have scratched or blemished surfaces. In general, this subgroup of typefaces may impart a feeling of chaos or anarchism.

There are a few other general niches worth mentioning: stencil, shadow, and outline types. However, most of these also have limited use

and potential. Few novelty faces are used beyond their specific affectation/application, and so while the Frankenstein typeface may catch your attention in the daily newspaper on Halloween and convince you to buy two pounds of chocolate candy for trick-or-treaters, you won't likely see that face again until next October.

Selection and use of these types should be governed by the same criteria you would use in choosing any specialty type.

Families of Type

Now you understand how typefaces are organized and the peculiarities of each group, but there is additional categorization. Typefaces are ordered by their family names and variations. Quite often the name refers to the type's designer: (Giambattista) Bodoni, (Nicholas) Jensen, (William) Caslon, (Claude) Garamond, (Frederic) Goudy, or (Robert) Slimbach, to name a few. Sometimes, though, the name may be descriptive of its design or function. Cloister, a black letter face, is reminiscent of the cloisters of medieval monks; the gaudy Lilith is named for the female demon of Jewish folklore; Barry Deck's Cyberotica is a futuristic face that would be perfect for the title of a science fiction novel. Type names may reflect a geographical area, such as the square serifs, Cairo and Memphis, or faces associated with some other place, such as Chicago, Monaco, or New York.

Families exist within each group of type, and although the families are different from each other, they share the basic characteristics of that type group. For example, Palatino, Georgia, Caslon, Bodoni, and Fenton are all romans; they all have serifs, variations between thick and thin strokes, and other roman traits.

Each family variation may also be further clarified by style. The *style* of the family refers to subtle architectural differences in the type structure itself. Usually, designers use the normal or regular style of the face. In fact, normal is so commonly used that it's not even included in the type's description. Other options include condensed, book, expanded, narrow, and italic. Therefore, the family of Caslon would include all

of the variations, styles, weights and other specifications of Caslon: Caslon Light, Caslon Light Italic, Caslon Book, Caslon Condensed, and so forth (see Figure 3–29).

Within these type families there are further divisions that are called *series*. A series within a family consists of all the sizes of that face (see Figure 3–30).

Finally, there is the font of a type. As noted earlier, although font is sometimes used interchangeably with "typeface"—as on most computers and computer programs—technically, a *font* is all of the characters and numerals available to a specific family variation *at a given point size*. Font is a hot type term that has carried over to modern terminology. Quite literally, it comes from the French fonte, which means "to cast or pour." Hot type was poured and cast from molten lead. These two concepts—series and font— were especially important to hot type and photo-typesetting, but they really aren't very relevant to digital type because modern design and graphics programs can run type in just about any size. Today, designers aren't hamstrung by font or series constraints.

Caslon Book
Caslon Medium
Caslon Bold
Caslon Black
Caslon Book Italic
Caslon Medium Italic
Caslon Bold Italic
Caslon Black Italic

Measurement of Type

Graphic design and printing have a unique system of measurement for type. Although the units of measurement may seem foreign to you at first, they are quite simple. Moreover, anyone working with printing or design needs to understand them thoroughly.

But first, a little background. For roughly 300 years after Gutenberg, there was no standard system of measure for printers. For example, one

Figure 3-29
A family refers to all the styles, weights, and other variations within a given typeface. Here are some of the versions of the Caslon family.

Point Size

6	abcdefghijklmnopqrstuvwxyz
7	abcdefghijklmnopqrstuvwxyz
8	abcdefghijklmnopqrstuvwxyz
9	abcdefghijklmnopqrstuvwxyz
10	abcdefghijklmnopqrstuvwxyz
11	abcdefghijklmnopqrstuvwxyz
12	abcdefghijklmnopqrstuvwxyz
14	abcdefghijklmnopqrstuvwxyz
16	abcdefghijklmnopqrstuvwxyz
18	abcdefghijklmnopqrstuvwxyz
24	abcdefghijklmnopqrstuvwxyz
30	abcdefghijklmnopqrstuvw
36	abcdefghijklmnopqrst

Figure 3-30
Here is a series from the Helvetica family, medium weight, from 6- to 36-point.

type-cutter might call a type "nonpareil," while another used the same term for a completely different size. Type specification was chaotic. Eventually, *nonpareil* became an accepted term for 6-point type.

Then, in the mid-eighteenth century, a French typographer named Pierre Simon Fournier established a system of sizing type by units of standard measurement called *points*, which was refined by his countryman, Francois Didot. Later, in 1886, the United States Type Founders Association adopted this formal standard of type measurement; Britain followed in 1898. Today, it is the international standard.

The *point* is the smallest unit of printing measure; it is approximately 1/72nd of an inch. If we're using the micrometer, it is 0.0138 of an inch. However, for practical purposes, typographers measure 72 points to an inch. For example, type set at 36 points is approximately one-half inch high (see Figure 3–31).

Type height—which is measured from the bottom of the descender (descender line) to the top of the ascender (ascender line) or CAP line, whichever is highest—is measured in points. So, too, are rules and leading (or line spacing). *Rules* are straight lines used to demarcate design elements from one another or to box art or other things. Rules that are used to frame illustrations or photography are referred to as *keylines*.

"Hot type" terms are still used today. Pica and agate are common ones. A *pica* is a unit of measure that is 12 points in width; and pica type is type that is 12 points in height. So, there are 12 points in a pica, and 6 picas in an inch. *Agate* refers to type or a unit of measurement that is 5-1/2 points in size. Sometimes, printers or advertisers use agate point size to measure ad space and consider 14 agate lines as equaling 1 inch to measure the depth of the advertisement.

Points and picas are as central to measurement in design and printing as inches and feet are to measuring things in our daily lives.

The *em* is an important unit of measurement in graphic design. Formally, an em is the square of the type size in question. For example, a 36-point em measures 36 points (or a half-inch) on all four sides. An em that measures 12 points, or a pica, on each side is referred to as a *pica em*. Its sister, the *en*, is exactly half the width of an em. Therefore, a 36-point en would be 36 points in height, but only half that measure—or 18 points—in width. To avoid confusion between the two, old timers referred to the em as a "mutton" or "mutt," and an en as a "nut." Both the em and en are other "hot type" terms that have survived the test of time. When type was set by hand, em and en spacers were literally put in a frame or rack of type to set off paragraphs and for other indentation.

Figure 3-31

Type and publication design space are both generally measured on a pica pole and design ruler (shown here in actual size), or on the computer. There are 6 picas in an inch, and 12 points to each pica.

Printer's rule or "line guage" with points, picas, metric and inches.

Graphic artist's rule with inches and picas.

Although the terminology and direct usage of ems and ens are in decline today, the terms are still used by many to indicate indentation. Computers, however, are quietly making them a thing of the past.

Type Specification

Electronic publishing, computers, and digitization have truly revolutionized communication, particularly with typography. Today type specification is no longer solely the realm and responsibility of the printer and typographer. Not only designers, but writers, photographers, reporters, production staff, editors, and others often "spec" (specify) type and make choices involving typography.

Additionally, you may find yourself dealing with publications regularly, so understanding type specification and sharing a common language with printers and designers is crucial to good communication with them, not to mention producing brilliant work that imparts your messages clearly and quickly.

The following are twelve suggestions based upon experimentation, experience, research, and testing that have proven to be effective in working with type. They also happen to be the heart of type specification.

1. Use the correct typeface (see Figure 3–32).
2. Size the type appropriately.
3. Lead the lines for a comfortable and efficient read.
4. Choose a proper line length.
5. Use line arrangement strategies thoughtfully.
6. Use uppercase (all-CAPS) sparingly.
7. Adjust space within and between words.
8. Match the weight to the voice of the message.
9. Give the words emphasis by adjusting posture and width.
10. Style the type appropriately.
11. Mix types carefully.
12. Remember the margins.

Figure 3-32
Think of type as the clothes that words wear. Notice how the typography connects to context or content.

1. Type can be light or **heavy**.
2. Type can be unassuming or graceful.
3. Type can *whisper* or **shout**.
4. Type can be monotonous or sparkle.
5. Type can be **UGLY** or BEAUTIFUL.
6. Type can be **MECHANICAL** or Formal.
7. Type can be *Social* or ecclesiastical.
8. Type can be **fat** or thin.
9. Type can be playful or SERIOUS.
10. Type can be easy to read or hard to read.

Key to the type faces listed above, left to right in order:
1. 18 pt. Avant Garde Extra Light; 18 pt. Futura Extrablack
2. 18 pt. Times, 18 pt. Adobe Garamond
3. 18 pt. Cochin Italic, 18 pt. Eras Ultra
4. 18 pt. Helvetica, 18 pt. ATBernhard Modern
5. 18 pt. Lithos Black, 18 pt. Trajan
6. 18 pt. Machine Bold, 18 pt. Caslon Open Face
7. 18 pt. Shelley Allegro Script, 18 pt. Dalliance Roman
8. 18 pt. Gotham Black, 18 pt. Mona Lisa Solid
9. 18 pt. Spumoni, 18 pt. Copperplate Gothic 33
10. 18 pt. New Century Schoolbook, 6 pt. Bembo

Use the Correct Typeface

The first step in selecting the correct type is to divide the contents of the message into two basic groups: display type and text.

Display type generally is any type that runs 14 point or larger. Typically, this includes headlines, titles, decks, and subheads, which are set larger for emphasis. *Text* or body type is the reading matter, the content of a story. Generally, body copy runs somewhere in the neighborhood of 7 to 12 points in size, with 8-to 10-point settings being the most common range. Also, it's important to keep the text and display faces in harmony. A foolproof, though not especially creative, ploy is to use the same face for both display and text. Notice how sophisticated and specific the type directives are in this stylebook for a recent redesign of *The Register-Guard* (see Figure 3–33).

Type selection is welded to function and using it effectively also involves "speccing out" its size, weight, leading, line alignment, and other specifications. Be appropriate. Is the message a terse, hard-hitting advertisement for truck tires? Perhaps a strong, bolded sans serif—Impact or Gill Sans Bold—would be a good choice. *The New York Times* and most other newspapers take themselves quite seriously, so it isn't by accident that so many of them run black letter nameplates. If the message is crisp and modern but dignified as well, a modern roman might be an appropriate face. Bodoni or Craw Modern would work.

When it comes to selecting body type, there is some disagreement. Some designers maintain that sans serif is the contemporary choice and that those who eschew it are old-fashioned. Others stick by the roman types. The argument for roman is threefold. First, we are most used to seeing roman faces because nearly everything we read—books, magazines, newspapers—is set in it. Secondly, the thick and thin strokes of the romans' more rounded letters cause less eye fatigue, making reading more pleasant. Third, some designers and typographers maintain that the walking serifs on the romans suggest a connection between the letters within a word. So, because we read groups of words at a time, it would follow that copy set in a roman face might be more readable.

Along with being considered more readable by many, roman faces tend to be more traditional, personal, and trusted. Sans serifs are generally thought to be cooler, more impersonal, and contemporary. Publications often juggle these two groups, using a roman face for text and the more legible sans serif for headlines. In more complex applications—as in a newspaper—the intricacies of the stylebook may be quite detailed. These are typographic samples of possible headline feature treatments in *The Register-Guard* (see Figure 3–34).

Size the Type Appropriately

As you might expect, there are no fixed rules for sizing type, but there are a few general guidelines to help you. Generally, research suggests that the most readable size for body copy in books, newspapers, and magazines is between 8 and 12 points. Copy set smaller than that will have your audience reaching for a magnifying glass.

Figure 3-33
This quick overview of detailed type styles for headlines, by-lines, decks, briefs, or story "quick facts," captions, drop caps, text, crossing heads, and more for *The Register-Guard* is a testament to the importance of type application. Effective typopgraphic stylebooks—or type usage of any kind for that matter—are based upon function and application. Courtesy of *The Register-Guard.*

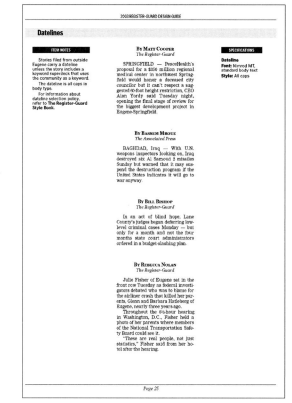

There are, however, situations in which a larger type should be used. *Reverses* (white letters on dark backgrounds) require larger sizes than they would if printed normally (black on white). And, since we're on the subject of reverse type, it's helpful to know that types with good legibility do better in reverse situations. Sans serifs and old style romans make logical reverse choices because they are more legible. In addition, children (who are just learning to make sense of words) find larger type easier to read. The same holds true for older folks; they do better with larger type because their eyesight has atrophied. The point is to keep the audience in mind when sizing body copy (see Figure 3–35).

X-height is almost as important as point size itself when it comes to readability. *X-height*, you recall, is the size of the lowercase *x*, or the distance between the baseline and mean line. Generally, the larger the x-height of a typeface, the more readable it will be as body type.

Figure 3-34

This is merely one page from *The Register-Guard* newspaper's stylebook; it offers a variety of predesigned headline treatments for feature stories. Courtesy of *The Register-Guard.*

The small size of body type are not as legible as larger ones. This paragraph is set in 6 point type, and it is far too small for ordinary reading matter, for it causes undue eye strain to make out the letter forms. Many of the ads now appearing in newspaper and periodicals contain types no larger than this and some are even harder to read than this paragraph is. Whenever possible, the use of such type should be avoided.

This paragraph appears in 8 point, and as you read it you are impressed with the greater ease with which it may be read. One may read it faster than the 6 point and with much less eye strain. However, it is still somewhat small for perfect ease in reading, as will be seen by a comparison with the following two examples.

When we get into 10 point type, we begin to get a sense of more comfortable, easy reading. The letters now are large enough that the eye can take them in at a rapid glance, without any strain or tension. This is a size of type found in many books and other reading matter, and we are quite familiar with it. Consequently, we read it with ease and speed. 9 1/2 point type, with 14-point leading, is used for the body of this book.

We come to the highest degree of legibility when we consider the 12 point size of body type. A great number of authorities designate this size of type, leaded adequately, as offering the maximum of legibility in the mass, and being the most inviting to the eye of the reader. At any rate, the range of sized for most satisfactory reading is around 10 and 12 point type.

Figure 3-35

Readability increases as point size is increased. Generally, 12 point is considered the maximum size for most text. When designating point size keep your audience in mind; very young and elderly readers need larger point sizes. X-height is also important to readability. (Sample adapted from Ralph W. & Erwin Polk's *The Practice of Printing.*)

Figure 3-36
Note the variation in x-height between these three typefaces: Avant Garde, Bernhard Modern, and Berthold Script.

Alps Alps *Alps*

X-height may vary significantly from one typeface to another (see Figure 3–36).

There are other factors to consider when sizing type. Unfamiliar letter forms make reading and comprehension more difficult. Using slightly larger sizes will make them a little easier to read. Finally, condensed faces, due to their more diminutive stature, may be set slightly larger.

Lead the Lines Effectively

Space lines of type so that your audience will get an inviting and efficient read. Printers refer to line spacing as *leading* (pronounced "ledding," as in LED Zeppelin). The term is derived from hot type technology. Printers literally inserted strips of metal—usually lead—in between the lines of type.

There are a few other important leading terms you should know. Setting the leading at exactly the same size as the type's point size is referred to as *solid leading*, written as 10/10 or 36/36. When marking up copy, the first number is always point size, followed by the leading size. Leading that is set at less than the face's point size is referred to as *minus leading*—10/8 or 24/20 (see Figure 3–37).

Sometimes in advertising layouts, designers like to place the baseline of an upper headline squarely atop the headline below. This is known as stacked leading (see Figure 3–38). It is accomplished by setting the leading at approximately 70 percent of the point size. For example, if you were working with 60-point type in a header and you wanted to stack it, you'd lead it at 42 points (.70 × 60 points = 42 points). The stacked effect can add more weight and power to a headline. This approach to leading is generally much more successful when using all-CAPS. Why? Well, if you were working downstyle, descenders would likely touch ascenders and uppercase letters from the line below. *Downstyle* is setting only proper nouns, acronyms, and the first letter of the first word in a sentence in uppercase; everything else

Figure 3-37
Leading affects readability significantly. Longer lines require more leading. For text a good rule of thumb is to add two points to the point size to determine leading. The default mode in many design software programs will auto-lead text; here leading is 120 percent of the text's point size.

❶

It may be said of all printers that their job is to reproduce on paper the exact face of the letters which they have set into pages. This face is of a definite, constant and measurable size and shape; with any one press and any one paper there is a right and exact quan-

❷

It may be said of all printers that their job is to reproduce on paper the exact face of the letters which they have set into pages. This face is of a definite, constant and measurable size and shape; with any one press and any one paper there is a right and exact quantity of ink and pressure necessary to

❸

It may be said of all printers that their job is to reproduce on paper the exact face of the letters which they have set into pages. This face is of a definite, constant and measurable size and shape; with any one press and any one paper there is a right and exact quantity of ink and pressure necessary to

❹

It may be said of all printers that their job is to reproduce on paper the exact face of the letters which they have set into pages. This face is of a definite, constant and measurable size and shape; with any one press and any one paper there is a right and exact quantity of ink and pressure necessary to

❺

It may be said of all printers that their job is to reproduce on paper the exact face of the letters which they have set into pages. This face is of a definite, constant and measurable size and shape; with any one press and any one paper there is a right and exact quantity of ink and pressure necessary to

❶ Improper word spacing; ❷ No extra leading; ❸ 1 point leading; ❹ 2 points leading; ❺ 3 points leading.

is set in lowercase. This textbook is set downstyle as are most copy and captions.

Proper leading is crucial to good readability. Some typographers vary leading from one typeface to another. Generally, faces with large x-heights don't require quite as much room between lines of type because their ascenders and descenders tend to be shorter, and there is more inherent space between the respective lines of type.

Often designers will simply add 2 points to the point size of the text face to arrive at the amount of leading for body copy; for example, 10/12 or 9/11. Today, most computers have an auto-leading default built into their design software programs of 120 percent, so they automatically lead text at 120 percent of the point size.

Remember that facets of type specification are symbiotically related; line length isn't mutually exclusive of leading, typeface, or point size. For example, long lines of type are difficult to track. To solve this dilemma, typographers add more leading. In other words, when the line length is increased, you can improve the read by simply increasing the leading.

Point size is another important consideration when leading type. Display type should be leaded differently than text. The larger display headlines become, the less leading they require. Generally speaking, you should avoid auto-leading display type. Some advertising and magazine headlines are solid or minus leaded. There is no silver bullet formula for leading display type, and most designers lead headlines by eye, and adjust it until they feel line spacing looks right. When the lines of a header are spaced too far apart, the unity will be compromised. Lead your headlines judiciously to maintain unity and not waste space.

Choose the Proper Line Length

Because we scan groups of words, not single words when we read, it's important to establish line breaks to complement our reading rhythm, particularly within headlines.

As noted earlier, lines that are set too wide are difficult to track. They tend to break our reading stride, and hurt readability. Reading becomes

Figure 3-38
Stacked type can be a very effective and creative approach to headline design, as this football preview cover demonstrates. The effect is achieved by using *stacked leading*, which spaces the lines at approximately 70 percent of the point size of the type being used. Heavier weighted type and all uppercase letters add to the implied heft of the headlines by grooming the different lines together so the header is basically one piece of type. Photography, Eric Evans; design and art direction Jan Ryan and Orion Design Group.

slow and frustrating because we can't track from one line to the next. We keep losing our place.

An equally aggravating but different problem occurs when line length is set in very narrow columns. The stubby columns force our eyes to do visual wind sprints—back and forth—and the result is that our eyes tire, and the read is slowed substantially. Imagine trying to swim a 400-yard relay in a swimming pool that's ten yards wide. Narrow columns of type have other serious drawbacks: they cause awkward word and letter spacing and force an inordinate number of hyphenations. The results are a disfigured page and columns of type that look like someone took a shotgun to them.

Proper line width is also affected by type size. Briefly, smaller type sizes, such as 6 or 8 point, can handle narrower columns than larger type (see Figure 3–39).

Researchers and typographers have developed a number of theories about *optimum line length*, which is the width of a line that is considered ideal for readability. One such theory suggests that you measure the lowercase alphabet (all the letters from a to z) at a given

point size and add one-half of it to that meas-urement (see Figure 3–40). Typographers using this theory believe the minimum width at which any type should be set is the width of one lowercase alphabet, and that the maximum width shouldn't exceed the width of two lowercase alphabets (see Figure 3–41).

David Ogilvy has another formula for line length. In his insightful book, *Ogilvy on Advertising*, he praises magazine designers, noting their standard three-column page layout, with each column averaging 35-45 characters. He suggests that their copy width be adopted. If you look closely at these theories, you'll notice that the recommended line lengths of each are approximately the same. Any one of these formulae works fine. The main thing to remember is that improper line length not only can ruin a good-looking layout, it can seriously impede the read.

Finally, avoid hyphenations in headlines, pull quotes, crossing heads, and in any other display type. Hyphenated headers look shabby and unprofessional.

Use Line Arrangement Strategies Thoughtfully

How you set your line endings—or "rack the type"—is the next piece of type specification. Basically, the two most common approaches to arranging your line endings are *justified* and *flush left* columns. Three less frequently used methods are *flush right*, *centered*, and *contoured* alignments (see Figure 3–42).

The oldest and most formal of the options is justification. *Justified* type is arranged evenly on both sides (except for paragraph indentations and endings): both left and right sides are flush and parallel to one another. The words you are reading on this page are set flush left. Early typographers borrowed this type nuance directly from the scribes, many of whom strove not to leave ragged lines open to the edge of the page, which wasted precious paper.

Indeed, justified type is a more economic use of space, but it has a few inherent weaknesses. In general, justified columns cause more hyphenation and create more gapping—word and letter spacing problems—than flush left copy.

Moreover, the narrower the column, the bigger the problem. However, justification is a more formal and traditional approach to handling line endings. Mario Garcia, the director of the graphics program at the Poynter Institute of Media Studies, maintains that one can tell how serious a publication takes itself by whether it uses justified text. Today, most print media use justification for body copy.

As the name implies, *flush left* columns are set, except for paragraph indentation, flush to the left and have ragged edges on the right. This approach is also referred to as *ragged copy*, *ragged right*, or *neat left*.

One advantage of running flush left alignment is that you won't end up with weird spacing or rivers of white running inside the columns. Flush left endings produce fewer hyphenations and bring more texture to the page. Some researchers believe flush left alignment is user-friendly and offers better readability. It is also more relaxed, more informal. Sometimes, newspapers will run their front, sports, editorial, business, and other more serious sections justified but will run entrée or entertainment sections ragged.

When *centered* text is used, it's most likely to be found in scant amounts. This approach centers up all the lines. Captions are sometimes set in this manner. Centered type may also rack headlines, book titles, or title pages. It is also commonly used in advertising design. However, centered text may have tracking problems. You would not want to read *War and Peace* centered.

Flush right is much less common. This method of alignment is exactly the opposite of flush left. Also known as *neat right* or *ragged left*, it has terrible tracking problems, precisely because it goes against the grain of how the occidental eye tracks—left to right and top to bottom—so its readability is not great. Also, when you do find flush right, it's applied in small amounts like centered copy. It is found in line arrangements for captions, credits, surprinted cover blurbs, book titles, or in contouring situations. Designers also like to use it to bookend graphics. In these situations, they'll rack one caption or paragraph flush right on the left hand side of the graphic and flush left on the right side.

The width of a column of reading matter influences its legibility. The ideal width for any piece of composition is based on the breadth of focus of the eye upon the page. For small types the focus will be narrow, and it will widen out as the type faces increase in size. If the column is set too wide in a measure, as is the case with this paragraph, the lines will be scanned with somewhat of effort, and it will be found harder to "keep one's place" as one reads. Also, it will require some effort to locate the starting point of each new line. A large amount of reading matter set like this would be tedious to read.

On the other hand, if the column is too narrow, fewer words may be grasped at a time, and thus, too frequent adjustments must be made for the numerous shortlines of the type, seriously hindering the steady, even flow of the message. In addition, a greater proportion of words must be divided at the ends of the lines, and the spacing of the lines is necessarily un-even and awkward, also affecting the legibility.

This group is set the proper width for the comfortable, easy reading of 8 point type. The eye may easily take in a line at a time, and in this way the message may be read without any mechanical encumberances. Larger types set to this width will present the same difficulties to the reader that are experienced in the 8 point example, set in the narrow measure, above. There is a suitable width for each size and style of type.

Figure 3-39

Examples of 8-point type set on three different line length measures. Note what happens to the word and letter spacing in very short lines. (Sample adapted from Ralph W. & Erwin Polk's *The Practice of Printing*.)

abcdefghijklmnopqrstuvwxyzabcdefghijklm

(Ideal line width: 1.5 times the lowercase alphabet)

Figure 3-40

The ideal ("optimum") line length is 1.5 times the length of the lowercase alphabet.

abcdefghijklmnopqrstuvwxyz

15 picas
(minimum width)

abcdefghijklmnopqrstuvwxyzabcdefghijklmnopqrstuvwxyz

30 picas
(maximum width)

Figure 3-41

Generally, this 12-point square serif type should not be set in lines narrower than 15 picas or wider than 30 picas.

Lorem ipsum dolor sit amet, consectetuer adipiscing elit, sed diam nonummy nibh euismod tincidunt ut laoreet dolore magna aliquam erat voluptat. Ut wisi enim ad minim veniam, quis nostrud exerci tation ullamcorper suscipit lobortis nisl ut aliquip ex ea commodo consequat. Duis autem vel eum iriure dolor in hendrerit in vulputate velit esse molestie consequat. vel illum dolore eu feugiat nulla facilisis at vero eros et accumsan et iusto odio dignissim qui blandit praesent luptatum zzril delenit augue duis dolore te feugait nulla facilisi. Lorem ipsum dolor sit amet, consectetuer adipiscing elit, sed diam nonummy nibh euismod tincidunt ut laoreet dolore magna aliquam erat voluptat.

Lorem ipsum dolor sit amet, consectetuer adipiscing elit, sed diam nonummy nibh euismod tincidunt ut laoreet dolore magna aliquam erat voluptat. Ut wisi enim ad minim veniam, quis nostrud exerci tation ullamcorper suscipit lobortis nisl ut aliquip ex ea commodo consequat. Duis autem vel eum iriure dolor in hendrerit in vulputate velit esse molestie consequat. vel illum dolore eu feugiat nulla facilisis at vero eros et accumsan et iusto odio dignissim qui blandit praesent luptatum zzril delenit augue duis dolore te feugait nulla facilisi. Lorem ipsum dolor sit amet, consectetuer adipiscing elit, sed diam nonummy nibh euismod tincidunt ut laoreet dolore magna aliquam erat voluptat.

Lorem ipsum dolor sit amet, consectetuer adipiscing elit, sed diam nonummy nibh euismod tincidunt ut laoreet dolore magna aliquam erat voluptat. Ut wisi enim ad minim veniam, quis nostrud exerci tation ullamcorper suscipit lobortis nisl ut aliquip ex ea commodo consequat. Duis autem vel eum iriure dolor in hendrerit in vulputate velit esse molestie consequat. vel illum dolore eu feugiat nulla facilisis at vero eros et accumsan et iusto odio dignissim qui blandit praesent luptatum zzril delenit augue duis dolore te feugait nulla facilisi. Lorem ipsum dolor sit amet, consectetuer adipiscing elit, sed diam nonummy nibh euismod tincidunt ut laoreet dolore magna aliquam erat voluptat.

Figure 3-42

These columns of type are set flush right (ragged left), flush left (ragged right), and justified. The latter two are standard approaches to typesetting copy; flush right is sometimes used with scant amounts of type in titles, captions, and advertising. Flush right is not a good text strategy.

Although more rarely used, *contour type* has its advantages. This ploy wraps or contours text around, within, and along the side of the graphics of a design. The term *rebus design* is often used interchangeably with contour type. Typically, this type form is often loaded with custom-fitted line arrangements.

Contoured type is often playful, energetic and eye-catching (see Figure 3–43). When meticulously groomed, it can deliver a very elegant and tasteful strategy for typography. Pentagram principal and senior designer, Kit Hinrichs, is considered the guru of rebus design. Rebus type designs are found across all media, especially in newspaper feature layouts, magazines, annual reports, advertising, and Web page designs.

Use Uppercase (All-CAPS) Sparingly

There was a time when printers and typographers believed that the most readable letters were the old roman capitals. Researchers have since dismissed that myth and proven without question that lowercase letters better define and shape words than do their uppercase relatives. Therefore, all-capital letters (all-CAPS) should be employed sparingly. Capitals take up a tremendous amount of space. In addition, they are blocky, monotonal, and less graceful than lowercase. In addition lowercase letters have more character and variety. They enhance readability.

Originally, lowercase letters were referred to as *miniscules*. In fact, their development evolved via the scribes, who invented miniscules as graphic

Figure 3-43

Kit Hinrichs uses contour (rebus) and flush left line approaches in this dynamic layout for the table of contents page of *SKALD* magazine. Along with the rebus layout, note the vertical arrangement of the content entries and seven-column layout. Courtesy of *SKALD* magazine/Kit Hinrichs.

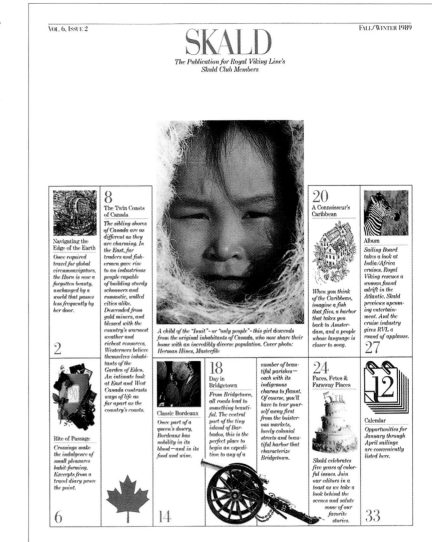

shortcuts for their uppercase (or majuscule) counterparts. Each lowercase letter is distinctive and not so easily confused as a capital, the structures of which have many similarities. Contrast, for example, the lowercase *c* and *g* with the uppercase *C* and *G* (see Figure 3–44). There is much less likelihood of a reader mistaking the architecture in the lowercase versions.

Research has proven that lowercase letters improve readability and that they're more pleasing to the reader. Moreover, they don't tire the eyes as all-capital settings do.

However, words or lines set in all-CAPS can be powerful design elements, particularly when used in short doses. Art directors often like to use them to create punchy headlines in an ad.

TBWA/Chiat/Day has used all-CAP, sans serif headers in this way for years in the acclaimed Absolut vodka print campaigns. Of course, their stopping power makes all-CAPS an enticing strategy in magazine nameplate designs (*ELLE, SKALD, THE NEW YORKER, NATIONAL GEOGRAPHIC*), newspaper section logos, or title pages (see Figure 3–45).

In instances where all capital usage would enhance a layout, designers suggest limiting them to two or three lines at a time. Try to keep the lines brief. In headlines and titles, you have a wide range of leading options—from stacked leading to very open leading strategies that may even use credits, decks, or subheads in between the much larger title or header type.

Figure 3-44
Lowercase letters have a well-defined structure and they're less likely to be confused with one another. The contrast in capital letter structure is not as clear or distinctive. Lowercase text (or downstyle) has much better readability than copy set all in caps.

Figure 3-45
Uppercase is fine for headlines or nameplates, like this handsome *SKALD* magazine cover. Can you identify the type group of the face used for the nameplate? Design and design direction by Kit Hinrichs; art direction, Terri Driscoll; photography, Herman Hines. Compare its look and voice to its corresponding contents page, Figure 3-43. Courtesy of *SKALD* magazine/Kit Hinrichs.

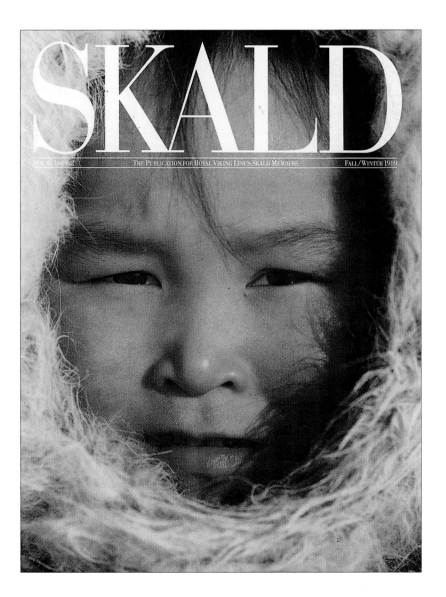

Adjust Space Within and Between Words

Due to inconsistent letter spacing within words, you may need to adjust the letter spacing via kerning and tracking. *Kerning* is adjusting the space between individual letters (see Figure 3–46). *Tracking* regulates the spacing between

Typography
Typography

large groups of words. Both *letter spacing* (space between letters) and *word spacing* (amount of space between words) are controlled in computers via the tracking program built into the software design program you're using (see Figure 3–47). Individual words, lines, or the entire text may be modified by adjusting the spacing units in small plus or minus increments or by selecting one of several spacing options.

A line of 8 pt. Baskerville is difficult to read with only a thin space.
its legibility is greatly improved when the words are separated.

A narrow type needs much less space between the words.
A wide type needs much more space.

A type with a small x-height requires only a thin space.
A type with a large x-height needs a thick space.

Generally speaking, display type is set more tightly than text. Kerning headlines eliminates inconsistent or irregular letter spacing within words. On the other hand, a designer may elect to intentionally give the typography a reshuffling via kerning and alignment as in the magazine story, "The End of the Road" (see Figure 3–48). The feature is a true story about a man who set out to murder an entire town and indeed, killed half the residents of McCarthy, Alaska. Again, type honors content.

Both kerning and tracking are easily accomplished on a computer using design software. Fifteen years ago, most kerning was done by hand, but technology has made that task incredibly easier. The purpose of kerning is to groom the type carefully by adjusting spacing irregularities.

Usually, kerning involves tightening up the space, but in some instances the space between letters may be widened. Kerning is standard design procedure. Literally all display type should be kerned. That includes cover lines, nameplates, logotypes, titles, and all headlines. Always check for readability after you've finished.

**Match the Weight
to the Voice of the Message**

Weight refers to the density or darkness of a typeface. In publications, it is literally the amount of ink that the printing press puts on the page's surface. Type weight may whisper, as in Garamond light italic, or it can blast the message, as in an ultra-black Impact.

Just as a family of type may have a variety of styles from which to choose—condensed, normal, book, italic, and so forth—that same typeface usually offers an assortment of different weights—extra light, light, normal, demi-bold, semi-bold, bold, ultra-bold, or black (see Figure 3–49). However, not all faces provide the same weight options. Some may offer less than a handful, while others present the entire gamut of blacks for your weight palette. This variance comes down to usage. Generally, the more popular a family of type is, the more weight variations it will have available.

Normal or regular weight is the one most commonly used in body copy. The type weight of the text of the book in your hands is normal. Research has proven that it is the most readable text weight. Practice and readability studies bear this out.

When creating headlines, titles, and other display type, designers may opt for more heavily-weighted type. The logic is simple and understandable, and it points up an important facet of type weight. Additional ink gives words and ideas a louder voice. Sometimes, though, the creative strategy for working with weight is not so obvious. Take the very hip VW ad campaign, created by Arnold Communications, for the new Beetle. In the tradition of the much older "Think Small" VW ads, the new Volkswagen magazine and outdoor pieces use wry humor and place small art in a large space: the photography is diminutive, floating the new Beetle in a sea of

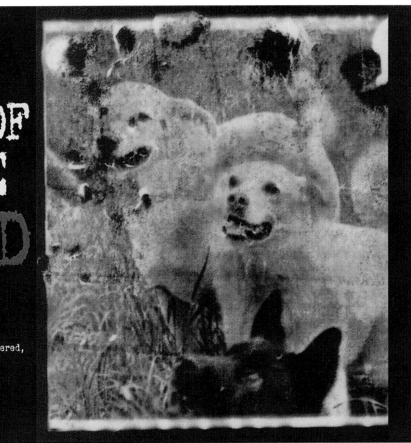

THE END OF THE ROAD

Fifteen years
after nearly half its
residents were murdered,
an Alaskan
bush community
struggles to rebuild

Story by
Kevin Coughlin

Photo
illustrations by
David Parmeter

The dogs of McCarthy, Alaska, roam the

dirt and gravel streets untethered.
There are no leash laws here and no police
within a hundred miles to enforce them even if there were.

A loose affiliation of about a dozen mutts, they respect each other's territories
and dispositions, often frolic when they gather, and rarely scrap.

When the dogs stray, they stray north, toward Kennicott, or up the hill east,
toward the dozen or so cabins scattered through the woods between McCarthy and its
gravel airstrip. Only McCarthy's natural boundaries limit their movement. McCarthy
Creek borders town to the south and flows into the Kennicott River, the town's
western margin. To the east and north lie thousands of square miles of mountains,
glaciers, and river valleys. Before the summer of 1997, the Kennicott was
traversable only by hand trams and afterward only by footbridges.

Tourists sometimes bring city dogs not used to this freedom. And, occasionally,
one of these well-groomed pets will loudly tangle with one or more of McCarthy's
pack, which usually rallies to repel the Outsider. The tourist dogs don't stay
long anyway.

flux 1998 13

Figure 3-48
Kerning may be employed
to deliberately give a
headline a rougher, edgier
look. What else has been
done to the type to help it
communicate the sense of
this dark story? Photo-
illustrations done by
David Parmeter; typogra-
phy, layout and design by
Jessica Obrist; story by
Kevin Coughlin.

Weight equals girth
Weight equals girth
Weight equals girth
Weight equals girth

Figure 3-49
Weight refers to the girth
or density of a typeface.
It reflects the amount of
ink put on the page. Here
the weights of Helvetica
are light, medium, bold,
and black.

white. To help underscore that same feeling, the type was run small. The words had to be just large enough and legible enough to be read. The type connected to the art and idea; it was kept small and understated.

Remember, the primary function of display type is to stop the audience. In the feature opener from *Civilization*, bold type, bold color, and generous white space make a powerful statement in "Acting Out in Japan" (see Figure 3–50).

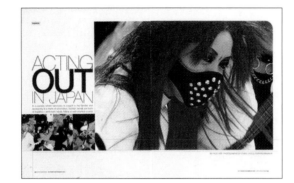

Finally, some technical talk. If you're working with any bolded weights—particularly at smaller point sizes—pay very close attention to the counters of the letters. Tighter counters may close up when bolded and can clot. Be careful of lighter weights, too, particularly when run small because they are lithe and may compromise legibility. Also, before you bold a headline, examine its normal weight at the display size you're using. Frequently, the larger size speaks loudly enough, and you don't need to bold it.

Give Words Emphasis With Posture and Width

Posture refers to the stance of type, or how upright it is. Essentially, there are three simple approaches to typographic posture; two of them—*roman* and *oblique*—are common posture strategies. The third version—*backslanted*—is rarely even available as a typographic option (see Figure 3–51).

Garamond Roman
Trebuchet MS Oblique
Textile Backslanted

The term "roman" may seem confusing here. In fact, it has two typographic references. The most common meaning designates typeface—that is, serif type. However, it also refers to any type's *upright posture*, its 90-degree vertical stance which is perpendicular to the baseline. This is the posture that nearly all typography adopts. Any minor variance is incidental and attributable to letter configuration. In terms of posture, roman type is the most readable.

Oblique stature, although seldom used, is a fairly common application of posture. In this instance, letter structure is pitched forward. Obliques should not be confused with italics. Italic letters not only lean forward, they have less weight, are slightly cursive, and are a tad smaller in stature than their roman counterparts. True italics occur only within roman faces. Some designers use obliques for variety or to give the headline or message a kind of urgency. Oblique posture is sometimes applied to headlines and other display type, as well as to accent captions, pull quotes, decks, dropped initial letters, and the like.

Last and least is *backslanted* or *raked* posture. Backslanted posture is pushed backwards and against the grain of our normal reading rhythm. When you do find this posture used, it's usually as a novelty type, and often in a message as trite as "BRAKE FOR A GREAT TIRE SALE."

Width is the horizontal space of a letter. The normal designation of width is 100 percent. Design and illustration software programs allow their users to adjust the width of any typeface (see Figure 3–52). Concurrently, type designers and purists are horrified that anyone would digitally tinker with the architecture and integrity of a typeface.

You may adjust a single letter, word, or an entire file's type width. Today's design software programs (notably PageMaker, InDesign, Illustrator, and Quark) all allow the designer to stretch or squeeze the width of type by changing its spatial measure. While purists frown on this strategy for aesthetic and philosophical reasons, tweaking the width of type affords designers an extra type tool that sometimes will help them fit a dropped initial letter perfectly, avoid a widow,

Figure 3-50
Weight can be used to stop an audience as shown in this poster-like opening spread from *Civilization*. Notice the bolded type sandwiched between lighter weight typefaces. Design director, Matthew Bates; illustration by Jameson Simpson. Courtesy of *Civilization* magazine.

Figure 3-51
Nearly all type uses roman or upright posture. Oblique type is pitched forward. Backslanted or "raked" type is quirky and normally found only in specialty or miscellaneous typefaces used for retail newspaper advertising.

or finesse a line into place. A *widow* is a short line ending a paragraph, sometimes consisting of just a single word or two. Many designers feel widows gap the page and avoid them like the plague. In design, function is everything and pragmatism rules the roost.

Style the Type to Affect the Message

Type style is another area where some disagreement arises over semantics. Many designers use "type style" interchangeably with "typeface." In fact, type style refers to one of a number of structural deviations within the letterform of a specific family of type.

Most faces have at least these four stylistic variations in their family tree—not counting combinations of those styles. They are: normal, book, condensed, and italic. Some faces have still other offerings; for example, swashbuckle, extended and expanded styles (see Figure 3–53). The majority of types mix style architectures. Garamond book italic and Palatino condensed italic are examples of mixed styles. However, a typical type family may not have all style options available.

Normal or *regular* styles are the pure, everyday versions of a typeface—the upright, medium-weighted type that we see most commonly. This book's body copy is printed, for the most part, in a normal style.

Book versions of types look nearly identical to their normal counterparts but are slightly smaller in stature and take up less horizontal space. The rationale behind their design is simple: a printer or publisher will use less ink and paper, and therefore cut costs, particularly with large publication runs using a book type. Book styles are typically employed for large-scale productions— typically book or magazine runs or for art-related purposes. If the text is set smaller, photography and illustration may receive stronger play. Usually, though, book type is chosen to save money and space.

Condensed type is even more narrow and diminutive than book type. It has the leanest look of all the type styles. A common use for it is in information graphics, insets, and diagrams, where a designer has little room for text. In these instances, a sans serif type is often employed because of legibility issues.

Italic was designed as a special face by Aldus Manutius in Venice in 1490 at his now famous Aldine press. It was conceived and cut largely for all the same reasons as book type was invented. Along with being a very successful printer and type designer, Manutius was a good businessman. He sought to develop a letter style that was more personal as well as smaller in stature, so that he could get more words on the page.

Swash or *Swashbuckle* type is a heavily embellished italic type. It is ornate and darker (heavier in weight) than its italic cousin. The finishing strokes of swash type tend to be exaggerated dramatically. This style is almost never used as a body type. Its purposes are clearly display-related.

ITC Caslon 224 Book at 80%

Futura Condensed Medium at 60%

Georgia Italic at 130%

ITC Caslon 224 Book

Futura Condensed Medium

Georgia Italic

Figure 3-52
Today computers allow designers to adjust the width or "horizontal scale" of a typeface digitally.

Figure 3-53
The availability of a type's stylistic options fluctuate from one typeface to another. Style choices may include italics, condensed, book, and swashbuckle.

Mix Types Carefully

Simple is better. Old-time printers knew what they were doing. They suggested, if you start a job with Bookman, finish it with Bookman, understanding that the most attractive printed product was one that mixed typefaces the least. Today, typographers refer to this philosophy as the rule of *mono-typographic harmony*—a big term for a simple but foolproof approach to typography.

The concept of mono-typography mandates that you keep the same family of type throughout the job. Variety within that face is achieved by varying that family's size, weight, postures, styles, and widths. Although this approach is quite defendable and produces the least amount of typographic noise, its overall texture and effect is as predictable as it is uniform.

Many publications like to mix a roman body face with a crisp, heavier sans serif type (see Figure 3–54). This helps achieve variety, contrast, and punch. And because the text and headlines are consistent with the stylebook, the look of the publication maintains its continuity. This was exactly what the award-winning newsletter *View Points* achieved, using Optima as a text face and offsetting it with Garamond headers. To increase contrast, Futura book was incorporated with Optima for the nameplate and interior logos of that publication.

However, when families are mixed, care should be taken to avoid combining families of the same race, particularly if they closely resemble one another. For example, the basic old style roman structures of Caslon and Garamond are similar, and their architectures are so close that mixing them is more likely to confuse the design than bring variety to it.

When faces are mixed, make sure a clear, inherent contrast exists to separate them. Think about contrasting function too. For example, you might use one group for display and another for text. Then, add subtle refinements for by-lines,

decks, captions, pull-quotes and the like by adjusting the weight, posture, width, style of the two main faces. Try to limit the type you're working with to two or three faces. This strategy is often a logical starting place for typographers and designers who are inventing or overhauling a newspaper or magazine's design. Indeed, many publications and corporations develop stylebooks to provide guidelines or a basic blueprint of the typographic and stylistic details of a publication. Typographical standardization is important to a company or publication's identity.

Feel free to experiment, and use your natural and acquired instincts to guide you when mixing typefaces. To be sure, integrating and blending type is often an intuitive art, but with study and experience most anyone can learn to mix typefaces effectively.

Remember the Margins

Think of your white space as an inviting island in a sea of type. A place to give readers pause and a little visual relief. In addition to providing this resting place, margins can help organize or divide your layout and show readers where one section or story ends and another begins. Margins also can establish unity throughout your pages and incorporate white space judiciously.

Margins are the white (or sometimes negative or textured) space that surround the art and type. Basically, their function is to frame the page. If the margins are too narrow, the framing effect can be lost or minimized, and the page will look cramped. Reading will be difficult. On the other hand, if the margins are generous, they'll anchor and frame the layout, help unify the page, provide an inviting window into your design, and make reading easier.

To demonstrate how important margins are to readability, do this: tear a page out of a newspaper or magazine, and, using scissors, trim as closely as you can to the edge of a column of text without cutting into it. Then try to read it. You'll discover that it's very difficult to track! Margins dramatically affect how well type reads and may determine whether your audience even reads the pages.

Figure 3-54
William Ryan designed *View Points*, a newsletter for AEJMC's Visual Communications Division. Three faces were used: Optima for text and half the publication's nameplate; Garamond for dropped initial letters, headlines, and accents; and Futura Book for interior logos, captions, teases, and the other half of the newsletter nameplate.

Remarkable as it might seem, publications—particularly magazines, viewbooks, and brochures—may devote 50 percent of the page's space to their margins. Margins also help present your message and content the same way that mats present the artwork in a framed picture. Typically, too, the more generous the margin of the mat, the more inviting the presentation. The magazine feature, "Common Ground," employs very generous margins, and a fresh mix of typography to make a grand presentation for readers (see Figure 3–55).

There are a variety of ways to stake out the perimeter of the page. Traditional book margins are known as *progressive margins*. In this instance, the smallest margin is the gutter margin, set on the inside of the page. The top margin is larger. The outside margin is wider than the top, and the bottom margin is widest of all. In other words, the margins are progressively larger around the page.

Communication Arts magazine runs a liberal margin around its cover. White space artfully frames the magazine's color block and type (see Figure 17-8). Generous margins suggest quality to the reader, appropriate for a publication that features the finest graphic art in world. Upscale designs often employ this strategy.

Tasteful margins of varying proportions are as suitable for academic journals as they are for museum brochures, fashion magazines, or just about anything you want to imprint with an elegant look.

Important Points to Remember

- Races are groups of types that have similar structures in common.
- A family of type consists of *all* the styles, weights, and other versions of a specific typeface.
- There are six basic groups of type: black letter, roman, sans serif, square serif, script/cursive, and miscellaneous or novelty type.
- Roman type has three subgroups: old style, transitional, and modern.
- Type size is measured in points. There are 72 points in an inch.
- Line length is measured in picas. There are 6 picas in an inch.
- The pica is used to express overall width or depth, as well as the length of a line. There are 12 points in 1 pica.

Figure 3-55
Wide, inviting borders and irregular edging make this a compelling layout. Gillian Brineger used type, textured backgrounds, and white space for this magazine spread. Ben Scott shot the howler monkey in a Belize jungle sanctuary. This *FLUX* layout received multiple awards for its design, photography, and use of type. Courtesy of *FLUX* magazine.

Figure 3-56

Type is multifunctional. To truly appreciate its possibilities, craft, application, and function, you should remember that typography needs: to be inviting, appropriate to the voice and context of the content, to help organize the message, to blend with all the other elements of a layout, and to elicit a response. Type may also be employed in very creative ways. That's what the following chapter will examine.

This prototype layout accomplishes all of the above. How does the optometrist's eye chart work as a visual pun in this example? How does the type accomplish the goals stated above? Actually, the artwork here is typography. However, the sharpness of the type has deliberately been manipulated, reversing how you might really see an eye chart. Here, the largest line is most blurred, with each continuing line being slightly less blurred until you get to the bottom line - which is tack sharp. Ironically, the headline of the ad is the smallest *and the* sharpest line of type - and it is positioned at the *bottom* of the page. The header - "Long time no see?" - is followed by the name of the vision center. Art direction and copyrighting, William Ryan; design and graphic manipulation, Jan Ryan. Courtesy of Orion Design.

Based on a visual angle of one minute.

E

F P

T O Z

L P E D

P E C F D

E D F C Z P

F E L O P Z D

D E F P O T E C

L E F O D P C T

F D P L T C E O

P E Z O L C F T D

LONG TIME NO SEE?

Washington Clear Vision
2247 N. State Street
322-0071

- The em is the square of the type size being used. The most common use of the em is to indicate indentation, typically at the start of a paragraph.
- An en is the same height of the point size being used, but half its width.
- An agate line is used to measure the depth of advertising space. There are 14 agate lines in an inch.

Graphics In Action

1. Collect examples of types representing each of the races: 2–3 examples for each race. Go to a variety of media for your examples: newspapers, brochures, viewbooks, newsletters, print advertising, posters, magazines, etc. Mount them on a white board or sheet of paper, and then measure the length of lines in picas and inches.

2. Select 5-6 magazines with a wide variety of audiences, for example, *Rolling Stone, Forbes, Seventeen, The New Yorker, Raygun,* or *The New Republic.* Compare the use of typography on their covers, table of contents pages, and in feature layouts. Bring your examples to class and be prepared to discuss how the types match the audience, voice of the publication, image projected by the magazine, and content therein.

3. From the same magazines (see #2 above), clip out headlines from two advertisements per publication. See if class members can match the ads to their respective magazines. Then discuss the likely type strategies employed.

4. You've been hired to redesign the nameplate of your local newspaper's new Saturday entertainment section that will be targeted at a young (15-25 year-old) audience. The editor has also noted that the entertainment section will have a tabloid format. Create four different nameplates for this section.

5. Dress out the cover of the above section; i.e., scan in a cover photo, create cover blurbs, and teaser boxes to hype several inside stories.

6. Create advertising headlines with appropriate typefaces and type treatment for the following products: Giant mountain bikes, Victoria's Secret, Swiss Army Knives, *The New York Times,* and the American Dairy Association.

7. The editor of *Climbing* magazine has hired you to build a typographical stylebook for the on-line version of the magazine. Bring in the stylebook and discuss it.

*Read the text before designing it.
Discover the outer logic of
typography in the inner logic
of the text.*
—Robert Bringhurst,
The Elements of Typographic Style

◄ *Bottle Caps,* for the cover of *Type Club of New York City.*
Gail Anderson

Develop a passion for typography. Good type is rapidly becoming a lost art and that's sad. If you don't know what a ligature is or you've never heard of Jan Tschichold—go ask one of your instructors... And hand letter a couple of alphabets while you're at it.

—Hal Curtis, creative director,
Wieden + Kennedy

Figure 4-1
Jim Parkinson is a master typographic designer who has designed logos and nameplates for magazines and newspapers world-wide. Some of his clients include *The Chicago Tribune, Mother Jones, Self, Reader's Digest, Esquire, Cromos,* Birkenstock, *InStyle, Rolling Stone, National Post,* and the Barnum and Bailey Circus. He also designs typefaces independently and for type houses such as the Font Bureau of Boston. Some of his fonts include Electric, Diablo, Amboy, Tupelo, and Azuza—a 2002 Type Directors Club winner. Portrait photo by Beth Parkinson.

Previous page
Along with being an artist and gifted designer, Gail Anderson is a high priestess of typography. This marvelous solution for the Type Director's Annual was inspired by her bottle cap collection. Art direction, design, and typography by Gail Anderson.

Creative Roots Run Deep

It is important for you to appreciate important typographic influences from the past to better understand the artistry and creative potential of type. Jan Tschichold (1902-1974) is a case in point; his vision and independent spirit made him one of the most creative type designers to ever put words on paper. His book, *Die Neue Typographie (The New Typography)* and his association with the Bauhaus and Soviet Constructivists resulted in the Nazis arresting and jailing him based on charges he was a "cultural Bolshevik" who'd created "un-German" typography. Jan Tschichold was an early advocate of sans serif type and asymmetric design. His philosophy was typically Bauhaus and emphasized function. Tschichold was also a minimalist and believed that messages should be reduced to as few words as possible—advice that many aspiring copywriters or creative directors could learn from.

Over the years, Tschichold mellowed, but his creativity continued to sing. His devotion to stripped down, sans serif types waned; and he developed a deep respect for classic roman typefaces. His mark on typography and graphic design is indelible.

Jim Parkinson is another typographic designer who has lettered more than his share of alphabets and made significant typographic contributions for all of us. In addition to designing type, his creativity extends to logo and nameplate design. Among his hundreds of designs are *The Wall Street Journal, Rolling Stone, Newsweek,* and *The Washington Post.* He reflects on how he became a designer of typography and logos.

I decided I wanted to be a lettering artist when I was about seven years old. I had an elderly neighbor, Abraham Lincoln Paulson. He was a showcard lettering artist and calligrapher. (Showcard lettering is essentially hand lettering for small signs for retail sales display and lobby cards for theaters.) Mr. Paulson would entertain at parties and lodge meetings and even had a booth at the San Francisco International Exhibition on Treasure Island in 1939. Making a living doing lettering in the age before computers was not an easy thing. I used to spend hours sitting in his studio, watching him work. Now, fifty years later, I am the old guy sitting and lettering in a studio in my house.

I went to the California College of Arts and Crafts in the very early 1960s. There were a couple of lettering classes and a class on how to spec type, but there were no courses on type design. Back then it just wasn't an option, so I focused on hand lettering. Hand lettering has had a big influence on my work ever since.

As a lettering artist, I did record album covers, book covers, posters, and lettering for packaging. Eventually, I drifted into designing logos for magazines and newspapers.

Until 1990 I did all my work the old-fashioned way: pencils, tracing paper, light table, pen and ink. It was hard work. When the Mac came along, with the right software, it was as though I had been set free. When I first started working on the Mac, I would do pencil sketches and scan them in as templates. Eventually, I realized that I wasn't following the scanned templates when I was drawing on the screen. It'd become a waste of time. Instant rubbish. Now I draw everything directly, using the computer. In fact, I always

work that way, unless I have to scan a logo to work from.

Every logo job is different. Some are new designs, some are evolutionary steps from older designs, some re-introduce logos from the past, with a twist. Newspaper logos are generally more conservative than magazine logos (see Figure 4.2). They have to be. They present the news and need to present a serious and trustworthy appearance. Some magazines also present the news, but others contain all kinds of messages and it takes all kinds of logo styles to express those messages.

There is one major difference between designing typographic logos and designing a typeface. A typographic logo is usually a word or name that will remain unchanged. The letters can be designed so they work well with one another in that word. The characters will always be in the same order, so no consideration need be given to how the characters would look if arranged in any other order.

However, a typeface is a set of letters that have to be designed in such a way that every letter works well in relationship to every other letter. Design characteristics and letter color, spacing, and kerning all need to be designed into the font— all details predetermined and designed for future use by someone other than the typeface designer.

The Roman alphabet, the letters we use every day, are fascinating. They have been in use for around 2000 years, and still, there seems to be no end to how many ways this set of symbols can be interpreted by a designer and still be functional.

Before the Macintosh, Postscript language, and font editing software, the business of making typefaces was the business of a handful of major companies. Today, smaller shops make significant design contributions, and many designers, like myself, freelance type design, too. The Macintosh, type design software, and the Internet made type design practical for individual designers.

My first type designs were based on the Showcard Lettering styles I am so fond of today. Showcard Gothic (Tupelo sample) and El Grande were faces I designed for the Font Bureau. They are two of perhaps two dozen showcard-based styles I've created. Showcard Gothic was a winner in the 1998 Type Directors Club Type Design Competition.

About six years ago, I was working part-time at the San Francisco Chronicle. Anyone who worked there had to join the union. I designed fonts for them, and I used to joke that I was the world's only union type designer. One of my type designs for the Chronicle, called Electric, was a cross between W.A. Dwiggins' Electra, designed in the 1930s, and the newspaper text face Corona that Chauncey H. Griffith designed for Linotype in 1941. The Electric family is still used in the Chronicle today as text and for some heads (see Figure 4–3).

Although I still like designing bold, expressive types, I also focus on more "serious" type designs. What I mean by serious is less flamboyant, less in-your-face, more conservative, more legible, and designed in a way that makes it the proper type for use in many situations.

Figure 4-2
Parkinson reflects upon two of his many nameplate designs. "Based on a series of typefaces I was commissioned to design for *Rolling Stone*, inlines, outlines, shadows and flourishes added to recall the original logo. ROLLING STONE® is a registered trademark of Rolling Stone LLC. All Rights Reserved. Reprinted by Permission. The *Detroit Free Press* nameplate is a redesign of a logo that had been modernized over and over until it had become laughable. The solution was to go back to a traditional newspaper logo design, with a touch of elegance." © *Detroit Free Press*. Reprinted with permission.

Figure 4-3
Here are two stridently different faces created by Parkinson. Showcard Gothic (Elvis/Tupelo example) is based on showcard styling and was created for the Font Bureau. Electric was influenced by Dwiggin's Electra and Griffith's classic Corona faces. Courtesy of Jim Parkinson.

Using Type Creatively

Like Robert Slimbach, Jim Parkinson exudes typographic creativity. His calligraphy background and familiarity with computers and sophisticated software programs opened up all kinds of creative opportunities for him in today's digitized world. Type establishes publication and branding identities. In fact, we need not even see all of the words in a particular magazine's logo to recognize immediately what it is. Type is a crucial component of a publication's identity—or anything's identity, for that matter. As Kit Hinrichs and Delphine Hirasuna (@*issue*: editor) suggest: "Used effectively, a distinctive logotype becomes the corporate signature." That is why many companies commission the design of a unique typeface, or wordmark, that incorporates clues to their line of business or operating philosophy. Other companies have adopted off-the-shelf typefaces that they have made their own through the use of designated corporate colors, upper or lower case styling, condensed or expanded leading, and other techniques. As with any branding tool, a logotype must be used consistently and frequently to work (see Figure 4–4).

However, creativity involves research, meticulous attention to detail, inspiration, and perspiration. In fact, Alex Kroll, advertising executive, suggests that "…getting ideas is like shaving; if you don't do it every day, you're a bum." So, right off the bat, it's important to point out that the creative process isn't something you do irregularly. Like most anything else, to become creatively proficient, you need to be well rehearsed and possess a solid work ethic.

Creativity involves experimentation, traveling off the beaten path, risk-taking, and thinking unconventionally. However, the most creative designers and visual journalists understand typographic theory and usage, in the same way that the most talented athletes understand the rules of their sport.

Again, type has a long and specific history of guidelines, syntax, and usage. Early typographic designers were calligraphers—like Parkinson and Slimbach—and borrowed many details from the scribes' letterforms and book design.

In other words, they learned and borrowed nearly all of the earlier typographic conventions. Remarkably, these practices have changed little over the course of hundreds of years. Now that you've studied the basic principles of type— usage, markup, and type specification—you might wish to experiment with it. For instance, although D. J. Stout constricts and deliberately wobbles the type alignment in his layout for "Rattled," his design really adds to the content and context of the story in a most insightful and memorable way (see Figure 4–5).

However, like language itself, the use and application of typography is as complex as it is conventional. Type is tightly bound to its own canon and conventions. Consequently, treating it

Figure 4-4

Alphabet soup—from A to Z. This wonderful chart from @*issue*: underscores the power and infinite possibilities of typography. Test your familiarity with some of the best-known logotypes by naming the brand that goes with each letter. See the back of this chapter for the answers. Courtesy of @*issue*: magazine.

creatively may seem difficult at first. Indeed, using it imaginatively may end up being a walk through a typographic mine field. After all, without any rules, messages become total chaos. Nonetheless, many creative typographic solutions involve running a stop sign of typographic convention (see Figure 4–6). In fact, *creative typography* is in large part revolutionary—even subversive. After all, you're deliberately disregarding the conventional wisdom, standard usage, and what all of us have come to expect with printed messages.

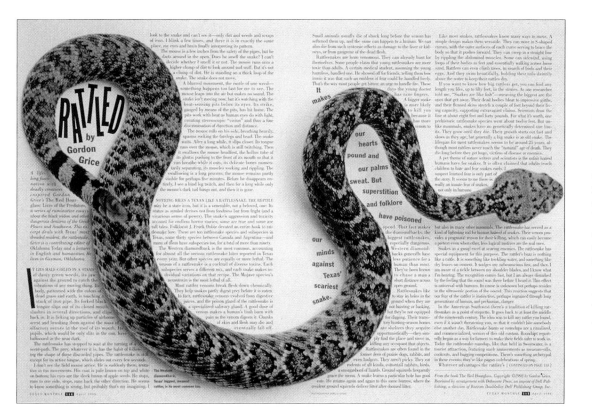

Figure 4-5

D. J. Stout, former art director at *Texas Monthly*, sculpted type for this award-winning layout. Stout's coiled snake: 1) Crushes the headline type; 2) sequences the reader (top-to-bottom and left-to-right); 3) breaks the text into an intricate rebus design; and 4) frames the by-line and credits, pull-quotes and captions. Art direction/design, D. J. Stout; story by Gordon Grice from his book, *The Red Hourglass*. Reprinted with permission of *Texas Monthly*.

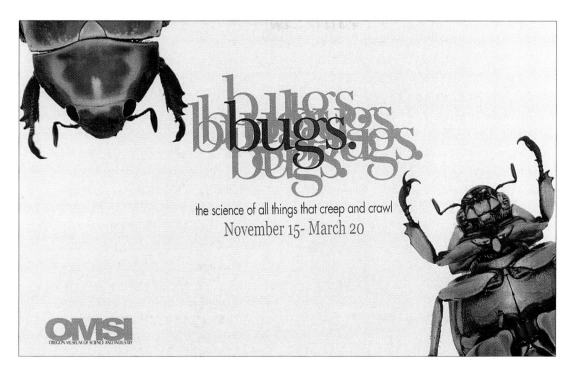

Figure 4-6

This layout received first place in the "promotions" category in Society of News Design (SND) national student competition. Designer Jessica Brittsan framed the busy typography with two beetles for Oregon Museum of Science and Industry's exhibit on "bugs." The blurred and scattered type helps suggest movement. Courtesy of Oregon Museum of Science and Industry.

Readability Is Crucial

Although selecting a typeface is largely situational and aesthetic, function should be your primary concern. The single most important tenet of typography amounts to effective and efficient communication.

Type should be selected and arranged to achieve maximum readability. Indeed, it is the foundation upon which printed communication is built. Frederic W. Goudy, one of the most prolific American type designers, put it this way: "Letters must be of such a nature that when they are combined into lines of words, the eye may run along the lines easily, quickly, and without obstruction, the reader being occupied only with the thought presented. If one is compelled to inspect the individual letters, his mind is not free to grasp the ideas conveyed by the type."

In addition to aiding readability, type should help suggest the voice of the message. The type should reflect the tone, attitude, and personality of the communication. In a word, the type should be appropriate to the audience, message, client, medium, and image. So how do you use type to sell water? Or—for that matter—how do you sell water? (See Figure 4–7.)

If you want to shout, the type should be loud. A bold or heavily-weighted sans serif works great in the headline. Bodoni might make for a wonderful headline face in a Microsoft annual report, but don't run it as body type in a newspaper because the hairline serifs will break up. If your message takes the form of an outdoor board, it might be best to run a heavier sans serif face because of its strong legibility. Remember, *legibility* refers to the visibility of the type, or how seeable it is.

An effective message must first stop the audience. That's precisely the strategy behind headlines in newspapers, magazines, and print ads.

The type is selected and fitted to snare the attention of the reader. Proper selection and arrangement of typography make our messages stand out.

Effective selection and use of type may also help establish identification. *Rolling Stone* magazine, for instance, can be spotted immediately at a newsstand because of the distinct typography that Jim Parkinson created for it. Likewise, the graphic design and typography of its inner pages—art directed by Fred Woodward and more recently by Andy Cowles—are unmistakable. The typography of Coca-Cola, the New York Yankee logos, or *The Wall Street Journal* are equally distinctive (see Figure 4–8).

The proper use and arrangement of type is both an art and a science. It is an art in that, within limitation, there is wide and open freedom to create with typography. You begin with a blank canvas—your page. Designers are artists who use type, rules, artwork, space, and color to create and shape their masterpieces (see Figure 4–9).

However, type is a science too. Tests and research have taught us invaluable lessons about typography, including lessons on readability, line length, leading, style, legibility, point size, and myriad typographic strategies. These guidelines, used creatively, blend the art and science of type to help you produce wonderful layouts.

Sacred Cows Make Tantalizing Steaks

We're having a typographic barbecue, and you're invited. BYOT: bring your own type.

The idea here is to break typographic rules. Don't worry, you won't go to jail for these heinous crimes against type. Concurrently, this is not a mission to disregard the rules arbitrarily. You break them purposefully to enhance the message, stop the audience, set a mood, or impart an emotion or sensitivity that is delivered *through* the type and its arrangement before the audience even processes the words.

When talented designers create compelling type solutions, they strive to make the typography nearly seamless with the entire design. It fits the artwork and headline, as well as the voice, attitude, image and feel of the message. There are no silver bullets here, or foolproof guidelines.

Figure 4-7
Humor and typography can make for seamless communication. Why is the typographic solution so effective and efficient for this engaging ad for Cascade Clear Bottled Water? Creative direction, Fred Hammerquist; art direction, Mike Proctor; copy, Ian Cohen. Courtesy of Hammerquist & Saffel.

Again, your mission is to break the rules so that your typographic solutions become one with the idea communicated. You're braiding content and form—in a new and arresting way.

Typeface: Think of Type as the "Clothes Words Wear"

You wouldn't likely show up for your wedding decked out in a bright yellow, short-sleeved Hawaiian shirt—Jimmy Buffet style—any more than you'd kick back at the beach in a tuxedo. Typefaces tailor the message. Type communicates through its voice, volume, or sensitivity. Without realizing it, the reader makes judgements and associations about a layout instinctively.

Again, carefully chosen words deserve a thoughtful choice of letters. What's more, type isn't just about print. Typography affects all media. The type for the credits and titling at the beginning of *Seven* not only helped set the dark tone of the film, it provided meaningful insights to the plot and the obsessive nature of the serial killer, John Doe. It was a masterful piece of art direction via its typography.

Since we're on the subject of typography and moving images, the next time you're watching television, pay attention to the *supers* (superimposed typography). Most of them are set in sans serif faces or thicker-stroked roman type. The same holds true for cinema subtitles and credits. Legibility helps type communicate cleanly and quickly—particularly in *reverse* situations, where the type is light and the background is dark.

No type should be selected capriciously. Improper type design can sabotage the message. You'd never choose a stencil type to advertise high-fashion jewelry, but stencil would do a great job selling combat boots for Uncle Sam's Army Surplus store. Similarly, a script or cursive face would look foolish on a World Wrestling Federation logo or as the nameplate for an extreme sports magazine like *CLIMBING*, but it'd likely be a good match for a wedding invitation.

Richard Wilde challenges his design students at the School for Visual Arts with a wonderful typography exercise that forces them to closely examine typography and its applications. Basically, the assignment goes something like this:

THE WALL STREET JOURNAL.
Before.

THE WALL STREET JOURNAL.
After.

Wilde provides a list of personality characteristics (schizophrenia, nervousness, etc.) and occupations (army recruit, bank president, etc.). Then, using part of one's name or nickname, he has the student choose a typeface and a variety of typographic treatments, color, and line to suggest the personality or occupation described. The medium used is small (business card or nametag size) and in small type, he has them type: "Hi, I'm ..." and below "and I'm a bank president," for example. He asks students to consider the style of the typeface, its size, weight, color, tracking, spacing, leading, use of upper/lower case, and peripheral spacing. Simplicity and minimal format make the exercise an invaluable experience for learning how to use type creatively (see Figure 4–10).

Figure 4-8
Great typographic design creates unmistakable icons. *The Wall Street Journal* is not just a newspaper; it represents *the* financial publication in the world *and* a brand. When redesigning a logotype with the power of this publication, it's crucial that the new design has a strong resemblance to the old one. Nameplate typography design by Jim Parkinson. *The Wall Street Journal* logo is a registered trademark of Dow Jones & Company, Inc. All Rights Reserved.

Figure 4-9
Using the rubber stamp tool and a series of filters in Adobe Photoshop, Nann Alleman used the spoon-like shape of Futura Book Bold to simulate the wild motion of Artis, spoon-player extraordinaire for the band Soundgarden. The layout's artwork is a series of photocopied photo prints that were heavily retouched by Alleman with a soft (graphite) pencil. Art direction/photography/illustration, Nann Alleman. Courtesy of *FLUX* magazine.

Figure 4-10
Here are three examples of work created using Richard Wilde's typography assignment. Come up with your own ideas and solutions for this exercise. Courtesy of Richard Wilde.

Figure 4-11
This back page from *@issue:* magazine features not only creative use of typography but a classic design solution for a city trying to lose its image as a "crime-ridden, dirty, and hostile place to visit." Today it is a cultural icon, one that many tourists take away as a souvenir from their visit to the Big Apple on everything from coffee mugs to T-shirts, buttons, and bumper stickers. Milton Glaser was the designer who conceived this brilliant rebus solution. How do the rounded serifs in the typeface work with the heart? This logo has been around since 1975, but Glaser recently updated it. As noted in *@issue:*: "Recently, Glaser redid the famous logo for a third time. Shortly after the 9/11 terrorist attack, he created a version that inserted the word 'still' and added a little smudge of the heart." *@issue:* credits: art direction by Kit Hinrichs; design by Maria Wenzel and Kit Hinrichs; editor, Delphine Hirasuna. I LOVE NY logo design by Milton Glaser.

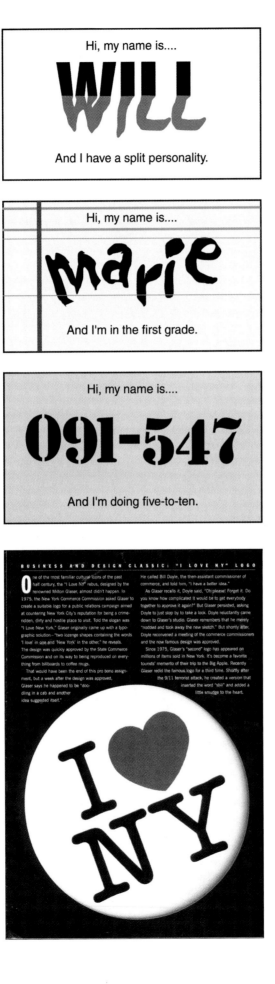

Finally, don't be seduced into thinking you can't design well unless you have a bazillion typefaces with which to work. After judging entries at the annual ONE SHOW's prestigious international competition, Bob Kuperman, creative director at TWBA Chiat/Day, recently lamented, "Print has reached a point where a new art director should be allowed to use only two typefaces for three years—Caslon and Futura—before they're allowed to use any other (kind of like a Learner's Permit)."

Size: See the Handwriting on the Wall
Normally, when working with headlines, the designer's standard inclination is to run the type large in the layout. How big? Well, it all depends.

Logos must run type large enough to be seen in something as small as a button. Milton Glaser's original prototype for "I LOVE NY" is a great case in point, but his original design - though unanimously adopted - wasn't good enough for Glaser, who later stumbled upon his classic icon doodling in a cab (see Figure 4-11). Fred Hammerquist and DDB-Seattle wanted a personal, understated advertising campaign for Brooks GTS-4 running shoes—a series of print ads that were emotive, sensitive, and different from the barrage of other running shoe ads. The solution? (See Figure 4–12). Think about the typographic strategies and rationales for each of these examples. Do you see how type shapes and helps communicate the message?

Sometimes, if a concept doesn't lend itself well to photography or illustration, type becomes the emphasis and replaces the art. It stands alone. After all, type is *designed* and employs all of the design principles within its architecture. In these instances, it's typically run quite large. Feature headlines in a magazine, newspaper headers, and titles are all good examples. However, there are occasions where creative insight might really affect point size.

Adele Droleshagen "super-sized" the type in her wonderful public service ads that educated the target audience about date rape. Her creative solution was to explode a very heavy version of Futura in a point size so large it couldn't fit in

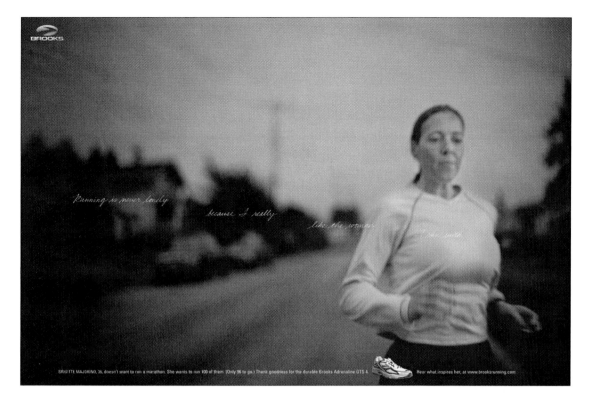

Figure 4-12
Calligraphy gives the Brooks GTS-4 ad a personal touch. To maintain the same voice, the words were run very small to keep the message understated and intimate. Creative direction, Fred Hammerquist; art direction, Larry Olson; copy, Angela Reid and Eric Guiterrez; photography, John Huet. Courtesy of Hammerquist & Saffel.

the upper two-thirds of a standard 8 × 10″ ad format (see Figure 4–13).

Sizewise, typographic creativity can go in the opposite direction too. Perhaps the most wonderful example of this strategy is Doyle Dane Berbach's famous Volkswagen ad campaign. In one print ad, a very small VW Beetle sits in a sea of white space. Beneath it, in smallish sans serif type, the headline reads: "Think Small" (see Figure 13-18). The concept and the typography are understated and stress smallness in the 1960s—an age when bigger was better and "family-sized" Chevrolets, Chryslers, and Cadillacs could barely fit in garages. Their campaign helped make the Beetle a cult classic.

Today's VW print ads return to that same understated concept. In fact, the more contemporary versions—created by Arnold Communications—are even more understated, and so is the lighter, smaller use of type.

Leading: Showing Your Mettle

Minus leading, especially stacked leading, can bring extra power and weight to a headline. If you recall, *stacked leading* is achieved by calculating the line spacing at roughly 70 percent of the type's point size; so, a headline set at 110 point would be stack-leaded at about 77 points.

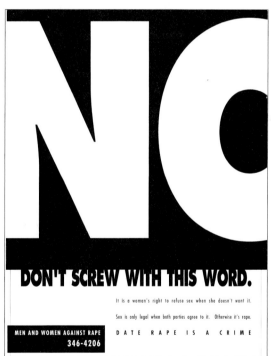

Figure 4-13
Both size and the blocky sans serif face make a loud case against date rape. The headline, a simple but very emphatic "NO," shouts at the audience. Adele Droleshagen wasted no time—or space—to get the audience's attention about a very serious crime. Art direction and design, Adele Droleshagen. Courtesy of *FLUX* magazine.

The *FLUX* magazine layout on rock guitarist Vernon Reid of Living Colour is a wonderful example of stacked type. Reid's name is stacked on the top, his band name is stacked on the bottom. In between is a sandwiched deck that uses uneven leading to make the feel of this story very edgy. Notice, too, how well the type works with both the story's content and the tight crop

of the photograph. Together, photo and type dominate the two-page spread and command your attention. You may not know exactly what the story is about, but you understand the mood and voice of the article immediately (see Figure 4–14).

Occasionally, art directors will opt to take a completely different leading strategy. A recent Mercedes Benz advertisement ran the leading of its body copy five or six times deeper than normal. The copy, though fairly scant, fills the page. The unusual use of space through the very generous leading suggests something about the car and its maker. There's a lot of space inside. It's almost as if Mercedes Benz is saying—in between the lines, "Hey, extra leading spacing in the ad? Don't worry about it, we can afford it."

On the other hand, crushing the message via minus leading may create a sense of tension. But be careful, because in the process of being creative, you don't want to break the ultimate rule: type is to be read.

Line Length: The Long and Short of It

Although there seems to be fewer liberties taken with line length, there are different creative considerations to employ here too.

Running lines incredibly short can impart the feeling of racing through the message. The short lines force the reader to do the equivalent of visual wind sprints. Conversely, a designer may choose to stretch the line length in a header to tie two pages together in a magazine spread by bridging the pages with type, or to show unity in a brochure by running a headline across its panels.

Sometimes, too, designers will adjust line length to deliberately break up the rhythm of a read. Normally, we read in clusters or groups of words at a time. So by extending lines and/or inserting unnecessary hyphenations on line breaks, you can disturb that rhythm. Again, this isn't likely something you'd want to do, but situations may arise where exploding the lines will give you a staccato-like effect you want to impart to the audience.

At the same time, remember to closely examine your line breaks. Think of the line arrangement, particularly in headlines, the same way that a poet thinks of line endings. Lines can also be *sculpted* to echo the shape of the art (see Figure 4–15).

Words should have a natural rhythm and flow to them. Try not to break line endings after articles or prepositions. Don't hyphenate display type, especially headers.

Figure 4-14
"Vernon Reid: Living Colour" is a riveting magazine article about music, culture, racial pride, and the early roots of rap. Reid's interview is edgy and powerful, and the design of this feature was meant to be equally edgy and powerful *visually*. Stacked leading adds weight and a powerful entrance for the article. Art direction, Matt Lowery; photography, Michael Shindler; design, Matt Lowery and Stephanie Knifong; story by Tonya Menefee. Courtesy of *FLUX* magazine.

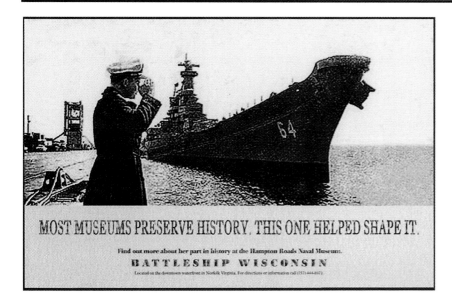

Figure 4-15

Diana Tung art-directed these ads for the Hampton Roads Naval Museum and the Battleship *Wisconsin*. Stressed and faded type give a retro post-World War II look to the ad. Creative writer Lee Remias' copy is wonderful: "It wouldn't fit into a museum, so we turned it into one." Courtesy of Arnika Agency (Creative Director, Pat Burnham); Art Director, Diana Tung; Creative Writer, Lee Remias

Word and Letter Spacing:
At a Loss for Word Spacing?

Word spacing and letter spacing are slightly different animals. Art directors and creative directors may opt to crush letters together or stagger them to give the type or message some attitude (see Figure 4–16). Or a designer might want to evoke a disenfranchised, postmodern look. When you tinker here, irregularity often results.

The flip side of adjusting letter and word spacing involves meticulous kerning and control over unit spacing between letters. Here you are performing surgery on the spacing: subtracting space to snuggle or fuse letters, or expanding that space to make letters appear neatly groomed in an expanded line of type. Some designers specialize in this area, building corporate logos and other typographic designs through custom type work.

The designers of *Raygun* go to great lengths to fool with line length (along with the deliberate abuse of many other typographic customs) to give the typography a raw, more irreverent voice. The founding art director of *Raygun* was David Carson, the father of what's sometimes referred to as "thrasher," "beach culture," or "skateboard culture" typography that is so popular today. In general, his stylebook and approach to typography is anarchism; his specs and use of type break just about every typographic convention. In fact, if you want to see type used to flaunt attitude in the guise of post-modernism and counter culture, examine *Raygun*'s pages (see Figure 2-35).

While his unorthodox use of type may not win many awards for readability, Carson has influenced typography to the point where its unorthodox use is, indeed, becoming common in some circles. Ironic, given his anti-conventional philosophy. David Carson gets quite inventive with word and letter spacing and how type is configured on the page. Indeed, his "Hanging Out on Carmine Street" from *Beach Culture* takes great liberties with typographic rules (see Figure 4–17).

Figure 4-16

In addition to the stacked leading, art director Matt Lowery and designer Stephanie Knifong stressed and broke up the word and letter spacing to achieve this edgy look. Notice, too, how this typographic treatment works with the other type for this article on Vernon Reid (Figure 4-14). Courtesy of *FLUX* magazine.

Figure 4-17

This layout exemplifies postmodernism at the height of beach/surf culture popularized by David Carson and his followers. This spread, "Hang at Carmine Street," was art-directed by Carson for *Beach Culture* magazine. Photography by Blashill. The headline almost imparts "hanging out" or "diving into the public pool" on Carmine Street. From *The End of Print: The Graphic Design of David Carson* by Blackwell and Carson. ©1998 John Wiley & Sons.

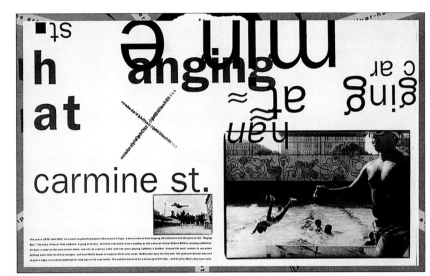

Line Arrangement:
The Radical Left, Right, and Center

Creative subterfuge in this department can be quite stunning. Robert Mackay and Jennifer Eggers adjusted line lengths and line arrangement so that the body copy of their *US Track & Field* ad echoed the shape of the shot putt in their art (see Figure 4–18).

In short doses, designers often take great liberties with line arrangement, occasionally centering type or running it flush right. Centering is a fairly common way to handle titles or headlines and even captions.

Probably the most dramatic and creative approaches to line arrangement occur when designers use a mix of strategies—flush left, centered, and flush right type—as well as contouring lines around, between, or against graphic elements within a design. Rebus designs are often loaded with custom-fitted line arrangements. In this case, the designer wraps or *contours* text around, within and aside the graphics of a design.

Rebus is considered very stylish these days, and the undisputed master of this approach to typography is Kit Hinrichs of Pentagram. His meticulous rebus architectures have graced the interiors of *SKALD* magazine (an elegant and colorful magazine published by Royal Viking Cruise Lines), *@issue:*, and annual reports for Potlatch and other corporations. Executing the most elaborate rebus layout usually requires that the art director and writer work together, since much copy ends up being a "write to fit" situation.

Rebus was used as much for its delicate ornate quality as it was for continuity in *Breaking 100*, the centennial book commissioned by the Eugene Country Club. The carefully laced type added grace and complexity to the book's pages (see Figure 4–19).

Figure 4-18

Adjusting line breaks is one way the designer can sculpt typography. In this instance, copywriter and designer Jennifer Eggers and art director and photographer Robert Mackay, repeated the shape of the shot putt in the ad's copy block. The ad is for *U.S. Track and Field*. The copy reads, "It's not who breaks the record, but that the record gets broken at all." The tagline is, "Be amazed." Courtesy of Robert MacKay and Jennifer Eggers.

Magazine and advertising designers tend to use a less complicated (and more executable) rebus approach by placing a simple text wrap command on graphics. Either way, type can add a special creative touch to any layout.

Uppercase: Making a Case for All-CAPS

From a creative standpoint, running all uppercase letters on type sized at 200 points, is sort of like standing on a chair and yelling to attract attention.

However, what this method may lack in subtlety, it tends to make up for in accomplishing the mission of stopping the audience. This self-promotions poster created by Virginia Commonwealth University (VCU) Ad Center student Greg Desmond succeeded in landing him a great position as art director (see Figure 4–20).

While most newspaper designers reserve this approach for only the most sensational stories, loud, very heavy uppercase headers are common in advertising where the mission is always first and foremost to stop the audience. Remember, too, that in the case of advertising, you aren't just competing with other ads, you're competing with the content of the medium at hand. Most people aren't reading their newspapers, magazines, and websites, or watching television for the advertising. They're reading and watching to be informed, entertained, or to be current on a subject dear to them.

However, you needn't always yell to attract them. Often, whispering can be just as effective, especially when the competition is hollering in

large, black all-cap sans serif. This Brooks GTS-4 running shoes ad helps make that point (see Figure 4–21). On a full page or panel of negative space, the diminutive type steers the audience to the message. This DDB creative work for Brooks athletic shoes uses type in an unusual but very personal way by speaking softly.

While it is not uncommon to see designers set headlines all uppercase, it is fairly unusual to find body copy run that way—but that's not to say it isn't or cannot be done. Indeed, setting the text of annual reports in small caps has become stylish.

Figure 4-19

Deep, inviting margins, a large dropped initial letter and rebus elements make this spread for the golf book, *Breaking 100*, a breezy read and a fine compliment to Eric Evan's wonderful photos of a golf ball-thieving raccoon. One of the more difficult missions of this design was that the 200-page book needed to be random accessed. The art director also wanted to keep it light and yet capture the intensity of the game of golf. Jan Ryan used Adobe Illustrator for the detailed raccoon tracks and was also responsible for the book's layout; art direction by William Ryan.

Figure 4-20

Muted color, fake fold lines, and a design featuring all upper case, sans serif type make this poster an effective self-promotional piece. Art direction and design by Greg Desmond for "El Desmondo Magnifico." Courtesy of Greg Desmond.

Figure 4-21
The quiet, introspective
strategy for this Brooks
ad is manifested
throughout its design:
small type, calligraphy,
muted color, and honest
copy: "A long run is
never so tiring as a long
day without one."
Brilliant work. Executive
creative director, Fred
Hammerquist; art
direction, Larry Olson;
copy, Angela Reid and
Eric Guiterrez;
photography, John Huet.
Courtesy of
Hammerquist & Saffel.

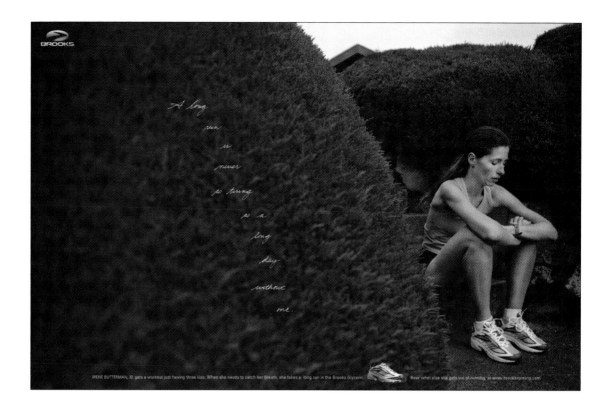

Although small caps bring more texture to copy
than all uppercase, it is still a more taxing read,
no matter how hip it might look.

Weight: Weigh Your Words Carefully

Weight is like a volume knob on your typogra-
phy. You can crank it up and rattle windows,
present your case in a respectably normal tone,
whisper, or adjust it anywhere in between.

In this instance, Kit Hinrichs wanted *@issue:*'s
feature article, "CHOCOLATE," to enter loudly
and lusciously. Along with bolded sans serif type
he integrated cherries jubilee and a truffle into the
type. There is no mistaking what this article is all
about (see Figure 4–22). Type weight played an
invaluable part in this layout's overall solution.
Remember, like posters, magazines have to hit a
moving target, too: fickle readers browsing or
quickly paging through the publication.

On the other hand, light weights can impart an
ethereal or delicate feeling in a title or headline.
Designer Rita Marshall uses typography gently,
almost tacitly, for the cover of Jim Brandenburg's
book, *Chased by the Light*. The light roman
characters, run in small caps, spread across the
very horizontal cover atop a tan tint containing
only the name of the author and book. Below the
title is a life-sized paw print of a wounded wolf,

and beneath the translucent vellum jacket is a
full-frame photo of frosted reeds in a pond in the
arboreal forests on the Minnesota/Canada
border. The type fuses with all the other elements
in the most delicate of ways (see Figure 4–23).

When thoughtfully employed, type and weight
should be connected (functional) to the commu-
nication as well as reflect content.

Finally, one last word on weight. Some
designers tinker with the *inking weight* of type.
This is achieved by screening back the ink used,
or by mixing color screens on the type. In the
first case, an art director may choose to run 50
percent black on, say, a magazine title. This gives
the type a middle gray tone. In the second
instance, let's say a job is being run two-color
(typically black and one other color for the
screen). And let's say that it's being run in black
and red ink; here, a designer may opt to run two
screen variances together to produce a new color.
For example, 30 percent red and 50 percent
black to achieve a brown color. Screening or
combining screens is yet another creative control
at the fingertips of a designer. The downside,
however, is that screening breaks up the type. So,
if you can afford it, you'd be smarter to choose
the exact color you wish, and run the type
directly.

Figure 4-22
The huge bolded type here is anchored to the page by use of a drop shadow, which adds a touch of sophistication while it concurrently grounds the headline to the pages. Design and art direction, Kit Hinrichs; designer, Karen Berndt.

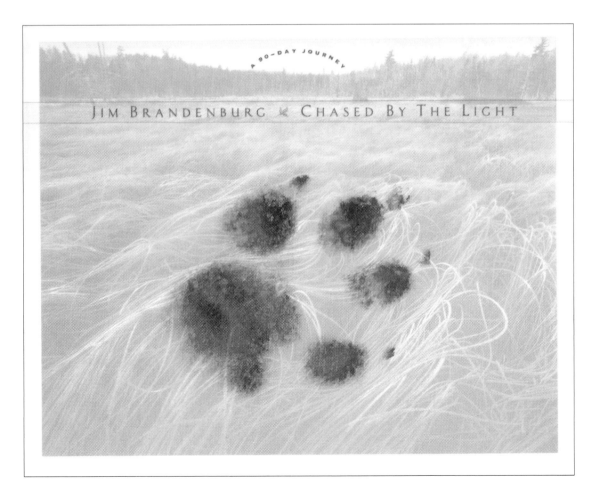

Figure 4-23
This image of the footprint of an injured wolf is contrasted by Rita Marshall's gentle touch with type. From the book, *Chased By the Light*, by Jim Brandenburg, courtesy of Creative Editions, North Wood Press. © 1998 by Jim Brandenberg.

Posture: To Oblique Or Not to Oblique —That Is the Question

Tabloids like the *Star, National Enquirer,* and their kind have a tendency to bold as well as oblique their headlines. Graphically, pitching letters forward adds a sense of urgency to the message by speeding up the look of the type a bit, making the words stand out more. That helps sensationalize the headlines "HOUSEWIFE LOSES 400 POUNDS ON KIWI DIET" or "MAN SUCKED INTO A ROARING JET ENGINE, BUT LIVES."

The People for the Ethical Treatment of Animals (PETA) organization not only adopted obliqued type in one of its recent campaigns, but its ads literally borrowed the entire tabloid format. In fact, in some ways the ads looked more like a tabloid than they did an ad campaign—perhaps not a good strategy for credibility.

Of course, this is not to imply that the messages of all oblique type should be equated with sensationalism. Oblique type offers another creative typography tool for designers. Dirk Barnett used an oblique version of Futura Bold to help impart a sense of speed for an article on prototype cars built like bullets and powered by well-muscled engines (see Figure 4–24).

Type Style: Making the Blind See

Italics are considered a *style*; they have inherent, rational cues or coding for us. When we see something set this way, we check the word's context. Normally, we italicize things like foreign words, books, film titles, and the like. We also use italic type to stress a point or word.

Italics possess an inherent beauty and eloquence (see Figure 4–25). Experiment with them in situations that call for an ornate or gentle touch, and see how they do. One of the beauties of working type in computer design programs is that you receive immediate feedback. You can see how typographic shifts change or affect the message.

Swash or *swashbuckle* style is a baroque approach to type. Typically, the finishing strokes of each letter are extended and flamboyant. The style is very close to italic, but the letters tend to carry more ink and are much more ornate. This style is intended to be used as display type, espe-

Figure 4-24
"Speed Record" uses oblique type to help suggest velocity and the forward engineering GM used on their Pontiac Solstice model. Design and art direction by Dirk Barnett; photography by John B. Carnett. Courtesy of Dirk Barnett and *Popular Science.*

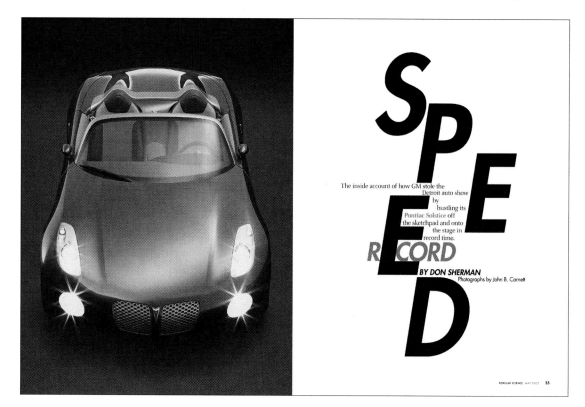

cially in headlines and for logos and announcements.

Perhaps the most common creative application for book and condensed type is an obvious one: to get more information or words in tight places. Again, the more you experiment and familiarize yourself with type and type style, the more likely you'll be finding wonderful applications for

these styles. Information graphics, weather pages, and charts and graphs often employ condensed type.

Of course, the inherent style and configuration of typefaces themselves may suggest a great deal. An ad encouraging responsible drinking makes its point by marrying the typography to simple but unforgettable art (see Figure 4–26).

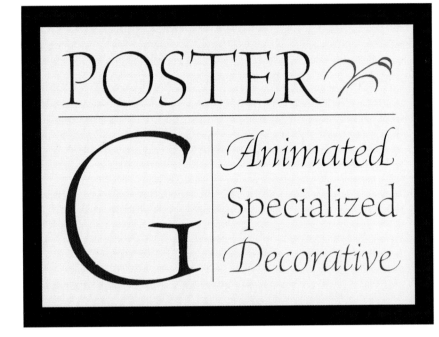

Figure 4-25
Like all of the typefaces that Robert Slimbach designs, Brioso has deep roots. Its strong calligraphic look is borrowed from formal roman and italic script and offers a wide array of applications for designers, ranging from formal to more dynamic and contemporary uses. Brioso takes its name from the Italian word for "lively." The Type Designers Club selected Brioso Pro as a winner in its type system category in 2002. It is an elegant and meticulously crafted typeface. Courtesy of Robert Slimbach.

Figure 4-26
Eric Kunisawa created this ad for responsible drinking. The typeface speaks volumes by itself, and coupled with the art—a revolver cylinder loaded with beer cans instead of bullets— communicates loud and clear about the dangers of immoderate drinking. Courtesy of Eric Kunisawa.

Mixing Types: Shaking It Up

Mixing type can be a frustrating proposition. Unfortunately, some novices take the "Well, if God didn't want me to use all these typefaces, they wouldn't be on the computer" position.

We've all likely seen the disasters that kind of philosophy may nurture. The list is a long and sad one. Newsletters from hell. Page designs that end up looking more like a post-modern catastrophe than a newspaper or magazine layout. Print ads with typography mixed so badly that they could easily be mistaken as ransom notes.

Unfortunately, there is no ironclad formula for mixing typography. Probably the three most important things to remember are the following:

1. Display type is meant to stop the audience.
2. Body type should be selected and designed to be read.
3. Normally, three faces are plenty for any job.

Notice how Kansas State University student designers mixed up types in the Sports page of the *Collegian*. The interior logo ("Sports") is a simple roman face run in small caps (see Figure 4–27). Below Kelly Glasscock's punchy photograph in large sans serif type is "BIG 12 BOUND," with a neat roman deck beneath the headline. Sans serif type helps mix up the mostly roman text face with dropped-initial letters, bylines, game statistics, scores, and crossing heads. Society for News Design (SND) judges thought enough of it to give it an *Award of Excellence*, and feature it in a recent issue of SND's magazine, *Design*.

"A Distant Crash" features three type faces in its design (see Figure 4–28). A bolded Caslon 224 was used for the text. Onyx, the very long and lithe modern roman, was employed for the header and the dropped initial letter. Finally, a sans serif—Shannon—was utilized for the cluster caption.

One of the more common creative tactics used by designers in the type shuffle is to stagger variations of a strong roman face for copy with an appropriate sans serif for headers, and vice versa.

Margins: Get the Edge on Your Audience

The importance of margins cannot be overstated. They demarcate space and establish boundaries, so columns of type, headers and copy, and type and art elements don't slam into one another. Imagine, if you will, driving down a busy highway without a center strip or lane stripes, where there are no clear road rules. It'd be like a moving parking lot with streams of cars in the midst of the jam traveling two or more directions at once. Margins separate page elements and help steer our vision. Our reading patterns need similar cues to help sequence our vision through a page of type.

However, perhaps a more creative way to think about margins is that they help frame and *present* the message. If you can imagine the newspaper or magazine page, website, print ad, or photography as a piece of art, how would you frame and mat it? With a broad edge around it? A narrow one? Normally, if you're looking to make a dramatic opening with your type, use wide margins.

On average, the more open a page's margins are, the more it will attract and hold attention.

Figure 4-27
Kansas State University students Sara Marin-Jackson (designer), Kelly Glasscock (photojournalist), and Derek Boss and Michael Noll received an SND Award of Excellence for this remarkable sports page. The grid design, generous white space, reader-friendly blend of type, and the wonderful headline (with the "OU" for Oklahoma University in the word "BOUND" emphasized in red) make this page a typographic delight. Courtesy of *Kansas State Collegian*, Kansas State University.

Advertising art directors tend to be very generous with their margins.

Art director Cody Spinadel came up with this "type only" solution for an ad campaign for Levi's Hard Jeans (see Figure 4–29). As a quick aside, when type is literally the *only* element in an ad, the concept better be strong, the copy killer, and the type treatment perfect. Writers Mark Fenske and Mike Collado collaborated for some powerful copy: "STIFFER THAN ALUMINUM SIDING, BUT NOT NEARLY AS COMFORTABLE." Or—"DENIM RIGOR MORTIS."

Spinadel is heavy-handed with the margins and white space in the Levi ad. Also, think about the image being projected. These ads exude toughness. The type is heavy sans serif, and like the jeans, it holds up to a lot of stress and abuse. The margins are uneven; so, too, are the lines of type. The message is very informal and edgy. Why? What might this suggest about the product? The audience?

Figure 4-28
The all-black background and reverse type was meant to speak to the grim reality and darkness of the Great Depression. Photography courtesy of the Farm Security Administration; photography by Arthur Rothstein, Ben Shahn, and Russell Lee. Layout by Jan Ryan, art direction and design by William Ryan.

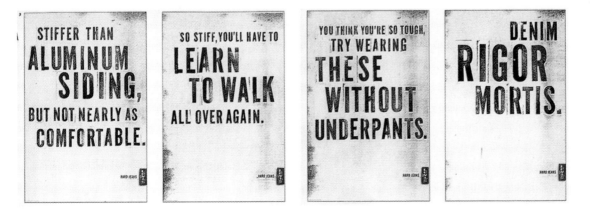

Figure 4-29
Who needs glamour shots of Levis' jeans when the message, layout, design, and typography clearly state the product's benefits? Cody Spinadal, advertising director; Mark Fenske and Mike Collado, writers; and Jerry Gentile and Lee Clow, creative directors. Levi's ®, Levi Strauss & Company. Used with Permission.

Creative Strategies:
Explode Copy-Heavy Pages

Today it's getting harder to grab and hold the reader's attention. We are bombarded by media, and consequently, more jaded and quick to leave a TV program or magazines. In fact, newspaper researchers suggest we've become "scanners," and that we've conditioned ourselves to receive information in bits and short takes. The average television news item is from 90 to 100 seconds long—barely 100 to 150 words. A half-hour TV drama packs a complete story line from introduction to climax into about 22 minutes.

Similarly, when readers are confronted with gray pages of reading matter, they tend to avoid them if the layouts appear too dense. Type can help cut through barrage. This MoMA poster for a Chuck Close exhibition makes its case with Akzidenz-Grotesk sans serif type (see Figure 4–30). If the read looks lengthy and gray and there's no art to hold the eye, there is a strong temptation for readers to skip it. As a designer, your job is to make copy-heavy pages more alluring and reader-friendly.

Figure 4-30

This student poster of a MoMA exhibition for super-realism/photo-realism painter, Chuck Close, uses no-nonsense sans serif type (Akzidenz-Grotesk BQ super) to boldly feature the artist's name and the MoMA URL. The top MoMA designator and information is run in Arial narrow. Type in posters, in addition to communicating, has to stop an audience, impart a mood, and capture the essence of the subject being communicated, as well as answer all the who, what, where, and when questions. All within a few seconds. Note the use of color, how the designer stacked the type (stacked leading is achieved by setting the leading or line spacing at approximately 70 percent of the point size), and how the end stroke on the "h" aligns with the "l" below. Layout and design by Brian Schmitt. Chuck Close, *Self-Portrait*, 1997. Oil on canvas, 102 x 84". © 2003 Chuck Close, courtesy of the artist.

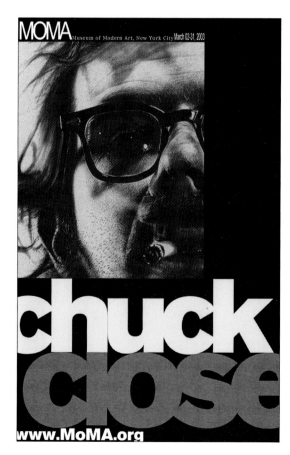

The following are some creative strategies to make densely packed pages more attractive. Color, large headers, generous use of white (or negative) space, and compelling decks are all effective ways to make type arresting (see Figure 4–31). Basically, the idea is to open up the typographic color of the page by varying type, adding graphic elements, and avoiding carpeting the page or space with type.

- The reliable dropped initial letter is one of the oldest and most effective ways to break up a copy-heavy page. The scribes were the first to use it as an entry point for readers. A dropped initial letter can announce the beginning of the article or show transition when used within the page. In situations where you're using several dropped initials over a number of pages, they can help maintain continuity. However, using too many on a page dilutes their emphasis and looks weird. You don't want the layout to look like an eye chart.

- A tint block or screened area dropped into the page for a story or sidebar offers variety. If using a black screen, it's best not to exceed a 20 percent tint for black type.

- Extra leading between paragraphs can help brighten the page.

- Crossing heads are invaluable, too. Briefly, a *crossing head* is a single line of type (or two) set within a story. Normally they are extra-leaded above and below. Typically, a crossing head is a terse statement or phrase that summarizes the section of copy that follows. Along with breaking up the gray, they can help show transition within a story or message, and they impart the gist or sense of the ad or story. They are valuable not only from a design standpoint, but also from an editorial one.

You've likely had this experience. You're thumbing through a magazine and are three or four pages into it, when suddenly a crossing head captures your attention. You stop and begin reading the story beneath the compelling crossing head that had stopped you. The next thing you know, you've paged back to the beginning of the article and have begun the read anew. You're hooked.

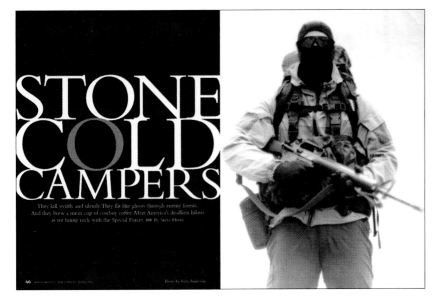

STONE COLD CAMPERS

Figure 4-31
Backpacker magazine art director Matthew Bates demonstrates how negative space, stacked typography, color, and a neatly centered deck make for a compelling layout for the ultimate backpackers —United States Navy SEALs. How is balance employed here? Art direction and design, Matthew Bates; photography by Andy Anderson. Courtesy of *Backpacker* magazine.

Creative type strategies such as crossing heads, decks, and pull quotes, improve the traffic through a story or print ad. They also make the page more reader-friendly.

- Subheads with a contrasting face or boldface or a larger size of type than the body type also can help break up the gray of the page.

- Bullets, rules, dingbats, and other graphic embellishments can help open up a copy-heavy page. But use them cautiously. If they're overdone or improperly used, they can disfigure a page or make the layout appear amateurish.

- Shorter paragraphs will also help open the page, make a longer piece more inviting, and speed up the pace of the read.

- Like crossing heads, pull-quotes (or "pull-outs") which are quotes extracted from the body text and enlarged, have superb stopping power and attract readers easily. It isn't by accident that they are so popular. Make sure the quote or summary you're using is powerful, though. You don't catch fish without properly baiting the hook, so choose words very carefully for your pull-quotes (see Figure 4–32).

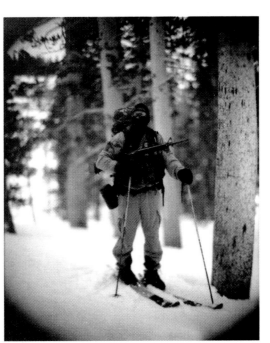

Figure 4-32
This pull quote uses color, brackets, and a vertical alignment to catch your attention. Its content— "For SEALs, 'Leave No Trace' isn't just an ethic, it's a matter of survival"— is equally arresting. How else does this *Backpacker* layout break up type? Art direction and design, Matthew Bates; photography by Andy Anderson. Courtesy of *Backpacker* magazine.

• The old standby—white space—is a smart designer's lifesaver. An island of white space can be exactly what the reader's eye will swim toward in a sea of heavy copy. Framing artwork or important graphic elements in white or negative space may be as attention-getting as it is elegant and inviting.

Type has rules, specifications, and learned cues that generally structure and present our messages. However, straying from these conventions in appropriate and insightful ways is often an engaging typographical solution (see Figure 4–33). To be successful in this creative realm of type, however, you must be typographically literate and understand the logic, application, and basis of typographic convention.

Graphics In Action

1. Examine the newspapers, magazines, and other publications you read. Find examples of improper use of type. Discuss their shortcomings. Then, see if you can solve their problems by reworking the type on your computer. Pin up your print-out next to the original and compare the two.

2. Below are seven phrases or headlines. Select 5 of them, and set them in a typeface that does their content and look justice. Don't forget to factor in things such as line arrangement, letter spacing, color, weight, style, posture, and other type nuances.

Beastie Boys Rock the House

Gallery to Feature Jackson Pollock Paintings

Figure 4-33

These additional examples illustrate how to break up the flow of type to make the page more reader-friendly and functional.

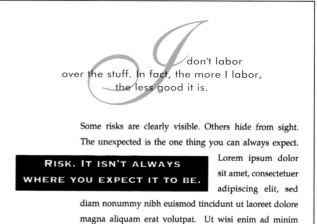

Avocado Said to Prevent Heart Attacks

ORCA: Treasure of British Columbia

Notre Dame Cathedral

50% SALE - EVERYTHING MUST GO

Shades of Indonesian Culture: Bali, Java
and Sumatra

3. You've been asked to design a three-piece outdoor advertising campaign for a Web auto dealership. Several benefits that the client, AUTORAMA, has expressed as important include no bickering, no dealings with high-pressure sales people, unlimited selection, and no overhead. Focus on only one of these per outdoor board. These boards will be placed in heavily traveled areas in town. The client wants you to use typography only. Be sure not to forget to include a place (your city) and both a phone number and URL.

4. Santana is doing a follow-up live version of their latest album, *Azteca*, which features a compilation of old and new music, and you've just learned that the creative director has asked you to build a prototype CD album that will feature the cover panel, spine, back panel, and a 3-fold, 6-panel inset. Create all or at least the front, back and spine portions and present to the class. Obviously, type will be a major component for this design. Don't forget to use color in your designs.

5. Build an idea file of creative uses of typography color from examples found in publications.

Find a good example of a copy-heavy article in a magazine or newspaper, and—using the strategies you've studied in this chapter to explode the gray in pages—create a 1- to 2-page layout of the piece.

6. Search the Internet, and find 2 examples of sites that use typography effectively and creatively, and 2 that do terrible jobs. Bring URLs to class and share. Be prepared to discuss the strengths and weaknesses of all 4 sites.

7. Using the fonts available in your computer, design 3 simple print ads selling the same product of your choice—for example, milk, tourism for Yellowstone National Park, GAP jeans, Jello—to 3 different audiences. For example, design an ad promoting milk for the American Dairy Association that's targeted at an elementary school-age audience, another aimed at college students, and a third focused on 60-somethings. Present them and explain your various rationales for selection of type and its treatment.

ANSWERS to the typographic puzzler, page 108:
A – Audi. B – Ball Fruit Jars. C – Chicago Cubs.
D – DHL. E- Ethan Allen. F – Firestone. G – Goodyear. H – Holiday Inn. I – IBM. J – Johnson & Johnson. K – Circle K. L – Lego. M – Maytag. N – NASA. O – Oreo. P – Perrier. Q - . R- Reuters. S – Sears. T – TWA. U - Unilever. V – Virgin Air. W – Westinghouse. X – Xerox. Y – YMCA. Z – Zenith.

Design: Inventing
Endless Solutions

Five Principles of Design:
Balance, Proportion, Sequence,
Emphasis, and Unity

Design, Layout,
and Design Stages

Graphics in Action

*Design puts art in the service of
communication.*
—Kevin G. Barnhurst

◄ *Metropoli (El Mundo)* cover, *"Acro,"* Rodrigo Sanchez

A ll the tools in the world are meaningless without an essential idea. An artist without an idea is unarmed.... An art director must be someone who treats words with the same reverence that he accords graphics, because the verbal and visual elements of communication are as indivisible as words and music in song.

—George Lois, Covering the 60s

Design: Inventing Endless Solutions

There are infinite solutions to every design problem. What's more, each design principle can be applied in equally limitless ways. Emphasis is a good example. Often, it is not who shouts the loudest that gets the most attention. For instance, a neon sign with a burnt-out letter or a flickering light might be more effective than the original that glowed bright and full. It's precisely that missing letter or random blinking that catches our attention. When Rodrigo Sanchez was asked to create a *Metropoli* cover announcing the launch of a special magazine website, his solution was as playful as it was effective. Like design itself, his

solutions for revamping *Metropoli's* weekly covers are endless (see Figure 5-1).

In a sense, graphic design is an ongoing puzzle, and it is the designer's charge to construct and assemble all the pieces appropriately—for a specific audience. That means arriving at a compelling solution that blends art and typography and uses design (as Barnhurst suggests) to communicate that "big idea." In addition, design principles help you address your readers, shape the message, and tell the story visually. Some design options are obvious and some not so obvious. Rodrigo Sanchez—art director and director of design at *El Mundo's* magazine supplements: *La Luna*, *Metropoli*, and *La Revista*— talks about audience and design solutions in an interview and statement with the author (see Figure 5-2).

Central to any design solution is the audience to whom you are speaking. For example, my approach to designing La Luna *(the teenage entertainment supplement of* El Mundo*) is to get into the teenager's skin. I have to adopt their cultural perspective, tastes, and aesthetic sensibility. I embrace their preferences graphically to present the content of* La Luna *and its stories, cover, and layouts. It's important to provide something that's visually arresting to them and offer them ownership of it—aesthetically. In other words, I'm shaping and presenting the magazine's stories directly to the readers, in a voice and style they understand* (see Figure 5-3).

But different publications often target different audiences and consequently are designed quite differently from one another. To properly design Metropoli *(the urban entertainment magazine of* El Mundo*), I have to speak to an audience quite*

Figure 5-1
Color, elemental form, humor, and smart design prove the adage, "Simple is better." What is the visual solution here? Note how the design leads, holds, and redirects your vision. Art direction and design, Rodrigo Sanchez. Reprinted with permission of *El Mundo/*Unidad Editorial, S.A.

Previous Page
Rodrigo Sanchez is a brilliant designer and art director who reinvents covers each week for *El Mundo's* celebrated *Metropoli*. This nameplate literally adopts the cover concept of signing the artwork by also using hand signs to replace the letters of the magazine's nameplate. Reprinted with permission of *El Mundo/*Unidad Editorial, S.A.

different from the readers of La Luna. Metropoli *has an older, sophisticated urbane audience, one willing to spend money on many of the plays, music, films, or other cultural entertainment Madrid has to offer. The magazine helps readers plan their leisure time. Probably, after reading* Metropoli, *readers will decide where to dine, or which film, concert, or play to take in. Sometimes the magazine offers outdoor activities, too. So it may contain features which have nothing to do with each other, such as cinema and cycling. Or even if the content or theme is related, their parts may have nothing in common. A film by Kieslowsky is quite different from a Spielberg film. Again, the point is that differences in story content should suggest different graphic solutions (see Figure 5-4).*

Design also has a lot to do with personality, change, and life itself. But life is unpredictable. Any event may modify our behavior; it can even lead our personal and professional lives down paths we'd have never envisioned. Like everyone else, I draw from my life experience—culturally, personally, and in many other ways—and apply it to how I see and how I design. That's precisely how I approach the Metropoli *covers and their eclectic, constantly adapting content. After all, the subject matter of* Metropoli *is always changing, and so should its cover. I often look inside myself and use intuition, visual metaphor, and my personal experience. That approach often results in some of my best work (see Figure 5-5).*

But often, too, design ideas are spawned in the moment. My state of mind or sensibility—coupled with the content and its voice—shape the covers I create. They may be bright and playful if the content and my frame of mind are positive, or dark if they're negative or deal with serious issues

Figure 5-2

Through his use of typography, illustration, and art direction, Rodrigo Sanchez has made *Metropoli*—the cultural supplement of the Madrid newspaper *El Mundo*—an international masterpiece. Sanchez serves as art director for not just *Metropoli*, but also for *La Revista* and *La Luna* magazines and other *El Mundo* publications. Sanchez alters *Metropoli*'s look and structure every week by shaking up the nameplate, art approach, and use of typography and design. Remarkably, *Metropoli*'s chameleon-like appearance doesn't ever quite lose its identity. Sanchez has received numerous prestigious awards, including being honored by the Society of Publication Design (SPD), The Type Director's Club of New York, *Communication Arts*, and the Society of News Design (SND). He has recently accomplished what no one else has achieved by receiving "best of exposition" from SND. Reprinted with permission of *El Mundo*/Unidad Editorial, S.A.

Figure 5-4

When is a *Metropoli* cover not a cover? Sometimes when it's traffic signage; other times when it's a cigarette package. This smart design once again morphs the magazine into a special cover featuring a special issue that examines the dangers and health problems of cigarette smoking. Reprinted with permission of *El Mundo*/Unidad Editorial, S.A.

Figure 5-3

Here is yet another Sanchez *Metropoli* cover invention. The lines of text on the bottom cover note: "Antonio Resines takes a trip that changes his life in Emilio Martinez-Lazaro's latest film." His solution? He turned the magazine cover into road signage! Reprinted with permission of *El Mundo*/Unidad Editorial, S.A.

Figure 5-5

The visual metaphor here is simple but as remarkably appropriate as it is unusual. The problem was how to produce a concept cover dealing with digital film. Ridges and contours of the fingerprint are made up of winding lines of type. The solution was typographical, and the type was also the art. Art direction, design, and illustration, Rodrigo Sanchez. Reprinted with permission of *El Mundo*/Unidad Editorial, S.A.

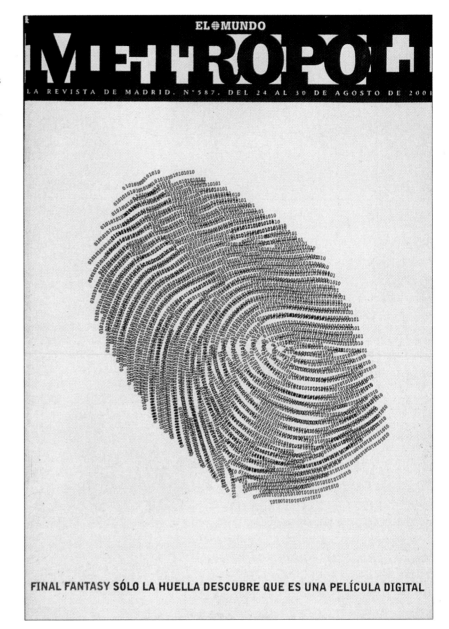

(see Figure 5-6). *Even the season, the day, or the time may alter the final solution to the same idea. Because design is such a personal activity, the evolution of the cover or feature layout runs parallel to my mood, situation, frame of mind, and way of thinking. In a way, it's a kind of permanent adolescence, in which you can trash ideas, facts, and even solutions you thought were perfect only a few minutes earlier. Often you cannot explain how you conceived a front page at a given time. That particular solution might never occur to you now, maybe because you're out of that particular moment. Or—maybe you're having a bad day, or your creativity is flat.*

Because design is fueled by so many things, and because the content of Metropoli is so varied, why have just one approach to its design? How do we communicate such contrasting content to the reader? (See Figure 5-7.) But at the same time, Metropoli is a brand and has a visual reference to the reader. So how does one adjust the design week in and week out while still keeping the magazine recognizable?

The solution was to evolve the cover and its nameplate. First, we knew it was crucial to maintain the image of Metropoli—its brand. We were redesigning the magazine, but it was important to make sure enough of the old design

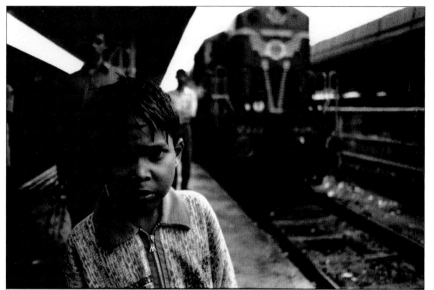

EL MILAGROSO PIE DE JAIPUR

Es la tecnología de los pobres. En Jaipur, La India, un cirujano ortopédico ideó un sistema para fabricar piernas artificiales por 500 pesetas. Hoy, su invento provoca colas de hasta medio kilómetro en los hospitales. A ellos acuden miles de tullidos con la esperanza de volver a andar Por Javier Moro. Fotografías de Ángel López

LA NUEVA PIERNA DE LOKESH

LOKESH, DE UNOS 11 AÑOS, PERDIÓ LA PIERNA AL SER ARROLLADO POR UN CAMIÓN. EN LA INDIA, SIN EMBARGO, LA PRINCIPAL CAUSA DE LA PÉRDIDA DE MIEMBROS SON LOS ACCIDENTES DE FERROCARRIL. EN UN PAÍS DONDE MUCHA GENTE VIAJA DURANTE MILES DE KILÓMETROS SOBRE LOS TECHOS DE LOS TRENES, SON FRECUENTES LAS CAÍDAS. LOKESH Y SU MADRE SE QUEDARAN EN CASA DE SU ABUELA HASTA QUE EL PROCESO DE ADAPTACIÓN A LA PRÓTESIS HAYA FINALIZADO.

MAGAZINE PAGE 59/59

was still visible. The goal was to get the reader used to a new nameplate without completely losing the old one. The type used in its logo—a square serif—would remain consistent throughout the first phase of the cover makeover. We experimented with textures atop the type and by employing different colors within the logo itself or in-between the nameplate's letters. During the second phase, we began to experiment with everything: the structure, style, and typeface itself. Then we shook up the cover designs, themes, and graphic solutions for the covers. The

magazine changed slightly every week, yet maintained enough that was familiar to keep it Metropoli. Our intent was to have readers think that the publication in their hands was not a conventional magazine. An analogy is we wanted it to be water when the issue was about swimming pools, sand when it was about deserts, or a rock poster when it was about music. The third phase was to reflect about all we had changed. Was it possible to achieve the same effects sought earlier but with some moderation graphically? Yes, it was possible. The nameplate is more consistent,

Figure 5-7
This two-page *Metropoli* spread on Catherine Zeta Jones uses the left page to run a photograph of her in an elegant gown. The right page employs elemental form—a giant reversed block Z—and edges off the top of the letter with CATHERINE and the bottom with JONES—clean, compelling design. Reprinted with permission of *El Mundo*/Unidad Editorial, S.A.

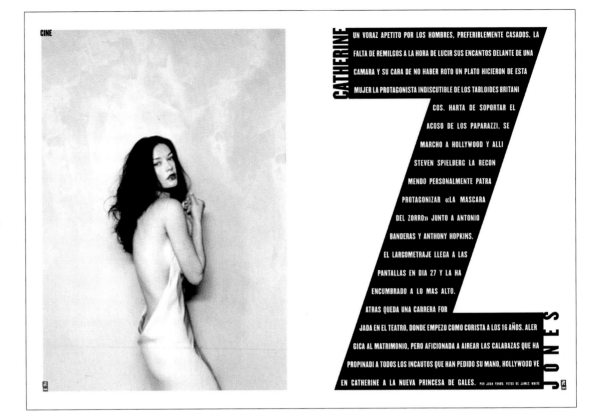

but we can now change it when it is befitting the content or theme.

Great design synthesizes content. Today's Metropoli *can create some powerful visual metaphors or exciting covers through minimal solutions or even something as simple as repetition (see Figure 5-8). Although the cover's stylebook has been expanded and has more flexibility, the cover is still vibrant, flexible, and useful to its readers. Probably the greatest thing about design and design principles are their endless solutions. The fact that the cover of* Metropoli *has a different design each issue makes a virtue of such variety. Each week the cover is a surprise, and for me that's the way it should be. Indeed, there are infinite solutions to every design problem.*

The fact that Rodrigo Sanchez reinvents the look and feel of *Metropoli* on a weekly basis is a most amazing feat; usually this is accomplished while he's working on several other publications concurrently. The work, however different stylistically, has these two things in common: one, graphically, his designs speak to the content and communicate the sense of that particular issue and audience, creatively and seamlessly braiding type, art, and content together; and two, all of

his work is a sage blend of the five principles of design.

Basically, *design* is the process of planning and shaping the form and structure of an object—or in this case, a layout, frame, or page. It is not magic, accomplished with mirrors, black cat bones, or sleight of hand. It may, however, seem quite foreign to the average person.

Design is central to the success of any communication. In fact, many would suggest that it is just as important an element of a publication, film, layout, or on-line site as writing. Please don't misunderstand. If your writing stinks, graphic cartwheels and high design acrobatics won't cover up the smell. Writing works without a net. Nothing can save it, save thoughtful edits and rewrites. Notice how the writing connects to the design and art in the Camelbak print advertisement created by Sasquatch advertising (see Figure 5-9). However, the point should be made that good design attracts and holds audiences, while bad design discourages and repels it.

Like it or not, we read externally first and internally second. Which is to say that we judge communications not only by their covers but by their overall graphic appearance. Design provides an outward structure upon which we further

communicate our messages, sell our soap, create identities, inform our publics, project our images, and otherwise hang our corporate hats.

All design requires planning, understanding the message, and knowing your audience. These are essential components of the design dynamic. Without careful tailoring of structure, visual thought, and order, your communication won't receive the attention it deserves. Without accurate targeting, your message will miss its audience. No matter how well-written and carefully edited your materials may be, readers will disregard poorly designed communications or misdirected ones. It's as simple as that.

For these reasons, then, it's necessary for you to first understand and be able to creatively apply basic design principles. Second, it's important to develop a vocabulary, so that you can communicate clearly with designers, photographers, artists, printers, and other media professionals. Third, you should understand design logistics: how the eye moves through a page and how various design strategies can attract and hold readers—so that you can steer visual traffic effectively through your message. Finally, you must comprehend the "parts of sight" as clearly as you know the parts of speech.

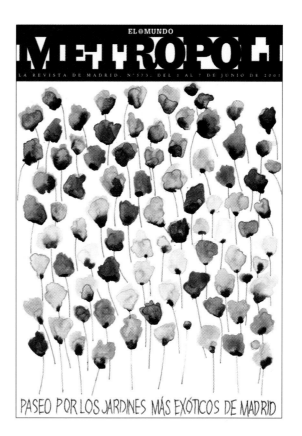

Figure 5-8
Motif established by repetition and color earned this *Metropoli* cover awards for "feature" and "cover" design. The lead feature is a story about a trip through the "most exotic gardens of all of Madrid." Art direction and design, Rodrigo Sanchez; design/illustration, Maria Gonzalez; design director, Carmelo Caderot. Reprinted with permission of *El Mundo*/Unidad Editorial, S.A.

Figure 5-9
The design of this ad uses ground thirds as a proportional strategy. Artwork takes up the top third of the two-page spread, while the header, "Your customers can go to Hell," takes up the middle third, followed by the copy block and product photos. Camelbak is a hydration system fitted to a backpack, which allows its user to get a good drink while on the move. Even the ad's tag line— "Hydrate or Die"— meshes with the overall voice and design of this clever ad. Media planning, Ken Chitwood; creative direction, Greg Eiden and Tim Parker; art direction, Ted Pate; copy, Ted Fulkerson; production, Kristen Holder; photography, Dave Emmite. Courtesy of Sasquatch Advertising.

Design is the skeleton of all publication and other media structure—no matter if we're talking about a magazine, a website, a film, brochure, or photograph (see Figure 5-10).

Five Principles of Design: Balance, Proportion, Sequence, Emphasis, and Unity

The average person doesn't pay much attention to a layout or a design when everything is correctly ordered. In fact, very few of us notice design at all. We process websites or read newspapers daily without seeing the skeletal framework and stylebook that neatly arranges the headlines, color, photography, graphics, text, and other elements of the page. Many of us raise our wine glasses and toast a birthday or anniversary—without noticing the design of the goblet, whose stem was extended to keep our hands from warming the wine. But the best design is like that: it is functional and it exists but doesn't call attention to itself. As Rodrigo Sanchez remarked, "A good designer doesn't design for design's sake. The best designs are functional ones, often invisible, and nearly inseparable from the content and message itself." Master designers prove that point, time and time again.

Not only are the best designs often invisible, but balance and the other design principles present in them also go unnoticed to the average reader. However limited your visual education,

though, you are generally astute enough to detect something amiss within a design. Typically, too, imbalance is the first problem you'll spot in a bad layout.

There are five design principles. They include the rudiments of balance, proportion, sequence, emphasis (or contrast), and unity. Though separate concepts, they relate significantly to one another and have a remarkable symbiotic interconnection. Gail Anderson, art director at Spot Design, New York City, and former assistant art director at *Rolling Stone*, has a gift for blending content and design. Also a master of typography, she speaks to the importance of those facets of design and designing for various media:

I've been designing for nearly twenty years, much to my surprise, and teaching for almost a dozen of them. I still get a little kick when I see something I've designed out there—someone reading a story I designed the layout for, a book cover, or these days, a theater poster (see Figure 5-12).

Good design is problem-solving with wit, speed, and style. You can't place a high enough value on the speed aspect. Interns and junior designers are always surprised by how quickly things have to be turned around in the real world. A deadline is a deadline and that's that. Design is all about communication, and a good designer must be able to articulate his or her concepts clearly and convincingly to clients and

Figure 5-10
Photographs, as well as moving film and interactive media, embrace the design principles within their composition. This N. D. Koster photograph uses strategic placement, framing, asymmetrical balance, ground-third proportions, emphasis, and sequencing within its frame. Shot in Calcutta, India, it is a sophisticated mix of design principles and composition. © N.D. Koster.

editors. It's not just about doing the work; it's about selling the work, too. Selling an idea to a client is something new to me. You want to believe that the work speaks for itself, but that really isn't the case. While I get excited about the intricacies of one cut of a typeface over another, clients want to know how what you've done helps them sell their product effectively. Talking about the work requires an art director to put on his/her marketing cap and start using words like "branding" and "strategy." People come to Spot because the work is smart and beautiful but also because it can really sell a film, show, or event in a fresh way. I have to step outside of myself and remember who the audience is, what the client really needs, and then how we can design something that solves the problem in a clever way. It requires you to think on your feet and be able to speak up. I'm still working on that: being able to convince people that our solution is right for them. Who taught that in school? We fight the "dumb designer" stereotype daily.

Moving from magazines to posters has meant more than merely adjusting the scale I'm used to working in. It's meant adopting a new set of considerations: how to sell as well as entertain and how to please a variety of audiences. A good poster should stop you in your tracks, if only for

a moment, and stir the instinct to want to rip it off the wall and take it home.

Theater posters sometimes have a lot of givens—celebrated actors and even directors sometimes have billing requirements that make design a real challenge. Big names often have to be designed at the same size as the title, and other important players' names work in descending order in percentages that are outlined at the beginning of the project. An important show is typically a real design puzzle.

Posters are about thinking big, not getting lost in detail at the beginning of the design process. Admittedly, this is difficult for me, since I've spent nearly all my career considering the nuances and making detailed changes early in

Figure 5-11

Gail Anderson is the art director of Spot Design. She is also a professor and thesis advisor in the Master of Fine Arts program at the School of Visual Arts. Her work has received numerous awards from the Type Directors Club, the Society of Publication Designers, the New York Art Directors Club, American Institue of Graphic Arts, and from *Graphis*, *Print* and *Communication Arts* magazines. Gail Anderson is a master designer but her ability to perform magic with typography is unsurpassed. Currently, Anderson is working on a Photoshop book with Steve Heller. Along with collecting bottle caps and many other things, she is a television junkie. Portrait art by Hank Woodward. Courtesy of Gail Anderson.

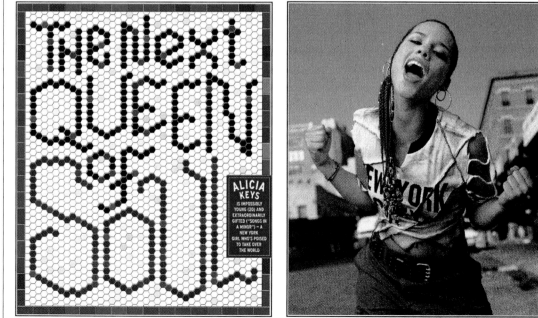

Figure 5-12

The best design answers sometimes come from the strangest of places, often from the niches of your daily, seemingly mundane, experiences. This brilliant typography solution for *Rolling Stone* is a wonderful case in point. Gail Anderson reflects on her graphic solution: "Alicia Keys presented herself as a streetwise New Yorker, so I figured I'd play off that by using subway tiles to illustrate her name." Art direction, Fred Woodward; design and typography, Gail Anderson; photography, Mark Seliger.

the process. I'm accustomed to the viewer looking at my work from a short distance. The magazine layout is in their hands, so the weight of a rule, letterspacing and all the subtle variations made for the lion's share of my design angst. Posters are a bit more forgiving in some respects, but any bad decision will have a much longer shelf life, and mistakes just scream when I look at them in print up on big boards.

There's more time to work things out than I had working on a bi-weekly schedule at Rolling Stone. On the other hand, I have to design with the understanding that the finished piece must work as well in tiny black and white newspaper ads as it does on a 14″×22″ window card or subway poster.

Designers have to be aware of the world around them; reading newspapers, magazines, and books is key. A love of pop culture doesn't hurt either, and the ability to see design everywhere adds to the joy of the craft.

Designers are often collectors, whether it's of prints, fine furniture, or bottle caps (see Figure 5-13). Designers make mental notes of store signage, textures on walls, and food wrappers—things that most people don't notice consciously. Everything feeds into my work, and good ideas

pop up in the unlikeliest of places. Designing with type is underscoring the significance of the words—making them sing. It's about making a big idea look even bigger. Or nail a design so that the layout looks the way it was meant *to look. Those are my greatest satisfactions.*

I love to work with illustrators and still enjoy the act of opening the FedEx package when it arrives. But integrating the words to that art is a key aspect of poster design and because they are equally significant, one shouldn't carry the other, even though there's often the temptation to let the art do all the work. A good poster is a perfect marriage of the two so they blend seamlessly into one, rather than one sitting on top of the other. A successful poster is a wonderful thing, especially because the medium is so new to me and so hardworking (see Figure 5-14).

Like Rodrigo Sanchez, Gail Anderson is at home with a wide range of media, typography, and design, and her solutions are often unconventional ones. Of course, it's worth noting that some of the most brilliant work may deliberately break the prescribed guidelines of design. However, before attempting that kind of experimentation, you need to first understand the rules you're breaking.

Figure 5-13

Gail Anderson is almost as celebrated for her organization as she is for her remarkable bottle cap collection. How she applied them as a solution, however, is ingenious. "I was itchy to find a good use for my bottle caps and bottle cap collection, and the opportunity finally presented itself in the Type Directors Annual program. I designed the judges' names on caps, using something that I knew about each judge as the inspiration." Art direction and typography by Gail Anderson; photography by Bob Grant. Courtesy of Gail Anderson.

Balance

Balance is as essential in our physical lives and environment as it is to the layouts and pages we create. When design elements are unbalanced, they tend to make us uneasy or bring instability or even chaos to what's around them. In our physical lives, when we're off-balance, we have to adjust ourselves or what we're carrying; otherwise, we'll end up crashing the bike, tipping the canoe, or stumbling into someone.

Essentially, *balance* involves equalizing the weight on one side of a vertical axis with the weight on its opposite side. The same sense of balance that we use to walk or ride a bicycle applies to graphic design. Graphically, balance involves placing design elements on the page in a way that will make them look secure and natural, not top or bottom heavy or leaning to the left or right.

We can achieve a sort of graphic equilibrium in one of two ways. *Symmetry* tends to be more traditional and formal. *Asymmetry*, on the other hand, is more informal and playful in its approach to balance.

Symmetry

Normally when we speak of symmetry, we mean bilateral symmetry. Briefly, *bilateral symmetry* aligns layout elements by centering them evenly or opposite one another, so that if split, the two sides basically mirror one another. Typically, the artwork is neatly centered, as are the headline and copy below. Although symmetrical balance imparts the feeling of formality, uniformity, strength, and precision, it may be too rigid or ordered for some design situations or audiences. Notice how Kit Hinrichs uses bilateral symmetry in both the cover and table of contents layouts in this *SKALD* issue (see Figure 5-15).

Of the two approaches to balance, symmetry is easier to create and execute—simply keep the layout's parts centered, and you can't go wrong. Magazine covers, wedding announcements, and academic journals are classic examples of symmetry. Sometimes, too, symmetry is used to be confrontational.

On the other hand, bilateral symmetry can also emphasize harmony. Symmetry may help project the image of no-nonsense, traditional,

Figure 5-14

This is a piece that worked as a poster and a subway board for the Def Poetry Jam in New York City—a unique cultural event that required painstaking promotion: something bright, colorful, and befitting the audience. Gail Anderson explains, "The theater work requires more strategizing than anything else I've ever done. This subway poster for Def Poetry Jam took some real figuring out. We had to reposition the show—which was already running with art another agency had done—and include the Def Poetry logo. We needed to sell the show as fun and not angry and show that it was multi-cultural, too." Mission accomplished. Art direction and typography by Gail Anderson; photography by Andrew Eccles. Courtesy of DEF Poetry/Gail Anderson.

Figure 5-15
Kit Hinrichs designed this bilaterally symmetrical cover for *SKALD* magazine. This publication's stylebook calls for tight, facial shots made straight-on and fully bled for all its cover art. The table of contents echoes the symmetry of the cover design, a more formal approach for a more traditional audience, largely composed of retired people who like taking Royal Viking cruises. These layouts were selected for this book because although older (they were created in 1988), their design is timeless and they'd likely win awards, again today, for their graphic power. Kit Hinrichs, design director; Terri Driscoll, art direction. Courtesy of *SKALD*/Kit Hinrichs.

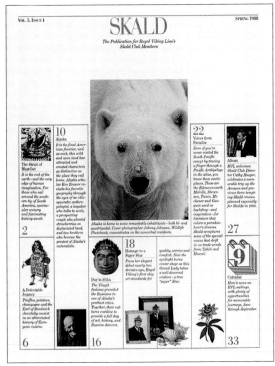

to-be-trusted communications. So, if your message, publication, or audience is dignified, formal, or reserved, a symmetrically balanced layout will tend to underscore that feeling.

Remember, though, a formally balanced layout has elements stacked and centered on the vertical axis. Symmetry has its place in design, but it may be too predictable or static for many situations.

Optical Weight

Optical weight is not to be confused with optical center. *Optical center* (see proportion) refers to an area of the page located slightly to the left and about a third of the way down the page. On the other hand, *optical weight* (as its name suggests) is a visual system of measure.

Briefly, optical weight is based upon these tenets:

- Large elements tend to weigh more than smaller elements.
- Dark areas weigh more than lighter ones.
- Color tends to have more graphic heft than black and white.
- Brighter hues (such as primary colors) weigh more than muted colors.
- Oddly configured elements attract more attention and, hence, weigh more than their regularly-shaped counterparts.

Justin Kistner uses a number of these tenets to work optical weight and balance in "On the Road Again," a playful layout that is well-tailored to a delightful magazine feature about a man who restores and collects vintage bicycles (see Figure 5-16).

Logistically, optical weight works this way: like physical balance, design elements placed farther away from the vertical axis will weigh more. Conversely, the closer an element is to the vertical axes, the less it will weigh. Imagine a teeter-totter. A large person sitting close to the fulcrum (vertical axis) will be raised up by someone much smaller, sitting well back on the seesaw. We understand this concept in the real world, so it's easy enough to comprehend and apply to design and the counterbalancing that we use in arranging asymmetrical layouts.

Asymmetry and Grids

Asymmetry tends to be informal. It's much more playful and dynamic than its formal, symmetrical cousin. Asymmetry is not centered up and equal on both sides. In fact, it's much more complex and involves counterbalance through the use of logistics and optical weight, so it tends to be more challenging as an approach to balance—at least initially.

Figure 5-16
Optical weight is employed here in a variety of ways: size, angle, irregularly-shaped elements (both the lower text block, bicycle partial knockout, and the curved tint block on the upper right page), white space, negative space, and the cluster of smaller photos. Sketch this layout to dissect the layout's balance and note how optical weight is used in this two-page magazine spread. Justin Kistner, art director; Sarah Cohen, art associate; Kipp Wettstein, photo editor and photography. Courtesy of *FLUX* magazine.

Working the asymmetrical side of the fence has lots of design advantages. Asymmetry may suggest motion or offer a playful arrangement of shapes, colors, and elements juggled within the layout. Again, this visual strategy of offsetting design components relies strongly on logistics and optical weight. Notice how this approach to design in *The New York Times* is appropriately tailored in a playful way to fit the content of the Yankees/Mets "subway series" (see Figure 5-17).

Asymmetry also tends to look more spontaneous and can bring tension and flexibility to a page's architecture. It's not by accident, for example, that most newspaper front pages and section pages use asymmetry. When incorporated with a *modular* (*grid* or *Mondrian*) format, its possibilities are virtually endless. Asymmetrical grids dominate newspaper section and front page designs; their inherent flexibility, invisibility, and versatility prove invaluable.

Modular or grid design is said to have been motivated by the grid-like paintings of Piet Mondrian, renowned artist and co-founder of the *de Stijl* art movement. His rectangular compositions —inspired by the plotted flatlands of Holland— were intended to express the state of the perfect and unalterable equilibrium. These asymmetrical

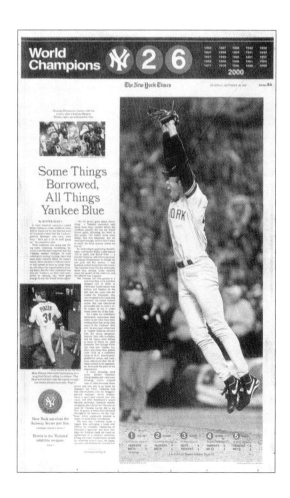

Figure 5-17
The designers split this *New York Times* page into ground thirds vertically. Good proportion. Details are everything: notice the subway train numbers at the top of the page for this Yankee-Mets subway series. Also, Mariano Rivera is looking into the header of the story. Good sequencing. Designers, Wayne Kamidol and Lee Yarosh; graphics editor, Joe Ward; picture editors, Steve Jesselli and Pancho Bernasconi; illustration, Joe Zeff. Courtesy of *The New York Times*.

paintings eventually led to modular design being adopted and applied within publication layouts. Today, this grid approach tends to be the skeleton of newspapers and nearly all other media.

Grids are especially evident in newspaper, Web, and magazine page design. Among other things, modular design works efficiently with the basic principles of design. Mondrian design is incredibly flexible; you can enlarge or reduce modules as well as add or subtract them from a layout. What's more, grids are mostly invisible to the average person, and although modular design usually goes unnoticed, we appreciate its inherent organization. It also provides tremendous variety to design, because its various configurations are endless. Examine all the examples in the chapter to differentiate between symmetry and asymmetry. Better yet, compare a week's worth of your newspaper's front pages.

Grids often establish parallel structure and continuity in layouts, something that's particularly important to advertising campaigns. Finally, the grid can also be used as a compositional device in photography or moving images.

Proportion

Perhaps the next most logical step in planning your layout is to decide upon a shape and format, and how you're going to divide the space within that format. *Proportion* is the relationship between one element in a layout to the entirety of that layout's space or the relationship among elements within the design.

Rectangles are the most common, utilitarian, and pleasant shapes we see and use each day. In fact, the rectangular format has long been a standard: books will fit on shelves properly,

brochures will fit basic envelope sizes, magazine layouts will lock into place easily, and outdoor ads will match their boards' format. In addition, the space you're designing—not to mention the paper—will be used more efficiently. Costs and waste will be kept to a minimum. After all, paper is sized to comfortably fit our media's dependence on the rectangular format. We've established standard sizes of $3'' \times 5''$, $4'' \times 6''$, $5'' \times 8''$, $8.5'' \times 11''$, and so on, for practical purposes: standard paper sizes and printing press uniformity.

Generally the most pleasing page size is considered to be one in which the length is approximately one-and-one-half times its width. Throughout history, the "golden rectangle" has been the dominant design configuration. It's derived from what mathematicians call the golden section, a formula that was a product of the revival of learning during the Renaissance in fourteenth and fifteenth-century Europe. The true golden section is a .616 to 1.0 ratio. In this Primax brochure spread, the artwork reflects the golden rectangle concept, and the relationship between the art and copy block is established by ground thirds. In this case, the copy area takes up roughly one-third of the layout space; the artwork takes up the remaining space (see Figure 5-18).

There are both aesthetic and pragmatic reasons for our predisposition to this format. The ancient Greeks recognized the combined functionality and beauty of the rectangle and constructed some of civilization's most attractive and timeless structures in the shape of rectangles. This configuration, illustrated by the Parthenon, became known as the "golden rectangle" or "golden mean." Its proportions are approximately three to five, and its beauty and design have endured.

Figure 5-18

Ground thirds was used as an underpinning within all the print ads, brochure work, and outdoor media for Primax's Commander fountain pen. Art direction and design for this brochure panel was done by William Ryan; photography by Louis Squillace.

Remarkably, the Greeks employed these same proportional ratios in areas quite separate from architecture: sculpture, mathematics, and painting. Today, we find this rectangular format everywhere. Look at the shape of the page in the book you're reading and at the ratios in the formats of your newspaper, magazines, and notebook paper. Look at the shape and configurations of the 35 mm photography frame, computer monitor, or your TV screen.

Although structurally solid, squares tend to be less dynamic and more monotonous to us visually because of their equidistant sides. However, the rectangle, though equally uniform and precise, provides more design possibilities, and it offers more layout variety within its form.

Do this: take a felt-tip marker and black out all the photos, tints, and info-graphics on a newspaper's front page. Do you see the grid? Look at the grid structure and how proportion is utilized in some of the earlier examples of asymmetry.

Most designers break up the space within their pages by employing a tactic known as *ground thirds,* by which space within a basic layout is divided roughly into one-third and two-third segments. You find this proportional arrangement everywhere: in print advertising, in the ratio of a magazine's nameplate to the rest of a cover, in a film or video frame. In fact, it is perhaps the most important and often-used design strategy we encounter, commonly employed both vertically and horizontally.

Most ads fracture space into roughly two-thirds art: one-third copy. Magazine layouts are usually split into a similar ratio. This book's pages are broken vertically into ground thirds proportions. Compositionally, cinematographers and photographers split the screen or frame into one-third sky and two-thirds ground or vice versa. In fact, it's even evident in type anatomy: typographers often establish this ratio (or a similar one) between x-height (2/3) and the length of the ascenders and descenders (1/3). This is referred to as "scale" in type structure.

However, designers often take great liberties with this concept, breaking their plane or space into ground fifths or tenths or fourths. Basically, the idea is to avoid breaking the layout or frame in half. The larger area also tends to dominate the space and emphasize what's in it; in that sense, ground thirds also helps sequence our vision. Matt Bates trims back the proportions to roughly ground tenths in this *Civilization* layout by framing the photography with the feature's vertical header, "CASTAWAY" (see Figure 5-19).

Reapply proportion by breaking your page space into other rectangles—one for the art, another for the copy, and one for the headline.

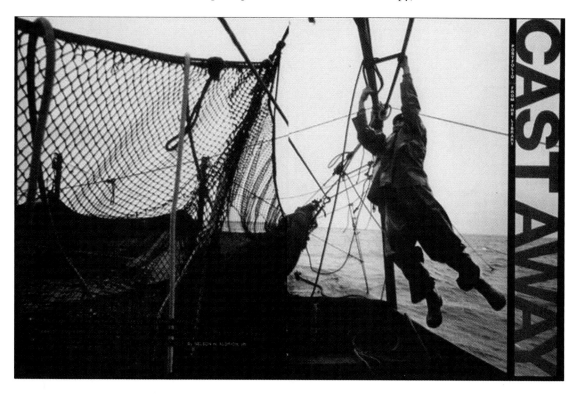

Figure 5-19
The designers took liberties with ground thirds here. In this instance, the vertical proportional ratio is probably closer to ground tenths. The point is to break your space in an appropriate and interesting manner. How does the art relate to the story title, "Castaway"? (Notice, too, how the sky-to-ground ratio in the photograph also employs ground thirds.) Art direction and photography, Dan Budnik; associate art direction, Matthew Bates; design, Matthew Bates/Timothy Jones. Courtesy of *Civilization* magazine.

Examine John Hornall's multiple use of ground thirds, again (see Figure 5-20).

Once you've figured out the proportions of the layout, you can experiment with placing the layout's elements. Consider using optical center and working out the balance of the layout's parts—art, copy, and headlines, for example.

Proportion may also suggest how formal a design is. Generally, evenly proportioned layouts (two columns, four columns, etc.) suggest a more formally balanced, traditional approach to design, while uneven ones (three or five columns) tend to be more informal. The *Bible's* two-column, classic layout is a prime example of formality.

The Secret of Optical Center

Any finished layout is worthless if it doesn't stop the reader and arouse interest. One common ploy used to attract and hold a browser's attention is the use of *optical center*.

Optical center is the spot where the human eye tends to enter a page. Normally, our vision gravitates toward an area on the page slightly above mathematical (or exact) center and just to the left. Try this: examine a newspaper front page or section opener and note what you see first. Usually, it will be above the fold at or around

optical center. It takes a mighty compelling element to pull your eyes away from this spot. Now notice how often photographs, magazine spreads, ads and other media place important elements around this area.

Although more commonly associated with balance, optical center is directly related to proportion. In fact, it is a vertical variation of the Pythagorean theorem, which suggests that in the proportional segmentation of a line, the relationship of the small section of a line to its larger segment would equal the ratio of the larger line segment to the entire line. Likewise, optical center is determined by dividing a page so that the upper panel bears the same relationship (ratio) to the lower panel that the lower panel does to the length of the entire page.

Luckily, you don't have to take out a ruler to precisely calculate this exact spot in every layout. By studying layouts you see every day and with a little practice making rough layouts, you can get into the habit of using this area strategically. Kit Hinrichs' meticulously designed pages for Evergreen paper demonstrate how liberties are taken with the exact proportions within a design (see Figure 5-21). Again, the important thing is not to be halving space without good cause.

Figure 5-20
Hornall Anderson Design Works designed this two-page spread for Holland America cruise line's magazine-brochure to Alaska. Its page is a clinic on using proportion well. Look closely on both pages to see if you can determine how many different ways interesting proportions have been achieved using ground thirds? Color, inviting photography, and generous use of white space make these materials as memorable as they are inviting. Note the prominence of blue and grids within the page layouts. Why do you supposed John Hornall and his team used that strategy? How have other design principles been integrated into this spread? Art direction, John Hornall, Julie Lock; design, John Hornall, Julie Lock, Jana Wilson Esser, Mary Hermes, Mary Chin Hutchison, Jana Nishi; photography (stock work); copy, Pamela Mason Davey.

Figure 5-21

Contrast the symmetrical and assymentrical designs of these two pages from the Simpson Paper Company's meticulously designed sample book. The concept was to show off its environmentally-friendly recycled paperstock, Evergreen, by featuring important naturalists the likes of Walt Whitman, Henry David Thoreau, Merriweather Lewis, Theodore Roosevelt, and J.J. Audubon. Which approach do you prefer? The striking differences in style, art, and design help differentiate the various paper stocks and demonstrate their strengths and how they hold and handle various inks. Art direction by Kit Hinrichs. Courtesy of Simpson Paper Company.

Sequence

It is important to understand how the human eye processes messages. Understanding our normal reading patterns will help you better plot and design your layouts. Remember: *not* directing your readers carefully through a design is misdirecting them.

Think of yourself as a visual traffic cop. Indeed, as a designer or visual communicator you are responsible for routing the readers through your publications and other media. Streamlining the communication and constructing the layout for a graceful sequence through the page is your central mission.

Visual Movement and Research

Over the years, researchers have closely scrutinized how we process messages visually. Notably, Drs. Mario Garcia and Pegie Stark Adam have conducted several extensive studies for the Poynter Institute for Media Studies. They carefully have documented the nuances of sight, reading patterns, and, generally, what seems to attract and hold our attention visually. They used a device called EYE-TRAC (a video camera that records eye movement) to determine how we

respond to color, photography, entry points, element size, graphics, where an element is positioned, and where we tend to enter and exit a page visually.

The occidental eye tends to move left to right and top to bottom. Consequently, most publications, images, and Web pages are designed with that dynamic in mind. However, our normal reading and visual processing patterns may be redirected by color, optical weight, strong entry points, and other strategies. Notice how Jesse Coulter takes advantage of this phenomena in his ad for Pastamatic; he moves you deftly left to right across the page (see Figure 5-22). The artwork even has an arrow-like shape to shepherd your vision to the product, tag line, and logo.

"Z" Readout

Additionally, our visual pattern makes a sweep of the page that is referred to as a "Z-readout," starting upper left and normally exiting lower right. Remember, too, that the lines within a layout may be real or implied, as in the connection we make in the Sonicare ad. Draw an imaginary line between the dentist's light, the

Figure 5-22
Jesse Coulter, art director and designer at Weiden + Kennedy, New York City, sequences our vision efficiently through this Pastamatic Pasta Maker ad. Without headlines or text, he communicates clearly that this machine creates the "fresh taste of Italy." The art was created using Photoshop to warp the image down to a thin line that comes out the Pastamatic as spaghetti. Courtesy of Pastamatic.

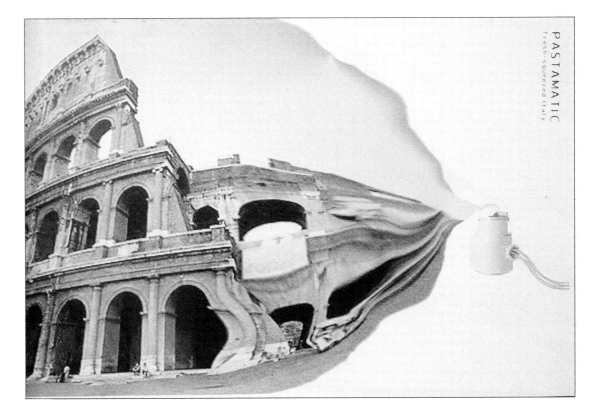

dental hygenist's face and hands, and finally to the logo at the bottom right (see Figure 5-23). It isn't by accident that print ads "sign off" or finish the ad by placing the client's logo lower right. It provides Sonicare one last shot to remind the reader who's ad it is—and to increase their brand awareness. The reference to the logo as the ad's "signature" is appropriate. Today, TV networks do the same thing by placing their logo at the bottom or in the lower right corner of the screen; it's fairly unobtrusive there, and it also automatically "signs" and copyrights any programming one might tape.

Sometimes the physical arrangement of the design can literally engage the reader to move or engage the sequence pattern.

Sequence Patterns

Most media we encounter and process each day reflect our visual predisposition. It should come as no surprise then that our messages tend to follow these sequencing patterns. Art dominates. Clearly, we prefer pictorial material. Normally, that's where our vision goes first. Usually, we move to headlines next, which normally precede copy. Generally, text (or copy) follows the headers. Think about the average poster, print ad, newspaper, Web page, newsletter, or magazine story you read. Probably the great majority of them follow this progression.

However, there are additional sequencing conventions. In newspapers, typically, the more important the story, the higher on the page it is positioned. Also, the left side of the layout is considered more valuable real estate, which is why advertisers like to buy left-hand pages or extreme left-hand columns on a page. Generally, the more important something is, the more likely it will sit high and to the left. Remember optical center?

It's likely your audience will congregate at the art, so, you should be thinking of how to redirect them into the guts of your communication— usually the text of the message. One effective ploy is to have a dominant element or the subject in the photograph looking or pointing toward the copy. You can reroute the audience to wherever you want to lead them via strong diagonal lines of force or line of sight. Photographers use strong

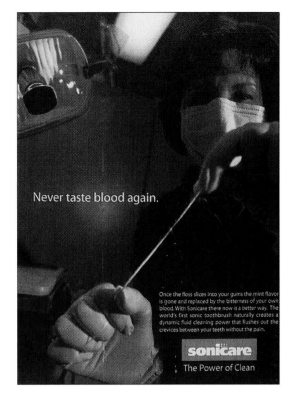

Figure 5-23
This ad for Sonicare electric toothbrushes ("Never taste blood again") uses a strong Z-readout. Can you spot it? Jeff Oliver, creative direction and copy; Kipp Wettstein, photography, art direction, and design. Courtesy of Sonicare.

diagonal lines within a composition to sequence your vision where they want to lead you.

You should also be thinking about strategies to establish a clear entry point for your layout. Dropped initial letters work well to that end, as do thumbnail photos, decks, rebus elements, or other graphics. Each of these strategies can attract and steer vision to a key point within a page or frame. Often entry points mark transitions or the beginning of the message. How did the designer steer your vision through these *Breaking 100* layouts? (See Figure 5-24.)

Proper sequencing establishes a rhythm, which may take advantage of the natural path the eye follows as it travels through a layout. So, if you arrange the elements on the page in a logical fashion along the Z path, you can route the audience smoothly through the message.

You can learn invaluable lessons about sequence by applying what you know now about design to all the media you encounter. Deconstruct the websites, magazine layouts, advertisements, newspaper pages, and posters you encounter. Notice how designers flow your sight through the layouts. The more you're able to pick the elements apart, the more you'll learn about how they go together, and the better

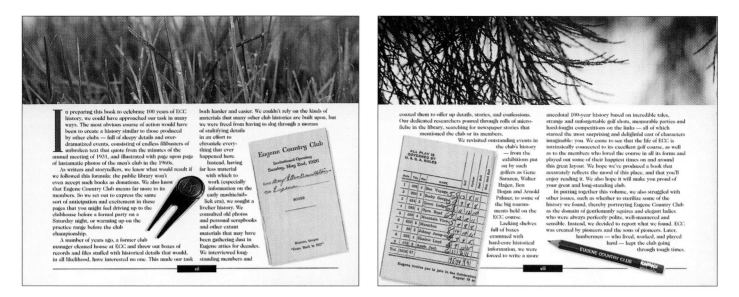

Figure 5-24
Here sequencing occurs between the front side of a righthand page and its back side in the book *Breaking 100*. Note how the scorecard (both front and back side) relates sequentially—front to back—on these two book pages. *Breaking 100*. Jan Ryan, design; William Ryan, art direction and photography; Jeff Wallach and Todd Schwartz, copy.

designer or visual communicator you'll become. The creative use of design principles is limited only by your imagination.

Emphasis and Contrast

Emphasis involves giving a single graphic element within a page or layout visual significance. Clearly, every design needs a focal point, something to dominate, to catch the audience's attention and hold it. When we move through the barrage of messages we're bombarded with each day, we travel quickly and selectively. We're both numbed and jaded by the sheer number of media messages we process each day. It makes us cautious, impatient, and difficult to stop.

Examine whatever is at hand—a magazine cover, the front page of your local newspaper, your favorite website, a photo or film frame, or an ad. Which element stands out? Typically, it's whatever the designer intended you to see *first*. That is precisely what emphasis is about: singling out and stressing *one* and only one element within the layout or frame (see Figure 5-25).

Much of what we disregard or pass over fails because it lacks emphasis. Because audiences are elusive and demanding, communications must have good stopping power. Again, media not only compete with one another, their content components vie for your attention. While the editor of *Rolling Stone* would be delighted if you read every issue cover to cover, he realizes how unlikely that is. In fact, his features, briefs,

reviews, departments, and columns all compete for your attention. And the advertising competes with the magazine content for your readership. You get the idea.

The point of emphasis, simply, is to have a point. Concurrently, resist the temptation to emphasize too many things. When you stress too much, you defeat your purpose and dilute the emphasis within the design. Chad Verly provides emphasis to his award-winning advertising design for SONY headphones by employing an unusual exaggerated format—a narrow print ad sprawled across two pages (see Figure 5-26).

Emphasis Strategies

There is no single best way to show emphasis, although if you took a quick survey, you'd discover that the most common tactic is size. Designers often stress the main element by running it big. Although that is the obvious tactic, there are many other ways to stand off whatever you intend to emphasize. Emphasis is basically achieved by making all the other components within a frame or layout subservient to the one that dominates. While the list below is by no means exhaustive or all-encompassing, it provides several strategies for showing emphasis:

Imbalance. By teetering or skewing the main element, you explode the natural "at rest" posture of the layout, and emphasize the tilted item to attract attention. If you adopt this strategy, be sure it's appropriate to the concept.

For example, a magazine layout on adrenaline sports might strongly tilt a large photo of a skydiver, a bungie-jumper, or a kayaker taking on a 30-foot vertical drop. Imbalance adds to the edginess and tension of the photograph and story. On the other hand, tilting a photo on a story on the biography of President John Quincy Adams wouldn't make much sense. Also, running lots of tilts or overusing any strategy can run it into the ground, defeat the purpose, and become predictable.

Selective focus blurs the background and foreground of an image. It is a commonly used compositional strategy of most photographers, cinematographers, and videographers. It is accomplished by shooting the film or video at a very wide aperture setting on the camera, such as $f1.8$, $f2.5$, or $f4$, for example, to compress the depth of field and limit what is in focus. Selective focus' connection to emphasis is clear: our eyes lock onto what's sharp in the image and mostly disregard anything out of focus (see Figure 5-27).

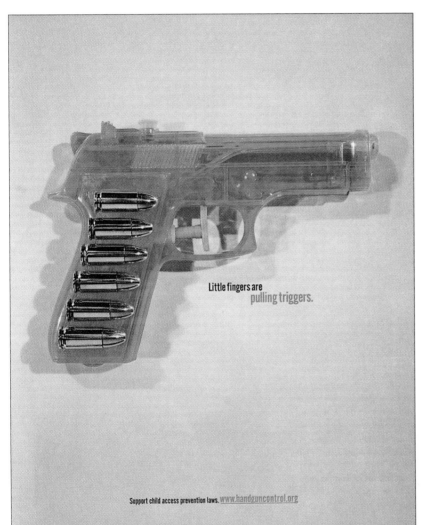

Figure 5-25
Each year handguns take the lives of many children—often by accident. Emphasis is achieved for this ad (www.handguncontrol.org) through isolation, color, incongruity (why are real bullets in the handle of a child's squirt gun?) and the sheer power of the idea: kids are unknowingly shooting themselves, friends, and others by playing with real guns. Concept, Elizabeth Ryan and Chris Hutchinson; art direction, Chris Hutchinson; copywriting, Elizabeth Ryan.

Figure 5-26
Sometimes an unusual or unique format can achieve emphasis simply from its physical difference. In this instance, Chad Verly conceived a series of ads for SONY headphones using exaggerated formats. The sleek use of space makes for an appropriate and attention-getting format. He's also isolated the product via knockout photography, and bounced and blurred the type in Photoshop to help suggest the tremendous bass response in the headphones. Brilliant idea and masterful execution. Design, art direction, and photography, Chad Verly; copy, Chad Verly and Ben Jenkins. Courtesy of SONY.

Little fingers are pulling triggers.

Support child access prevention laws. www.handguncontrol.org

super aural headphones with powerful bass provided by a neodymium ... a 50mm driver ... beat matching DJ work

SONY MDR-V700DJ

Size. It's not the size of the graphic that counts, it's how you use it. There are two basic approaches to size: run it big, or run it small. In the first instance, the sheer size of art, type, or other element commands attention. On the other hand, you can isolate small art in a sea of white space. Both are effective emphasis ploys. Use them creatively and appropriately for the situation.

Color. Sometimes color is used to dominate a layout. It might be the color on a headline backdrop, the powerful use of color in a photograph, color purposely muted, or even color knocked out of a large portion of a full-color image with the use of Photoshop. Notice how André Ranieri eliminated all the color in his full-color photograph except for the avocado (see Figure 5-28).

Isolation. This strategy helps convey emphasis via contrast, scale, detachment, or the generous use of white or negative space. It might employ optical weight or even use ground neutrally. *Ground* refers to the background or subordinate areas within a design, as opposed to the *figure*, the dominant or featured element. For example,

an illustration might employ a stripped out background or a photograph might be knocked out or shot against a seamless white, black, or gray backdrop or even blue sky, as is the case in André Ranieri's photograph of ostriches. This strategy basically insulates the visual content from its format, making it stand out from the rest of the layout (see Figure 5-29).

Unusual shapes, uneven borders, ragged edges. These tactics rail against the conformity and uniformity of the page, frame, or feature's layout. Something out of the ordinary, however simple and minimal, may attract attention, as in Coulter's Pastamatic ad (see Figure 5-23). At the same time, using the same borders or ragged edges on photos within a feature, website, or book also maintain unity and continuity (see Figure 3-55).

Juxtaposition. Oddly enough miscues can capture our attention. Juxtaposition involves the art of misdirection. Specifically, it is featuring the main element of a photograph or a design by facing it in the opposite direction of the other subjects, elements or components. Although this is more a compositional device common to pho-

Figure 5-27
The photo in this arresting *La Luna* spread demonstrates the power of selective focus and emphasis via high contrast and framing. Photographer Luis de las Alas focuses on the eyes of the subject and with a wide aperture setting dissolves the detail in both the foreground and background. The hand also complements the huge quotation mark in the lefthand page design and frames Ana Torroja's face. Rodrigo Sanchez, art director and designer; Eva Lopez, Francisco Dorado, Chano Del Rio, designers; Carmelo Caderot, design director; Luis de las Alas, photography. Reprinted with permission of *El Mundo*/Unidad Editorial, S.A.

tography and illustration, it may also be employed within a layout. Dorothea Lange's icon, *Migrant Mother*, uses juxtaposition (see Figure 8-3).

Contrast. This strategy may be achieved literally by putting dark things against light things and vice versa or figuratively by juxtaposing images depicting opposite qualities—rich and poor, young and old, dead and alive, etc.

Incongruity. The tactic of incongruity or *transposition* pulls an element out of its normal context and gives it an especially unusual, ironic, sarcastic, or humorous spin. Incongruity may suggest that "something's wrong with this picture." When a major visual piece of the design puzzle appears out of place, that strident difference brings emphasis to the design. In a sense, the knocked-out color in Raineri's photo of the avocado accomplishes that end.

Just as photographers often isolate a subject in a portrait by neutralizing backgrounds or using selective focus, designers must also be subtractive and provide a focus within the layout that isolates or emphasizes the layout's main subject or design component. Sometimes the emphasis

Figure 5-28
André Ranieri shot this award-winning photograph for the *Tri-City Herald* as a photo-illustration for a feature on avocados and their health benefits. He phtographed the image in full color, then knocked out all the color within the image excluding the avocado itself, using Adobe Photoshop. Think about how crucial visualizing this idea was in the first place. The quality and impact of the idea itself is always the most important piece of any effective graphic solution. Courtesy of André Ranieri and the *Tri-City Herald*.

Figure 5-29
The subtractive nature of this wide-angle photograph is established from framing (ostriches against the blue sky), scale, and the low camera angle. Together these compositional devices give the image tremendous impact. Ranieri gives the ostrich in the foreground even more power because of its relative size. Photograph courtesy of André Ranieri.

may come off gently, as in Boo (Tiong) Khoo's Volkswagen Beetle ad, "Stop and Smell the Flowers" (see Figure 5-30).

Customarily, though, the *visual* element dominates. That shouldn't surprise us. We have a visual predisposition and are drawn to strong graphic elements that are presented cleanly, simply, and directly.

Unity

Unity refers to the overall cohesion and collection of a layout's parts, especially as each separate element relates to the rest of the design's parts. Headlines, text, artwork, and the other graphic nuances of the page should fuse, be in harmony, or at the very least, be compatible with one another. You sense unity intuitively and can tell if something is out of place or doesn't mesh with its design components. Notice how the pages work together in the information kit created for Weyerhauser Paper by Ad Group (see Figure 5-31).

However, too often these instincts stop short of understanding why or how unity works. This is sort of akin to saying that we realize a vehicle is dysfunctional when smoke pours out from beneath the hood and the car comes to shaking halt, but we haven't the foggiest notion of what's wrong, or how to fix it.

Like our forebears, we possess a penchant to see a composition's parts assembled. Gestalt investigations and applied theory have proven that we perceive the people and things around us as wholes before we begin dissecting them into parts. For example, when we look across a table at someone, we don't initially see ears, hair, eyes, and other features of the person sitting there; we see and recognize a person.

In the case of *Water: Asia's Environmental Imperative* (see Figure 5-32), continuity is established between the publication's cover and respective chapter openings via the page's parallel structure. So even though full color is not used for the inside openers, the page architecture carries the unity of the design. We continually process whatever we see into simple, harmonious wholes. The concept of continuity is, in large part, why we seek visual order. It allows us to

Figure 5-30
Boo (Tiong) Koo—creative director and partner of the Singapore advertising agency, Icecream—created this simple Volkswagen (VW) Beetle print ad. "Stop and smell the flowers" makes reference to the 1960s when VWs were counter-culture vehicles of many of the "flower children." The simple outline of the car is unmistakable. Its simplicity speaks to the legacy of work started by Bill Bernbach and Helmet Krone, whose use of understatement, wry humor, and minimal design are classic. The emphasis here speaks to the power of lines, both real and inferred.

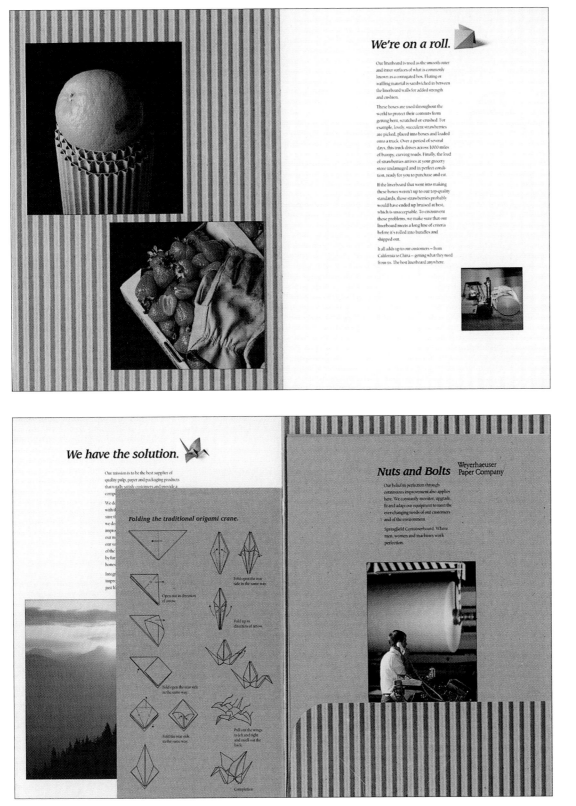

Figure 5-31
Unity is important to all media. Weyerhaeuser Paper Company produced this information kit specifically for the Japanese market to show off Weyerhauser's pulp, paper, and packaging products. Part of the strategy was to use origami to sequence and unify these brochure pages. Corrugated cardboard backgrounds were used on each left hand page as well as on the front and back inside pocket pages. Design and art direction, Brian Sabin; copy, Jan Ryan; photography, Kent Peterson.

Figure 5-32
Compare the layout of this
book chapter page to its
cover in the next chapter
on color. See if you can do
it without any references.
The parallel structure of
the two should help you
make the association. Art
direction and design,
William Ryan.

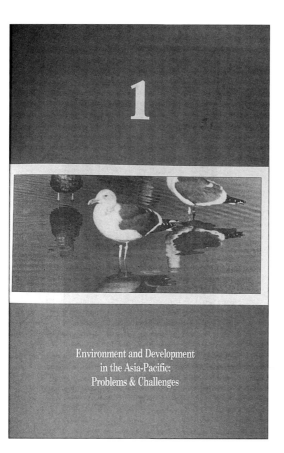

Figure 5-33
Max Pechstein's artist
page (left) offers a large
amount of room for his
biographical background
and portrait, and a
comparatively small area
for the art example
("Killing of the Banquet
Roast," 1911) on his
MoMA website page. The
arrangement of space on
Ernst Kirchner's opening
panel (right) is configured
just the opposite: the
artwork ("Winter
Moonlit Night," 1919)
takes up the lion's share
of the space, and the
artist and other
information is smaller -
approximately the size of
the left-hand panel's art.
Although the pages'
respective content is
flipped, the spatial ratios
within the frames are
about the same. How else
are the panels similar?
Both frames are
wonderfully conceived
and executed: design by
Allegra Burnette,
programming by Tanya
Beeharrilall and George
Hunka, May 2002.
© The Museum of
Modern Art.

make sense of our environment or understand
that things go together.

Our eyes and brain are continually running
over objects, people, artwork, publications,
ordering the various parts of each into wholes.
Continuum is central to most communications,
including the Web and interactive design. These
wonderful pages from Museum of Modern Art's
"Artists of Brücke" website do a great job
explaining expressionism. How do these two
pages use unity? (See Figure 5-33.)

Unity helps hold publications together. It is
what makes two separate pages connect. It's the
thread that weaves a seven-page magazine feature

together. Compare, for example, two pages of the
FLUX article, "On the Road Again" (see Figure
5-34). While they are certainly not carbons of
one another, they have wonderful unity. Why?
What are the visual cues that relate the pages to
one another?

Strategies for using and establishing unity are
varied. Following are several of the more effective
ones:

Bridging is a connective device used to hold
two or more pages together. It can be accom-
plished in myriad ways by crossing a two-page
layout with art, type, color, rules, keylines,
headlines, or graphics. Artwork that bridges two
pages is referred to as a *crossover*. It costs more
but is worth its unification value. What examples
in this chapter employ bridging as a strategy for
unity?

Multiple-page bridging may use the opposite
side of the page to join art and type on one side
of a page to the backside of that *same page*. In
Breaking 100, the art, a golf scorecard was posi-
tioned so that a turn of the page revealed its
backside on the following page. A similar
strategy was applied to the front and back of a
FLUX magazine self-cover (see Figure 5-35).
While the opportunity for multi-page bridging is
limited, the strategy can be a fresh and engaging
tactic for readers.

Color also offers lots of unification potential to
designers. For example, selecting a dominant
color from the opening artwork and using it (or a
tint or complement of it) for color blocks, rules,
type, or other graphic elements helps bring unity
to a layout. The color in dropped initial letters or
in borders works similarly and can be especially
useful with jumped pages. The reader associates
the color used earlier to the jump page and

his 1951 J.C. Higgins girl's bike is Dunham's favorite. Collectors often break down girl's bikes and use them for parts because they don't sell as well as the boy's models. But Dunham likes the girl's frame better. "I like the curves," he says. The J.C. Higgins also features handlebar turn signals and a rare "batwing" headlight. Dunham thinks of his bikes as rideable art. "I don't like any of the newer bikes that are out," he says. "There's no design to them. The mountain bikes, they're more for utility purposes. There's no creativity to them, no style."

Kipp Wettstein is pursuing a career in commercial and news photography. He spends his summers working his chain saw and fighting forest fires in the West, where he documents people and the land.

39

Figure 5-34
These are the closing two pages of an eight-page *FLUX* magazine feature on vintage bicycles. They demonstrate how type, color, photography style, sculpted type, and playful layout can achieve unity. See Figure 5-16 and compare the two layouts for unity and continuity. Justin Kistner, art director; Sarah Cohen, art associate; Kipp Wettstein, photo editor and photography. Courtesy of *FLUX* magazine.

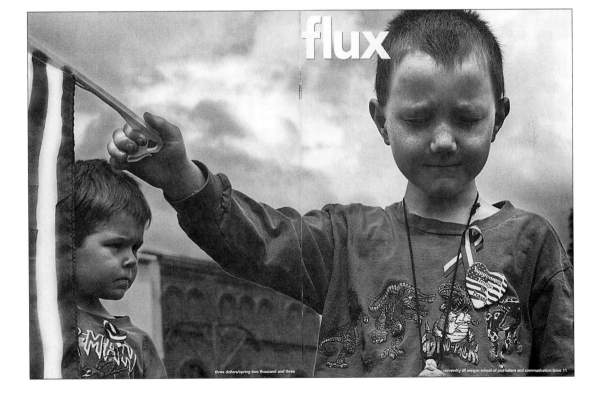

flux

three dollars/spring two thousand and three university of oregon school of journalism and communication Issue 11

Figure 5-35
The opportunity to bridge a cover's design between the front and back doesn't present itself often, but when it does, arching a photograph or design across both pages can be a powerful solution. Photography, Luis Salazar; art direction and design, Laura Chamberlain for *FLUX* magazine. Courtesy of *FLUX* magazine.

knows immediately that the separated layout parts go together.

Typography and stylebooks help establish unity in a publication or website's pages—overall and within specific layouts.

How the artwork is used may also help show unity. Black and white or a sepia toning treatment throughout a feature or layout suggests the art goes together. More subtle, but equally effective and important, is the style of the illustration or photography used. With unity, consistency is a virtue.

Parallel structure is another powerful unifier, one that's most common to print advertising. It's especially important in print ads because it helps thread separate ads together through their art, design underpinnings, color, type, and other elements. Why? Because when readers see the second, or fifth or fifteenth, ad in a campaign, they associate it with earlier ads. This helps communicate more than just the information in the current ad, it reverberates and surfaces recall in the readers' minds of the previous ads. This strategy is very important in establishing *brand image*, or in reinforcing the message. These simple ads for Jack's Snack-N-Tackle Shop from

Sasquatch advertising use parallel structure (see Figure 5-36).

Continuity is a strategy employed by all media to help hold their parts together to maintain unity. While one approach may work fine by itself (color, for example), designers, Webmasters, directors, and other graphic communicators will often employ a mix of unification devices (see Figure 5-37).

Finally, although design principles are distinctly different entities, they blend and work together to be the glue that holds your messages together.

Design, Layout, and Design Stages

Is there a difference between layout and design? Although closely related, they are intrinsically different. Think of it this way: buildings have a structural form held together by a foundation, footings, beams, trusses and girders, all of which are carefully planned and integrated into the design by the architect through the use of a blueprint. Similarly, designers, Webmasters, and art directors craft a blueprint which employs design principles, graphics, art, color, type, and words for their messages At their *functional* best, both layout and design are a marvelous blend of pragmaticism and aesthetics.

Figure 5-36

The concept, visualization, and execution of these Jack's Snack-N-Tackle Shop ads are as functional as they are funny. Because they were to be used as newspaper and local magazine advertising, they had to be minimal and reproduce well in media that didn't exactly have the best reproduction. The first one—"Better not forget your glasses"—uses fuzzy photography; the upper image is labeled "nightcrawlers," and the bottom one "gummi worms." The copy for the second ad reads: "In Japan, we'd be a 4-star restaurant. In Oregon, we're a bait shop." Media planning, Ken Chitwood; creative direction, Greg Eiden and Tim Parker; art direction, Ted Pate; copy, Greg Eiden; production, Kristen Holder; photography, Deve Emmite. Courtesy of Sasquatch Advertising.

Figure 5-37
In this example, "Supermodels with Six Legs," both the style of the photography and the minimal page design bring continuity to the layout. How do the opening two pages of this *Smithsonian* magazine layout connect to its closing spread? Gilles Mermet, photography. Courtesy, Suzanne Crawford; courtesy, Gilles Mermet; originally appeared in *Smithsonian*, June 2000.

Architects share their plans with carpenters, masons, electricians, and others who make their vision a reality. Art directors, Webmasters, and creative directors share their designs with others, too, who lay out the pages, ads, online sites, and so on. Directors use cameramen, gaffers, lighting technicians, and others to shoot, record, light, block, and edit their films. A newspaper graphics editor creates and uses a stylebook and oversees the newspaper's design; page designers, illustrators, layout artists, photographers, and copy editors help execute the actual page layouts. Of course, sometimes the designer or director may carry out the actual layout. But the point is clear: design is the structural concept and overview of a project—no matter what the medium is.

Art directors, creative directors, and design editors are the architects of publications. They are responsible for the master plan, which is carefully conceived and tailored to the budget, audience, image and editorial needs of the publisher, producer, or client. Design is not a cosmetic makeover, but a skeletal, inner architecture upon which all else is supported. Along with structure, designers bring a tasteful aesthetic to the publication. They utilize composition and the basic principles of design, choose typography and artwork, and develop a suitable format. Think of design as the *form* of the publication; the permanent visual framework that shapes the contents. It may establish identity, mood, continuity, or visual flow.

On the other hand, a layout is the execution of a design, and it uses the very same principles as the overall design itself. Having said all that, you should know that some professionals use these terms—layout and design—interchangably.

Conception and Visualization

Dirk Barnett, art director and designer at *Popular Science*, has been making an impact in magazine design circles. He's worked at many magazines including *Mirabella, Men's Journal, Entertainment Weekly, Travel and Leisure Golf, Worth, Popular Science*, and other publications. When *Ad Age* recently released its "hot list" of magazines "with revenues under $60 million," *Popular Science* was ranked number three.

Barnett's insightful visualization and execution are reflected in two very diffferent layouts he did recently for *Popular Science* magazine. Good ideas evolve from hard work, focused thinking, and visualization (see Figure 5-39). Formula design is bad design. Barnett discredits the notion that tight stylebooks, a less than Bohemian audience, and science as a subject area restrict a designer's creativity. Compare his two layouts.

As a designer, your first and most important job isn't executed with a computer, it's accomplished by using your imagination, and usually a sketchbook. You should keep one with you at all times. You never know when good ideas will surface. Impeccable design means little if the idea behind it is lame, inappropriate, or predictable. Use association lists, brainstorming sessions, freewrites, and research to evolve your "big idea." But whatever you do, don't start creating layouts until you settle on the main idea or solution.

Next, match your ideas to the audience. Again, if the design, writing, and art are exceptional, but you target the wrong audience, you've failed. Speak to your audience in the proper voice—both with words and graphically. Apply what you've learned about using design principles sagely. If you're unfamiliar with a particular audience, interact with them. Talk with them. Learn how they see, think, and feel. Using that information, visualize a series of graphic solutions that speak to your audience.

Try to visualize a solution for this problem: you've been asked to come up with a print ad campaign for Fram Oil filters. The client wants to target young males, ages 18-30, who own cars. The client also wants to position its product and its use against all of the drive-through oil change/lubrication garages. Fram has asked for something that's hip and fun—a campaign with a little attitude. So, the ads should be strong visually, communicate quickly to the audience with a minimum of words, and establish Fram as a top-of-mind brand through the "*do-it-yourself*" positioning. Conceive your strategy and visualize how the ads will look. After you've come up with your solutions, see what Rob Nollenberger did for his Fram advertising campaign (see Figure 5-44).

Dirk Barnett

What is particularly interesting about the design of these opening magazine spreads is that although created for the same magazine (*Popular Science*) and audience, their presentations are remarkably different from one another. The pages reflect their content, primarily because of Barnett's visualization. The stylebook for the headline typography is minimal and specifies that only Futura (a sans serif face) and Celeste (a roman type) will be used.

"JUMP! JUMP!" uses an unusual triptych approach. Barnett explains: "We went through many stages with this opener, until it became

clear that the most powerful way to show Cheryl Stearns was not with one big photo, but 3 spliced photos. This also allowed us to show off the wonderful aerial photography of Tom Sanders. I love that middle panel because she looks like a pod ripping through the sky. After the photos were selected, the type was simplified to pick up the direction of her body and the different sizes of Cheryl in the photos."

By contrast "Bio-Pharm" uses a conventional opening with one page designated for the headline and the other for art. There is a unity here, though it exists as a kind of skeleton. The headline is set at a very small point size, as a callout to the diagram of a stripped ear of corn: "Something funny down on the pharm." The strategy is clever and uses smart visualization. The feature focuses on the controversy over genetically modified food.

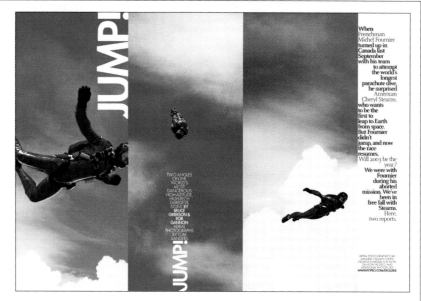

Figure 5-38 (LEFT)
Dirk Barnett caught the attention of the photo editor at *Mirabella* immediately. He made himself invaluable to her because of his professionalism, gregarious nature, computer skills, and design savvy. Two weeks after he'd begun the internship, his overseer moved to *Men's Journal*. A few days later, he received a call asking him to sign on as an assistant to her, so he resigned his internship. Since then, he's worked with some of the most celebrated art directors and designers in the world. In addition, he has amassed many awards for his work from The Society of Publication Designers, The Type Director's Club, *American Photography*, as well as National Magazine Awards. Photography by John B. Carnett.

Figure 5-39
(Above) *JUMP! JUMP!*: Design direction, art direction, and design, Dirk Barnett; photography, Tom Sanders; story by Bruce Grierson and Rob Gannon.

(Below) *BIO-PHARM*: Art direction, Hylah Hill; design director, Dirk Barnett; designers: Hylah Hill, Dirk Barnett; photography, Holley Lindem. Courtesy of *Popular Science*.

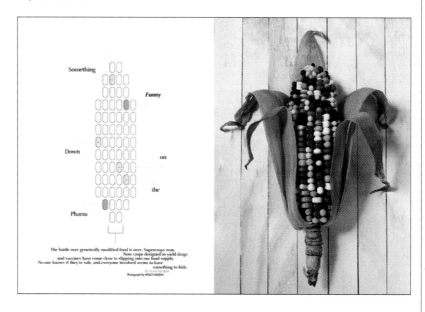

Visualization provides concrete direction. It gets you started. It takes your ideas and translates them into a visual reality—no matter how rough or unfinished. After you've determined your audience, understood the thrust of your message, and decided what you want to say and how you want to say it, start sketching.

Design Stages

Before we even discuss the stages of the design process, build a brief creative strategy. You should use this strategy for *all* of your work—no matter what your medium is. Follow each of these points faithfully:

- Define your audience.
- Clearly articulate (in words on paper) the concept, idea, or solution to the problem at hand in no more than one short paragraph.
- Create a terse 1–2 sentence rationale or defense for your idea.
- State the bottom line: what's your mission and what do you want your graphic work to achieve? After your audience processes your design and message, what am are they supposed to do? Read the story? Buy the product? Be emotionally moved by the message? Learn about your cause, candidate, or documentary theme?

Reaching a good solution usually means that you've examined your problem, story, documentary, product closely enough to have weeded out peripheral ideas and story lines and angles. Good ideas are arrived at through visualization, largely a *subtractive process*. Both words are key here; it is a process, and the main idea is established by sorting out all the ideas and reducing your possible directions to the best one. Proceed to your initial layout.

There are three different layout stages: thumbnail sketches, roughs, and finished layouts. Certainly, variations within each stage run the gamut from very rough to painstakingly finished, so what constitutes a rough to one designer, might be closer to a finished piece to another. The important thing to remember is that every layout should evolve from the conceptual experi-

mentation stage (thumbnail) to a finished comprehensive layout. In advertising, usually very rough ideas are presented to clients at the initial meetings. Why? Well, it doesn't make sense to waste time and money on ideas that may be rejected. It's important to offer several alternatives to get a better feel for what they want, to provide more insight into what's needed, and to allow clients more ownership and direction for the work.

The Thumbnail

Novices are often likely to slam together a rough version of a layout without ever giving thought to creating a series of *thumbnails*—miniature replicas of what the lifesize layout will look like. Thumbnails need not be detailed because their function is to provide the basic direction or "big" idea for you—a preliminary overview of a layout's structural possibilities. Consider thumbnails graphic experiments—possible scribbled solutions to the problem at hand. Don't stop this process after you happen upon one good idea. Don't circle the wagons. Instead continue to experiment and sketch additional ideas. For example, the Hinman Vineyards' brochure went through a lot of brainstorming, as evidenced by a few thumbnail examples shown here (see Figure 5-40).

If you're sketching, use a soft lead pencil or and/or a black felt tip pen for your sketches. Outline the general shape of the art, or if you wish, rough in the general configuration of the art idea you have. Indicate type with lines or zigzag doodlings or by "x"ing it in to designate where the header and other type elements go. Again, the function of a thumbnail is to provide a rough idea of all your design possibilities, so don't scribble off two of them and presume you're finished.

The more you create, the more likely you are to arrive at a successful solution. This point cannot be overstated. When you're satisfied that you've sketched enough thumbnails, select the strongest two or three for additional development. At this point, you want a closer look at the layout. As you're visualizing your thumbnails for

the Fram example noted previously (Figure 5-44), think about how you're going to use color in your refinements.

The Rough

Normally, *roughs* are rendered at reproduction size, except when working with outdoor or poster designs. Designers and layout artists used to trace visuals and lettering. Today, it's much easier to find and scan the artwork, "spec out" the typography, and complete the process using a computer. The tracing exercises, though, are still useful because they will familiarize your hands, eyes, and mind with the type's architecture, voice, and peculiarities.

Extensive swipe files will provide you with a great variety of artwork for your roughs. A *swipe file* is a collection of "clipped" artwork snipped from magazines, catalogs, and a variety of places. They are often used to suggest the style, content, scale, or mood of the art. Remember, this art is to be used only as an initial working model; you *don't* want to use anything under copyright for publication.

If you're using your computer, begin the rough by keylining in the dimensions of your layout. Keylines are borders; they're used to enclose the art or frame the layout. Then refine each element—art, graphics, headline, copy, and other type—from your thumbnail proportionally to the full-size model. If copy is not available, use *greeking*, which is "dummy copy" used in a rough layout to simulate what the real text would look like. (*Lorem Ipsum* is the greeking file provided in PageMaker.) Don't cheat on the type; really examine your choices. Do they speak in the correct voice, project the image you want? Is the type legible, readable, and appropriate to the message and audience? For example, given what the Fram ad needs—a quick-hitting message with attitude—and given the audience, what typeface will you choose? How big will you make the art? Type? How will you use color? Should the design be more formal or informal?

If you're using pencil and paper, consider using a chisel point pencil because it produces a broad stroke and a fairly hard edge, so you can put

Figure 5-40
These are two to three of the thumbnail sketches of perhaps 12-15 pages of noodlings that were done for Hinman Vinyards and Silvan Ridge Winery's brochure and collateral materials. The examples shown here came from a lined "Composition" notebook; others were executed in sketchbooks, and some were even scribbled on napkins. Courtesy of Hinman Vineyards.

down lettering quickly and cleanly. Today, the computer is the standard tool for working up more finished roughs, but quite a few designers still prefer to use a sketchbook and pencil for initial roughs. Drawing is an invaluable skill. Typically, roughs go through a lot of experimentation and changes.

If you intend to run a 48-point headline, set it at that size, using the weight, posture and positioning you intend to use for publication. Type specimens are available in type books or various texts, but today most computers are loaded with a fairly sophisticated library of typefaces. If copy is available, set it as if it were going into the finished layout, using the correct typeface and point size, weights, leading, column width, and other typographical particulars. The closer the rough is to the finished version, the better. Apply color and other particulars to flesh it out.

If you don't like the full-size rough as much as you did its miniature counterpart, return to your thumbnails and sketch a variation or two from the originals, or go back to the drawing board. Smaller layouts permit you to rearrange elements and work a kink or problem out of the layout quickly.

Finished layouts further refine the idea. Don't even think about going to the comprehensive phase if you haven't resolved every issue raised by the rough. Finished layouts require a good deal of time and effort, so you need to be confident about what you produce. The last thing you want to do is invest a huge amount of time and effort into a piece you can't use.

The Comprehensive

Some designers or production people use the term *comprehensive* or "comp" interchangably with *finished layout* or *mechanical*. Comprehensives should always simulate the quality of the finished piece. Like the other stages, comps vary in their refinement. How detailed they should be depends largely on the client and your needs. The less a client knows about this process, the more finished your comprehensive should be. Very often headlines, copy and other typographic elements are typeset and laid out with the artwork and photographed or photocopied. In this instance, the comprehensive isn't the original work.

Comps are normally mounted and matted for presentation. Sometimes a presentation will include slides of the comprehensive, its evolution and specific components so clients have a larger than life view of the work and understand its development. Pinning up an 8″ × 10″ finished

layout and discussing it 15 feet away doesn't do it justice. Using a poster-sized layout in this situation isn't the best way to present it, either. Slides or even presentation programs, such as Powerpoint, may be expected in formal situations, but be sure to have first generation mechanicals or tight printouts of the work at the presentation. Computers, digitization, powerful software programs, and high-resolution printers make it possible to produce sophisticated work. Indeed, clients, editors, and others expect sharp imagery, true-to-life color, immaculate type, and flawless design from comprehensives.

In summary, the thumbnail evolves only after serious visualization and looking for a solution to the problem at hand. This evolutionary process is evident in the design of Hinman Vineyards' brochure. The company wanted to show that although they were relatively new to wine-making, they used traditional, Old World approaches to growing and harvesting grapes and were "pioneers in the Oregon wine industry." Concurrently, Hinman's facilities and technology were state of the art. The visual metaphor for their brochure cover used a knockout photo of a grape seedling. The top half spoke to their innovations and state-of-the-art facilities; the bottom half noted that their "roots ran deep" and that tradition is central to fine wine-making (see Figure 5-41).

Figure 5-41
Good ideas evolve—through thorough visualization and brainstorming. The execution of the big idea or concept evolves via the rough and comprehensive or "comp." Notice the changes and refinements along the way for this design. Hinman Vineyards ended up adopting two brochures: one less detailed and basic for general purposes, the second for marketing to vendors. Photography, Eric Evans; design, Jan Ryan; art direction and copy, William Ryan. Courtesy of Hinman Vineyards.

Presentation is everything. So after you've printed your comprehensives, consider mounting them (see Figure 5-42). Fome-Cor board is replacing cardboard and posterboard stock as mounting material. In addition, it's become a common practice to laminate the pieces after they've been dry- or spray-mounted. A plastic surface will prevent smudges, fingerprints, coffee cup rings, and creased or crinkled layouts and keep your work looking crisp, clean, and professional. Many students and professionals laminate portfolio pieces.

The Markup

When we refer to a "markup" in graphic design, we aren't talking about changing the price on the potato chips that were on sale over the weekend back to their usual $2.99/bag. A *markup* is a rough or finished rough that includes instructions for the printer (see Figure 5-43). Today a file is usually delivered intact—usually on a CD-ROM, DVD, or a even a portable hard drive—along with a rough printout of that file for the printer to use as a touchstone for comparative reasons. Smaller files, typically in PDF format, may arrive at the print shop via E-mail or on disc.

You may or may not have reason to send a markup to a printer, but in any case, you should understand the process, its directives, and the printer's needs. Typically, you would include the following in the markup:

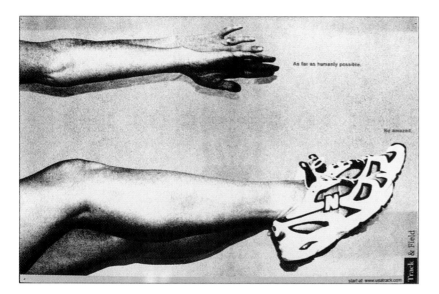

Figure 5-42
This is a great example of a very finished comprehensive layout for *US Track & Field*. Compare it to its "comped up" counterpart (Figure 4-18). It's nearly impossible to discern any difference between the finished rough and the mechanical. How do the two examples establish unity, sequence, emphasis, balance and proportion? Art direction and photography, Robert Mackay; copy, Jennifer Eggers. Courtesy of *US Track & Field*.

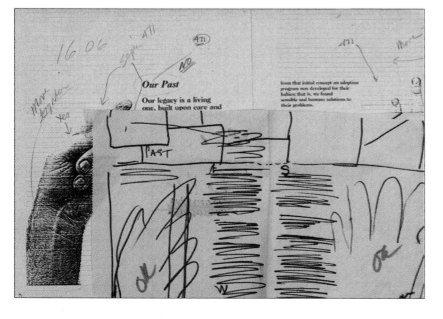

Figure 5-43
This markup was used for a fund-raising brochure and information kit for Florence Crittenton. It is shown with a very large version of a thumbnail that was actually produced for the client on a legal pad over lunch. Art direction and design, William Ryan.

- Type specifications: family, size, leading, weight, style, line length, and alignment (justified, flush left/right, etc.). Family names may be abbreviated: Bodoni, "Bod;" Helvetica, "Hel;" and so on.
- Color choices: be specific with PMS designations.
- Artwork information: positioning (should the art be bled?), keylines, meticulous identification of imagery (so photos aren't accidentally switched or confused). Usually, label the photos first with the page number on which they appear, and if there is more than one photo going on that page, a second designator (number of letter), e.g., 1-1, 1-2, or 1-A, 1-B. Be sure the artwork is also numbered and corresponds to the layout; that is, put the number on the slide or back of the photograph and in the corresponding window(s) of the layout. If the art is digitized, number the files on the disc similarly.
- Include anything else that might test a printer's clairvoyance about your file.

Below are the most frequently used terms for indicating instructions on roughs:

CAPS	Set in all capital letters
U&lc	Set downstyle
lc	Set in all lowercase
BF	Set in boldface
8/10	Point size of type/leading. Also written as "8 on 10."
8/10/18	A third number indicates line length; in this case, the markup suggests the printer set the copy in 18 pica columns.
][Center whatever is highlighted and bracketed.
[Flush left
]	Flush right
U&lc	Set downstyle

The object of all this is not to invent more work for you. Actually, it's just the opposite: to ensure your work is run exactly as you intended it to be printed. Markup assures better communication, saves time, and helps minimize costly and very unpleasant mistakes.

Graphics in Action

1. Using, print ads, websites, photographs, newspapers, magazines, brochures, and other media, search out great examples of the design principles discussed in this chapter; focus on 1 principle per example. Mount them neatly as exhibits and using your computer create captions explaining how each one exemplifies its respective principle.

2. Take turns reviewing the examples above and find and discuss the other design principles in each of the examples. Do any of the design principles interrelate or work as more than one principle? How? Discuss.

3. Find a symmetrically-balanced print ad and assess its various elements. How do the design principles relate to one another? Then, redesign the ad as an asymmetric layout, using its existing parts. Scan the art, but try to recreate the headline yourself. Greek or dummy in the copy.

4. Recently, Red Bull, the high energy drink, announced that it was planning to sponsor Formula One drivers from the United States to raise its market share. Formula One racing is an appropriate association for a brand positioned to deliver extra energy. Design a special logo that would go on the side of a Formula One racing machine. Be sure to include some of the current logo and the phrase "it gives you wings." Don't forget: the logo has to be clearly seen from a distance on a moving car.

5. Create the next month's cover for the magazine, W. Use three recent covers as a starting place for your design research. Your job is to basically replicate the existing cover's use of type, art, nameplate, voice, and visual footprint. Find new art and background color and create your own type for the cover. The mission? Obviously, you have to use the same nameplate and typographical approaches and so forth, but you need to produce a fresh-looking cover that clearly is W, without making a carbon of it. Seem easy at first? Hardly. This is the problem that design directors are faced with every issue. Rather than copying the nameplate of W, try to match the type yourself using your computer's font library.

6. Invent a travel page for your local newspaper. If it already has one, invent another section it does not offer. Be sure to use as much of the paper's existing stylebook as possible. You might even wish to invite the newspaper's design and graphics directors to class and to critique what you've done. Amaze them with your prototype.

7. Applying what you've learned in this chapter, as a team, rebuild your professor's class website. Break up into working teams of 2-4 students and compete for the best website revision. In your presentation, address the audience, state the rationale for your design updates and changes, and query the class to see if they think your plan and redesign worked. If your instructor doesn't have a website, build one.

8. Eminem is performing a benefit concert at your school for homeless people in your community. Your task? Design a poster promoting the event. Start this assignment the way you should begin all your visual work—with a short creative strategy. The poster should communicate appropriately to your audience, obviously, but also evoke the artist's image. If you aren't a big Eminem fan, feel free to substitute Ozzy, Jennifer Lopez, Darkstar Orchestra, the Red Hot Chili Peppers, Sheryl Crow, Jurassic 5, Los Lobos, Garth Brooks, or your favorite recording artist or group.

9. Bring the past 5 front pages of your local newspaper to class and deconstruct them by blacking out the photos, illustrations, and other graphic elements. Pin them up to the board and compare them. Examine the papers' design structure by first comparing their upper fold areas and then their entire pages. What did you learn?

10. The attendance at the Lincoln Park Zoo of Chicago has been holding steady. That's good news for the director of the zoo, but she wants to increase their visitor numbers. She's hired you to come up with an outdoor campaign to increase traffic. Furthermore, she's asked you to do two other things. First, push the outdoor medium so that it's more engaging and truly

unusual. She wants your work to "create a stir." Second, she has asked you to come up with ideas for where to place the boards. One idea she offered you as a tag line, which kind of captures the feel of what's she's after, was "Go ape." You're to come up with successive tag lines that go with the concepts and boards you create calling attention to other animals or zoo features.

11. Times change and packaging and design must change with them. The publisher at Viking Press wants to create a new boxed set of five of John Steinbeck's novels: *The Grapes of Wrath, Cannery Row, The Red Pony, Tortilla Flat*, and *Of Mice and Men*. You've been asked to do something new, but "retro-looking." Working as a team (in groups of 2 to 5), break up the task into the box itself, and the five different dust jacket covers. Remember, though, while the materials must be unified, each should be clearly discernable from the other pieces. The publisher's art director suggested incorporating some of the documentary photography of the Farm Security Administration (FSA) in the design. The direction, however, is up to you. Remember, create something that's smart and inviting, but smacks of the time period, the 1930s and 1940s.

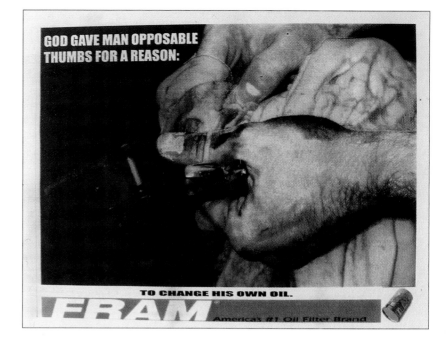

Figure 5-44
Rob Nollenberger uses humor ("God gave man opposable thumbs for a reason: To change his own oil."), simple photography, clever copy, consistent typefaces, and orange framing to help the unity. The color photography is deliberately tweaked to give it a "little edge." How did your visualizations compare to Nollenberger's? Concept, copy, and art direction, Rob Nollenberger; design, Bruno Rinaldi; photography, Rob Nollenberger and Kipp Wettstein. Courtesy of FRAM Oil Filters.

*A palette nowadays is absolutely
colorful: sky-blue, pink, orange,
vermillion, strong yellow, clear
green, pure wine red, purple.*
 -Vincent van Gogh

Many of the pigments for earth tones literally come from the *earth*. This Cary Wolinsky image from "The Quest for Color" first appeared in *National Geographic*. He notes: "Early humans created permanent colors with natural pigments. Paleolithic cave painters used numerous minerals, including black-ish manganese dioxide as well as red and yellow ochers" (pictured here).

Sometimes, pigments don't create color; the Morpho butterfly, for example, essentially works as its own prism. Wolinsky comments: "The blue in Morpho rhetenor butterfly wings comes from light reflected by microscopic texture variations on colorless wing scales."

"Expensive synthetic red dye even serves tradition when diluted with corn starch on a roof in New Delhi, India for use in a festival." Story and photography by Cary Wolinsky, courtesy of Cary Wolinsky and *National Geographic*.

Previous Page
Dal Lake, Kashmir, India, 1996, Steve McCurry. This image first appeared in *National Geographic*. Its caption read: "A flower seller paddles through Dal Lake's quiet waters. Few observers expect diplomacy to restore equal serenity to his homeland. Buffeted from within and without by waves of seemingly intractable strife, Kashmir faces a stormy future." The color in the photograph, which is richly saturated and opulent, contrasts the quiet beauty of the moment. In a sense, this McCurry image is a visual metaphor for Kashmir and its deep contrasts. Courtesy of Steve McCurry.

Color responses are more tied to a man's emotions than to his intellect. In general, people do not respond to color with their minds.

—*Deborah Sharpe,*
The Psychology of Color and Design

The Quest for Color

Color has a fascinating history—one that's bridged centuries, cultures, science, fine arts, and media. Cary Wolinsky, photographer and writer for *National Geographic*, traced some of that evolution in "The Quest for Color," a compelling feature in *National Geographic* magazine. Wolinsky provided an insightful and well-researched overview of color's impact on civilization. Additional excerpts from that article and a gallery of Cary Wolinsky's photography are available at his website: http://www.carywolinsky.com/. He also examined the origins of color—the dyes and pigments that formed the hues: "Pigments of purple, saffron, and ultramarine were, at times, worth their weight in gold. Ancient cities were built on fortunes made in part from a purple dye from mollusks. In Nuremberg, a man was burned at the stake in a fire made of his own imitation saffron. Ultramarine, extracted from lapis lazuli, was reverently reserved in Renaissance art for painting the robes of the Virgin Mary" (see Figure 6-1, Figure 6-2, Figure 6-3). Although acquiring color today is obviously less arduous, its importance and application are at least as important to graphic communication. Along with being central to effective graphic communication, color is a dynamic closely studied in a wide range of disciplines, including physics, psychology, chemistry, philosophy, and fine arts.

Pegie Stark Adam is equally passionate about color—in more ways than one—as a designer, newspaper design consultant, journalism professor, and a painter. She is as adroit at implying a mood with her oils and watercolor (see Figure 6-5) as she is at navigating readers through a newspaper page or website by strategic use of color and by employing color as punctuation, among other things.

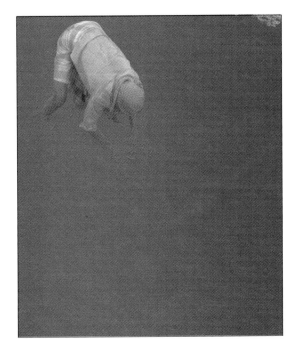

When I first began working with editors in the newsroom, I became frustrated when I tried to explain why I used spot color to draw the eye from one element on a page to another. So I decided to borrow from the vocabulary editors and writers use: I spoke of applying color as "punctuation." Literally, punctuation is a signaling device. It tells the reader when to begin (caps), when to pause (comma, hyphen, or semicolon), when to expect a list, quotation, or explanation to follow (colon), and when to stop (period.) Consider how color is used on this page. It is a navigational tool to guide your vision from one element to another—according to the designer's plan—allowing the reader to travel on an orderly and logical path through the page from start to finish (see Figure 6-6 and Figure 6-7).

But color is much more than punctuation. Color is information, not decoration, and it can suggest a good deal about place and identity. Every town has its own spirit, flavor, accent and colors. If you live in Florida, your town may be daubed in an array of pastel tones—peaches, mints, apricots—all bathed in sunlight. However, in New York City, colors may be more muted with townhouse browns, skyscraper grays, and deep Central Park greens, punctuated with neon primaries (bright lights) scattered here and there. In the tropics, your colors will be more saturated—turquoise, mango, and jade—deep hues of primary colors. In Scandinavia? Perhaps muted with diluted shades of all the colors.

Similarly, each publication is unique and has its voice, spirit, and color. So, when you select a color palette for a story, brochure, identity package, or newspaper, make sure its environment is reflected in your color choices.

Harrisburg, Pennsylvania is an older, traditional town filled with deep red brick homes and Dutch blue trim. Rich green farmland surrounds the city. Deep golden tones shimmer on the rivers and water around the city. Harrisburg is the capital of Pennsylvania, and The Patriot-News in Harrisburg is the newspaper of record. Recently, when I redesigned The Patriot-News, I created a

Figure 6-4
Art has always been a passion of Dr. Pegie Stark Adam. She truly is a renaissance person who writes and edits as wonderfully as she paints and designs. Over the years, she has worked as the graphics director at the *Detroit Free Press*, graphics editor at the *Detroit News*, and art editor at the *St. Petersburg Times*. She has also been a member of the faculty at the University of Florida, Indiana University, The Poynter Institute for Media Studies, and, most recently, Syracuse University. Her research is focused on her first love—graphic communication. Stark's work with Dr. Mario Garcia, *Eyes on the News*, is a compelling study on how we process visual information; she has also written *Color, Contrast and Dimension in News Design*, and was creative director and writer of its sister website. Photograph by Debbie Silliman. Courtesy of Pegie Stark Adam/Debbi Silliman.

Figure 6-5
Breakfast, a painting by Dr. Pegie Stark Adam, demonstrates the effect of warm colors in this beautiful still life. The use of color exudes the warmth and subtlety of morning light. Painting by Pegie Stark Adam, oil on canvas (30″ × 24″), 1999. Courtesy of Pegie Stark Adam.

Figure 6-6 and 6-7

These two pages from *The Patriot-News* (Harrisburg, PA) are good examples of how color can both reflect place and be used as punctuation to help sequence readers through pages. Examine these two layouts and note how Pegie Stark Adam has moved your vision through the layouts. Courtesy of *The Patriot-News*.

color palette based on the paper's philosophy and the environment in which it is read.

First, I needed a sense of color and place. As I drove around Harrisburg on my initial visit, I stopped intermittently to make pastel sketches of the environment. Later I matched the pastel colors to PMS tones in QuarkXPress on my Mac. Ultimately, I changed the PMS colors to CYMK and built a color palette using six main hues. Then, I created 50 percent and 30 percent tones of each of the six hues, which became The Patriot-News color palette (see Figure 6-8 and Figure 6-9).

When you create a color palette, include several versions of all three primary tones to provide enough color choices for all types of packages. Note that I included a blue tone, a red tone and a yellow tone in the palette. While not primary colors, they are versions of primaries that are saturated or diluted to 'match' the environment of Harrisburg. In addition, the colors are rich and sophisticated, not garish, thereby reflecting the paper's traditional 'newspaper of record' spirit.

A color palette does not always have to be about the surroundings. Study the content, the philosophy, the energy, the attitude of the stories on the pages you are designing. Then, examine the voice, tone, and spirit of the information in the story. A light, upbeat story may look best with cool tones, a dark story could be accompanied with richer, more saturated colors. Look to art for inspiration. Study the color palettes that

artists use to create mood and meaning in their works. Note the subtleties, variation, and intensity of the colors. Note also how the choice and placement of color can make things appear in the foreground, midground, or background. Experiment with color contrasts on your pages. Contrast creates dimension. Work with the contrast of light and dark tones, saturated and diluted tones, and complementary colors to push elements forward or pull them back. For more information on how to create dimension with color, go to the online version of 'Color, Contrast and Dimension' at www.poynter.org.

The point is that you should use color to tell your story. If you are designing an edgy, underground Paris entertainment guide, select lush, rich, almost surreal tones. Think of the movie Moulin Rouge. If you're designing a literary magazine, select rich, deeply saturated jewel tones for the tapestry of deep, richly written stories. Think Renaissance. Or maybe opt for an electric, Andy-Warhol-like palette if you are publishing a story that's lively, electric and fun. And, if you're in a tropical paradise, think Henri Matisse.

Whenever I think about color, I'm reminded of these words of Johannes Itten from his book, The Elements of Color (1961): "Colors are forces, radiant energies that affect us positively and negatively whether we are aware of it or not."

So, listen to color, pay attention to its tone, its mood, and its message. And, respect its presence in your work.

These are but a handful of insights on the function and application of color in design that Dr. Pegie Stark Adam prepared as a statement for this book. For a more thorough review, read her text, *Color, Contrast and Dimension in News Design.* Or go to her award-winning website: http://poynterextra.org/cp/colorproject/color.html. It is a site with intuitive usability and allows visitors to learn about color theory through their own experience and by completing a group of smart exercises (see Figure 6-10).

In addition to making our world immensely rich and enjoyable, color is a powerful communication tool; its impact upon commerce, art, fashion—and graphics and design—is huge. In

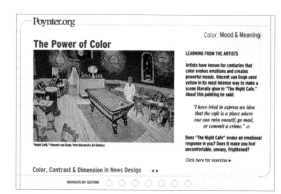

Figure 6-8 and 6-9

Normally, along with refining stylebook entries for type, design, photography, and other graphic components, a designer also establishes a color palette for a publication, website, ad campaign, or identity materials. These palettes were created for the redesign of *The Patriot-News* by Pegie Stark Adam. The colors were gleaned from numerous sketches that she made of Harrisburg, Pennsylvania. She literally integrated the town's environment into the paper's stylebook. Palettes and sketches executed by Dr. Pegie Stark Adam for *The Patriot-News.* Courtesy of *The Patriot-News.*

Figure 6-10

Recently, *Communication Arts* honored Dr. Pegie Stark Adam, Anne Conneen, and The Poynter Institute for Media Studies for their website on color. It was selected from thousands of international entries for *CA's* Interactive Annual. The Flash-built program has wonderful usability and employs a slideshow-like approach to allow users to experience the psychological, physiological, and dimensional aspects of color. Dr. Pegie Stark Adam, creative direction and writing; Dr. Pegie Stark Adam/Anne Conneen, art direction and architecture; Anne Conneen, interface and graphic design. Courtesy of Pegie Stark Adam.

fact, according to marketing researcher Patricia Roderman, color is the single most important factor when it comes to people making purchasing decisions, and therein lie important marketing and packaging lessons.

Color is perhaps the most persuasive component in a designer's tool kit. It communicates simultaneously in myriad ways: aesthetically, culturally, emotionally, and personally. Recently, @*issue:* (Volume 6, number 1) featured a fascinating survey on color. Here are six of the twenty questions asked of the readers (the answers are placed at the back of the chapter):

1. "What color car is outlawed by Brazil and Ecuador because of its high incidence of traffic accidents?"

2. "What color are stop signs in China?"

3. "What food color is most popular among adults in Western nations?"

4. "On signage which color combination is most visible?"

5. "What color has proven so effective in reducing anxiety that it has been used as a deterrent to suicide?"

6. "What two colors were the first to be given names in primitive cultures?"

Clearly, color is a critical facet of marketing, branding, and identity. We associate IBM with "big blue," *National Geographic* covers with their chrome yellow borders, McDonald's with its "golden arches," and Hershey's with its dark brown packaging suggesting rich chocolate. Speaking of marketing, advertising guru David Ogilvy points outs that "Advertisements in four-

Figure 6-11 and Figure 6-12

The Commander is Primax Pen's top-of-the-line "writing instrument," and features handcrafting, brass appointments and a gold-plated tip. To help communicate that quality, the pen was photographed with a fine-grain color transparency film on a 4″ × 5″ camera and printed 1:1 for maximum detail and deep color saturation. The rich color suggests quality. The pen, in effect, becomes the hero of these award-winning, understated ads and seems to take on a life of its own. Louis Squillace, photography; William Ryan, art direction, copy, and design. Courtesy of Primax Pens.

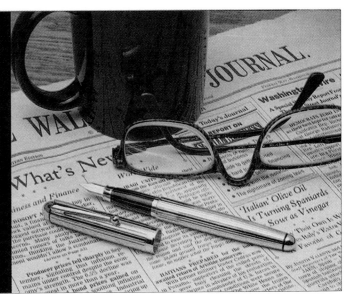

color cost 50 percent more than black and white, but, on average, they are 100 percent more *memorable*. A good bargain."

Drs. Pegie Stark Adam and Mario Garcia, former graphics directors at the Poynter Institute for Media Studies, explored the impact of color in newspaper design. Among other things, their research examined how we process and react to the dynamic of color, spot color, and color photography. Color can guide our eyes top to bottom in a page. The authors discovered these things, too: "Color tints over text *do* make the information stand out more prominently. The size and placement of a photograph appear to have greater importance than the question of color versus black and white. Readers prefer color over black and white when presented with a choice." They confirmed that color is a potent design element that attracts and sequences readers through the page. If you're interested in color and specifically how it relates to newspaper design, you should give their book, *Eyes on the News*, a good read.

Advertising art directors and designers know how important color is to the identity and image of a product. Color also has a huge impact on credibility. It may suggest lush settings and add to a product's image, as evidenced in a brochure

panel for the Primax Commander fountain pen (see Figure 6-11 and Figure 6-12).

Clearly, color is an invaluable and irreplaceable design element in film, advertising, package design, photojournalism, magazines, viewbooks, annual reports, newspapers, brochures, and in website design. Among other things, it can help identify a product. Coca-Cola's bright red can is synonymous with their product. BMW's blue swatches of color within their circular logo communicate their identity to us immediately. *Time* magazine's red cover borders also flag us. Think about other products, logos, and publications. How does color cue your association to them? Look at Jesse Coulter's ad for Q-tips (see Figure 6-13). Does its color combination bring anything to mind?

Like its complements—type, design principles, and artwork—color is also a potent component of visual communication. To master its nuances and possibilities, you need to understand the language, elements, and physical and psychological implications of color. Photojournalists use color as a vital component in documenting our world and in visual storytelling. Steve McCurry, long-time freelance photographer for *National Geographic* and many other publications, used color dramatically in this chapter's opening image.

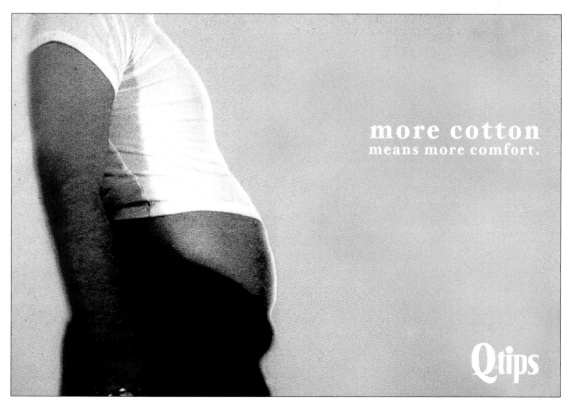

more cotton
means more comfort.

Qtips

Figure 6-13
Jesse Coulter employs a sea of baby blue in this two-page spread for Q-tips. The message— "More cotton means more comfort"—is underscored by the photography. So how is color employed? Light blue and white dominate the product's packaging and logo. Neils West, copywriter; Jesse Coulter, art direction. Courtesy of Q-tips cotton swabs, Unilever.

Figure 6-14
Steve McCurry's career
was launched when,
disguised in native garb,
he crossed the Pakistan
border into rebel-con-
trolled Afghanistan just
before the Russian inva-
sion. When he emerged,
he had rolls of film sewn
into his clothes and
images that would be
published around the
world as among the first
to show the conflict there.
His coverage won the
Robert Capa Gold Medal
for "Best Photographic
Reporting from Abroad,"
an award dedicated to
photographers exhibiting
exceptional courage and
enterprise. He has won
many of photojournal-
ism's highest awards,
including Magazine
Photographer of the Year,
awarded by the National
Press Photographer's
Association. McCurry has
published five books: *The
Imperial Way* (1985),
Monsoon (1988),
Portraits (1999), *South
Southeast* (2000)—the
first-prize winner in the
book category of the
Pictures of the Year
competition—and
Sanctuary (2002) is an
exploration of the temples
of Angkor Wat in
Cambodia. *The Path to
Buddha* (2003) is his
latest book. In this image,
McCurry works chest-
deep in the floods, making
images for *Monsoon*.
Courtesy of Steve
McCurry.

Figure 6-15
*Red Boy, 1996, Bombay,
India*, Steve McCurry
McCurry photographed
this boy participating in
the festival of Ganesh
Chaturthi in Bombay,
India. He is covered with
the luminous red powder
used during the exuberant
celebration. Courtesy of
Steve McCurry.

Steve McCurry: Color and Reality

The gravitation toward color photography in journalism has also been a quest, and it has an interesting history. Today, however, color imagery is common to most media. Perhaps more than any other publication, *National Geographic* magazine has pioneered the application and use of color photography by supporting "explorations and research projects, adding to knowledge of earth, sea, and sky."

The list of photographers who have graced the pages of *National Geographic* reads like the who's who of documentary photography and photojournalism. Steve McCurry is one of those photographers. In a telephone interview with author William Ryan (May 2003), McCurry talked about photography, color, and visual storytelling.

Color and the visual realm have always intrigued Steve McCurry: he studied cinematography and worked as a newspaper photographer at Pennsylvania State University. He was also fascinated with other cultures and spent his summers roaming Europe, Africa, and Latin America during his college years. "I knew then that I wanted to spend my life traveling and observing the world." Today McCurry has

parlayed those passions in photography to become one of the most respected and decorated documentary photographers in the world.

The "repetitious and static nature" of freelancing for a suburban Philadelphia newspaper soon left McCurry restless. "One day I simply quit. I had saved up some money and decided to go to India to freelance. Up to that time, too, I'd been shooting Tri-X exclusively, so I went cold from black and white to color." Asia and its rich palette would have an indelible touch on McCurry's vision and work. "Above all, I feed on the colors of Asia: deep henna, hammered gold, curry and saffron, rich black lacquer, and painted-over rot. As I reflect back on it, I see it was the vibrant color of Asia that taught me to see and write in light" (see Figure 6-15).

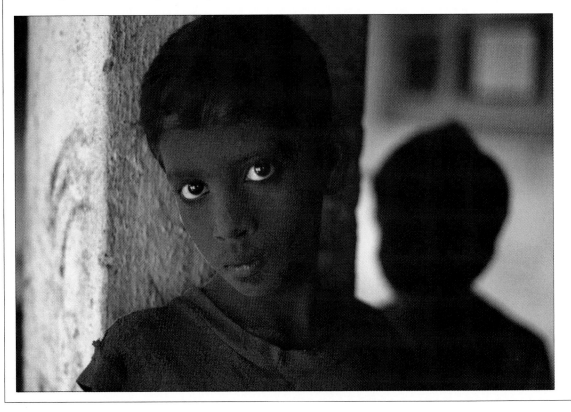

McCurry also mused about some of the differences between black and white and color photography: "For me, color adds another element and layer to the imagery. It's another problem to solve. So it is important to get the values just right and have the correct color palette. But at the same time I don't rely on color to carry my photography. Storytelling, impact, capturing the moment, and making emotional, honest connections to whatever I'm shooting are what's most important" (see Figure 6-16).

Figure 6-16
Mother and Child at Car Window, 1996, Bombay, India, Steve McCurry
As McCurry noted in his interview, while color is important to his work, it is the narrative quality of a story and "the emotional content and impact of the photograph that are most important." In this image a mother and child beg for alms through a taxi window in Bombay during the monsoon. "Most of my photos are grounded in people. I look for the unguarded moment, the essential soul peeking out, experience etched on a person's face." Courtesy of Steve McCurry.

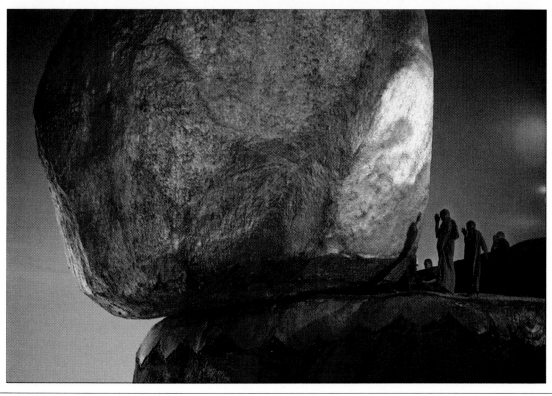

Figure 6-17
Pilgrimage, to Kyaikta, 1994, Kyaikta, Burma, Steve McCurry
Color, the subtlety of light, reflection, scale, and the tension of the rock, make for a stunning composition in this McCurry image. Here monks offer prayers at the Golden Rock in Kyaikta, Burma. Courtesy of Steve McCurry.

The world is an ever-changing swath of color. Most of us move through our daily lives without noticing color shifts, subtleties, or even the presence of color unless something unusual catches our attention. That is one of the challenges for a photographer. As Steve McCurry points out, sometimes color is intricately connected to a subject or project. "Color—often lush color—is an inherent part of the religious festivals in Asia. The robes, temples, flowers, and rituals. They're all full of color, and it's important the photography shows it accurately" (see Figure 6-17).

Steve McCurry appreciates the significance and power of color. Sometimes, however, it is more difficult to use color within an image when the color isn't aglow, but understated. "I guess my feeling is that some of the best color pictures use muted color. They're simple, have clarity, and add to the composition. These photographs also have an instant impact and narrative quality to them" (see Figure 6-18).

All stories are multi-faceted, so it's important to think of telling a story almost cinematically. "Longer, establishing shots give the viewer a sense of place. Medium shots may show interaction, relationships between people or between the subjects and their environment. Tighter shots help impart a sense of intimacy. Like a good film, a picture story has a rhythm—an ebb and flow that conveys a sense of place and tells the story of those who live there. Finding a feature's most relevant moments, however, is seldom a matter of luck; it's hard work. It requires fortitude, persistence, and vision." Steve

McCurry's image of a stranded dog in Porhandar, India is a wonderful visual metaphor for the monsoon. Compare the camera angles, content, and sense of place you get with other images from his book *Monsoon* (see Figure 6-19).

McCurry's photographic images and visual storytelling are simple and direct: "I try not to concern myself too much with technique. I work with a couple of lenses and keep it simple and uncomplicated. I like to let the situation or person carry the day. I believe that often a good color photograph can be converted to a black and white picture and still have strength and power" (see Figure 6-20).

Figure 6-18

Afghan Boy Soldier, 1993, Kabul, Afghanistan, Steve McCurry
Color figures into this photograph in a very understated way, almost seamlessly with the selective focus, soft light and the haunting incongruity of a young boy who has been conscripted to participate in Afghanistan's Civil War. McCurry directly and honestly connects the viewer to those he photographs. "I try to convey what it is like to be that person—a person caught in a broader landscape that I guess you'd call the human condition." Courtesy of Steve McCurry.

Figure 6-19
Stranded Dog-Monsoon, 1983, Porbandar, India, Steve McCurry
This image raises questions and is puzzling at first glance. In fact, a pet dog is trying to escape rising monsoon floodwaters. Here the muted color, contrast, and content add to the power of this photograph. "Sometimes, it's interesting to have ambiguity or mystery within an image." Courtesy of Steve McCurry.

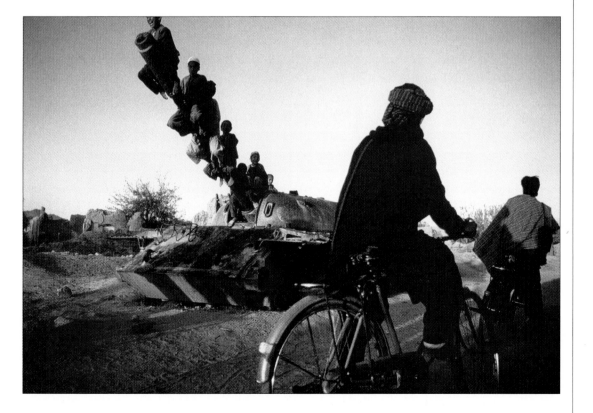

Figure 6-20
Children on Soviet Tank, 1992, Kandahar, Afghanistan, Steve McCurry
War has many faces. The war photography of Steve McCurry tends to focus on its moments, the human consequences of war, not the battles and the dark scar of war on landscape, but upon those affected by its horror. In this image children play on an abandoned tank. Their lives have been marked by many years of internal strife after the Soviet occupation of Afghanistan. Courtesy of Steve McCurry.

Color: A Powerful Communication Tool

The brief sampling of Steve McCurry's poignant imagery demonstrates the power of color in human communication. Color may be lush or understated. It floods our senses. Color may be explosive, subtle, arresting, calming, symbolic, numbing, or seductive. It is pervasive, and it is everywhere: neon signage, glowing sunsets, concert light shows, product packaging, the deep color saturation of cinema, autumn hues, or even the color combinations hanging in your closet. To be sure, we live in a colorful world. In outdoor and poster design, color has to have strong projection and be arresting.

Initially, color was much more limited, discounting nature's rich palette, of course. Color pigments were borrowed from nature: plants, minerals, and occasionally animals supplied them. Mineral oxides, seashells, clays, various crystals, and semi-precious stones were crushed and mixed to create color. Today, there are literally thousands of dyes and pigments that produce hues of every imaginable tone and intensity. Additionally, most computers and design and graphics software programs have "built-in" color libraries and the potential to create a most amazing electronic palette for contemporary designers. Technology has also improved color. Computers and sophisticated design and production processes have cut the cost of producing color separations, and digital technology is eliminating printing plates completely.

However, the endless array of colors may not always be perceived as a good thing. Mario Garcia makes a good point about "keeping it simple" when working with color for an interview in SND's *Design Journal*. "A color palette is like a box of crayons in kindergarten—if you give your designers 30 colors, they'll use them well. But if you give them a big boxed set, they will use them all, and bite them and eat them, too." Mario Garcia's point is clear: restraint is a good and wise part of the best design.

Color affects communication in numerous ways. It can help accomplish the first job of any communication—attract attention. In addition, color may provide many perceptual cues for us: yellow road signage warns us to yield, avoid falling rocks, or note upcoming curves. Red stops us before we become a bloody mess. Color, as Pegie Stark Adam noted, can impart the mood or atmosphere desired and provide accent and contrast where needed to emphasize something. It can help steer or sequence a reader through a layout.

Color may also take on symbolic roles. But the metaphor and meaning vary from culture to culture. In Western society, black is often associated with death and white with purity and weddings, but in India white is worn by mourners and red at weddings. In Chinese culture, colors take on different meanings, too. Professor Tien-Tsung Lee, who teaches journalism at Washington State University, is a noted researcher in visual communication. In a recent interview with the author, he reflected on the color white: "The Chinese don't like *anything* associated with death, including colors. White is associated with death, and mourners wear white to funerals. White and yellow flowers are also associated with death and blue ink is inscribed on white paper for funeral notices. Consequently, the Chinese avoid white for 'happy' events like weddings and birthdays. For example, you would not wear a white dress, tie, jewelry, or hat to a wedding. Interesting, because in Western culture the bride wears white. To the Chinese, red and gold are considered 'lucky' colors. So a wedding invitation often employs red paper and black ink. Blue is considered unlucky. My mother likes flowers in greeting cards. When I send her a birthday or Mother's Day card, I make sure there are no white or yellow flowers on the card. Also, white cars are not popular in China or Taiwan."

Color associations exist across cultures; their meanings or implications often contrast one another dramatically as exemplified here. We often can identify some of the cultural, religious, or social codes by their colors. For example, what color associations come to mind with Buddhism? (See Figure 6-21.)

In addition, color can suggest the feel or sensibility of a given time period. Sepia tones often give an image an older look (see Figure 6-22). Also, color may be applied to create identity in the same way that it does in flags, logos, or

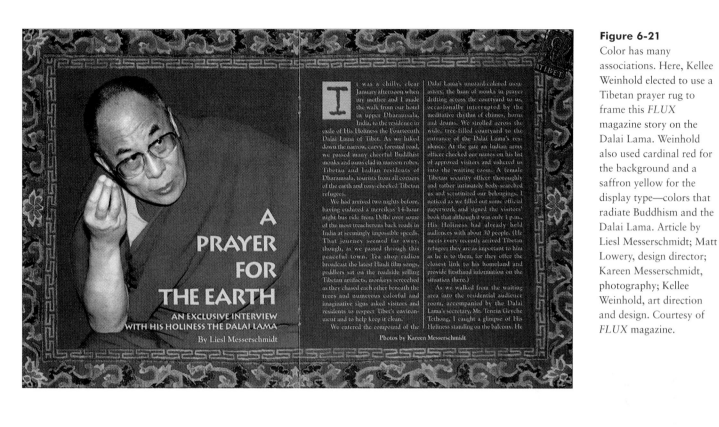

Figure 6-21
Color has many associations. Here, Kellee Weinhold elected to use a Tibetan prayer rug to frame this *FLUX* magazine story on the Dalai Lama. Weinhold also used cardinal red for the background and a saffron yellow for the display type—colors that radiate Buddhism and the Dalai Lama. Article by Liesl Messerschmidt; Matt Lowery, design director; Kareen Messerschmidt, photography; Kellee Weinhold, art direction and design. Courtesy of *FLUX* magazine.

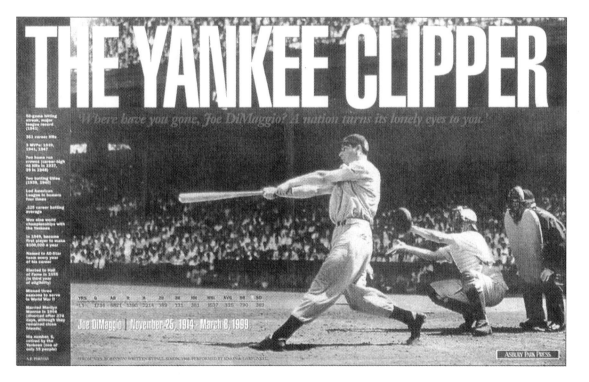

Figure 6-22
The *Asbury Park Press* uses red here and a two-color duotone (red and black) to give this layout on Joe DiMaggio, "The Yankee Clipper," an antiquated look of sepia tone. Andrew Prendimano, art and photo director; Harris Siegl, M.E./design and photo, designer. Courtesy of the *Asbury Park Press*.

athletic uniforms. Think of Campbell's soup, UPS or United States currency. What colors do you visualize?

Still, color isn't a design cure-all. It won't hide terrible writing, inappropriate typography, shoddy printing, lame layouts, or bad ideas. And while not a silver bullet, it is powerful ammunition within your graphic arsenal.

This chapter will address the following aspects of color:

- Color's physical and psychological implications.
- The reproduction of color in the printing process.
- Color harmonies and their relationship to one another.
- The strategic use of color: how to best integrate it with type, artwork, or other elements in a layout.

Sight: Physical and Psychological Implications of Color

The physiology of sight involves light passing through the eye via the pupil and lens to the retina, the inner, backside of the eye. Here the cones and rods, the light-sensitive cells of the retina, connect to the optic nerve, which sends the light and color sensations to the brain. We use our cones in bright light; essentially, they're responsible for detail and receiving vivid color and for things such as reading or normal activity in artificial or daylight. Rods, on the other hand, are employed in dimmer situations and aid our peripheral and night vision. That's the abbreviated version.

Sight is one of our most precious gifts. In and of itself, sight (or any sensation, for that matter) is an incomplete dynamic. The other half of sight involves *perception*—how we understand and filter what has been sensed visually, so that we can identify or understand what we're seeing. Often, too, color may suggest other sensations. A child's drawing may surface smells from your childhood and the strange, singular scent of crayons. Warm colors—red, oranges, and yellow—stimulate appetites. Many musicians—notably Strauss, Mozart, and Liszt—sometimes ascribed color to explain or plot their composi-

tions. Studies have also revealed that people suffering from sore or itchy throats are drawn toward the color green. Expressionist and other painters used color to establish mood and emotion or to infer various psychological implications. Clearly, colors have a powerful and sometimes inexplicable effect on us.

All color comes from light. Reflection and absorption of light produces the effects we know as color. A lemon is yellow because it absorbs all colors except yellow and so reflects yellow. In an unlit room we wouldn't likely be able to discern a bright yellow lemon. In fact, we'd likely not see it at all. Under dim light, its reflected yellow rays would be so weak our rods would take over for the cones and we'd perceive the lemon by its shape—a small oval gray object.

Our brains utilize a number of things to make *sense* of the world and what we see, including size, shape, figure-ground relationship, form, texture, patterns, and color. Think of how your brain would identify the lemon using some of these tactics.

From birth onward, perception is intricately tied to learned information: social imprinting, experience, culture, education, environment, and other "learned" associations. Perception's mission is, simply stated, ordering a flood of sensual information and filtering it through our acquired knowledge and experience.

Mind you, most of this happens nearly instantaneously and unconsciously. While color is closely connected to how we recognize and understand reality (or at least our version of it), it is but one piece of a very complex process.

However, color also has psychological implications that are both innate and learned. Scientists have proven that we all have inherent, unlearned physiological reactions to color stimuli. These are *biological responses*. Experiments have shown that people exposed to red are physiologically stimulated. Depending upon the intensity of the color and length of exposure, blood pressure increases and respiration and heartbeat speed up. Red excites us. Finally, it's not by accident that many automotive ads elect to show us their product in red; it's attention-getting (see Figure 6-23).

Figure 6-23
Think about the many automotive ads you've processed and how color is presented in them. Here the Mini Cooper is dramatically presented against a black background and equated as having punch via its visual metaphor. Amee Shah, art direction; Scott Linnen, copy; Alex Bogusky, creative direction; Mark Laita, photographer—for Crispin Porter + Bogusky (Miami, FL). Courtesy of MINI Cooper.

We also have cross-cultural responses to color—what Rudolf Mahnke, the author of *Color and Light in Man-made Environments*, describes as a "collective unconscious" association: relating blue with sky, red with blood, green with trees, for example. Swiss-born Johannes Itten, who authored *The Elements of Color, Design and Form* and *The Art of Color*, devoted fifty years of his life to researching and teaching color theory, five of which were spent at the Bauhaus School with Groupius, Klee, and Kandinsky. His cross-cultural focus included beginning his color classes by having students go through color-orientation exercises. "Colors must have a mystical capacity for spiritual expression, without being tied to objects... He who wants to become a master of color must see, feel, and experience color in its many endless combinations with all other colors." Itten's comments emphasize the importance of understanding and *feeling* color systems and how colors interrelate. Sometimes the colors reinforce one another to underscore a feeling, as in this book cover, *Water: Asia's Environmental Imperative* (see Figure 6-24). On the other hand,

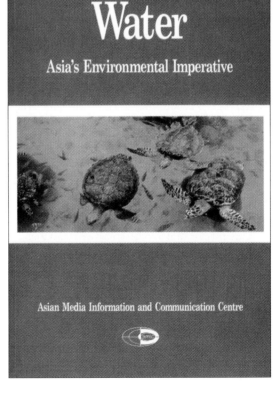

Figure 6-24
Here, the lush colors (blue, turquoise, and cyan) of the reef and sea turtles are reinforced by the cover's border color—PMS 307. The darker blue-green hue connects logically to the artwork, but at the same time its deeper, flatter background makes the photograph's color really pop off the page. Art direction, design and photography for this (Asia Media Information & Communication Centre (AMIC) book by William Ryan.

the colors may be stridently different and unnatural. For example, the use of blues and other cool color for flesh tones is almost ghoulish. Together, our own learned color sensitivity and formal color systems help communicate our messages.

One such system separates color into two categories: warm and cool. Fire and sunshine make red, yellow, and orange—warm colors. The shadows of deep forests and the coolness of water make blue, violet, and dark green—cool hues. Night brings on darkness and sleep, while day offers brightness and hope. Although this explanation is a simple one, its associations and logic are clear.

Airlines know that proper color schemes in airplane cabins can help relax anxious travelers. Hospitals and doctors' offices are commonly decorated in cooler colors, light blues and variations of green, for similar reasons. Theatres and television studios use "green rooms" for actors and guests to keep them calm before appearing. Marketers have learned that sugar sells best with blue packaging. Blue is the color of "sweetness." Blue, in addition to being our preferred color, is also associated with hygiene and serenity. Green is thought to be "astringent," like a lime, but also is associated with growth, nature, and ecology among other things. What correlations do you make with these colors?

Of course colors have many other associations, most of which are learned through cultural coding and personal experience. Black is a formal color. It's commonly worn in this culture by clergy, grooms, and mourners. Black is also an "arty" color; if you don't believe that, do your own survey on the color of clothing worn by art professors, art directors, and graphic designers. Recently, a colleague noted at an advertising annual awards show that so many people wore black that "it looked like a wake."

Blue, though cool, is a strong color. However, as a color, blue has other strengths. A recent feature in @*issue:* magazine educated readers with some fascinating facts about the color blue: "Through color experiments, researchers have found that children tested in rooms with blue ceilings tend to score as much as 13 points higher on IQ tests." Cinematographers use blue filters with color film to "cool" the light and perhaps suggest a night scene that was actually shot during the day. Blue may be used without fear of adverse psychological effects, unless it's employed *unnaturally*.

Without reading the caption for Figure 6-25, look at the image and build a rationale about how color was used. Yellow may suggest the happiness of a sunny day, but don't stay around yellow too long: a little goes a long way. It is also associated with cowardice and treachery. Medieval artists painted Judas' robe yellow. Orange is a cheery color, too. Brown is a very versatile hue. Men associate it with wood and leather, women with furs, gardening, and handbags. It also tends to be fairly neutral and is associated with the earth. Green tends to be universally popular, with obvious connotations with nature and growth. Purple is associated with royalty and is found in church vestments and the pomp and splendor of ritual. In 1971, purple was selected by OSHA to be used as the official nuclear warning sign. What other color associations can you ascribe to these and other colors? In many metro areas, colors and numbers are combined to alert regular commuters and visitors to their appropriate train, bus, or subway ride (see Figure 6-26). They provide quick, easy-to-remember logistical codes.

Figure 6-25
The strong yellows and golds in this point of purchase poster for PJ's Coffee have powerful projection. The stratified color—overlaid atop the art (a shelf of strange bottles and dolls)—makes the imagery a little unsettling. The headline has fun with the content and reader: "Jokingly, some people have accused us of using voodoo to achieve such flavorful coffee... Those people are now goats." Ashely Caballes, art direction; KT Thayer, copy; Craig Evans/Wade Koniakowsky, creative direction—for Big Bang Engineering ad agency. Courtesy of Big Bang Idea Engineering, San Diego, California.

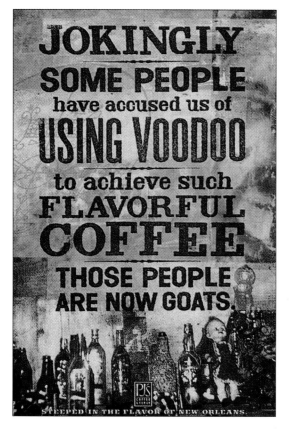

JOKINGLY SOME PEOPLE have accused us of USING VOODOO to achieve such FLAVORFUL COFFEE THOSE PEOPLE ARE NOW GOATS.

STEEPED IN THE FLAVOR OF NEW ORLEANS.

Next time you eat at or drive by a fast food restaurant, notice how reds and yellows tend to dominate everything—interior color schemes, booths, signage, and company logos. These colors stimulate our appetites, but we can't tolerate heavy doses of these colors for very long: a great strategy to sell you a burger or taco and get you on your way.

However, *unnatural* applications of color can cause adverse reactions. Printing a juicy T-bone steak in green or blue not only fails to communicate effectively, it creates a strong sense of repulsion. Running halftones of people in a cool color is equally unnatural. Putting a green tint on the president's duotone in the annual report will have her looking more like the Wicked Witch of the East than the corporate leader.

Here are a few other things to remember about employing color in your designs. Remember some of the points Pegie Stark Adam made earlier. First, warm colors advance; cool colors recede. Note how designer Chad Verly employed that principle in his ad for Elmer's Glue (see Figure 6-27). Warmer colors like red, orange, and yellow tend to dominate the page. Indeed, if you could turn colors sideways and check their *projection* factor, you'd quickly see that reds and oranges have great reach and yellow extends even farther.

Second, use natural color associations in printing as much as possible (particularly with spot color and duotones): warm colors for skin tones, sunny mornings, and foods; cool colors for green forests, blue skies, and riverscapes.

Third, printed publications *reflect* light; monitors, slides, cinema, and websites *project* it. Therefore, don't expect the color you see on your monitor to be replicated exactly in your print materials. Remember, too, website color palettes don't have the range of those used with print materials; generally, stick with 216 colors. Also, when working with computers, realize the legibility you see on your screen won't necessarily translate to the page. Regardless of the medium, be especially careful using black type atop deeper colors; adequate contrast between the type and the background needs to be maintained for visibility. Black on deep red, green, or blue has terrible contrast and poor readability, for example.

Figure 6-26
Color is a significant component of signage. Here are good examples of how New York City signage employs shape, line and color to communicate. Yellow is a caution color, YIELD, DANGER, CURVES AHEAD, MERGING TRAFFIC; red can stop us or suggest no entry. Along with shape, line, and letters or numbers, color may also help us find our way or help code direction or transportation systems. Photographs by William Ryan.

Figure 6-27
The bright primary colors on the stapled turkey move forward optically, pushing it off its muted blue background. Do you see, too, how the client's colors (orange and blue) are used in the art? This ad for Elmer's Glue makes its point with wonderful humor: "Imagine kindergartners armed with staplers." The stapled turkey appears to be in a bit of pain here, bulging forward to get loose. Chad Verly conceived, art directed, and designed this ad; Ben Jenkins and Chad Verly wrote the copy. Courtesy of Elmer's Products. Inc.

Figure 6-28
Color doesn't exist in a vacuum. A different color field or background often strongly influences a given color's contrast, projection, intensity, or—seemingly—even its perceived relative brightness. In which of these two examples is blue deeper or darker? If you picked either figure, you're wrong because the blues are identical. It's the lighter chrome yellow background that suggests the blue is darker, and the deeper purple field that fools your eyes into thinking the blue is a lighter shade.

Figure 6-29
These charts show some of the colors that can be created by combining screen tints of two process colors. Because color printing is not a precise science, examples such as these can be used as guides only; identical screen combinations printed on different paper or with different inks can vary in appearance.

Figure 6-30
In process color printing (CMYK) four inks are used: cyan, magenta, yellow, and black. The semi-transparent inks are overlaid in fine dot patterns to give the illusion of full, continuous tone color.

Fourth, color is affected by what's around it. A color doesn't necessarily look the same when it's placed against two different colored backgrounds.

Color Terms and Reproduction

It's important to understand the terms used in color reproduction, as well as how colors seemingly change their intensity or saturation when placed in fields of different colors (see Figure 6-28).

For starters, if you're going to be discussing color with a printer, you need to be familiar with these six terms: *hue, tone, value, shade, tint,* and *chroma*.

The term *hue* is derived from the ancient Gothic word *hiwi*, which means "to show." Basically, the term hue is interchangeable with color. It *designates* or names the color, for example, blue, red, turquoise. *Tone* and *value* are terms used to indicate the variation or relative lightness or darkness of a hue. There are lighter *tints* of color, created by adding white ink to a hue, or darker *shades* of color, created by adding black ink to a hue. Sometimes, however, printers or designers may use the terms, shade and tint, interchangeably (see Figure 6-29).

Chroma indicates the intensity of a color and is determined by the amount of pigment saturation in the ink that produces the color. Increasing a color's chroma boosts its intensity. In the evolution of color, societies concealed information on pigment sources or formulae used to create them; generally, the more intense and vibrant the chroma of the color, the more guarded it was. Many of the Crayola (literally, French for "oily chalk") crayons are vibrant and rich in chroma. Red, by the way, is the crayon most likely to disappear from heavy use. Intense colors are still highly valued, but their sources aren't as scarce or arcane today.

An artist who wants to create different colors or shades and tints of colors mixes paints on a palette. The printer does precisely the same thing when a color is specified for a printing job. The inks for the designated color are mixed on an ink plate and placed on the press, unless the manufacturer premixed that color. The basic Pantone Matching System (PMS) colors which are created from combinations of the four process colors: cyan, magenta, yellow, and black (CMYK) can create literally any color consistently, regardless

of where the job is run (see Figure 6-30). For example, PMS 307 (a deep, flat blue-green) uses a specific amount of each of the four process inks: 100% cyan; 6% magenta; 0% yellow; and 34% black.

However, there are other ways of thinking about color. For instance, yellow, red, and blue are the three primary colors: all other colors may be created from them. Primary colors have a strong association with children, because they are both attracted and fascinated by strong, brilliant color. But primary colors can be used for many other applications. Matthew Bates used them loudly in a whimsical feature in *Backpacker* magazine on "The Seven Deadly Sins" (see Figure 6-31). Primary colors are also important to color reproduction systems. There are, however, additive and subtractive approaches to primary color.

this case, the printer uses cyan, magenta, and yellow. Cyan is blue green and magenta is red violet. These darker colors are called *subtractive primaries*. "Subtractive" because they absorb light. And they're referred to as primaries because a full range of color may be produced by mixing the inks together in various proportions (see Figure 6-32). The subtractive primaries, together, with black, form the "CMYK color" system, used in printing.

In the traditional method of preparing visuals in full color for reproduction, four plates (and printing passes) are made through a process called color separation. Each of these plates will print a color of ink in the density required so that when it is combined with an impression from another plate, it will create the tone or shade desired. In effect, the printing press becomes the palette of the designer. If the technicians using

Figure 6-31
"The Seven Deadly Sins" was a magazine feature package—a collection of seven essays, one for each sin. Art director Matthew Bates explains: "The essays were rather light and fun, so I didn't want to have a layout that was overly dark and evil. I chose to use bright colors and give more fun but very graphic treatment to the images. I also used the bands of color and use of one illustrator to hold the seven essays together." Ward Sutton's illustration is marvelous and a perfect match for Bates' vision. Notice how the jump page styles maintain their continuity through color, design, and illustration. Art direction and design, Matthew Bates; illustration, Ward Sutton. Courtesy of Matthew Bates and *Backpacker* magazine.

The *additive primaries* are red, green, and blue. They're called additive because they produce white light when all three are combined. Additive primaries are the dominant colors of the rainbow. An excellent example of color created from the additive primaries is the color television image. Color televisions use a red, green, and blue color projection system of "color guns" to fuse and create the sensation of full color. The additive primary color system used in television, video, and computer monitors is also referred to as "RGB color," names for its component colors.

However, the process is different when a printer needs to produce a full range of colors in a magazine cover. Three colors, which are slightly different from blue, green, and red, are used. In

this process are skilled, the reproduction will be difficult to distinguish from the original, continuous-toned imagery. Today, using Photoshop software, a designer can "drop out" (remove the color from) an entire full-color photograph and highlight small, selected areas within the image to run in full color (see Figure 6-33).

The printer utilizes inks called process inks when producing full-color publications. Process inks have a unique translucent quality, so that when they're superimposed upon one another they blend, producing other colors of the spectrum. When overlaid, yellow and magenta produce red, yellow and cyan produce green, and magenta and cyan produce blue, and so on. Thousands of tints and shades can be replicated

Figure 6-32
Ink color is often referred to as subtractive. The primary ink colors are cyan, magenta, and yellow. Secondary colors are mixed from the primaries. Magenta and cyan make blue. Green is made from cyan and yellow. Red is mixed from magenta and yellow.

Figure 6-33
Color is subtracted from this *FLUX* layout, except for the gold nuggets and flakes. Art associate Brenda Chastain makes this image unique from the rest of the artwork in this full-color magazine by knocking out the color via Adobe Photoshop. The color in the display type and tint block also accent the gold in Tom Patterson's photograph. Art direction by Emily Cooke. Courtesy of *FLUX* magazine.

through detailed combinations of these inks. Black is added to provide depth and to better define dark areas and shadows realistically. Black also steeps the contrast and gives the imagery more snap.

As mentioned earlier, most computer design and graphics programs come with existing PMS and other color matching libraries. They're immensely helpful and can streamline the color part of the design process.

Again, the distinctive sensation we see and identify as a certain color is actually reflected or projected light waves. In the case of printed materials, it is the reflection of light waves that weren't absorbed by the object. For instance, if white strikes a surface and the surface absorbs green light waves, we see the red and blue light waves that weren't absorbed. We see, then, the color magenta, which results from the combination of red and blue. If the surface absorbs blue light waves, we see the combination of red and green light waves, or yellow. And, if the surface absorbs red light, we can see cyan—a combination of reflected green and blue light.

Therefore, to make plates for full-color reproduction, one plate is made with a green filter and used to print magenta ink. Likewise, a red filter is used for the cyan plate and a blue one for the yellow plate. Again, the fourth plate—black—

adds contrast and shadow detail for density. Without the black ink impression, the artwork (especially photography) would appear flat and lifeless without true blacks.

Full color is commonly referred to as "process" color or CMYK. The actual process is much more complex than this brief description, but the point to remember is that it takes four plates, hence four separate impressions or passes through the press, to produce full-color reproduction.

Offset press technology has both improved and reduced the costs of process color. The quality of high-end, full-color offset presses today is spectacular, and the resolution of the imagery is very tight. In fact, today printers also have a plateless, fully digital process available to them.

Selecting Colors for Harmony

Artists, scientists, and philosophers, including Aristotle, da Vinci, Goethe, Newton, Albers, and Munsell, have investigated color and theorized about how to order it. Perhaps Albers and Munsell made the most important and influential breakthroughs. Their research and systems are helpful because determining which colors work well together may be a tough call. Many of us have good instincts and can sense if colors are compatible, but others need assistance arranging

color schemes. Luckily, help is available via various ordering and charting systems.

In 1899, a Boston educator, Albert H. Munsell, began research to establish an ordering system for color. What resulted was a method that charted color values on a numerical scale of nine steps, ranging from black to white. Munsell's system was adopted by the National Bureau of Standards and slowly expanded until it contained 267 different color names.

Out of this research came the color wheel (see Figure 6-34). Situated around the wheel are the colors that comprise the primary triad of red, yellow, and blue. They're ordered adjacently to one another in an equilateral triangle. Halfway between the primaries are the secondary colors: orange, green, and purple. In all, the wheel divides the color spectrum into twelve hues or colors. When choosing colors for a layout, a designer can select from five basic color combinations that have been devised to maintain color harmony.

- *Monochromatic:* This is the simplest color harmony because it's constructed from different *values* of the same color. Remember, values are the variations of a hue. Some of these values may be simulated in printing by screening artwork or color blocks at different percentages, for example, gradating back a dark brown to get tan or beige. Monochromatic harmony is the simplest way to obtain color unity and works cleanly in printing. Be advised though, screening type will result in a loss of clarity and definition.
- *Analogous:* This harmony is created with two colors that are immediately adjacent to one another on the color wheel, such as blue and blue-green.
- *Complementary:* To achieve this harmony, two colors that are positioned directly across the color wheel from one another are used, such as red and green, blue and orange, violet and yellow. Complements add drama due to their contrasting warm and cool hues. Sometimes logos, page design, or even team colors are complementary: the Chicago Bears don blue and orange uniforms, for example.
- *Split Complements:* This strategy is basically the same as the above technique, except that

you use a color next to the complement for the second color, rather than the complement itself. For example, a split complementary harmony for red would be blue-green or yellow-green. Split complements may have an edgier look to them, which is precisely what Cyrus Coulter was going for in his layout for Diamond Grill Matches (see Figure 6-35).

- *Triad:* As the name implies, this harmony uses a combination of three colors, each of which is at the point of a visualized equilateral triangle placed on the wheel. As the triangle is turned to any position on the wheel, its points will designate the three colors that are compatible.

A *matching system* is another color harmony and selection tool. It consists of color samples, or chips, showing the various hues as they will appear in print. It is similar to the collection of swatches found in most paint stores. Perhaps the most widely used such guide is the Pantone Matching System, commonly referred to as *PMS*. It shows how colors will appear on coated or

Figure 6-34

These four color wheels, though plotted identically, have various color relationships built into them to help combine colors in harmonious ways.

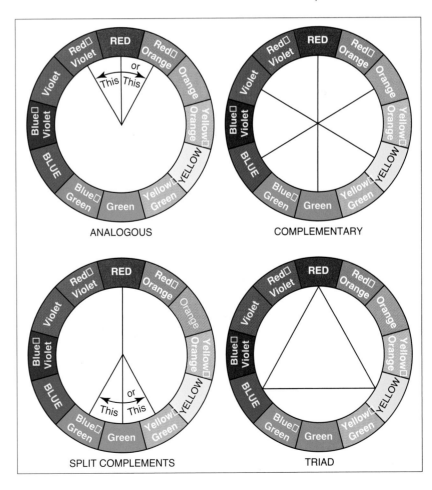

ANALOGOUS

COMPLEMENTARY

SPLIT COMPLEMENTS

TRIAD

Figure 6-35
The concept for this compelling Diamond Grill Matches ad contrasted Diamond's longer grill matches against common but foolish ways men often ignite charcoal briquets, stove burners, and gas hot water heaters. Split complementary colors with a weird tinge really set these ads off to give them the same attitude as the accompanying copy: "Go ahead. Stick your hand in there. The medical field is making great advancements in the area of skin grafting." Art direction, photography, and copy by Cyrus Coulter. Courtesy of Diamond Grill Matches.

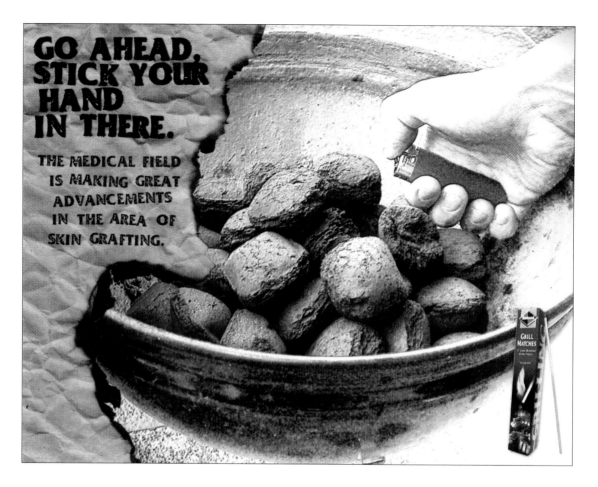

Figure 6-36
Designers have even more colors available to them than the elaborate color libraries' four-color systems provide. Metallic colors are also an option. This full-color *FLUX* cover ran its nameplate and Oxford rules in Pantone 8580 CVC —metallic gold. Art direction, Nan Alleman; photography, Kim Nguyen; design, Matt Lowery. Courtesy of *FLUX* magazine.

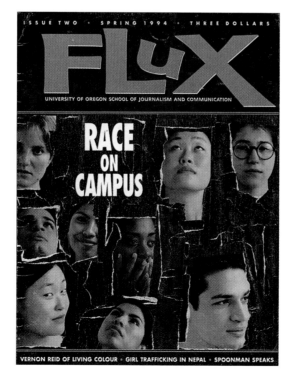

uncoated paper stock, and even has special swatches for metallic and other specialty inks (see Figure 6-36). As noted earlier, PMS and other matching utilities, are available to you electronically on most computer design and graphics programs, such as PageMaker, QuarkXpress, and InDesign.

Color Strategies

To be able to use color strategically, a designer must first understand a number of tenets of optical or spatial effect. All other things being equal, a smaller area of a warm color will tend to dominate a larger area of a cooler color. Therefore, warm colors have more projection and tend to dominate a page or frame, while cooler ones recede.

Of course, contrast is important, too; a lighter area will dominate a larger dark one, and more brilliant hues will dominate their flat or muted counterparts. This means that primary colors have more pop, and muted ones tend to be subservient to solid, brighter colors. Sometimes designers can adjust color to flatten or mute it;

carefully muted colors may suggest a specific time period.

Format may also figure into a designer's thought process when it comes to using color. How did Rodrigo Sanchez wed format to color strategy in some of his *Metropoli* examples in Chapter Five? Here, Brian Gross combines color and street signage into a unique newspaper sports page design featuring the Boston Marathon (see Figure 6-37).

One of the cheaper ways to utilize color's effects is to print on colored paper instead of white. Make sure the ink and type contrast strongly with the paper color, though, so the message or graphics are not lost. Also be aware that ink color is affected by the color of the paper used. For example, blue ink printed on bright yellow paper can appear muddy green. Keep this in mind if you're considering colored paper.

Spot color (or two-color) printing is the technique of adding a single color (typically a PMS color) to the basic color (generally black). An additional ink added to the basic color can dress out a publication for approximately 35 percent more cost. Each added color means an additional impression or pass through the press, but the results can be well worth it (see Figure 6-38).

Spot color, especially color screens that are mixed together, can extend color possibilities, resulting in the creation of other color and tinting possibilities. For example, adjusting screens of red and black can produce brown, orange, beige, and other colors. When selecting a second color to be run with black in your duotone, choose one that relates to the content of the art.

Of course, you may also simultaneously print one solid color and vary its tints or gradations on the same press run by screening or printing type and art from screened negatives. The tints are selected in the design stage, and the type or other graphics are screened accordingly from full density (100 percent) to light variations (as low as 5 percent).

When working with photographs, a *duotone* is another color strategy that can be employed. A duotone is a two-negative, two-color halftone made from a screened photograph. Normally, it's

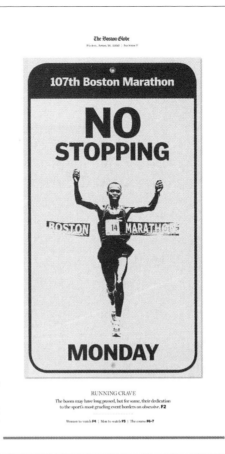

Figure 6-37
This *Boston Globe* sports page layout for the Boston Marathon featured a story theme on "compulsion" and running. The use of color here is not only attention-getting, the color, sans serif type, and format suggest street signage. Actually, there are signs very similar in appearance posted along the route of the Boston Marathon. Brian Gross, design. Republished with permission of Globe Newspaper Company, Inc.

Figure 6-38
Normally, blue is not a color you'd apply to flesh tones; here, however, it amplifies a cool spotlight effect in a jazz club. This *New York Times* print ad— "When was the last time something you read seduced you?"—employs funky blue type to mesh with the blue spotlight on the jazz trumpet player. The copy: "A seductive offer—50% off for the first 8 weeks of home delivery." When using color, always think "creative application." Courtesy of *The New York Times*.

run in black and one other color. Both negatives are made by shooting with the screens angled 30 degrees apart to help eliminate the chances of creating an unwanted pattern (called a *moire* effect). By printing the two halftone images in precise registration, a duotone is created.

Duotones can be very effective, particularly when used naturally. When selecting a second color to run with black, choose one that relates to the content of the art. Blues and greens, for example, combine well with black for seascapes or forest imagery, while yellows and other warm colors are appropriate for flesh tones or sunsets (see Figure 6-39).

Figure 6-39
Brown, red, yellow, and orange are often mixed with blacks to warm an image. This mortised photo (grazing Angus cattle) within a larger photo (tall summer grass) is a duotone using chrome yellow and black inks. Why do you think it works for this content? Design, Jan Ryan; photography, William Ryan.

Today, many advertising designers and art directors opt for tints and duotones to stand their client's message apart from the sea of full-color magazine advertisements. Again, this may be an especially wise tactic when the concept is smart and the tint or duotone strategy fits the big idea of the ad, the mood suggested, or the image of the product or client. Contemporary design tools also extend the possibilities and options of graphic communicators.

Sometimes, too, designers find interesting ways to push the envelope on color compositions. Occasionally, the solutions are "over the top" as in the dazzling display of color used on the

Metropoli cover featuring the John Travolta film, *Primary Colors* (see Figure 6-40).

Computers and sophisticated graphics software help streamline the use of color in both design and printing. One of today's important color applications is in interactive media. Fewer color options shouldn't be viewed as a drawback; in many ways it brings a Spartan kind of strength to that facet of design. The visual feedback is immediate, and the built-in color libraries available to the designer are state-of-the-art.

Having all the color options in the world available to you, however, doesn't ensure great design. It's essential that you understand the technical, psychological, and other visual aspects of employing color in design. As Mario Garcia noted earlier, you don't need every nuance of the spectrum to communicate effectively with color. As you learned with type and design, simple is better.

Once mastered, you'll find color to be an invaluable asset to whichever facet of graphic communication you pursue. Like gaining a real sense of composition, design, or typography, it's important to acquire an intuitive, reflexive sense of working with color. The more you study it—in the abstract, through thoughtfully analyzing it in media, and by experimenting with it in your own work—the more adroit and skilled you'll become with using color.

This quotation from Pegie Stark Adam's *Color, Contrast and Dimension in News Design* sums it all up: "Color creates dimension. Color gives life to images. It sets a tone, a mood and enhances the contents of the page. Color is the first stimulus readers get when they look at a page. Color is the guiding light for the reader."

Graphics in Action
1. Find a newspaper section page that you feel does a good job with color. Using what you've learned in this chapter—color schemes, screens, harmony, etc.—review the page's strengths. Bring the page and your review to class for discussion.
2. Examine several *National Geographic* issues carefully and select 3-5 features that you think do an especially extraordinary job with their visual reportage. How does color help tell the

stories? Is there special cultural, environmental, political, or social significance to how color is used? Where? Why? How? How is color integrated into the design, typography, and other layout elements? How does color help unify or package the story and its design, artwork, and presentation?

3. Look through your favorite magazine for advertising that employs arresting color arrangements. They might include a variety of color-related strategies: targeting the audience, symbolism, psychological inferences, product associations, etc. Evaluate the ads and their color implications.

4. Collect 3 or 4 full-color magazine feature openers that use color as a main component of their designs. Where appropriate, select pages in addition to the opening ones that continue the color motif. What did the designer or art director do to make their use of color unique or especially appropriate? How does color relate to the story's title? Audience? Mood? Time, place, or setting?

5. Read one of the stories whose design caught your eye (see #4 above). Explain whether the color and other design nuances (type, artwork, graphics) do a good job aligning or meshing with the intent and content of the story. Write an evaluation of each sample, or discuss your choices.

6. Find a newspaper layout that you feel does a poor or ineffective job of employing color. Using the existing titles, artwork, and page area, redesign the story or page and its color scheme. You can scan the art. Provide a succinct rationale for your color choices and other changes.

7. Select 3 to 5 corporate logos and examine their use of color. What are the color implications or associations with the company, its product, or its image?

8. Based completely upon color (and its overall continuity, appropriateness and effectiveness), choose what you feel is the best-designed website on the Internet. Remember, color is king here. Be prepared to defend your site against the others selected by your classmates.

9. Clip out 4 or 5 solid swatches of color from various publications or packages. Using your computer design program, try to match them as closely as possible.

Figure 6-40
Rodrigo Sanchez provides a pulsing pattern of color on this cover of *Metropoli*. It is used for a special review of the film *Primary Colors* with John Travola. The cover lines and even the nameplate are camouflaged via outline type. Color used functionally meshes with pure concept here. This is a great example of the power of visualization and a great idea. Design and art direction, Rodrigo Sanchez. Reprinted with permission of *El Mundo*/Unidad Editorial, S.A.

10. Create a specific use for each of the colors you selected in #8 above; for example, a newspaper backdrop for a feature section, dropped initial letter or color in the type for a magazine feature, logotype, ad background, or website color scheme.

11. Find several pages in a brochure, annual report, or newsletter containing spot color. Use the color library in your computer design program to try to match them with PMS or another matching system. Analyze the colors and give your opinion about their use and effectiveness.

12. Your editor has asked you to design a new outdoors or cuisine section for your tabloid newspaper. She wants color to play a big part in the design. Build a prototype section that features a story or theme for that page; for instance, if you've opted to do an outdoors section, perhaps you can focus on rock climbing or fishing, or if you chose the cuisine page, you feature Cajun cooking. Don't forget the medium (newsprint) and the issues of contrast, readability, and legibility.

Answers to questions on page 172: 1 - red, 2 - green, 3 - brown, 4 - yellow & black, 5 - green, 6 - white & black.

*Play creates new situations and
new solutions to old problems.
In terms of a sense of play, art
and humor share common
origins.*
 —David Lance Goines

I believe strongly in the picture as narrative: an image frozen in time that sets the stage for the action that follows; a picture that invites the viewer into it and offers up a sense of mystery.

—Wendell Minor, Wendell Minor:
Twenty-Five Years of Book Covers

Illustration: A Brief Overview

Illustration has a long and extraordinary history, one that precedes the written word. Early illustrations were found on cave walls, urns, tombs, and artifacts, among other places. Later, after the discovery of the alphabet, illustration adorned the pages of hand-copied bibles and other manuscripts known as *illuminated manuscripts*. Though it's not a full-blown history of art, the second chapter of this book offers an interesting overview of the interrelationship between fine and graphic art. It might be a good idea to revisit it.

Words and Pictures

Illustration appeared in our very first communications and was commonly used prior to the development of books. In fact, the original alphabets and our earliest messages were largely

pictorial, and their illustrative nature evolved into the abstract collection of signs we know as the alphabet (see Figure 7-1).

Despite the simplicity and compact utility of language and the written word, illustration remained important after the invention of *writing*—and rightly so. Words perform a myriad of tasks. They record, synthesize, abstract, classify, describe, edify, entertain, and document life. What's more, the written word is reproducible and transportable. However, although words are convenient, permanent, precise, and irreplaceable, they cannot flesh out or depict as explicitly as visuals can.

Artwork may provide a literal or figurative graphic spark to light up our attention and retention. Illustration can meticulously plot the cycle of insects, parasitic infection, and disease, provide a compelling visual metaphor for one's love of fried chicken, or present Elmer's Glue as an alternative to staples (see Figure 7-2 and Figure 6-27). Indeed, as noted earlier, illustration can literally show or suggest anything you can imagine. Conversely, illustrations have inadequacies; at their base or most minimal level, they may show—but not completely tell. On the other hand, the written word and illustration complement each other beautifully. And, because there are limitations to both communication systems, marrying word and image is a logical and powerful combination used throughout media today.

Shaping the Message:
Interpretive Visual Communication

Wendell Minor offered a simple but important list of basic tenets for creating effective illustration.

Figure 7-1
The Egyptians evolved illustration to language; they were the first to combine artwork and words, a kind of rebus writing. In fact, they developed phonograms; hieroglyphic illustration that represented words and specific sounds. Technically speaking, it was illustration that initiated the development of the written word.

Previous page
Mark Ulriksen is an artist and designer who also happens to be one of the most successful and sought-after illustrators in the country. His illustration, *Circus Dogs*, is a delightful swirl of color, motion, balance, composition, and whimsy. Ulriksen's style is unique and immediately recognizable; in fact, it also serves as a signature. © Ulriksen Illustrations.

"**1.** Style should not exceed concept for the sake of trends;

2. Elements in the composition should be kept to a minimum;

3. The visual message should be ambiguous enough to allow the reader to participate with his or her own imagination;

4. The image should honor the story, honor the written word."

Those guidelines were never more appropriate as they are today. Minor's third point suggesting that the illustration be ambiguous enough to encourage viewer participation is so obvious, yet often neglected by illustrators and graphic artists alike. That slight nuance is often what fuels the power of an illustration and ignites our curiosity and interaction with the image. Finally, it's only by respecting and understanding the story thoroughly that the illustrator can truly bring special meaning to the content, context, and slant of the story. Christian Potter Drury, art director and illustrator for The Hartford Courant, created a simple but powerful illustration for *Dance of the Disappeared*—a powerful play about a woman trying to understand the brutal political crimes of Chilean despot Pinochet (see Figure 7-3). Drury's grasp of the story led to this sensitive and award-winning illustration and cover.

Today illustration is enjoying a wonderful renaissance, despite some ambivalence toward using it, particularly in magazines. However, technology, multimedia, and digital applications continue to expand illustration's boundaries and, there is nothing that makes ideas more visible and memorable than illustration. Among other things, this chapter will provide a brief history of illustration, demonstrate its applications, styles, and versatility and offer you a window into the lives of several people who work with illustration.

Potential applications are staggering and as diverse as illustration itself. It offers a kaleidoscope of styles, from primitive renderings to tack sharp representation that can rival any photograph, and just about every art period and style in between. There is no mistaking the unique style of Mark Ulriksen. In the illustration, *Tupac Shakur*, Ulriksen truly captures not just the

Figure 7-2
This New Orleans *Times-Picayune* food page is an excellent example of photo-illustration and demonstrates the power of a strong visual metaphor. Two fried drumsticks are arranged to suggest a heart and used as a rebus in the headline "I (love) fried chicken." Beth Aguillard-Straka, designer; Kenneth Harrison, illustrator; Ellis Lucia, photographer; Dale Curry, editor; Jean McIntosh, art director; and George Berke, design director. © 2003 The Times-Picayune Publishing Co. All rights reserved. Used with permission of *The Times-Picayune.*

Figure 7-3
The feature title, "Dance of the Disappeared," and the deep crimson footprint suggest something dark—in this case, a play about a woman searching out the horrible truth of Pinochet's death squads in Chile. The simple illustration, use of color, isolation, and handwritten headline make a powerful emotive connection with us. This layout received Society for News Design awards for not only illustration but also magazine cover design. Joseph Hilliman, senior designer, and Christian Potter Drury, art director and illustrator, both work for *The Hartford Courant.* Reprinted with permission of *The Hartford Courant.*

likeness but the attitude, posture, and aura of the rap artist and poet. Ironically, the final image went through serious transformations: from Tupac looking vulnerable to powerful, almost impenetrable (see Figure 7-4).

Illustration also utilizes a wide range of media: oils, charcoal, washes, watercolor, crayon, acrylics, pen and ink, gouache, etchings, scratchboard, tempora, wood or linoleum cuts, airbrush, collage, and mixed media. These days of course, digital renderings are available from a wide selection of computer software programs, many of which imitate one or more of the above media. But don't dismiss the real thing: pencil, crayons, charcoal, and non-electronic rendering. Either way, simple is better with illustration (see Figure 7-5).

Sadly, photography, stock art, and the celebrity mentality of magazines have nearly pushed illustration off the map as cover art. It wasn't always that way. In 1929, *Time* magazine publisher Henry Luce decided to invent *Fortune* magazine. He expected it to be the most beautifully designed and illustrated magazine in the world. "The magazine will look and feel important—even majestic... every page will be a work of art." Great irony, too, in his timing; namely, launching a business magazine in the midst of the Great Depression. Kudos for his intrepid decision.

True to his word, Luce's standards shone brightly. The early *Fortune* covers were works of art. Indeed, the litany of illustrators whose

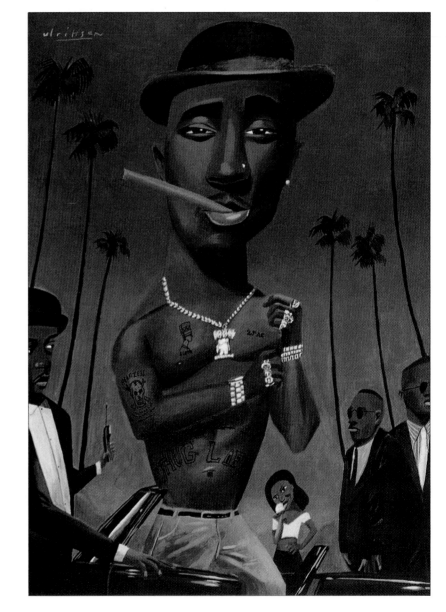

Figure 7-4

Mark Ulriksen shares the evolution of this powerful illustration: "This is my favorite assignment to date—an interesting story that started off as a single full-page portrait of Tupac Shukur. *The New Yorker* wanted him to look vulnerable, so I painted him against a brick wall, looking vulnerable, with palm trees low on the horizon to suggest Los Angeles. Then the magazine added four more quarter-page portraits and an additional page, but decided that Tupac actually wasn't so vulnerable after all. He actually was enthralled with the high life, chauffeurs and bodyguards, women and jewelry, hence this illustration. Then the magazine added one final full page—due in one day. You've got to work fast in editorial, but sometimes stress-induced adrenaline really helps me produce work I love." Illustration editor, Chris Curry. © Ulriksen Illustrations.

work graced *Fortune* covers reads like a who's who among fine and graphic artists: Antonio Petruccelli, Diego Rivera, Ben Shahn, Miguel Covarrubius, Paolo Garretto, Matthew Leibowitz, Edmund D. Lewandowski, Herbert Bayer, and Fernand Léger. The quality of those covers is timeless, arresting, and eloquent (see Figure 7-6).

Shrek,
un ogro poco convencional
de un cuento
de hadas
poco convencional
en una película de animación poco convencional

Figure 7-5

Just when you think Rodrigo Sanchez has taken design over the top, he does something else with a cover strategy that leaves you slack-jawed. At first glance, the art here seems a clever match: a childlike illustration for a film (*Shreck*) targeted at young people. However, upon closer inspection, the genius of this cover solution becomes more apparent. The art isn't crafted by crayolas, but by type—in fact, by the same line written over and over and over again. *"Shreck es el nueve héroe."* (Shreck is the new hero.) But there is more. Check out the nameplate. It reflects the playful experimentation mentioned by Sanchez in the design chapter. In addition, the nameplate is assembled from more type. This time it's an aggregate of the word *metropoli* layered hundreds of times to achieve the effect. Art direction and design, Rodrigo Sanchez; illustration and type, Rodrigo Sanchez. Reprinted with permission of *El Mundo*/Unidad Editorial, S.A.

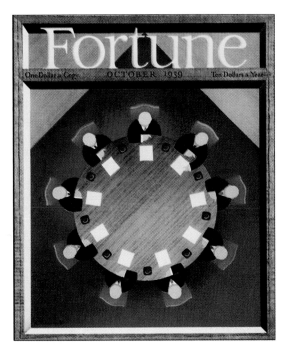

Figure 7-6

This Petruccelli *Fortune* cover (October, 1939) matches the symmetry and wit of Binder's illustration. What we have here is an incredible visual metaphor. On the surface, this is a most interesting perspective of a meeting table seen directly from above, but if you squint the scene looks like a cog or gear from a machine. Perhaps the *Miami Herald* said it best in 1930, when they reviewed the business magazine: "*Fortune* transforms the beast of business into a prince of beauty." For a more thorough overview of the *Fortune* covers, take a good look at *Fortune— The Art of Covering Business*. FORTUNE/ ©1939 Time Inc. All rights reserved.

Figure 7-7

Christine Curry has been the illustration editor at *The New Yorker* since 1989. Her work has produced a series of award-winning covers and illustrations at the Society of Illustrators and the Society of Publication Design and inclusion in the American Illustration's *Annual*. Curry was a freelance, production coordinator at Condé Nast Publications from 1987 until 1989 and worked at *Gentlemen's Quarterly* magazine as assistant art director, and later as *GQ*'s bookings editor. Curry holds a Bachelor of Fine Arts from the Rhode Island School of Design and is a member of The Art Director's Club. Recently, she was elected chairperson of The Society of Publication Design's annual Spot Illustration Competition. Photo by Lillian Valentine Curry (Chris Curry's two-year-old daughter). Courtesy of Christine Curry.

Unfortunately, the majority of today's magazine cover art is little more than mindless, cookie cutter formulae. Contemporary art directors could learn a lot from the concepts and artistry of those old *Fortune* covers. One obvious lesson might be to employ more illustration.

However, there is hope and safe haven for illustrators. Since its inception in 1925, *The New Yorker* has literally published thousands of pieces of art—mostly illustration—produced by almost as many artists. Chris Curry, Illustration Editor at *The New Yorker*, reflects upon her role for the magazine in a recent interview:

To take a story and spin it into an image is a great challenge. To do this at a weekly magazine where there is such a reverence for the written word is the ultimate challenge.

With each New Yorker *cover or feature piece we try to find the perfect marriage—or match of artist to subject. It's a challenge because the illustration has to reflect the tone of the piece, the topic, and, we have to have enough the lead time for the artist. Will the piece require a portrait, a concept? How can we push the limits on this image, how can we break new ground? All of these factors come into play when we try to figure out who will do the artwork (see Figure 7-8).*

Working closely with illustrators is kind of like having a large, extended family. We learn the artists' strengths and weaknesses, their passions (hockey, jazz, baseball, dogs). We know their schedules. I have had the good fortune to work at a magazine that has been supportive of art and illustration for many years and have had the pleasure of watching and working with various artists as their careers evolved.

To single out favorites is an impossible task, because each artist brings his or her own great and distinct vision to our magazine. Mark Ulriksen, for example, once an art director at San Francisco Focus *magazine has become a full-time and very successful illustrator. Barry Blitt, an amazing artist, is also an exceptional humorist and thinker. Ed Sorel, with his pen as a sword, once drew irreverent and pointed political carica-ture for* The Village Voice *and now graces our pages with work of great wit, intelligence, and distinction (when we are lucky enough to get him!). Robert Risko, whom I feel carries the torch for artist Covorrubias, brightens our pages*

with his sharp wit, graceful line, and color. Istvan Banyai (a wild man, whose cinematic renderings recall the work of Winsor McCay), the late Al Hirschfeld, Steve Brodner, Ralph Steadman, Gerald Scarfe, Charles Burns, Guy Billout, Floc'h, David Hughes, Richard Merkin, Andrea Ventura, Jules Feiffer, Seymour Chwast, Pat Oliphant... I could go on and on. You can't pick a favorite when they're family (see Figure 7-9).

The passion that I have for illustration stems from a life-long love of painting and literature. I can't think of a place that I would rather be. I can't imagine working with a more talented group of people.

As Curry suggests, illustration is a powerful and emotive medium. It can create or achieve anything you can envision. Nothing compares to the medium when it comes to making incredible visions and ideas come alive. Truly, illustration can be artwork born of the imagination. Images not encumbered by the limitations of reality or photography. Illustration's perspective, style, use of color, context, and strong design potential knows no limits. What's more, it adorns the pages and frames of all our media—magazines, websites, newspapers, film, advertising, business communications, and collateral materials. In the case of *The Type Director's Club Annual*, Gail Anderson wed a "paint-by-numbers" theme to her illustration: a playful and engaging solution for a tough assignment targeted as a very sophisticated and demanding audience (see Figure 7-10). But illustration also boasts an especially compelling history in poster design. In the case of the L. A. Summer Film Festival, which is held in August, the hottest and most uncomfortable month of the year, the poster solution was a marriage of photography and illustration (see Figure 7-11).

Rodrigo Sanchez is another contemporary who continues to demonstrate the power of visual metaphor via his illustration for *La Luna, Metropoli, La Revista* and *El Mundo Magazine* covers (see Figure 7-12).

Along with providing a rich visual legacy for us, illustration often mirrors our culture—literally and figuratively—as demonstrated in the last illustrations. However, illustration is incredibly flexible. It can capture raw emotion in loud vibrant color, or whisper to us through gentle lines gracing a page. It can hold a true essence through portraiture, establish a unique point of view, document a country's history, or suggest the ambiance of a period long since gone. Or, it can borrow from another genre—comic books—to work as an illustration for teen films. Today, it also happens to be collectible and shares the same venue as its fine art counterparts in museums, galleries, and exhibitions.

Figure 7-9

Al Hirschfeld's illustration is classic. His style is minimal and unlike anyone else. Perhaps his greatest gift is the ability to capture personality *and* likeness with a most remarkable economy. Many would argue that his caricatures are untouchable. This artwork from *The New Yorker* demonstrates all of the above. He is missed by illustrators, readers, and the staff of *The New Yorker*. Illustrator, Al Hirschfeld; illustration editor, Chris Curry. Drawing © Al Hirschfeld/Margo Feiden Galleries Ltd., New York, (www.alhirschfeld.com). Originally published in *The New Yorker*. Reprinted by permission. All Rights Reserved.

Joseph Mitchell, a matchless chronicler of Gotham exotica, published his last article in 1964.

Figure 7-10
Illustration has many influences. In this instance, Gail Anderson borrows from Americana-kitsch with this wonderful "paint-by-numbers" motif for the cover and theme of the Type Directors Annual spreads (*Type Director's Club*, #22). The look and color adds to the fresh presentation; and the minimal type is impeccable. Illustration, typography, and art direction by Gail Anderson. Courtesy of Gail Anderson.

Figure 7-11
The Los Angeles Summer
Film Festival actually
went someplace even
hotter for its award-
winning poster design—
Singapore! Dentsu Young
& Rubican (Singapore)
created this poster for
Imagine Productions:
what a wonderful visual
metaphor for a film "fest"
that showcased a series of
summer-related films.
Jeanie Tan, art direction;
Felix, illustration; Teo
Studio, photography;
Robert Gaxiola, copy.
Courtesy of Dentsu,
Young & Rubican-
Singapore.

Figure 7-12
Rodrigo Sanchez uses
little more than type and
hand-written inscriptions
for this compelling
Metropoli cover featuring
the film, *A Beautiful
Mind.* He's conceived a
brilliant juxtaposition
between the very complex
mathematical formula on
the board in the
background and the
simplistic "2 + 2 = 4"
atop it. Brilliant. Carmelo
Caderot, design director;
Maria Gonzalez, designer;
and Rodrigo Sanchez, art
direction and design.
Reprinted with permission
of *El Mundo*/Unidad
Editorial, S.A.

Commercial Art

In graphic communication, anything that is not
typographic is referred to as art, although type
may sometimes be integral to the illustration or
actually be the medium used by an illustrator (see
Figure 7-13). Illustration may also employ pho-
tography, which will be discussed more thor-
oughly in the following chapter. Indeed,
photo-illustration plays an important role across
media today. Again, illustration has a wide
assortment of media it may employ—air
brushing, pen and ink, etching, painting, pastels,
charts and graphs, info-graphics, scratchboard,
maps. Remarkably, a single computer and its
software can offer most of those different media
and more. In fact, some software programs—
such as Illustrator, Painter, or Freehand—allow
you to fuse different media and work on your
computer through an electronic stylus and tablet.

As D. J. Stout suggested earlier, commercial art
is an appropriate name for illustration and
graphic arts. Although the term is often
disdained, *commercial art* is a very fitting
reference for most of today's illustration. It is
commercial in the sense that it's specifically
designed or created for editors, art directors,
publishers, webmasters, and corporate designers.
Also, it's commercial because it's original work
created by staff or freelance artists who happen
to be compensated for their artwork. Contrary to
what some high-minded aestheticians might
suggest, it isn't really sinful for artists to accept
money for contracted services.

In fact, *Communication Arts*—a graphic arts
magazine with a most fitting name—actually
publishes an *Illustration Annual.* It features what
its jury of art directors, artists and designers have
deemed the very best illustration of that particu-
lar year, along with a thoughtful review of the
work and an overview of the judging process.
Other publications that showcase illustration and
media utilizing illustration include *Graphis,
CMYK,* and *Print.* All offer an inspiring array of
illustration and other commercial art.

Of course, there are remarkable similarities
between fine and commercial art. Illustrators and
designers employ the same design, color, composi-
tional, aesthetic, and technical skills that fine

artists use to create artwork that hangs in galleries and museums. Actually, most illustrators *are artists*; that is, they paint, etch, or work in a medium for purely aesthetic reasons for themselves.

Selecting the Correct Art Medium

The media used for illustration are nearly as varied as the styles employed. Acquiring the right illustration begins with selecting a specific medium for the art. Normally, that's the responsibility of the designer, graphics editor, creative director, or illustration editor. It might be created from any medium imaginable, but today the art is often a fusion of more than one medium. Or, it might be created digitally on art or illustration software—regardless of the look of the illustration (see Figure 7-14).

Oils or acrylics in a loose painterly style might be perfect for a magazine cover. Scratchboard's inherent detail, contrast, and drama could be ideal for a Tiffany's print ad, selling diamonds against a jet black background. Scratchboard— a subtractive medium—uses a special sheet of heavy paper that has bright, white clay baked into it and a painted surface, usually black. The artist scratches away the paint to reveal varying shades, from the stark white of the clay to the full background of the color of the paint atop the board (see Figure 7-15). A woodcut might suggest feudal times and be the ideal medium for a poster celebrating a medieval or renaissance fair. The point is simple. Sometimes a specific problem or situation will dictate the medium of the illustration.

Choosing the Appropriate Illustrator

On the other hand, an art director often knows immediately who the illustrator should be for an assignment. For example, when D. J. Stout was asked to design the poster for the call for entries for the Society of Illustrators 39th annual competition, Anita Kunz was the perfect choice. Kunz, who lives in Toronto, Canada, and is one of the top editorial illustrators in the world, also happened to be the first woman illustrator to receive that honor. Stout, principal and senior designer at Pentagram Design, reminisces: "Together Anita and I decided to do an illustration of an *illustrated woman*. The woman's screaming face may be interpreted a couple of ways. She can be seen as either 'calling for entries,' or she is an illustrator wailing in anguish

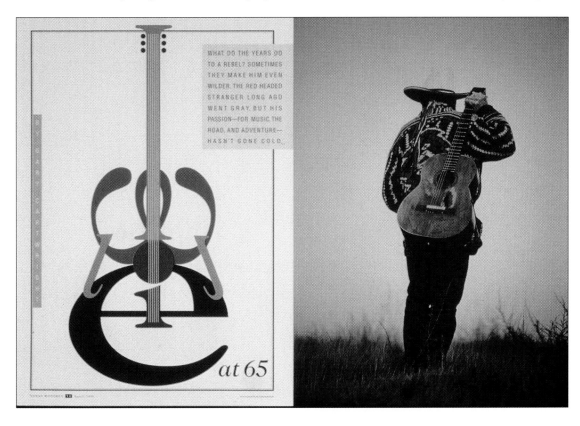

Figure 7-13
D.J. Stout and *Texas Monthly* provided a sterling example of wedding type *and* photography - and using typography as illustration (left). Note the intricate balance, construction, and merging of the headline, "Willie at 65." Stout created this amazing assemblage in an article for *Texas Monthly* on the redheaded stranger's thoughts on turning 65 years old. Reprinted with permission of *Texas Monthly*.

Figure 7-14
This simple but effective illustration is reminiscent of Monopoly cards. The art, typography, and design were created in Abode Illustrator as both direct mail and advertising components for a career placement fair. Artwork courtesy of Orion Design, Jan Ryan, art director, designer, and illustrator.

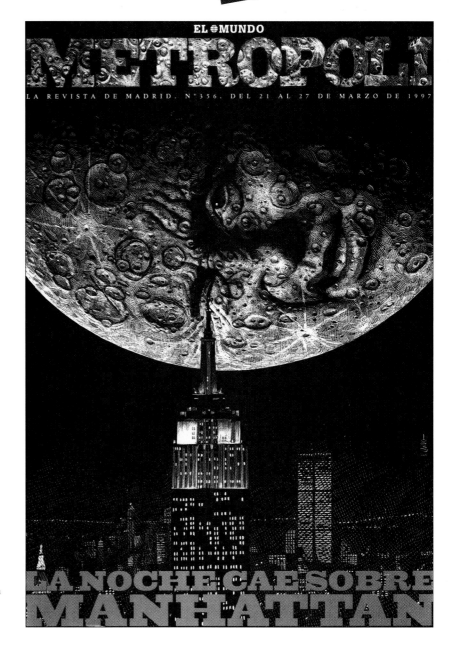

Figure 7-15
Illustrator Ricardo Martinez (a master of scratchboard) and Rodrigo Sanchez teamed up for this *Metropoli* cover. The meticulous detail of the New York City skyline literally collides with the wonderful Martinez man-in-the-moon illustration for the cover feature, *"La Noche Cae Sorbe Manhattan"* ("Night Falls Over Manhattan"). Reprinted with permission of *El Mundo*/Unidad Editorial, S.A.

because of the frustrations of being an illustrator in today's market." The result was this striking poster, which received numerous awards, including the Society of Illustrator's gold medal that year (see Figure 7-16).

Graphic style is also a visual code that reflects or recalls the aesthetic sensibility that may suggest the content and feeling of a story. For Chris Curry, Mark Gustafson was an "automatic" choice as illustrator for a *New Yorker* feature on ballet because of his fashion background and ethereal painting style (see Figure 7-17). It is not unusual for art directors and designers to seek out an illustrator with a specific style to communicate the intended message, feel, or emotive power of a magazine spread or cover, a website, annual report, or poster design. Sometimes, too, an artist or illustrator has a favorite subject or theme that might flag an art director for a particular story or assignment. More often, however, illustrators are selected because of their command of a medium, skill, and style.

Making that decision may be difficult, though. For Gail Anderson, former assistant art director at *Rolling Stone* and current senior designer at Spot-NYC, the process is a taxing and involved one: "Choosing the appropriate illustrator gets easier over time. I remember my first assignment, a tiny piece in *The Boston Globe Sunday Magazine* that had a budget of $125. I spent the entire day poring through binders of illustration samples, weighing the options, and hunting for just the right artist for the story. It's easier now. Sometimes the right person comes to mind instantly, and other times I have to make a list of four or five artists and whittle it down. You get to know who's usually up for something meaty and political or who prefers doing straight portraits. It's fun to shake it up once in awhile and ask someone to do something that's outside their area of expertise. That's often when the real breakthroughs happen."

Great planning, however, may give birth to incredible graphic solutions. Examine the Gail Anderson artwork that appears throughout this text to see some of those "breakthroughs" and fresh vision. Her illustrative solutions vary from "paint-by-numbers" animals to illustrated typog-

Figure 7-16
This most remarkable illustration by Anita Kunz—a "Call for Entries" poster for the Society of Illustrators—is almost mesmerizing. D. J. Stout, senior designer and principal at Pentagram Design, was asked to design the poster because of his interest and support of illustration over the years through the pages of *Texas Monthly* magazine. Recently, Stout noted that the "typography and design of the poster picked up on the carnival" aspect of the illustration's theme. Illustration: Anita Kunz; art direction and design: D. J. Stout. Courtesy of Anita Kunz, D. J. Stout, and the Society of Illustrators.

N.Y.C.B.'s lead women were all true to themselves in the Odette/Odile role. Here, Monique Meunier—big, free, and fun.

Figure 7-17
Chris Curry's instincts and vision as an illustration editor are unmatched. In this instance, she chooses Matt Gustafson as illustrator for a *New Yorker* piece on dance, "Dry Lake." "Matt Gustafson is a remarkable painter. His work has been mostly that of a fashion illustrator. Here he offers his fluid, water-filled line and tone to an illustration of ballet." © Matt Gustafson. Originally published in *The New Yorker*. Reprinted by permission. All Rights Reserved.

raphy ("Axl Rose's Lost Years"), subway tiles ("The Next Queen of Soul: Alicia Keyes"), and type as illustration (*Man of La Mancha* poster).

Putting the Pieces Together

After the illustrator and illustration are decided upon, however, it's the art director's job to assemble the artwork and words into a cohesive and meaningful whole. Type, color, lines, and other graphic nuances shape style or the look of illustration.

Ultimately, words, type, and visuals should be shaped, refined, and configured, so that every element will work together to best articulate or suggest the planned effect. Like design, effective illustration begins with brainstorming, at the point where the initial ideas are hatched. Here, the marriage of type, words, and illustration can make for a classic solution that seems almost magical (see Figure 7-18).

Contemporary readers have less time. They're also restless, so publications are dedicating more area to artwork—be it illustration or photography. In 1982, *USA Today* initiated the trend toward succinct, easy-to-read stories with stronger graphics and visual complements to newspapers; that tact has proven to be very successful for newspapers. However, other media—like it or not—are still moving in that direction.

Rolling Stone, for example, recently abandoned its longer, in-depth stories and features for "sound bite" journalism and shorter stories. Magazines in general have gravitated toward using fewer words and more pictorial area per story.

The majority of us scan newspapers, magazines and other publications quickly, seldom reading them cover to cover. Consequently, both editors and designers employ illustration for a number of good reasons, some of which overlap and work in combination with one another. Visuals—be they illustration or photography—attract attention; our eyes prefer illustration and other graphic information over the written word. The fact is artwork stops the audience. Magazine covers and features don't adopt the poster format for no reason. Artwork may also prove to be more functional because it is striking and memorable, as this beautifully designed Guide cover for *The Dallas Morning News* (see Figure 7-19).

Illustration, as Chris Curry suggested, may establish a particular mood or feeling to a story, cover concept, or idea. At the very least, illustration presents a potent opening or suggests the theme of a story. Or the art could reflect or reinforce a headline (see Figure 7-20). "Out of the Blue," a powerful magazine feature about

Figure 7-18

Sometimes the combined talents of the art director, designer, and illustrator come together in a most spectacular way—where the artwork, layout, color, design and typography gel perfectly. This award-winning spread for *Rolling Stone*, "The Axl Rose Lost Years," is a resplendent example of that magic. Alex Ostroy's illustration is almost hypnotic; its painstaking detail seems a mysterious mix of photo-realism and fantasy. Also, notice how Gail Anderson's intricate typographical work meshes perfectly with the illustration. Fred Woodward, art direction; Gail Anderson, typography and design; Alex Ostroy, illustration. © Illustration by Alex Ostroy. Article by Peter Wilkinson. From *Rolling Stone*, May 11, 2000. © 2000 Rolling Stone LLC. All Rights Reserved. Reprinted by Permission.

depression on college campuses needed equally potent artwork and design. In this instance, Rebecca Goldschmidt sought to capture the crippling effect of depression through color and agitated strokes in her illustration. Visuals may illustrate an aspect of the story that isn't readily apparent to the reader or offer a perspective that words can't impart. Goldschmidt's artwork really connects to the story's content. Sometimes, too, captions, subheads, decks, or pullouts further flesh out important aspects of a story that can't be communicated by words or art alone.

Experienced art directors and designers look for a specific illustration style to add to the unity of story or theme. This tact may also extend visual continuity for an entire issue. In this case, the style of the illustration should be appropriate to both the story and the publication. Make sure to use other graphic devices in the same way Kerri Abrams did to connect to the illustration's style and voice: color, gesture, and use of space. It is important to match type and design nuances appropriately, too.

The Role of the Illustrator

Successful illustrators and designers understand that visual form and verbal content should be inseparable. Illustration and graphic design shouldn't be thought of as simple cosmetic overhauls or introductory tap dances, or as ends in themselves. Try to think of illustration this way: conceptually, you should use artwork to make your layouts seamless with the editorial content, where everything—color, typography, layout, design nuances, and artwork—meshes appropriately with the content and voice of the story.

Perhaps Mark Ulriksen understands that concept as well as any illustrator. His comments

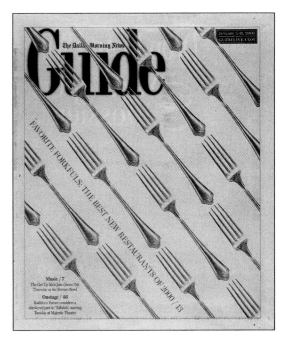

Figure 7-19
Photo illustration and smart design make a statement for *Guide*, the entertainment and magazine section of *The Dallas Morning News*. The strong diagonal, repetitive motif of forks is a suitable solution for the "Favorite Forkfuls" cover on the best new restaurants in Dallas. Kerri Abrams is responsible for this beautiful poster-inspired design. Reprinted with permission of *The Dallas Morning News*. Staff Photographer, Natalie Caudill. Staff Designer, Kerri Abrams.

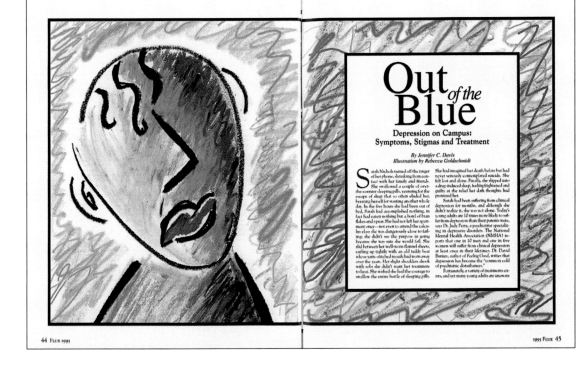

Figure 7-20
The illustration for this magazine feature complements the story's content—depression among university students. Goldschmidt's style, modeling and bold line are reminiscent of Picasso. Her style and use of color suggest the impact of depression; what's more, they connect to the story's title, "Out of the Blue." Illustrator and designer, Rebecca Goldschmidt; art director, Steve Asbury; design director, Matt Lowrey. Courtesy of *FLUX* magazine.

Figure 7-21
Mark Ulriksen is a man in love with life, music, dogs, design, art, illustration, and his wife—Leslie. His artwork has graced the pages of *The New York Times Magazine*, *Rolling Stone*, *Newsweek*, *The New Yorker*, *Sports Illustrated*, *The Atlantic Monthly* and many other magazines and publications. Ulriksen has also been featured in *The Society of Illustrators*, *Communication Arts*, and *American Illustration*. He is also one of the founding members of the Illustrators' Partnership of America. Photo by Leslie Flores.

Figure 7-22
Randy Johnson looks like the dominant, overwhelming player he is in this Mark Ulriksen illustration for *The New Yorker*. The artist's strategy was clear: "I wanted to make sure you felt his height (he's 6′ 11″), and by making his rear foot smaller I was able to convey the feeling of him coming right at the viewer." Notice, too, how Johnson seems to be coming off the page and *at* you. This was accomplished by adjusting the uniform and background colors in a subtle way. "The hardest thing was to paint his white uniform on a white background. I first painted his clothes light brown, then painted white over that so that my white was darker than the board's white." Illustration, Mark Ulriksen; illustration editor, Owen Phillip. © Ulriksen Illustrations.

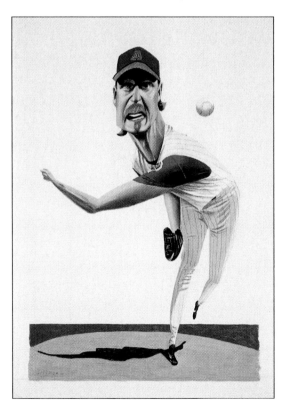

are especially insightful because he worked with illustrators prior to becoming one. Before launching his illustration career, Ulriksen worked as a graphic designer and then as art director for eight years at San Francisco *Focus* magazine. His artwork is widely published and has received many awards.

If I'm going to spend my days largely in solitude—drawing and painting—then I want to draw and paint things that I care about: people, relationships, music, sports, politics, pets, children. I'm not enamored of computers, corporations, or marketing, so I hardly ever get assignments on those subjects.

One thing I've learned is that one needn't always wait for the phone to ring. Once I read

that four baseball stadiums were in their final year of operation. So, I thought, 'Wouldn't it be cool to visit all these stadiums and have a magazine commission me to paint them (and foot the bill for my travel expenses)?' My former agent and I wrote a letter about my plan to travel and interview local fans and stadium employees about the ballparks' last hurrah and submitted the idea to a few publications. The New Yorker, my steadiest client, consented and soon I was off to Detroit, Houston, Seattle and my home town, San Francisco. Dreams can and do come true (see Figure 7-22).

I know that my first creative decision whenever I begin a new project is to decide where I am going to find my inspiration. I believe everything should be fair game for illustration content and context. I love it when a couple of pieces of tracing paper I've sketched on overlap each other in some unusual way and I see something totally unexpected. I once inadvertently double-exposed a roll of film I had shot off of the TV of the Iran-Contra hearings and the film Fanny and Alexander. *There were stunning juxtapositions and I learned an important lesson. Look for the unexpected.*

A case in point: recently my daughter had received a kaleidoscope for her birthday, and I had been looking at things through it, enjoying the patterns and hoping to someday be able to utilize the idea of creating a pattern to tell a story. About the same time I received an assignment to create a theater poster for a play at Arena Stage in Washington, DC. Perfect opportunity. I wanted to create something to capture the gist of the play. Basically, the plot revolved around an all-female cast who were gossiping about a woman whose husband was having an affair, unbeknownst to her. I created a grid to place the women in. The women at the top and at the bottom have closed eyes but open mouths, sort of like a Greek chorus (see Figure 7-23).

I trust both my intuition and serendipity, and I look for the unexpected. I want the best possible solution, composition, and execution—regardless of their inspiration. Actually, the kaleidoscope motif inspired another piece of art, this time as a cover for The New Yorker (see Figure 7-24).

Advice to Aspiring Illustrators

I'll offer a few pieces of advice:

Paint what inspires you. *Don't look to contemporary illustration for inspiration. Find your own. I still hope someday to do a series of paintings for myself based on Gang of Four song lyrics. Don't worry about your style or lack of it. If you draw and paint enough you'll improve and develop your own style* (see Figure 7-25).

If you're stuck or floundering—switch gears. *Paul Klee once said, 'diligence stands higher than talent.' I believe it. Some days it feels as if you can't even draw a square. Other times, it feels like you're flying. If I can't get a likeness right, I'll try beginning my drawing over at some totally different place. I usually start a likeness by outlining the head shape. Next I start with one eyebrow and work my way down or across the face. If I'm having some sort of hand-eye meltdown, I'll start by drawing just the lips or draw the entire body and then make the face from the neck up—just to break up the routine. In* Save the Marriage for the Children, *I drew the shouting face for one character, flopped it over and changed its gender so that the two are mirror images of each other* (see Figure 7-26).

Be professional. *Return calls promptly. Be courteous.*

Submit at least two ideas or compositions for each piece so the art directors can do their job. *It allows them some choice and more ownership to choose one idea over the other.*

Realize the value of ambiguity. The Couple *is not meant to portray two real people. I just loved how simple the piece was. I entered it in* American Illustration, *the bible of contemporary juried exhibitions, and it got published. Soon afterwards, the art director at* Texas Monthly *called and bought the rights to use it for a story entitled "Are Men Necessary?" Later that year a trade magazine for doctors, the now defunct* Hippocrates, *licensed the piece for an article about the ordeal of being the spouse of a doctor in residency. My painting was simple and vague enough that two different publications thought it solved their unique problems* (see Figure 7-27).

Figure 7-23
Inspiration may come from a variety of places. Mark Ulriksen explains.

"Recently my daughter had received a kaleidoscope for her birthday, and I had been looking at things through it, enjoying the patterns and hoping to someday be able to utilize the idea of creating a pattern to tell a story. The two women directly above the protagonist and directly below her all wear the same face, adjusted slightly. I made their hair color alternate, gray and blonde, blonde and gray. While they eye each other knowingly, the two women to either side of the main character look on with pity." Illustration, Mark Ulriksen; illustration editor, Neil Roan. © Ulriksen Illustrations.

Figure 7-24
Actually, Ulriksen does more than reemploy the faceted pattern in this illustration, *"Love the One You're With."* There is a kind of multiple repetition in the art for this theme cover. Ulriksen reflects, "I knew the pattern idea could get old fast, so I ration its usage. I had an idea to do a takeoff of a rather famous *New Yorker* valentine cover by Art Spiegelman where an African-American woman kisses a Hassidic Jew. I wanted to create a pattern of kissing couples one doesn't often see together, with the center couple the only typical pair." Illustration, Mark Ulriksen; art editor, Francoise Mouly. ©Ulriksen Illustrations.

Remember that the basic job of an illustrator is to create an image that solves a client's problem, and the illustrator then licenses that work to the client, charging very specific dollar amounts for very specific rights to use that image. Sometimes, however, for whatever the reason the artwork gets 'killed.' For example, Newsweek never used my piece, Putin's Long Russian Winter. *At news weeklies, such as* Time *and* Newsweek, *stories come and go all the time as the news evolves. I've done many pieces for* Newsweek *that never ran. You still get paid the same, but no one sees your work. Of course, that's one of the main reasons you illustrate. Among the ways to get a piece such as 'Putin' published is to enter it in competitions, use it as a promo, or have it appear in a college text book such as this one! (See Figure 7-28).*

Ask questions. *I'll ask art directors why they called me to see how others picture me: 'The*

Figure 7-25

Splash Landing meshes Ulriksen's love of dogs with plastic (well, acrylic) surgery. "This was an old canvas, halfway done with a portrait of my Lab jumping over sand dunes. The day I brought my paintings to the galley I was distressed to find that my show was too small, I needed more canvases to fill the wall spaces. I had two days to do something. So I came home, found this canvas, and in a few hours changed the scene to water and the dog to a Portuguese water dog."
© Ulriksen Illustrations.

Figure 7-26

Inspiration may come from anywhere. Sometimes it's a kaleidoscope, pet, comic book, incident on the subway, or even classic art; in this case, the scenario or composition was inspired by the film, *American Beauty*. Mark Ulriksen explains, "Kids tune out the arguments that punctuate some marriages. Here, the meal has barely begun and already the husband and wife are making threatening gestures with butter knives and meatballs. Only the dog, with its tail between its legs, seems shaken. The movie *American Beauty* was currently showing, and I borrowed the formalism I found in some of its dinner scenes."
© Ulriksen Illustrations.

story's about a sense of something wicked just below the surface and I thought of you,' or 'There's a dog that steals the Thanksgiving turkey as the guests arrive and I thought of you.' I'll end the conversation with my usual question, 'By the way, do you have a contract?'

Sometimes clients will want to use the illustration for everything in the known universe. If I sign a contract, they'll have the right, in perpetuity, without additional payment, to reproduce the image for any purpose they like. That's where I get out my pen, circle all these contract clauses and say, 'No, not without additional payment—to be negotiated,' and return the contract. Either no one in the art department says a thing and my revision is accepted, or we haggle. Or, their

lawyer and I haggle over terms. If these additional rights mean so much to them, they should provide compensation. Otherwise, I thank them and move on. With illustration rights, everything is open to negotiation.

If you're interested in these aspects of working as an illustrator, there's plenty of good information about the business end of illustration in the Graphic Artists Guild Handbook: Pricing and Ethical Guidelines, *tenth edition.*

My friends remain envious of my working arrangement and environment. No boss, no dress code, get up when you want, work when you want, listen to what you want—as loud as you want. If you're like I am, it's a great way to be an artist, make a statement—and earn a living.

Figure 7-27

The Couple is an example of inspiration coming from outside. In this case the illustrator went to an art museum for inspiration and found it in the miniscule brush strokes of Grant Wood. Look closely at the image. The likenesses were spurred by an odd couple: Elizabeth Taylor and Franz Kafka. Mark Ulriksen clarifies: "I utilized reference photos of celebrated people to create my own characters. This wasn't intended to be a portrait of Elizabeth Taylor and Franz Kafka, they just happen to have interesting faces." © Ulriksen Illustrations.

Figure 7-28

The upper left area of the art was deliberately left black here to accommodate where the art director and designer at *Newsweek* had plotted the header and deck typography. This is a wonderful example of collaborative design. Ulriksen handles color and space here to underscore cold, solitude, and isolation. *Putin's Long Russian Winter* was never run by *Newsweek*. Sometimes even brilliant work is not used due to the fickle nature of news and the fleeting value of a story. © Ulriksen Illustrations.

Figure 7-29
The marriage of ancient Tibetan inscriptions with knocked out photos made for an interesting graphic that imparted a mix of the past and present in this approach to pull quotes for this magazine article—"A Prayer for the Earth." Layout and photo illustration, Kellee Weinhold; art direction, Steve Asbury. Courtesy of *FLUX* magazine.

Mark Ulriksen's advice is golden. What follows are additional practical suggestions for ambitious, young illustrators.

Further Advice to Aspiring Illustrators

First and foremost, have a thick hide, and be able to differentiate between personal and constructive criticism. As Gail Anderson and Mark Ulriksen pointed out, illustration (like all free-lancing) is a *business*. The art director, graphics editor, or illustration editor likely appreciates what's needed in the artwork to present the story or idea and knows the audience more lucidly and intimately than any outside party. To that end, leave your ego at the door, listen closely, ask questions relevant to the assignment, read the story or its brief closely several times, and evolve your research.

Try to establish reasonable deadlines. Sometimes they can be immensely unrealistic and constrained. If that's the case, you need to make it clear to the editor whether you can meet the deadlines—or not. Be honest.

Work with the graphics contacts for the assignment—the illustration editor or art director. Get their input, ideas, and reactions to your ideas before you start the assignment. Listen carefully, not only to their ideas, but to their sense of the story and vision of it. The best illustration solutions are collaborative ones.

Try to disengage your ego. Be professional, realistic, and willing to accept an idea that works more effectively than yours. Swipe files can prove invaluable. Mark Ulriksen saves clippings as resources: "I keep photos I've clipped from magazines, newspapers, or what-have-you. I organize the visual material into categories like body language, walking, sitting, handshakes, kisses and hugs, colors, mother nature and so forth." Ultimately, possessing such a file may save you time, money and a lot of misdirection. For example, you may have a perfect example of the sort of art you'd like to use or a great posture or angle to apply to the illustration at hand.

Again, have a clear idea of the story, theme, or concept the art director is going for. Sometimes "kills" and misdirection occur not because the artist is a prima donna but as a result of poor communication, or the artist not understanding the story or what the visual expectations are.

Read the manuscript, story pitch, or prospectus before ever picking up a brush or pencil or booting up your computer. In a recent design featuring an interview with the Dalai Lama, art director Steve Asbury and designer Kellee Weinhold decided to use Photoshop to blend photography with Tibetan prayer tablets for pull quotes in the story. Through photo illustration, they connected content with artistic flair that wasn't overstated—a great solution for the problem at hand (see Figure 7-29).

Set the bar high. Live up to your expectations, ethics, and standards. Often, the best graphic answers come from thorough research and the proper mix of inspiration and perspiration—as in the Dalai Lama example.

Get as much specific technical and logistical information as you can from the art director or contact. Is it a vertical, horizontal, or square layout? What is the exact size? Will it be running on a left or right page? If it's going to be less than a page, is it running on the right or left side of the text? If the illustration is running across two pages, don't put important visual information—heads, type, or other important elements in the gutter or crease of the pages.

Showing is always better than telling. Some art directors expect to see a series of sketches before deciding on the concept or art, and may select one or two of them for further development. Swipe file examples may again prove useful.

Read books on artists, design, art history and contemporary art. Know what constructivism, post-modernism, art nouveau, art deco, futurism, and other styles look like. Go to art galleries. Where appropriate, apply the new (and old) ideas you assimilate within your work.

Experiment. Explore the possibilities of new media, and improve your skills and artistic possibilities by learning and teaching yourself new software programs. Become familiar with media you don't normally use. Scratchboard is a good example. It's an older process that's almost the antithesis of drawing or painting because your renderings involve *scratching* or subtracting material from the surface of the board. Even if you don't become facile or highly skilled at

Figure 7-30
This art is from a collection of "aliens" illustrated and art directed by Nicholas Wilton for self-promotion. Along with being fascinating visually, they are unusual from the standpoint that they are executed with acrylic on cement blocks. This particular image was featured on the cover of *Communication Arts Illustration Annual #43*. And no wonder—its color and illustration are stunning. Mark Murphy worked as designer along with the illustration and art direction work of Nicholas Wilton for Murphy Design. © Nicholas Wilton.

scratchboard or watercolor or pen and ink, you will learn more about illustrating, and you may be able to fuse the other media into some of your work. Try experimenting with different surfaces as well. Today illustrators are trying startlingly different things, from cinder or cement blocks to plywood (see Figure 7-30). Of course, scanners and software programs can integrate any medium or apply their own affectations or unique blend of media.

Learn more about composition and visual communication. Take out a camera and make images that integrate and stretch your sense of line, composition, angle, color, and spatial arrangement.

Finally, stay current with what's happening in visual communication. Subscribe to a number of good design or graphic arts publications. There are excellent publications available to you. *Communication Arts, Print, Graphis, HOW, Step-By-Step Graphics,* and *CMYK* are just a few. Keep a scissors at arm's reach. Most art directors, creative directors, and designers who subscribe to numerous graphic arts publications maintain swipe files, which they constantly update and refer to regularly.

Following this advice won't turn you into Anita Kunz, Mark Ulriksen, or Ralph Steadman, but you will have a richer visual sense and you'll feel much more at ease working with art directors or illustration editors.

Info-Graphics: Presentation and Telling Stories Visually

Many assume "info-graphics" (information graphics) originated in the 1980s when *USA Today* and the *Chicago Tribune* began using them extensively. Actually, Nigel Holmes, art director at *Time* magazine, basically invented pictographic charts about that same time. The fact is, however, they were not a new phenomenon. *The Times* of London first used graphic diagramming in 1806 to present the logistics of the "Blight" murder scene by providing a ground plan of the victim's mansion for its readers.

Max McCrohon, former managing editor of the *Chicago Tribune*, invented the first "graphics editor" position in 1974. The intent was to connect the editorial and graphic areas in newsrooms. The *Tribune*—along with *The New York Times, The Christian Science Monitor, St.*

Figure 7-31

Gail Anderson's first project at Spot Design was designing the key art for *Man of La Mancha*. She relives the pressures: "I read the script, listened to the soundtrack from the original stage production, and pored over a ton of websites looking for a different hook to inspire me, other than windmills. My strength is type design and working with illustration. Drew Hodges, Spot's owner and creative director, suggested I combine the two. In an effort to pare down to just the basics, I designed the type to resemble a horse. I could read the 'horse type,' but it took at least a dozen versions before everyone else could. Then there was the question of the rider on the horse. What would he look like? What would he be carrying? What kind of beard would he have and what would he wear? Although I thought my original looked pretty convincing, the end result became a collaboration of two illustrators—Ward Schumaker and James Victore. Our gut instinct as designers is to fear the client's input. Typically, they just want it bigger and bolder. But this time, the client was genuinely interested in the detail and nuance. Every line had to mean something." Courtesy of SpotCo.

How to Work with Illustrators —Gail Anderson

Gail Anderson, art director and designer for Spot-NYC and former assistant art director and designer at *Rolling Stone*, has worked with countless photographers and illustrators (see Figure 7-31). She provides these insights about working with illustrators:

1. Be flexible. If you have a sense of what the direction of the illustration should be, share it, but be open to the illustrator's ideas.

2. Encourage the illustrator to use e-mail regularly and responsibly.

3. Get the money arrangements out of the way as soon as possible.

4. Be clear about the deadline.

5. Ask for several sketches, particularly if you've not worked with the person before.

6. Be collaborative. Make the process a joint venture where both you and the illustrator share ownership in the evolution of the work.

7. Hope to be surprised.

8. Check in with the illustrator regularly during the process to monitor things.

9. Remember to call to say thank you.

10. Don't forget to send tear sheets or issues to the illustrator once the work is published.

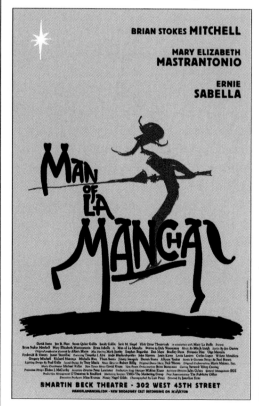

Petersburg Times, Orlando Sentinel, and *The Orange County Register*—set the bar for the use of information graphics in newspapers. Some of these papers were also leaders in color experimentation as well. Ironically, though, info-graphics weren't brand new to everyone. Designers of annual reports had been using and refining ways to show statistical information on charts, graphs, and pictographs prior to the boom in info-graphics in mainstream media.

Information graphics can be invaluable to readers. They can help tell complex stories that mere words cannot. For example, they might illustrate how the human eye ages and how researchers are developing new treatments to offset atrophy and diseases of the eye (see Figure 7-32). Info-graphics often serve as blueprints to diagram just about anything—from the scene of a tragic train wreck to both the skeletal and physical anatomy of a dinosaur.

The best graphics have superlative presentation. In fact, if carefully planned and plotted, we process them without ever giving a thought to their organization, flow, and structure. That's because the graphic editors have done everything to assure the art, words, charts, diagrams, and other components work seamlessly. Great design is like that—nearly invisible.

Angela Hill, graphics editor at *The Times-Picayune*, is one of the finest visual storytellers in the country. Although beautiful layouts and stunning information graphics are important, presentation and imparting the story graphically and cleanly are the most important aspects of her charge. She explains:

One of the most rewarding aspects of being the graphics editor for The Times-Picayune *is that I work in a shop that values teamwork and collaboration above all else. This is not simply an enjoyable way to work, it is also essential to good journalism.*

Information graphics require a high degree of coordination. And presentation is music on the page. All of the components—words, graphics, illustrations, photographs—must be composed in a way that ensures they're playing the same song (see Figure 7-34). Failure to communicate clearly and frequently throughout the creative process will bring noise to the page. Noise readers are very astute at hearing.

How to Work with Art Directors
—Gail Anderson

Gail Anderson's perspective for working with art directors is invaluable:

1. Try to send more than one sketch.

2. Get the money arrangements out of the way as soon as possible.

3. Get the size specs, format, and other technical particulars.

4. Be flexible. If you have a sense of what the direction of the illustration should be, share it, but be open to the art director's ideas.

5. Always meet your deadlines.

6. Try not to take on more than you can handle.

7. If you're dropping off your book, expect to leave it for more than one day.

8. *Don't* call to ask what the art director thought of your portfolio.

9. Send out samples regularly with your name on each piece.

10. Expensive holiday presents are always welcome.

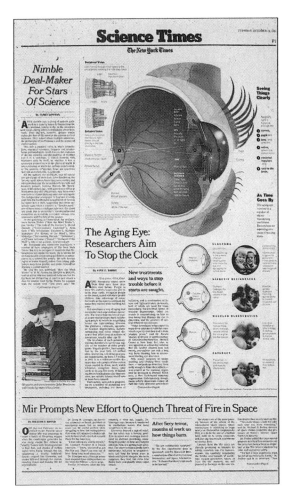

Figure 7-32
Most detailed features that are science-oriented—particularly complicated stories—need illustration. When *The New York Times* ran "The Aging Eye" story, they used a mix of cutaway graphics, diagrams, information lists, and photography to help tell the story. Charles M. Blow, graphics editor and Michael Valenti, art director. Copyright © 1997 by The New York Times Co. Reprinted with permission.

Figure 7-33
Angela Hill wrestles words and pictures even better than she does alligators. Over her tenure as graphics editor at *The Times-Picayune* in New Orleans, Hill and her dedicated team of designers and illustrators have amassed a sizeable collection of awards for their work. Included among her many honors was the series, "Oceans of Trouble," an "in-depth look at the world's imperiled fisheries resources." It received a Pulitzer Prize for public service. Angela Hill began her design career at *The Times* in Shreveport, Louisiana, shortly after graduating from Louisiana Tech University. © 2003 The Times-Picayune Publishing Co. All rights reserved. Used with permission of *The Times-Picayune*.

For newspapers to compete and hold readers' attention in a fast-paced world, all of the story or package components have to fit neatly together. That's what we strive for every day. From story headlines and subheads to photo captions to graphic headlines, decks, and subheads—each layer of material must build upon what preceded it. Repetition should be avoided in favor of expansion and clarification. Long before readers arrive at a chart or information graphic, they should already understand a lot about the information we're about to present. When executed thoughtfully and cleanly, a well-designed newspaper page can communicate better than any other mass medium.

As a child, I loved drawing and creating stories to go along with my artwork. Today, I get paid for doing essentially the same thing. My graphics have a story to tell, and the art of designing a good graphic is the art of telling a good story.

At college, I majored in graphic design and carried a young woman's dream of being a painter. It was during an internship at The Times (Shreveport, LA) that the reality of earning a living set in—which was also about the same time I discovered my love for newspapers and graphics. Later, when I moved to The Times-Picayune, I came to a place where visual communication was considered an invaluable part of telling stories.

We work hard on graphics, and try to edit them with the readers in mind. It doesn't matter if I'm explaining how tiny mosquitoes can carry a deadly disease, how a hurricane works, or how aquarium visitors can fall into a shark tank (see Figure 7-35). The fact is that graphics provide readers a clearer and deeper look at a story—and a visual way of understanding things.

For example, the termite story illustrates a fundamental principle we apply in creating and editing graphics; it's called flow. Flow refers to the visual and textual structure of the graphic that helps steer readers logically through the layout. A good graphic, like a good story, has a clearly stated beginning, a middle structure (where most of the information is imparted), and an identifiable ending.

When the graphics department began working on this award-winning series on termites, "Home Wreckers," we thought, "This looks pretty straightforward." It would prove to be anything but a simple story.

The objective was to give readers a window into the life a pest that costs home owners hundreds or thousands of dollars trying to exterminate them. We went through hours of discussion and piles of preliminary sketches before the

Figure 7-34
This graphic of the Christmas Eclipse in New Orleans reads quickly and clearly, demonstrating what an eclipse is, how it happens, and when it will reach maximum eclipse. You know immediately what the artist is conveying. The images need few words to support them. Graphic editor, Angela Hill; illustration and graphics by Daniel Swenson; source, NASA research staff. © 2003 The Times-Picayune Publishing Co. All rights reserved. Used with permission of *The Times-Picayune*.

main graphic finally crystallized. Once most of the pieces were conceived, we began the challenging task of organizing them so that the graphic would flow smoothly. Several devices are used at once to achieve a sense of flow. At first glance, the main drawing is a single, continuous illustration. But the main drawing is divided into three panels numbered consecutively and arranged logically.

The first unit deals with the birth and development of a termite colony. The second describes the colony expanding and looking for food. And the third explains the concept of a swarm that emerges from a mature hive. As you flow through the graphic, you follow the growth of the colony. The first item deals with eggs; the last with termites swarming from the nest to lay additional eggs (see Figure 7-36). Finally, across the bottom of the page, a separate unit describes the life cycle of the bugs, from eggs to alates (winged termites).

When done well, flow is seamless. This graphic looks like it's in this particular order because that's the only order that makes sense. In truth, flow is difficult to achieve and requires constant editing and re-editing to perfect. When it works, it's gratifying for the artists and satisfying for the reader.

The process of creating information graphics and presenting them clearly is a sizeable challenge, as Angela Hill so deftly explained. Sometimes, part of that task involves making important decisions about the style or art. Will you use illustration? Photography? Photo illustration? How will the content shape the look or voice you use? The style of info-graphics, although usually minimal line drawings, may vary widely, too. *Newsday* art director Ned Levine opted to use a comic book motif to celebrate "The Jackie Robinson Story" (see Figure 7-37). In contrast, *The Seattle Times* design/illustrator/artist Susan Jouflas uses pen

Figure 7-35
The "Terrifying Tour" was a *Times-Picayune* feature about the horrifying story of a catwalk that gave way in a New Orleans aquarium, dumping ten people into a shark-filled tank. The graphic has a natural "flow" left to right and provides both an overall shot and an inset information graphic of "the fall." Angela Hill and staff mix words and graphics effectively. Graphic editing, Angela Hill; graphic illustration, Daniel Swenson and Matt Perry; source, Aquarium of the Americas. © 2003 The Times-Picayune Publishing Co. All rights reserved. Used with permission of *The Times-Picayune.*

and ink and watercolor for this looser, painterly style for "Backyard Buzz," an overview of local Hymenoptra (see Figure 7-38). Often, too, photography and special use of color may stretch the look of information graphics.

Popular Science art director Dirk Barnett chose a pictographic approach to assemble a photo illustration built from knockout photos. The result is a clean and fresh presentation (see Figure 7-39).

Figure 7-36
Sometimes the story and visual mission of the information graphic are so complex that they require using a two-page newspaper spread. "Fortress of Destruction" takes *The Times-Picayune* readers through the birth and expansion of a colony of Formosan termites. This memorable graphic has tremendous presentation and flow. It also provides a wealth of information on these pests in a compelling way. Angela Hill, graphics editor; Daniel Swenson, graphic artist; James O'Byrne, *Sunday* editor; George Berke, design director. © 2003 The Times-Picayune Publishing Co. All rights reserved. Used with permission of *The Times-Picayune.*

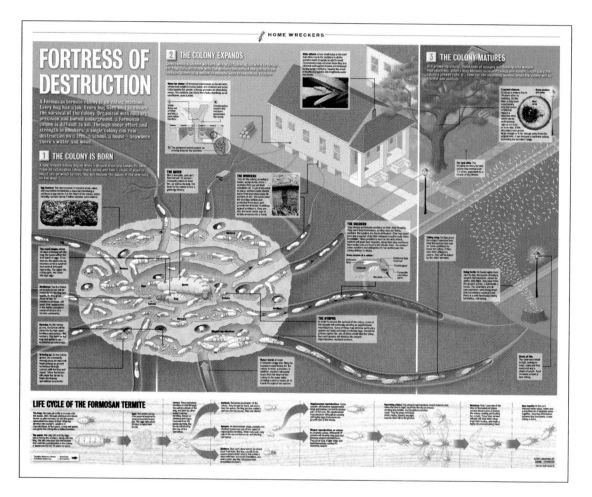

Figure 7-37
Newsday's art staff hit the target with this work. The audience? Baseball fans who are really still kids at heart, no matter their age. This format is not only unusual and eye-catching, it builds upon the nostalgia and fanaticism of die-hard Brooklyn Dodger fans. Ned Levine, art director; Bill Zimmerman, editor; Peggy Brown, writer; Yancy Labat, Frank Springer, and Steve Geiger, comics artists; Bozena Susla, student briefing page designer; and Jonalyn Schuon, copy editor. Distributed by Tribune Media Services. © *Newsday.* Reprinted with permission.

Art and Illustration **219**

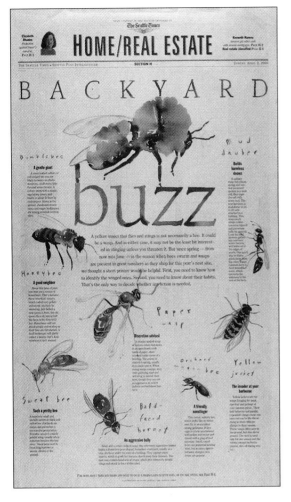

Figure 7-38

Susan Jouflas—designer and illustrator—demonstrates her
command of watercolor and pen and ink in this stunning
Seattle Times homepage design. She integrates the color of
the bees, wasps, and other insects into the header and type.
This inviting page showcases her artwork. Its design,
arrangement, type, and use of white space are stellar.
Reprinted with permission of *The Seattle Times*.

Anatomy of an Info-graphic

Regardless of the style, art, or format, most
finished information graphics consist of these
components:

1. Header. The headline—an easy-to-read title
or label, which should employ as few words as
possible.

2. Briefer. Normally, a briefer is a short para-
graph that explains what the graphic is about
and why the information is important.
Sometimes a deck—usually a sentence or two
that teases the story, fleshes out the headline, or
provides a summary—is used instead or in com-
bination with the briefer. Many longer informa-
tion-graphics also have extensive body or text;

sometimes, there are several text areas, as is the
case with several of the preceding examples.

3. Artwork. The visual element often trans-
forms data into visuals that articulate the infor-
mation clearly. Sometimes the art is something as
simple as a chart, map, or graph. Other times it's
a very intricate illustration, or it consists of
many renderings or diagrams to show process,
cycles, evolution, or chronology. However, the
art may simply present a quick plotting of the
logistics of a murder scene, terrorist attack or
urban renovation.

4. Sourcing. A source line is also included
when warranted to document where the infor-
mation originated.

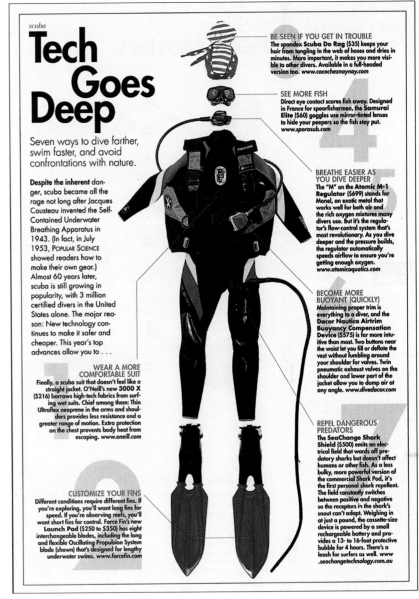

Figure 7-39

This pictograph from
Popular Science is a photo
illustration assemblage on
"seven ways to safely dive
farther… and avoid
confrontations with
nature." It incorporates a
headline, deck, briefer,
body, artwork, sources
(websites) for each point,
and credit. Large screened
numerals (1 to 7), bolding,
and color enliven this
strong mix of type and
artwork. Art direction and
design, Dirk Barnett;
photography, John B.
Carnett. Courtesy of
Popular Science.

5. Credit. The artist or illustrator who created the work should be credited. Often this is included at the very beginning of the story or publication and typically cited along with the author or photographer. Sometimes, a publication will place the credit below or along each side of the graphic.

In the production of info-graphics, the graphics editor—or someone assigned by that person—is normally responsible for creating the header, briefer, source line, and credits, as well as working with the design and typography. Space is normally tight, too, so typography is generally run small. Sans serif type, because of its strong legibility, is most commonly used for headers, copy, and other type and often is run in its condensed style. The graphics editor also decides which stories will receive info-graphics and how they will be employed. This means the graphic's editor has to wear a lot of hats and be familiar with both the word and image sides of the story. In addition, it means the graphics editor must think like a reader does. What's of interest? What needs to be shown, diagrammed, mapped, charted, illustrated, or otherwise shared visually to help the reader get the message? Again, graphics and illustration should not be used as window dressing; they should serve specific purposes and do things words cannot.

Tables and Charts

There are several options to consider when using tables or charts. *Fever charts* (sometimes referred to as *line* or *rectilinear* charts) are the best way to demonstrate or illustrate *temporal change* (see Figure 7-40). They may also be multi-referenced (i.e., more than one plotted line is used, usually

for comparative purposes). As is the case with any chart or table, make sure that you have a clear starting place on the graphic and that your axes and intervals are even and consistent.

Bar charts present statistical information horizontally, and use the left side as the baseline or starting place (see Figure 7-41). They are excellent at giving at-a-glance comparative information, such as how the yearly crime rate varied in Baltimore, Md. for a five-year period. A *column chart* functions exactly the same way as a bar chart, except that it is vertically oriented. Both are one-directional (see Figure 7-42). The baseline of a column chart is located at the bottom. Art directors and graphics editors normally select one or the other, depending upon whether their page design or pictorial treatment is basically horizontal or vertical. Still another variation of bar or column charts are *histograms* (or *step charts*); unlike bar charts, their columns touch. However, they measure two variables.

Pie charts are great at demonstrating relationships of parts to the whole, such as how 100% of the voting electorate cast votes for several primary candidates or where the average dollar of tax money goes. However, pie charts have their shortcomings. You don't want to have too many pieces in your pie because if they become too slivered, comparisons will be compromised and you won't be able to understand or even read them.

Finally, *pictographs*—what you commonly see in *USA Today* and news magazines—integrate one (or more) of the above with pictorial information to help personalize the information. In fact, pictographs are common in nearly all newspapers today (see Figure 7-43).

Figure 7-40
Fever charts show trends and changes over a period of time. This chart communicates quickly and clearly. Insets (comparing or contrasting something) are commonly used in fever, bar, and column charts.

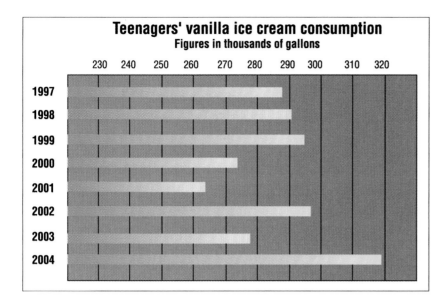

Teenagers' vanilla ice cream consumption
Figures in thousands of gallons

Figure 7-41
Bar charts always present their data horizontally and always begin on the left—that is, the baseline is far left. For example, the bars on this chart graphically compare teenagers' consumption of vanilla ice cream in gallons by year, from 1997-2004.

NEW ORLEANS TRADE VIA PANAMA CANAL

The Panama Canal serves as a funnel for a major portion of the cargo that moves in and out of Louisiana. Most exports are bulk cargo, such as grains from America's heartland, handled by the Port of South Louisiana in LaPlace. Most imports are in the form of general cargo, which includes products shipped in containers and break-bulk items such as steel. The Port of New Orleans is the state's primary handler of general cargo.

THE BIG PICTURE
A large portion of the goods flowing in and out of the Port of New Orleans goes through the Panama Canal:

Total cargo — Panama Canal cargo
General cargo in millions of tons

Year	Total	Panama
1992	6.87 million	2.28 million
1993	7.47 million	1.97 million
1994	10.38 million	2.67 million
1995	10.49 million	3.21 million
1996	10.04 million	2.48 million
1997	10.29 million	2.32 million
1998	14.09 million	5.34 million

LEAVING LOUISIANA
60 percent of the 63.4 million tons of bulk cargo exported from the Port of South Louisiana was shipped through the Panama Canal last year

Panama Canal-shipped exports: **38 million tons**

NEW ORLEANS BOUND
Largest general cargo exporters to the Port of New Orleans through the canal in 1998:

Rank	Country	Cargo volume (tons)
1.	Japan	2.6 million
2.	Indonesia	629,326
3.	S. Korea	585,468
4.	Chile	225,980
5.	China	223,777
6.	Peru	219,244
7.	Thailand	204,792
8.	Malaysia	125,248
9.	Australia	118,384
10.	Taiwan	85,742

STAFF GRAPHIC BY EMMETT MAYER III

Figure 7-42
Functionally, column charts are identical to bar charts; the difference is that the graphic orientation of the column charts is vertical—with the baseline on the bottom. This *Times-Picayune* information graphic uses several charting methods within one graphic. The column chart on the right is an *inset bar chart*. It is color-coded to measure two things at once; the green portion of the column represents shipping tonnage that goes through the Panama Canal to the Port of New Orleans; its beige counterpart column denotes total tonnage received. To the left of the column chart is a *pie chart*, which provides at-a-glance information on New Orleans tonnage through the Panama Canal. Finally, the graphics staff placed a list of the "largest cargo exporters" using the port of New Orleans via the Panama Canal at the lower left. Angela Hill, graphics editor; Emmett Mayer III, graphic artist. © 2003 *The Times-Picayune* Publishing Co. All rights reserved. Used with permission of *The Times-Picayune*.

RUN, RICKY, RUN A close-up look at Williams' season:

Figure 7-43
Pictographs can be fun as well as informative. In "Run, Ricky, Run," Angela Hill tracked the yardage gained by then-Saints tailback Ricky Williams—team by team. Note the use of photography and illustration. Angela Hill, graphics editor; Daniel Swenson, graphic artist. © 2003 *The Times-Picayune* Publishing Co. All rights reserved. Used with permission of *The Times-Picayune*.

Nigel Holmes is considered by many to be the father of the pictograph. Part of his job was reducing complex news and events involving statistical information to personalized and easy-to-read tables, mainly charts. The challenge, though, Holmes says, is "to present statistics as a visual idea rather than a tedious parade of numbers. Without being frivolous, I want to entertain the readers as well as inform them."

Maps: Cartigraphically Speaking

Last, but certainly not the least of the info-graphic tools are maps. They're immensely helpful to readers. Think of the course of history without them, or imagine yourself trying to make a cross-country trip without a map. They answer obvious logistical questions. Where is Bhutan? What countries and seas surround Italy? (See Figure 7-44). How far away was the terrorist training camp from the port they bombed? Why did the fleeing gunman choose Lake Shore Drive for his getaway? How are the Olympic Games going to affect the highway infrastructure? What is the topography of Afghanistan like, and where are the tribal and political strongholds? Like other information graphics, maps should help flesh out the story. Maps, however, also show spatial or geographic relationships and help answer important questions for the reader. They can do a lot of things: show population figures, topography, geology, distribution, weather, routing, boundaries, and flesh out logistics for readers.

For obvious reasons, make sure that your placement and scale are correct when using maps. If you make glaring mistakes in these regards, you will lose credibility.

Again, the typography you use should have excellent legibility. Most maps use sans serif type. Employ contrast and color carefully, too, so that

what you're attempting to highlight is clearly featured.

There are also a number of information services that market their graphics, maps, and digital information. One such company is Kendall Netmaps—an international cartography company located in Barcelona, Spain. Xavier Kendall, one of the principals, explained that digital technology and the Internet offer them a worldwide audience: "Netmaps provides mapping solutions to different industries worldwide. Among our clients, spread in 28 different countries, are graphic design companies, publishers of reference and textbooks, travel guide publishers, hotel corporations, and media groups. Our major sales are in Europe, basically in Spain and the UK. We are also very strong in Mexico."

The creators of digital information are many and include smaller specialized companies, such as Kendall Netmaps, and much larger ones, such as the Associated Press, Reuters, and Knight-Ridder. But newspapers and other media have artists and illustrators on staff, too. That said, freelancing still offers a wealth of opportunities for those interested in editorial illustration. In some instances, graphic artists will alter maps for specific applications.

Stock Art

Sometimes, a tight budget, an hour turnaround time, or a special situation will call for stock artwork. Most *stock* or *clip art* illustration (i.e., non-photographic) is line art that's prepared and sold for general application. Prior to computers, clip art was quite literally "clipped" out of books and pasted into layouts, hence the term, "clip art." Today, however, although many stock companies provide catalogs, most clip or stock art is digital, and the services that provide it offer

their products on-line. While some of it meets high standards technically, its quality ranges from poor to excellent. It is highly reproducible for most all offset printing situations.

Those who don't have an art director or the budget to hire an illustrator or outside artist have to search out the artwork themselves. To that end, a number of companies sell stock art in a variety of sizes, shapes, and solutions. Typically, they contract their artwork yearly, offering monthly publications or on their on-line counterparts. The topics—especially monthly catalogs going to newspaper retail advertisers—tend to be seasonal: pumpkins and fall leaves for October or firecrackers and stars and stripe motifs for July, for example. The line art usually reproduces extremely well, even on newsprint. Line art, such as pen and ink drawings, scratchboard, and

etchings, consists of definable lines of black laid down on white space. Basic line art uses just black lines or dots atop a white space.

Artwork that exists in the public domain has no copyright or an expired copyright; it is available for use by everyone. However, be careful that you don't get involved in copyright problems. Standard procedure? If you're unsure whether a piece of work is in the public domain, check with the publisher or owner before you use it. There are far too many on-line clip art suppliers to even begin to list. A quick search on the Internet may induce many hours of surfing suffering. Most of the companies offer free or "royalty-free" graphics. Unfortunately, an inordinate number of them are "come-ons;" their motives are to get you to sign up for one or more of their services—not gratis illustration.

Figure 7-44
Kendall Netmaps is a cartography company which provides mapping solutions to a wide variety of clients and industries worldwide. Their offerings are literally encyclopedic. If the country or region is anywhere on the face of the earth, they have it. Usually, too, they offer a wide range of maps for a specific place—mapping that reflects topography, population density, rainfall, mineral concentrations, and other information. Courtesy of Netmaps Geografia Cartografia.

There are a number of publishing houses and on-line services which market enormous collections of line drawings, etchings, and engravings for a set fee. Often these collections focus on a particular subject. Dover Publications' *Animals*, for example, contains over fourteen hundred wood engravings of mammals, birds, reptiles, fish, insects, and invertebrates—all for less than $20, (see Figure 7-45). Dover has many other collections in its Pictorial Archive series. Other publishers who furnish quality line art collections are Hart Publishing, Art Direction Book Company (this is the same publisher that produces *Art Direction*), Getty Images, STOCKART, INXART.com, and Sutphen Studio—to name but a few.

Truly, this art has wide application. It may be used for newspaper or magazine illustration, logotypes, brochures, interactive art, posters, and just about anything else you can imagine. However, there may be limitations on how much of the art you may print within a single issue of your publication. Dover, for example, allows that "you may use the designs and illustrations for graphics and crafts applications, free and without special permission, provided that you include no more than ten in the same publication or project." More may be used if you secure permission.

A large number of stock art suppliers offer monthly or regularly published catalogs—both traditionally printed and on-line versions. Other graphics companies provide clip art on a monthly basis. Payment is normally arranged on a sliding scale, so publications with very large circulations pay more for their graphic subscriptions than do smaller ones. Cost may also vary if graphics suppliers offer a number of different services. For instance, some companies provide a creative or general service, which consists of seasonal art, portraits, landscapes, sports, and the like. Their retail or promotional services offer organized sections with artwork of food, clothing, appliances, automobiles, and so forth. Both normally include splashy graphics, sale tags, and other artwork—all in an assortment of sizes.

Dynamic Graphics, Metro Creative Graphics, and PMS are a few of the larger graphic services companies. Subscriptions are normally sold on yearly contracts, payable monthly. Typically, rates range from $300 or $400 to $4,000 per year, depending upon services received and the size of a publication's circulation. The basic limitation is that despite the art's quality, you likely will not be able to use very much of it. No matter how well executed a line drawing is, if you can't use it, it is worthless.

Over the years, some of these services have evolved into complex operations. Dynamic Graphics, for example, offers considerably more than clip art and catalogs of stock illustration. Today, they're an institution, and offer everything from photography to illustration, training programs, art services, graphic arts and "how-to" publications, and a wide variety of on-line stock art and services.

Stock art includes computer graphics, available on zip disc, CD-ROM, and DVD. The graphics include everything from well-rendered illustration to photography, backgrounds to borders, and layered graphics—all in just about any format you can imagine: GIF, JPEG, PDF, TIFF, EPS, and more.

Cartographic services make up another important segment of stock art. Maps are important components of many publications and

Figure 7-45
The tiger used for this literary magazine cover was a copyright-free piece of art from Dover's *Animals*. Firecracker packaging, with the tiger integrated in the title—"Tiger Crackers"—serves as an unusual format for this *Prologues* literary magazine cover concept. Artwork courtesy of Briar Cliff University.

are used in books, newspapers, magazines, TV, annual reports, websites, and many other media. Although their quality varies, most of them are accurate, meticulously rendered, and beautifully colored—like the detailed map of Italy from Kendall-Netmaps (see Figure 7-44).

For the novice designer, it's easy to become caught up in the graphic work, select a drawing, and work backwards. Tailoring your copywriting or lead paragraph to match the graphic, instead of coupling the graphic to a finished story, is a clumsy arrangement that can be limiting and usually ends up costing you precious time. Finally, anyone can subscribe to these clipper services or catalogs. Why is that an issue? It means you may find the illustration or photography you used for your annual report showing up on a matchbook ad, in a shopper, or on a tasteless bumper sticker. If you're thinking about using a clip art service, most companies will provide you with past monthly catalogs for examination (usually at a fee). You can also tour the Web. That said, however, the services may prove invaluable. Although the media used to produce the art varies, the overall quality of the clipper services is actually quite good.

The best illustration—whether it's portraiture, editorial, or information graphics—starts with good research. That could be a thorough read of a story, intensive library and Internet sleuthing, an open exchange with an art director to understand the content and context of a story or assignment, or any combination thereof. Exemplary illustration is also meticulously executed and speaks lucidly and meaningfully to the audience for which it is attended. When all these things happen, magic can happen, and the artwork can be at least as important an element in a layout or design as the words themselves.

Parting Shot

This chapter has provided you with a good background for understanding the world of illustration. To be sure, it is important to print and electronic media, and its applications are as varied as the media used to create it. Sometimes illustration takes the form of an information

graphic, book jacket, map, thumbnail entry point, website insert, magazine cover, or the medium of an advertisement. Regardless of its medium—watercolor, pen and ink, scratchboard, digital software—or how it is used, never underestimate the power of illustration.

An illustrator is able to accomplish a range of things: illustrate, paint, create digitized renderings, build an info-graphic, and make a map—all for the same assignment. That's a tall request, but not for David Fierstein, a gifted young artist and illustrator who has concentrated most of his illustration work in science-oriented projects. He parlayed his interests in the environment, natural history, biology, and chemistry with art. Initially, Fierstein worked as a patent illustrator, but in 1995 he enrolled in a science illustration program at the University of California Santa Barbara and later interned at *National Geographic* magazine. Today he specializes in scientific information-graphics and freelances regularly for *Scientific American*.

His work is a grand way to close this chapter, because along with being meticulous, beautiful, and diversified, it is functional. In addition, it shows process. Nothing is sacred or static in today's world of graphic communication. Indeed, the very nature of any facet of visual messages involves change, flexibility, and communication. Here artwork is shaped to help tell a complex story, provide logistics, and in this instance, explain volcanic eruption. And, Fierstein's illustrations tell the story visually through compelling graphics—and—when coupled with words, Mark Clemens' art direction and page design—become a seamless message that brings us new information in a fresh and memorable way.

Again, even the best story will be passed over if its graphic presentation is mediocre or missing. Clearly though, not all stories warrant illustration. They do, however, need some graphic reference—even if it's undersized and understated artwork in a field of white space. However, where appropriate, illustration can help tell a story, explain a complex subject, provide precise logistics, or be a perfect visual metaphor that stops us in our tracks.

Evolution of an Info-graphic

Illustration can be especially challenging when the subject is complex and requires an information graphic depicting the life cycle of pond parasites and how they cripple frogs and figure into the eco-system. Illustrator David Fierstein worked closely with *Scientific American* art director Mark Clemens and editors Ricki Rusting and Sarah Simpson-Lyons throughout the process. Good communication ensured a collaborated evolution of the illustration through numerous exchanges, sketches, and "comped" renditions (see Figure 7-46).

Editor Sarah Simpson-Lyons provided David Fierstein with a detailed, annotated sketch that outlined the basic layout strategy and most of the elements to be included in the frog deformities-parasite life cycle illustration. She included detailed notes and rationales with her sketch. The illustrator worked from there: he revisited the illustration's composition and enlarged the egret's head coming in from the right side to add a dramatic focal point. Proper flow was crucial. Fierstein reflects: "I tried to lead the eye from there in a circular fashion, following the parasite life cycle. Every square inch of the illustration contains elements that contribute to the complexity of the problem. The editors and art director were insistent I include the cows, orchard, cattails, tractor, fields, and crop-dusting biplane, for example. The items needed to be visible but natural, yet not clutter up the artwork."

To further complicate the illustrative mission, several perspectives and scale shifts were required in one view: microscopic parasites, tiny tadpoles, small frogs, birds, snails, cattle, trees, and the entire pond. It was difficult to fix a point of view that brought the eye close enough to see details in the frog yet encompassed the landscape and other detail. The water and animals were rendered in one program (Lightwave), the land was modeled in another (Leveller), then exported to a third (World Construction Set), where the land along with the vegetation was rendered and meshed with the

Figure 7-46
The "maestro" approach is important to all media, but it is particularly invaluable to illustration. Illustration, David Fierstein; art direction, Mark Clemens; editors, Ricki Rusting and Sarah Simpson-Lyons; story, Andrew R. Blaustein. Courtesy of David Fierstein and *Scientific American.*

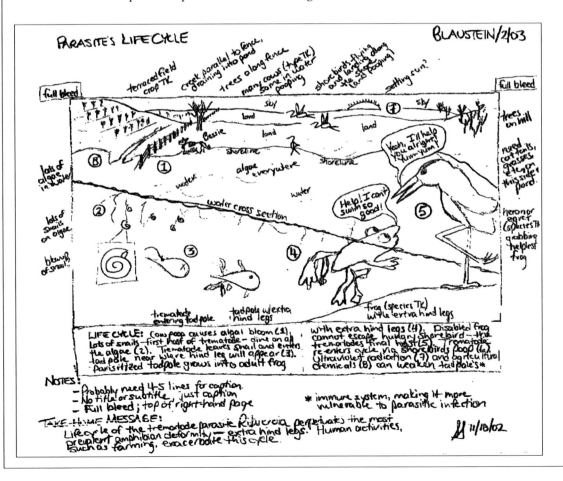

renderings from Lightwave. The tadpole, parasite, snail, and bird models were created from scratch. Fierstein recalls: "Initially, I thought the tadpoles and snails were small enough in scale to require being enlarged in size and put into inset boxes.

The art director and editor of *Scientific American* later determined that the insets could be eliminated, that the tadpoles were visible enough without them. This change improved the flow of the illustration, and the parasites remained in circle insets, indicating what is going on at the microscopic scale at each stage in the life cycle."

David Fierstein's final illustration is clean, clear, and reader-friendly because its flow is flawless. Clearly, however, the input Fierstein received as the information graphic was developed proved invaluable. Mark Clemens, art director at *Scientific American*, works daily with artists whose charge it is to tell complex stories visually. He explains his approach to working with freelance artists: "When I start to gather reference for an illustrator I am thinking of five different concepts that need to be addressed: emphasis, perspective, clarity, accuracy and impact. Figuring out what to emphasize is crucial. In the frog legs diagram, the lifecycle of the worm was the central, so we needed to tweak the layout so the worms stood out. We discussed the perspective long before a first sketch was produced. Although the whole worm cycle takes place underwater, contributing factors that affect the cycle occur on land and in the air; so we had to figure out a strategy that included the land, air, surface and the pond environments. It's easy to jam up an information graphic rife with many

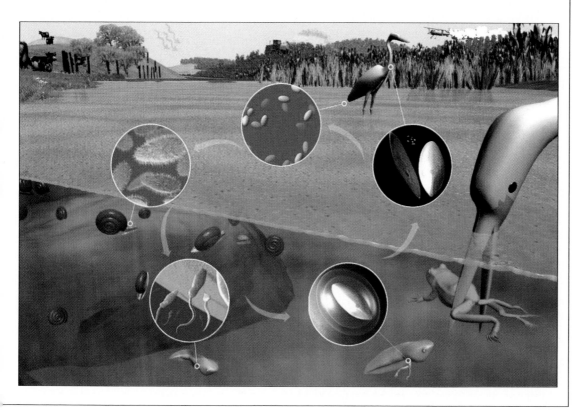

elements, and as the art progressed, clarity became a problem. I made sure the illustrator eliminated unnecessary elements to simplify the illustration and add impact. Color choices were also made to emphasize detail areas and to ensure blocks of text, labels and captions had neutral backgrounds. The backgrounds had to fit and blend in with the graphic, but usability and readability were equally important. The greatest detail and attention is paid to accuracy in the frog diagram. Obviously, the cycle had to be correct and the worms we were depicting had to reflect their correct stages and species; the wildlife had to be indigenous to the location, too. The addition of the plane, cows, fence, and tractor added to the illustration's authenticity and environmental dynamic."

HOW PARASITES CAN CRIPPLE FROGS

EXCESS ULTRAVIOLET RADIATION

FERTILIZER RUNOFF

LIVESTOCK MANURE

PESTICIDE RUNOFF

EGGS

1 Parasite larvae infect snail

6 New larvae hatch, to start the cycle again

5 Adult parasites reproduce in bird

INFECTED SNAIL

ALGAL BLOOM

CYST

DEFORMED LEG

2 Larvae enter tadpole

3 Cyst forms in tadpole, disrupting development

4 Cyst waits dormant for frog to be eaten

LIFE CYCLE of the trematode *Ribeiroia ondatrae* enables the parasite to induce deformities—including extra hind legs—in generation after generation of frogs. In its first larval form the trematode infects snails (1). After transforming into a second free-swimming form inside a snail, the parasite embeds itself near a tadpole's future hind leg (2). There it forms a cyst that disrupts normal limb development and can cause the tadpole to sprout extra legs as it grows into a frog (3). The disabled frog then becomes easy prey for the parasite's final host, often a heron or egret (4). The parasite matures and reproduces inside the bird, which releases trematode eggs into the water with its feces (5). When larvae hatch (6), they begin the cycle again. Human activities can exacerbate this process, especially where livestock manure or fertilizers enter a pond and trigger algal blooms that nourish, and thus increase, snail populations. Excess ultraviolet radiation and pesticide runoff—which might cause other types of deformities when acting alone—may facilitate the cycle by weakening a tadpole's immune system and making the animal more vulnerable to parasitic infection. —A.R.B. and P.T.J.J.

Graphics in Action

1. Pore over samples of great illustration from one or more of the design magazines; *CMYK, Communication Arts, Print,* or *Graphis* would work well. *Communication Arts* actually publishes a large illustration annual. Select 2-3 illustrators whose artwork you really admire; then try to analyze why you're smitten by their work. Is it their graphic style, use of color, narrative quality? Their deft caricatures or sense of humor? Or perhaps their ability to conceive marvelous visual metaphors is what is most impressive. Finally, write up a short review of your favorite 2-3 illustrators and bring it to class, along with several samples of their illustration.

2. The *New Yorker* has asked you for 5 ideas for a spring cover. They should be radically different from one another—and not derivative. Sketch them out on a blank sheet of paper or in your art book. You may use artwork you cut out from elsewhere as "for instance" examples. In any case, scan and incorporate them into the cover design along with the magazine's nameplate, datelines, and so forth. Then provide a typed, 25-word scenario for each cover idea.

3. Using a newspaper, select a story from one of the sections that you really like. It could come from sports, world news, food, business, or arts and entertainment sections. Choose 1 story. After you've read it, develop either a follow-up story idea or sidebar feature concept—complete with a visual strategy. Be sure you don't steal from or compromise the original story and its artwork. Remember, too, the art must be illustration of some sort.

4. Snip out 4-5 information graphics from a daily newspaper over the period of a week and bring them into class. Using the chapter's discussion of information-graphics and "info-graphics components" as your guide, define and critique them.

5. Deconstruct several magazine cover illustrations. Try to figure out what their context is within the magazine? Is it thematic? Seasonal? How do the illustrations complement the image of the publication? Does the magazine seem to have a stylebook for illustration?

6. Select an abstract word—such as kindness, hatred, prejudice, wealth, or justice—and see how many ideas you can come up with to illustrate the word.

7. Choose an article from a magazine, newspaper, annual report, website, or other source whose content might've been improved via info-graphics. Create the graphic, or provide a detailed description of what it would be. Finally, find a source for the information you would use.

8. Find 2 examples each for the following: pie chart, fever chart, column chart, bar chart, step chart (histogram), and pictograph. Analyze them. Did their graphics editors use the correct tool (chart, table or graph) for the job? Try to get the charts from various media: annual reports, newspapers, fund-raising materials, magazines. Many large university libraries—or even business school libraries—have collections of annual reports.

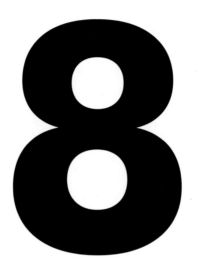

8

Light, Camera, Magic

Documentary Photography:
Truth with an Agenda

Photojournalism:
Telling Stories Visually

Sports Photography:
Capturing Images on the Fly

Composition: Structuring
the Photographic Image

The Moving Image

Commercial Work: Persuasive
Photography in Media

Technical Issues of
Printing Photography

Captions: Fleshing Out the
Image and its Relevance,
Details, and Message

Graphics in Action

*If I could tell the story in words,
I wouldn't need to lug a camera.*
—Lewis Hine

◀ *B. B. King, 1982 (from Concert Photography)*, Jon Sievert

Photography is a system of visual editing. At bottom, it is a matter of surrounding with a frame a portion of one's cone of vision, while standing in the right place at the right time. Like chess, or writing, it is a matter of choosing from among given possibilities, but in the case of photography the number of possibilities is not finite but infinite.

—John Szarkowski (from "A Brief Anthology of Quotations,"
On Photography, Susan Sontag)

Light, Camera, Magic

Anyone who has ever huddled over a tray of Dektol watching one of their images slowly emerge from a blank sheet of printing paper knows firsthand the thrill and magic of photography. *Magic* is the perfect word for a medium that combines physics, chemistry, technology, and aesthetics.

As a medium, its range is truly amazing. Photography includes the snapshots you pin to the wall or hang with magnets on your refrigerator door. It includes the photojournalism that connects you to your neighborhood and the farthest corners of the globe. It includes commercial work: compelling magazine, book, and annual report imagery as well as glossy print advertisements. Photography includes newspaper pages you discard, wrap fish with, or recycle to be made into paper to carry even more photographs. It graces the walls of museums. It includes documentary work and more.

All photography, regardless of its intent or genre, is a process of discovery and documentation. Typically, though, when we think of documentary photography, social documentary comes to mind and we immediately visualize the weighty imagery of Dorothea Lange, Lewis Hine, W. Eugene Smith, Robert Frank, Doris Ulmann, Mary Ellen Mark, Walker Evans, Danny Lyon, or Steve McCurry.

Documentary Photography: Truth with an Agenda

Usually, there is a kind of quiet sanctity we place on documentary photography and along with that often comes the assumption that the work is objective. The fact is that the entire process of photography is subjective. Each stage of the process—pre-visualization, visualization, and post-visualization—is comprised of personal choices. Initially, photographers—or photo editors, art directors, and editors—make decisions about what to shoot. In fact, often they build "shooting scripts" as tools for executing the shoot. That's all pre-visualization. At the visualization stage, photographers have to make many critical judgments regarding a wide range of things: what to shoot, which lens to use, whether to use natural or artificial light or a combination of both, and how to frame an image—to name just a few considerations. Once the shooting is completed, more choices have to be made at the post-visualization stage. Next, the imagery has to be edited. This is initially accomplished by reviewing contact sheets, slides, digital images, or whatever has been shot. This step involves deciding which images they feel best capture the essence of the event, moment, or person. Finally, decisions are made about which image will be featured (run large) and which ones will be presented smaller and how they might be cropped.

In addition, documentary photographers, particularly social documentarians, have a personal point of view and a specific agenda. Jacob Riis (1849-1914), who also happened to be an immigrant, was hell-bent to effect social change. He was outraged over the horrendous living conditions that awaited immigrants in New York City's slums. His photography was very subjective, and his mission, which was both social and political, was to provoke action against a system

309.

that that allowed such indignity and inhumanity to exist. Similarly, Lewis Hine's focus was fixed on eradicating the horrors of child labor (see Figure 8-1). Doris Ulmann wasn't interested in social issues per se; instead, her work focused on ethnography and preserving the Gullah culture visually (see Figure 8-2). For Roy Emerson Stryker and the Resettlement Administration (RA) and Farm Security Administration (FSA), their charge was to document the Great Depression and help eliminate the causes and conditions of poverty that were paralyzing rural America. Dorothea Lange, who was a photographer for the Resettlement Administration, brought sensitivity and structure to her imagery documenting the plight of migrants and the unemployed (see Figures 8-3). Dennis Dunlevy photographed the revolutions in Nicaragua, Honduras, El Salvador, and Guatemala when he lived among the people in smaller villages there. He brings a very personal view to the human horror of war (see Figure 8-4). W. Eugene Smith's mission was to unmask the evil and horror of the Klu Klux Klan and the industrialists in Japan who were literally poisoning and disfiguring the citizens in *Minimata*.

The tradition of social documentary photography continues today. Danny Lyon documents the disenfranchised, outcasts, and people living in the margins of society: bikers, convicts, and prostitutes (see Figure 8-5). Some of his later work, however, celebrates work and the common man. Steve McCurry's photography focuses on the "human consequences of war, not just showing what war impresses on landscape, but rather on the human face." He is a regular shooter for *National Geographic*, and has been honored by the National Press Photographer's Association as Photographer of the Year (see Figure 8-6). Although their work and subject matter is stridently different, each of these documentary photographers have this in common: their work is subjective and they each have a mission or agenda.

Documentary film is another facet of this genre. Like the past film documentary filmmakers, today's documentarians are largely independent and operate on meager budgets to share reality with us. Gail Dolgin and Vicente Franco are two gifted documentary filmmakers. Their film, *Daughter from Danang*, is a brilliant and moving documentary that examines the protracted tatters of war and how cultural differences can be more separating and real than time, distance, or place (see Figure 8-61). Vicente Franco's cinematography also underscores the value and impact of composition in documentary film.

Documentary has a fascinating and poignant history. Lewis Hine is considered by many as the father of social documentary photography. In many ways, he picked up where Jacob Riis left

Figure 8-3
Migrant Mother, Dorothea Lange
This image is an icon. Indeed, it surfaces in the minds of many at mere mention of the "Great Depression." The exodus of migrant workers seeking work in California moved Lange. She put aside her formal portrait work and began documenting the plight of the evicted and disinherited. Several things make this photo so compelling. First, Lange captured a "decisive moment" and revealing expression; secondly, the image is meticulously composed. Intersecting lines, selective focus, juxtaposition (mother looking forward, children huddling into her shoulders and looking away from the camera), and good contrast all contribute to the structure of the image. Great content. Great form.
© The Dorothea Lange Collection, Oakland Museum of California, City of Oakland. Gift of Paul S. Taylor.

Figure 8-4

Boy with a Gun, 1990, Dennis Dunleavy Dunleavy documented the horrors of war in Central America. "Boy with a Gun" delivers a powerful visual message about who is affected by war, without the gore and graphic depictions we're often numbed by in the media. Dunleavy reflects on the moment: "It was made very early in the morning and I had made my way past tarp-covered huts to the top of a road leading out of the village. Behind me, I heard the light footsteps of a rebel patrol heading out for the day. I photographed a group of six rebels through the morning fog and then stopped as they approached me. The leader of the patrol, an 11-year-old boy, had been born in Mesa Grande, a refugee camp in Honduras. He returned to El Salvador a year earlier and joined the guerrillas. I realized as he got closer, with great relief, that he remembered me from an earlier visit. That anxious moment has always stuck with me." Courtesy of Dennis Dunleavy.

Figure 8-5

Chain Gang, Danny Lyon From 1968-1969, Danny Lyon took his cameras into a high-security prison in Texas and produced *Conversations with the Dead.* This collection is a stunning achievement in documentary photography. Lyon has framed this image so all the heads of the men are positioned below the horizon. What does this do to the composition and how does it relate to the image's content? What is suggested spatially? Metaphorically? In the background—behind several rows of electrified barbed wire fencing—freedom looms. What is the significance of the tree? © Danny Lyon/Magnum Photos.

off, documenting the arrival of a flood of immigrants at Ellis Island in New York. Like Riis, he followed immigrants and recorded their simple but forlorn lives on the streets and in crowded slums of the Lower East Side of Manhattan—and beyond. His crusade grew with his outrage. Hine, who studied sociology at the University of Chicago and Columbia University, combined his humanism with his vision. He realized that photography could reveal the tragic impact of an economic system that exploited immigrants, the indigent, and disenfranchised. Eventually, he followed these people into the workplace where he was horrified to discover young children working in deplorable conditions for long hours in textile mills, sweatshops, and coal mines. His resolve and photography eventually led to the establishment of child labor laws. He said the goal of all of his photography was to "illuminate the dark areas of human existence, to inform and move the viewer." And that he did. Later, he celebrated the dignity and contributions of the common man by documenting the construction of the Empire State Building in *Men at Work*.

Mary Ellen Mark follows that same social tradition. Like many other social documentarians, she took up the causes of the forsaken,

forgotten, and disinherited. *Ward 81* (1979), was inspired by work she was doing while shooting stills for the movie, *One Flew Over the Cuckoo's Nest*. While on this assignment, she visited the women's mental facility in Oregon and later returned to share the lives of the patients with the outside world. Later, in 1980, she traveled to India, and while there, discovered, befriended, and photographed a group of prostitutes, most of whom as mere children were sold into prostitution, sometimes by their own parents. This experience resulted in *Falkland Road* (1981), one of the few documentary projects she shot in color. Mark first began documenting the life of the Damms, a sad homeless family, in 1985 (see Figure 8-7). She also documented the lives of Tiny, Rat, and the many other abandoned or runaway children she found on the cold avenues of Seattle in *Streetwise* (1988). Most recently, a collection of her photographs, taken between 1965 and 2001, was featured in *Photo Poche: Mary Ellen Mark* (Paris: Nathan, 2002).

Mary Ellen Mark reflects on documentary photography in a recent interview with the author.

Ryan: Can you comment on how you see documentary photography being used today, and specifically upon photography's role in magazines?

Figure 8-6
Kabul, Afghanistan, 1992,
Steve McCurry
McCurry has done extensive photographic documentary work in very dangerous situations, been beaten, jailed, and has nearly lost his life several times. Among other things, he has covered numerous wars, insurrections, and revolutions globally, including many parts of Asia and the Middle East. This ominous image was shot in Kabul when an armed militia paraded a suspected looter through the streets. The man was later executed. Justice is often swift and final in this part of the world. Courtesy of Steve McCurry.

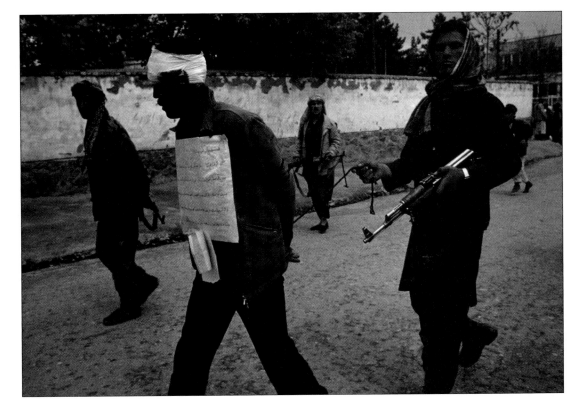

Mark: *Today there is very little demand for documentary. When I started out there was a real place for documentary photography in magazines. And so there was always room for more photographers if you were good at it, if that was your passion, and you worked hard. Today magazines are dominated by a sort of mandatory imagery, and a certain slickness. They're not dealing with content, they're dealing with surface: celebrity portraitures or fashion pictures that are all totally superficial. It's aimed at young people. I don't think that young people today are used to seeing documentary, and I'm not sure that they know what it is. It is sad because they grow up with images that are much less profound. They're being deprived. We're all being deprived of an opportunity to view reality. We're all losing out (see Figure 8-9). I think that there will always be documentary work, but these days you have to see it in books because you are not going to see it in many magazines. The whole balance of power has shifted; the power of magazines is now in advertising. Today, everyone is thinking about the bottom line, you know, magazines are about making money.*

Ryan: What about documentary work in other media? Film and video—how do you feel about the role of those media in documentary?

Mark: *Well, I think that in television there are certain magazine shows that have adopted a magazine role. Look at shows like* 60 Minutes *and* Nightline. *They have taken the place of magazines and they tell the stories. I saw a documentary on* 60 Minutes, *and I was really envious and just thought of the excitement of the various producers planning their shows. That used to be like it was in magazines. We would go out there and have these amazing assignments (see Figure 8-10). It is very different now as we aren't given the time first of all, to shoot a project thoroughly. It's very different.*

Ryan: In your opinion, what is it about the still image that continues to carry so much power?

Mark: *What's there in the photograph is there forever. I think with film (cinema), the imagery is fleeting. So photography is different. It's all about capturing a moment with photography. But also I don't think that still photographers necessarily make great filmmakers. They don't go hand and*

Figure 8-7
The Damm Family in Their Car, L.A., 1987,
Mary Ellen Mark
This Mary Ellen Mark photograph has been has been compared to the breath-taking imagery that Dorothea Lange recorded of the migrant laborers in the 1930s for the Resettlement and Farm Security Administrations. Even Mark has referred to this photograph as a "dustbowl picture." The Damm family had lost their home and were living in their car and in a rundown shelter in North Hollywood when Mark found them. Charles Hagen summed up her gift in his essay for *Mary Ellen Mark: 55.* "What makes her work distinctive is her ability to blend the two sides of documentary in an interesting way—to take pictures that remain rooted in reality but deal in the larger human meanings that can only be approached through fiction." That says it. Even Mark's fixation on getting the "single image" really speaks to her talent for making images with tremendous narrative quality— photographs that record the humanity behind social issues, individually—one life at a time, one frame at a time. © Mary Ellen Mark.

hand. I'm interested in the single image. *I'm interested in pictures that stand by themselves and work, and I think that is what is so great about W. Eugene Smith's work. He's made so many great single images. We remember the single images more than the story. Don't we? And there is a balance there. You remember that man—the country doctor—walking in the neighborhood. And the picture of the stitches. You remember that. And in* Minamata *you remember Tomoko—the connection to* Pieta.

Ryan: Speaking of balance, how do you maintain that equilibrium between being objective—if there is such a thing—and not becoming involved with the lives of the people you photograph?

Mark: *Well. you always have a point of view. I'm not sure if you can really be objective. You are looking at something—photographing—and the picture should express your feelings about that moment. That's your own objectivity, you know. It is not: well, that's supposed to be a bad person, or that's supposed to be a good person. Of course, you try to go into a situation with an open mind, but then you form an opinion—a point of view—and it's expressed in your photographs. It's important to have a point of view.*

You're very focused and looking for the truth, which is very elusive (see Figure 8-11).

Ryan: What about color versus black and white? How do you decide which way you're going?

Mark: *I'm much more a black and white photographer. I prefer black and white, and I find it very difficult to do both simultaneously. There are great color photographers, and I don't picture myself as a great color photographer.*

Ryan: You have mentioned a couple of times about how important the single image is to you, but I guess one of the things that has always taken me aback about your work is how strong each picture is.

Mark: *Well, I like individual pictures, I don't think of myself as a journalist. Things just present themselves. You are always looking for ideas. I don't like to plan. I'm not like those conceptual photographers who take pictures of some actors or actresses and decide which dress they are going to wear. I like pictures that are really about the person—pictures that really tell me something about the person. I think all of these years of work helped me a lot. You reach a point where you can anticipate what your subjects are going to do. But that's why you become a photographer, that's what it's about. It*

Figure 8-9

Mother Teresa at the Home for the Dying, Mother Teresa's Missions of Charity, Calcutta, India, 1980, Mary Ellen Mark Mark spent nearly two months over several years documenting the work of Mother Teresa and the many suffering and dying souls who were brought to her Mission of Charity in Calcutta. © Mary Ellen Mark.

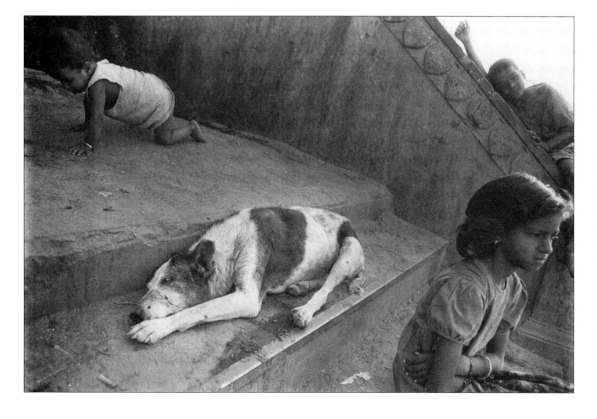

Figure 8-10

Sleeping Dog and Crawling Baby, Burning Ghat, Benares, India, 1995, Mary Ellen Mark The spatial arrangement and juxtaposition in this Mark image impart an unsettling feeling. The head of the girl on the lower steps (right) catches a ray of light. Note how Mark applies a slight tilt of the camera frame and in so doing, echoes the triangular repetitions and frames the boy upper right. Burning Ghat is an area in Benares where Hindus cremate their dead. The children are a *living* contrast in this powerful Mark image. © Mary Ellen Mark.

is about really trying to make a great picture. But not every picture I take is a great picture. I edit my pictures and choose the ones that really work.

Ryan: Do you have any advice for young students who are looking to go into photojournalism or documentary?

Mark: *The thing that I tell students is not to despair. Fight for what you believe. If documentary is what you want to do, work on your own projects. Technique is important, too, because it enables you to have greater range in your work. Stay with it, and don't be pushed into something that's more commercial just because you think that's your only opportunity. You're going to be great if you really believe in the work. You just have to go where your heart is and fight!*

Mark's documentary work is sometimes gut-wrenching: Mother Teresa's Missions in Calcutta, *Streetwise*, her work with the dysfunctional Damm family, or *Ward 81* all come to mind. But it may also be less serious, even whimsical; for example, her circus projects in Vietnam, India, and Mexico. Or her projects might lie somewhere in between. However, no matter the content, Mary Ellen Mark's photographs are unparalleled at capturing the unusual, mundane, or poignant in ways that touch us deeply.

Photojournalism: Telling Stories Visually

Photojournalism is a sprawling beast. Strictly speaking, photojournalism is a graphic way of telling a story: the integration of photograph and word to meaningfully explain, recount, or report an event.

For Mark, the separation between documentary and pure photojournalism is paper thin. "I have never known the difference between one and the other. To me a documentary photographer and a photojournalist are pretty much the same thing. If I have to make a distinction, I'm more a documentary photographer. I don't think of myself as a photo-essayist in the sense that I always consider a magazine layout when I'm working. To be honest with you, I always try to think of the specific pictures. What's important to me is to make strong, individual pictures" (see Figure 8-12).

Great photography is loaded with great moments and compelling expressions that tell the story or capture the essence of the event, person, or situation (see Figure 8-13). Henri Cartier-Bresson, a brilliant and very talented French photojournalist, coined the phrase "decisive moment" photography. He espoused that there is a critical moment when the lighting, composition, expressions, action, and essence of an event

Figure 8-11
Ward 81, Oregon State Hospital, Salem, Oregon, 1981, Mary Ellen Mark Ward 81 was the women's security ward for the Oregon State Hospital, a mental institution; its occupants were considered "dangerous to themselves and others." Mary Ellen Mark and Folger Jacobs, a social scientist and writer, spent 36 days living in the ward while interviewing and photographing the patients there. Mark writes in the Epilogue of the book, "The patients we knew as the women of Ward 81 are tattooed on our memories like graffiti. For the rest of our lives, we will dream about them and their confinement. Again and again we will be surprised to wake up in the beds without straps and padlocks, surprised to be able to see out of windows free of wire barriers." © Mary Ellen Mark.

Figure 8-12

Floating Guru, Ganges River, Benares, India, 1989, Mark Ellen Mark Benares (also known as Varanasi) is considered the holiest of Hindu cities, and for that reason many Hindu people come to bathe there in its sacred waters. It is also a place pilgrims cremate the dead, scatter ashes, and perform other rites on the Ganges. Selective focus, ground thirds and the play of light upon the water lend an ethereal quality to this image. Mark, again, is working the "decisive moment" and caught this expression on the face of the "floating guru." © Mary Ellen Mark.

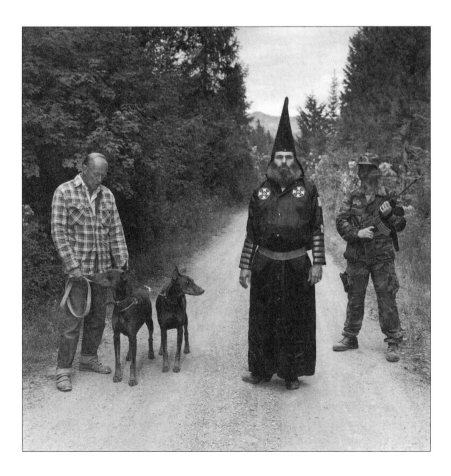

Figure 8-13

Grand Wizard at Aryan Nation's Congress, Hayden Lake, Idaho, 1986, Mary Ellen Mark Mark sometimes speaks of having acquired a "psychic" intuitive sense about capturing the truth in a photograph. The spatial quality and subjects within this image have a chimerical quality. The bowed head of the man holding the dogs, the animals' seemingly vigilant glances in opposite directions, the man in fatigues with the assault rifle—they all surround the gowned "wizard." The triangular-shaped road and sky converge and hold your eyes to his darkness against the light—the personification of evil itself. © Mary Ellen

intersect, and the photographer must be attuned to that moment. And capture it. Most contemporary photojournalists subscribe to that theory. What's more, they hone their skills to the point where composition, metering, anticipation, and working with light all become intuitive. Steve McCurry's instincts, intuition, and gift for capturing "the essential soul" of his subjects is remarkable, as evidenced by his photograph, "Afghan Girl," in the first chapter. He, too, is a master of decisive moment photography.

What constitutes true photojournalism is a long-standing argument, but the answer to that question probably lies very close to Mark's inference to the photo-essay. Realistically, however, the daily responsibilities of photojournalists are as broad as they are varied. Shooters are accountable for a wide-range of charges: hard news, "spot" news, sports, features, photo-essays, studio shots, photo-illustration, wild art, mug shots, and more. But, clearly, there is an enormous difference in covering an airplane crash or a revolution and photographing set-ups in the studio for the cuisine section on Thai cooking. That said, the best photojournalism and documentary work does share structural concerns.

The documentary and photojournalist work of Dennis Dunleavy has always been focused on developing an artistic vision, one that can be critically defined as having social and humanistic purpose (see Figure 8-14). His images and words shared here genuinely reflect that effort. Between 1987 and 1996, in the midst of civil unrest in Central America, he traveled from Texas and

California to document the lives of displaced and marginalized citizens in El Salvador, Honduras, and Guatemala. His goal was "To present a perspective that is more complex and fully human than is often superficially depicted by the sound bites of mainstream news. In this case, I truly wanted to understand the dignity, industry, and integrity of people who had been forced from their homelands under the worst of circumstances. This project was deeply personal for me, and I came to realize my own grandparents' struggles as refugees from conflicts in Ireland and Poland."

Dennis Dunleavy, an accomplished photojournalist, documentarian, and professor, reflects more on some of these issues in an interview with the author.

Photojournalism has always been about the relationship between light and life. Since its emergence in the nineteenth century, photojournalism has come to signify a social and empathic visual encounter with "reality," one that is capable of accentuating the texture of the human condition with dignity, grace, and compassion. That photojournalism could ever be conceived of, as "objective" is rather difficult to accept. The magic of photojournalism, after all, is to allow the viewer to see beyond the picture-making process by entering into and connecting with humanity and the world as it is fixed within a collective memory of place and time. However, it is in the subjective and emotional experience of the photojournalist that reality is observed, recorded, edited, and conveyed to us; therefore, this is where the process of fixing the collective memory begins.

Today, we are socially conditioned to the deluge of photojournalistic impressions that meet the eye daily, from the run-of-the mill to the iconic. However, within our visually-oriented culture, photojournalism remains committed to documenting the immediacy and intimacy of life as it unfolds around the corner or across continents (see Figure 8-15).

The skilled photojournalist responds to the world emotionally and intellectually by documenting it with honesty and humility. The power of photojournalism, then, resides in its insistence

Figure 8-14
Portrait, Dennis Dunleavy, El Peten, Guatamala, 1996, Marty Shea Dunleavy's background, professional experience, gripping photography, and communication Ph.D. landed him the directorship of the photojournalism program at San Jose State University. A New York City native, Dennis Dunleavy realized early that photography would be his passion and career. In 1979, he began freelancing for the Associated Press as well as several New York dailies before landing his first newspaper photographer's job in Ypsilanti, Michigan near Detroit. In 1985, he accepted a position as staff photographer for the *San Antonio Express-News,* but left the newspaper in 1993 to freelance in Central America and Mexico. He lives with his wife, Karen, a pediatrician, and their three-year-old son, Liam Benjamin, in San Jose. Courtesy of Dennis Dunleavy.

on being a holistic and humanistic enterprise. The photojournalist, in turn, must be faithful to a moment of truth, as he or she perceives it. Photojournalism, at its best, must goad the viewer to consider twice what they are looking at.

Whether we define what we do as photojournalism or documentary photography, the important question to ask is, 'why we do this work in the first place?'

Within a documentary context, my involvement with my subjects usually spans a long period of time. In documenting refugees from

Central America, I found the level of commitment to the families I photographed day-in and day-out for more than two years, more emotionally taxing. In documentary work, there is never really a sense of when the project would end, so I always felt less in control of the final outcome.

From a personal perspective, the relationships I developed through my documentary work required a great deal of trust—more than anything I experienced on a news assignment.

However, another important distinction lies in a documentarian's ability to produce images over

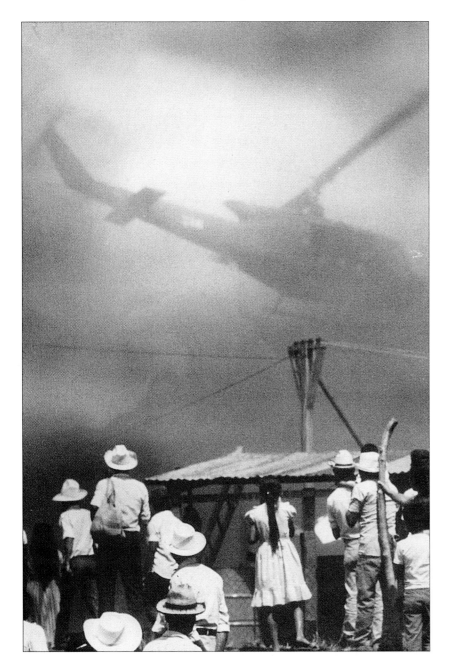

Figure 8-15
Helicopter—Segundo Montes, Morazon, El Salvador, January 1990, Dennis Dunleavy
This photograph has a very ominous feeling. To the Salvadorans, the sound and sight of approaching helicopters meant two things: death and destruction. At this point, refugees were beginning to return from nearly a dozen years of exile in Honduras. Donleavy remembers: "I was there to celebrate the naming of their new community after one of six Jesuit priests killed by the Salvadoran army during the 1989 rebel offensive. During the ceremony we heard a government helicopter circling from high above the center of the repatriated community. The regional military commander had come to pay a visit to the returning villagers." Courtesy of Dennis Dunleavy.

a period of time, images that speak truth to power. This approach presumes that in documentary work the viewer is presented with an interrogative and alternative perspective that goes beyond the blare of a quickly forgotten headline or the triviality of a sound bite.

Clearly, many images produced in photojournalism meet these criteria as well, but not all working in documentary would consider what they do as photojournalism. Both work with visual facts to share a truth, so the documentarian may very well be a photojournalist by occupational association, but I do not believe that the title is necessarily requisite for a visual truth to be explored and revealed.

For weeks and sometimes months at a time, Dunleavy entered the lives of refugees to tell their stories, lend a voice and an ear, and to make the invisible truly visible. "The wars have ended but human marginalization, exploitation, and displacement persist—perhaps this too is a shameful part of the human condition (see Figure 8-16). But photojournalists—many of us, anyway—are social reformists and idealists, and for me, the camera has always been not only an extension of my eye, but also my heart. Looking back at this work now, I am not sure how successful my efforts were."

Surely, that has to be a difficult question for all photojournalists, particularly those who've documented the horror and brutality of wars and revolutions. For W. Eugene Smith, who'd hoped his horrifyingly graphic images from World War II would prevent all future wars, the answer to that question put him into severe depression that lasted more than a year.

But you needn't cover revolutions or travel to exotic places to find interesting stories. They're all around you. Paul Carter, senior photographer and assistant director of graphics and photography at *The Register-Guard*, makes his photographs much closer to home. He has literally dedicated his life to photojournalism, documenting the lives of simple people working in small communities in the American West (see Figure 8-17).

The first pictures that mattered to me appeared in a tray of developer rocking back and forth in a cramped space beneath the control room of a United States Navy submarine. I was a 17-year-old sailor and all I knew about photography I had learned in two days of instruction at the Philadelphia Naval Shipyard.

The diesel sub wallowed in a rolling sea at periscope depth. The air was stale and hot, but I was transfixed by the emerging prints. Nothing before in my life had exerted such power.

A life in photography started there in the dim, red gloom inside SS385. Leaning over a tray of Dektol, I discovered a way to grasp the world, to hold it in my hands on a piece of paper and pass it around—to say, "Look, this is what I saw."

I still have some of the prints. The pictures were made with a camera attached to the eyepiece of the periscope. They're small; the images occupy a circle a bit more than two inches in diameter. The rest of the field is black, though many of the badly fixed prints are streaked and fogged. Mostly there are pictures of destroyers and other ships, but I also made pictures just for myself.

One of the round photographs shows a few hundred yards of coastline on the island of Bermuda. Seen through the periscope, superimposed crosshairs on the photo are taking aim

Figure 8-16
Salvadoran Rebel, Usulutan, El Salvado 1991, Dennis Dunleavy There is a quiet but unsettling power to this image of a young woman revolutionary. Dunleavy has captured Orby's defiance, resolve, and grace in this simple portrait. There were many like Orby who took up arms because of death and other atrocities they experienced firsthand in their lives. Courtesy of Dennis Dunleavy.

improbably on vacation homes and an idyllic beach. I suppose it's a meaningless picture, but I can look at it today and feel the place and time in which it was made.

I know it's a cliché, but it was magic. And it still is. The power of photography over me is undiminished. After my Navy service, taking pictures became the best part of college, propelling me into journalism school and a working life as a small-town journalist. I started as a reporter in the suburbs of Baltimore. Newspapering is an itinerant craft and eventually I headed west to work at small dailies in Utah, Montana, and Oregon. But writing always seemed to fail me. No story adequately conveyed the emotional truth of an event that I witnessed or the people that I met.

As I learned how to be a reporter, I also took pictures. At my first job I used a Polaroid camera. I have vivid memories of rushing to bank robberies and homicide scenes, snapping pictures with the awkward camera and then waiting impatiently for the 60-second prints. I chased cops for interviews with the still-wet prints held carefully like precious artifacts. The pictures were often more relevant and immediate to me than reporting.

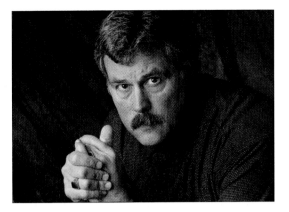

It was all superb training for photojournalism. As I developed the instincts of a reporter, I also learned to be a reporter with a camera. Sometimes I made pictures first, then asked my questions, sometimes the other way around. I found my best stories in quiet, kitchen table conversations, as well as the welter and confusion of news events.

It took years, but I learned the simple technical skills of photography and the complex art of maneuvering my way delicately into the lives of the people I photographed. A Nikon F loaded with Tri-X film and the old cliché of "f8 and be there" was enough technique at the start (see Figure 8-18).

Figure 8-17
Portrait, Paul Carter, Rob Romig
Paul Carter had his initial experience with photography while serving in the US Navy Submarine Service (baptism by Dektol). Later, he studied journalism at the University of Maryland. After graduation, he worked for small weekly newspapers in the Baltimore area as a reporter and copy editor. But photography was his love, and he took pictures whenever the staff photographer was not available. In 1977, he moved west. Currently, he is a senior photographer and the assistant graphics editor at *The Register-Guard.* He and his staff were runners-up for a Pulitzer for their poignant coverage of the Thurston tragedy. Like McCurry, Carter has an incredible gift for visual storytelling. Courtesy of Paul Carter.

Figure 8-18
Boy Shooting Basketball, Opheim, MT, Paul Carter
Opheim is a small Montana town near the Canadian border, the land of high prairies and endless stretches of dryland farms. "I was there for my newspaper at the time, *The Missoulian,* covering a story on the drought. As I drove through the town one evening with a reporter we both noticed the boy tossing up his jump shots against a Montana 'big sky.' I pulled over, made a few frames of him playing his solitary game; and drove on." Courtesy of Paul Carter.

Life in the American West is a subject worthy of a lifetime of work. It is a landscape of spirit and thought as well as place that has inspired an enduring photographic record. In many remote corners, newspaper photographers provide the most authentic documentation (see Figure 8-19).

This is what I have done, encountering ordinary people at little-known crossroads. Oilfield roustabouts in Wyoming. A recluse in an Idaho cave. Monastic mendicants in the Utah mountains. Montana mill workers weeping on the day yet another mill shut down. The Third World desperation of an Indian reservation. Men living and dying in prison; women outside the walls waiting for them. In these places and many more, I met wanderers, wretches, and poets, all with stories to tell (see Figure 8-20).

A comment about style. News photographers are in a constant struggle to find another approach to the banal. It drives many photographers to dress the ordinary in stylistic sleight of hand. I admire a signature style, but I've always believed that good pictures must reveal human emotion. If we haven't achieved that, technique will not save us. Tilted horizons or toy camera pictures are best left on gallery walls. It's challenge enough to take the viewer into direct contact with another human being and keep them there for more than a few seconds. Emotion and the moment, however elusive, are everything in reportage. It is, if you will, the "gold standard."

Elsewhere in the world, photojournalists are witnesses in the halls of power, the lives of the famous and infamous, at the depravity of war and the immense suffering of famine and disasters. But in rural places, newspaper photographers hold up a mirror to plain folk. The reflections may seem mundane and unremarkable, but just as often are sublime and inescapably truth telling. All in all, I prefer the mirror where I have held it (see Figure 8-21).

Paul Carter proves that documenting life in small town and rural America can be fascinating and rewarding. What is important to understand, too, is that great photography isn't made by sophisticated cameras and photo gear, it's made by great photographers—no matter where they happen to live or work (see Figure 8-22).

Figure 8-19

Branding at the Round-up, Montana, Paul Carter This ain't a still from an old John Wayne oater, Maude. Photo-stories in the American West have great range—in more ways than one. Paul Carter comments on this image, "Buckaroos on the ZX Ranch in eastern Montana use old-fashioned ways to brand calves in the annual spring ritual for a 1994 story about the largest contiguous cattle operation in the United States. At 1.4 million acres, the ranch near Paisley covers more ground than the state of Delaware." Courtesy of Paul Carter.

Figure 8-20

Firefighters, Paul Carter
Wildland firefighters move through the charred landscape left by the Warner Creek forest fire near Oakridge, Oregon. Forest fires are an annual story in the American West and increasingly more difficult to cover for photojournalists because the forest service restricts access to the fire lines. This Carter image has a haunting quality.
Courtesy of Paul Carter.

Figure 8-21

Protesters, Paul Carter
Cutting old-growth forests is an especially contentious issue in the Northwest. In this instance, protesters had chained themselves together, blocking a logging road in the hopes of stopping the timber harvest. Carter captured this powerful image with his wide-angle lens. "Earth First! protesters are dragged out of the way of a crew of loggers waiting to get into a forest sale to harvest old growth trees. The incident occurred after several days of protest in which the protesters camped in the logging area, chained themselves to trees and temporarily halted the sale. This confrontation was typical of clashes between environmental activists and the forest service in the war over the future of Oregon's dwindling stock of old growth Douglas Fir forests on federal lands." Courtesy of Paul Carter.

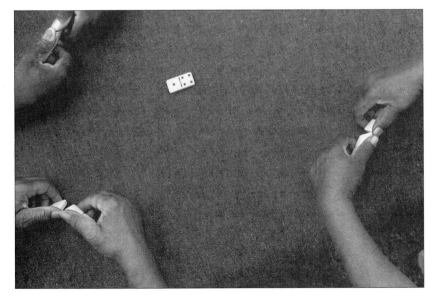

Figure 8-22

Dominoes—Riverside, CA, Carlos Puma
The textures, steep contrast, and tight drop shot of three men playing dominoes impart a bit of drama in this simple image. Notice how Puma shows us how all three men guard their tiles. We needn't see the faces of the competitors to get a sense of how seriously they take the game. Courtesy of Carlos Puma / Riverside *Press-Enterprise*.

The Mennonites by Paul Carter

Jim Goldberg said of his approach to documentary in his book, *Rich and Poor*, "This (work) fits with the tradition I believed I was part of, the social documentary school of photography. I believed that as an outsider I could enter a world different from my own, process 'information,' and somehow create for other outsiders a better understanding of a life we either refuse to see or are ignorant of." Clearly, Paul Carter is part of that tradition, as evidenced in this moving documentary on the Mennonite community in the Willamette Valley. He reflected upon the moving documentary in an interview with the author.

Drive Peoria Road north from Harrisburg, Oregon to Corvallis and the overwhelming imagery sweeping past your car windows through most of the year is the sea of green. This is grass seed country. The farm fields stretching across the broad Willamette Valley are a saturated, electric green. Acres and acres of intense color; it is here that many of the world's lawns begin.

So it's easy to overlook the neat, white-frame houses with manicured lawns, gardens and barnyards. Little noticed is the plain church, the nondescript schoolhouse, and the old grange hall.

Many of these prosperous farms are owned by Mennonites, theological cousins of the Old Order Amish of Pennsylvania. They live quite successfully in the world, but well apart too. They describe themselves in their Articles of Faith as "strangers and pilgrims." Strangers, indeed. The tight-knit families keep the surrounding community at arm's length. Though not as conservative as the Amish (they use automobiles and modern farm equipment), the Mennonites steer well clear of much in the dominant culture. They particularly shun the onslaught of media in American society (see Figure 8-23).

Small-town newspaper work sometimes allows a journalist the time and freedom to step back and let a story unfold in its own time. That is what writer Bob Welch and I decided to do

when we realized our mutual interest in the Mennonites.

We approached these people cautiously and respectfully. Letters were written. Meetings were arranged and we talked with community leaders. There was polite acceptance of our interest, but a studied disinterest as well. We learned quickly that these folk would tolerate our curiosity and graciously accept our visits. We could tell their story, though most of them would probably never read it.

Bob and I visited several farms along Peoria Road over a period of many months. We visited the Lake Creek Mennonite School (see Figure 8-24). We watched hard-working farmers through a growing season (see Figure 8-25). We attended Sunday worship services.

Photographing the Mennonites challenged many of my concepts of privacy. It was necessary to overcome an internal conflict over asking people to surrender their intense spiritual privacy and permit me to find images beyond the routine and sentimental. It was particularly difficult finding a way to respectfully make photographs of the Mennonites at worship.

I began a campaign of weekly attendance at Sunday worship. For hours, over many weeks, I sat in the back of a Mennonite chapel. I did not bring a camera. One Sunday I attended with a single camera over my shoulder; I did not make pictures. There were no objections.

Finally, one Sunday evening in late summer I made several frames from my seat. Still no objections. A final visit produced the image I had hoped for of worshippers on their knees facing the backs of their pews in prayer (see Figure 8-26). One member of the congregation voiced his disapproval and so I stopped photographing.

I drive the green corridor up Peoria Road these days and nothing seems to have changed. It is a peaceful road. I have no wish to disturb that peace. I was allowed a moment to glimpse the Mennonite community and attempt to tell its story (see Figure 8-27). My cameras stay tucked away in their bag.

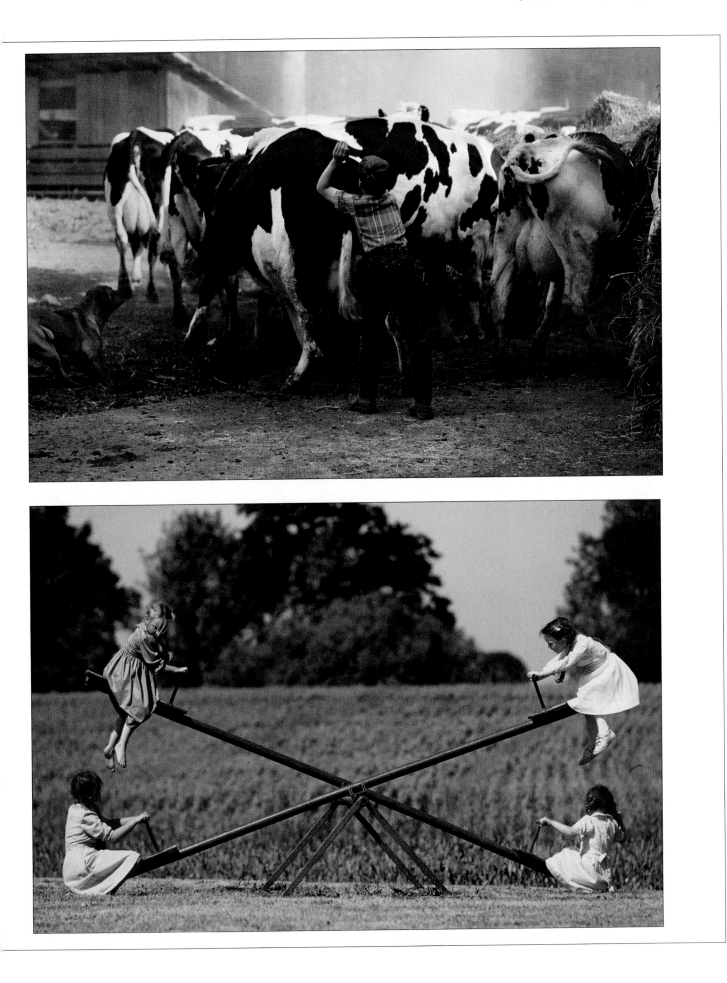

The Mennonites,
Paul Carter
Figure 8-25
Laban Kropf takes a
dinner break during the
grass seed harvest. Wives
gather in the fields to serve
their husbands through
the long hours of the
harvest. Courtesy of Paul
Carter.

Figure 8-26
At prayer in the
Harrisburg Mennonite
Church. Women sit on one
side of the church, men on
the other, in one of the
two Sunday worship
services that last a total of
about four hours.
Courtesy of Paul Carter.

Figure 8-27
At dusk, an elderly
member of the community
takes a stroll walking the
perimeter of the field near
her house. This image was
a most fitting "closer" for
the original series on the
Mennonite community.
Courtesy of Paul Carter.

Sports Photography: Capturing Images on the Fly

Sports photography is an especially difficult facet of photojournalism. It requires a keen eye, patience, stamina, good instincts, and sharp reflexes. The primary charge of the sports photographer is to capture the action and essence of the game, event, or match (see Figure 8-28).

Sports pages tend to consistently attract an inordinate amount of newspaper readers. Many fans are, indeed, fanatical about following their favorite teams. Many can recite chapter and verse of line-ups, statistics, records, and dates and can bear witness to having experienced at least one special moment. Speaking of record books, smart sports photographers not only know the game, they check with statisticians regularly and anticipate new records. In many ways, fans are not unlike the athletes they follow. They both share a relentless commitment to the sport. It isn't by accident that most sports, but particularly professional sports, have become big business. Sadly, the bottom line has alienated some fans and jeopardized supporter loyalty in major league baseball and the NBA. But for the most part, sports continue to thrive, not just professional sports but their college and high school counterparts. Even metros devote a large chunk of space to high school coverage, scores, league listings, features, and season overviews.

Clearly, great sports photographs tell the story in a single image. It's about the critical moment that sums up the agony or elation of a contest's outcome. That might be a razor-sharp image of stopped action, beads of sweats exploding off the faces of two basketball players leaping for a rebound, or that split second the running back hurls himself over battling linemen and into the end zone. A masked goalie arches and turns to catch the puck. A "bronc" rider launches high off a bucking horse. The image might freeze the coach nose-to-nose with a referee, or record fans ecstatic over a last-second, half-court swish to win the game, or a despairing cheerleader. Expressions are important to any "decisive moment" (see Figure 8-29). Sports are no exception.

Some photojournalists make a career of sports photography. In some instances—at large metros, for example—they may work for, or primarily for, the sports department. Sports magazines may have a small staff of photographers and/or use contributing and freelance photographers. There are also many other opportunities; the list is extensive but quite incomplete: sports equipment companies, college and university athletic departments, professional sports teams or clubs, athletic sportswear, stock photography, catalogs for companies who specialize in gear for every sport you can imagine—from soccer to whitewater

Figure 8-28

Goal!, Carlos Gonzalez This image is a dramatic example of "decisive moment" photography. Carlos Gonzalez was in the net for this one. Well, at least his camera was. Truly, nailing a crucial instant in a game that moves as swiftly and frantically as hockey is extremely difficult. Carlos Gonzalez, photographer; Deb Pastner, photo editor; Mark Hvidsten, sports designer. Image courtesy of Carlos Gonzalez and the *Minneapolis Star Tribune*.

rafting, from baseball to skiing and mountain climbing. And, of course, there is also advertising.

One photographer who has made a splendid career for himself as a sports shooter is Eric Evans (see Figure 8-30). His path to this career choice sprang from three things: a passion for photography, a passion for sports, and an aversion to an eight-to-five job. Evans has worked as a freelance photographer for over ten years, pursuing his life-long dream of combining his passion for outdoor pursuits with photography. He's trekked, kayaked, mountain biked, and skied all over the world, sharing his spectacular view of the world through his camera lenses. His clients have included Amoco, JVC, Ford Motor Company, Hinman Vineyards, Canon USA, Marlboro, Wrangler, Kodak, Dagger (kayaks), Stohlquist (lifejackets and whitewater gear), Silvan Ridge Wineries, and Subaru. His photojournalist work has appeared in many publications, including *Sports Illustrated*, *Paddler*, *FLUX*, *Parade*, and *National Geographic Adventure* magazines. He has worked as a com-

mercial photographer for stock companies and shot for athletic departments; he has also been chief photographer for Cascade Outfitters' award-winning catalogs (see Figure 8-31). Evans has also provided photographic imagery for film and TV projects and was hired as a still photographer for the critically acclaimed PBS series, *Trailside*; Universal's *The River Wild*; and *Anything Wild*.

Eric Evans' statement comes from an edited series of interviews he had with William Ryan for an article on sports photography.

If your experience is anything like mine, you'll probably get your earliest photographic opportunities working for campus publications. If you're thinking about internships or securing a job as a photographer, the first question you'll likely be asked is 'Did you shoot for the university newspaper?' The second will be to see your tear sheets and portfolio. Whatever you do, don't pass up that opportunity.

My first serious breakthrough was a photoessay that I did on the homeless that I pitched to the university magazine. In addition, I did quite a

bit of sports photography for the university newspaper, the Oregon Daily Emerald. *Getting accepted after graduation for the "Eddie Adams Workshop" was another highlight in my photographic education. But the most important lessons I learned were in the field. Shortly after the workshop, I hooked up as a photographer's assistant for several accomplished photographers, including John Justina and David R. Stoecklein.*

In 1994, I took a job as a photo assistant with David R. Stoecklein, renowned commercial photographer. For two years, I helped his fast-paced, international commercial photography operation. He organized all aspects of the photography department, including management of a stock library (encompassing more than 200,000 images), as well as coordinating all photo assignments and productions. We worked for a wide range of clients, including Amoco, Canon USA, Ford Motor Sports, Kodak, Marlboro, Wrangler, and United States Tobacco, just to name a few. But the lessons I learned were priceless. Not just technical aspects of working commercially— shooting, lighting, or working with a variety of systems—but how to work with clients, copyright and legal issues, how to sell and lease photographs, secure credentials, keep records, and how to survive as a freelancer—all of which

proved to be invaluable when I decided to begin my own freelance photography operation—Eric Evans Photography (see Figure 8-32).

What follows is a short list of things I hope will help anyone thinking about working as a freelancer in this business. And it is a business. Make no mistake about it.

- *Clearly define what kind of photography you want to do. Weddings, sports, photojournalism, wildlife, studio work, whatever.*
- *Assist others. A full-time assistant position with an established professional will teach you more about the industry faster that you can figure it out on your own. It's a less traumatic school of 'hard knocks.' And for some people,*

Figure 8-30

White Horse Rapid—Deschutes River, Eric Evans (self-portrait with assistance of Karen Belshaw) Eric Evans specializes in sports photography, with a preference to work with extreme sports. Evans recently joined the ranks of Imagestate—a stock agency in New York, NY. When he's not on the road or freelancing for clients, he is the official sports photographer for the University of Oregon Athletic Department. Evans was also the chief photographer for the golf book, *Breaking 100.* Evans is an alumnus of The Eddie Adams Workshop. Courtesy of Eric Evans Photography.

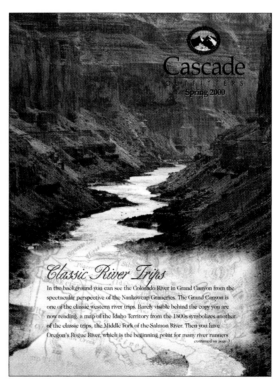

Figure 8-31

Lone Pine Rapid—South Fork of the Payette River, Idaho and *Grand Canyon Vista, Colorado River,* Eric Evans

Evans demonstrates two dramatically different approaches to cover photography for Cascade Outfitter's stunning catalogs. The first is a photograph made at the main drop on the South Fork of the Payette River. Evans captures the split second the raft—completely inundated—punches through the drop. The rower's expression says it all. The second image is a shot of the Grand Canyon. Both are breath-taking for different reasons. Courtesy of Cascade Outfitters/Eric Evans.

Figure 8-32
Skiing, Eric Evans
The most difficult sports photography involves fast-moving sports—skiing, football, basketball, auto racing—and sports where the movement or direction of participants is unpredictable. This explosive image was shot with a long lens and fast shutter speed. Courtesy of Eric Evans Photography.

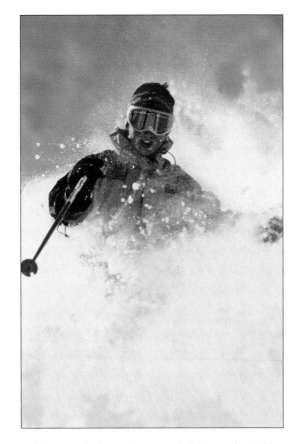

it's a good alternative to a finishing school like Brook's Institute or the like.

- **Develop your own style.** *Study the work of the best photographers in the field or genre of photography you plan to pursue. Even emulate them, if you want. You'll learn an incredible amount about composition, lighting, and style, and eventually your own vision will materialize.*

- **Develop your portfolio and website.** *Normally, at least to start, have 15 to 20 strong images. Make sure most of them have people in them, unless you plan on doing studio or landscape work. If you're trying to get a job with a newspaper, you should have a good mix of sports, spot news, and feature work. Most of the images can be stand-alone stuff, but have at least one photo-essay included with three to five photographs that work together to tell a story. Remember this too: photographers are not judged by what they shoot, they're judged by what they show. Be your own toughest editor, and don't compromise a portfolio by putting anything in it that isn't solid.*

- **Enter student competitions.** *Competing is a great way of testing your mettle against your*

peers and a good way to get your name out there. CMYK has regular photo competitions.

- **Educate yourself.** *Learn how other professionals work in your chosen field. This means going beyond your college courses. Go to local magazines, newspapers, and other publications or agencies and talk to working professionals. Join SND, NPPA, and local photographic organizations.*

- **Invest in yourself.** *That means making some sacrifices. You'll also need to put together a photo system for yourself. Nothing about photography is cheap, especially today. So, you'll likely start off with a camera body and several lenses, a strobe unit, and a tripod. Build on it from there. One of the nice things about working for a professional photographer or a newspaper is that they typically have equipment you can use. Today, it's also important to have tools such as Adobe Photoshop and QuarkXPress. Definitely, know Photoshop thoroughly. Newspapers and other likely places for you to score internships will appreciate any computer software savvy you have.*

- **Set serious goals for yourself and follow through with them.** *Remember: it's unlikely you're going to go from student to professional photographer in one leap. It takes time, patience, hard work, and a good plan.*

- **Shoot a lot of film.** *Take your cameras and equipment everywhere you go and make pictures. Shooters shoot.*

- **Learn to keep good records.** *Do all the paper work, assignment and work sheets, billing forms, etc. This probably sounds boring, but it will not only help you keep track of your business, it will prove valuable when working with the Internal Revenue Service.*

Sports photography is all about shooting for the ultimate *individual* photograph: ideally, one that will tell the story of the event, game, or its outcome—the game-winning goal, hit, shot, catch, slam-dunk, move, block, or throw. Typically, that means getting hundreds of other shots because you never know which of those will determine the final outcome. Therein lies one of the most compelling aspects of athletic contests—anything can and often does happen.

These are some tips for covering sports:

Try to record strong expressions both on and off the court or field. Coaches are often as emotional as their players are, and don't forget fans, mascots, cheerleaders, or even vendors. Photojournalist David Grubb assembled a marvelous feature on Pac-10 basketball coaches. Along with the feature story, Grubb provided animated shots of each coach in the conference.

Know the sport (subject) you're shooting. Whether it's hockey, gymnastics, baseball, kayaking, football, or ping-pong, if you don't know the sport, how can you anticipate the action or strategically plan a shot? Anticipate the action. The more you watch sports and a particular team, the more you get a sense of the ebb, flow, and tendencies of the sport. Think ahead and try to be where you think the action will be going. Position is crucial. Understand the lighting situation as well. Where is the sun? The old diagrams on the boxes of Tri-X film provided helpful information; they suggested you keep the light source to your back. That's still good advice. What does the background look like? Where is the action headed? Again, photography is a subtractive medium—work to eliminate distractions (see Figure 8-33).

Use your shutter speed to help tell the story. Slower shutter speeds can lend a sense of motion to an image. Conversely, faster shutter speeds or a strobe can stop or freeze the action (see Figure 8-34). Understanding your camera and lenses is crucial. Use depth of field, selective focus, and shutter speed to capture the action. Panning with the action can also add to the sense of motion, especially when shooting at slower shutter speeds. Some sports photographers will pan with flash. The result is the subject you're panning will be stopped and in focus, but the background will be blurred.

Employ selective focus to blow out the background. This is accomplished by shooting at a *wide aperture* setting. It is also important to learn how to position yourself to subtract busy backgrounds (see Figure 8-35). Photography is the art of subtraction—no matter what the specific genre is.

TYPICAL SPORTS PHOTOGRAPHER'S KIT

(2-3) Digital camera bodies
(2-3) Film camera bodies
Lenses:
 17-35 mm *f*2.8
 50mm *f*1.4
 70-200 mm *f*2.8
 300 mm *f*2.8
 400 mm *f*2.8
 600 mm *f*4
 1.4 Extension
 2× Extension
Lightmeter
Flash
Camera remotes
Strobe kit
Grip kit
Waterproof housing
Mono pod
Sturdy tripod
Compact Flash Cards (data storage for digital cameras)
Film
Canned air
Batteries
Battery charger
Knee pads
Good fanny pack
Rain coat
Rain pants
Hand towels (if raining)
Camera covers
Umbrella with clamp (attaches to tripod)
Hand truck
Shot list!

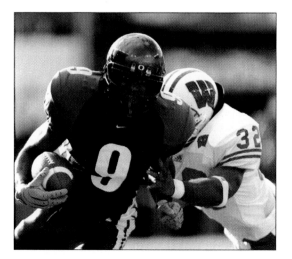

Figure 8-33
Sweep Right, Eric Evans Long glass (i.e., a long telephoto lenses) brought this football action up close. Note the low camera angle (Evans shoots much of sports from his knees), blown-out background and extreme selective focus that is inherent with wide aperture settings and long telephoto lenses. Courtesy of Eric Evans Photography.

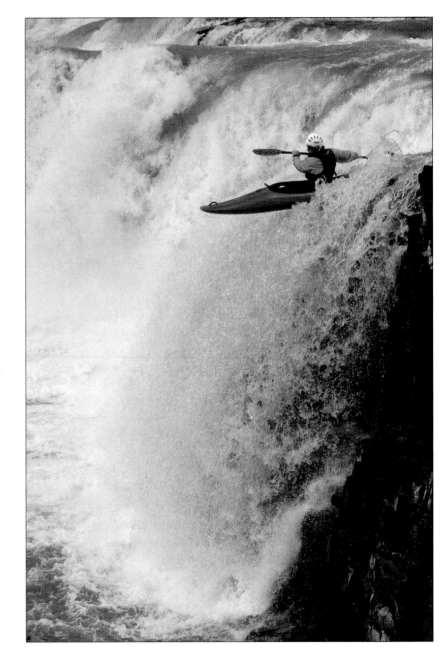

Figure 8-34
Kootenai Falls—Montana, Eric Evans
Launching yourself off a waterfall this size can be more than a little bit intimidating. Evans nails the moment at 1/1000th of a second, the instant the kayaker "boofs" himself off the rim of Kootenai Falls. In this instance, it was important that you see not just the boat dropping over the falls, but the size of the drop. The kayaker and kayak establish a sense of scale. Courtesy of Eric Evans Photography.

Figure 8-35
Breaking 100, Eric Evans
How the action is shot is almost as important as the sports action itself. Here, Evans employs a ladder to shoot the golfer hitting out of the trap. Shooting downward provides a unique camera angle, and it can eliminate distracting backgrounds.
Photography by William Ryan (macro shot, left page) and Eric Evans (ladder shot, right); art direction by Ryan.

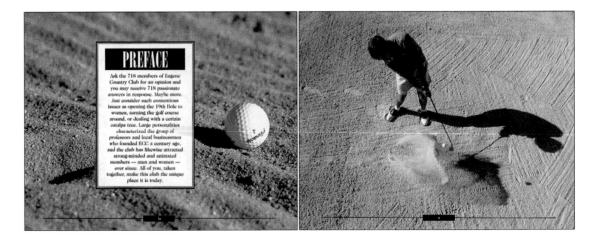

Consider using fixed or position focusing. This technique is useful if maintaining a specific sense of scale in a series of photos is important to you or your assignment. Using this method, you adjust yourself to focus. For example, if you want to have consistently scaled images of people—fans, coaches, and players alike—and you want them at a distance of five feet from you, simply focus at someone five feet away and don't touch to focus control; instead, simply adjust yourself so that you're five feet away from the subject. You also can use the distance scale on the top of your lens to determine five feet.

Use a motor-drive or auto-advance system to make a continual series of shots. This will ensure that you're able to capture at a critical moment, such as the release of a javelin, the ball meeting the bat, or a great spike at a volleyball game. Don't forget, though, the more film you shoot, the more you have to edit. More technical talk: zoom lenses can prove invaluable when working the sidelines or at basketball games to pull up and down the court. A long lens is invaluable for baseball, football, or any other situation that requires you to have a lot of reach (see Figure 8-36).

Depress the shutter before the action peaks out for extremely fast moving sports. A racecar tearing around a corner, or a golfer hitting out of a sand trap might be past the height of the action by time you expose the frame (or gone in the case of the lead Ferrari). As with anything involving timing and coordination, practice makes perfect. Exercise your reaction time. Keep your eyes open and intuition sharp (see Figure 8-37).

Try to keep good logistics in mind. In real estate, there's an adage, "Location is everything." It also happens to apply to photography. Get low when shooting long lenses. Eric Evans has a good rule for shooting action: "I shoot a lot of sports from a kneeling position. I find this cleans up the background and squares you up to the athlete's body." Getting low to the ground can also offer an unusual and compelling angle. "Explore other interesting angles. Always look for a good vantage point to give you an unique shot—and be patient. Not all the plays will come your way, perhaps 30 percent in a football game, so be ready for the action when it does come your way. Don't count on luck. Be ready to nail it when you get your chance."

Attempt shooting from different angles, perspectives, and positions. Doing that will help you avoid predictable frames of reference and making predictable pictures. Recently, when shooting golfers for *Breaking 100*, Eric Evans and your author made sure they had a stepladder along. Getting above the action may provide a fresh vantage point and help eliminate background distractions (see Figure 8-35).

Figure 8-36
Baseball at Recess at the Mennonite School, Paul Carter
Sports have a universal appeal, no matter the culture. On graduation day at the Mennonite School in Harrisburg, Oregon, children play a fiercely competitive game of softball. Great photography is all about capturing the essence of an event, expressions, and compelling content and context. Courtesy of Paul Carter.

Figure 8-37
Headless Horse, Kim Agersten
Following a horse in a viewfinder at a race or steeplechase is a difficult task, and so is keeping track of rear action. Note how the composition shows a relationship between the horse (upper left intersection) and disgruntled rider (lower right). Kim Agersten, photographer; Per Folkver, photo editor for *Politiken* (Copenhagen, Denmark). Courtesy of Kim Agersten/*Politiken*.

Figure 8-38
Eagle on Eight,
Eric Evans
The success of this image
is a mix of compositional
ploys (ground thirds,
selective focus, strategic
placement, and a low
angle of vision) and
capturing a decisive
moment: making the
exposure at the moment
the ball is falling into the
cup. Cover shot, *Breaking
100.* Photography by Eric
Evans; art direction,
William Ryan.

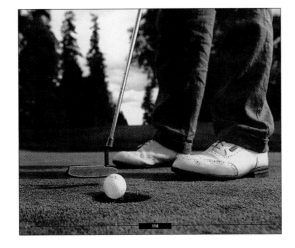

Don't forget to keep a program. Typically,
veteran photographers are familiar with the
home team, but not so well acquainted with the
visitors. That fact might not seem like a big deal
at kickoff. Several hours later, when you're
writing captions, however, a program may prove
an invaluable identification tool.

**Don't forget: your job is to tell the story
visually.** Try to nail a lead photograph, a good
"closer," or a summary image—a photograph that
reveals not just the action of the sport or event,
but its drama and emotion (see Figure 8-39).

Tom Wheeler is the former editor of *Guitar
Player* magazine, a professor of journalism, and
widely publisher author. His book, *Phototruth
or Photofiction,* examines how digitally
manipulated photography has provoked a flood
of ethical questions and "raised doubts about the
public's ability to trust photographs as represen-
tations of 'truth' or 'fact.'" Today, we are cultur-
ally conditioned by a nonstop flow of visual
impressions daily, from the run-of-the mill to the
iconic. However, it is important—*crucial*—that
the reality in our contemporary world is
delivered honestly through photographs.
Photojournalism must be committed to truthful-
ly documenting the immediacy and intimacy of
life as it evolves across the street or across
continents. Wheeler's book provides a serious
step in maintaining that direction, along with a
brilliant polemic about a grave problem which
hopefully will not start debates about photo
manipulation, but help end them. The following
is taken from an interview your author
conducted with Tom Wheeler for *Visual
Resources Journal*—and from an edited
statement Wheeler prepared for this text.

Figure 8-39
Finished Line, Paul Carter
Key moments needn't
always be photographs of
the winners. This image is
a case in point. Paul
Carter reflected, "I don't
often photograph sports,
but the annual Prefontaine
Classic Track Meet at
Hayward Field in Eugene
(Oregon) is an 'all hands'
event. Stationed at the
finish line, I made this
picture long after the
winners had crossed the
finish." Courtesy of Paul
Carter.

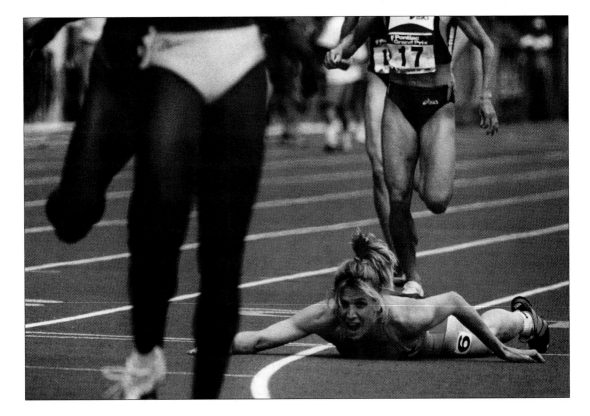

Ethics and the Photographic Image
—Tom Wheeler

We can think of many reasons not to trust mass-media photography. Despite our knowing that even news photos might be no more objective than the stories they accompany, and that some photos, even famous ones, were staged, doctored, or otherwise manipulated for the better part of the twentieth century, we bestow upon photography a remarkable degree of authenticity. We depend on it to document our own lives; to teach us about the world and its peoples, places, events and history; to prove assertions in court; to show the horrors of war, the serendipity of everyday life, and the delights of childhood.

But in a time when seemingly photorealistic, yet obviously implausible, images appear daily in all sorts of media, some observers worry that authentic photos may soon be considered exceptions, throwbacks to a more naive, pre-cyber era. Back in 1990, Andy Grunberg of The New York Times *went so far as to predict that, "In the future, readers of newspapers and magazines will probably view news pictures more as illustrations than as reportage, since they can no longer distinguish between a genuine image and one that has been manipulated." And John Long, former president of the National Press Photographers Association, has said, "The war is over and we have lost… images in computers are totally changeable, liquid, whatever you want them to be. In ads, art, whatever, I have no problem with this, but it is killing documentary photojournalism."*

Not everyone agrees. My colleague, Professor William Ryan of the University of Oregon's School of Journalism and Communication, has said, "I don't believe photography's 'credibility' is on the ropes. We still use it to document our lives… to take us places we've never been via National Geographic, *to catch a glimpse of a celebrity in* Rolling Stone, *to rerun our experience of a football game in the sports section of the local paper… average readers*

know enough about manipulation and its potential for misuse to bring fairly sensitive antennae to their judgment about what they see."

It remains to be seen whether a weakening of faith in photographic authenticity ultimately will undermine the credibility of visual journalism in print, broadcast, cable, and online media. Various books have explored the ethics of digital imagery, as well as the cultural and social implications of manipulated visual media. Over the past 15 years or so, photographers, critics, and educators have explored these topics in scholarly papers and at conferences. Notorious manipulated images, such as Time's *"photo-illustration" of O.J. Simpson, have sparked still more debate, and many practitioners profess to have learned valuable lessons.*

Yet it's difficult to say how far we have come. As image-manipulation tools flood more niches of the consumer market, as we become more accustomed to seeing manipulated images and more accustomed to "Photoshopping" them ourselves, questions about the lines between illustration and visual journalism will continue to defy easy answers.

On the one hand, we recognize that photography itself is an inherent manipulation—a manipulation of light, a process whose many steps and stages are all subject to biases and interpretations. We know that photography is neither absolute "reality" nor unqualified

Figure 8-40

Portrait of Tom Wheeler, photo by Fotomat Will the real Tom Wheeler please stand up? Professor Tom Wheeler teaches magazine writing and editing, as well as a new course called Photofiction at the University of Oregon's School of Journalism and Communication. His most recent book is *Phototruth or Photofiction: Ethics and Media Imagery in the Digital Age* (Lawrence Erlbaum Assoc., Inc.). Among other things, Wheeler is interested in how photo manipulation has affected the credibility of photojournalism today. Wheeler has written for *Rolling Stone,* and later joined the staff of *Guitar Player* magazine, where he served as its editor-in-chief for ten years. He is the author of *The Guitar Book,* as well as *American Guitars,* which reviewers called "the best book ever written about guitars." Wheeler has also contributed to many other books and academic journals. Courtesy of Tom Wheeler.

"truth;" it was never *purely objective. And yet we also know that a photo can* reflect *reality in a uniquely compelling and credible way. We remember the photos that touched our own hearts, horrified us, made us rethink or re-imagine our own place in the world. We wonder, in a media environment saturated in "photofiction," can journalists maintain a stronghold of credibility regarding authentic images, isolating them in the public mind from photo-illustrations and other concoctions?*

Such an accomplishment will require that we take more care in the presentation of our images to the public, not only those images within the narrow boundaries of "photojournalism" and "hard news," but others as well. After all, controversial manipulations to images outside the confines of hard news have already undermined faith in mass-media photography.

In considering an altered image for publication, let's ask whether it will appear in a "non-fiction photographic environment?" This term suggests a mass-media context broader than "hard news," or the strictest definitions of "photojournalism," and includes photos taken for news, editorial, documentary, or any other nonfiction purpose. Simply put, the nonfiction photographic environment is a publishing context to which reasonable readers bring an expectation of veracity.

Of course, purportedly nonfiction photos that are in fact deceptive are unethical, regardless of whether their misleading aspects were introduced before or after exposure. But pre-exposure activities such as posing and staging have already been exhaustively discussed in the literature of photography, so let's focus here on post-exposure processing or alteration. Let's ask, has the image been altered by accepted darkroom practices such as dodging, burning, color correction, or nonmisleading cropping (or their digital equivalents)? Or, have the alterations been so extensive as to render the image an example of what might be called "photofiction?" That is, regardless of technology or methods, have material objects large or small been added, deleted, or rearranged within the frame?

In my view, placing a photofictional image in a purportedly nonfiction environment is ethical only when readers are made aware of the fiction, either by an unambiguous and appropriately prominent disclaimer or label such as "Computerized photocomposite by Imaginary Digital, Inc.," or by the fact that the image is so obviously implausible (e.g. a "photo" of Mt. Rushmore featuring a chiseled-granite Homer Simpson alongside the familiar presidents) that no one is likely to be misled.

Visual journalists will have to accommodate not only new technologies but also shifts in public assumptions about the reality of photos and re-examine their own practices and obligations of disclosure if they are to successfully separate their work from art, cartoons, fantasy, and fiction. No one suggests that the same standards and procedures must apply to classroom photos in yearbooks and battlefield photojournalism in newspapers, even though both categories are ostensibly nonfiction. When assessing the ethics of mass-media photographs, choices must be made, judgments rendered at every step. Where professionals draw the line will depend upon their tastes and their own perceptions of their responsibilities.

But in any case, the promise of a legitimate nonfiction photo is that it fulfills its implied authenticity; it means what it says. The survival of nonfiction visual media's credibility will depend on whether we make good on that promise. In that regard, not much has changed. The ultimate test, as before, is a two-faceted standard of perception as well as honesty: Do our readers think we are truthful? Are they right?

Wheeler addresses serious issues about ethics, credibility, and how and when altering a photo is acceptable. Today, most publications, and other media as well, have rigid guidelines to help eliminate misrepresentation. Still, the challenge of maintaining authenticity is a formidable one, especially given the tools of photo manipulation and the power of visual communication.

Composition: Structuring the Photographic Image

Composition is the organization or grouping of an image's parts into a cohesive whole. It is achieved by strategically ordering the space and elements within your frame and finding and showing meaningful relationships between the various visual elements and the context of the situation, person, or event. How does Cary Wolinsky achieve those ends in his image *Skateboarder*? (See Figure 8-41.)

Photography is not only the most commonly used means of visual communication today, it's central to our experience. We encounter it everywhere. It documents important moments in our personal lives, records history, sells products, makes artistic statements, and bring us visual reportage from all over the world in our magazines, newspapers, websites and other media. How images are structured and presented to us varies enormously, though. Typically, there is a vast difference compositionally between photography as an elite art form and the snapshots that fill the dog-eared pages of our scrapbooks.

Interestingly enough, however, that difference in form (or even content) may not be so evident between photos on gallery walls and documentary images, photojournalism, or commercial work. Those genres of photography share and employ the same basic compositional principles. What's more, using these concepts may blur the boundaries between documentary and art, or even photojournalism and art. Indeed, galleries and museums all over the world collect photojournalistic and documentary work.

First and foremost, photography is a subtractive medium (see Figure 8-42). Clearly, the most common reason photos fail—beyond the technical requirements that they be sharp, properly exposed, and have good contrast—is because they're too busy. Their intent and often their information are lost in a ghetto of visual junk. As a photographer, your charge is to impose order within the image, whether it is moving or still. Your tools include all the design principles, elemental form, and an array of compositional (visual) devices.

Common Compositional Shortcomings and Their Solutions

Understanding the most common photographic shortcomings is a good starting place to begin learning composition. The five most common photographic clichés are halved imagery, over-centering, overuse of the horizontal format, posed photographs, and working too far from your subject.

Figure 8-41

Skateboarder,
Cary Wolinsky
Composition is about capturing the essence of a subject or situation, and ordering its elements in such a way as to impart a sense of having been there. In so doing, it is important to understand the *subtractive* nature of effective composition, too. In this case, *National Geographic* photographer, Cary Wolinsky, selects a low camera angle, strong diagonal lines of force, and strategic placement. Notice, too, how he's used a neutral background (sky) to set off the skateboarder. Courtesy of Cary Wolinsky.

Figure 8-42
Water Buffalo, Varanasi, India, Cary Wolinsky
Wolinsky's photograph of a water buffalo bathing in the River Ganges in Varanasi, India, transfixes the viewer. The animal appears to be floating in space rather than the Ganges. Notice how Cary Wolinsky uses contrast, textures, and repetitions (buffalo's head and reflection) in this meticulous composition. Courtesy of Cary Wolinsky.

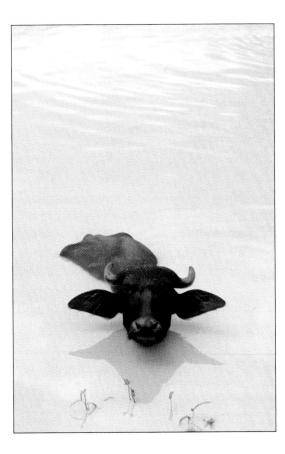

Halved Imagery

Halved imagery or breaking images into halves, one-half foreground/one-half background, makes for a static spatial dynamic. Nothing is emphasized or featured. Nothing dominates. *Solution? Ground thirds.* This concept is also known as golden mean or golden oblong. It suggests breaking images up into one-third/two-thirds divisions to provide emphasis and a better sequencing to the image. That the space is precisely broken off into pieces of one-third to two-thirds proportions is not imperative. You might employ ground fifths, or eighths, or tenths. What is important is that you emphasize something and break the space within the frame in an interesting and meaningful manner (see Figure 8-43).

Over Centering

Over centering of the subject is often due to the photographer's reliance on the center-weighted metering and focusing systems of most cameras, particularly the 35mm format. Typically, photographers focus on the main subject or principal element of the image, which goes where? Correct. Dead center. *Solution? Rule of thirds,* also known as strategic placement or off-centering. Basically, this strategy divides the image area into thirds,

Figure 8-43
Wind Turbines, Columbia River Plateau, Kipp Wettstein
Anyone who has walked or driven through the Columbia Plateau or its high desert terrain knows how huge the sky looms there. Montana isn't the only area that warrants the moniker, "big sky country." Wettstein frames this image so that only a sliver of the barren landscape is visible at the bottom of the image. This spatial division is a real stretch of "ground thirds"—probably ground twenty-fifths. What does he communicate in the composition? What does his use of space suggest? How? Why? Courtesy of Kipp Wettstein and *FLUX;* art direction, Emily Cooke.

both vertically and horizontally (see Figure 8-44). The optimum points of placement are situated at or around those intersection points. Those spots are considered ideal locations for placement of subject and main elements (see Figure 8-45). The rule (or principle) of thirds is related to but completely different from ground thirds. Centered images, though, can be used effectively for confrontational purposes, or for creating bilateral symmetry in an image.

Figure 8-44
The concept of the rule of thirds is basic. To eliminate the visual cliché of over-centering a photo's main element or subject, divide your frame up into thirds vertically and horizontally; at or near the intersection points are ideal points of placement.

Figure 8-45
Flag, Toronto: 9/11/01, The Toronto Star
This moving photograph captures a Canadian woman's grief over the tragedy of September 11. Rule or principle of thirds was employed here. The woman's face is at the upper right intersection, and the flag is at the lower left intersection. Note, too, how the two prime areas (woman's face and the star area of the tattered flag) relate to one another. Hans Deryk, Photo Editor; Tannis Toohey, Jim Rankin, Bernard Weil, photographers. Courtesy of Toronto Star Syndicate.

Overuse of Horizontal Format

Often beginning photographers never think to adjust the camera's format or alignment from a horizontal position (the way the camera is configured and slung on the camera strap) to a vertical position. *Solution? Linear thought.* This strategy simply suggests that the shooter note the basic flow of the lines within the frame. If they are predominantly horizontal, make a horizontal image. If the lines are predominantly vertical, move the camera a quarter turn and accommodate the image vertically. Look at Gordon Parks' classic Farm Security Administration photo. See if you can apply all three of the above compositional strategies to this famous photograph (see Figure 8-46).

Posed Imagery

Over the course of a normal day, a photojournalist may likely be called upon to make portraits, and—even more commonly—to cover planned or staged events, such as news conferences, speakers, ribbon-cuttings, and a variety of what Daniel Boorstin referred to as *pseudo-events.* Predictable results include mugging subjects, subject

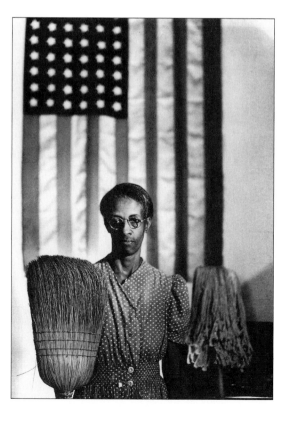

Figure 8-46
American Gothic, Washington, D.C.,
Gordon Parks
Gordon Parks was an intern and the only black American who worked with the FSA for Roy Emerson Stryker. Clearly, he was also the most multi-talented man in the agency. Poet, fashion photographer, filmmaker and director (*Shaft*), playwright, documentary photographer, and athlete. What is this image reminiscent of? What are the vertical cues that correspond to linear thinking in this image? Courtesy of the Library of Congress. © Gordon Parks.

in front of a microphone, hand-shaking, and myriad other boring images. *Solution? Make images both before and after the event*, in addition to the event itself. Look for interesting behind-the-scenes activity and use interesting camera angles (see Figure 8-47).

Working Too Far from the Subject

Beginning photographers have a tendency to be a little shy; consequently, quite often they'll shoot their work at a distance. Your author refers to this as the "hey, look at this great shot of the deer" syndrome. The result is a photograph with a deer about the size of a pea in a 5″×7″ print. The photographic equivalent of *Find Waldo*. *Solution? Get used to getting up close to your subjects and the action* (see Figure 8-48). Often, though, physical circumstances, police lines, crowds, or other factors impede your proximity to the subject. In these instances, go to your telephoto lenses. A good rule of thumb for any assignment that involves a portrait is to make several very tight images. It isn't by accident that magazines and other publications run tight portrait shots on their covers. They can be compelling and capture the soul of a subject, and we're all interested in people. In any event, if a photograph of the subject is what's going to drive the story—and it often is—make sure you get a variety of good shots. That includes *tight* shots (filling the frame with the person's face, *environmental images* (showing subjects in their surroundings or engaged in the activities that say something about who they are), and other shots and angles that help reveal the personality of the subject being photographed.

Other Compositional Strategies: Form & Order

In addition to the solutions to compositional problems discussed in the previous section, there are several other devices that can be used to bring form and order to the composition of a photograph.

Intersecting Lines

The human eye is invariably and involuntarily drawn to junctures; therefore intersection points are used as strategic points for placement in composition. Remember, too, lines may be literal—an arm, tree limb, or rifle barrel—or they may be implied—a series of dots or pieces with which our eyes connect. Look at Lange's *Migrant Mother*: where are the implied lines and their intersection? (See Figure 8-3.) The lines also may be very real; in William Ryan's *Opening Day, Clay County. S.D.*, a rifle barrel and car rack intersect at a key area of the photograph (see Figure 8-49).

Figure 8-47
Senate Debate, Patrick Davison, *The Dallas Morning News*
Basically, this assignment was another staged event with its usual limited photographic options, clearly, a 'talking heads' kind of an event. However, photographer Patrick Davison manages to capture this wonderful image of the principals and uses the raised hands of reporters to frame the image, and in so doing, gives it a surreal kind of feeling. The hands of the reporters also help frame the image while working as directional devices. Patrick Davison, photographer. Courtesy of *The Dallas Morning News*.

Figure 8-48
Teodora, Carlos Puma
Teodora is an 80-year-old Kumeyaay elder spokeswoman who heads the tribal government in La Huerta, Mexico. Gordon Johnson, the *Press-Enterprise* reporter who wrote this photo-story observed: "In the heat of the day, Teodora sits on an old car seat propped against the trunk of a mulberry tree. The midday wind rankles the leaves, pushing them this way and that, like petting a cat opposite to the way the fur grows." Teodora has reared 13 children and buried three of them—"casualties of life, in the graveyard just down road." Photography by Carlos Puma; story by Gordon Johnson for the Riverside *Press-Enterprise.* © Carlos Puma/*Riverside Press-Enterprise.*

Figure 8-49
Opening Day, Clay County, from *The Deerslayers,* William Ryan.
This photograph is one of a long series of images made on the opening day of deer season in Clay County, SD. Intersecting lines are a very important component of this composition. What other compositional ploys are used here? This image has been sepia-toned; the brown tones warm the image. Why do you suppose the photographer decided to tone all of the photographs for this documentary project? Photography courtesy of William Ryan.

Circular Form

Like intersecting lines, circular forms, frames, and shapes funnel our vision. The best photographers (the likes of Cartier-Bresson, Mary Ellen Mark, Walker Evans, Danny Lyon, Steve McCurry, and Cary Wolinsky), who realize that tenet of composition, use circular form, as well as intersecting lines, selective focus, and the like throughout their work (see Figure 8-50).

Lead-ins

Associated most commonly with diagonal shapes, *lead-ins* direct our vision into or through a plane. Strong lines of diagonal force can help suggest motion to us. In a photo from *Conversations with the Dead*, Danny Lyon sequences our vision through the entire frame via the "z-readout" pattern that is discussed in chapter five on design principles (see Figure 8-51). He is also showing us

Figure 8-50
Untitled, 1999,
George Rowe
George Rowe framed Jean Millies in this photograph from the inside of the aging 48-foot trawler, Orca. The photograph, from "One Last Catch" in *FLUX* magazine, demonstrates how circular cropping can be an effective framing device. What other compositional devices has Rowe employed in this simple but well-composed photograph? Courtesy of *FLUX*.

Figure 8-51
Photograph from *Conversations with the Dead*, Danny Lyon
Lyon is a master of composition and incorporates elemental form, design principles, and a mix of other structural strategies in his work. He has a gift for maintaining a delicate balance between content and form. Lyon is capable of delivering scintillating structure to even his most grim subjects—hardcore convicts in one of the toughest penitentiaries in the country. Look closely at the photograph, even the gardens within the prison have walls around them. © Danny Lyon/Magnum Photos.

some of the more obvious manifestations of being institutionalized. In prison, lines are part of the daily ritual: moving from one area to another, eating, showering, or work detail (see Figure 8-5).

Selective Focus

Selective focus is another subtractive device and is achieved when the photographer shoots or records an image at a comparatively wide aperture setting ($f1.4$; $f2.5$; $f4$; $f5.6$). Wide aperture settings physically compress the depth of field in a still or moving image, and consequently limit what you can see sharply in the frame. *Depth of field* is what is sharp (or in focus) in an image, i.e., what amount of the foreground and background that is in focus along with the subject or main element. Ryan's image of the hanging deer (*Deerslayer Series*) uses just the right amount of selective focus (see Figure 8-52). All photographs and moving film have depth of field. However, the area of sharpness varies, depending upon what aperture setting is employed by the photographer or cinematographer.

Framing

Another subtractive compositional technique, framing, uses elements (typically, non-essential ones) in the film frame to enclose or structure the image. Usually, framing devices sequence or direct our vision to the framed area or the components within it. Very often, elemental forms are used as framing devices, most commonly, L, T, O, and even triangular shapes which suggest strength and security, as in Dennis Dunleavy's moving portrait of a mother and her newborn infant (see Figure 8-53).

Figure 8-52
Hanging Deer, from *Deerslayer,* William Ryan This image is part of the larger *Deerslayer* documentary series (see Figure 8-49) mentioned earlier. Here selective focus has been used. (This image was shot with a 105 mm NIKON lens at $f/5.6$.) Compositionally, the subject was deliberately centered to bring an eerie kind of symmetry to the photograph's "still life" quality. It is not a color photograph in the conventional sense; this silver gelatin image was hand-colored with oils by the photographer. Photography courtesy of William Ryan.

Figure 8-53
Teresa and Her Newborn Infant, Diana Carina, San Antonio, Texas, Dennis Dunleavy. Both selective focus and framing are employed in this memorable portrait. "Teresa came from El Salvador three months pregnant. During her case for political asylum before a federal judge, Teresa described her rape by government soldiers in her village. However, without help from the Salvadoran government in corroborating her claims, the case was denied. While waiting for possible deportation, and after several months in a detention facility, Teresa joined her mother, who had entered the United States illegally three years earlier, in San Antonio. Before dawn, shortly after Halloween, Teresa gave birth to Diana Carina at home with the help of her mother and a mid-wife. This image of Teresa and her baby was made just minutes after birth. The photograph reminds me of many of the religious icons depicting Mary with the baby Jesus. There is intimacy in this moment that is hard to describe, but it is something I will never forget." Courtesy of Dennis Dunleavy.

Figure 8-54
Leaf, Paul Carter Textures help dress out the color and contrast in this Paul Carter macro shot of a leaf, adding the sense of touch to this touching photograph. Beauty and powerful visual content often come from the simplest of things. Courtesy of Paul Carter.

Contrast

The use of contrast—placing dark things against light backgrounds and vice versa—may be literal or figurative. Non-visual concepts also may be contrasted, for example, rich and poor, young and old, life and death. Heavy contrast in an image may help bring a dramatic edge to it. Photojournalists used to "burn in" the outside edges of their images to steep the contrast and give them more visual "pop." Dunleavy's photograph (see Figure 8-53) uses contrast doubly: light and dark, literally, as well as the young and old subjects.

Texture

Texture, the use of closely interwoven elements, has an inherent incongruity. We normally don't equate *tactile* sense with sight, but that's precisely what texture suggests to our vision. It brings a tactual sense to imagery, allowing our eyes to play Braille, so to speak. Our eyes love to examine and compare textures. When you can integrate color along with those textures, the effect is even more dramatic and effective (see Figure 8-54).

Figure 8-55

Flooded Forest in Western Australia, Cary Wolinsky Once again, beauty thrives in simplicity. This time the point is driven home clearly by *National Geographic* photographer and freelancer Cary Wolinsky. Among other things, the master photographer has a gift for isolating his subject. Here, though, repetitions from the lines, organic shapes, and water invoke a hypnotic kind of beauty. Courtesy of Cary Wolinsky.

Repetition or Repetitious Form

Repeated elements echo a shape or configuration. Eyes like visual repetitions. Some common examples include motif, reflection, shadow, and form. How does *National Geographic* photographer Cary Wolinsky achieve that effect in his image of a flooded forest? (See Figure 8-55.)

Juxtaposition

Simply, *juxtaposition* is an arrangement in an image where (usually) the dominant subject or element is facing one direction in contrast to other elements within the frame. Juxtaposition, too, is a strategy that is subtractive; it works by directing our vision to the element that is linearly in contrast with the rest of the composition.

Gridding

The *gridding* approach to composition is closely akin to framing. Typically, it makes use of windows, doors, shadows, pillars or other physical or implied lines to create smaller modules within a space. In a sense, it is a more involved version of framing that helps structure and layer the image to create separate pictures within the larger one.

Close-ups

Close-ups or tight shots, in and of themselves, often do several good things concurrently: fill the frame so there are no problems with visual clutter and bring interesting textures and details, as well emphasis, power, and impact. *La Luna* uses a gritty, tight crop of David Bowie's face on its cover to feature him (see Figure 8-56).

Parallel Structure

Parallel structure involves finding a strong element within a composition, perhaps an O-shape, strong diagonal line, cropping strategy, or some design element, and reestablish it structurally into other images. Art directors will often deliberately set up a physical structure in a print ad, and, using its configuration as a footprint, build successive ads that use that same structure. Absolut vodka ads come to mind. Using this strategy, photographers can work interesting structural relationships between images, too, as Rick Williams demonstrates in his book *Working Hands* (see Figure 8-57, Figure 1-47, Figure 1-48, and Figure 1-49). Remember the Gestalt approach to visual communication theory?

Combination of Compositional Strategies

Good composition is best achieved when a combination of devices or strategies are used together. In addition, compositional devices are not ends in and of themselves, which is to say they should lead up to something. Finally, less is more; simple is better. Look closely through all the examples in this chapter and study how multiple compositional ploys are used within the photographs.

The best photographers and artists have an inner sense of composition, but clearly, it can be easily learned. Great photographers often don't have the time or situation to ponder compositional issues, using ground thirds and lead-ins, or to think about how they're dissecting the frame, they simply react to a scene or situation and make the image. Instinctive composition comes from practice and great familiarity with structuring the image. Decisive-moment photography is accomplished by the well-rehearsed. Composition becomes second nature. Sometimes, though, photographers will look for something specific within a composition, taking structure a step farther and integrating it within the content and form of a group of images. Rick Williams' book, *Working Hands*, takes that idea a step farther by using similar structures within the frames of the photographs and the sequence of images within the book itself (see Figure 8-58).

Figure 8-56
David Bowie has made significant contributions to the pop music scene since the 1970s. His music, no matter its genre or styling, is always fresh and has as much appeal with young people today as it has with his older fans. Sanchez's strong, tight crop of a gritty photo of Bowie meshes with the minimal but bright use of the edgy, disco yellow color. The design speaks directly and clearly to *La Luna*'s young audience. Reprinted with permission of *El Mundo*/Unidad Editorial, S.A.

Figure 8-57
From the Crow's Nest (left) and *Snakes* (right), from *Working Hands*, Rick Williams Williams used parallel structure as one of his primary structural elements in the photography and the presentation of the documentary photographs in his book, *Working Hands*. Williams and D. J. Stout's compositional savvy and intuition provided an inward architecture to the imagery that subtly interrelated groups of images through their composition. Photography, Rick Williams; art direction and design, D. J. Stout. © Rick Williams Photography.

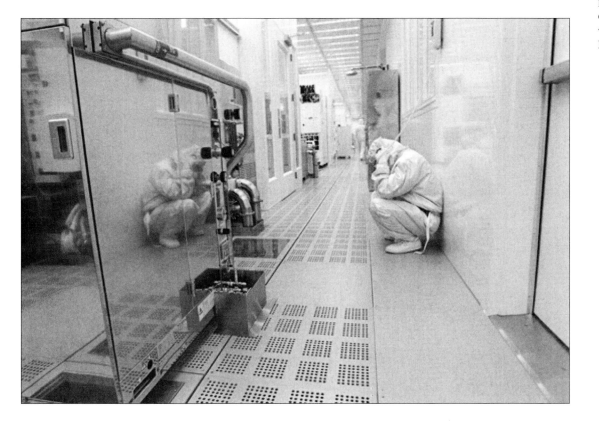

Figure 8-58
Road Talk, Green Ranch 1981; Outside Contact 1996, Rick Williams How does composition figure into each of these images? One way to look at them is that they represent ways that workers in two diverse fields communicate with each other. The cowboys ride over huge expanses of land in trucks or on horseback and meet on the road or in the pastures to pass on information.

Microchip industry technicians work on the same land as the cowboys but in complete isolation from the land and often in isolation from each other, communicating from behind face masks with phones and computers. A cultural theme that is implied might be that, as one becomes more isolated from the land and those things associated with working on and with the land, one also becomes more isolated physically and emotionally from other workers. © Rick Williams Photography.

One Photojournalist's Guidelines
— Paul Carter

1. The act of photography is often an equation out of balance. The language of photography is very much about aggression, about "taking" and seldom giving. In some cultural contexts, we all know, the act is tantamount to assault. The journalist or documentary photographer who makes human connection brings a sense of morality back to the exchange.

2. Every photographer must be prepared to confront the question of when it is time to put the camera down and intervene in circumstances of human suffering or life risk.

3. I abhor the idea of hectoring people in the news. I know it is common practice in many places to stalk subjects, particularly celebrities. I am against it. That said, I think it is important to emphasize that news photographers are required at times to act aggressively. News photographers bear witness for us all. To be a witness is to be as close as possible to events. That calls for the willingness to be in front of the crowd and to act decisively.

4. As a corollary, Capa was right. If your pictures are not good enough, you are not close enough.

5. No amount of technology or equipment can make up for lack of an idea. Photographers get caught up in gear. Sooner or later, you will decide that some picture will be better if you have a certain camera, a certain lens. Maybe. Maybe not. Good pictures always start with an idea. Technique will not save a bad idea or no idea at all. Cameras don't make great photographs, photographers do.

6. Emotion is the *lingua franca* of photojournalism. We look at documentary photographs to vicariously experience the human condition. Emotion provides a universal connection. It gives us something to remember, to carry with us, and to apply to our own lives.

7. The study of composition is not a bad thing. There is a long history and a legacy of imagery that demonstrates how to put the world within a frame. That is what we do in all photography, and it is worth knowing how it has been done before us.

8. I hear photographers these days talking about how to introduce "tension" into their pictures. This sounds to me like so much sleight of hand. There is tension or there is not. Tilting the camera may occasionally juice up a failed picture. Most of the time, however, it's snake oil.

9. Talking about pictures is fine. Taking pictures is better. Take pictures every day.

10. Wear sturdy shoes.

The Moving image

All of the things you've learned about design, color, photography, and composition apply every bit as much to the moving image. Film, video, and animation regardless of their specific genre (cinema, documentary, reportage, cartoon, commercial television, advertising, or sports) structure the frame using precisely the same compositional elements. They are after all comprised of *single frames* moving in rapid succession. But filmmakers, animators, and videographers aren't the only ones who need to be visually literate. Film critics, screenwriters, and others who conceive advertising spots, write about film, or work in some other aspect of moving imagery also need to be well studied in graphic communication. Rob Elder, who works as a film and entertainment critic for the *Chicago Tribune*, makes a strong case:

"Film lovers are sick people." Francois Truffaut said that. If that's true (and there's convincing evidence on both sides of the argument), then we're all infected with the same incurable disease. Who doesn't love film, after all?

Film has become America's, and perhaps the world's, populist art form. To appreciate cinema you don't have to have a degree in art history, literature, or even design. But to be a filmmaker or cinematographer, it is essential to have a grounding in composition and design.

Being raised in the media jungle of flashing television screens, black and white classics, and quick-cut cable programs, we've developed an innate sense of style, form and structure. Most of us aren't even aware of it, yet we can tell when a film is being emotionally manipulative and when we're sitting through another car chase, love scene, or comic set piece.

"Movie directing is a perfect refuge for the mediocre," said Orson Welles, director of what's largely considered the best film ever made, Citizen Kane. And he's right. The motion picture industry, now that it's punctured our home lives with the Holy Trinity of VHS, DVD, and HBO, is a multi-billion dollar industry today. There's money to be made, and the impressive often wins over the expressive in cinema—explosions over emotions. When art and commerce collide, commerce has the tougher chin.

Yet we still know when we're experiencing something extraordinary, whether that be Stanley Kubrick's ethereal camerawork in 2001: A Space Odyssey, *Preston Sturges's rapid-fire dialogue in* Sullivan's Travels *or Guy Ritchie's frenetic poker game in* Lock, Stock and Two Smoking Barrels.

Primary Elements of Film

The very best cinema makes us experience an emotion freshly for a scene we've basically witnessed a hundred times, in life or on the silver screen. How directors achieve this feat varies, but they all still deal in the medium's four primary elements: composition, content, pacing, and sound—basics that are invaluable to them and to those who write about film. The term "film" is used here loosely to also mean video and other media with moving images.

Composition

Composition includes everything seen on the screen: set design, actors, camera movement, lighting, color, sound—everything.

In regards to composition, the cinematographer acts much like a photographer, and is most effective when using the compositional principles of still photography. A low angle shot will empower its subject, even lend a sense of dignity, as Welles did in Citizen Kane. *If the same composition is lit from the bottom of the frame, you're*

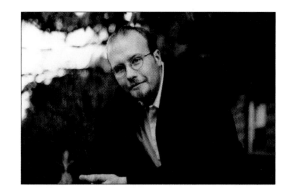

left with a rather ominous shot, straight out of a horror film but still just as compelling.

The rule of thirds applies to cinema as well and is often much better used in film because as the frame moves, more information is revealed about the characters and their surroundings. For static opening shots or sweeping establishing shots (see any of Sergio Leone's Clint Eastwood westerns), tucking the protagonists into the left third of an expansive shot can tie character to landscape, landscape to metaphors. Ground thirds is equally important for framing or structuring the visual elements in the frame (see Figures 8-60 and 8-61).

Content

Acting, action, dialogue, and image quality are some of the qualities that directors must weigh when selecting takes and sequences for the final cut of their film. Since this is a design book, I'll

Figure 8-59
Robert K. Elder writes about film and culture for the *Chicago Tribune*. His work has appeared in *The New York Times*, *Premiere*, Salon.com, *The Oregonian*, *The Milwaukee Journal*, *The Seattle Times*, and many other publications. Elder is currently working on a new book about John Woo for a celebrated film director's series. You can find out more at: http://www.robelder.com.

Figure 8-60
Ground thirds is an important compositional feature in this frame from Chris Taylor's *Bicycling Cuba*. Notice how Taylor has framed the image—two-thirds sky and one-third ground—and placed the subject on the horizon. His use of color is strong throughout *Bicycling Cuba*; here the textures and shadowed *malecon* contrast the soft blue skies. Finally, note the repetitious forms Taylor found in the man's knee and the capped column of the malacon. Courtesy of Chris Taylor.

Figure 8-61

These still frames from *Daughter from Danang* underscore the value of composition; visual structure is as important to documentary film as it is to any genre of film or still photography. Edward Guthmann, film critic for the San Francisco Chronicle, praised *Daughter from Danang* as "that rare documentary that incorporates so much of the human experience—drama, conflict, tears, and suspense—that it transcends the normal divisions between fiction and non-fiction film." To be sure, it explodes any notions you might have of predictable or happily-ever-after endings. The film follows a young Vietnamese girl (Heidi Bub//Mai Thi Hiep) who travels back to her home country to meet her birth mother; at the same time, the film contrasts her relationship with her adoptive mother and provides a background of her life growing up in Pulaski, Tennessee. The young woman's trip back to Vietnam in 1997 opens up a Pandora's box of stridently contrasting cultural differences and emotions, and serves up a tragic climax. In 2002, *Daughter from Danang* received a long list of awards, including New Directors/New Film Award (New York City), San Francisco International Film Festival Grand Prize, Sundance Film Festival's awards of Grand Jury Prize and Best Documentary. It was also nominated for an Academy Award as best documentary film (2003). It was also featured on PBS' *American Experience*. Vicente Franco's cinematography is stellar. Can you identify the strong compositional devices employed in these three stills? Courtesy of Gail Dolgin and Vicente Franco.

refer you to Robert M. Pirsigís Zen and The Art of Motorcycle Maintenance *for a long-winded debate on the concept of quality.*

For now, let's say that quality of an image or sequence can sometimes be overridden by the potency of performance and action. While a frame might be technically flawed or composed better, what's in the frame might be emotionally compelling or simply a happy accident of film-making.

Example: When Bruce Willis' stunt double in Die Hard *(1988) leapt from one vent opening to another inside a steel shaft, he missed the mark and fell out of frame, and injured himself. Instead of cutting the mistake, director John McTiernan kept it in, heightening the tension by reshaping the story so that Willis' character misses the first vent, but narrowly snags another.*

Pacing

The velocity of dialogue, action , and camera movement have been manipulated by an art form that came into its own in the latter half of the twentieth century: editing. Long thought by film-makers as simply a way to transition from scene to scene, the craft of editing has been used as revolutionary as the camera itself.

Jean-Luc Godard's Breathless *(1960), with its jarring jump cuts and rapid pacing, have changed the way people watch film. Today, a whole generation of MTV viewers have been raised on commercials, television programs, and movies saturated with rapid-fire quick cuts, not to mention eye-popping computer-generated effects.*

Sound

Star Wars *guru George Lucas once famously said, "Sound is 50 percent of the motion picture experience."*

Even silent films had accompanying scores. However, setting a soundtrack aside, ambient or environmental sound design creates an almost three-dimensional movie experience, especially with the advent of surround sound technologies. Hollywood now produces movies you can feel, for example, the approaching T-Rex in Jurassic Park.

And even when not much seems to happen, as in Paul Thomas Anderson's Punch-Drunk Love, *sound design can contain enough tension to carry audiences through a character's inner turmoil.*

Epilogue

So if we know all of this instinctively, you may ask, why do we need to know anything about film design?

Simple. The more we know about media and the world of cinema, the deeper the insight we can gain about the influence of cinema on style, commerce, and even cultural trends. Knowledge of film principals, composition, and design result in a greater depth of appreciation for the medium itself. And if Truffaut is right about film lovers being sick, then having names for our symptoms gives us more power over them.

Next time you view a film, TV spot, or documentary, deconstruct the film frames by applying what you now understand about design and photographic composition. In so doing, you'll strengthen your graphic literacy by exercising your vision and soon begin to understand the strategies and motivation behind the film's structure.

Commercial Work: Persuasive Photography in Media

It might be easily argued that, indeed, all photography is persuasive; however, commercial photography's very purpose is to be persuasive. The best work in any genre has great stopping power, is compelling, and captures and communicates a special moment—one that is both credible and emotive.

As you might suspect, there are as many facets for commercial work as there are applications and outlets. Large users, of course, would include print advertising, annual reports, brochures, outdoor boards, identity materials, posters, books, stock art companies, Web stills, packaging, and more. Many photographers who work primarily in other areas, for example, as photojournalists, sports shooters, or documentarians, may create commercial work in addition to their main area of expertise (see Figure 8-62).

Advertising agencies, design houses, and business communication firms may keep a photographer around, but for the most part, they hire freelancers or lease artwork from stock photo services. Because agencies and clients have specialized needs, they don't want the expense of another full-time employee.

Photography is widely used in print advertising, outdoor media, and business communications because of its realism and believability. Art directors and creative directors work closely with the photographers they hire. It's common for them to produce shooting scripts for the photographers, and they are often present at the shoot. Art and creative directors will typically select models, wardrobes, shooting locations, and help direct the "shoot."

Figure 8-62
National Geographic Adventure Magazine,
Eric Evans
Eric Evans, primarily a sports photographer and photojournalist, also takes on commercial work as many of his colleagues do. This Evans' photograph announces the launch of a new magazine—*National Geographic Adventure.* The headline connects with the concept of launching the magazine, "Just ten days left to join the launch." Courtesy of Eric Evans Photography.

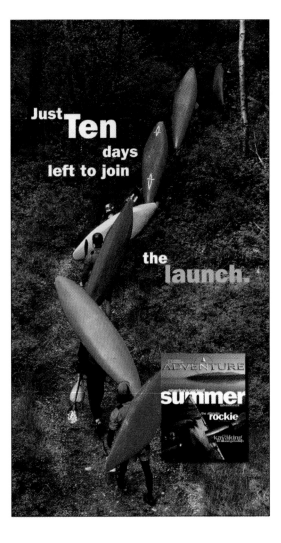

How to Work with a Professional Photographer

To work successfully with a professional photographer, an art director or designer should be knowledgeable about photography.

Perhaps the most important thing you can do is to take a photography course at a community college, university, or craft center or learn the basics of the medium on your own. Purchase a *manual* camera and learn how to operate it. Learn how to use both shutter speed and aperture, so you can understand how to stop or blur action and use depth of field. If possible, work in a "wet" lab so you can develop film and make prints. Learn composition by using it and become more visually literate. Study the work of the master photographers. At the very least, read a basic photography text and teach yourself.

While it's unlikely that this experience will lead to a career as a professional photographer, you'll share a common vocabulary with the photographer and have a clearer sense of the medium. What's more, you'll better understand photography's limitations and possibilities. And, you will have a better appreciation of the magic of the medium.

Most agencies keep mini-books, portfolio work, or sample work from photographers on file. Art and creative directors also look closely at work in magazines like *Communication Arts*, *Print*, *Graphis*, and *CMYK* to stay current with photography work. They also utilize stock services for a lot of the photography, film, and illustration they use. Typically, too, an art director or designer will already have established working relationships with a variety of photographers and know their styles, strengths, weaknesses, and how they work. Just because a photographer is fantastic when doing outdoor or sports shooting for Nike, does not mean that person would excel at shooting studio work for GAP. There is also a tremendous difference between a portrait photographer and a landscape photographer. It's largely a matter of securing the services of the right person for the right job. Often creative strategy shapes the needs and styling of the photography. For example, compare the photographic approaches of these two student advertising campaigns for Leatherman (see Figure 8-63 and Figure 8-64).

Figure 8-63
Leatherman, a company famous for its beautifully crafted pocket tools, recently introduced rich, vibrant colors for their "Juice" model. Copywriter Jonathan Clements and designer/photographer Matt Graff blended minimal design, knockout photography, smart copy, and tight product shots for these compelling print ads. The Purple Juice ad reads: "Juice. We've reversed our position on 'corkscrew not included.'" The Blue Juice ad reads: "Juice. The ability to run with scissors. Safely."

Figure 8-64
In this instance, Cyrus Coulter opted to target a completely different Leatherman audience—women—to show simple, real life situations that warranted the use of the Leatherman Juice pocket tool. A bold creative strategy, the ad features a tightened belt, and subtly integrates color into the image. The layout more closely resembles an upscale catalog page than conventional print advertising. Art direction and photography by Cyrus Coulter.

Always review your needs and objectives with the photographer, the more thoroughly the better. Share the creative brief, marketing strategy, or any other pertinent information you might have with the photographer. If you have a swipe file showing the kind of portrait, color, style, or feeling you're going for, so much the better. Visual or "for instance" samples are an invaluable resource. If copy already exists for the annual report or print ad, share that too. Always ask for input from the prospective shooter about all aspects of the job: its concept, the end result you're looking for, the lighting, physical layouts, personalities involved, and other particulars. Giving the photographer more ownership in the project will invariably produce better results.

Make it clear what you expect visually, including the number of images you'll need and the mission of each required shot. Provide the shooter with a detailed list of your proposed shots, including such details as whether an image needs to be in a horizontal or vertical format. Again, swipe files or specific examples will help put you both on the same page. Be specific. In-progress layouts or even sketchy thumbnails may prove useful. Avoid open-ended photographic assignments.

Get the most out of your opportunity by listening closely to the reactions, ideas, and suggestions of the photographer. Clarify your ideas visually with thumbnails or quick sketches. Remember, you're getting across important visual ideas, you're not Van Gogh putting the finishing brushstrokes on *Starry Night*. The more specific you are, the better the finished art will be.

Be sure the photographer shoots a lot of film. Truly, film stock is the cheapest part of any photography project, and it's the last place to cut your budget. It's not unusual for *National Geographic* photographers to expose tens of thousands of frames for a feature that will run 12 to 30 images. It's much better to have a dozen strong images to choose from than to be forced to decide between a reshoot and serious Photoshop surgery on problem photographs. Likewise, if portraiture is the main thrust of the shoot, have the photographer compose the subject looking left, right, and straight ahead. An annual report layout or print ad might be shifted from a right to a left page, or vice versa. Commercial work seldom runs smoothly and each project has its own share of adventure.

The bottom line is simple: plan the photographs as meticulously as you can, *before* the shoot with the art director, creative director, photographer, and any other visual people. Plan your work and work your plan. This is always important but particularly so when working a theme or concept for an annual report, such as the one Samata/Mason produced for Granges, Inc. (see Figure 8-65). Often, a good strategy is to establish a theme or concept and execute it by the numbers. Whenever possible, plan the entire design, start to finish, from specific images to how you'll use color, from type selections to directing vision through the layout. That way the photographer will not only have a clear overview of the project but will know specifically which photos go where. Sometimes a simple sketch provided to a photographer will turn out to be nearly a carbon of the finished work, as was the case for Hinman Vineyards (see Figure 5-41).

There is a most detestable term often applied to suppliers of art: "wrist." It is as derogatory as it is inaccurate. The inference of the term *wrist* suggests that the photographer, illustrator, or graphic artist is an unequal partner, a menial participant. Artists rightfully resent that mentality and moniker. Like anyone else in the creative process, photographers and other graphic staff like to be appreciated, not just for their compositional and technical skills, but for their ideas. What's more, their input, ideas, and role in the final product are crucial. Finally, the secret to working successfully with photographers is to think of them as equally insightful partners. After all, they truly are. For example, photography and video add credibility to a mostly hilarious advertising campaign for Eggbeaters and communicate the clever idea without the use of words (see Figure 8-66).

Page Layouts: Working with Photographs

Putting photography to work in the layout, while clearly not as important as securing the imagery in the first place, is still significant. Imagine a collection of Mary Ellen Mark images in a ragtag book design or Carter or Dunleavy photographs

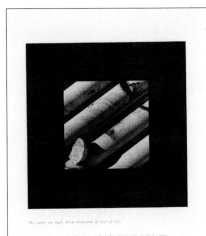

Figure 8-65
The Granges, Inc. Annual Report is an excellent (and award-winning) example of an annual report that reflects great interaction and planning among the photographer, writers, and planners of this report. Granges, Inc. explores, acquires, develops and operates mineral properties in North America. One of their missions is to achieve excellence in their operations and explorations without disturbing the environment. They wanted an annual report that both said and showed that concern. With that in mind, SamataMason set out to produce a clean, smart-looking report. Notice how the use of black and white photography and the photo style underscore the clean lines of the design and the message of the report. Top: two-page spread with the left being a topographical map set silver on black, and the right page insetting a photo of geologists exploring a possible drilling site. Middle: two-page photo spread of a pilot and plane used in their explorations. Bottom: two-page spread—photo of core drillings and operations review. Photography, Jeff Corwin; art direction and design, Dave Mason; printing, Blanchette Press. Courtesy of Vista Gold Corporation.

Figure 8-66

Sean Haggerty conceived this student campaign for Eggbeaters—a delicious egg substitute product made from real eggs with all the nutrients and protein of eggs but without the fat or cholesterol. The creative strategy pits real eggs against the product because the eggs feel threatened by Eggbeaters' superiority. Here are two examples—a poster where the eggs have literally "egged" the Eggbeaters ad, and a frame from a TV spot where the eggs unsuccessfully attempt to push a carton of Eggbeaters off a countertop. The idea underscores the benefits of products in fresh, humorous, and memorable ways. Art direction and photography by Sean Haggerty; creative direction by Sean Haggerty and Jonathan Clements; copywriting, Jonathan Clements.

going into a newspaper page with a half-baked layout. Or, visualize an ad campaign or annual report featuring pristine imagery that's plopped into a horrid design with inappropriate typography and uneven columns.

This section is not meant to replace the valuable information you learned in the design chapter. Instead, think of it as a complementary guide for properly featuring photographs within your page designs.

The first rule is simple: if you have it, flaunt it. Or, if you have an outstanding photograph, run it big (see Figure 8-67). A powerful image run pint-sized diminishes its impact and increases the likelihood that its full potential will be missed. Worse yet, it might even be passed over if it's run too small or if subtle elements are lost via its diminutive scale. By the way, running a mediocre image huge only makes it more mediocre.

If you opt to bleed an image, make sure important visual information is not lost in the process. A *bleed* is artwork that is run beyond the perimeter of the page. A *full bleed* would be a photo, say, that runs off the top, bottom, left,

Figure 8-67

It Takes Two,
Chris Taylor
Chris Taylor's dazzling imagery captured the movement and verve of the tango and warranted the strong, photo-dominant, two-page spread in *FLUX*. Photo editor, Alana Listoe, decided that "It Takes Two," a feature on the tango that "originated on the sultry streets of Buenos Aires," warranted the strong visual opening. Story by Autumn Madrano. Courtesy of *FLUX* magazine.

and right of the page. A *horizontal bleed* runs off the page to the left and right only; a *vertical bleed* runs off top and bottom only. When you bleed a photograph, make sure you run off the page by at least one-eighth of an inch. That way if a page is slightly misaligned during the trimming stage, there will not be a white edge showing at a page's edge. Magazine and book covers, print ads, and feature layouts are often bled (see Figure 8-68).

When cropping an image showing motion, give the moving subject sufficient room ahead of its implied direction. Cropping too tightly will stop the motion (see Figure 8-69).

Generally, don't have subjects within photographs looking off the page. This placement can miscue the reader and lead vision off the page. Smart designers try to steer a line of sight from within a photo to a headline, copy block, or other area within the page (see Figure 8-70).

Allow one photograph to dominate in a series of images. If you have a layout with a photograph that's the same size as other images, a nameplate, cover lines, or other elements, nothing dominates. The average reader won't understand how the page is supposed to be sequenced. Not having emphasis or a focal point typically leads to confusion. For example, Chris Meighan created the layout, "Transition Game" for the *San Diego Union-Tribune* using a dominant knocked out photograph and the headline to frame the deck that explains the story concept. The football shoes dominate, but Meighan

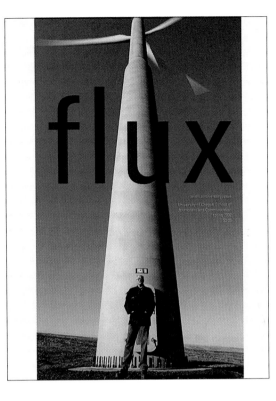

Figure 8-68
FLUX Cover, Kipp Wettstein
This cover runs a fairly uncommon, two-way vertical bleed. The image is only bled top and bottom, and the unusual white framing to the left and right sides add to the vertical feeling of the art. The nameplate and date/folio cover lines are run atop the photograph. Kipp Wettstein, photographer and photo editor; Emily Cooke, art direction; Arlene Juan and Russ Weller, designers. Courtesy of *FLUX* magazine.

grouped the supportive photography on the right to complete the layout (see Figure 8-71).

Grouping is a good strategy when presenting a number of subordinate or supportive images. If you don't group those images, you typically end up with a checkerboard page design.

Generally, keyline the photos or artwork. A keyline is a rule (usually a hairline or half-point rule) that boxes a photo or illustration. It helps demarcate the photo from the rest of the page for the reader. For example, all of the artwork in this text is keylined.

Figure 8-69
Surfer, Paul Carter
On a lonely beach on the southern Oregon coast, a surfer works to catch a good wave. Notice where Carter has positioned him—far right—giving the surfer plenty of room in the frame to move left (full frame image). Had Carter positioned him far left against the frame's edge the implied movement would have been stopped (cropped image). Graphically, bumping a moving subject against the frame stops the action. The subject or object moving through the frame needs plenty of room ahead of it to impart a sense of motion. Note that this is not Paul Carter's frame or crop, but the author's to demonstrate how improper cropping can stop the sense of motion in a photograph. Courtesy of Paul Carter.

Figure 8-70
The late Kirk Kahrs was a gifted creative director and writer who worked in advertising and marketing communications. His serendipitous nature created wonderful work for clients that included Caterpillar, Nissan Automotive, Interlakes, Taco Bell, and Nekoosa Paper. This feature layout is designed to lead your vision to the article's headline, deck, and text. Art direction and design, Jan Ryan; photography by William Ryan; story by John Joyce.

Figure 8-71
Chris Meighan explains how form and function fit into this great layout. "The challenge of this cover was, how to illustrate 'Life after the Super Bowl.' We had no image that really illustrated that, so we decided to take an iconic approach to the problem. We got some busted-up cleats and took them into the studio and shot them, basically a different take on hanging up the spikes. The story interviewed several people, who have had success in the real world and some who have not been so lucky. So we paired the cleats image with some recent shots of players in their post-NFL careers with captions describing what they are up to now." Courtesy of Chris Meighan and the *San Diego Union-Tribune.*

Never run significant photo elements into the crease or gutter in between pages. This maxim includes eyes, faces, or other crucial components of a photo. Information run into the gutter is compromised or even lost, and you're doing a disservice to the art and person(s) who created it—not to mention frustrating your readers.

Consider using elemental form to help nest art. Shapes, such as L and T, built within the page design from type (headlines and copy block) can help frame artwork, and solidify the structure of a page. Employ all the tenets of design principles in the layout and arrangement of photos and/or illustration on the page (see Figure 8-72).

Make use of white (or negative) space. An invaluable tool, it can provide a resting space for the eye in a sea of typography. White space can also work formally, for example, as a mat or border would be used in framing a painting (see Figure 8-73).

Consider borrowing a dominant or complementary color from the main photo within the layout, when you're incorporating color in the backgrounds or in the typography. Color may be echoed from the photography by the use of dropped initial letters, headlines, rules, tint blocks, or background color, as Greg Manifold did in his wonderful sports page layout, "Coming Full Circle" (see Figure 8-74).

MORE THAN SKIN DEEP

BY BETH HEGE
PHOTOS BY KIM NGUYEN

RACE ON CAMPUS Flux 13

Figure 8-72
More Than Skin Deep, Kim Nguyen Matt Lowery, *FLUX* designer and assistant art director, created this smart and very efficient layout. The headline, dropped initial letter, deck, and text form an L-shape to frame Kim Nguyen's wonderful photograph. She shot this image at a slower shutter speed to pick up the blurred motion of people moving through the frame, while the seated student stares at the camera. Great photography, typography, and design come together in this Lowery page. Story, Beth Hege; art direction, Matt Lowery and Steve Asbury; photography, Kim Nguyen. Courtesy of *FLUX* magazine.

Figure 8-73
SamataMason provides a generous amount of white space in this Granges, Inc. annual report. In fact, the exaggerated horizontal format of this photograph straddles two pages—without a single word or piece of type. Compare this layout to those shared earlier (see Figure 8-65). Deconstruct them and compare their compositions. Photography, Jeff Corwin; art direction and design, Dave Mason; printing, Blanchette Press. Courtesy of Vista Gold Corporation.

Figure 8-74
San Diego Union-Tribune designer Greg Manifold uses a backdrop circle to draw readers into "Coming Full Circle." Manifold wanted the circle to attract attention and relate the art to the title and content of the story. "The circle is a play off of the jockey silks he is wearing, which often feature circular shapes and distinctive colors. The circle connects the cutout to the package well, but adds to the page by having the circle spill into the other stories. The use of the burgundy circle is obviously not a complicated design element, but one I hoped would pull readers into the story." Courtesy of *The San Diego Union-Tribune*.

Less is more. Don't be repetitive with your photography. Sometimes, a designer might be inclined to use two great photographs that are basically the same. Don't. Pick the stronger of the two. Remember, too, it's better to use two to three really great photos in feature story, rather than two to three good ones and several more mediocre images. Don't dilute the power of the visual message. Besides you can't possibly show everything within a story. Select the crucial elements that lend themselves visually to the story and get great photographs for those pieces.

Let the photography do its job and allow the words to do theirs. In that spirit, try to keep surprinting (printing over the image with type) to a minimum. It is puzzling that a publication will pay huge art fees to a celebrated photographer, only to pave the image over with type.

Making Effective Photographs

To qualify as an effective photograph, an image must meet several technical requirements, in addition to the more subjective rules of good composition. It is not surprising that most of these needs really have to do with lighting, since photography is literally the process of "writing with light." Whether you are a photographer shooting a photograph or an art editor selecting them, keeping these requirements in mind will help ensure that a photograph powerfully conveys the message intended and that it prints well.

A good photograph has adequate contrast; it isn't muddy. Particularly if you're working in black and white, put dark subjects on light backgrounds and vice versa. Also give powerful photos good white space and their due size (see Figure 8-75). Softer light, such as the diffused light of an overcast sky or low light early in the morning or very late in the afternoon, produces the most flattering tones when photographing people. Likewise, low light makes for more interesting landscapes. We've all driven along a country road in the late afternoon and noticed the steeped hues of the countryside glowing, almost as if someone had plugged the landscape into an electrical outlet (see Figure 8-76). Conversely, shooting a subject at high noon will likely deliver washed out faces, deep shadows, and blown-out textures and detail.

Because photographs are made under a wide variety of lighting conditions, it is incumbent upon the photographer or art associate to produce images that have average contrast. Black-and-white images with too much contrast have no gray scale, and ones with too little contrast reproduce flatly. Printers and designers sometimes refer to contrast as "density range," and can tell at a glance if an image will reproduce well. Technically, *density* is the lightness or darkness (contrast) of a photograph. A *densitometer* is a photoelectric hand-held device that measures and averages the density range within an image. For newspapers, the recommended reading is 1.4 to 1.8 for a black-and-white photo and 2.5 to 2.8 for a color transparency.

Generally, avoid images that have been split lighted; that is the light source is coming *across* the subject. What typically happens is that your light meter "averages" the light and what you end up with are photographs where half of the image is over-exposed while the other half is under-exposed. In any case, even if the picture is salvageable, it isn't worth the hours in the darkroom or in Photoshop trying to save it.

A good photograph is sharp—that is, clearly focused. There are few things more frustrating than discovering a key photo you've selected for a cover, ad, or layout is out of focus. A photograph is either *in focus* or *out of focus*. There's no such thing as "sort of in focus" or "mostly in focus." In a sense, it's like pregnancy. You either are or your aren't. Period.

Image detail should hold up to a standard size enlargement. This is particularly important for high-traffic areas such as a cover or a two-page spread that's going to bleed photographs in a cross-over layout. A *cross-over*, you may recall, is art that bridges the pages. If detail is a significant item, consider shooting photographs with fine grain film because its tighter/smaller grain structure will reproduce better at large sizes. Fine grain film is also referred to as "slow" film; the lower its ISO number (or light-sensitivity rating), the slower the film. Faster film, consists of bigger silver halide crystals, and will deliver a coarse, salt-and peppery look when enlarged. Another good strategy is to consider a larger film format. A bigger film format such as 2¼″ (medium) or

4″ × 5″ or 8″ × 10″ (large) has a larger negative, so you won't need to enlarge it as much in printing as you would 35mm.

Negatives, transparencies, and prints should be handled and stored properly. There shouldn't be any dust, lint, abrasions, fingerprints, or discoloration on the emulsion or surface of the print. Use white cotton gloves when handling them. Keep slides or negatives properly stored in archival quality sleeves or dust-free environments. Also keep them away from heat, direct sunlight, and humidity. A little bit of care in this department will save you hours of Photoshop work. Proper cosmetics also include even borders and squarely printed photos.

Good photographs are consistently printed. Each image in a given grouping of photographs should be tonally equivalent to the other photos. That means that, in addition to being sharp, clean, and properly contrasted, their gray scale or overall tonal range should be about equal. Go back and take a look at any of the series of photographs in this book and note the imagery's tonal consistencies. Images from Paul Carter's *The Mennonites*, Rick Williams' *Working Hands*, or Steve McCurry's photographs are all good touchstones.

Figure 8-75

When the great Ted Williams died, *The San Diego Union-Tribune* wanted to do a feature section on the passing of the city's hometown 'kid.' The special tribute was planned ahead of time. Designer Brian Gross recalls the photo editor suggesting "the unusual lead image." Its direct angle, tight crop, and directness impart power and credibility. Note, too, how the rebus photo, generous white space, and boxed statistics add to the page's clean presentation. Courtesy of *The San Diego Union-Tribune.*

Figure 8-76

The Mennonites, Paul Carter This moving image of a tractor plowing the fields very late in the day, the soft rich light, and the silhouettes bring a quiet beauty to the photograph. Courtesy of Paul Carter.

An Art Director and Photographer's Guide to Managing Photography

There are a lot of bad things that can happen to artwork of any kind. In the case of a photograph, often it cannot be replaced. Ever. Ask art directors; they'll surely have tales of fear, loathing, and woe involving some unforeseen and unwanted catastrophe that befell photos under their care.

Even if a shoot can be rescheduled, the costs in terms of time, effort, and money are substantial. If you follow the suggestions that follow, you'll likely experience fewer problems in this area:

- **Log photography in the moment it arrives (or is sent) and put it in its appropriate storage area.** Doing this is one way to keep appropriate tabs on photography. Another is to scan incoming work that's not already in a digital format soon after it arrives, then label and file it. There is a danger that if photography is passed around or left unattended, it will disappear. Deadlines sometimes have a way of creating at least a temporary chaos—not a good environment for your art. Digital images should be clearly identified, organized, and even backed up in some cases.

- **Sandwich prints between two pieces of corrugated cardboard or foam board whenever you must pass along or mail photography.**

- **If possible, always keep the original print, slide, or negative.** Make a digital file to the specifications and explicit needs of the client or publication.

- **Keep original photographic materials safely stored, away from elements detrimental to them.** Unsafe elements include light, heat, moisture, and dust. If you have digital files, make sure you back them up. A second hard drive is relatively inexpensive, so too are CD-ROM or DVD discs.

- **Organize the materials.** Label slides, slide sheets, or negative sheets and put them in labeled binders. If photographs are stored on disc, label the disc itself, as well as its jewel case. Some art librarians suggest keeping and updating a master list as both hardcopy and a computer file. It may take you a while to do this, but the time it will save you in the long run is substantial.

- **Keep food, drink, and liquids away from the photos.** It sounds obvious, but even water can spot photographic surfaces. If you're going to be handling prints, wear special gloves, or, at the very least, make sure your hands are clean. Glossy prints will pick up fingerprints easily. If you have to handle them, keep your fingers to the edges and back sides of prints or negatives. If moisture gets between resin-coated prints and is allowed to dry, you'll tear the emulsion off the photos trying to get them apart.

- **Store retouched work as if they were masterpieces.** They are, after all, selected photos that have been repaired, refined, and finished to specification.

- **Never write on photographs.** If you must label the images, use Post-its on the backs. Better yet, scan, label, and return them to their source or your file cabinet.

- **Never use paper clips to attach photography to layouts or mechanicals.** Photo surfaces are fragile so they may mar the photograph's surface and appear in the production image. If you're bent upon using clips, place the photos in a $9'' \times 12''$ envelope first and clip that to the layout.

- **Don't crop photography with an Xacto-knife.** This also may seem obvious, but stranger things have happened with the uninitiated. Once you slash up a photo, you're stuck with it; which means that if you miscalculate the cut or the scaling, you're in deep trouble. You may also discover, too late, that you have another application for that image.

- **Make sure you have any necessary releases in hand well before going to press.** The photographer can cover releases for subjects while on assignment. Don't let that requirement fall through the cracks; make release forms a standard part of your workload, along with shooting lists, names of principals, contacts, numbers, and so forth.

Technical Issues of Printing Photography

As discussed earlier in this book, a photographer has a bagful of technical details that must be considered, both before and during the shooting of a photograph; likewise, the art director and designer have their own list of technical decisions

to make. Printers, too, have a plate of technical requirements to worry about. It will save time, money, and potential problems in the reproduction phase if photographers and designers are knowledgeable about the production process.

Exposure and Contrast

How a subject is lit and the amount of contrast in an image are crucial to how well a photograph will print. The following guidelines will help ensure that a photograph reproduces as closely to the original as possible:

- Details should be clearly visible in both highlight and shadow areas.
- There should be solid contrast within the midtone range.
- Shadows should be kept to a minimum.
- Even lighting (as opposed to "split-lit") on the subject produces the best results—especially if the images are without highlights or extreme shadows.
- Avoid images with dark shadows; they don't print well on coarse paper, such as newsprint.
- Bracket for best results when making an important photograph, one you know will be crucial to a story or project. *Bracketing* is making a photograph at the metered setting, and exposing several more frames that slightly over- and under-expose the same composition, thereby assuring that you get a good exposure.
- Keylines help eliminate the problem of photos with light backgrounds merging into the page.
- Select a neutral background when there are dark and light subjects in the same photograph. It will provide fairly good contrast to both.

- Stridently different hues, such as a bright red, green, and blue, will likely translate to the same shade of gray in a black-and-white print because panchromatic film is not equally sensitive to all colors.
- More intrinsic contrast is obtained in color photography even though the subject and background are of similar tones. Tonally, subtleties in hues are much clearer in color imagery.

Sizing

Photographs are not always used in a layout in standard sizes or in the same proportions at which they were shot. There are basically two techniques for re-sizing non-digital photographs: cropping and scaling. There are similar techniques for re-sizing digital photos in digital imaging programs.

Cropping

Cropping is the process of removing unwanted elements in a composition. The best time to crop an image is while you're making the photograph, by adjusting your subject, yourself, or your camera settings. Sometimes, however, different situations will require you to further crop an image going into a page layout or design. Ideally, the photographer does the best job of cropping within the camera at the moment the image is recorded. Often, though, post-visualization finds a more interesting arrangement or presentation for the photography, or a photo editor or designer may crop the image for layout or page design purposes (see Figure 8-77).

Figure 8-77
Jerry Garcia, 1975, Jon Sievert (from Sievert's book, *Concert Photography)* Action in the real world—wars, protests, sports, and even rock concerts—moves very quickly. Cropping may be a photographer's preference after the fact. Jon Sievert explains the format crop on this wonderful image: "My camera was fitted with a 105mm f/2.5 lens, and it was horizontal when Jerry turned his head in my direction. There was no time to reframe, which left wasted space. But because I had captured enough of the guitar's headstock and his hand, and it was well exposed and sharp, I was able to crop the shot vertically and present a stronger angle." Courtesy of Jon Sievert, humblepress, and *Concert Photography*.

Often crops are made to adjust to the format of the publication; for example, a horizontal photograph selected for a magazine cover. Sometimes, a mug or tight shot is needed for a small hole, so a medium shot or portrait is cropped more tightly. Cropping may also be used to emphasize the center of interest, or more commonly, to eliminate technical errors or a busy or other unwanted portion of an image. Photoshop and other computer software programs make cropping a breeze.

Scaling

Scaling is sizing artwork to specific enlarged or reduced dimensions from its original size. Normally, cropping is accomplished one of three ways: one method is to use a self-explanatory scaling wheel where you align the original width to the new one; the wheel will give you the exact percentage of reduction/enlargement and the new length. A second way is to use a simple algebraic equation: original width to x, and so forth. The third involves simply taking the image, and using the cropping tool in your computer software program to scale the original artwork to the new needed size. Today, the latter is the most commonly used method for traditional photographs. Most production cameramen will tell you not to exceed fifty percent reductions; they also discourage enlarging from the original photograph to the halftone.

In digital imaging programs, resampling involves not only the length and width, but the resolution (pixels per inch) of the image as well. For example, in Photoshop, if you deselect the "resample image" box, changing the dimensions will affect the resolution: the resolution will become higher if you reduce the dimensions and lower if you increase the dimensions. To maintain a particular resolution and at the same time make the photo smaller (reduce the dimensions), the "resample image" box must be checked. A very useful feature is to be able to select the unit of measure you want to use for the dimensions; by switching back and forth, you can see the equivalent of inches, for example, in centimeters, picas, points, or columns. Or, you can choose to resample by a percentage of the original dimensions, for example by 25 percent.

Screening

Black-and-white photographs, regardless of whether they are prints, transparencies (slides), negatives, or digital files, are continuous-tone images. That means they contain a full range of grays between black and white. Neither letterpress nor offset can reproduce the gray, or continuous tones, by varying the tonality of the ink. Rather, presses can only run ink where the image is and no ink where it isn't. Unlike line art, continuous-tone images must be screened to reproduce naturally (see Figure 8-78).

Halftones

Halftone screens convert photos (continuous tones) to a series of dots or lines, which vary in size and concentration. For example, when screened, a charcoal gray area from an original photo would convert to a series of larger dots clustered closely. However, a very light gray portion of the photo would translate to much smaller black dots spaced widely apart. Our eyes mix the dot patterns on the white field of the page to give us the illusion of seeing various shades of gray. Put a film loupe or magnifying glass on a newspaper or magazine photo and you'll see the dot patterns.

The greater the number of lines or dots per inch, the finer the detail on the printing plate and on the printed image itself. For high-quality reproduction, a fine screen is used, usually along with a high-gloss paper. Coarse papers, such as

Figure 8-78
Newspapers and other publications use halftones to convert photographs (continuous tone) to screens (a series of dot patterns) that simulate full tonality through their line or dot pattern.

newsprint, cannot hold fine screens well because of the rough, uneven surface of the paper. Most newspaper halftones are run on screens between 85 and 100 lines per inch. Halftone screens reduce tonal contrast, so expect to lose some of the detail from your original photographs. To compensate, you need an average or slightly greater than average amount of contrast in the original photograph. It's important, too, that the photography have good tonal shifts. Without them, the halftone tends to run only slightly different tonal gradations together as the same gray. Finally, to minimize the amount of detail you'll lose in the halftone transfer, make your original at least twenty percent larger than its reproduction size. (See earlier remarks on contrast.)

Line Conversions

A *line conversion* is continuous tone art that's been converted to line art for printing. In this process, the art director may use a variety of screens or patterns to convert the art from continuous tone to a variety of (mostly texturing) effects, including posterization, etching, mezotint, and so on. Today, these affectations and other adjustments are more easily accomplished in Photoshop (see Figure 8–79).

the printer was a crapshoot at best. Today, however, Photoshop can precisely tweak conversions from color to black and white quite easily, and still maintain natural relative brightness within the image.

Captions: Fleshing out the Image and its Relevance, Details, and Message

Photographs cannot tell the complete story. Indeed, the interrelationship between image and word is a long and useful one. Captions *complete the picture* and in so doing increase the power of photography. The Weegee image in chapter one is a great example (see Figure 1-41).

Generally speaking, in newspaper design in the United States, headers above illustrations and the copy located beneath the photographs describing them are referred to as *cutlines*. However, in the United Kingdom, cutlines are referred to as *captions*. Actually, the two terms are used interchangeably. Regardless of what they're called, there are a number of ways to handle them on the page. Whichever method you use, be consistent. Captions or cutlines should neither rehash the obvious, nor be unrelated to the photograph. They should share necessary information, such as providing names, places, situation (where appro-

If working from prints, some pressmen suggest making the photography 20 percent larger than the running size for maximum detail. Good scanners, gathering digital information from slides or negatives, can better control resolution by making scans at high resolution, typically 300 dots per inch (dpi) or more. In the past, transferring color prints to black-and-white halftones at

priate), time, and the significance of what is pictured. Remember, without the proper explanatory remarks, your readers may misinterpret the image. Because we tend to bring our own interpretations to unexplained visuals, captions must communicate beyond what is pictured and provide context. For example, without a caption, the content and context of Steve McCurry's

Figure 8-79
Variations of Billy— 3 Years Old, Jan Ryan This example reveals but a mere handful of the possible Photoshop alterations involving patterns, contrasts, textures and more. The first image (far left) is the original, which is not manipulated; the second is a high contrast duotone; the third uses a "neon glow" effect; the fourth is a high contrast embossment of the original.

intriguing image of huddled women might be missed. Is it an image of women dancing? Women in mourning or at a wedding ceremony? Was it shot in the Sudan, India, Ethiopia, Yemen, or Mali? (See Figure 8-80.)

Here's an interesting exercise. Imagine that you know nothing about the running photograph. Often that is precisely the situation for copy editors or those responsible for writing caption explanations because they weren't present when the photographs were made. Consequently they may inadvertently bring the wrong interpretations to the imagery. Briefly, the function of a caption is to fill in whatever blanks might exist. Photographers are the most logical staff members to write captions and are the real test of their content and relevance. Some publications insist shooters prepare captions. That's not a bad idea.

Newspapers and most magazines consider cutlines a must. Some insist a cutline accompany every photograph or illustration. The following are common ways they are written and stylized:

- The cutline is boldface with the first few words run in all caps.
- The caption is set in the same typeface as the body but in a different point size (most usually smaller).

Figure 8-80
Rajasthan, India, 1983, Dust Storm, Steve McCurry (from McCurry's book, *Monsoon).* The content and place of this moving photograph don't relate to any of the scenarios referenced in the text. In fact, this award-winning image captures huddled women in Rajasthan, India. They are praying while encircled to "protect themselves from the onslaught of the monsoon winds." The message drives home an important point about the interrelationship of image and word. Courtesy of Steve McCurry.

- The caption is run in the same typeface as the body but in italics.
- The cutline is set in a completely different race of type.
- The caption is set in the same race but a different face, one that harmonizes or contrasts with the body copy type.
- The cutline has a sideline head, which is a line or two of display type placed together with the cutline, but to the left.
- The cutline has a catchline. A *catchline* is a display line placed between the art and the cutline. Catchlines are normally set flush left or center.

Whichever approach you adopt, use it consistently.

Cluster captions are the exception to the above rule. Cluster captions combine a series of captions for several pieces of art, but run all of them together in one large paragraph—or a series of stacked cutlines. Often an art director may opt to use cluster captions for grouped photos, for example, but use a separate caption style for stand alone images. A caption block, often highlighted by a screen or box, provides remarks for each photo in the grouping and normally refers to the images in a clockwise or top-to-bottom fashion. They tend to be more common in magazines and books. This approach is smart because it minimizes the tedium and work of designating a space for every single caption. In fact, in situations where photographs are grouped together, it's easy to reserve a small module among the images for the cluster caption. In that instance, the block literally becomes one with the photo layout. Designers at the *Boston Globe* illustrate how captions can be woven into a layout with a beautifully stacked photo layout for its sports section (see Figure 8-81).

It's a good idea to keep captions clear and concise. Again, avoid the obvious and scrutinize every word you use. If the caption, minus a word or phrase, reads as clearly and doesn't take away from the integrity and meaning of a photograph—purge the extra verbiage. Research proves that captions are typically read before the copy. In fact, sometimes they're scanned before headlines because of our predisposition of going to art first, and captions complete the art.

Tense varies. Some publications write in the present tense and others in the past. Largely, the choice of tense is a matter answered by your stylebook or the content of the photo itself. Generally speaking, use present tense for either candid or action photography and past for posed imagery. Present tense may also add to the impact of photography.

Make sure that the caption is unmistakable. If there's any doubt about the content or meaning of the photograph, rewrite it.

Directional information is important, but if identification is obvious without it, don't use it. "Pictured above..." or "left to right" when only two people are in the photo is superfluous. It's more important to provide a starting point for the reader such as "moving clockwise" or "top" or "bottom" row, so readers understand where to start and finish. Mugshots get straight identification. No less, no more.

Figure 8-81
Initially, the art director and designers at *The Boston Globe* considered running sports covers from the biggest news days, but these individual sports photos packed more impact. Their captions are clustered rather unusually by integrating them within the text in this smashing design. Page design by Brian Gross. Republished with permission of the Globe Newspaper Company, Inc.

When a caption is written singly, it is best to place it beneath the image. Occasionally, a design may call for positioning the caption to the side of the image. As already mentioned, captions may also be clustered in photo-essays or situations where photographs have been grouped. A caption for an opening page photograph might also be located on the "turn" page, or be grouped within the caption for a photo on the following page. Designate clearly, though, if you opt to do this. A designator, such as, "previous," page should suffice.

Research suggests that readers track first to the visual, then to the head, then to the caption, and finally to the copy. However, given their proximity to artwork, captions receive a lot of traffic. Again, words are meant to flesh out the artwork.

The vote on whether all photographs need captions or identification lines is not unanimous. However, if you look closely, you'll find few photos run without them. Actually, even covers receive captions in "cover notes" on the first page, in the table of contents or occasionally on the cover itself. Photographs that don't require them are few and far between, so a good rule of thumb is to use them—period.

Graphics in Action

1. Select a documentary photographer from this chapter whose work you really admire. Go to the school library and check out several documentary projects or books the photographer has published; also go to the Internet to read reviews, essays, and collections of the person's work. If you're interested in Mary Ellen Mark, visit her website— www.maryellenmark.com/.

Also, try to find more work from the other documentary photographers featured in this chapter: Rick Williams, Steve McCurry, Lewis Hine, W. Eugene Smith, Danny Lyon, Dorothea Lange, Jacob Riis, Robert Frank, Gordon Parks, or one of the others. Write a short report and bring images you've downloaded and printed out to class.

2. Is there a particular social issue or cause you empathize or align with? Research it to see if a photographer who's shared your concern might have documented it as a project or book to share with society. What did you learn?

3. With a classmate, choose a social concern or an interesting group that you would like to document photographically. Make a plan and some photographs for your team project and bring them to class. Some examples you might consider are runaway kids living on the street; homeless people; eating disorders; a religious group; an interesting or unusual occupation; or a culture or a way of life that is disappearing.

4. Look through 2-3 issues of your official state newspaper, or one of its larger dailies, and cut out all the photographs. Then organize them in a variety of ways and compare. Some common groupings might be sports, local, spot news, politics, business, features. Then note how many are generated from that newspaper photo staff and how many are from wire services. Repeat this activity on the same day of the following week. Compare the clips: is there a pattern?

5. Divide the class up into 3 to 4 groups. Choose an important sports event that will occur sometime during the term: NBA championship, Stanley Cup playoffs, NCAAs, World Series, Super Bowl, or an important PGA tournament.

Each group should be assigned to a specific magazine. Clip the photos from the magazine you're assigned, and bring them in to compare with the photography covering the same event from the different magazines. Select a winner. Examine the photography and see how the action was captured and treated. What similarities do the best photographs share?

6. Select 5-6 images of an established photographer or two whose work you admire. Deconstruct their compositions and analyze the photos you're examining. List the compositional devices or strategies they employ. Are there consistencies or patterns of how they use their vision and structure images?

7. Review the basic compositional tenets discussed in this chapter. Then select your own subject or content, and using your own camera, shoot 1-2 rolls of film (or make 20-30 digital images) and bring in the best 5-10 images to review in class.

8. Design a two-page magazine spread that features one or more of the photographs that you shot from the above exercise. Make sure you have a dominant shot if you're using a series of images. It's crucial, too, that you include within your layout many of the other graphic elements you've studied: design principles, typography, color, composition, and other visual strategies.

9. Using Photoshop and a recent photograph of yourself, create an interesting document using a manipulated version of that photo. Formats might include a postage stamp (you'd want to create both an actual size and blown-up version of the stamp), a wanted poster, magazine cover or opener, twenty-dollar bill, driver's license, or cereal box front panel. These are just suggestions; you can invent your own application too.

10. Very realistic, yet obviously implausible, images appear daily in all sorts of media from tabloids to news magazines and posters to advertising. As Tom Wheeler suggested earlier, many editors, photojournalists, and media critics are concerned that authentic photos may soon be considered anomalies. Find 4-5 examples of obviously manipulated photographs in the media and bring them to class to discuss their meaning, usage, relevance and your ethical concerns about their place in media today.

11. Create a CD cover using your own photography for a local band (could be your own) or for the next CD of your favorite band. Again, you create the photography and format for the CD cover and components (back cover, spine, liner notes, etc.) using typography, color, design, illustration, and other graphic elements. In addition, first write a half to one-page description to accompany the work of the CD concept, content, and your visual goals. This statement will be used as a yardstick to measure how well you've succeeded.

12. Break up into teams of 3 to 5 students. Then plan and photograph a newspaper story idea, magazine feature, or a public relations project. Bring your work in and ask members of other groups to write captions for your photographs and vice versa. Each group should produce and present their captions to the class and have the originators of the photography react to the outsiders' cutlines. Follow that up with a discussion of what you have learned.

The Art of Crafting
the Printed Word

Printing Processes

Paper

Ink: Colorful Solutions

Special Printing Processes

Pre-Production: Getting It Right

Pre-Production and
Post-Production Tips

Graphics in Action

*In addition to being a powerful
vehicle to spread ideas about
the rights of man and the
sovereignty of the people,
printing stabilized and unified
languages.*
—Phillip B. Meggs,
A History of Graphic Design

◀ *Four-color Dot Pattern,* Kit Hinrichs

All new technology comes from old technology, and is going somewhere else, and leaves a trail of terminology, ideas and techniques in its wake. Change is inevitable; preparedness for change can spell the difference between survival and extinction.

—David Lance Goines,
A Brief History of Electronic Printing

The Art of Crafting the Printed Word

In medieval times, original publishers were often illustrators, designers, and type-cutters, as well as printers. Peter Schoeffer (1426-1502), who was an understudy of Gutenberg, epitomized all of the above. Indeed, Schoeffer had worked as a University of Paris scribe and was also an accomplished artist, illuminator, and designer, intimate with the great monastic, hand-crafted books whose art, rubrics, and letterform he revered (see Figure 9-1).

Early publishers were mostly renaissance men, a collection of artists, illuminators, and artisans who also were inventive printers and writers. They took great pride in producing books and other materials that were impeccably printed. Some of them, such as Albrecht Dürer (1471-1528), adapted their painting, goldsmithing, and artistic skills to printing through the ingenious use of woodcut illustration (see Figure 9-2). Like artists, many print illustrators and designers signed their work through colophons, printer's marks, trademarks, and even their own signatures.

That kind of dedication and imagination is still found among both print specialists and designers today. Along with being a gifted designer, artist, and the recipient of many prestigious design awards, Thomas Ryan is intimately familiar with printing and its many subtleties. His overview is a testament to the significance of printing and its fascinating history, as well as the nuts and bolts of production and its importance to those who work in visual communication. And, despite years and years of corporate design work, he still maintains a grand sense of humor:

I started in a field more than twenty years ago where tradespeople worked their craft with careful and attentive detail. They were typographers, darkroom processors, film engravers, and retouchers—people who were more skilled in production and process than I was.

Me, I was a dreamer. In my college days, I was naive enough to believe you could make a living being a fine artist. All I wanted to do was be creative and communicate my thoughts and ideas to the world—period. However, I stumbled into graphic design through the campus

Figure 9-1

Johann Fust—a clever burgher and merchant who bankrolled and then sued and barred Gutenberg from his printing shop—took possession of Gutenberg's press and other printing equipment. Around 1468, Schoeffer married Fust's daughter, and the family printing company was born. Ten years later, they published *Psalter in Latin* using rubrics, ornate dropped initials, intricate engravings and three-color inking, the earliest color printing in Europe. The book was a huge success and Fust and Schoeffer dominated the young European printing industry for more than a century. The typography, design, and use of color were reminiscent of the monastic, hand-crafted manuscripts. They are as breath-taking today as they were over 500 years ago. The example shown here is the *Psalter in Latin* colophon. From *History of Graphic Design*, 3rd edition, 1998, by Phillip B. Meggs. This material is used by permission of John Wiley & Sons, Inc.

Previous page

Our eyes mix patterns of adjacent color dots into what appears to be continuous-tone color. Courtesy of Kit Hinrichs.

Nach Chriſtus gepurt. 1513. Jar. Adi. 1. May. Hat man dem groſmechtigen Kunig von Portugall Emanuell gen Lyſabona pracht auß India/ein ſollich lebendig Thier. Das nennen ſi Rhinocerus. Das iſt hye mit aller ſeiner geſtalt Abcondterfet. Es hat ein farb wie ein geſpreckelt Schildkrot. Vnd iſt vō dicken Schalen vberlegt faſt feſt. Vnd iſt in der gröſ als der Helfand aber nydertrechtiger von paynen/vnd faſt wehrhafftig. Es hat ein ſcharff ſtarck Horn vorn auff der naſen/Das begyndt es alleg zu werzen wo es bey ſteynen iſt. Das doſig Thier iſt des Helfantz todt feyndt. Der Helfant furcht es faſt vbel/dann wo es Jn ankumbt/ſo laufft Jm das Thier mit dem kopff zwiſchen dye fordern payn/vnd reyſt den Helfant vnden am pauch auff vñ erwürgt Jn/des mag er ſich nit erwern. Dann das Thier iſt alſo gewapnet/das Jm der Helfandt nichts kan thůn. Sie ſagen auch das der Rhynocerus Schnell/Fraydig vnd Liſtig ſey.

1515

RHINOCERVS

6–16

design department where I worked as a student aide. There, I watched and learned through others.

That was then, this is now. Most of those publishing specialists—engravers, strippers, and typographers—are gone. Today, all or most of those responsibilities are within my control with one or two clicks of the mouse on my Macintosh. The client wants to change the color of the sky. The headline type needs to be set in a lighter weight and in a warm gray shade. The text has been e-mailed to me and the client is expecting a PDF via e-mail this afternoon.

Clearly, understanding printing has made me more effective and more efficient—invaluable attributes if you expect to function and be competitive in the world of communication design: for example, knowing what press sheet size I can use most economically for a client's 24-page marketing brochure to keep the project within their budget range: being able to downsample "high-res" (high resolution) images while opening up the midtones for a web presentation;

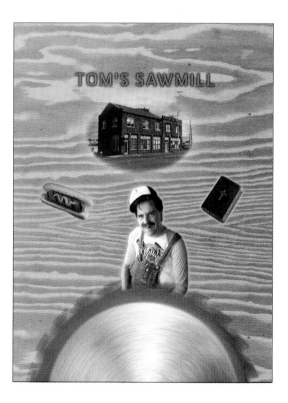

TOM'S SAWMILL

directing a new story concept with a photographer on a magazine project, solely through PDF and e-mail. Each of these talents makes a huge difference in how skillful and proficient I'll be.

Today's business world exists through e-mail, PDF, and digitization. It used to be you'd specify and mark up the type for a project, send it to the typographer for changes, and if you were good, the type would fit the layout you had in mind and it'd be delivered tomorrow. If there were mistakes or missed typos or graphic errors, you'd send it back and wait another day—or more.

Now, the project's text arrives on the screen before you—only seconds after a phone call. Clients often expect multiple variants of the design rough (PDF) you sent them last week—and they want it today. Meanwhile, there are two ads being developed to mate up graphically with the style of the final brochure. And, by the way, they need all these materials tomorrow.

All the high-speed technology and instantaneous communication has not only streamlined the process, it's increased the responsibilities of graphic communicators. Designers must not only exude visual communication savvy, strategic thinking, good verbal skills, and financial acumen, they have to have great PR skills to maintain client happiness and possess a healthy respect for time management. And, they must possess a working knowledge of the production process and stay technologically current or ahead of printing and material developments. Or, they run the risk of being unprofitable, losing clients, and losing sleep.

Strategy for a client: Corporate Board Member

We launched a quarterly business magazine project called Corporate Board Member *(see Figure 9-4). The magazine editorial is created in New York. The design is executed in my offices in Nashville. The magazine itself is printed in Virginia. We concept and commission illustration or photography and coordinate photo sessions with executives. We also "Greek in" the layouts for each spread and format typography of live copy. In addition, we have to prepare, format, and retouch images, assess random and composite proofs. Finally, we revise alterations, work on prepress production, and oversee press checks for each signature. Since Thomas Ryan Design is a virtual office, directing this project requires thorough communication between editor, art director, photographer, illustrator, proofers, prepress staff and the web offset printer.*

This magazine is targeted at executives and board members of U.S. companies. The audience members are visually literate, and they appreciate quality. They usually have top-notch corporate communications presented to them. They sit on

Figure 9-4

Tight, full-bleed photography, minimal type and bottom-line content make this a handsome but no-nonsense cover. The minimal cover lines have good contrast. What other design nuances make this *Corporate Board Member* an effective cover? What assessments might you make about its audience? Design, Thomas Ryan; photography, Matt Barnes; printing, Cadmus Mack. Courtesy of *Corporate Board Member.*

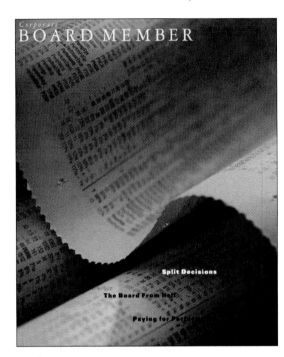

Figure 9-5

Just because your audience is composed of high-level executives doesn't mean that they don't have a great sense of humor. In this instance, the passing of the torch—or scepter—featured CEO Carly Fiorina atop Queen Elizabeth's coronation portrait. Cover lines further involve the reader: "Succession Planning—Who's *Your* Next CEO?" Design, Thomas Ryan; photography, Pete Cosso; printing, Lithographics. Courtesy of *Corporate Board Member.*

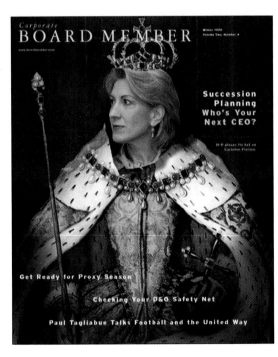

boards of museums and such. In fact, most have art collections in their homes.

So, the magazine addresses timely, pertinent board issues for this sophisticated audience. Our challenge on one issue was visualizing board succession. We used Hewlett-Packard CEO Carly Fiorina in a torn photo and overlaid it atop Queen Elizabeth's coronation portrait (see Figure 9-5).

Another new CEO we featured was John Barbour of Toyrus.com. Basically, the story was about how the company had gone online to modernize its marketing and reach. He was willing to get on a scooter and appear to ride through the cover image—a fitting graphic solution for an important feature story (see Figure 9-6).

Like any design firm working in business communication, we also are challenged to communicate compelling information (often statistics and spreadsheets) through creative, graphic presentation in charts or diagrams to help tell the story. Sometimes these numbers or information graphics have to work as the lead image. The trick is—how do you do that in an interesting and visually arresting way? (See Figure 9-7.)

One of the amazing parts of working on Corporate Board Member magazine is that no matter how tenuous the details are in relation-

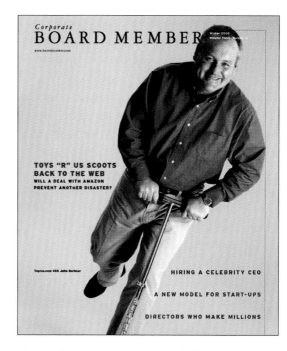

ships—discussions, e-mails, and phone calls—a creative idea often surfaces in the midst of the discussions and presents a sort of "what if" solution.

Every year, Corporate Board Member produces a "Special Law" issue that features the top law firms in the country (see Figure 9-8). Each of the top law firms is profiled and a separate photo spread appears for each of them. One of the firm's (Arnold & Porter) legal specialty is

Figure 9-6

The art and design nuances for the cover of this issue of Corporate Board Member are playful. The photography features John Barbour of Toysrus.com on a scooter. Cover lines reinforce the incongruity of having a CEO on a toy scooter: "Toys 'R' Us Scoots Back to the Web." The balance here is also playful, and the strong diagonal lines in the art are reinforced by framing the type to either side of Barbour. Compare this cover to the previous ones (Figure 9-4 and Figure 9-5). Design, Thomas Ryan; photography, Bill Cardoni; printing, Cadmus Mack. Courtesy of Corporate Board Member.

Figure 9-7

Business communications, regardless of the medium, often contain numbers in the way of financial reports, statistics, or economic overviews. An important facet of good design in this area requires that you present them accurately and in an interesting way. Mainstream business publications, news magazines, and even newspapers have adopted the same tactic: using pictographs and attractive charts and tables to provide readers with information. An important item to remember is to choose the appropriate graph or chart for each application. Review the section on information graphics in Chapter Seven for more particulars. Design, Thomas Ryan; illustration, Sataporn Nualaong; printing, Cadmus Mack. Courtesy of Corporate Board Member.

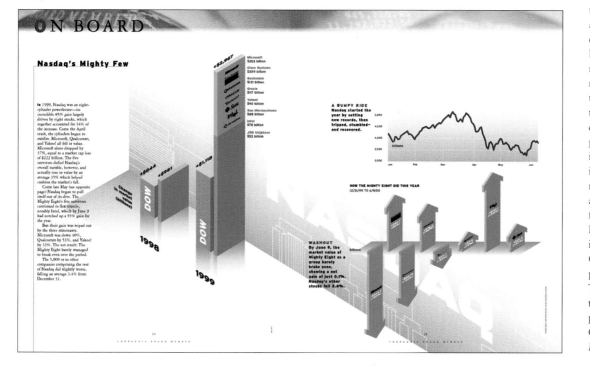

biotechnology. *While joking through a discussion with the editor, we came up with the idea to shoot two lawyers at a conference table and dupe portrait outtakes next to them—in effect, creating clones in Photoshop, complete with reflection on the table surface. For grins, a framed picture of Dolly, the sheep, was added onto the wall behind them.*

Although much more sophisticated and specialized, today's printing houses are run by craftspeople whose work is as fascinating as it is demanding. They are professionals who are artisans and artists in their own right. Moreover, because printing is the last piece of design, it's essential that you understand its possibilities, vocabulary, materials, and different processes.

As Thomas Ryan pointed out, graphic communication may also involve writing, editing, and preparing material for production, as well as dealing with the details of pre-production. Consequently, it's important to know what happens in the "back shop." *Back shop* refers to the production end of the business.

In many instances, designers and other staff perform all the tasks involved in production except actually running and tweaking the printing press. Most of the printing you'll use will be

executed by one or more of these methods—letterpress, flexography, screen, gravure, offset, and digital. Of course, laser printing, ink-jet printing, and high-speed copying are other printing alternatives, but are for smaller, less-finished projects.

Typically, when you hear the words "printing press" you immediately think of Gutenberg of Mainz, Germany. Gutenberg, however, did not invent printing. His contribution was to devise a method of casting individual letters, composing type, and combining all of the necessary printing components into a workable press system.

Scientists at the University of California, Davis, have discovered further evidence of Gutenberg's genius. They have broken down his formula for making ink and found that it contained lead and copper. That is the one of the reasons his famous Bible remains fresh, glossy, and black after more than 500 years.

But printing had existed long before Gutenberg's ingenious achievement. Chinese and Korean printers worked with movable type in the eleventh century. However, because of the fragility of the materials used (often clay and porcelain) and the enormous number of individual pictographs or ideographs used in the Chinese alphabet, it remained a rather obscure practice.

Figure 9-8
Examine this two-page *Corporate Board Members* spread. Once again, Thomas Ryan's wry sense of humor and creativity take over what might easily have been a status quo type of layout. Often, there are creative shards around you, but you have to look at the different design pieces and make something of them. In this case, outtakes of a pretty straight-forward photo shoot. The concept—"What if they began cloning lawyers?"—took on a delightful whimsey. Outtake shots were converted into artwork in Photoshop, and the coup de grace? A framed picture of Dolly, the cloned sheep, on the wall. Design, Thomas Ryan; illustration, Sataporn Nualaong; photography, Regis Lefebure; illustration, Ron Brandt; printing, Lithographics. Courtesy of *Corporate Board Member.*

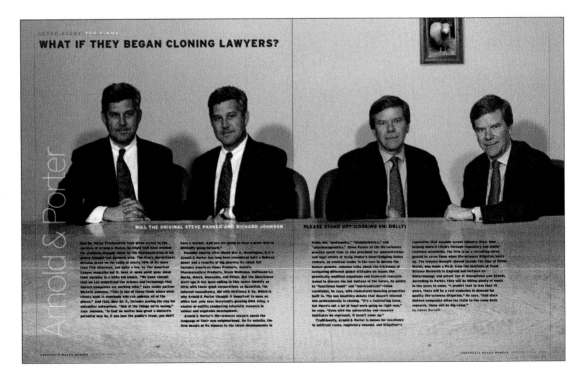

Printing Processes

The Letterpress: Three Variations on a Theme

These early attempts at printing—both Chinese and German—were based on basic letterpress methodology. The letterpress prints via its raised surface. The image to be printed is positioned *above* the base on which it rests; it is then inked, and paper is *pressed* against it to transfer the image to the page. If the image is a letter, then it is pressed to form a print; thus, *letterpress*.

Letterpress printing is also called *relief* printing. Remarkably, today's letterpress printing is basically a refinement of the 500-year-old process. Indeed, it remained the principal method of commercial printing through the 1950s and 1960s, well after the onset of offset printing.

Initially, letterpress was a slow, laborious procedure, because all the type was set by hand, one letter at a time. Essentially, the press itself was a crude technology, inspired by the simple winepress. But this same method was used for more than 300 years. Even though it had been refined over time, letterpress continued to be the basic printing process for another 20 or 30 more years and remained a viable printing method in some parts of the world for another 100 years.

Two men working one of these presses—typically, crafted from wood and iron—could turn out about 500 impressions a day. Today a simple offset press can easily produce ten thousand impressions an hour. What's more, paper refinements (such as those of Stora Enso North America) and the sophistication, quality, and detail of the offset press continue to push printing standards (see Figure 9-9 and Figure 9-10).

While the letterpress can still be found in a few commercial printing plants, its uses are limited and its technology antiquated. There are three types of letterpress printing presses: platen, flatbed cylinder, and the rotary letterpress.

Platen Press: It Slices, It Die Cuts, Scores, and More

The faithful and versatile *platen* press is dubbed the "job press," because it can be used to produce everything from letterheads to tickets, posters, business cards, and other miscellaneous printed materials. In addition to printing, the platen press can die cut, emboss, score (set a

Figure 9-9 and Figure 9-10

C Magazine: The Design of Culture is a beautiful and ambitious publication produced by Stora Enso North America, an international paper company based in Helsinki, Finland. Each issue features a survey of the photography, graphic design, and applied arts of a different part of the world to inspire Stora Enso customers by sharing unique visions that contribute to cultural diversity. This inaugural issue focused on Scandinavia. Cover: photography by Hakan Ludwigson; interior artwork: Martti Mykkånen'; the illustration. Courtesy of Stora Enso.

crease in a piece of paper), blind emboss, and perforate.

This version of the letterpress is called a platen because it operates by having a platen, or flat surface, upon which the paper is placed, move against the stationary type, which is locked in a chase, and in turn is locked in the bed of the press. Because the platen operation is reminiscent of the opening and closing action of a clamshell, it is often referred to as a "clam" or "clamshell press." Its strength lies in its simple and reliable design. There isn't much that can go wrong with the "job" press and because of its multi-functional nature, it's the most long-lived and useful of the three letterpress variations today (see Figure 9-11).

magazines, newspapers, advertising brochures, and other multiple-page publications. It uses a rotary impression cylinder and a rotary-type bed as well, plus a web—a continuous roll of paper—rather than single sheets. It can also print on both sides of the paper as it travels through the press. The rotary press utilizes forms cast into curved metal or plastic plates, which are then locked onto the cylinder.

It was *The Times* of London that again scored a triumph in printing when in 1869 its newspaper was printed on a continuous roll of paper from curved stereotype plates on a rotary press. During the next ten years, Robert Hoe, the American printing press manufacturer, improved and developed newspaper printing by making it

Letterpress Printing

platen flatbed cylinder rotary

Figure 9-11
Letterpress. Three methods of letterpress (raised image) printing: platen, or flat surface (left); flatbed cylinder (middle); rotary (right).

Flatbed Press: Power to the People
In 1841, Friedrich Koenig sold the first power-driven letterpress to *The Times* of London. It was steam-powered and continuously rotated a round impression cylinder. It is called a *flatbed* cylinder because the forms to be printed were placed atop the press's flat surface. This press was hailed as "the greatest improvement connected with printing since the discovery of the art itself." Later improvements to the flatbed press included the installation of automatic sheet feeders and folders to crease the sheets as they emerged from the press.

Rotary Press: The Letterpress Gone Full Circle
The basic shortcoming of the flatbed cylinder press was overcome when the *rotary letterpress* was developed. This version of the letterpress is fast and efficient and can be used for long runs of

possible to deliver a complete newspaper—folded, counted, and ready for sale—from a roll of blank paper. Pretty remarkable when you think of it.

Today web-fed presses can run so fast that production is measured in feet per minute of paper running through the press—rather than the number of sheets that are printed. Although other printing methods have taken center stage in the world of visual communication, letterpress is not quite dead. A new development, flexography, has revived the basic letterpress principle. We will consider "flexo," as it is called, later in this chapter.

Although the reputation for high letter quality and sharp resolution is well deserved, the letterpress is expensive. One reason for the exorbitant outlay is that all the artwork must be sent out for engraving, a very costly operation. The technolo-

gy has drawbacks as well. Letterpress is a "hot type" process and is difficult to reconcile against offset, which is a much more cost-effective, cleaner, faster, and self-supporting system because the artwork doesn't have to be sent out to expensive engraving shops. In fact, many printers create their own plates. For these and other reasons, the use of letterpress is dying; its primary function is not for printing so much as it is for specialty functions, such as die cuts, foil or hot stamping, embossing, and the like.

Gravure Printing:
Well and Good Impressions

Gravure, or *intaglio* as it is also called, is almost the antithesis of letterpress. It's printed from a *recessed* surface instead of a raised one.

Like the other printing processes, gravure printing has a long and sometimes murky history. Its beginnings can be traced all the way to the fifteenth century. A finely detailed print of the Madonna enthroned with eight angels is considered the earliest known engraving. It was produced by an unknown German artist with the initials E.S. and is dated 1467.

Gravure printing is excellent for photographic reproduction. Its process is unique because its entire image must be screened (type and line art as well as halftones of photographs). Many of our largest magazines are printed by rotogravure. They include *National Geographic*, *Vogue*, *Reader's Digest* and *Redbook*, to name a few. R.R. Donnelley of Chicago, a mammoth commercial printing company, is one of the biggest gravure printers in the world.

At first glance, the *rotogravure* (web-fed gravure) process appears to be a clone of the rotary letterpress. Despite the roller assembly configuration being similar, the process is actually the opposite because the type and artwork in gravure printing is recessed. The plate cylinder runs through an ink trough, which pushes the ink into the well depressions on the plate. Immediately afterwards, the *doctor blade* (see Figure 9-12) scrapes off the excess ink, and concurrently cleans the plate's surface. Then the impression cylinder presses the plate against the paper, which transfers the ink from the wells to the sheet.

Gravure

Like the letterpress, gravure is a relatively expensive printing method. The exclusive use of very fine screens (typically 150-line or more) produces remarkable resolution of halftones; indeed, the imagery closely resembles the continuous-tone of the original. The minor fuzzing characteristics of gravure help fuse the tonal and gradation shifts in the photo reproduction. Rotogravure is also fast-drying. However, because of the costly nature of making plates, only publications with very large runs tend to use this printing method today. The biggest users are large circulation magazines, such as *National Geographic*, whose photography must be of the finest quality. High-end catalogs with massive circulations and publishers of quality photographic books also use this process extensively (see Figure 9-13).

Figure 9-12
Gravure. A schematic drawing of the gravure process. The image to be printed is engraved or carved into the impression surface. The entire area is inked, and the ink is removed from the non-printing area. Pressure of paper on the plate pulls the ink out of the recessed areas.

Figure 9-13
Rotogravure. Diagram of a rotogravure press that uses the gravure process. Many of the largest magazines in the United States are printed by this method.

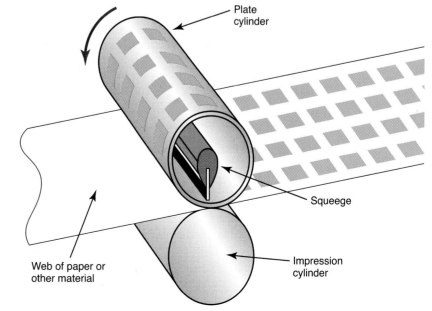

Screen Printing

Screen printing, also called *silk screen* or *screen process* printing, uses a fine, porous screen made of silk, nylon, Dacron, or even stainless steel mounted on a frame. A stencil is cut (manually or photomechanically) for the lettering or design to be reproduced and placed over the screen. Printing is accomplished on a press by feeding paper under the screen, applying a thick, almost paint-like ink to the screen, then spreading and forcing it through the fine mesh openings with a rubber squeegee. The range of sophistication in screen printers is enormous. They may be small and crude (24×24 inch wooden frames with a piece of silk stretched across them) or huge and refined, often employing four-color (or greater) machines that are capable of accommodating billboard-sized materials (see Figure 9-14).

The use of the stencils to produce imagery can be traced back to 1000 B.C. in China, but screen printing didn't become an important part of the printing industry until after World War II. Today automatic screen presses, four-and five-color screen presses, and rotary screen presses are used to turn out posters, T-shirts, banners, menu covers, bumper stickers, packaging—even outdoor billboards. While the application of silk screen is limited, its technology has become quite sophisticated. What's more, it is markedly flexible—capable of running huge jobs such as printing logos on soda bottles and printing posters or very small jobs, such as creating sample packaging materials or running a mere five T-shirts. It's also unique in that it can print on just about anything: paper, textiles, glass, metal, and so on.

Flexographic Printing

Flexography (flexo), which once looked extremely promising, is on the decline today. In the past, the flexographic method was considered practical only for specialized uses, such as printing paperback books, packaging materials, and plastic bags. Today, flexography is used to print comic books, Sunday newspaper sections and inserts, television news magazines, business forms (the Internal Revenue tax forms are printed by flexography), telephone books, point-of-purchase materials, and magazines. There are also printers who use flexo almost exclusively for packaging materials and labels.

Flexo printing is a comparatively simple process. It uses a water-based ink. The ink comes in contact with an engraved "anilox" cylinder. This cylinder distributes the ink to another cylinder which carries a *flexible* letterpress-type plate that is made out of rubber or photopolymer (a plastic material). This inked plate makes the impression on the paper.

Anilox cylinders have a hard surface with millions of tiny cells of equal size and shape. The ink fills these cells; excess ink is scraped off by

Figure 9-14

Screen. In the screen printing process, the ink is squeezed through a stencil and a screen onto the surface to be printed.

doctor blades, much as the ink is scraped off a gravure printing plate. However, the function of the anilox cylinder is to distribute the ink on the printing plate. This gives an even, fairly reliable distribution of ink.

Flexo advocates cite a number of advantages. It can print on very light paper with no show-through. Full-color illustrations with fine definition can be printed with excellent results. Since water-based inks are used, the problem of rub-off (ink from the printed sheet imprinting on adjacent printed material or on the hands of people handling the sheet) is virtually eliminated. There is little waste of paper compared with offset, which must be carefully adjusted for registration and color correction. Vibrant colors are possible with flexo, and it can print large solids without "ghosting" (the appearance of light blotches in large areas printed in color).

Laser Printing

The use of laser printers is widespread today. Just a few years ago about the only place you could find them were in large-volume design and printing shops, such as Kinkos. Today, however, they're commonly found in schools, offices, and homes. To be sure, they're very sophisticated printers (see Figure 9-15).

Laser printers may be used for creating mechanicals—completed pages of newsletters, flyers, and magazine pages that can be used for making printing plates. Laser printers are also good for creating proofs and for producing limited copies of printed materials. Students and others use laser and "fiery laser" printers for portfolio materials or sample comprehensives for clients.

The laser printer uses a tiny pinpoint of light that passes through a finely tuned and complex optical system and lands on a light-sensitive drum. As the drum revolves, a strong charge is applied to its surface. The laser beam pulses on and off at amazing speed as it scans the surface of the drum. Wherever it strikes, a different charge appears and dots are formed at these points on the drum. A series of dots forms the letters or illustrations on the drum. When toner is applied, an image appears. As the drum rotates, this

image is attracted to an oppositely charged sheet of paper. Heat and pressure fuse the toner to the paper, creating a permanent image.

The density of the dot patterns determines the quality of the printed product. The more dots per inch (dpi), the greater the quality or clearness of the image to be printed. For instance, a printer that uses 200-300 dots per inch is considered at the low-to-average end on the quality scale—which is typically what a print house like Kinko's would use. The 600-dpi laser printer is capable of producing very tight resolution for small runs. However, some laser printers with 1200-dpi resolution can produce high-quality press proofs and camera-ready mechanicals. Today, digital printing has borrowed some of this technology and re-applied it, using ink in lieu of toners.

Offset: Reversing the Course of Modern Printing

In recent years, letterpress has been abandoned for the most part, and *offset* has become the preferred printing method. In fact, probably 80-90 percent of today's printing is accomplished via offset.

Actually, offset is a modification of *lithography*, or printing from a flat surface. Lithography is also referred to as *planographic* printing. This method of reproduction was invented almost by accident.

Figure 9-15

Laser. A laser printer. The printer receives a page that has been created in a computer. The page is formed into a bit-map image, and a laser beam "etches" the image on the rotating drum with an electrostatic charge. After toner is applied to the image, the image is printed when the toner is fused onto blank paper.

In 1796, Bavarian Alois Senefelder, a twenty-five-year-old artist from Munich who dabbled in the theater, playwriting, sketching and drawing, was busy in his workshop. Senefelder was seeking an efficient means to duplicate plays he had written. He experimented with copper plates and limestone slabs. His rationale was that he could etch his copy into plates or stone and then ink and print from them. He hoped this would prove a quicker and cheaper solution than setting type by hand for letterpress.

While he was working on this idea, his mother arrived and asked him to write a list of clothing he needed washed by the waiting laundress. He reached for whatever was handy and picked up a piece of limestone and some correction fluid he had concocted to fill in the errors he made on the engraving plates.

Senefelder scribbled down the laundry list with greasy correction fluid on the flat limestone slab. Later he noticed that ink had stuck to the words he had written, and that water could wash off the ink on the blank areas of the stone. *Voila!* Senefelder had stumbled upon the chemical fact that is the basis of lithographic printing—oil and water don't mix.

How do we know so much about Senefelder's achievement? He kept meticulous journals and wrote it all down in his *Invention of Lithography*, which was later published in New York in 1911. In addition, he wrote *A Complete Course of Lithography*, which was translated from the original German and published in London in 1819.

As mentioned, the central principle of lithography is that oil and water don't mix; in fact, they repel each other. All procedures of lithography observe this basic tenet. The stone is the carrier of the printing form. The design to be printed is applied to the stone's surface by various techniques. Drawing pens, brushes, or grease crayons may be used. Although lithographers have complete control over their creations, they must execute the design backwards, so that it reads as a mirror image. Then, when a print is made, the image and type arrangement will read normally and not be inverted.

After the design is completed, the stone is covered with a watery and slightly acidic gum arabic solution. This "seasons" the stone. There are a few additional steps in preparing the stone, but for our purposes it is enough to say that the design on the stone is "prepared for reprinting." Then the stone is dampened and rolled with an ink roller. The grease-receptive design areas will accept the ink; however, the areas that have been moistened won't pick up the ink. After a series of inkings and moistenings, the paper is pressed against the stone and the reverse or mirror image of the original sketch is printed on the paper. The press and basic method devised by Senefelder are still used today to make lithographic prints.

Improvements were made over the years, and in 1889, the first lithographic press to print with zinc plates went into production. This greatly increased the printing speed. Today's plates are usually created from an aluminum alloy.

In 1906, the first modern offset press began rolling out printed sheets in Nutley, New Jersey. Although some offset printing had been done in Europe well before this time, the press developed by Ira A. Rubble, a paper manufacturer, is considered the one that launched the offset revolution. Today's paper companies produce papers whose qualities and variations are literally staggering. Along with demonstrating the range and control their papers have with a variety of media, paper samplers also like to show off a paper stock's typographic response (see Figure 9-16 and Figure 9-17).

Like lithography, the *concept* for offset was discovered quite by accident, but we don't know for sure exactly when and how. At some point, someone noticed that when the lithographic press missed a sheet, an impression would be made on the paper carrier (platen or cylinder), and the next sheet through the press would pick up this impression in reverse, that is, a backward imprint. Amazingly, the quality of the reverse print was excellent.

But offset utilizes *two* media. We've already discussed the *lithography* half. Its sister component is *photography*. How does it figure into the picture? The original typography and halftones are shot by production cameras or processed digitally, and the composite *negatives* (referred to as *flats*) are then literally contact-printed—much the same as a photo contact sheet

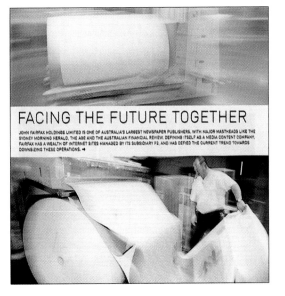

**Figure 9-16 and
Figure 9-17**
Imprint magazine is
published by Norske
Skog, a global Norwegian
paper company. It uses
offset printing to
showcase its paper and
bring publishing news to
the printing industry. This
clever cover features a boy
throwing a paper
airplane, suggesting
something about the light
quality of their papers.
The opening page from a
spread on their refined
offset stocks displays their
Phoenix gloss (cover) and
their Norcote silk stock.
Courtesy of *Imprint*
magazine.

would be produced—on photosensitized metal plates and then developed. These plates don't have to carry a reversed image because their type and imagery is transferred from the plate to the rubber blanket to the paper. Moreover, because the plates themselves never actually come in contact with the paper, the imagery wears well and remains sharp (see Figure 9-18).

The process is remarkably simple. Offset uses three separate cylinders: a plate cylinder, a blanket cylinder, and an impression cylinder. The printing plate (flat) is mounted to a plate cylinder, which has ink and water systems fitted alongside it. With each revolution, the plate on the printing cylinder is dampened and inked. The inked image is then transferred from the printing plate to the blanket, which is located directly below the plate cylinder, and in turn transfers the ink to the paper as it passes between the lower cylinders. The nonprinting area of the offset plate accepts the water, but not the ink. Conversely, the image area, which is "greased" or treated chemically so it accepts the ink, repels the water (see Figure 9-19). The process gets its name from the fact the inked image is *offset* to the blanket from the plate and imprinted onto the paper as it passes between the blanket and impression cylinder.

Comparatively speaking, offset is much cheaper than other printing methods because plates don't have to be sent out to engravers, and the turn-around time is fast. In addition, offset

Figure 9-18
This attractive two-page spread from *Imprint* (Norske Skog) demonstrates trendy typefaces and the use of color. The article features the typography and design of Phil Baines, a designer who teaches type, printing, and design at London's St. Martin's College of Art & Design. Courtesy of *Imprint* magazine.

Figure 9-19

Offset press. A schematic drawing of the offset lithography printing process. The printing plate with the planographic image is clamped on the plate cylinder; the dampening rollers coat the plate with water; the ink rollers ink the plate (the ink adheres to the image area but not to the area not to be printed); the image is offset to the offset cylinder and then transferred by impressions onto the paper.

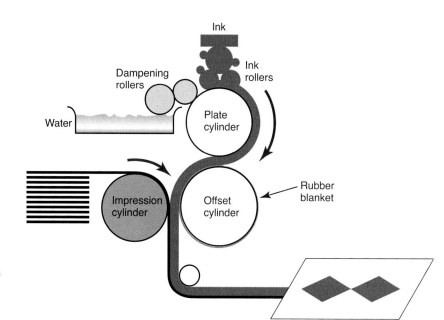

Offset Lithography

uses less ink, which decreases drying time and minimizes smudging. The flats may also be stripped, scrubbed, photosensitized again, and reused.

A new development in offset printing is being promoted as the wave of the future—the waterless offset press. So far, though, a seemingly interesting offset technology that was essentially waterless hasn't panned out. Doug Koke, principal and partner of IP/Koke Printing, reflects on the future of printing technology in an interview with the author. "Waterless has not been widely accepted. The plates are far too sensitive, scratch easily, and tend to be temperamental with temperature shifts while a job is running. We have the temperature control on our newest presses and that alone has made printing more consistent balancing the ink and water. As the day goes on, the press heats up from internal friction and pressmen have to '*chase*' their ink/water balance. The temperature control minimizes that problem. We've never tried waterless plates, and I don't know of anyone who is using them at this point. We are using digital offset presses, though, and they look to be an important part of the future of printing."

Today, offset dominates printing. Heidelberg and other press manufacturers continue to refine the process. Soren Larsen, a senior vice president at Heidelberg, USA, reflects about the future of

offset printing. "Digital technology has been an integral part of offset printing for more than a decade and computer-to-plate is clearly a dominating and growing area. Most recently, digital has demonstrated promising results in short-run printing and workflow, and these technologies work in harmony with offset. In the commercial print industry, a combination of digital and offset presses is often the optimal way to attain increased profitability and productivity. Printing, like type and much of graphic communication, is often a blend of old and new visions. While trending toward a real-time print market that responds to immediate customer needs is certainly a worthy goal, there remains a healthy share of jobs that require the quality and execution at which offset technology excels. So to our customers and colleagues, do not 'stop the press;' offset remains a viable and growing business that will continue to benefit from advances in digital technology." (See Figure 9-20.)

Digital Printing

As Bob Dylan would sing, "But the times, they are a-changing." In 1993, Benny Landa, a printer and inventor from the Netherlands, astonished the world with the first digital printing system—Indigo. Although digital has been used for quite a while in offset technology, its role has been more peripheral and used as a *means* to the end, and

not an end in itself. It is an offshoot of offset (rubber blanket) technology that incorporates lasers, ink, and direct digital input.

Landa, who holds more than 140 patents and is chairman and founder of Indigo, conceived a variable data digital system in his Indigo printing process. The resolution and finish of the Indigo's digitally-printed materials rival offset. What's more, the entire press system could be comfortably placed in an area roughly half the size of a single car garage. The Indigo press cranked out small (12 × 18-inch) sheet-fed jobs with a minimum of preflight production tweaking, quickly and cleanly.

Recently, Landa accepted a merger proposition from communications technology giant, Hewlett-Packard. The latter is competing with Fujifilm, Heidelberg, and Xerox (which uses toners and not inks with its digital printing press systems, notably, Future Color and DocuColor uGen3). Oddly enough, they compete for *different* market shares—so far, anyway. Hewlett-Packard is looking more to bring printing to corporations to allow them to "personalize their printing" in-

house, and in so doing eliminate much of their outside commercial printing needs.

Landa and others, however, believe that the printing industry itself is on the cusp of a digital revolution. "The industry is going to change dramatically—we are on the verge of real upheaval in printing." At the time of this writing, digital printing only accounts for 1-2 percent of the $500 billion printing industry globally. Basically, there are three main reasons why digital color printing has not really snowballed yet.

1. There is little customer demand; printers and consumers don't understand the advantages of the current digital/offset technology;

2. Printers have too much money invested in their current presses and offset technology to want to convert;

3. For many print houses in the industry, the most interesting and cost-effective digital equipment is sheet-fed and uses relatively small (12 × 18-inch) paper. There are larger systems, but printers are wary of them because of possible bugs in the new technology and start-up cost factors. But the systems are getting more sophisti-

Figure 9-20

History is not forgotten at *Imprint*, as evidenced by this thoughtful article that asks the question, "What is it that makes a typeface survive centuries?" The answer is classic design and this article on Giambattista Bodoni. Along with this back-of-book feature article are three information boxes at the bottom of the page: famous books set by Bodoni; data on Bodoni faces that are available digitally; and a short biography of Giambattista Bodoni. Courtesy of *Imprint* magazine.

cated and powerful and now are capable of web printing, plus, the cost per sheet is decreasing.

That said, digital may likely—as Landa projects—replace offset technology eventually. This is not a capricious printing fad. Landa was awarded the Edwin H. Land Medal recently from the Optical Society of America and the Society for Imaging Science and Technology. The award acknowledges "pioneering and entrepreneurial creativity that has had a major public impact in printing." The medal recognizes Landa's remarkable invention, as well as the commercialization of ink-based electro-photography.

Digital offset color printing technology combines the power and flexibility of digital imaging with the quality of offset printing. Applications for this technology include commercial printing, industrial printing, and photo-finishing.

Additional Technological Advances

In recent years we've seen the introduction of ink-jet and photo stylus printers that produce excellent color work. Additionally, xerography is so universally used in the business world that its brand name (*Xerox*) has become synonymous with photocopying. *Xero* is a Greek word meaning "dry;" thus, dry printing. Xerography is used for copying text and graphic material, and improvements are constantly being made in these copying devices. Xerox and most other photocopy machines use reflective light to expose a photoconducting surface. A negatively charged toner on this surface is transferred to a positively charged sheet of paper and fused through the use of heat and a pressure roller. It produces an exact copy of the original.

Another printer that has recently emerged is the ion deposition printer. *Ion* means "atom" or "group of atoms." An ion cartridge creates an image on a rotating drum by shooting charged particles onto it in dot matrix format. Then toner is employed to develop an image, which is then fused to a sheet of paper. Cold roll pressure is used to make the image stick, rather than heat and pressure as is used in a laser printer. Ion printing produces a very high-quality product that can sustain long runs of a printing press.

The recent changes in printing are substantial and sophisticated. Doug Koke of IP/Koke Printing grew up at his father's side as a printer's devil. He has seen many systems and printing processes come and go. Today he runs one of the most sophisticated full-service printing houses in the country.

The past ten to twelve years in the printing industry have seen a complete revolution in the way artwork is prepared for pre-press and printing. From 'galley' type on photographic paper being waxed or glued down on art boards by hand, complete with position overlays, 'Ruby' (rubylith acetate) windows for photographs, and with tissue flaps with instructions to the printer to the wonderful world of computer graphics and file preparation. In fact, graphics programs have become so versatile and imaginative that a novice, as well as the trained, seasoned designer, can create striking print pieces in less time and with greater accuracy, ready for the printer.

Today's digital methods have eliminated large copy cameras, light tables, and countless hours of hand stripping film for plates. With the use of computers and computerized imaging systems, jobs are completed more accurately, in less time. The trade-off is that the new equipment is very expensive.

For example, an imaging device to make plates for a 40" press costs just under $350,000. In addition, a digital proofing system runs approximately $135,000. While these advances certainly improve quality, accuracy, and speed of output, they may not necessarily translate into lower costs.

In the future, digital presses may eliminate the plating process altogether—no film, no plates,

Figure 9-21

Doug Koke is a master printer and uses a range of state-of-the-art presses in his plant. He was also one of the first to experiment with digital offset. When he isn't overseeing his model printing plant, Koke enjoys driving his classic muscle cars or cruising on his "soft-tail" custom-painted Harley-Davidson motorcycle.

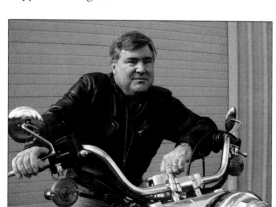

lower overhead costs—and go directly to press. The technology is here now, but it has its limitations. Currently, these types of presses are not cost-effective with longer print runs. Most of today's digital presses are limited, too, because of their small formats (12×18 inches). Although there have been great strides made in digital printing in the last five years, I don't believe digital presses and printing will eliminate high-speed, high-quality offset printing. In my opinion, the future of digital printing will rely more on serving smaller job runs and 'on-demand' print markets.

Regardless of how we place words on paper, the basic theme of this book will not become obsolete. No matter how we create our messages—arranging their elements via a pagination device using a video monitor or with a pencil on a piece of paper—we still must use type, design principles, artwork, color, and an appropriate array of other graphic strategies to communicate effectively with our many audiences.

Color Printing Variations

Spot color (or two-color) printing—the process of adding a second color ink (typically a PMS color) to the basic color (generally black)—can dress out a publication at about a third more of the cost than using one color.

Blending screens of the two colors creates still more color and tinting possibilities. For example, adjusting screens of chrome yellow and black can suggest brown, orange, beige, olive, and other hues (see Figure 9-22 and Figure 9-23).

Of course, you may also simultaneously print one solid color and vary its tints or gradations on the same press run by screening or printing type and art from screened negatives. The tints are chosen in the design stage, and the type or other graphics are screened accordingly from full density (100 percent) to subtle tonalities (5-to-20 percent).

A *duotone*—a two-negative, two-color halftone—is another great printing strategy, particularly when used naturally. For example, a

Figure 9-22 and Figure 9-23

These four pages demonstrate a small part of the tonal and color ranges available by tweaking two-color printing. In this case, chrome yellow was used as a second color; the tonal variations were achieved by adjusting various screen percentages of yellow and black inks. Art direction and design by William Ryan; photography from Eugene Country Club archives and the Lane County Historical Association.

designer might mix a second color such as red or another warm hue, to be screened together with black to create flesh tones (see Figure 9-24). Normally, a duotone is run in black and one other color.

There is a difference between spot color and duotones. Spot color is simply the use of a second color in a print job. Duotones use spot color for screening two negatives—one from each color employed.

Figure 9-24
Duotone photography seemed a logical direction for the feel of this image. Red and black screens were mixed for this two-negative, two-color image. Photography by William Ryan.

Figure 9-25
This five-color (CMYK plus silver) magazine cover "match print" uses metallic silver on its nameplate and a special aqueous coating. Printing by I. P. Koke Printing. Artwork courtesy of *FLUX* magazine; cover design, Creighton Vero; photography, E. R. Brown; art direction, Matt Lowrey.

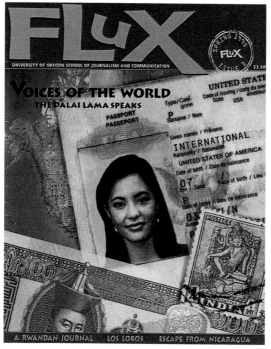

*Full colo*r is commonly referred to as *four-color*, "process" color, or CMYK (cyan, magenta, yellow, and black). The actual process is much more complex than this brief description, but the point to remember is that it takes four plates, hence four separate impressions or passes through the press to produce full-color reproduction.

Today, most color plates are created photographically or digitally. Color proofs provide the printer, designer, and client a preview of publication. Proofs come in a variety of ways. *Overlays*, like Chromalins, are composed of four acetate sheets (one for each color separation: cyan, magenta, yellow, and black). When overlaid, they achieve the effect of full color. *Integrals*, on the other hand, combine or *integrate* the color separations into one print, which is also known as a "match print." This *FLUX* cover is a good example of a five-color integral (see Figure 9-25). There are also a wide variety of other "proof" pages that vary from "water" proofs to laser print outs that a printer may use.

No matter what printing method is used, each color is applied separately during printing—one plate at a time. The semi-transparent inks are "stacked," going from the lightest (yellow) to the darkest (black), giving the illusion of continuous tone color. A film loupe placed atop a printed color page will reveal the dot patterns of various screens. The quality of the finished page is largely dependent upon the quality of the original art, the printing method used, how fine the screens are, and the skill and artistry of the pressmen. Typically, five-color, six-color, or more are run for most sophisticated publications; automobile view books, university promotional materials, or annual reports, for example. Typically, too, the extra impressions carry metallic inks, varnishes, or aqueous coatings. Of course, printing costs increase with each additional color and press pass.

Offset press technology has both improved and reduced the outlay for process color. The quality of high-end, full-color offset presses today is spectacular, and the resolution of the imagery is remarkably tight.

It is also important to be familiar with the physical components of any printed message: paper and ink.

Paper

Like artists, designers need to understand their materials as intimately as they know their tools. Printing materials have their own nuances: strengths, limitations, frailties, peculiarities, and tendencies. Along with the responsibility of the many design and art decisions you'll make, you will have to carefully choose which materials you use, particularly when it comes to paper and ink.

A quick education in this area may be acquired by closely examining paper sample books. Some of the finest designs on the planet are supported by paper companies. For instance, *@issue:*, a "Journal of Business and Design," is a quarterly magazine designed by Kit Hinrichs and Pentagram for Potlatch Paper (see Figure 9-26 and Figure 9-27). Paper companies pull out all the stops to show off the latest colors, textures, and other features of their paper stocks. Not a big surprise when you consider their audience: art directors, printing houses, and creative directors—perhaps the most sophisticated and demanding audience out there.

Monadnock Paper Mills also uses a design magazine format—*M.P.M. Edge*—to show off its Astrolite paper. Contrast it to *@issue:* (see Figures 9-28 and Figure 9-29). These materials should give you an idea of the thoughtful and dazzling

Figure 9-26 and Figure 9-27

The success or failure of theme or concept covers depends primarily upon the idea itself and great execution. This *@issue:* cover also had to demonstrate the brilliant color range of Potlatch's paper for this gorgeous John Hersey illustration. Contrast it with the same issue's homage to the simple paper clip on a back page. Design direction, Kit Hinrichs; designer, Amy Chan; illustration, John Hersey; photography, Paul Davis and Barry Robinson. Courtesy of Kit Hinrichs, Pentagram, Potlatch, and *@issue:*.

Figure 9-28 and Figure 9-29

It's important to show the range of a paper with sample books or magazines featuring paper stocks. Here, Monadnock Paper Mills shows how its Astrolite paper handles four-color (left) with a *touch* of fluorescent ink. Art direction by Jeff Pollard and Dave Van de Water; photography by Hidetoyo Sasaki. On the other hand, it may be important to show how the stock handles a halftone, black ink on white paper (right), in this wonderful Timothy White portrait of Tim Robbins. Art direction by Jeff Pollard and Dave Van de Water; photography by Timothy White. Courtesy of Monddnock Paper/Pollard & Van de Water.

design possibilities for this genre of work. A few years back, the Simpson Paper Company combined compelling writing (some from the journals of Merriweather Lewis, Thoreau, Whitman, Audubon, and others) with a remarkable array of art to launch its uncoated Evergreen paper. The idea was to fuse great environmentalists and naturists with Simpson's environmentally-friendly paper line (see Figures 5-21 and 9-32). The list of themes and paper companies could continue on and on. The common thread is obvious: paper manufacturers do a masterful job of showcasing their papers and how they perform in many different circumstances.

Remember: paper is much more than a passive recipient of your ink and the medium of your printed message. Paper is often central to your design ideas. It is loaded with sensory cues that we can see, feel, and intuit; cues that involve our sight, touch, and even our sense of smell. The proper paper choice can strengthen your communication, play a crucial role in achieving optimum readability, establishing a mood, or increasing the durability of the message itself. Finally, and equally important, paper may constitute roughly 25 to 50 percent of your total publication costs.

Specialty papers—and there are *many* different versions and unique applications—may play a part in your design scheme at some time or another. Keyston papers, for example, have a different color on each side. Translucent or "transparent" stocks (sometimes incorrectly referred to as "vellums") are popular papers for situations where a see-through effect is sought for an overlaid page or cover. This specialty paper is often used for divisional pages in annual or business reports or for other upscale or custom publications.

Get the right tool for the job at hand. A modern look may be achieved with expensive, coated papers that are bright and smooth. A paper's finish may also dramatically improve the contrast and reflectance values of illustration or photography. Types with hairline serifs and thin crossing strokes (or light-weighted faces) show up best on coated and enameled papers. Conversely, heavily textured or coarse paper surfaces can accentuate the crude details and built-in imperfections found in the architecture of some

old-style letter structure and perhaps even make them appear more antiquated.

Highly glossed finishes on papers may reduce legibility and impede readability. We've all had the experience of picking up glare off of high-gloss pages, and having to read the magazine at an angle to minimize the high reflectance. Along with decreasing visibility, glossy pages may even cause eye fatigue and strain. A matte or dull-finish stock works best for long reports and magazines with lots of copy-heavy pages. What's important is that you select specific papers to achieve the intended effect of the project.

Designers, art and creative directors, and anyone concerned with printed communications should understand how paper is made, its terminology, many characteristics and variations, as well as its graphic possibilities and limitations.

How Paper Is Made: From Rags to Riches

Before the early 1700s, practically all paper was made by hand. The raw materials, rags, were soaked in tubs or vats, then mixed and literally beaten to a pulp. Then the wet residue, pulp, was dripped from the tubs by hand and placed in fine-wired molds stretched across wooden frames.

The milky mash drained and dried on the frames to become damp sheets of paper. They were then inserted into a press that squeezed out the excess water by flattening them. Finally, they were hung on wires to dry and stiffen (see Figure 9-30).

Although sophisticated machinery is used to manufacture paper today, the basic process has not changed much. Wood is the most widely used raw material, though some of the high-quality papers are created from cotton and linen fibers. In addition, paper companies are trying other materials as a base for paper, including hemp. In addition, various chemicals, fillers, and treatments may be added throughout the process to produce papers with a wide variety of finishes, weights, colors, and other characteristics.

For instance, *rosin size*, a type of resin, is added to create water-repelling qualities so the paper can be used for pen and ink drawing, offset printing, or improve the paper's resistance to weathering. Fillers (most commonly, clay) are used to improve paper *bulk* and smoothness, to

increase density and *opacity*, and to help ink better adhere to the sheet. Bulk refers to the thickness or "caliper" of the paper, and opacity refers to how *opaque* the paper is. Most applications require the paper to have enough opacity to keep the imagery from one side of the paper showing through to its opposite side, thus compromising photos and hurting readability. Dyes and pigments may also be added to produce papers of just about every color imaginable.

Paper can be *calendered* (smoothed) by passing it through a serious of steel rollers, or *supercalendered* and *enameled* for an even smoother finish. Some papers are produced with a high gloss (or *coated*) surface to enhance the reproduction of photographs and artwork (see Figure 9-31).

Figure 9-30
Papermaking in seventeenth century Europe is quite similar to the papermaking procedure students use today in graphics classes. Pulp is heated and beaten or otherwise mixed and dripped from tubs by hand into molds constructed of fine wires stretched across wooden frames.

Pulping

Digester

Barking Drum

Washer

Beater

Pulp Lap Machine

Figure 9-31
The steps in converting wood into paper are shown in the upper drawing at the right (provided by the Wisconsin Paper Council). The logs enter the pulping machine on the left and leave as a mushy pulp on the right. The process of converting pulp to paper by machine is shown on the lower right. Pulp enters the machine on the left and emerges as a continuous roll of paper on the right.

Paper Making

Headbox

Felt

Dryer Felt

Wire Mesh

Wire Mesh Presses Dryer Rolls Calendar Stack

Most paper companies offer a wide variety of finishes. Some are embossed to resemble leather, linen, or tweed. Still others are available with all sorts of pebbly, lined, or textured surfaces (see Figure 9-32). In these instances, the paper is usually run through embossing calenders. Still other papers are produced with a special watermark (or some other aegis) by spot impressing it with one of the rollers during the process. This roller, called a *dandy* roll, is a wire cylinder

for making *wove* (a paper with a uniform, unlined surface and soft, smooth finish) or *laid effects* (a paper with a pattern of parallel lines giving it a ribbed appearance). Still other papers are translucent and used to open publication chapters or sections; these are often referred to as "transparent" papers.

Only coated paper with at least 10 percent post-consumer waste is considered *recycled*. Thirty percent for uncoated paper. Recycled

Figure 9-32
These two examples of Simpson Evergreen, an environmentally friendly paper stock, both feature a lightly textured finish with mildly mottled fibers. Two dramatically different illustration styles are contrasted on the papers. Compare these with the previous Simpson samples (see Figure 5-21). Art direction and design by Kit Hinrichs and Pentagram design. Courtesy of Kit Hinrichs.

paper is much more common today and is available to printers in most grades and finishes. Although the costs of recycled paper is getting less expensive than its "virgin" grade counterpart, it still carries a higher price tag. Also, because recycled paper tends to have shorter fibers, it causes more problems and slows production in today's high-speed presses, binderies, and folders, and adds to the cost of the job.

Characteristics of Paper

Grab a magnifying glass or film loupe and look closely at a sheet of paper. You'll discover its sides are different from one another. The side that was on the wire mesh as the paper traveled through the manufacturing process is called the *wire side*. The flip side is referred to as the *top*, or *felt*, side. The latter usually has a smoother finish. Normally, the front side of a paper—particularly a letterhead or business form—is printed on the felt side of the sheet.

Today it's more difficult to distinguish between the wire and felt sides of paper because of the improvement of paper-making technology. The wire side of the sheet does have more fiber in it due to gravity while the fibers are suspended (in the water) in the machine.

Paper also has an inherent grain. *Grain* is the direction the fibers lie within the sheet, and it affects paper in several ways. For one thing, paper folds smoother when it's scored *with the grain* (same direction). You can check a paper's grain direction easily. Fold a piece of construction paper or cardboard in both directions and note which direction produces the smoothest fold. Another simple grain demonstration is to take a newspaper page and tear it lengthwise and sidewise. The straighter tear reveals the true direction of the grain. For books, brochures, and magazines, the grain should run parallel with the binding or the folded edges of the pages. That way, the pages will turn easier and lay flatter (see Figure 9-33).

Additionally, grain direction makes a big difference on the press, particularly on multicolored, four-color, sheet-fed presses. The grain direction in almost all cases must run the width of the cylinder, or *long grain*. If the grain isn't run properly, the sheet can actually change sizes

between units in the press, making it impossible to register the different colors correctly. That said, folding against the grain is less an issue these days on *most* paper weights. A folded signature is a good example of folding both with and against the grain of the sheet. *Cover weight* papers that need to fold against the grain may be scored on a letterpress, or on a stand-alone scoring machine.

Brightness is a measure of the amount of light that's reflected from the paper. *Whiteness* is mostly a shade issue. *True white* (that is, a white that reflects all colors of the spectrum equally) is warm. A *blue* white sheet reflects more blue light than any other color. Most printers will tell you that the latter is "whiter" than a true white. Similarly, house painters often put a few drops of blue tincture in their "true white" paints.

Paper Sizes and Weights

For reasons that include both logic and utility, papers are manufactured in standard sizes and weights. They are identified and selected for printing by these measures. As an example, consider the standard paper used for letterheads known as *bond*. This kind of paper is produced with a hard surface to receive printing and

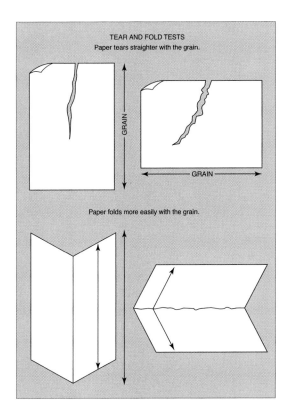

TEAR AND FOLD TESTS
Paper tears straighter with the grain.

GRAIN

GRAIN

Paper folds more easily with the grain.

Figure 9-33
Grain is the direction that fibers run in paper, much like in a piece of wood. Ideally, grain should run parallel with the binding edge or fold in books, brochures, or other publications with folded pages or panels.

writing inks without blotting, so letters won't soak into the paper and become distorted.

Bond papers are made in a basic size of 17×22 inches. They will cut into four $8\frac{1}{2} \times 11$ inch standard letter-sized sheets per full sheet. Bond comes in weights ranging from 13 to 40 pounds. The most common available weights are 16, 20, 24 and 28. These include special bonded papers made especially for ink-jet and laser printers as well. The basic weight is 20. This means that a *ream* (500 sheets) of 17×22 bond paper will weigh 20 pounds. You can cut costs and have a lighter (and probably more transparent) letterhead by ordering 16-pound bond paper. Or, you can spend a little more and have a heavier, more impressive-looking letterhead by ordering 28-pound bond. On the other hand, if you're doing a massive direct-mail campaign, working with lighter weights may help save you both paper and mailing costs.

The basic size is different for different kinds of paper. Consequently, it's important to be aware of how papers are classified and sized. The vast number of papers and paper companies may make this appear overwhelming at first glance, but the classification system is really quite simple because nearly all papers can be arranged into several categories. The number of classifications may vary slightly between paper companies, but most manufacturers recognize those listed below (see Figure 9-34):

- **Bond** (17×22"): These are the standard papers for business forms and letterheads. They have a hard surface that works well with pen and ink, typewriter, ink-jet, or laser printers. They come in a large variety of colors, but

mostly whites, ivories, grays, and pastels. Manufacturers usually offer matching envelopes as well.

- **Coated** (25×38"): Coated stock has a smooth (often glossy) surface. This paper is used for high-quality printing: view books, annual reports, media kits, magazines, brochures and the like. The surface may be dull-coated as well as high-glossed. There are a variety of other surfaces, including one-sided coating for labels (see Figure 9-35).
- **Text** (25×38"): Text papers come available in a variety of colors and finishes. They have a wide range of use: booklets, announcements, brochures, and quality printing jobs.
- **Book** (25×38"): Although not quite as expensive as text papers, book paper is used mainly for (you guessed it) books, but it is also used for pamphlets, media kits, magazines, and the like. Book papers are available in a wide range of weights and finishes from antique to smooth. Usually, printers include coated and uncoated in "book weight."
- **Offset** (25×38"): These papers are made specifically for offset lithographic printing where dampening is a factor. They have *sizing* added to the paper to avoid drying problems or possible shrinkage from the offset printing process. They are quite similar to book paper in most other regards. Generally, offset is considered uncoated book stock.
- **Cover** (20×26"): Cover stocks seemingly come in an infinite variety. Many carry the same texture and color as book and offset papers, but they're more heavily weighted and stiffer, too. All sorts of finishes are available in

Figure 9-34

Careful planning that considers paper size is wise and cost efficient. On the left, six cuts—possibly eight if paper grain isn't a factor—produce 7-x-10-inch sheets from a 25-x-38-inch sheet. By reducing the size just 1 inch for both width and depth to 6 x 9 inches, sixteen cuts can be obtained. That's a 50 percent reduction in paper cost.

UNCOATED
Ink pigment and vehicle are absorbed into the paper

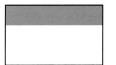

COATED
Ink pigment is retained on the surface and the vehicle is absorbed into the coating

Figure 9-35
Uncoated papers allow the ink to penetrate the paper, while coated papers hold most of the ink on the surface. Art and photographs are best reproduced when coated stock is used.

cover papers. As the name implies, these are designed for use as book jackets, magazine covers, pamphlets, media kits, and so on. Like many high-end magazines, the cover stock of *Backpacker* is enameled, heavy, and well-calendered (see Figure 9-36).

• **Index** (22½ × 35" and 25½ × 30½"): This category is less sophisticated and quite utilitarian. Index stock is specifically made to be stiff yet printable. As you might suspect, index cards are an example of this group, along with some poster board paper.

• **Newsprint:** Today many newspapers are switching over to the narrower and less costly 50-inch broadsheet. Basically, *newsprint* is cheap paper used for shoppers, circulars, and newspapers. It is also widely used as a drawing paper, because it's economical and takes charcoal and graphite nicely. Better offset printing technology and paper refinements have produced a brighter, tighter product (see Figure 9-37). It's surface is rough and pitted—not exactly the best surface for a magazine cover, annual report, or photography monograph, but excellent (and inexpensive) for mass-circulated daily newspapers. Put a film loupe or magnifying glass on a newspaper to see how pitted and uneven its surface is.

• **Cardboard** (24 × 36"): Sometimes referred to as *tag board*, cardboard stock is a heavier, stiffer version of index paper. Lighter weights are commonly used for tickets, cards, tags, and display stock. This paper comes in all sorts of colors and may be colored on one or both sides. Corrugated cardboard may also be a design option (see Figure 9-38).

Figure 9-36
Backpacker magazine is a handsome, outdoor specialty publication that is as beautifully designed as it is impeccably printed. The covers feature a glossy cover stock and cover lines hawking the magazine's contents. Art direction by Matthew Bates. Courtesy of Matthew Bates and *Backpacker* magazine.

Figure 9-37
This vibrant and beautifully designed *San Diego Union-Tribune* sports page by Christopher Barber reveals the snap and strong reproduction capable of offset on newsprint. Helio Castroneves, nicknamed Spiderman because of his fence climbing antics, made his second visit to the Indy 500 in May 2002 at the same time the blockbuster movie *Spiderman* was released. Brilliant design and layout strategy on highly reflective newsprint paper. Courtesy of *The San Diego Union-Tribune.*

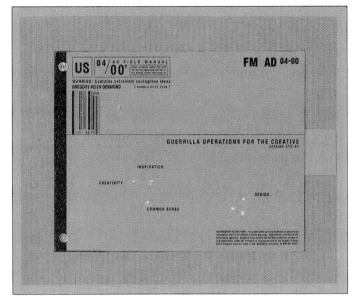

Figure 9-38
Greg Desmond used simple corrugated cardboard stock for the cover of his self-promotional portfolio materials to gain entrance to Virginia Commonwealth University's Ad Center Master's Program. He adopted a military theme, which was quite appropriate as Desmond had just completed his tour of duty for the United States Army as a communications officer. The portfolio cover is stamped "TOP SECRET." Courtesy of Greg Desmond.

Papers for a New Age

New technology requires new papers. Today, paper mills are producing papers specifically designed for electronic printing methods, such as laser and ion deposition. Most have a cotton content of 25 percent to 100 percent and are available in sizes from 8½ × 11 inches to huge rolls that are designed to run on web-fed presses.

These aren't old papers with new names, but new sorts of papers, specifically created for electronic printing, special inks, and high-speed offset presses. They are designed to reduce the possibilities of trouble as the sheet travels through the press or printer. Their cotton content gives them added strength for better longevity and extra brightness for contrast. At the same time, these papers have just enough stiffness to pass easily through electronic printing machines. Two, two-page spreads from @*issue:* demonstrate just about everything a paper company would want to show in its "new-age papers" (see Figure 9-39).

Another feature of many new papers is dampness control; this helps prevent static buildup that can result from improper moisture levels on offset presses. Also, the sheets have uniform *porosity*, which is the amount of air that can pass through the sheets. Porosity affects print quality and the ability of the toners to bond to the paper. Uniform porosity allows an even distribution of air to pass through the sheet.

Recycled paper use is on the rise, thankfully, and the trend will surely continue. As demand for this paper by consumers and others increases, the cost of recycled stock should continue to fall.

Specifying the Right Paper for the Job

It is noteworthy to mention all the information the printer needs in order to obtain the right paper for the job at hand, along with the other paper and printing specifications. Most papers are readily available from distributors within a few days. Larger amounts are ordered from the mill directly and can take up to a week to two weeks for delivery. Most mills keep jumbo rolls in the warehouse. Sheeting stock from the rolls could take longer. Nonetheless, it makes sense to check on the availability of a paper you plan to use. To that end, make paper selections early in the game.

Sheets of paper are stocked in standard sizes: 23 × 35, 25 × 38 inches, and so on. Custom sizes are available for any project using 5,000 pounds of paper or more. For example, a brochure design that is 15 × 8½ inches would run most efficiently on 19 × 32 inch paper, not a standard size. That would realize a sizeable savings—almost 25 percent. However, getting it takes a bit of lead time, usually not more than a week or two, depending upon the paper's manufacturer.

Typically, paper is specified by listing the basis weight, color, brand name, finish (or texture),

Figure 9-39

Kit Hinrichs really mixed up the design features of these double-page spreads to show off Potlatch's coated Remarque velvet stock in this edition of *@issue:*. The opening spread uses a near perfect, bilaterally balanced design, complete with tint blocks, screened type, black-and-white photography (upper bio-sketches of Harley-Davidson's CEO and head designer), and a macro full-color image of the Harley logo. The second two-pager uses a smart asymmetric rebus design that carries colored type, and both illustration and photography. Kit Hinrichs, design director; Amy Chan, designer; Jack Unruh, Bob Esparza, James Schnepf, Mark Swisher, and Robert Clark, photography and illustration. Courtesy of *@issue:* magazine.

and grade—in that order. The basis weight is the weight in pounds of one *ream* (or 500 sheets of paper) cut in its standard size for your application. Just about all papers are listed by weight except some cover stocks, which might be cataloged by thickness. When choosing color, be sure to use the exact designation used in the sample book. Paper mills, like paint manufacturers, may have their own names for colors and typically offer a wide range of shades for a given color. For instance, a tan paper from one manufacturer comes in English Oak, Chatham Tan, India Ivory, and Monterey Sand. Be sure to check a current swatch book or catalog because mills change colors as well as their monikers from time to time.

Next, note the full brand name and its finish or texture. Finally, record the grade. While this may seem obvious, it often gets overlooked. The grade might be bond, offset, or book, for example. If the grade is not listed, you may find yourself making wasted trips or extra phone calls to the printer or paper supplier. Worse yet, you may end up having to reschedule a printing date.

As an example of paper specification, you might designate the paper for a brochure in this manner: 80 pound, soft coral, Gilbert Oxford, antique, text.

As noted earlier, paper is one of the major cost factors in printing, so it's always wise to talk to printers and clarify your paper selection well in advance. In addition to pouring over swatch books, it's to your advantage to ask a printer or paper supplier for an example of a real publication run from the paper you're considering. Most printers have a file of publication samples. Indeed, paper samples should be part of every designer or art director's kit. Also, before signing off on a paper choice, check to see if the printer might have a glut of a paper stock that meets your needs on hand. That could save you a considerable amount of money.

One last important point: you need to assess how critical image reproduction is to the client. Incidentally, since we're on the subject, if imagery reproduction is critical, always use coated stock in the best grade affordable for the run (see Figure 9-40). Photography collections, fabric samplers, art collections, museum programs, annual reports, upscale magazine (such as *Communication Arts*, for example) all require top-grade paper. In addition, the stock should be designated *before* the images are scanned. A good scanner operator will make subtle corrections based upon the brightness or finish of the paper being used for the press run. For product reproduction, always use the highest line screen value possible. Lower line screens (133-150) are easier to print. Higher ones, however, are clearer and produce better detail.

Ink: Colorful Solutions

Normally, the printer chooses the ink for your job. Nonetheless, it's a good idea to understand the role ink plays in the printing process.

Ink has been a part of civilization for more than 2,000 years. Chinese artists and scribes used various combinations of ingredients for drawing and writing more than 1,600 years before Gutenberg developed movable type. Likewise, the early Egyptians concocted an ink to apply to papyrus long before the printing press. There are also references to ink in the *Bible*, and of course, writers used ink to create that book. But how was ink fabricated? In fact, ink makers made their product by grinding ashes, soot, or

Figure 9-40
Reflections is a handsome newsletter published for the University of South Dakota's School of Education. The nameplate design, *Reflections*, is literally a visual play on words, using the crimson-and-white school colors. Its enamel paper has great opacity, smoothness, and brightness and does a wonderful job reproducing photography and other art. In addition, this stock is cost-effective; the 16-page newsletter costs 32 cents apiece for a 10,000 copy run: excellent quality at an affordable price. Courtesy of *Reflections*/University of South Dakota.

lampblack to a fine powder and adding it to a vanish base created from boiled linseed oil.

In the 1850s the discovery of coal-tar dyes, pigments, and new solvents ushered in the age of modern printing ink. Today ink-making is a major industry and science.

Every printing ink contains two basic ingredients: *pigment* and *vehicle*. The pigment is a dry powder that gives the ink its color. Usually, linseed oil is used as the vehicle (or liquid) that carries the pigment and bonds it to the paper. Depending upon the process, inks may be applied thinly or thickly, be fast- or slow-drying, and transfer heavy or near-transparent amounts of pigment. *Tack* is the intrinsic tendency of ink to stick to the page. When ink has too much inherent tack, it may lift or tear the paper during printing.

Pressmen, artists in their own way, control ink application or density via a densitometer. By measuring each color on the color bar at the tail of the sheet, they can adjust ink distribution and maintain its consistency from start to finish on a run (see Figure 9-41). Designers or art directors who monitor quality control by standing in at "press checks" oversee the printing and have pressmen adjust the color as needed. Pressmen use handheld meters that can quickly assess color density and measure how much cyan, magenta, yellow, and black inks are used and tweak accordingly.

There are two basic types of ink: *opaque* and *transparent*. Opaque ink will cover whatever is beneath it, either another color or the paper itself, completely. Consequently, it cannot be used for full-color production. Transparent inks, however, will allow a color beneath it to show through, thus blending colors via the mixing process as discussed in Chapter Six.

Inks are manufactured to be compatible with every type of paper. There are quick-drying inks for high-speed production on rotary presses; water-resistant inks to lay down cleanly on offset presses; inks that harden to combat rubbing; metallic inks that simulate gold, copper, silver, and other metals; and fluorescent inks that store light and actually glow in the dark. Some special fluorescent inks can add extra glow and contrast to the page's art as well (see Figure 9-42). There are even perfumed inks that provide a subtle aroma to catch your nose off-guard. Of course, there are also inks used on your morning newspaper that smudge on your hands and clean white shirt. However, experiments with water-

Figure 9-41
Registration marks, color bars, and other specifics are standard information run on the borders of signatures and printed paper stocks. Skilled pressmen can accurately measure minute color ink shifts to correct color on a print run. This signature for Primax's brochure pages was tweaked for maximum color reproduction. Art direction, design, copy, William Ryan; photography, Louise Squillace. Courtesy of Ryan and Orion Design.

base and soy inks may solve this problem in the future. *WIRED* magazine recently used a heat-sensitive ink that changed color on its cover from the heat in the reader's hands.

For centuries, ink was available in only one color: black. Today, however, the development of synthetic pigments and sophisticated mixing technologies, such as the Pantone Matching System (PMS) and Munsell, offer an incredible rainbow of color possibilities (see Figure 9-44). What's more, colors can be matched meticulously using these systems. Color matching to a specific tint, shade, or hue has become an exacting procedure, regardless of whether you're printing in Los Angeles, Singapore, Montreal, Buenos Aires, Cairo, or Amsterdam. Most computer design programs offer built-in PMS and other color matching system libraries.

Never overlook the potential inks might provide. Spot color (two-color) adds a great deal to a publication without a great deal of added expense.

As mentioned earlier, metallic inks may add a special touch to a full-color cover or advertisement. Metallic inks may also bring great range and brilliance to photographs when run with black ink as duotones. It's a simple and logical solution (especially given that black and white photos are silver-based), but few designers use it as a strategy. Some photography collections may use duotones using a metallic ink. Annual reports, magazines, and many business communications also employ metallic inks, both separately and in duotones (see Figure 9-43).

Remember, too, that inks and paper, along with all the other supporting elements, should be used strategically and play a major part in your designing and publishing efforts. Like type, color, design, and artwork, ink and paper should be used thoughtfully and creatively.

Special Printing Processes

There are a number of unique printing processes that may be employed to add distinction, elegance, or a special touch to a publication. Often, some or all of these options may be used on an annual report, brochure, letterhead, or even in books. For example, spot varnishing embellished a beautifully designed children's book (see Figure 9-44). Some of the special techniques include engraving, embossing, scoring, hot stamping, thermography, varnishing (and spot varnishing), die cutting, and metallic inks.

Engraving is an excellent method for projecting a high-quality, prestigious image. The sharp lines and crispness of an engraved announce-

Figure 9-42
Compare both versions of the portraits' contrast, snap, and color quality: the left page was run in normal four-color and the right in four-color fluorescent ink. Timothy White shot this portrait of Joe Jackson for Monadnock Paper Mills' *MPM.Edge* magazine. Today the science of printing materials—paper and ink—is truly amazing. Courtesy of Timothy White.

ment, invitation, or letterhead project refinement, strength, and dignity. Engraving reproduces fine and tapered lines and small type well by bringing out subtle shadings and patterns.

An engraving press utilizes a chromium-coated copper or steel plate with an etched design and an ultra-smooth counter plate. The etched plate is covered with ink and wiped dry; the ink remains sunken in the recesses of the etched area. Paper is fed into the press, and the impression transfers the ink to the paper. Most engraving plates are small—typically 4 × 8 or 5 × 7 inches.

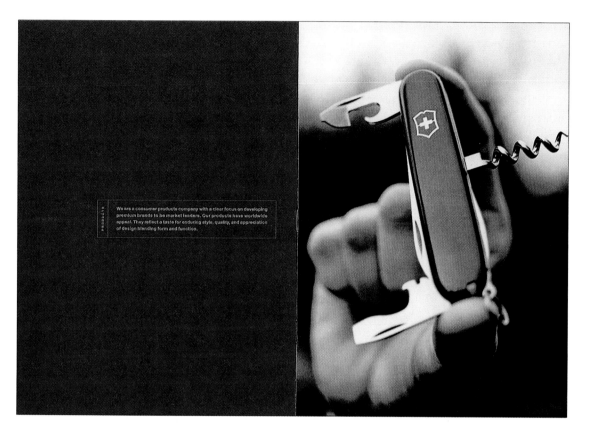

Figure 9-43
This two-page spread from a recent Swiss Army Brands annual report features an uncoated black paper stock with metallic silver ink (left) immediately adjacent to its corresponding high-gloss enamel page (right) with a duotone photograph featuring black and silver inks. Annual report design created by SamataMason. Provided by Swiss Army Brands, Inc.

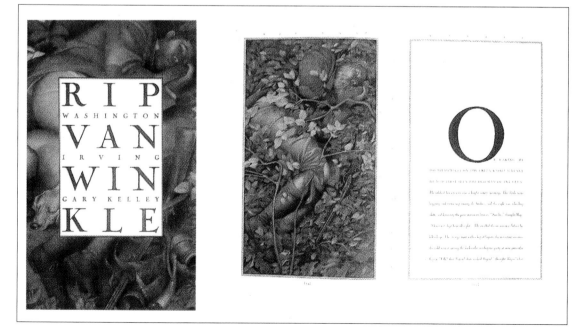

Figure 9-44
This elegant children's book was designed by Louise Fili. Take a look at the cover page (left). She inserted a mortise within full-page art of the sleeping Rip. The proportions of the mortice are the same as the page. The text and illustration on the two-page spread are framed within similarly proportioned boxes. Note the generous leading of the text and the dynamic initial cap that invites the reader into the story. Courtesy of Louise Fili, Ltd. Illustration by Gary Kelley.

Paper selection is critical, too, because of the stress exerted by the press. Paper lighter than 20 pounds is generally not used.

Embossing results in a relief or elevated surface on the paper, in effect producing a *third* dimension to the page. Essentially, the paper is run between convex and concave dies and stamped; the result is a raised surface in the pattern or configuration of the die. Dies are made of metal, often brass, although plastics are used today, too. Logos are probably the most common application for embossing. A standard embossment consists of the inked raised (relief) area. An example of the use of both embossing and engraving is a Chiquita Brands International Annual Report (see Figure 9-45).

Embossing may be used on something as simple as a business card, or as extravagant as an annual report or viewbook. There are four styles of embossing: *standard*, *blind*, *deboss* (or *sunken*), and *foil-embossing*. Normally, ink is applied to the raised surface—*standard*. *Blind* emboss uses the process without ink or foil. Braille is a blind emboss method, and business cards and letterheads are commonly blind embossed. Sometimes, though—as in the case of

the *Seventeen* magazine media kit discussed in chapter twelve—a client will request a deboss or sunken embossment. As its name implies, the regular embossing is flipped, so the embossment is recessed. Foil embossing uses a thin material faced with a thin layer of metal or metallic pigment.

When using embossing, remember that the embossed area is molded and may use slightly more paper than the layout would suggest. Consequently, make sure that type or other graphic elements aren't placed too close to the embossed area.

Scoring is a simple procedure that creases the paper where it's meant to be folded. It is a common tactic used with brochures, direct mail, and other multi-fold publications to ensure perfect folding. Typically, scoring is executed on letterpress or a special scoring machine. Improved paper-making technology and sophisticated folding machines have made folding less of a problem.

Hot stamping uses the same heat-pressure system as embossing, but during the process it transfers a foil material to the paper's surface. Most foils are available in a wide array of metallic colors—gold, silver, bronze, and copper are common color options. Some clients may elect to save money by simply using metallic ink instead of hot stamping. Foil is used a lot on greeting cards, ribbons, packaging, letterhead, and sometimes as an elaborate cover option for brochures or annual reports. Foil stamping is the solution Hornall Anderson Design Works decided upon for Ghirardelli Chocolates packaging (see Figure 9-46).

Hot stamping is fairly simple: a very thin ribbon of foil is fed into a press and stamped. It releases its metallic pigment when heated and run between the die and impression plate. Hot stamping, however, is expensive and may cost 15 percent more than engraving or embossing. Paper selection is important too because the heat can discolor some paper stocks.

Themography is sometimes confused with hot stamping. This process produces a raised surface by dusting the wet ink printed on the surface

Figure 9-45
This annual report, designed by SamataMason for Chiquita Brands International, employed both engraving and embossing for the art pages within the report. It's impossible, obviously, to *feel* the embossment, but the edges of each separate banana are raised here, as is the Chiquita logo. The use of color and design add to the 3-D effect. Using illustration in this manner is as unusual as it is refreshing. Courtesy of Chiquita Brands International.

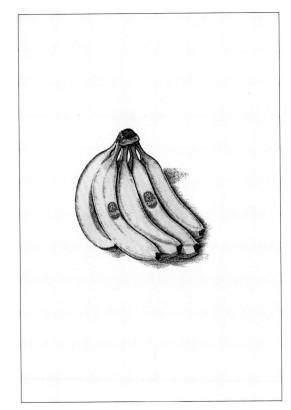

Figure 9-46
Packaging is a common medium for hot foil or foil stamping. In this case, upscale, delicious Ghirardelli Chocolate is the perfect client for this use of foil and the very elegant design executed by Hornall Anderson Design Works. Courtesy of Ghirardelli Chocolates and Hornall Anderson Design Works.

with a resinous material, which fuses to the ink when heat is applied. The image produced is both chip-proof and crack-proof. Some feel it's similar in appearance to engraving. The advantage, though, is that it can be added anywhere on the page, and it isn't limited to smaller sizes. It may also be used with any color ink.

Varnishing, also referred to as *clear coat*, is a transparent coat that's applied, like ink, to a printed piece of paper during the printing process. Often it is used to gloss a cover, but it comes in a variety of sheens from flat to matte to highly glossy, with lots of choices in between— satin, semi-gloss, demi-gloss, and so on. *Spot varnish* is applied to a specific area or areas on a page, such as a nameplate, a logo, or small art area. Sometimes, too, type is run "sans ink" as a spot varnish. The varnishing process may be very subtle and elegant, or it may be utilitarian, as a protective coating or to give a flat paper stock some sheen. Today aqueous coatings are often used in lieu of varnishes.

Most modern offset sheet-fed presses have an *aqueous coating* unit in the last printing position. As the name suggests, aqueous coating is water-based. Like spot varnish, it comes in finishes that run the gamut from high gloss to matte. Its

biggest advantage is that the ink dries quicker, allowing the next steps (cutting, folding, binding, and so forth) to proceed in a more timely fashion. Aqueous coatings can be applied as spot coating, too, and in this instance, a special plate needs to be made.

Die cutting literally punches a hole into the paper in much the same way as a cookie cutter penetrates dough. Cuts can be executed in any shape you wish. Die cuts may be *internal* (inside the page), for example, a square shape out of the middle of a cover, or *external*, such as cutting around the rounded shape of clouds atop a page. *One.a* magazine, a quarterly published by the One Club for Art and Copy, uses its signature die-cut of the number one on the cover of all of its magazines (see Figure 9-47).

Letterpress, special die-cut machines, or even lasers may be used for die cutting purposes. Avoid lacy or intricate patterns with any die cut, and make sure you use a relatively heavy paper stock, one that has the strength to take cuts without ripping. It's important the paper will hold the cut and remain stiff without compromising the function of the page.

Metallic inks are specialty inks that are laced with metal flakes. Although they may be used

Figure 9-47
The large magazine
format—10½″ × 15½″
inches—and distinctive
one die-cut make an
unmistakable profile for
one.a magazine. One
showcases the finest
international creative
advertising, and regularly
features forums,
interviews with celebrated
advertising creatives, and
retrospectives of some of
the most important
copywriters, designers,
and art directors in
advertising. This powerful
art is from Adidas' "eye-
catching Moori man"
from Saachti & Saachti,
Wellington, NZ. The
punched out number one
is inserted in each
magazine copy and serves
as a working bookmark
and subscription form.
Editor, Warren Berger;
designer, Edwin Laguerre;
editorial director, Mary
Warlick; managing editor,
Tiffany Meyers. Courtesy
of *one.a magazine.*

alone, they're usually applied as a fifth color.
They can add luster and flair to a page.
Magazines often use metallic ink on covers, but
they may be applied to any printing job.

Pre-Production: Getting It Right
Preparing Copy for the Press
Hard copy should be at least double-spaced for
initial editing. Standard editing marks generally
used in marking up copy are shown in Figure 9-
48. Although basically the same as editing
marks, proof marks are also important to know
(see Figure 9-49).

A printer may provide you proofs or galleys
after the type has been transferred from a word
processing file, "speced," and printed out. Today
a computer printer basically may serve the same
purpose. Nonetheless, it's remarkable how often
obvious errors go unnoticed until bluelines,
Dylux, or other proofs appear. *Bluelines* are
proofing pages provided by the printer complete
with graphics, art, and type; they're contact-
printed from the flat negatives onto a photo-
sensitive paper with a deep cyan base color.
Hence the term "bluelines." *Dylux* is a water-
based, full-color proof made by Dupont. Today,

the correction proofs are available in a variety
ways, including "water proofs," laser proofs, etc.
Corrections are normally made on the proof
pages and passed back to the printer.

Measure Twice, Cut Once
The old carpenter adage is still important and
applies to pre-production. You can't be too
vigilant searching out and correcting errors
before they appear in the finished product. The
effort spent checking, reading, editing, and
rechecking can save you time and money.

The following is a list of pre-production
suggestions:

• Adopt a stylebook for your publication, no
matter if it's a humble newsletter or full-blown
magazine or annual report. Use it faithfully.

• Proofreading is a bifunctional task. First, it's
meant to catch and correct errors in the copy
itself. Second, it allows you to compare the
proof with the original to make sure it con-
forms in every way.

• There is strength in numbers. One proofreader
may read over the same mistake any number
of times; however, a second reader will likely
catch the missed errors.

Correction Desired	Symbol
1. Change form:	
3 to three	③
three to 3	(three)
St. to Street	(St.)
Street to St.	(Street)
2. Change capital to small letter	⌀
3. Change small letter to capital	d
4. Put space between words	the#time
5. Remove the space	news⁀paper
6. To delete a letter and close up	judgement
7. To delete several letters or words	shall always be
8. To delete several letters and close up	supererintendent
9. Delete one letter and substitute another	Receⱸve
10. Insert words or several letters	the of time
11. Transpose letters or words, if adjacent	recⱸeve
12. To insert punctuation (insert mark in proper place)	

comma	⋏	parenthesis	{ or }
period	x or ⊙	opening quote	⤷ or ⤶
question	?	closing quote	⤴ or ⤴
semicolon	x	dash	⅟M or ⅟N
colon	x or ⊙	apostrophe	⤵
exclamation	!	hyphen	═

13. To start a new paragraph	¶ or ⌐ It has been
14. To center material	⌐Announcing⌐
15. Indent material one side	Categories
	⌐a. the first
	⌐b. the second
Indent material both sides	⌐one two three four⌐
	⌐five six seven
Set in bold face type	The art of
Set in italics	The art of

Figure 9-48
These are standard editing marks for correcting copy before it is set into type. Although there may be some differences, these symbols are also commonly used for proofing or mark up purposes.

- In the case of multiple readers, it's a good idea to use different colored pens or pencils in the mark up so there is a frame of reference, particularly if questions arise. Initial the copy after you've finished proofing it.

- It's common to mark carats on the edges of the line of type where the error occurs. This helps prevent overlooking a correction or change that might otherwise be buried. It's also common to make the correction in the margin, but most editing mark ups are in the text where the error occurs.

- Some proofreaders or editors like to draw a line from the error to the correction mark in the margin. What's important is that no matter which system you use, it's employed clearly and consistently and understood by all parties involved.

Figure 9-49
Standard proofreading marks are very closely related to editing marks. See Figure 9-48 for comparative purposes.

- Graphics need special care. Charts, graphs, and sidebars should be checked for mathematical accuracy, as well as for typos. Check further to make sure that the numbers or percentages used within a story match those in the charts.

Pagination and Binding:
Keeping it All Together
Actually, pagination is a very important piece of the pre-production process. Essentially, *pagination* is the process of arranging and numbering the pages in your publication. It's crucial to figure out the publication's logistics.

If you took an eight-page newspaper section apart, you'd notice how the pages are arranged. Pages 8 and 1 are adjacent to one another; on the back of that sheet are pages 2 and 7. Pages 6 and 3 and 4 and 5 are broken out on the other sheet. These are printer's pairs.

In larger publications such as magazines or in elaborate brochures, page combinations and their signatures become much more complicated. As a designer, it's your responsibility to configure or plot the pages' respective placement within your design document. This becomes especially important when some of your signatures are full-color and some black and white or two-color, because your space must be explicitly budgeted

and arranged. A *signature* is a single sheet of paper, both sides of which have been printed in a prearranged grouping of single pages, commonly referred to as *printers' pairs*. Signatures are usually run in multiples of 16 pages on a single sheet of paper, but may be run smaller depending upon the format and total number of pages in the publication.

Generally, the binding process begins by organizing the signatures, cutting, folding, and arranging them—nested atop one another—in chronological order. In lightweight binding, the signatures are configured into four-page sections, collated, stitched and trimmed. If paper weight or stiffness burdens the process, printers first score the signatures.

After the signatures have been collated, they're ready for binding. There are several approaches to binding: side stitching, saddle stitching, edition or case binding, perfect binding, and spiral binding (see Figure 9-50). Many large or bulky publications find *side stitching* the best method of binding. In this case, the folded signatures are neatly arranged atop one another and stitched approximately one-quarter inch from the left edge. Typically, covers are glued on afterwards;

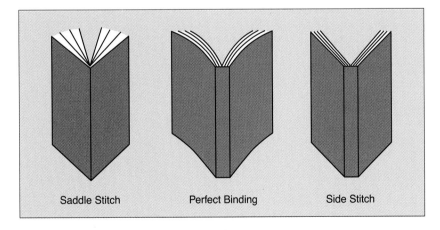

Figure 9-50
Magazines normally use one of these approaches to binding.

this further strengthens the binding. *Saddle stitching* is easier and less expensive. Collated signatures are nested upon one another and staples or stitching is applied to the center of the publication's spine. *Perfect binding* is a binding method that uses a flexible adhesive to hold the backs of assembled signatures together while they're ground to size and more adhesive is applied. The cover is put in place while the adhesive is still wet. Most paperback and some

hardcover books are bound in this manner. Finally, *spiral binding*, while it doesn't have the same aesthetic of any of the other binding methods, can be very functional, particularly with training manuals, directories, or other publications you need to lie flat (see Figure 9-51). After pages have been collated and trimmed, holes are bored or punched into the paper, then plastic or wire is twirled or inserted into the openings. If you use a spiral bind, make sure you use paper that's stiff and heavy enough, so the pages aren't easily worn or torn up.

Working with the Production Staff

Whenever you work with production personnel and commercial printers, make sure you agree on all the bid's conditions from job specifications to delivery dates and everything in between. Speaking of bids, when you compare printer's estimates, examine them meticulously, so you aren't comparing apples and oranges. It may sound obvious, but it's not uncommon to accept a lower bid without noticing that something has been omitted. Below are the main "trade customs" of U.S. printers:

1. *Quotations*: A price quotation not accepted within sixty days is subject to change or review. All prices given by a printer are based on material costs at the time of the quotation.

2. *Orders*: Regularly placed orders, verbal or written, cannot be cancelled except on terms that will compensate the printer against any subsequent loss incurred.

3. *Experimental work*: Experimental or preliminary work performed at the customer's request will be charged at current rates and may not be used until the printer has been reimbursed in full for the amount of the charges billed.

4. *Creative work*: Any creative executions—sketches, photography, dummies, or prep work developed or furnished by the printer—shall remain the printer's exclusive property and no use of the such work (nor ideas obtained from it) shall be made without compensation to the printer. This compensation shall be determined by the printer, and such charges would be *in addition* to the original price agreed upon.

5. *Condition of the copy*: If copy to the printer is different from that which was originally

Figure 9-51
Spiral binding may be a cheap and easy way for a student to assemble a portfolio, plansbook, or assignment, or it may be the preferred binding approach for technical materials or materials that need to lie flat. In this instance, SamataMason elected to use a spiral binding for this sophisticated annual report for Dentsply International Incorporated. Why do you suppose the designer opted to employ a spiral binding? Courtesy of SamataMason.

described by the customer and upon which a quote was made, the original quote may not apply and the printer has the right to bid the job again.

6. *Materials*: Working mechanical art, type, negatives, positives, flats, plates, and other physical items supplied by the printer remain the printer's exclusive property unless otherwise stipulated in writing.

7. *Alterations*: Work done on changes from the original copy will be quoted at current rates and an accounting will be provided to the customer.

8. *Pre-press proofs*: The customer should insist on proofs before a job is printed. The printer should insist that all proofs be signed off and "initialed" by the customer with a formal "OK" or "OK with corrections" and signed. Both parties should agree upon *how many* pre-press bluelines or proofs will be allowed. The printer can't be held responsible for errors in the proofs if they were marked "OK." Changes should *never* be made verbally.

9. *Overruns and underruns*: Overruns or underruns not to exceed 10 percent on quantities ordered, or the percentage agreed upon, shall

constitute acceptable delivery. If you need exactly 10,000 copies, be sure the printer is aware of this. Under this custom he could deliver as few as 9,000 copies on a 10,000 order and still be technically correct as far as filling the order is concerned. But if that's the case, the printer should bill you for 9,000 copies. Most reputable printers would not short you on a job, however.

10. *Terms*: Payment shall be whatever is established in the quotation or invoice unless you've made previous arrangements—in writing—with the printer. Claims for defects, damages, or shortages must be made by the customer in writing, usually within fifteen days of delivery.

Pre-Production & Post-Production Tips

Establishing and maintaining a good relationship with a printer revolves around making their job easier, by doing yours. Recently, one of your authors talked to Genevieve Astrelli, art director at *CMYK*. He asked her for a list of practical suggestions you should know to streamline the production of whatever it is you're publishing. For starters, though, check with the printer to acquire file specifications and other particulars

necessary to prepare and print your job. Having files meticulously prepped will save you and the printer numerous hassles, telephone calls, time, and possible mistakes. It will also save you money. Each printer will likely have slightly different requirements. Most printers provide clients with a sheet of guidelines, but you have to ask for them. Astrelli's guidelines follow:

1. *Make sure all images and fonts used in the document are included.*

2. *When supplying Adobe Illustrator files, it is best to create all type as outlines. This way no fonts need to be included. If the type is not outlined, and was not supplied, the production house should be informed that font is missing. The rationale here is simple, if the font does not show up when the file is being ripped, a default font (typically, Courier) will be substituted if the mistake isn't caught. If it is discovered, the job will have to be stopped, and you'll be asked to provide the correct font. Time and money lost.*

3. *Illustrator files may be supplied in two ways: one has all files linked, and the other has all the files embedded. If the files are embedded, it means that the production house does not have access to the individual files for color adjustment or corrections. In this case, they'll have to get these files from the designer. This will also slow down production time. If there is no possibility of any changes being made, then it is okay to supply an Illustrator file with embedded links.*

4. *When producing Illustrator files which include smaller type sizes, it is better for quality purposes to change the resolution from 800—which is the software's default—to 2400. This will mean that the outline fonts will reproduce better in the final printed version.*

5. *When producing QuarkXPress documents, it's better for the production house to have five two-page documents supplied instead of one ten-page document. The larger document is much slower to refresh on the screen and any corruption in the document will make the entire file unusable. In general, the larger the document is (in QuarkXPress or any other software), the slower it will run.*

6. *When supplying any job, it is much simpler for the production house if the images linked to the job are not scattered individually, or put in a lot of different folders; place them in one or two large ones. Being organized makes it easier for you to work, too. Once the production house opens up the supplied documents, Quark says that all the images are missing and they are required to search for them, so it is much easier if they have to search in only two or three folders, instead of having 32 small folders for a 32-page publication. It's much easier to have everything in one folder, so all the images will automatically link when the document is opened.*

7. *Because the industry is slowly moving away from film to CTP (direct to plate), it means that production house specifications are changing. Before, the final product was imposed film, which would be supplied to the printer for plate production. Now the final product is becoming high resolution PDF files, which are supplied to the printer, who in turn, imposes these files directly to plate. With film output, it meant that all pictures had to be supplied as high resolution CMYK TIFFs or EPSes for a pre-separated work flow. Now, JPEGs can be used because the PDF work flow is a composite one.*

8. *Always request a color proof to sample the color and see the document. You don't want unpleasant surprises in a final run. Production houses supply a variety of color proofs to fit your needs and budget.*

Figure 9-52
Genevieve Astrelli is originally from Ticino, Switzerland, but currently resides in San Francisco where along with duties at *CMYK*, she freelances packaging, collateral, and other design work. Astrelli is the co-founder and creative director of *CMYK* magazine, an art publication that showcases the best student and non-professional advertising, design, photography, and illustration nationwide. Courtesy of Genevieve Astrelli.

9. *Technology is always being updated in this industry, so it is best to call your production house on how they want materials to be prepared. They are usually very helpful with detailed instructions. It benefits both the artist and the production house to work together.*

Good advice. After your work has been produced, make sure you pay for the services rendered in a timely fashion. Maintain a good relationship with your printing house and main production contact person. You'll find this extremely helpful when you are in a rush, or if for some reason there is a hang-up with your job. Learn from every project, and every mistake that occurs. Jobs will not be perfect every single time.

However, you will be on your way to becoming an expert.

Graphics in Action

1. Start a collection of paper swatches by visiting or writing to a paper wholesaler or printer (assuming they are willing to part with samples) and collecting an assortment of different papers that are available.

2. Obtain samples of papers of various weights and textures. Examine them under a film loupe or magnifying glass and see if you can determine which is the felt and which is the wire side of the sheet. Fold them with and against the grain. Tear the paper in both directions: lengthwise and across. Do you note any differences? What are they?

3. Using a film loupe or magnifying glass, compare the halftone patterns and resolution of your college or university newspaper and the halftones of a slick full-color magazine. How are they different? Similar? Why?

4. Research paper-making and try to make your own paper. There are a number of books available to you that give good instructions.

5. Try to locate a paper company's special sample book—or two, or ask your instructor to bring several to class. These are the ones promoting or launching a company's new line, ones that are targeted at art directors, not a typical swatch book. Carefully, go through it. Note its theme, premise, creativity, rationale, and just as importantly, how it shows off its product—paper and demonstrates how that paper handles different inks, photography, line art, typography, and printing situations. What did you learn?

6. You are an art director asked to launch a new, reusable, and environmentally-friendly coated paper stock for Georgia-Pacific Paper. Come up with a concept or theme to support the paper stock and your idea. Remember: you're targeting art directors and creative directors here.

7. You've just been appointed head designer. You've been asked to select a paper and ink(s) that would be most suitable for each of the following clients, and to present your recommendations to the creative director of your company. Be sure to consider weight, texture, opacity, and color. Explain the reasons for your choices.

 a. A brochure announcing an exhibit of a special showing of Mary Ellen Mark's photography for the MoMA.

 b. A catalog for J. Crew, featuring its new spring line-up of clothing.

 c. A gatefold cover for a 25-year anniversary issue of *Guitar Player* magazine. It will feature a collage of color photography of the most famous guitarists since the magazine's inception.

 d. A two-color fund-raising brochure for a high-profile public service group—the Soroptimists, a women's club. They wish to promote their annual "Walk for Life" event, which educates the community about breast cancer. The proceeds from the fund-raising activity go to women who cannot afford breast cancer treatment or special medicines for that disease. The Soroptimists want something very tasteful and creative, but have a *very* limited budget.

 e. A six-color viewbook promoting the latest Volvo models.

 f. A newsletter for the local fine arts club. They need excellent reproduction of photography and line art but haven't much money to spend.

 g. A fund-raising poster for a high school crew team.

 h. Your school's yearbook.

Today's Corporate Image: Black
Eyes and Greener Pastures

Public Relations—An Overview

The Annual Report: The Swiss
Army Knife of Communication

Graphics in Action

*If an annual report can help
raise the price/earnings ratio of
a medium-sized company by
even one point, this translates
into an increase of millions of
dollars in total stock value; for a
blue chip company, the increase
might be measured in billions.*
— Richard Lewis,
Graphis Annual Reports

◀ *George 2003, Photo Illustration, Jan & William Ryan*

A person's perception of a company is the cumulative result of input acquired from surprisingly few sources: personal experience; the media; trusted advisors; and a company's internally created communication. An annual report is an opportunity to have a conversation with someone important.

—Pat Samata, Principal, Creative Director
SamataMason, Chicago, Vancouver, New York

Today's Corporate Image: Black Eyes and Greener Pastures

Perhaps the most challenging areas of design lie within the realm of public relations (PR). In fact, there may be more visual relevance *and different media employed* in PR than any other area of communication. Applications include annual reports and other yearly publications, tabloid-format newspapers, newsletters, brochures, identity materials, Web and interactive sites, outdoor media, magazines, television, photography, banners, media kits, catalogs, and virtually everything from envelopes and reply postcards to hard-bound books.

Unfortunately, however, recent scandals at Enron, WorldCom, and other large corporations have exploded the average person's trust of the corporate world. Obviously, too, those transgressions have impacted the stock market and the economy considerably and presented public relations professionals with huge challenges. Greg Samata, Pat Samata, and David Mason are partners and creative directors at SamataMason, one of the most respected agencies in public relations and business communications. They reflected on corporate credibility, "investor confidence," business communications and establishing trust in a recent interview and June, 2003 statement prepared to open this chapter:

"We treat others as we would like to be treated ourselves. We do not tolerate abusive or disrespectful treatment."
—Enron 2000 Annual Report
Say what?
Nobody believes much of what corporate America has to say these days. And why should

they? One after another, the skeletons are emerging from the corporate closets, putting the lie to platitudes and projections so readily accepted when stock prices were heading the other direction.

Death by accounting is currently the most popular form of corporate suicide. Generally accepted accounting principles aren't generally accepted any more. Words such as reserves, goodwill, depreciation, amortization, capitalization, write-downs *and* deferrals—*the lexicon of business—now sound like the lingo of thieves. To the broad investing public, the scandals that have exacerbated the retreat of the stock market paint everyone with the same brush.*

Investors are taking a "shoot first, ask questions later" approach. But wait. Isn't that the same approach they took when they were snapping up dotcom IPO's without doing any real due diligence. The same approach gave us "irrational exuberance." It's just that now the shoe's on the other foot; this time everyone's guilty until proven innocent.

So how do we reverse the trend that made "investor confidence" an oxymoron? Greater regulation may be inevitable and tougher rules for management are probably a foregone conclusion, but any company worth investing in understands that external forces aren't really going to get the job done. The battle to regain investor trust isn't being fought in a government office, it's happening in the real world. It's happening in corporate offices, in the media, and on the street. And the ultimate winners will be the companies that do the right things from the top down and who retain their credibility when others lose theirs.

A person's perception of a company is the cumulative result of input from surprisingly few sources: personal experience; the media; trusted advisors; and a company's internally created communication.

In a climate of distrust, effective corporate communication is a critical part of the picture. The old formulas and words—quality, commitment, value, growth, service, excellence—just don't work any more. And the tried and true ways to position a company in an ad or on the cover of an annual report now sound pretty empty. Photos of shiny, happy people shaking hands and pointing at computers just won't cut it.

Because when things go bad out there, sounding and looking like everyone else can be dangerous.

It's no accident that regulators are asking corporate executives to swear to the veracity of their financial statements.

Now it's getting personal.

Corporate communication has to change to meet the new reality: more open, more honest, and more human. What investors are concerned with now more than ever are the people behind the corporate "we." The investing world needs to know that there's someone with a beating heart behind the words and numbers.

An annual report is an opportunity to have a conversation with someone important.

We help our clients find their own voice.

Indeed, finding a company's "voice" and presenting its case graphically, in a meaningful and credible way, is a difficult task, especially today.

In an interview (January, 2002) with *Graphic Design USA*, Bill Cahan, founder and senior creative director of Cahan & Associates of San Francisco, spoke to some of those contemporary economic and business issues. Cahan, another respected leader in business communication and graphic design, underscores SamataMason's views and discusses his agency's stance:

The combination of the economic downturn and the September 11 tragedy has forced us to look at our business model and at ourselves. We are making a concerted effort to diversify in terms of projects, broadening out from a strong base of annual report design into branding, packaging, collateral, websites, and more. We

Figure 10-1
The principals for SamataMason are (left-to-right, discounting blocked faces) Pat Samata, Greg Samata, and David Mason.
• Principal and senior designer Pat Samata has lectured extensively and taught graphic design at the Illinois Institute of Technology's School of Design. She and her work have been honored in virtually every significant design industry publication and competition. She is also president of the Evans Life Foundation.
• Greg Samata cofounded Samata Associates in 1975 with Pat Samata, and is a principal and designer at SamataMason. He is also a board member of AIGA (American Institute of Graphic Arts) and—with Dave Mason—co-founder of OpinionLab, Inc., the leader in automated user feedback systems for the Web.
• Although he was born in England, Dave Mason grew up in Canada, where he founded Mason & Associates. Mason lectures around the world on design, and he is a past president of the Society of Graphic Designers (Canada).

have been lucky that many of our long-term clients are coming to us for all kinds of projects, including many that are different from what we have done for them in the past.

With tighter budgets, we have also become more sensitive to doing more with less. This challenge has pushed us to sharpen our talents, and in many cases to make our work more direct, impactful, and fresh. For example, annual reports must walk a fine line, conveying a sense of confidence and substance but not crossing over into excess or exuberance at a time of reduced earnings, diminished dividends, and even widespread layoffs.

Cahan's views are well-grounded. The fact is the 9-11 tragedy, corporate scandals, and economic slumps only make effective business communication and public relations more important than ever before. One thing is sure; government-imposed mandates for annual reports will not go away. Indeed, it was the government that created the Securities and Exchange Commission (SEC) and required publicly owned companies to provide a yearly accounting of themselves after the stock market crash in 1929. Corporate fraud will likely cause the government to monitor Corporate America even more closely. Finally, the fact that business is in a downturn is all the more reason to engage public relations and corporate marketing consultants.

Public Relations—An Overview

The field of *public relations* is one of the most misunderstood areas in the world of communication. Its missions are varied—from corporate image-making to delivering yearly financial accountings of a client, from hospitality activities

to event-planning and damage-control, from formats very specific to its genre, such as annual reports and identity and collateral materials, to the use of more familiar media: magazines, brochures, newsletters, video, and billboards.

The professional public relations practitioner might describe the process of public relations as *the planned effort to influence public opinion through satisfactory—even exemplary—performance and two-way communication.*

Public relations may involve advising management, evaluating public attitudes, analyzing an organization's policies and procedures as they affect the interests of the publics (groups of people with particular interests in the organization) and the community. Activities include implementing programs, publications, and other communication designed to earn public understanding and acceptance. Indeed, among other things, SamataMason shaped the QLT annual report to underscore new company directions and advertise new products to current and future shareholders (see Figure 10-2).

To accomplish these goals, public relations people lobby, launch publicity activities, create press releases, plan events, help with advertising efforts, and work with the media, as well as advise management on policy and procedure. The media and visual strategies that PR practitioners employ to accomplish these and many other tasks are tailored to the audience and mission at hand.

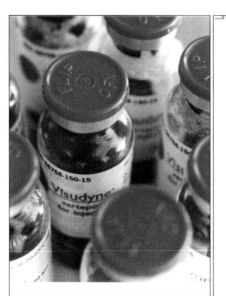

Figure 10-2
Simplicity, vibrant color photography, and direct presentation demonstrate QLT's marketing directions and showcases their product breakthroughs in this handsome SamataMason design. Visudyne and other pharmaceutical products the company has created have made QLT the success it is for over 20 years. This smaller format, 6 × 8 inches, is consistent with many SamataMason annual report designs. Along with saving money, the smaller size is distinctive and very user-friendly. Art direction and design, SamataMason. Courtesy of SamataMason.

One professional approach to handling a public relations problem is to create and follow a four-step plan. Sequentially, it includes:

1. Research: Define the problem and gather as much relevant information as you can for background and to solve it.

2. Planning: Establish short- and long-term goals and a timetable to attack the problem. Examine all options. Anticipate and discuss possible difficulties that might arise and make adjustments and secondary plans to overcome them. Assess your research and resources to decide what you need to accomplish your goals. Sometimes, to shake up the predictable presentation, designers opt for smaller or more unusual formats for the annual report (see Figure 10-3).

3. Communication: What media action will you pursue to inform your publics and educate them about your problem? Do your media planning: determine which medium or media combination is best for your message.

4. Evaluation: Assess your plan to determine what has worked. Evaluation is not just after-the-fact, it should be an on-going monitoring

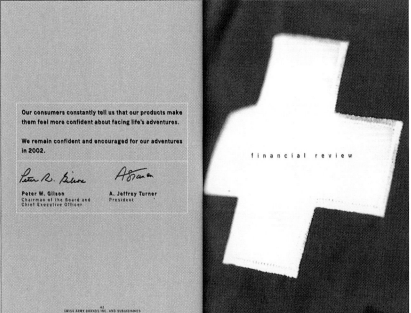

Figure 10-3
Both of these two-page spreads for the Swiss Army Brands, Inc. echo the theme of the following year's annual report: "Swiss Army products are engineered for people who tend to see life as one big 'to do' list and who want to be equipped for whatever comes their way." The entire book stacks these lists ("take a chance, drink more water, camp out, fly business class, make sacrifices, don't sweat it") in deep silver type throughout the report, on pages by themselves, atop artwork, and even on the translucent vellum jacket of the report. This report employs an unusual format dimension (as did all the previous examples)—5 1/2˝ × 8.˝ SamataMason's Dave Mason and Pamela Lee art directed and designed these beautiful materials; photography by Victor John Penner and James LaBounty. Copy written by Steve Zousmer. Provided by Swiss Army Brands, Inc.

and assessment procedure that begins at the research stage and continues throughout the process. Don't settle for success; determine how you might've done even better.

The array of visual tools at your disposal is amazingly diverse and will surely play a crucial role in public relations problem-solving.

Sometimes solutions to an annual report's theme or concept may come from the most unlikely sources. For example, Equus Design of Singapore used the name of the manager, Charlie Chan, for inspiration on Craft Print International as their inspiration (see Figure 10-4).

Most of these media are discussed in other chapters (for example, newsletters, collateral materials—brochures and identity materials, packaging, websites, photography, and magazines). Rather than be redundant here, please look at those chapters to learn about utilizing the respective media.

Typically, most annual reports take six months or more to plan and produce and on-going teamwork. Normally, an art director and a creative director oversee and orchestrate the report. Normally, too, they employ a staff consisting of a designer, writer, photographer, a pro-

duction coordinator, and possibly an illustrator. If you're involved with the creation of a yearly report, it will consume an inordinate amount of planning, effort, and time. It also involves considerable on-going review, scheduling, coordination, and regular deadlines.

It should come as no surprise then that good planning is essential, and the first step in producing any yearly report.

The Annual Report:
The Swiss Army Knife of Communication

The annual report is, indeed, like a Swiss Army knife. Its possible functions are many. First and foremost, it provides a yearly financial accounting of a company. It also can be an invaluable investment document, a recruitment kit, advertising, a news vehicle, and perhaps a corporation's most valuable public relations tool. The primary missions of the annual report, however, are clear: to provide a financial accounting and overview of a company and to present the company in its best light.

As Richard Lewis noted earlier, even meager price/earning ratio increases can mean millions or even billions of dollars more for a corporation. Remember, too, that of all its communications, the annual report is the most credible corporate document.

If the annual report can help raise the price/earnings ratio of a company by even one point, that may translate into an increase of perhaps millions of dollars or more. Remember, too, that of all its communications, the annual report is the most credible corporate document.

A common strategy is to establish a theme for the publication, one that stresses one message or "big idea," as Equus did. Regardless of the theme or visual direction, however, the best annual reports offer arresting photography, smart graphics, tight writing, and a unifying design to underscore the report's thesis. For Swiss Army Brand, SamataMason wanted to feature their client's new products and expansion into the outdoor sportswear sector. The report's photography provided a window into the lives of those who use their new products and drive home a simple point in a simple but effective manner (see Figure 10-5).

Figure 10-4
Andrew Thomas noted, "The theme for the printing company's first annual report is based on a coincidence, actually. The managing director happens to have the same name as the 1930s fiction detective, Charlie Chan. The report mimics a detective novel with cases solved by the company finding solutions for their clients." The cover of the report reads "Featuring Charlie Chan, Print Detective"—a fun and creative design. Andrew Thomas/Alex Mucha, art direction; Chung Chi Ying and Gan Mong Teng, designers; Michael Lui, illustrator. Equus Design (Singapore) conceived and produced this report for Craft Print International, Ltd. Concept, design and copy by Equus Design Consultants Pte Ltd.

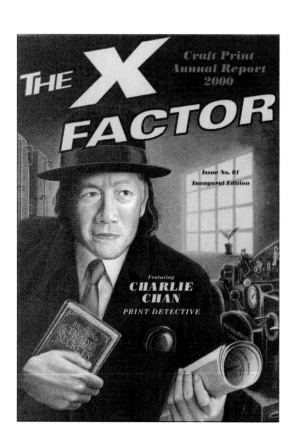

Cahan & Associates has an established creative reputation in marketing communications, particularly in the area of annual reports. The San Francisco-based design company also has an inordinate number of clients in the areas of medical research, science, and pharmaceuticals. That's a tough niche, seemingly, but Cahan & Associates continue to win award after award for annual reports in this client niche. Their strategy for Coulter Pharmaceutical was to reveal the tragedy, drama and hope of lymphoma patients using Bexxar, through very direct presentation,

moving black-and-white portraiture, and sensitive writing (see Figure 10-6).

Several years ago, HGMO of Chicago actually used real advertising in an Interlakes, Inc. annual report as part of its "big idea." At the time, the steel industry had taken a huge nose dive. However, Interlakes had foreseen the encroaching economic problems several years earlier and reinvented the company through aggressive divestiture. The problem was that the average shareholder or man on the street still thought of the company as a steel maker. The fact was Inter-

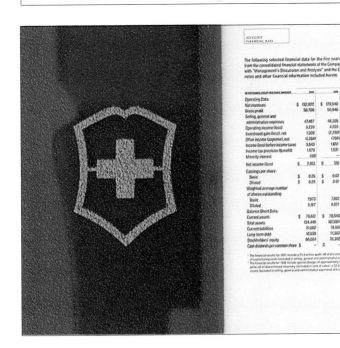

Figure 10-5

Function and effective communication are at the heart of all successful annual reports. Dave Mason muses, "This book revolves around the idea that brand extensions (that is, new products in new categories) must carry all the attributes the consumer expects in order to be successful." Notice the strong parallel structure between the callouts and lines into a Swiss Army knife with blades extended. Coincidence? Hardly. Brilliant graphic insight and planning is more like it. Dave Mason and Pamela Lee, art direction and design; photography, Victor John Penner and James LaBounty. Provided by Swiss Army Brands, Inc.

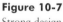

lakes had largely shifted from steel production into
more sophisticated areas: ferroalloys, conveyance
systems, strategic metals, packaging, and die-
casting. HGMO's solution? Adopt a news-
magazine format to report the company's changes,
and advertise the products of their acquisitions.
Creative director Kirk Kahrs imitated the design
and writing style of *Time* magazine to "bring the
news" to stockholders and prospective investors.
The message was clear: Interlakes had transformed
itself. The use of ads from the newly adopted
companies reinforced the message and helped
"change perspectives" of stockholders, literally

reporting the company's transformaton and new
acquisitions. (see Figure 10-7). The Interlakes
report received numerous accolades and awards
for its creativity, design, and brilliant strategy.

Normally, themes change dramatically from
year to year, but they may remain constant. For
example, for years Cracker Barrel has adopted a
"down-home flavor" for their annual reports.
Their retro look exudes nostalgia and suggests
connections to a simpler time when television
and today's hectic pace "hadn't jaded our sensi-
bilities." (See sidebar on Thomas Ryan Design
and Cracker Barrel, Figure 10-8.)

Pure Nostalgia:
Thomas Ryan and Cracker Barrel

Thomas Ryan Design proves convincingly that great concepts and design genius are alive and well in smaller shops. Creative director Thomas Ryan has received accolades and awards for the stunning work he produced for Cracker Barrel. Indeed, there probably isn't a single design house that has received more attention for its annual reports as consistently as those Ryan created for Cracker Barrel. All three of these examples exude nostalgia. The art, color, type, and other design nuances are soft and evoke feelings for a time gone by. What's more, Thomas Ryan kept the various reports fresh each year, and continually reinforced the simple "down home" image so important to Cracker Barrel. Examine the various approaches. The covers and accompanying spreads are from (top to bottom) Cracker Barrel annual reports for 1985, 1992, and 1995.

Figure 10-8

Credits—1985: Thomas Ryan, design; Señor McGuire, photography; John Baeder, copy.
Credits—1992: Thomas Ryan, design; Señor McGuire, photography; John Baeder, copy; Paul Ritscher, illustration.
Credits—1995: Thomas Ryan, design; Señor McGuire, photography; John Baeder, copy.

Of course there are many thematic directions or areas of inherent interest to readers of annual reports, most of whom are prospective or current shareholders.

Those directions include:

- Greatest accomplishments of the year.
- Steps being taken to increase future earnings.
- Broader examination of what's happening in the industry or outside the company that will affect its future.
- Changing the views or perspective of a corporation. Some organizations opt to change or update their image. Others may have shifted or revamped their business and goals and require a brand new profile, as Interlakes did.
- Featuring how the company had positively affected the community. New ecological policy? Gifts or programs that are public service oriented? Or perhaps a company has remedied a problem area.
- Educating shareholders about important changes within an organization: new product launches, recent acquisitions, expansions, downsizing, mergers.
- Historical overview of the company, especially in benchmark anniversary situations.
- Featuring outstanding employees might not only help personalize the report, it might work as a great *internal* public relations strategy as well.
- Some corporations have taken a slightly different tact on the above direction and focused on a cross-section of consumers.

Creative solutions are endless. Robert Louey, art director and designer at Louey/Rubino Design of Santa Monica, used a "Formulas for Success" theme and the periodic table for its award-winning Reliance Steel & Aluminum annual report (see Figure 10-9). Leimer Cross Design emphasized their client's code as their graphic solution for B-Square Corporation, a computer software company (see Figure 10-10). Finally, a Kit Hinrichs' annual report for Potlatch Paper created a personal and interesting spin on personalizing reports. Hinrichs invented a "logger" rebus page that educated readers about different areas of the country where Potlatch harvested various *kinds* of trees—pine and hardwood from

the South, maple and oak from the upper Midwest, and alder and fir from the Northwest. The overall effect is a marvel, and this particular report, although nearly twenty years old, still reigns as perhaps one of the finest and most interesting reports ever put to page (see Figure 10-11).

Sometimes though, the best plans may become hamstrung by the budget. Occasionally, financial problems arise in the midst of the annual report's preparation, due to market turndowns, cutbacks, or budgeting shifts. In any case, before you begin planning, establish your printing and other costs, and design within that budget. Should it get cut back midway through the process, try to be flexible without stifling creativity or short-changing a good design idea.

Create a timetable for the annual report. Schedule timelines for photo shoots and other art, writing and editing stages, the financial report itself, pre-production and printing deadlines, and distribution. Display the timeline and list all responsible parties concerned; obviously, this information needs to be shared and understood by all report staff members.

Putting It Together

Annual reports aren't a publication frill. Indeed, the Securities and Exchange Commission (SEC) mandates that any publicly owned company must create and distribute a yearly accounting of itself within 90 days after its annual figures have been compiled.

That said, few designers keep a full set of SEC regulations on the bookshelf between their PMS color guide and recent issues of *Communication Arts*, *Print* and *CMYK* magazines. Nonetheless, the SEC constraints are real and many: from declaring minimum point size for the text (10), to mandating a formal letter from the president or CEO, budget statements, and a full public airing of the organization's yearly financial records. But Bill Cahan and his staff have never let SEC mandates stifle creativity. Their recent report for SciClone Pharmaceutical demonstrates form (concept, art, and writing) following function—in this case, alerting the reader to the staggering statistics of various life-threatening

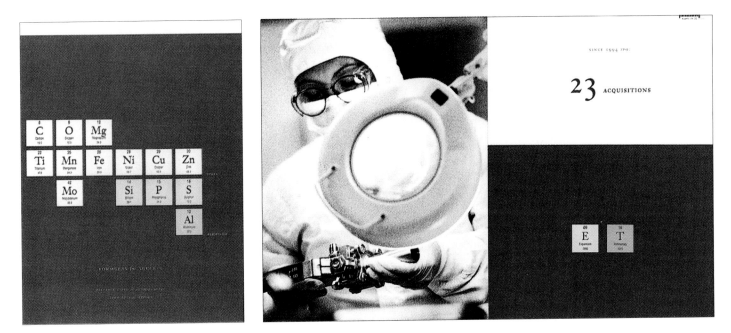

Figure 10-9

The cover mates up nicely with the interior of this Reliance Steel & Aluminum report and connects parallel structure to theme. Robert Louey explains, "The 'Formulas for Success' theme embodies the core values that have sustained the steady growth and a positive balance sheet enjoyed by Reliance year after year. Rich, black-and-white photographs, coupled with an engaging use of the periodic table, deliver the story in a dynamic fashion." Robert Louey, art direction/design; Karen Dacus, strategy; Eric Tucker, photographer. Courtesy of Louey/Rubino Design Group, Inc./Reliance Steel & Aluminum Co.

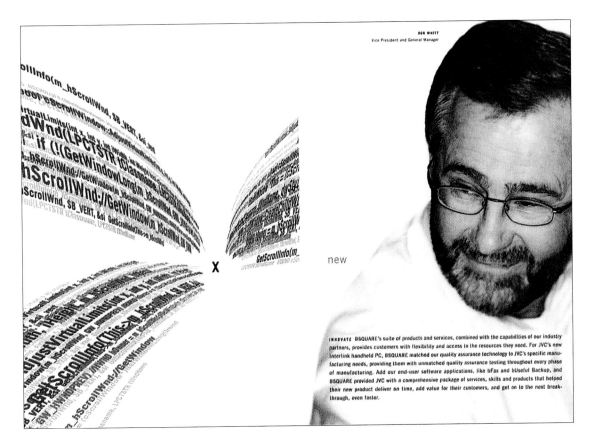

Figure 10-10

In order to assist readers to better understand their client—BSquare Corporation, a computer software company—Kerry Leimer and Leimer Cross Design blurred and converged typography to suggest computer coding. Kerry Leimer, art direction/design; Eric Myer, photography. Courtesy of Kerry Leimer/Leimer Cross Design.

Figure 10-11

Kit Hinrichs sets the theme immediately on the cover of this Potlatch Corporation annual report; the group photograph of loggers suggest its theme. Also, notice the clean and inviting design on the president's page: the deep silver background provides a good base for the reverse copy. The informal photography of the president holding seedlings in the Potlatch nursery supports the ecological message in the adjacent copy. Finally, both two-page layouts help personalize this report while educating the reader. Design by Pentagram. Photos by Tom Troey. Reprinted by permission of Potlatch Corporation.

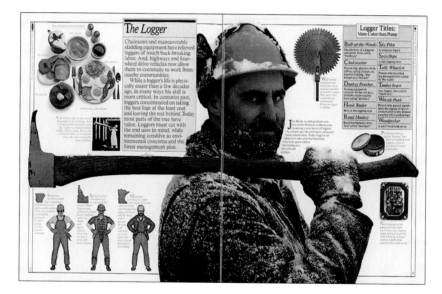

The first spread is a rebus bric-a-brac of information about loggers: how they differ from one another regionally, logging terminology, and even a typical breakfast. The second design provides an elaborate rebus info-graphic of the logging tools. Kit Hinrichs, art direction/design; Jonson Pederson Hinrichs and Shakery, design; Tom Tracy, photography; Justin Carroll, Will Nelson, and Colleen Quinn, illustration. Reprinted with permission from Pentagram Design and Potlatch Corporation.

diseases and the increasing number of people affected by them. At the same time, notice how Cahan maintains a personal feel through the photography's style and by warming the art and page background with a gentle brown tint (see Figure 10-12).

Corporate America, however, is not the only filer of these reports. They are also published by many non-profit institutions and used for fund-raising purposes or included with grant proposals to help evaluators put a face and personality on the organization. They employ similar strategies already noted in the work of Bill Cahan, Kirk Kahrs, Thomas Ryan, Pat and Greg Samata, Kit Hinrichs, Dave Mason, and others (see Figure 10-13).

Despite SEC regulations, strapped budgets, and limited resources, annual reports can be incredibly creative. *Financial World*, *Print*, *Graphis*, and *Communication Arts* showcase the best of them. Communication agencies and design houses like Pentagram, SamataMason, Cahan & Associates, Immortal Design, Tolleson Design, Thomas Ryan Design Group, Hornell Anderson Design Works, VSA Partners-Chicago, and Taylor and Browning of Canada, and others have truly brought a renaissance to this publication form.

As noted earlier, formats can be a logical place to be inventive. You've seen multiple variations on *borrowed* formats for media in this chapter and throughout the book, but the physical format of a report may be stretched as well. Although a standard magazine-size is the norm, many designers opt for other dimensions. SamataMason's recent Swiss Army Brands, Inc. reports, for example, are 5½″ × 8″ and their Hartmarx report 8″ × 8½.″

Like many creative endeavors, research is crucial to the success of an annual report. Learn more about the shareholders; they are, after all, your target audience. Remember, too, that the average investor has stock in approximately twenty *other* companies, so you want to make the design of the report to be distinctive, memorable, and reader-friendly. To help make a report reader-friendly information-graphics can be used to personalize or dramatize the statistics, comparisons, and numbers within the publication. The best of today's annual reports utilize info-graphics as one tool among many visual strategies.

Figure 10-12
The size of the photos in this SciClone annual report help communicate how important the accompanying statistics are to numerous life-threatening diseases. The photographs of the disease (see microscopic shot of cystic fibrosis-affected cells) and those it affects (children: over 70,000 of them) literally flesh out the statistics and give both the disease and its startling numbers a face. Bill Cahan, art direction; Sharrie Brooks, design; Robert Schlatter, photography. Courtesy of Cahan & Associates.

There are four common options to select from when creating an annual report: producing it in-house; employing a public relations agency (some ad agencies do them too); hiring a design house; or using a business communications firm that specializes in annual reports. Regardless of which one is used, the creator basically uses the same basic steps to produce the financial report.

Annual reports normally include these components:

- The **cover** should reflect the "big idea" or theme of the report and concurrently reinforce the company image. It should also establish the publication's theme, and draw the reader into the book. SamataMason used the logo from a Swiss Army Brands jacket for its 2000 report cover. Among other things, the report was introducing new products of the company, including their upscale luggage, cases, and "upright medium mobilizers." (See Figure 10- 14.)

- A **table of contents** should probably be used if the report is longer than twenty pages or more. Most investors and analysts prefer a clear outline of the report up front—on the inside cover page or opening page. These days,

Figure 10-13
WITS—an acronym for Working In The Schools—has made significant contributions to improving education for children in inner-city Chicago. This annual report is *pro bono* and demonstrates the successful impact one-on-one tutoring and mentoring had on the children. WITS is a grass-roots volunteer program begun in 1991. These two-page layouts from SamataMason have a warm, honest, and personal touch. Because they are public service materials, the printing budget was tight. Nonetheless, notice how the inserted "school tablet paper" pages break up the layout. These simple pages suggest elementary school and offer personal information to the reader—words and illustrations created by the kids themselves. The heartfelt words and sketches of the children are moving. They contrast but also add to the photography, which documents the interaction between the children and the volunteers. Brilliant and simple design. Art direction and design by SamataMason; photography by Sandro/Marsha Brook. Courtesy of SamataMason.

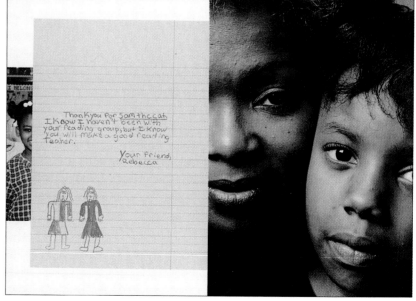

however, designers often elect to shake up the front of the book with dramatic art or lead with the strongest material of the report. In the case of Hartmarx, an apparel marketing company, the standard table of contents was by-passed, and instead, SamataMason ran *29 pages* of tight, fully bled photos of their prod-

ucts—Kenneth Cole, Pringle, Tommy Hilfiger, Claiborne, Burberry-London—and interspersed partial pages of close-up full-color shots of the men's wear (see Figure 10-15).

- The **letter to shareholders**, a mandated item, should discuss the concerns of the shareholders as revealed through your research. It may also

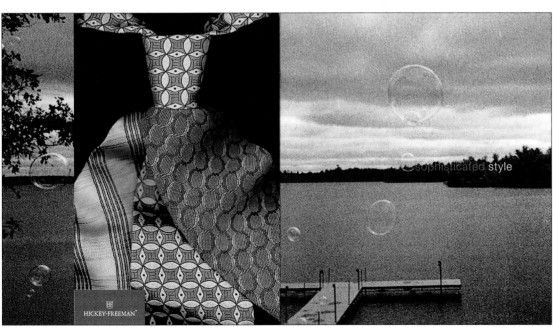

Figure 10-14
The copy is seamlessly tied to the art within this Swiss Army Brands annual report layout. "Look closely at our products—closer than you've ever looked before. Don't be surprised if you find yourself staring at the photos in the following section, pulled in by the depth of detail that reveals not only meticulous design and engineering but an aesthetic value shaping understated works of art." The case should be made, too, that you are "pulled in" by the same attention to meticulous detail and design crafted by the minds and hands of SamataMason. Brilliant, eye-riveting photography and design. Dave Mason, art direction; Pamela Lee and Nancy Willet, design; Victor John Penner, photography. Provided by Swiss Army Brands, Inc.

Figure 10-15
Hartmarx is all about style. The letter to the stockholders says it all. It opens, "A world of choices: Hartmarx is an apparel marketing company that believes good customers are gained and maintained with products that are superior in design, value, and quality." Lush, full-color beauty shots of different brands (Hickey-Freeman here) on smaller inside pages contrast with the larger black and white imagery of the book. SamataMason is also all about style *and* lucid, effective communication Greg and Pat Samata, art direction; Dimitri Poulios, design; Marc Norberg, photography. Courtesy of SamataMason.

touch upon the theme or concept of the report, and *it must be readable*. The letter is usually written by the public relations department and approved by the client and the annual report's overseers. The CEO also, literally, signs off on the letter. Often this is one of the last report components to be finished. The letter should be *brief, clear,* and *reader-friendly*. It is perhaps the most closely read section of the publication. It should communicate succinctly and directly to the reader. The letter is the litmus test of the quality of management of a company.

- The **financial highlights of the year** expand upon the CEO's letter. In many instances, this component may in fact be the theme of the report or be woven into the report's theme. In the case of The Progressive Corporation, the theme wasn't woven; it was painted on a performance artist. This award-winning annual report is one of the more innovative ones to ever be printed (see Figure 10-16).

leading. A company's real worth or direction goes well beyond the bottom line.

Along with your timetable, create a work plan. It should clearly detail everyone's responsibilities, meetings, long- and short-term goals, and deadlines—for everything from initial approval to first copy reviews, from photo shoots to art selection, from final layout sign-offs to pre-production delivery. Case studies are also an important item to consider using within the report, or even as its theme. Also, case studies are generally user-friendly to timetables because they already exist, and that can be a valuable edge—if you plan them carefully ahead of time (see Figure 10-17). Remember work plans aren't cruel or arbitrary, they're meant to facilitate the process. Stick to the plan, budget, and schedule.

Specific items to remember include: stock price data, financial notes, certification of the accountant's report, a management report, and a section that discusses the long-term company projects

Figure 10-16

Nesnadny + Schwartz design firm of Cleveland wanted to do something really fresh for The Progressive Corporation to reflect the innovative firm. Their rationale is illuminating: "As Progressive continues to reinvent itself to serve customers, it has become a designer and agent of change, both internally and throughout the industry. The art was commissioned to directly address the concept of change. The Russian-born artists use their own faces and bodies as canvases for the transformation of their still performances." Mark Schwartz and Joyce Nesnadny, art direction; Joyce Nesnadny and Michelle Moehler, design; Peter B. Lewis, The Progressive Corporation, copy; Rimma Gerlovina and Valeriy Gerlovin, artists. Courtesy of The Progressive Corporation and Nesnadny + Schwartz.

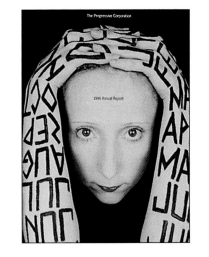

- The **text** is usually prepared using one of two main approaches; the first is more of a straightforward review of the year, department by department; the second is a thematic approach. In either case, someone from the PR staff or an outside writer may be assigned to do the writing (see Figure 10-17).
- The **financial statements** included in the annual report are prepared by the firm's accountants. Some designers demand that the head accountant provide an *explanation* of the numbers—and—that a writer then processes that information and converts it into an accompanying sidebar. Numbers can be mis-

and/or directions. Often the future projections are the guts of the report. You'll also need to include a complete listing of all the corporation's officers, corporate data, and the financial review, of course.

Producing an annual report requires the close management of its details, components, momentum, and evolution. Maintaining its schedule and budget are crucial. This means regular meetings that check the progress and timeline of the project. If you blow a deadline and still expect a timely delivery, be ready to pay substantially more, *if* the printer can even squeeze you in.

 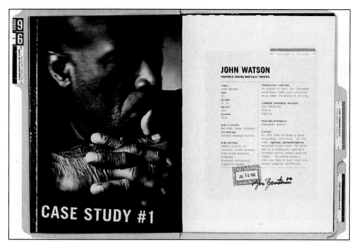

Figure 10-17
COR Therapeutics has a history of including a section within its annual reports to educate readers about cardiovascular care. In this instance, Bill Cahan inserted a medical case study inside the report in the form of a physician's docket or manila folder. It provided three case studies—complete with examination records, medical evaluations, scans, and other tests to provide insights and a personal window into the lives of several patients diagnosed with cardiovascular disease. Bill Cahan, art direction; Kevin Robinson, designer/illustrator; Marc Bernstein/Alicia Cimbora, writers; Keith Bardin, John Kolesa and Tony Stromberg, photographers.

The schedule should be as detailed as it is realistic. One pivotal date is when the accountants surrender their financial statements. The stylebook, layouts, photography, and graphic design should be confirmed and finished early. The SEC and stock exchange set the due date—normally 90 days after the close of the fiscal year. *Pro bono* or non-required reports may not have to follow that time frame, but they usually do.

Graphics in Action

1. Choose a company whose products you've long admired. Go to their website and research their positioning, offerings, company history, new products, and mission. After you feel you have a fair assessment of who they are and how they operate, speculate what you perceive as a current or potential problem. It could be the economy has hurt them, or perhaps their image has aged and doesn't reflect their current direction, or maybe they're about to launch a new product or company division. Then write up a short but well-organized overview of what you discovered.

2. Given the above, devise a creative strategy that specifically addresses whatever you've determined to be the problem. Then, establish short- and long-term goals and a timetable to attack the problem. Examine all options. Anticipate and discuss possible difficulties that might arise and make adjustments and secondary plans to overcome them. Review your research and resources and plan a theme for an annual report and its parts. What will you do for the cover? Table of contents? Will you adopt a theme? Use photography, illustration, or both? How will each of

these address the problems you intend to solve? Deliver your findings and solutions to the class.

3. Using the above information, create an annual report mock-up cover, president's letter, financial report page, and 2-3 pages that illustrate your theme, style, use of artwork, and overall design. Present your prototype annual report to the class. Try to secure a recent real annual report from the company you've adopted. Check the university or other libraries; if that fails, find out *who* did their actual annual report and try to secure a copy. Compare it to yours.

4. Get on the Internet and surf the sites of design firms notorious for brilliant corporate and annual report work. A short and *very* incomplete list might include: SamataMason, (Bill) Cahan & Associates; Hornall Anderson Design Works, Thomas Ryan Group, Nesnadny + Swartz, Pentagram, and Tolleson Design. After examining their sites, work, annual reports, and collateral material, make a dozen frame or screen grabs of the work that most impresses you. Bring the printouts to class to discuss their designs and art—and the conceptual strategies, backgrounds, or problems/solutions behind the work.

5. Your client is Mars Candy company. Their board of directors has requested that you come up with a "playful" theme for their annual report, one that not only uses their products, but helps launch a new chocolate, caramel wafer. Create a cover, president's page, and several infographics showing the percentage of market share of each brand.

6. The president of Blue Note, a recording label long-recognized for its classic jazz, has

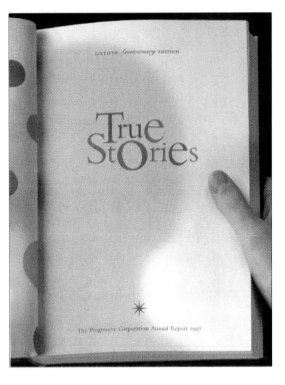

decided to remix and reissue some of its earliest jazz albums of Eric Dolphy, Miles Davis, Herbie Handcock, Dexter Gordon, Art Blakey, and Cannonball Adderly. You've been asked to integrate the revival of the older music and its packaging into an annual report. Try to do something with the format of the report that is both innovative and appropriate to Blue Note and its needs. Create a cover and 3-5 other sample pages for the annual report.

7. Create an annual report in the format of a "pop-up" book for Mattel Toys. Produce 2-6 sample pages and bring them into class.

8. Examine the SamataMason Swiss Army Brands, Inc. annual report pages in this chapter. Keep their current format of 5½″ × 8″ and create 3-5 pages for the following year's annual report. The client wants some sort of continuum and a similar look, but has asked you for a "fresh"

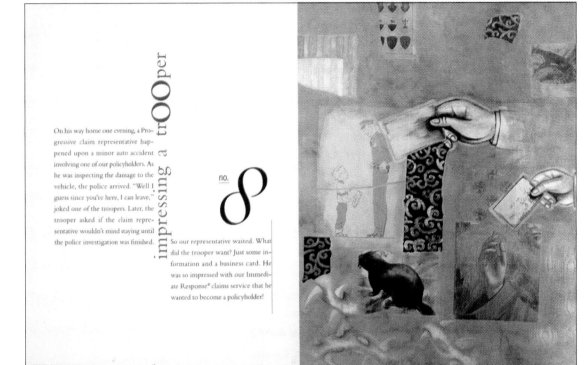

version that complements the previous ones.

9. Thrasher Snowboard, Ltd. has really hit it big and invited you to "pull out all the stops" and create an annual report that is edgy and reflective of their hip-hop, counter-culture clientele and shareholders. Build a typographic stylebook for the annual report, and produce several sample pages. Use art, too, but remember that the function of the pages is to showcase and present *type*. Make color and a post-modernism style essential elements of your solution. Present the work to the instructor and your class.

10. The local humane society has asked you to consider creating an annual report/fund-raising brochure for them. Working as a team with 3-5 other students, create the photography, stylebook, cover, and several sample pages. One of the things they've asked you to consider is installing pockets in the front and back of the book to insert a cover letter and other materials. Try to "comp up" the materials as professionally and finished as you can. If you feel especially industrious, actually contact the local humane society to see if they might be interested in having you create a *pro bono* publication.

11. *La Pluma*, a relatively obscure "writing instruments" company is perceived as cheap and nearly invisible. This view is largely due to a stingy and mostly ignorant marketing plan established by the owner's brother-in-law, who is thankfully no longer calling the shots. The fact is *La Pluma* makes wonderful pens. It's sales woes are largely an image problem perpetuated by lousy marketing and *poor* design. You've been hired to solve their problem via a series of brochures. Create a plan and a brochure; the latter will be based on a six-panel format. Expand the possibilities of the format.

12. Along with a plans outline and rationale, design a sample cover, table of contents page(s), and one other page for the *La Pluma* annual report.

13. A well-known and respected international company, Chiquita Brands International is best known for its bananas. However, Chiquita is a very strong player in other markets, including its tropical mangoes, kiwis, and various citrus fruits. In addition, it has branched out and currently produces fruit and vegetable juices and other products. Get on the Internet and research Chiquita, then brainstorm with a partner and come up with several theme ideas for an annual report for the company, featuring all of its fruits and other products. Your prototype should be a 10-16 page mock-up for Chiquita Brands International.

NEWSLETTER FOR MONTEREY BAY AQUARIUM MEMBERS VOLUME 11 NO. 2 SUMMER 19

MONTEREY BAY AQUARIUM

SHORE LINES

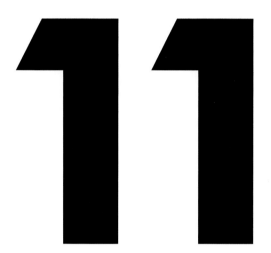

Newsletters: The Stepchildren
of Marketing Communications?

Newsletter: An Old
Medium Comes of Age

A Public Relations Tool

Designing the Newsletter

Newsletter Components

Graphics in Action

*Newsletters are the red-haired
stepchildren of marketing
communications.*
 David Funk, Partner & Art
 Director, Funk/Levis Design

Most organizations don't put the same effort into newsletter design and content development that they might put into an ad or a brochure. Newsletters are often relegated to in-house staff or desktop publishers, while the "more important" communication vehicles are given to design firms and ad agencies. Consequently, they are undervalued by organizations who regard them as necessary evils. This is unfortunate because newsletters usually go to your most important and influential constituency, your existing customers.

David Funk, Partner & Art Director, Funk/Levis Design

Figure 11-1
Kit Hinrichs has been exploding the notion that newsletters are boring and predictable design projects for a long time. His minimal but strong visual approach with fully bled photography and understated type make this *Fuse* newsletter cover rival even some of the best designed magazine covers—an area, along with corporate and annual report design, for which Hinrichs is famous. *Fuse* was created for the Museum of Glass / International Center for Contemporary Art. The newsletter's design speaks clearly to its audience while maintaining the image of its client. Art direction, Kit Hinrichs; design, David Asari and Myrna Newcomb. © Jeff Corwin/Museum of Glass: International Center for Contemporary Art, Tacoma, WA.

Previous page
Shore Lines is a beautiful yet very functional newsletter. It makes a dramatic entrance via its design and use of art. Its reverse block nameplate is sandwiched by a staggered skybox and the dominant photography below. Art direction, Kit Hinrichs; design, Karen Berndt and Kit Hinrichs. Courtesy of Kit Hinrichs and the Monterey Sea Aquarium.

Newsletters: The Stepchildren of Marketing Communications?

In the world of marketing communications, as in most endeavors of humankind, there are hierarchies. The elite and prestigious include television ads, annual reports, and identity materials, while newsletters tend to be the blue-collar workers. Typically, in the marketing communications field, we celebrate famous television art directors, creative directors, designers of

corporate materials, advertising art directors, and ad copywriters, but seldom designers of newsletters. This is not to say that there aren't famous designers creating newsletters. There are, but designing newsletters is not the reason for their fame (see Figure 11-1).

David Funk is one such celebrated designer who specializes in marketing communications for clients globally. His observations on newsletters and marketing communication were prepared for this text May, 2003. He offers an interesting overview on newsletters and insightful advice on how to create them:

Despite reams of evidence to the contrary, newsletters can be interesting. They can be compelling, aesthetically pleasing, and engaging. They can educate and inform. They can encourage involvement and action. In fact, they can also be powerful branding agents. However, if designed and written as most are, newsletters can also be tremendously boring.

Newsletters are the red-haired stepchildren of marketing communications. Most organizations don't put the same effort into newsletter design and content development that they might put into an ad or a brochure. Newsletters are often relegated to in-house staff or desktop publishers, while the "more important" communication vehicles are given to design firms and ad agencies. Consequently they are undervalued by organizations who regard them as necessary evils. This is unfortunate because newsletters usually

go to your most important and influential constituency, your existing customers.

The term "newsletter" is a particularly apt name for this often-maligned medium. In the world of print, newsletters fall neatly between letters and newspapers. They are more personal than the latter and less personal than the former. Like letters, they rarely carry advertising and thus appear more person-to-person and less commercial than magazines or newspapers. Typically, too, they're less formal than brochures and flyers (see Figure 11-3). Usually their emphasis is on editorial persuasion and news rather than on the features or benefits of products or services. No matter their emphasis, though, it is important the pages gel (see Figure 11-4).

In recent decades, some organizations have turned to the Internet as a delivery mechanism for newsletters. Newsletters delivered electronically fall between e-mail and e-zines. The typical e-mail newsletter is all text; however, that convention is slowly changing as companies try to use embedded graphics or links to websites to help project their brand personality. Companies such as Sony—with their e-bridge product, a CD-based system that links the CD content dynamically with a Website and provides options for feedback—add another layer of possibilities to e-mail newsletters.

An absolute key to newsletter publishing success is to know your audience. One critical thing to remember about your readers is that they live in an over-communicated society. With so much information aimed at everyone, we have become more and more selective about which things we will pay attention to. Often companies seem to assume a "build it and they will come" attitude when developing newsletters. However, as in all media, this approach has long since become obsolete.

Breaking through consumer defenses becomes of paramount importance in content and design development. While the idea of breaking down defenses may seem objectionable and manipulative, it is actually beneficial to the reader. When we talk of breaking down defenses as it relates to marketing communications, we simply mean that we have to make the content and presentation

Figure 11-2
David Funk is a principal and senior art and creative director of Funk/Levis & Associates, an Oregon-based marketing/design firm.

Funk/Levis, founded in 1980, produces a wide variety of printed marketing communications and interactive materials for firms located throughout the world. Their work has been featured in *Print*, *Graphis Magazine's 100 Years of World Trademarks*, *The Korean Design Journal*, *American Corporate Identity* annuals, and many other venues. David Funk is a frequent speaker and consultant on design, branding, and corporate identity issues. He is also a whitewater rafter, climber, cross-country skier and hiker, and an environmentalist who works with several organizations involved in river, desert, and native forest protection. A world traveler, mainly to less-frequented environs, he is also a collector of primitive native arts, most notably antique Navajo rugs. Photography, David Loveall. Courtesy of Funk/Levis & Associates.

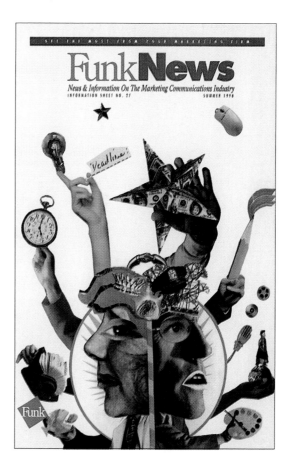

Figure 11-3
David Funk's agency newsletter, *FunkNews*, is designated technically as an "information sheet." In fact, its design utilizes a rough template, which maintains its distinctive format (7″ × 11″) and nameplate. *FunkNews* is crafted to provide real, useful design and marketing communications information to marketing communications personnel in Funk/Levis & Associates' client and potential client companies. Each issue is focused on one aspect of marketing and design and includes information about staff members, awards, industry trends, and new work. Design and illustration, Jason Anderson and Krista Lippert: Art direction, David Funk. Courtesy of Funk/Levis & Associates.

interesting, easily absorbed and useful to the recipient. This means creating articles and layouts that are easy to read, informative, and easily scanned by readers to determine if the content is of interest or value to them. Presenting fresh formats is also important when the opportunity arises (see Figure 11-5).

Regardless of the method of delivery, a complete rethinking of the function and possibilities of newsletters is a useful exercise. Whether you publish in-house or use an outside source, you need to develop a clear strategy:

- *What are your objectives for publishing the newsletter?*
- *Who is the market?*
- *What topics are of interest to the market?*
- *How will the newsletter reflect and reinforce your brand?*
- *Who is responsible for content and scheduling?*
- *How often do you publish?*
- *How will you solicit reader feedback?*
- *How will you use graphics?*
- *How long should the articles be?*

Figure 11-4
The interior page arrangement for this *FunkNews* issue utilized a two-fold, three panel, six-page brochure format. Its overall 21″ × 11″ format uses space and paper wisely. Here you see all six pages or panels of the *FunkNews* information sheet, front and back. Notice how the pages work together as well as the simplicity of this newsletter design. Courtesy of Funk/Levis & Associates.

- *How does newsletter publishing integrate with other marketing communication vehicles?*
- *What will you budget towards newsletter content development and publishing?*
- *How will you know you are making an impact that is reflected in R.O.I. (return on investment)?*

These and other questions need to be addressed before you design an effective newsletter. If you address them all, you are well on your way to creating a publication that will work for your organization (see Figure 11-6).

David Funk's comments are fitting and right on the money. Newsletters—because of their minimal nature, economy, informality, and user-friendly context—are often construed as not requiring the same creative thought and attention to detail as many other media. Technology also shares some blame. "Desktop publishing" seemed like a godsend. Unfortunately, those using the design programs to create newsletters typically had little or no graphic training. The computer adage, "Garbage in—garbage out," is especially true in the realm of newsletters.

Newsletter: An Old Medium Comes of Age

No matter what new technology brings in the coming decades, one form of communication, the newsletter, is sure to survive—and prosper. That said, it's important to point out that some newsletters are not printed. The Internet and intranet are common formats for today's newsletters. Yet another design morphing for this medium is the catalog format. Two good examples of the catalog format are *Cascade Outfitters* and *Getty Images*. Earlier, David Funk noted that newsletters don't carry advertising. Most of the time they don't, but many do solicit ads to help offset expenses, and some *are* advertising in the sense that they are basically catalogs in the guise of newsletters. *Cascade Outfitters* uses that approach to make their newsletter-formatted catalogs more personal (see Figure 11-7).

The newsletter is certain to keep its place in today's media arsenal, especially given its adaptability and variety. No wonder. Because of its simplicity, efficiency, regularity, accurate targeting, and modest publication costs, the

Figure 11-5
For this issue of *FunkNews*, Funk/Levis & Associates designer Jason Anderson uses a cereal box for his inspiration. Notice the diagonal die-cuts—top left and lower right—to help add to the cover's 3-D effect. Typography and smart writing help parody Total Marketing cereal with clever cover lines: "Low Fat" and "100% Daily Value of Brand Building Essentials" and even a come on ("Visit Us! www.funkandassociates.com") to hit on their website. Meanwhile, the back panel of this issue's four-page format returns to the publication's familiar three-column layout with ample space for mailing needs: a logo and return address, U. S. Postal indicia, and an open area for the mailing (address) label. David Funk was responsible for the art direction. Courtesy of Funk/Levis & Associates.

Figure 11-6
Compare this *FunkNews*
cover with those presented
earlier (Figure 11-3 and
Figure 11-5). Which one(s)
do you favor? Why? Art
direction, David Funk;
illustration and design,
Beverly Soasey. Courtesy
of Funk/Levis &
Associates.

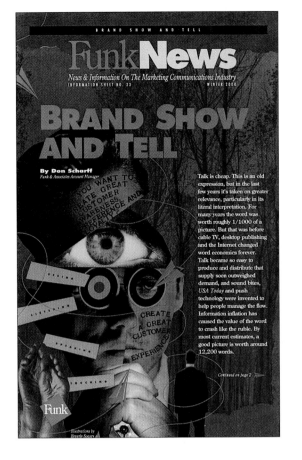

newsletter is the ideal communication tool for
many organizations and businesses—particularly
for non-profit or public service organizations.

However, contrary to what many think, the
newsletter isn't a new medium. It has been
around for a long time. Research reveals that the
Han dynasty in ancient China published a daily
newsletter in 200 B.C. In fact, the forerunners of
the modern newspapers were leaflets and
pamphlets—*newsletters*—which described an
event or happenings from some other place.
These printed mini-papers were called diurnals,
curantos, and mercuries and were sold in the
streets (see Figure 11-8). The first successful
newspaper in America was called the *Boston
News-Letter*.

The modern American commercial newsletter
can be traced back to 1923 when Willard
Kiplinger brought out the first issue of the
Kiplinger Washington Letter. Today the newslet-
ter is one of the fastest growing segments of the
printing industry in the country (see Figure 11-
9). Hundreds of thousands of them are
produced and distributed on a regular basis.
Newsletters range from the small photocopied
parish or club sheets to elaborately designed and
printed publications that are more closely
related to corporate "magapapers," significant

Figure 11-7
This *Cascade Outfitters*
publication marries
magazine, newsletter, and
catalog motifs into a
colorful, engaging format.
The dynamic cover (left)
and editor's page opening
format are attention-
getting and reader-
friendly. Smart marketing
communications and
innovative use of a quasi-
newsletter/catalog.
Photography by Eric
Evans. Courtesy of
Cascade Outfitters and
Eric Evans Photography.

nonprofit fund-raising brochures, or in-house magazines.

Millions of newsletters are sent to subscribers who pay one dollar to several thousand dollars a year to receive them. The newsletter producer with the largest circulation is the Kiplinger group, whose *Kiplinger Washington Letter*, *Kiplinger Agricultural Letter*, *Kiplinger Tax Letter*, and *Kiplinger California Letter* together reach over 2 million readers. Today, although their newsletters are thriving, Kiplinger offers as well on-line newsletters with communication options such as interactive media, videos, books, and magazines.

The newsletter format is so popular and has such high reader interest that many magazines borrow its format for special interest and updated information pages. This also allows editors to offer succinct and unrelated tidbits of information to be presented in brief—a smorgasbord of information for readers to glance over. Business and organizational publications have found that a page of upbeat information in newsletter style has good readership. Much of that kind of interest, however, is connected to content: in the case of many newsletters—Kiplinger's, for example—that means *money*.

Why are newsletters so popular?

They're specialized, yet offer adaptable targeting. Some marketers find them an ideal communication link with a wide range of audiences. They can be used *vertically* and targeted at an audience within a company—literally everyone from the front desk receptionist to the CEO at Intel, for example. Or they may be utilized *horizontally* and aimed at a specific group with a shared interest—a visual communications group at the Association for Education in Journalism and Mass Communication (AEJMC), for instance (see Figure 11-10), or the St. John's church group or the Appalachian Ski Club. A special audience can be targeted easily and reached on a continuing, regular basis. Since the newsletter is brief and to the point, it can be aligned easily with audience interests. Identification with the interests of an audience is one of the criteria for effective communication.

Messages in a newsletter can be tailored neatly to the situation, time, location, and audience.

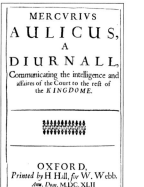

Figure 11-8

Actually, newsletters were popular before newspapers came into existence. Many *newsletters* or news pamphlets were sold in Europe in the 1500s and 1600s.

Figure 11-9

The pioneer commercial newsletter, the *Kiplinger Washingon Letter*, was founded in 1923. It set the design style that has been known as the "classic" newsletter format. The fourth page of the classic newsletter concludes with an ending similar to a personal letter. Reproduced by special permission of the Kiplinger Washington Editors, Inc.

Figure 11-10

View Points is the official newsletter of Visual Communications division of the Association for Education in Journalism and Mass Communication. It has a well-read and savvy audience, but a tight budget. This recent design used a second color —its only extravagance— to help break up the academic publication's copy-heavy pages; the second color was changed with each edition to add variety. Art direction and design, William Ryan.

Newsletters also often have their own personalities and may come closer to one-to-one communication than other media. Some offer a chatty style and share readers' reviews and reports on group activities. Others are extremely sophisticated—such as *VIEW* (a newsletter for the San Diego Art Museum), *Fuse* (published by the Museum of Glass and the International Center for Contemporary Art), or *Images* (a newsletter catalog for Getty's stock art). However, the newsletter that receives the award for the most minimal covers is *Advantage Quarterly*. SamataMason of Chicago designed this stunning newsletter for Gallagher Bassett Services (see Figure 11-11).

Because of its modest looks and cost, the newsletter can afford to be extremely specialized. Generally, its turn-around time is amazingly quick compared to other print media, especially if a template for the publication is built so that the newsletter's structure can be used over and over again. It'd be difficult to find a more cost-efficient method of printed communication, particularly in today's digital world. For that matter, on-line or Web newsletters may also be extremely cost-effective. One wonderful example is the Breast Cancer Action Newsletter, which has both on-line and print versions; the web version appears here in Figure 11-12.

Finally, audiences like newsletters—no matter their formats—because they contain specific information that cannot be found elsewhere, *inside* information. Additionally, newsletters often condense information from many sources. Web-newsletters do the same thing by providing links to related material, which can be a real bonus and draw for subscribers. Most newsletter readers don't have the time or situation to be accessing all these sources. People really like what newsletters do: provide relevant information *in brief* via succinct writing for a subject or organization in which they're already interested.

A Public Relations Tool

The newsletter can be an effective public relations tool, as well as accomplish other things, too. It can be used to target specific publics with specific interests as well as an audience within an organization.

Figure 11-11
Advantage Quarterly is a newsletter created by SamataMason of Chicago for Gallagher Bassett Services, a management health care company. The minimal design of the publication covers is functional, clean, and inviting. The open layouts contrast with the cluttered appearance of most other newsletters. Though the design is Spartan, the smaller graphics—a fire alarm and weekly/daily medication dispenser—make for a strong and attractive hook for these *large* (11″ × 17″) corporate, quarterly newsletters. The latter cover uses the open Friday receptacle to carry the publication's teases and cover blurbs. Design by SamataMason; design, Steve Kull; photography, Emma Rodewald and Lynne Nagel; prints, Sandro; copywriting, Tura Cottingham; printing, Blanchette Press. Courtesy of Gallagher Bassett Services, Inc.

Case in point? The Art Center of Pasadena, California is considered perhaps the finest educational institution for the study of fine arts, design, and art application. Its program of study and "orange dot" have been associated with the Bauhaus and functionality since its inception. The Art Center is renowned for its exciting intellectual environment and its professional faculty—artists and designers whom not only have unique and strong opinions, but opinions that are often "in opposition to one another." The Center's curriculum is incredibly diverse and includes programs of study such as film-making, environmental design, photography, advertising, automotive design, illustration, photography, fine art, and graphic design.

So how does that translate into a newsletter? Matching the look and function of the *REVIEW* to its very astute and design-conscious audience is especially important. The Art Center *REVIEW* is a large format (11 × 17 inches) newsletter that reaches students, faculty, alumni, board members, prospective students, and the professional community. Given that audience, you'd expect the publication to meet very high aesthetic standards. It does (see Figure 11-13).

Kit Hinrichs (see Chapter Fourteen on magazine design) conceived the REVIEW 's design. It is handsome, functional, and borrows some of its design nuances from a variety of places. Its cover probably looks more like a magazine than the typical newsletter. But typical, it is not. Notice the rebus teases just below the nameplate (see Figure 11-14). Do they remind you of another medium? Yes, newspapers often employ rebus or pictorial graphics atop front and section pages. In newspapers, these elements are often referred to as "skyboxes" or "skylines." So, here's a publication that looks like no other newsletter, and draws from media other than what it is—a newsletter. Not surprisingly, it has received a great deal of recognition and many awards for its design from the likes of Print and Communication Arts. Kit Hinrichs and the REVIEW prove convincingly that newsletters can be dynamic, full of surprises, functional—*and* beautiful (see Figure 11-15).

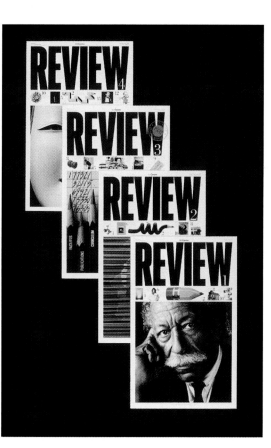

Figure 11-12
The Breast Cancer Action on-line newsletter provides multiple functions. Along with providing up-to-the minute health information, it educates and encourages the support of various research projects and offers personal support to people battling breast cancer. Courtesy of Breast Cancer Action.

Figure 11-13
Look at the continuity, power, and subtle graphic nuances that are integrated into these memorable *REVIEW* covers. Art director and designer Kit Hinrichs conceived the original design and stylebook for this tabloid-sized newsletter and designed these four issues for the Art Center of Pasadena. Courtesy of Art Center College of Design, Pasadena, California, USA.

Figure 11-14
Kit Hinrichs uses a large format and borrows design stylings from both magazines and newspapers in the Art Center of Pasadena's *REVIEW* newsletter. Rebus elements are sprinkled below the nameplate and function as a mini-table of contents *and* as a newspaper-like skybox, teasing readers into the publication. The rich artwork is a graphic montage. Design by Kit Hinrichs and Lenore Bartz, Pentagram Design; photography, Henrik Kam; pencil illustration, Walid Saba;. Art direction, Hinrichs. Courtesy of Art Center College of Design, Pasadena, California, USA.

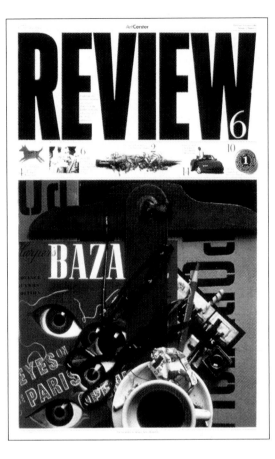

Figure 11-15
This *REVIEW* cover employs rebus elements atop the cover along with simple but richly-colored artwork. The two-page spread (right) reveals some interesting strategies for continuity by bridging artwork and using graphics that are stitched into the layout. The rebus ploy reflects elements of the *REVIEW* cover design. Art direction, Kit Hinrichs; design, Hinrichs and Lenore Bartz; photography, Steve Heller; illustration, Walid Saba and John Mattos. Courtesy of Art Center College of Design, Pasadena, California, USA.

Designing the Newsletter

But not all newsletters are works of art. As their name suggests, newsletters initially provided "news" to their readers via a "letter" format. For the most part, they were informal, unpretentious and direct. In fact, many of them even resembled letters—set single-column, flush left, and often signed.

The bare bones, uncomplicated format might not seem to offer much of a challenge to a designer or editor, but therein lies the problem. Because newsletters are so utilitarian, many novices without design training slam them together. In fact, the great majority of newsletters today are assembled on kitchen tables or in-house, often by secretaries or staff who have no training in design or graphic communication. The results are amateurish and (at the extreme) ugly publications. But they needn't be. Thoughtful typographic and design ploys can change an unattractive, ineffective newsletter into one that is an asset to its publishers. *The Confluence* is a publication that doesn't warrant a lot of art or high design; it is understated and well-shaped for its mix of content and its boating audience (see Figure 11-16).

Thanks to the revolution in printing initiated by the microcomputer and electronic (formerly,

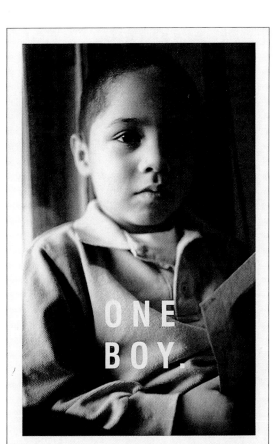

"desktop") publishing, the newsletter has shed its modest appearance and adopted a more sophisticated styling. Many of today's newsletters more closely resemble a magazine or newspaper than their original form. This is partially due to format—usually 8½ × 11 inches, or thereabouts—which is also the standard for magazines. But newsletters aren't limited to this size and configuration. Many are tabloid-sized, others smaller, adopting 5 × 7-inch dimensions.

SamataMason created a powerful newsletter for the Evan's Life Foundation, using a larger format. Its powerful cover, "ONE BOY," doesn't resemble *any* newsletter you've likely seen (see Figure 11-17). But that's just the beginning. SamataMason uses a direct and very graphic presentation for this newsletter. Its tight, compassionate photography and strong typography give this publication the impact of a poster (see Figure 11-18). This example proves, *again*, that newsletter formats and presentations are largely what you make them. The list of possibilities are endless: square formats, horizontal formats, extremely vertical formats. Folded panels that offer multiple pages on a single sheet of paper—brochure style. Electronic formats. The design options are almost endless because software programs can adopt to any size or configuration and finesse even the most demanding problems into submission.

Figure 11-16
Left: The older design of *The Confluence* had several inherent graphic problems. Its cover—shown here—used several similarly sized elements competing with one another. The high-contrast graphic, nameplate *(The Confluence)*, association name and slogan, and oval "splash" confused readers because they didn't know where their eyes should go first. Right: Contrast the full-color prototype *Confluence* with the old version. The framed artwork clearly dominates the page, and the nameplate —a play on a dictionary definition for the word *"confluence"*—incorporates the association name and the newsletters' date and folio lines. Finally, the three strongest articles are bulleted atop (or at the bottom of) the page. Notice, too, how color cues from Eric Evans' photography have been incorporated as the framing or background cover color. Art direction and design by William Ryan; photography by Eric Evans. Courtesy of Orion Design and the North West Rafters Association.

Figure 11-17
The two words, "ONE BOY," and the moving photography make this newsletter as unusual as it is effective. If that doesn't direct you inside this publication, nothing would. Design by SamataMason; design, Steve Kull; photography, Emma Rodewald and Lynne Nagel; prints, Sandro; copywriting, Tura Cottingham; printing, Blanchette Press. Courtesy of SamataMason.

Figure 11-18
This tender image (left) coupled with the header, "This kid is at risk," stops you in your tracks. The two-page spread explains the program, Evan's Life Foundation. Evan was a two-year-old boy (Evan Wilder Samata) killed in a automobile accident. In his memory, Evan's Life Foundation was born. It established a simple mission: to help children at risk. (Below) The spread's strong, ground-thirds design, diminutive photo of Evan, and remaining type contrast—literally and figuratively—with most of the rest of the publication, which is almost exclusively photography of the four-year-old boy on the cover at school and play. Design by SamataMason; design, Steve Kull; photography, Emma Rodewald and Lynne Nagel; prints, Sandro; copywriting, Tura Cottingham; printing, Blanchette Press. Courtesy of SamataMason.

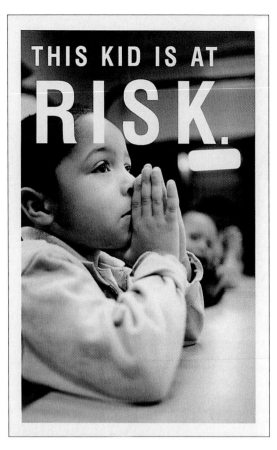

Getting Started

The first step is an obvious one—planning. You need to factor all of the following into your plan:

1. **Establish your audience and design to it.** The earlier example of the Art Center *REVIEW* is an appropriate meshing of audience and design, so is the redesign of *Food for Thought*. Because most non-profit organizations are run on a shoe-string budget, the job of producing a newsletter often falls into the lap of a secretary, or, in the case of *Food for Lane County*, its publicity manager. Gathering information, writing stories, shooting photographs, and finally organizing everything into an attractive, inviting newsletter takes time. Dana Carvey, who oversees the publication, felt her time was better spent raising money and gathering food donations for those in need. As a result, she contacted Jan Ryan, art director and designer of Orion Design Works—to redesign the publication (see Figure 11-19).

2. **What is the purpose of the newsletter?** What's your mission statement? It is important to first think long-term and *philosophically*: fig-

WITHOUT HELP THERE IS NO HOPE. WITH HELP THERE IS EVAN'S LIFE FOUNDATION AND ANYTHING IS POSSIBLE.

ure out what you expect the newsletter to be and do. Is it a simple club publication, a bi-weekly financial investing guide, a sophisticated vertical communication intended to speak to employees of the entire corporation? A quarterly museum guide and update, a monthly insert included in your electric bills, a public relations tool for a hospital across town, a communication center to establish fishing outings and camping trips? A gardening inset that's delivered with your newspaper? Make a clear and terse list of what you expect the newsletter to accomplish.

3. How will you fulfill your mission? Think more *pragmatically*: what components and newsletter parts will you adopt to fulfill your purpose and to meet your readers' needs? Draft a second list of *how* you expect to accomplish those goals. Standing columns? Features? Personality pieces? A section for new products or programs? Reviews? Reports?

4. What is the image you hope to impart via the newsletter? Does it reflect the essence of the church, museum, sports club, hospital, or organization? Specifically, how do you plan to employ art, design, type, color, and photography to achieve that image projection?

5. What will the newsletter's architecture be? What sort of basic grid system will you employ? How many columns? Will they be equally sized? Will you utilize a horizontal grid breakout of the page? A vertical one? Will you use any rebus elements?

6. Will color be a part of your newsletter? Can you afford to use full-color printing? Three-color? Spot or two-color printing? If the latter, do you intend to run duotones or to mix screens to suggest color beyond the two you're using?

7. How will typography be used? Typography is always central to effective communication in newsletters or any publication. What typefaces were considered for the nameplate? Why? How will the rest of the typographical section of the stylebook shape up? Text, headlines, pull quotes, folio lines, subheads, captions, interior logos? How do you handle type style? Column alignment—ragged or justified? Why? Type communicates immediately and suggests a lot about your image and publication.

Figure 11-19
Food for Lane County's (FFLC), old *FOOD for Thought* newsletter (top), although fairly well-organized, was rather drab, and out-dated, and it had numerous problems with photography, paper stock, and a loose two-page insert within its four-page, single-fold. It needed a serious overhaul. Designer Jan Ryan explains: "Like a lot of newsletters, information in *FOOD for Thought* is doled out in a 'sound-bite' fashion: very brief articles and bits of easily digestible information that can be read in one sitting. A big problem, then, is how to organize so many disparate pieces so that the newsletter doesn't end up looking like a checkerboard. So for cohesiveness, I used dropped initial letters that included elements of the FFLC logo, added screened boxes (or tint blocks), and used artwork to help separate information and to move the reader through the pages. Think contrast and size. The more important the information, the larger the art and other devices that break up the 'gray,' (i.e. subheads, lines, art elements, bolded type)." Compare the old version to the new one (bottom). Courtesy of Jan Ryan, Orion Design, and FOOD for Lane County. Courtesy of FOOD for Lane County.

8. **What is the budget?** Is your design concept and overall graphic plan realistic given the money you have available for the newsletter?

9. **Using the architecture as a blueprint, think** *physically*: literally shape and design the publication to the specifications outlined in the earlier planning phases.

Physical Issues

Decide upon a format and specific size. Again, the normal newsletter shaping and size is 8½″ × 11″, the same specs as the standard business letter. This size is easily filed, folded to fit into a standard business envelope, or punched and snapped into a binder. In addition, a four-page 8½″ × 11″ newsletter can be printed on an 11″ × 17″ sheet, two pages at a time, in most Kinko's, "quick print" shops, or in-house printing facilities.

The "classic" newsletter format is run on a standard 11″ × 17″ sheet of paper folded in half to produce four 8½″ × 11″ pages. More pages can be added, of course, but this configuration is ideal for many communicators; a single page insert makes a six-page publication and two 11″ × 17″ sheets would result in an eight-page newsletter, and so on. *FunkNews* employs a slim, more diminutive 7″ × 11″ perimeter. Some designers might suggest that if there is material enough to warrant more than four pages, it might be time to consider more frequent publication. However, it is not unusual for some organizations to build sixteen- or even twenty-four-page issues, particularly if there is an upcoming conference or convention and schedules or other material need to be included. In addition, more frequent issues usually mean more postage costs, too, if the issue is mailed out to members.

Newsletters can be found in all shapes and sizes. Some, called *magaletters*, are actually more closely related to magazine or tabloid newspapers in format. *Magapaper* formats are a hybrid mix of newsletters, magazines, and tabloid newspapers. The designer responsible for configuring these crossbreeds may employ design strategies from all three media in creating such a publication. Magapapers are typically very expensive and elaborate. The Art Center's newsletter, *REVIEW*, is an elegant example of this format.

The Internet offers a completely different medium for the newsletter—one that provides the flexibility and timeliness of constant updates, reader interaction, news, or calendar information. Occasionally, newsletters may even be composed of folded panels, as a brochure would be. Notice the folding panels in *FunkNews* (see Figure 11-4). As noted earlier, the catalog format is another avenue on the highway of possibilities, as demonstrated by Cascade Outfitters (see Figure 11-7).

A newsletter produced on office equipment or an ink-jet desktop printer could adopt a standard letter size folded in half. This would make four 5½″ × 8½″ pages. Obviously, there are other ways to fold a standard page. In every instance, make sure you build a dummy and examine the logistics in order to ensure that you position each page or panel in its correct place.

Since we are talking logistics, *remember your margins*. Don't run text too close to the outside margins, *particularly* if you've got folded panels in newsletter.

Other physical considerations range from very practical motives—punching holes in the left margin so the newsletter can be snapped into a three-ring binder—to more extravagant ones—using intricate die-cuts or hot-foil stamping, both of which cost a client plenty. Three-hole punching is a particularly good idea if the publication is going to be saved religiously or used for future reference. Again, you're not limited to standard formats and sizes, but realize that more unusual shapes or sizes will cost you more money, time, turn-around time and limit your print house choices.

If the newsletter is a self-mailer, be sure to build a "mailing side" or panel for the address label. It would be wise to weigh sample paper at various weights to project mailing costs. Being "slightly" overweight might not seem like much, but multiply 5,000 pieces monthly, for example, and figure out the annual cost differences. Finally, bring your mailing panel to the Post Office for their "official" blessing before you sign off on your design and take it to the printer. If your organization is non-profit and your circulation large enough, a "bulk" rate might also save you a good deal of money.

Paper is also an important "physical" consideration, but make sure you select a paper that is *bright* enough. This is especially important if you're printing with a second color or in full-color. It's also an issue if you're expecting to get good reproduction from your photography. It's also crucial to pay close attention to the *weight* and *opacity* of the paper. Remember, if you have mass-mailings, weight might just be your most important deliberation; you literally pay for how much your materials weigh, even if you're bulk-mailing. Finally, the bulk and opacity of the paper should be dense enough so that color or imagery doesn't show through the page.

Color is another important tool that can lend a distinctive touch to the newsletter. Note how the border color meshes with art (see Figure 11-20). While full-color may not be a design option due to the expense involved, two-color can provide variety and make a stunning statement at a reasonable price. Two-color (or "spot" color) can prove to be an invaluable tool in newsletter design. This is particularly true when the additional color is integrated strategically in the nameplate, tints, rules, or with mixed screens.

The "Classic" Newsletter Model

Some newsletters continue to employ the classic newsletter format. As noted earlier, it uses the 8½″ × 11″ format. Its characteristics include:

- Type set one column to the page—flush left (ragged right)—to resemble a personal letter.
- A short, punchy writing style in which obvious words are often left out and key sentences, phrases, and names are underlined.
- A limited number of graphic elements designed with care and used consistently. Simplicity is the heart of this model.
- One style of type for the content; italic and/or boldface may be used for emphasis or to differentiate between heads and text. To maintain the "letter" look and personal feel, a typewriter face such as Courier or American Typewriter is often used.
- Avoidance of a magazine or newspaper look.

This newsletter format was developed by Kiplinger, and many newsletters follow it faithfully. Indeed, it is the standard for many newsletters with financial, investment, or business

Figure 11-20

Top: These nameplate variations represent five distinctively different approaches for *Confluence*, a newsletter for the North West Rafters Association. The background of one selected by the designer was a mock up of a dictionary definition of confluence. "n 1 a: an act or instance of congregating b. CROWD 2 a: the flowing together of two or more streams b: the place of meeting of two streams c: the combined stream formed by conjunction 3: an incredible newsletter put out by the North West Rafters Association for lovers of white water, especially those who cherish rivers and the act of being one with the water." It seemed to capture the attitude and spirit of the NWRA. Bottom: Notice, too, how the logistics of the newsletter's nameplate have been reworked; that ploy offers additional variety to the cover of The Confluence. Design and graphic work by William Ryan; layout and Photoshop work by Jan Ryan; photography by Eric Evans. Courtesy of Orion Design and the North West Rafters Association.

emphases. A classic format might also be considered when there is a need for short-term communication such as during a campaign or event. It can be effective as a regular publication for a smaller organization with limited facilities or one that's looking for a simple, unpretentious two-to-four-sheet bulletin.

To help reduce costs, the nameplate and masthead specifics can be printed in a large quantity, perhaps a full year's supply. This is especially sensible if the newsletter is a one-page (two-sided) information sheet.

Some designers have criticized the single-column page, saying that the column width is too wide for easy reading. However, since this is a standard for letters, most people are used to it. Should you choose this one-column format, a good strategy you can use to minimize reading tracking problems is to increase the leading in the text. If you prefer narrower line widths, an alternative is to indent the columns and place the heads to the side in the left-hand margin.

Even with one column, using wider margins and more space between paragraphs can improve readability. For example, if the margins are 6 picas, the line width can be held to about forty-five characters.

Format Strategies: Column Options

There are two ways to handle a two-column format. One is to vary the widths of the columns. The other, of course, is to plot two columns of equal size.

The two-column format has a number of advantages. It is more readable because of the shorter lines. In addition, it is more interesting, offers more potential for variety and graphic manipulation. For example, a two-column format makes it much easier to employ artwork and graphics such as charts and illustration.

Three-column formats offer still more creative freedom. Structurally, it more closely resembles magazine page architecture. However, because newsletters don't have the same talent and resources of a large magazine, its look is not as slick or sophisticated. That said, the three-column page still affords the designer an opportunity to blend the best qualities of magazine design with those of the newsletter. The additional column allows the layout much more flexibility with artwork, pull quotes, and graphics. *Update*, a newsletter published by the Society of Newspaper Design (SND), takes great liberties in the size and number of columns used within a page, which adds a dynamic quality to its page design (see Figure 11-21).

Figure 11-21
Two standard features of Society of News Design's (SND) newsletter, *Update*, are a "how to" page (this one demonstrating a Photoshop cutout) and a Letters to the Editors page, "Dear Update." Examine the subtle column treatments and layout differences between the two. Courtesy of Society for News Design.

Some designers may even opt for four-or-five column layouts, particularly with formats larger than 8½″ × 11″. *REVIEW* is a great example with its six-column page breakouts. However, along with deciding upon column format, you need to determine column size. Page margins should be at least 3 picas all around. If the pages are to be punched for a binder, the margins should be slightly wider to prevent the holes from obliterating the reading material. If the newsletter is set in single column, margins of 6 picas are not too much (see Figure 11-22).

Try to restrict space *between* columns to 2 picas or less. Too much white space between columns can destroy the unity of the page by creating an alley of white space in the middle of the page.

Some newsletters are designed with column rules. Rules and keylines can be effective, too, but use them purposefully. As the Bauhaus suggested, "Form follows function." Rules make good demarcation devices, and keylines are excellent for bordering art or unifying page elements. When you do opt to use column rules,

Update, although a humble black and white newsletter, does a smashing job of design. Sometimes it uses a single (albeit relatively narrow) column on its cover. Inside it might use a three-column format, or two, or four—or a three-column layout with two columns of equal width and the third set more narrowly. Or it may vary column arrangement on a single page. *Update*'s audience? Newspaper designers, art directors, and graphics editors—all of them very visually oriented people. In this case, the designer bridges *huge* sans serif type across two pages, sandwiched with roman type as decks above and below the headline ("THE BIG PICTURE") (see Figure 11-23).

make sure to keep them thin. Hairline or half-point rules work fine. Don't exceed 1 point for this purpose.

Because of the personal and informal nature of newsletters, body type is often set ragged right. Justified alignment—along with being more stodgy and formal—can create awkward word and letter spacing on the page. Remember our discussion on type: the narrower the column, the more spacing irregularities become problematic. Although widening columns and tightening tracking will help justification difficulties, it won't solve them.

Figure 11-22
Do you recognize this stripped-down, distinctive design? Examine the inside two-page spread. Again, Hinrichs and friends built a user-friendly, playful design with a simple grid, rebus elements, wrapped graphics, and bold color. Like the earlier twisted pencil, the bicycle bridges the pages. Compare the cover and feature pages to earlier examples: Figures 11-13, 11-14, 11-15). Courtesy of Art Center College of Design, Pasadena, California, USA.

Figure 11-23
This attention-getting article by David Kordalski (Cleveland's *Plain Dealer*) provides "do and don't" advice for using photographs effectively in layouts and making "sound visual decisions" in newspaper design. Courtesy of the Society for News Design and SND's newsletter, *Update*.

Newsletter Components

The Nameplate

The newsletter nameplate and all of its components—dateline, folio line, slogan—create the first impression of the publication. It should clearly identify the newsletter and impart its image, but not overpower the other elements of the page. A good rule of thumb is that it should not exceed 20 percent of the page.

The nameplate should be unique to distinguish the publication from thousands of others in circulation, and it should be imaginative but appropriate to the image of the publisher *and* to the content. Nameplate typography should contrast the text and header type.

Nameplates can be made in different sizes to be used in the masthead and other places within the publication, as well as for envelopes, letterheads, ads, and the like. It's important to maintain consistency for identity and recognition purposes.

Again, color adds an extra dimension to the nameplate and other components of the newsletter (see Figure 11-20).

When Kiplinger created the name for *Kiplinger Washington Letter*, he deliberately omitted the word news because his plan was to write about the news rather than report it. Important distinction. Many newsletter publishers have adopted this personalized style.

SND's *Update* uses a screened back sans serif with a *white* drop shadow on a slightly gradated background. Its smart, minimal use of type speaks clearly—not just via its nameplate but throughout the publication. In many ways, the publication, which is about design in the first place, is a working model of exemplary newsletter design (see Figure 11-24).

Sometimes a slogan can be useful. It might be incorporated with the nameplate or inset within a heavier rule. Such phrases as "all about airplanes," "fire-fighting in the Western United States," or "your financial adviser" can identify the newsletter and clarify its mission. For a more detailed discussion of the planning that goes into logo creation, see Chapter Twelve.

The Folio Line

Newsletter design should make it easy for the reader to find out by whom, where, and when the publication is produced. The standard practice for most four-page newsletters is to include the volume number, issue number, and date in a folio/date line which is normally located just below the nameplate or logo. Usually, additional information, such as the publisher, address, telephone, staff members, and subscription details, appears in the masthead area.

Repeating the name and date of the publication isn't necessary, but maintaining some kind of page numbering is important. The first page needn't be numbered. If the publication is filed or stored for future reference and an index is issued, however, it might be worthwhile to consider a protracted numbering system.

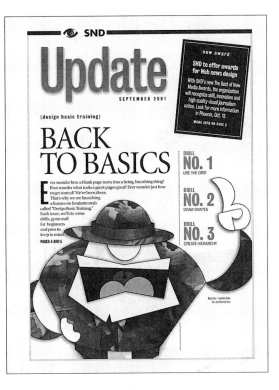

Figure 11-24
Update just might be the epitome of symbiosis. It is a newsletter put out by SND and targeted at newspaper designers, graphics editors, art directors, and the like, and it supplements or bridges its sister publication, *Design*, a quarterly journal or magazine published by SND. The newsletter covers are simple, feature one article, tease a different feature in the upper "black box," and occasionally run an inside mini-table of contents. Its design blows away many full-color newsletters. Courtesy of the Society for News Design and SND's newsletter, *Update*.

The printers of "mercuries" (sixteenth and early seventeenth century English news pamphlets) numbered the pages of a volume or series consecutively. For example, the first four-page issue would be numbered pages 1 through 4, the second 5 through 8, and so on until the series was complete. *National Geographic* used to follow this pattern until recently.

In addition to their own system of filing, some newsletter publishers obtain an International Standard Serial Number (ISSN) and include it on the first page or within the masthead. The ISSN may be obtained at no cost, and the assigned number is registered in a worldwide computer data bank that libraries can refer to when ordering subscriptions. Information concerning the ISSN can be obtained from the National Serials Data Program, Library of Congress, Washington, D.C. 20540.

The Newsletter Cover

Due to obvious space constraints, most all newsletter covers tend to be self-covers. And given their limited pages, most cannot afford to devote the entire page to the art. *Shore Lines*, *Fuse*, *FunkNews*, and *REVIEW* are exceptions. Typically, the newsletter cover tends to resemble a miniaturized newspaper front page.

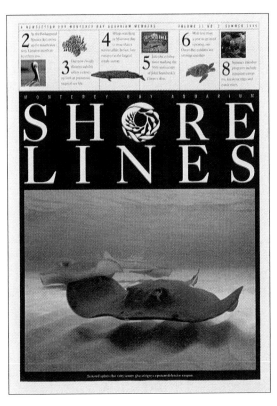

Figure 11-25
Shore Lines makes a dramatic entrance via its design. Its reverse block nameplate is sandwiched by a staggered skybox (notice how the number and text and artwork switch positions each panel) and the dominant photography below. This memorable design work was created by Kit Hinrichs for the Monterey Sea Aquarium. Courtesy of Monterey Bay Aquarium.

Sometimes the use of a second color is a relatively cheap and effective way to make a newsletter a little more distinctive. Or, it may serve as an option to full color and its additional expense.

Usually, the cover contains a nameplate, folio/date lines, art, one or two (seldom more) stories, and perhaps a preview feature to tease important inside stories (see the *Shore Lines* cover—Figure 11-25). Generally, however, artwork rarely occupies more than one-fourth of the page, and usually consists of photography, illustration, or a chart of some kind. Notice, too, how the inside pages mesh and complement the exquisite *Shore Lines* cover (see Figure 11-26).

Speaking of artwork, newsletters tend to have one glaring weakness: poor photography or art. Too often, the photography is as predictable as it is sparse. Where it does appear, it tends to be run small and is dominated by snapshots and posed imagery.

There are a number of reasons why photos tend to be problematic in newsletters. First of all, there isn't much space in the typical four-page newsletter, so words dominate and whatever art that does appear is run small. Indeed, many newsletters *don't* use photos. Secondly, the typical newsletter doesn't have a staff photographer and cannot afford to hire a professional. So

Figure 11-26

Like magazines and other publications, newsletters must maintain continuity—not just from the cover to the insides, but from page to page and article to article. Note how the inner pages of the newsletter *Shore Lines* relate to one another, and, how the type from cover and pages mate up. Kit Hinrichs bridges the pages in both of these two-page spreads with dominant art areas, color, and the refined rebus design for which he is so celebrated. Art direction by Kit Hinrichs, Pentagram Design. Courtesy of Monterey Bay Aquarium.

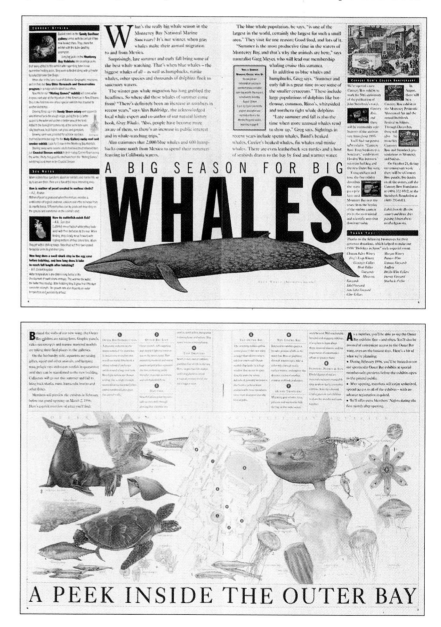

where do the photos and other graphics come from? Readers often submit photography that may be shot with "point and shoot" cameras. Or an editor serves as the shooter—generally someone who is *not* trained in photography. Typically, too, photos are shot in color; most newsletter photography, however, is run in black and white. The result is often flat mushy tonal values or the opposite effect, high contrast images with little or no gray scale. Finally, the nature of many smaller newsletters is design by the seat of your pants, where often deadlines are missed or the issue's content arrives all at once, typically sans art. In these instances, the design is sort of made up on the fly.

Few newsletters can afford an illustrator or decent artwork, so editors and designs of smaller newsletters often use clip art. Finally, quick-copy shops and even photocopy machines are commonly employed, resulting in high contrast imagery that lacks definition. Given this combination, it is no wonder newsletters are considered the graphic ogres among media—warts and all.

Photoshop and good scanners can help alleviate many of these difficulties. Also, it would be smart to review guidelines for composition in the photography chapter of this book to improve that aspect of the newsletter.

When photography is used, strive to choose strong, well-composed imagery. Mug shots (or high-contrast line art) are fine for columns and simple stories about someone. When offered the opportunity to run excellent photography, run it big. Ensure good photo-reproduction by printing crisp images on bright paper stock. Try to avoid converting color imagery to black and white or using flat or contrasty photos. Those situations will typically guarantee terrible results. Notice the strengths of the photography, logistics, *and* cover design of Funk/Levis & Associates design of *The Estate News* (see Figure 11-27).

The cover (first page) should feature a strong nameplate, some kind of artwork, and your lead story. You might also want to include a preview or mini-contents teaser or a second story on the cover page.

Figure 11-27
The Estate News is a slick, full-color newsletter for the King Estate Winery. Funk/Levis and Associates produced a newsletter that is designed for a mixed audience of consumers, retailers and distributors. It manages to appeal to all, without disengaging any one group. It includes tasting notes, recipes and news from the winery. Art direction, David Funk, design, Beverly Soasey. Courtesy of Funk/Levis & Associates.

Typography: The Newsletter Stylebook

A graphic stylebook is crucial to the success of any newsletter. Remember: less is more, particularly with this medium. Keeping that mission in mind, create a newsletter stylebook that is simple and functional. Two or three typefaces are plenty. Notice how *View Points* integrates three faces: Garamond (for headlines and dropped initial letters), Optima (for text and part of the nameplate), and Futura Book (for captions, interior logos, teaser heads, and part of the nameplate) (see Figure 11-28).

Running the text or body copy justified makes the publication more traditional and formal. Many designers prefer to run newsletter text ragged (flush left) to minimize hyphenation, keep the copy more personal, and to open up the page. Whichever approach you choose, be consistent with your stylebook.

Most newsletters use a serif or roman face for copy. Some, however, opt to run a typewriter-inspired font, such as Courier or American Typewriter, to establish a personal feel and to suggest more informality and immediacy. On the other hand, a few designers lean toward the more modern look of sans serifs— Universe, Gilsans, Franklin Gothic, Lucida Sans, or Arial, for

Figure 11-28

This View Points article on Resettlement Administration (RA) photography, "America in the Depression Years," demonstrates how a simple mix of typefaces breaks up and helps structure the page and the publication's continuity. Headers: Garamond bold italic; subheads, Garamond bold; text, crossing heads, and bios are style and weight variations of Optima; folio lines in bold Futura book. The photograph— "Wife of a Resettlement Administration Client-Jackson County, Ohio, April, 1936"—was shot by photographer Theodor Jung. Art direction and design William Ryan.

America in the Depression Years:
A review of Instructional Resources' collection of FSA imagery

This is the first installment on a lengthy review of IRC's collection of FSA photography.
> *Bill Ryan, Editor*
> *University of Oregon*

*a*s a writer, designer and visualizer, I know full well the limitations of words. Case in point: teaching the impact of the Great American Depression.

Indeed, words and numbers cannot clearly communicate the scope of human misery and heartbreak that was the Depression. Statistics may provide important numbers; and written explanations, however worded, are just that. But a photograph can *show*. It can tear through intellectual processing and cut straight to the heart. William Stott in his remarkable book, *Documentary Expression and Thirties America*, says it best: "We understand a historical document intellectually, but we understand a human document emotionally. In the second kind of document, as in documentary and the 30s' documentary movement as a whole, feeling comes first." Enter Roy Emerson Stryker and the RA and FSA.

Overview

Enter, too, if you will, the Instructional Resources Corp's FSA collection, *America in the Depression Years*. Assembling a photographic collection of the Great Depression that is fairly representational of that period in less than 500 images is one matter. However, creating such a set that also does justice to a photo staff that reads like

Wife of a Resettlement Administration client. Jackson County, Ohio, April, 1936. Theodor Jung. LC USF33-4100M1. (Courtesy of the Library of Congress.)

a *Who's Who* among photographers of that period is far more difficult.

IRC has included photography of all then 48 states and the District of Columbia. This choice presents some problems with the disproportionate wealth of imagery that exists within the FSA collection from specific states and regions of the country. For example, photographs made in the southwest tend to be powerful—loaded with content: dust storms, extreme poverty, tractored-out tenant farms and an entire population on the move. Most of this was shot by celebrated FSAers — Dorothea Lange, Russell Lee and Arthur Rothstein. On the other hand, true to its name, *America in the Depression Years* provides a balanced view of the entire United States from

the mid-30s to the mid-40s. Most monographs and collections of FSA work tends to be regionally limited. Not so with this grouping.

The collection includes some of the more celebrated FSA images. There are images of Lucille and Floyd Burroughs and Bud Fields and their families from Evans and Agee's *Let Us Now Praise Famous Men*, and Rothstein's poignant image of a farmer and his two children staggering against the force of a driving dust storm in Cimamaron County, Oklahoma, as well as Dorothea Lange's "Migrant Mother." These photographs carry a strong sense of context while remaining timeless.

Make no mistake, there are visual treasures here, images that only the more astute and long-studied

photo historians have seen. In most instances, they are not as familiar as others because they have been photographed by the less famous of Stryker's shooters. That is unfortunate, because a wealth of documentary images was made by lesser known FSAers: John Vachon, Marion Post Wolcott, Gordon Parks and Theo Jung, among others. Along with providing memorable visual imagery of rural America and a changing agriculture, the FSA traced the rural exodus to the cities and recorded that dynamic—the increase of urban blight and the effects of the Depression in the cities.

The next installment reviews more imagery and the guidebook of the America in the Depression Years *collection.*

PAGE SIX

example. Two sans serifs that have more texture and both thick and thin strokes are Stone Sans and Optima.

Headline type should harmonize but stand out from the text type. Newsletter headers should be kept small—usually 12-18 points are adequate: try not to exceed 30-36 points. Mix up weight, style (italics, condensed, and book, for example), and letter width for variety. The Loras College newsletter is a wonderful example of the effective use of type as well as stretching the medium's format (see Figure 11-29).

Some newsletter designers simply set heads all uppercase in the text face. Others use all caps or lower caps for the first few words in the opening paragraph, or underscore the first line of the paragraph. Usually, though, heads are handled in

the traditional manner, but kept relatively small. Regardless of the style selected for headline treatment, however, to be consistent: maintain unity. Remember, too, to give your headers ample white space.

Since the newsletter thrives on efficiency and upon its ability to provide information quickly, most articles are short. When longer pieces are used, though, consider employing dropped initial letters, pull quotes, or crossing heads to break up the page and make the piece more functional and punchy. Normally, subheads look best when set in the same face as the text or header type. Keep it simple.

To vary the crossing head styling slightly, consider using an italic, bold, or other variation of the families used in the newsletter. Adding a

point or two with some bolding and an extra line of leading above and below the crossing head will help stand it off and open up the page. Crossing heads should be used sensibly, to show transition, time and subject shifts, or the like.

Standing heads are used for features, such as columns, forums, departments, reviews, that appear in every issue. Adopt a separate style and look for these items to separate them from the

rest of the newsletter content. A standing head normally has an interior logo of some sort that often is related to or reflective of your nameplate (see Figure 11-10). It may be supplemented with crossing heads or a *kicker* (a head, usually just above or just below the interior logo) so the subject can be changed from issue to issue.

Quite often the organization of the newsletter can be improved by the use of boxes, tint (or screen) blocks, rules, spot color, tabs, and column rules. Dropped initial letters, screens, and tints may also help energize your page. Incorporate these strategies into your graphic stylebook for consistency. While most newsletters tend to be word-driven, using art and graphics largely and boldly will stop and involve readers.

Things to Avoid

Newsletters have more than their share of clichés and common errors. Some typical shortcomings and design problems to avoid:

- Crowded pages. Remember, if you try to jam too much material into your pages, the result will be a claustrophobic hodgepodge that won't be read anyway.
- Dull, static layouts with little accent or variety.
- Busy pages with way too much gingerbread in designs.
- Poor quality clip art that clutters the pages and cheapens the image and look of the newsletter.

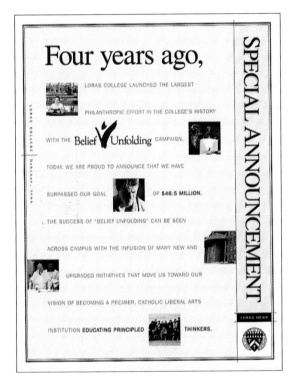

Figure 11-29
This Loras College (Dubuque, Iowa) newsletter, *Loras News*, uses type in fresh and exciting ways. It mixes up three typefaces efficiently. The cover (left) has no header; instead the first three words of the copy "Four years ago" are set in roman, the generously leaded opening copy is set in sans serifs, all uppercase. Inside the flow and form of the newsletter's contents are logical, and its design attractive. Its contemporary layout borrows from magazine page design, but its folding presentation is more brochure-like. *Loras News* uses a two-fold/three-panel format on an enameled, cover stock, 11″ × 25″ paper. Shown here are its cover and a three-page interior. Courtesy of Loras College, Dubuque, Iowa.

- Drab black and white layouts. The use of spot color can enliven a design when solid and screened color are added to rules, nameplates, boxes, tints, and sidebars—at a minimal increase in cost.
- Bad photography. There's no point in running imagery that no one can make out in the first place.
- Color photos that have to be run in black and white.
- Group photos shot at a distance. In this case, faces are hardly recognizable, usually because they are too small, out of focus, over-or under-exposed, or a combination of all three.
- Tiny photos that might've had impact had they been enlarged.
- Gray pages. Even if you've no artwork, you can open up newsletter pages with screens, bullets, dropped initial letters, crossing heads and the like.
- Inconsistency in design.
- Inconsistent use of typography.
- Small, difficult-to-read typefaces for body copy.
- Too many different typefaces. Three faces for a newsletter are plenty.
- Messy layouts with problems such as headless stories, odd-shaped text blocks and quirky layouts. Modular design and a simple grid can help order and structure the page.

Finally, although it may sound redundant, the content, audience, and function of any publication should shape its design (see Figure 11-30). Perhaps the best way to conclude this chapter is to return to the sage advice of David Funk. "Breaking through consumer defenses becomes of paramount importance in content and design development. While the idea of breaking down defenses may seem objectionable and manipulative, it is actually beneficial to the reader. When we talk of breaking down defenses as it relates to marketing communications, we simply mean that

we have to make the content and presentation interesting, easily absorbed, and useful to the recipient."

Graphics in Action

1. Plan the general format and design for a four-page 8½″ × 11″ newsletter about your favorite love or hobby. (Examples might include horseback riding, stamp collecting, dog breeding, rock climbing, fashion, hockey, skateboarding, golden retrievers, ice cream, or collecting PEZ dispensers—you get the idea.) Begin by researching both your subject and your audience. Then decide upon your structure: the number of columns per page and the design of the nameplate, folio lines, and all the graphic and typographic elements, color, and image. Explain what you did—and why.

2. Find a newsletter with a one-column page and redesign it as a two-column format. Be creative and consider using such innovations as boxes, tabs, rules, tint blocks, and so on.

3. Create a simple graphic stylebook for a newsletter for your department, college, or university's admissions and recruitment program.

4. The president of the local electric utility company has decided to update its newsletter design and has mandated that the new version will also use two colors. You are the art director. To select the spot color, go to the color "library" provided for you by your PageMaker, QuarkXPress, InDesign, or other design software program. Working from the company's existing newsletter, redesign the cover and one other page. Be sure to include the new color and a variety of screens in your mock-ups. You may even wish to build several cover prototypes.

5. Plan a newsletter to accompany a letter soliciting funds for eating disorders research for a hospital in your community. The newsletter will be one page (two sides). You want the publication to be simple but smart, stylish but not

slick. Among other things, the newsletter will be promoting a volunteer walk to help raise money for educational materials for teenagers. You may use spot color if you wish.

6. Fender Guitars has decided it needs an upscale newsletter targeted at young musicians and guitar retailers. Your communications company specializes in newsletters and brochures, and you've learned your director wants an "unusual format—something unique yet functional" and that she desperately wants the Fender account. Working with one or two other students, build a cover, an editorial page, and a two-page feature on classic 1950s Fender Telecaster guitars. Consider the other groups in your class as teams from competing agencies. Also consider adopting a 1950s graphic style.

7. The Boston Aquarium wants to increase its traffic and its membership. Part of the media strategy includes a 16-page newsletter that will target two basic groups: first, the current membership and recent visitors and second, young parents (20-40 years of age) with children. One of the director's request is a two-page feature each issue on one of the animals in the aquarium. Design a cover, editorial, and two-page feature layout as a prototype for the aquarium board. Although this will *not* be a money-maker for your design firm, your creative director and the firm's partners see this as an opportunity to raise their profile in the community while producing some really exciting design work for the client. Assume that cost is not an issue due to *pro bono* printing from a local shop. The materials will be printed on high-grade paper and in full color. Although they don't want a huge format, they'd like something unique to make a strong entrance and leave a memorable impression of the aquarium; something very visual. Don't forget your audiences.

8. Select a section from a metropolitan Sunday newspaper (sports, business,travel, etc) and plan

a newsletter devoted to that area of interest. Write a prospectus for such a newsletter including the research and audience assessment that should be done—along with a description of the format and graphic elements the newsletter would contain.

9. Select one of the above exercises and adapt your design to the Internet. In other words, using the same criteria and problem, convert your print design to a newsletter website. Remember, too, that an on-line newsletter—though similar in mission—is different from print. Be sure to consider interactivity, usability, function, and links for your newsletter site.

10. Using either the aquarium or Fender guitar as your client, create a newsletter using a "catalog" format.

Figure 11-30
Good design often mixes *surprise* and relief from predictable graphic solutions. Perhaps the most unique feature of this *Frameworks* newsletter design is that it incorporates a table of contents within the reverse block (complete with page number references) atop the page. In the newsletter medium, where space is precious, this strategy is functional and fresh. *Frameworks* is a quarterly newsletter designed by Kit Hinrichs.

12

Identity: Hospitality, Packaging,
Product and Logo Design

Hospitality and Packaging:
Dressed to Sell

Branding: Red Spider
and Branding Strategy

Letterheads:
Making an Impression

The Envelope:
Making an Entrance

Collateral: Supplemental Media

Delivery: Getting the Business

Graphics in Action

*Brands are trustmarks not
trademarks. So, how would you
set about measuring trust in
brands? As David Ogilvy, famed
Scottish advertising man once
said: "Brands are products with
personality."*

Charlie Robertson,
Red Spider, UK

◀ *Chicago Cubs Baseball Cap, Eric Evans, photography*

Brand packaging cannot stand still but must be reviewed periodically to make sure that it remains in tune with the market. Design changes may seem subtle but are nevertheless vital if the brand is to retain its strength and not become outdated.

—*Marcello Minale, Sr. Designer/*
Chairman, Minale Tattersfield Design

Identity: Hospitality, Packaging, Product and Logo Design

Despite the omnipresence of identity materials and marketing communications, many aspiring student designers often fail to consider a career in that facet of visual communication. Film, Web, photography, illustration, newspapers, magazine, advertising, and other media are more visible and considered a more likely professional path to pursue.

It is ironic, though, that the media and tools within the realm of identity—packaging, logotypes, letterheads, hospitality materials, audio/visual design, and the design of the products themselves—*seem* less visible to us because they're everywhere: point-of-purchase materials, menus, skis, logos, CDs, letterheads, and packaging, signage, and design on every-

thing from ABC Goreng noodles to Jack in the Box, from K-2 Skis to Ghirardelli Chocolates, Adidas, and Swiss Army Brands. The list is endless. What's more, they are central to branding.

Hornall Anderson Design Works (HADW) created Kazi beverage identity materials that are as hard-working as they are vibrant. The strategy behind the brand identity graphics was to create a masculine and contemporary look, with a slightly edgy feel to it. HADW media relations manager Christina Arbini summed it up: "The filtered photography treatment adds to the classic, cool positioning, and suggests a melding of J. Crew meets *Saturday Night Live*" (see Figure 12–1).

Branding and product identification are central to the success of any product, corporation, or publication. In fact, a company's image, credibility, and familiarity revolves around both public and private perceptions. Package design, logos, advertising and public relations play an invaluable *external* part in establishing a brand, often expressing the fundamental nature of the product and client while concurrently underscoring their unique image. On the other hand, hospitality materials, exhibitions, corporate magazines, installations, annual reports and environmental/architectural design tend to be more private; not a lot of people see those things (see Figure 12–2). However, their influence is important, though less visible than their packaging, catalog, brochure, advertising, promotion, and web counterparts. This chapter will examine identity materials, packaging, logos, letterheads, envelopes and a number of specific collateral media: brochures, CD design, catalogs, and media kits.

Figure 12-1
Hornall Anderson Design Works created these colorful identity materials to complement their award-winning packaging designs for KAZI's "original" and "cranberry" beverages. The product was marketed as "liquid entertainment." Some of the accompanying marketing and promotional components included these tags (top) and t-shirts and baseball caps (bottom). Art direction: Jack Anderson and Larry Anderson; design: Larry Anderson, Jay Hilburn, Kaye Farmer, Henry Yiu, Sonja Max, Dorothee Soechting, Mary Chin Hutchison, and Bruce Stigler; photography: Angie Norwood Browne. Courtesy of Hornall Anderson Design Works.

Previous page
Chicago Cubs management showed keen media savvy when it extended its local WGN-TV game coverage to cable—the first major league baseball team to make such a move. Today, the "Cubbies"—despite hexes, goats, and countless heartbreaks—are America's team. Their simple logo is know worldwide.

Hospitality and Packaging:
Dressed to Sell

Today—given the shrinking nature of the planet—cultural graphic cues make the problems of collateral and identity even more challenging. Jeremy Myerson, founding editor of *Design Week*, speaks to the growing "logistical and cultural nightmare" of branding and design. "Finding the right visual and verbal language to cross national frontiers and attract the consumer in large numbers is no easy task. This Esperanto of design has become the Holy Grail of marketing."

To be sure, Saxone Woon knows a lot about that challenge. He is a founder and senior partner of Immortal Design, with offices in Singapore and clients throughout Asia. Woon, a native Singaporean, knows about multicultural communication firsthand. Indeed, Singapore is the melting pot of Southeast Asia, along with being its communication hub.

Perception is an interesting concept. What's contemporary, stylish, or logical to you may not seem that way to another person. What is black to you may be gray to someone else. Hard to believe, but true. Culture and meaning often swirl that dynamic even more. This has become especially evident to me working in Southeastern Asia. In Singapore, for example, we have four 'official' languages—English, Mandarin (Chinese), Malaysian, and Tamil, an Indian dialect. In addition, religious influences are stridently different yet exist side-by-side: Hinduism, Christianity, Buddhism, Islam, Taoism, Judaism and other sects. Sometimes that kind of diversity complicates communication.

As a designer, it's important to delve deep into the culture of the country. Unless you really understand the mentality and cultural distinctions of the audience, it is impossible to create a viable visual strategy for your work. Everything from color usage to typography, graphic elements, and semiotics may be crucial to the message, image, and voice of your client. These nuances may make or doom your design.

At first glance, using colors in a cross-cultural society may not seem like a difficult task. How best can we develop an effective color scheme, a palette that best suits a client and its audiences?

Figure 12-2
Immortal designers played off of the Balinese art and architecture of the Four Seasons Hotel-Sayan resort with their flora and fauna motif. Note the carvings of tigers, monkeys, and mythological creatures in the background as a backdrop to the tea set and its meticulously arranged complements (cream, skim milk, sugar). The tags add to the ambience and rich experience of staying at the resort. Courtesy of Four Seasons Resort Bali at Sayan, Indonesia.

Figure 12-3
Immortal Design's principals are Saxone Woon, Stanley Tan, and Theresa Yong. Saxone Woon is co-founder and managing director; Stanley Tan is co-founder and creative director; and Theresa Yong is creative director and designer at the firm. Immortal is a multi-disciplinary design consultancy specializing in brand identity, strategy, design, and management in the areas of corporate identity, retail identity, hospitality identity, and retail packaging. Their clients included Danone (UK), Kimberly Clark, Adinax, Prudential, Tangs, Corelle, Hard Rock Cafe of Bali, ABC President Enterprises, and Motorola. Courtesy of Immortal Design.

In Asia, vibrant colors are everywhere: in architecture and jungles, markets and clothing, food and spices, in seas and skies. But today, the challenge that most designers face is maintaining color's traditional associations and cultural authenticity, while inventing new colors and color combinations to keep the designs fresh and interesting—a delicate chromatic balancing act. No easy feat. Having said that, as values, attitudes, and lifestyles change, you need to stay current with research that support your recommendations. Indeed, that's why many clients seeking identity facelifts come to you—for a more contemporary look.

One of my favorite clients, Four Seasons Resort Bali at Sayan, is appropriately touted as an elite hotel. But Four Seasons Hotels is not your average hotel chain, and Bali is not exactly your average destination. In this case, they were about to embark on a revolutionary change in their corporate livery by inventing a most remarkable hotel-resort in the highlands of Bali.

Built on a ravine above Ubud, its architectural design is breathtaking. Located in Sayan, amidst an idyllic landscape of river, rice terraces, mountains, and lush tropical forests, the Four

Season Resort Bali at Sayan is perhaps the most luxurious boutique hideaway in Southeast Asia. Maybe even the world. It encapsulates the essence and beauty of Bali in every way (see Figure 12–4).

We selected a lush but subtle tropical color scheme to reflect the nuances of Balinese culture. The secondary colors were employed to portray the ethnicity. Luckily for us, Bali and Indonesia were not new to us, because of our extended research, interviews, and other experience studying Indonesian culture when we created FMCG packaging earlier. We studied Balinese architecture, art, sculpture, and just about everything from flora and fauna for inspiration. And, we evolved uncountable renderings and designs in the process of creating this project.

Eventually, we decided to adopt the island's indigenous dragonfly and frog as design motifs and integrated them into all of the identity and hospitality materials—from menus to letterhead, architecture to signage (see Figure 12–5). The graphic images are immortalized as the resort's signature motifs and are complemented by a rich palette of Indonesian colors and natural materials that synergized with the lush environment and the contemporary architectural design of the resort itself. The result is a perfect blend of style and ambience that gives the resort a unique, fitting, and memorable identity. However, achieving that 'blend' meant maintaining a balance between form and function (see Figure 12–6).

Balance is at least as important to packaging design as it is to hospitality materials. For example, ABC Instant Noodles wanted us to redesign its packaging because it had become a bit outdated. We were targeting Indonesia, which has a population of approximately 250 million people. Imagine how many packages of instant noodles they can sell there!

Anyway, when we were called in to design their first line of instant noodle brand and packaging, we were given a very detailed brief and market segment data. During the briefing sessions we were told to visit potential sales points. (They didn't have to tell us that, because we always take the setting seriously.) The product's environment may prove immensely significant to the design. Besides the supermarkets, there were many "tokos" (small provision stores) scattered

Figure 12-4

Hospitality design is an integral part of the luxurious Four Seasons Resort Bali at Sayan's identity. Immortal Studios adopted the island's indigenous flora and fauna (notably the dragonfly and frog) as design motifs used throughout the resort's identity and hospitality materials—menus, letterhead, architecture, and signage. Woon designed "night lamps" outside each room. During the day, patterns in the shapes of dragonflies and flora echo the motif. By night, the openings cast softened projections of dragonflies and flora to underscore the resort's theme. As evidenced here, great design is all about attention to detail. Concept and design by Immortal Design. Courtesy of Four Seasons Resort Bali at Sayan, Indonesia.

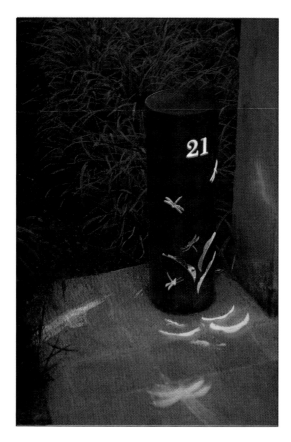

along main roads and highways in and outside large Indonesian cities and along the countryside. As it turned out, tokos were the main sales points, due to the sprawling nature of Indonesia.

The tokos were amazing, and offered nearly every essential household product you could imagine—all crammed into a shop of about 100 square feet. All the products on the shelves had a heavy layer of dust on them, due to the tokos' proximity to the road. In fact, many of them are literally built on the shoulder of the road. Why was that important? Well, our original ideas about using white for their background would've proved catastrophic, because the

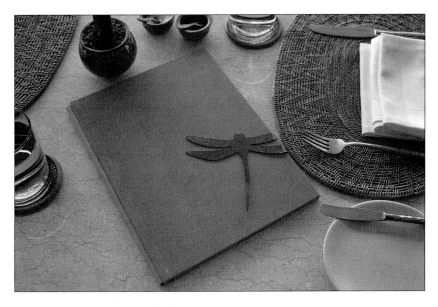

Figure 12-5
Hospitality materials need to maintain stylistic and coding consistencies throughout the environment; that includes all the minutia, such as the signage and directional cues for guests at the Four Seasons Resort Bali at Sayan. Concept and design by Immortal Design. Courtesy of Four Seasons Resort Bali at Sayan, Indonesia.

Figure 12-6
The dragonfly and frog motifs are employed throughout the Four Seasons Resort Bali at Sayan. Immortal designers incorporate the repetitive theme on the menu, compendium, stationery, and letterhead here. Immortal Design (Singapore) is a significant part of the Design Alliance of Southeast Asia. Courtesy of Immortal Design and Four Seasons Resort Bali at Sayan, Indonesia.

Figure 12-7
Recently, ABC President Enterprises, an Asian leader in noodles, asked Immortal Design to update their branding and product packaging. Immortal Design's Saxone Woon wanted the packaging "contemporary," yet reflecting Indonesian culture: "For the instant noodle—selera warisan (with illustrated batik tablecloth background and ingredients) the color coding for each of the particular flavors was examined, based on two primary factors: first, the flavor it had to represent and secondly, the authenticity of the batik color schema employed. Also, a batik table cloth was used as the background to convey a sense of home-cooked style as most 'typical' homes used batik tablecloths." Courtesy of Immortal Design.

packages wouldn't have remained white very long.

For the instant noodle (selera warisan) with illustrated "batik" tablecloth background and ingredients the color coding for each of the particular flavors was examined, based on two primary factors: first, the flavor it had to represent, and secondly, the authenticity of the batik color schema we'd employ. Also, a batik tablecloth was used as the background to convey a sense of "home-cooked" style as most "typical" homes used batik tablecloths. Of course, being the most renowned textile art of Indonesia, it represented a natural, credible look as well.

The product was positioned as a "home-recipe" premium pack, therefore the touches of gold trimming around the box. We used a matte finish in the POP packaging material to enhance the look. The printing technique, gravure, helped us to do this. We took the cultural and historical development of Indonesia and its peculiarities into consideration, and used an ivory color for background and mixed in a palette of bright colors, traditional illustrations and modern graphics for the packaging.

If we hadn't understood the characteristics of the Indonesian culture and society, we'd have failed (see Figures 12–7).

Another wonderful example of packaging design is Flying Dog Ales of Aspen, Colorado. Their marketing staff hired none other than Ralph Steadman, celebrated illustrator whose work has appeared in a multitude of media from *The New Yorker* to his incredible cover and inside illustration for Dr. Hunter Thompson's book, *Fear and Loathing in Las Vegas.* Flying Dog is not your average brewery. Their company history cites these dates and notations: "1983: On a hot summer night in Woody Creek, CO, George Stranahan, Richard McIntyre, and Hunter S. Thompson have 'induced' visions of the Flying Dog. 1990: The Flying Door Brewery opens and is the only Brewery in Aspen, CO in over 100 years." And so on. Their target is not the average Joe Six Pack, but a hipper, less mainstream audience who appreciate fine custom ales and packaging with a little attitude (see Figure 12–8).

So, what's the process for designing or redesigning packaging for ABC Instant Noodles, Flying Dog Ales, or creating hospitality materials for an exotic resort? Actually, the course for any of these is very similar and akin to the development of many other media—from advertising to publication design.

• **Know your audience.** As Saxone Woon pointed out, understanding the culture, environment, mentality, needs, and sensibility of the audience is crucial. Who are they, specifically? Where and how do they live? Often, sample design ideas are shared with members of the audience through focus groups, surveys, interviews, and informal application sessions. When the graphics team at the *Orange Country Register* was redesigning the newspaper and experimenting with the idea of introducing new sections, it maintained an ongoing exchange with readers to help create a better publication. Yes, newspapers are products, too, and their stylebook and design are their packaging. In 2001, Flying Dog celebrated its long court battle publicly after the ACLU won a lawsuit against the Colorado Liquor Enforcement group who had Flying Dog products removed from shelves in 1995 over a non vulgate word that appeared on the brewery's labeling. The case provided Flying Dog and their customers an interesting public relations victory. Everyone loves an underdog. (See Figure 12–9.)

- **Understand the product, service, company, or client thoroughly.** That means familiarizing yourself with their culture, history, successes, failures, missions, and direction. Most clients eat, sleep, breathe, drink, and live the company. In the case of Ghirardelli Chocolates that might seem a dream job. Their history is steeped in tradition and the company name is associated with the finest chocolates in the world. How would you communicate that visually?

- **Do your homework.** Research the company: who they are, what they do, what they produce. And while you're at it, research their competitors and know them as well as your client. Ultimately, you'd like to understand your client's business, problems, and needs as intimately as they do.

- **Make sure you perceive precisely what the client's problems or needs are.** Ask good questions based upon your research and how it relates to what they want to do. Are they simply updating packaging? Launching a new product? Looking to change or reshape their image? Trying to better compete because they've lost a significant market share? Better brand themselves? Evoke a particular feeling about their beer, hotel, service, chocolates, or candidate? Are they looking to become "top of mind" for that particular market?

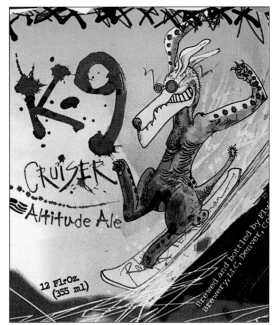

ABC Noodles had a great product whose packaging needed a graphic overhaul. The Four Seasons Resort Bali at Sayan was launching the opening of a new resort tucked away in paradise—Bali—and needed a full range of hospitality materials—menus, signage, letterhead, environmental nuances, lighting, and more—to communicate elegance, beauty, exclusivity. Woon and Immortal Studios solved those problems through thoughtful planning that married Balinese culture and the environment to design.

Figure 12-8
The legend of Flying Dog Ale is immortalized on its the website: "The Flying Dog litter of Ales was born from an auspicious vision during a period of imposed exile, and bred at the Flying Dog Brew Pub in Aspen, Colorado, one of the first brew pubs in the Rocky Mountain region." Tire Bite Golden Ale's ideal drinking time? "Lawn mowing ale, best consumed in times of dire thirst." Illustration by Ralph Steadman. Design and copy by Dara Bassock. Courtesy of Flying Dog Brewery.

Figure 12-9
Ralph Steadman's unmistakable illustrative style is a perfect match for the packaging of Flying Dog Ales. The ale itself is commensurate with the marvelous packaging design, and delightful copy. The ideal time to have an Old Scratch? "Lazy days when life is at its finest." And K-9 Ale? "When you're safely at a distance from harm." The packaging design, copy, voice, and positioning of this product are perfect for its young, hip, ale-drinking audience. Illustration by Ralph Steadman. Design and copy by Dara Bassock. Courtesy of Flying Dog Brewery.

Hornall Anderson Design Works (HADW) was hired to design the "skin" of new, faster, high-performance skis for K2. The challenge was to create an "ownable trait" in the marketplace by way of "mod structure," because K2 was the only company in the industry to use a sculpted, wood core in its skis. The solution was to literally integrate the design of the skis into their graphic design. Christina Arbini of HADW explains; "After a few long meetings, we talked the client into showing this core through translucent materials. This created a unique look that was honest to K2 and helped support their story of being a ski company with soul, designing skis for skiers by people who ski. In the end, the message is about having fun, and keeping it real. Showing their 'insides' (wooden cores) surely supported this message and in a unique, ownable manner" (see Figure 12–10). A perfect marriage of technology and graphics ensued, using bright colors and brash design to match the edginess and flair of the skis.

- **Know the history of the product, problem, market situation, or branding efforts.** Brand packaging is reviewed to make sure that it's in proper synch with its audience, and that it is remaining competitive in the marketplace with its traditional counterparts and new products. Launching a new product in an already crowded market segment is always a dicey proposition.

When Hornall Anderson Design Works was hired to create packaging design for KAZI Beverages they wanted to add a touch of humor into the packaging, so they created "pick-up" lines on the backs of the labels. With lines such as "I'm not the best-looking person here, but I'm the only one talking to you," the humor definitely leans toward the twenty-something male—KAZI's main target. Promotional materials were also designed for that audience (see Figures 12–11 and Figure 12–1).

- **Understand clearly what it is you're trying to communicate and, to whom you're communicating.** Concept: what is the idea, theme, or basic message you're trying to get across. If you cannot put your idea in a single sentence, you've failed. Next, how does that message translate visually? Do you want to be formal? Informal? How does color figure into the message?

Ghirardelli wanted to upscale their image, promoting the premium quality of their chocolate through the quality of the packaging design.

Figure 12-10

Sometimes packaging design and identity work merge with product design. In this instance, Hornall Anderson Design Works wanted K-2 to show the 'insides' (wooden cores) of their skis. The result was that HADW helped design the core and skin of the product itself: a perfect marriage of technology and graphics. The bright colors and brash design complement the edginess and flair of the skis. Art Directors: Jack Anderson, Andrew Smith; designers: Andrew Smith, Elmer dela Cruz, Tiffany Scheiblauer. Courtesy of Hornall Anderson Design Works.

Color was of prime importance is establishing that message. The designers at Hornall Anderson needed the packaging to exude quality, so when it came to color execution, they spared no expense. Jack Anderson noted, "We were able to breathe a beautiful color palette of jewel tones printed on metallic paper, using both transparent and semi-opaque specialty inks and embossing the logo. It is a complicated logo that prints primarily in 6 colors. The transparent ink was used for the individual product colors that flank the center gold band. It allows for the beauty of the light to bounce back through the ink." The result was packaging for Ghirardelli that almost glowed (see Figure 12–12). Review Chapter Nine on printing and production for a more detailed discussion. A book is judged by its cover design, and a premium chocolate by its packaging design.

• **Write up a brief defense or rationale for your creative graphic solutions.** In a paragraph, assert your concept or "big idea." In a second paragraph, support it. You better have concrete evidence and information to back it up. All great packaging and design solutions begin with extensive research.

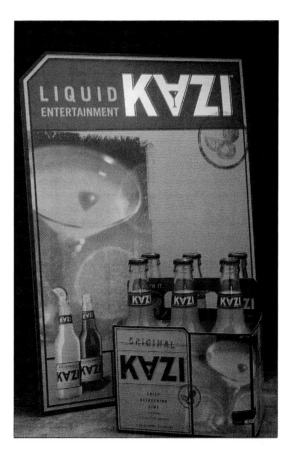

Figure 12-11
Packaging is a large part of what Hornall Anderson Design Works does for its clients. Principal and art director Jack Anderson speaks to presentation and the "visual acuity" of product design and marketing. "There's a fine line between presenting, sharing and selling, and the determining factor often lies in 'visual acuity,' which basically means sizing up your audience, and the ability to 'see' things… connect the dots… and understand how concepts can be fleshed out." This KAZI point of purchase (POP) display and packaging make a distinctive visual presentation to its audience. Courtesy of Hornall Anderson Design Works.

Figure 12-12
To suggest premium quality, Ghirardelli Chocolates requested that its packaging exude colors that nearly "glowed." So when it came to color execution, they spared no expense. Their target was primarily women. While design was at the core of this design solution, special printing methods, foil packaging, and transparent inks saved the day. Art Directors: Jack Anderson, Debra McCloskey; designers: Debra McCloskey, Darlin Gray, Jana Wilson Esser, Mary Chin Hutchison, John Anderle, Beckon Wyld, Tobi Brown, Taro Sakita. Courtesy of Hornall Anderson Design Works.

- **Have a firm and clear mission,** which is to say, know what you're supposed to accomplish. It is essential that both you and the client concur on this point. Establish a timeline and regular meetings to share your ideas and design roughs with the client.

Hornall Anderson established a clear mission for its redesign of the food packaging for the Jack in the Box fast food restaurant chain. Their problem was simple. The advertising was, like Jack, witty, edgy, irreverant. But the packaging "seemed lackluster." The mission? To create packaging that was colorful, graphic, and appropriate to the image of Jack and the product. Further, it was to be designed with "functionality" in mind. HADW created "design attribute" sheets that underscored their mission and the purpose of the packaging (see Figure 12–13). Actually, the evolution of the finished product was the result of brilliant design that built upon ideas from both Jack in the Box and the designers of HADW. Great designs evolve from research, teamwork, client involvement, and truly understanding a client's goals.

While there is no *perfect* methodology, most designers, regardless of the media being used, follow a plan similar to the one outlined above. Effective packaging and hospitality design are a result of these additional basic steps:

- **Analyze existing materials;** assess what it is about the current packaging, hospitality, or product design that doesn't work. Be sure to examine the visual impact, marketing effect, targeting, and the original strategy of the old packaging. Assess what was right or wrong about it and *why* from both your perspective as well as the client's.
- **Research the graphic elements of the old design** and then build a creative strategy or brief to share with the client about the direction you feel they should pursue.
- **Make sure the creative strategy you devise speaks to the visual, marketing, and audience needs or concerns.** When Hornall Anderson refaced Ghirardelli chocolates, their research found that the old packaging was masculine, but the audience was largely female. "The type was heavy and industrial." Their brief addressed those existing type and graphic issues.

- **Produce a list of possible solutions for the problem at hand along with your assessment of it, using the new creative strategy.** Research design options. Often, focus groups are used to test strategies and even designs. Create a series of possible graphic solutions and present them in a "finished rough" or "comp" state to the client. When offering a *smorgasbord* of ideas to a client, most firms prefer to present the weakest of their ideas first, and finish the presentation with the strongest graphic solution.
- **Make note of the client reactions** and adapt or adopt the best graphic ideas for the final design accordingly.

Another crucial component of identity and marketing communication involves branding. While this text doesn't pretend to be a consummate source of information on the subject, it would be erroneous not to at least address branding.

Branding: Red Spider and Branding Strategy

Red Spider is synonymous with creative brand strategy. It is widely recognized as the world's leading source of training in advertising planning and branding. Although their offices are physically located in the United Kingdom, they work globally.

Their style of branding and planning employs meticulous analysis and insightful strategy sessions. They preach that branding and advertising can break down in any one of its three basic stages: strategy, concept, and execution, and they teach clients how to understand and keep the three separate. Their research is keen on consumer insight and attitudes. Because they are a virtual company and independent, their solutions are born of "pure strategy that never compromises the whims and wishes of creative departments." Charlie Robertson, a founder and the managing director of Red Spider, offers his perspective on branding.

Your life is full of choices.

Some become automatic, easy, and comparatively trivial, with little conscious thinking involved. Others may cause you great angst. "Burridan's Ass" is a tale of the donkey unable to decide which of two bales of straw to eat, equi-

Bag Front

Side View

Larger Cold

Top

Side 1

Side 2

Jumbo Jack Wrapper

Jumbo Jack Wrapper

Jumbo Fries

Bag Front View

Side View

Larger Cold Cup

Top

Side 1

Side 2

Jumbo Jack Wrapper

Jumbo Jack Wrapper Flat

Jumbo Fries

Bag Front View

Side View

Larger Cold Cup

Top

Side 1

Side 2

Jumbo Jack Wrapper

Jumbo Jack Wrapper Flat

Jumbo Fries

Best EVER

Figure 12-13
Design is a process. One that's based or initiated upon a clear plan that clarifies what it is you're supposed to accomplish. Hornall Anderson Design Works used a "product attribute" sheet as a yardstick of sorts to keep them on course over the design evolution for Jack in the Box. HADW established a clear mission for its redesign of the food packaging for the fast food restaurant chain. Actually, the evolution of the finished product was the result of brilliant design that built upon ideas from both Jack in the Box and the designers of HADW. Can you see how the mission affects the design process? Consumer impressions of Jack in the Box were that the fast food chain was unique, innovative, energetic, exciting—yet friendly, lovable, and real. The branding espoused many of those things, and more: authentic, no-nonsense, classic tastes, pride, and bold, colorful, and honest. The designer's task, among many other things, is to help transfer those attributes, build them into the packaging we use everyday. Art direction/design: Jack Anderson; Illustrator: Gretchen Cook. Courtesy of Hornall Anderson Design Works.

Figure 12-14
Charlie Robertson is a founder and the managing director of Red Spider, an independent consultant agency focused on brand strategy. Red Spider is sought out by corporations as well as by design and advertising agencies; its clients include Nike, ABC Television, *WIRED* magazine, Wieden & Kennedy, Alberto Culver, The BBC, Barclays, and Lego. Along with being a branding expert, Charlie is a football zealot, who supports the Scottish team to the bitter end—representing them here at the World Cup, at Stade de France—even though they'd long been eliminated from the final. Photo by Choloe Robertson.

distant from where it stood, to its left and right. It stayed there so long in indecision that it starved to death—poor soul. Fortunately, branding decisions are seldom life and death propositions.

However, you could be driven as mad as Burridan's Ass, trying to work this puzzle out (see Figure 12–15). To the naked eye, these figures appear to be exactly the same. It takes a label to allow you to differentiate that the one on the left has 999 sides, and the one on the right has 1000 sides. Today parity is rampant in the marketplace. As products increasingly become more similar than different, their labels become ever more important as a means of identifying distinctions between them. Using the information that labels provide means we can decide rationally if an extra product feature is worth the additional cost.

When things hang in the balance, any decision may be better than none. What usually tips the scales amounts to believing one label has a meaning—conveying it is different and better than another choice.

The over-riding assumption is that the product or service on offer is of sufficient quality for it to compete in satisfying the need of its purchaser.

There are numerous surveys showing the price people are prepared to pay for one brand over another, based on their belief that there is difference. It is a price trade-off and a value judgement, which goes beyond the merely rational. People are prepared to pay a premium for a commodity, based upon their perception and feeling about the product.

Brands live in the mind of the purchaser: in the soup that is a blend of beliefs, dreams, and values, and are composed from a jumble of information and associations. Brands are built up like nests, weaving together lots of images, experiences, hearsay, half-truths, rational conscious thoughts, and emotional sub-conscious feelings. Not least of all are the associations attached to the provenance or origin of the product.

Rationally, products may be different, but their emotional attachments can swing the purchase despite the price-value equation. Brands differentiate products through a competitive set of choices and simplify the decision-making process in comparing which product or service to buy. Brands short-circuit and simplify the real complexities hidden in making a choice. Labels convey meaning and tap into emotions, often steering one's affinity toward a particular brand.

Brands are trustmarks not trademarks. So, how would you set about measuring trust in brands? As David Ogilvy, famed Scottish advertising man, once said: "Brands are products with personality."

The relationship we have with brands is similar to the relationships we have with people. From a business perspective, brands are valuable tools in a very competitive marketplace; but they reside in the mind of the customer—the viewer. And the viewer is not an ass.

Figure 12-15
This simple "circle construction puzzle" makes an important point about branding. As Robertson notes: "As products increasingly become more similar than different, their labels become ever more important as a means of identifying difference."

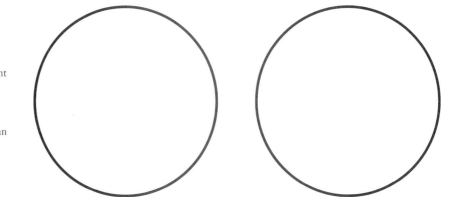

Brand equity, the worth of a brand to the corporation that owns it, is something that exists independently of the product itself. As Charlie Robertson suggests, it exists more in the minds and hearts of the consumer than within the product itself. Consumer loyalty, *perceived* quality, positioning, emotional ties, and the many other associations that accompany a brand are priceless assets to the marketability and identity of a product. Logotypes are the equivalent of corporate flashcards. They are, in fact, a graphic representation of a company's product or service, and, like the concept of brand, they represent a lot more than meets the eye.

Logotypes: Signing the Work

Logotypes tie seamlessly to identity and branding. An effective logo marks a product or company indelibly and memorably. They are also commonly referred to as signatures or trademarks. Whatever the term, they tend to be sacred cows. A logotype represents a company or service graphically, often integrating type with a graphic. However hallowed, they do require restyling and timely adjustments to remain relevant or to be contemporary.

The National Basketball Association's (NBA) Seattle Supersonics is a great case in point. The return of the "green and gold" evokes the tradition and rich heritage of the Sonics and is reminiscent of the team's 1979 championship identity.

Larry Anderson explains, "Hornall Anderson Design Works partnered with the Sonics' organization to create a timeless look, composed of similar classic attributes shared by such teams as the Chicago Cubs, Green Bay Packers, and New York Yankees logos. The strength and honesty behind the Sonics symbol renders these ideals tangible" (see Figure 12–16).

Advertising has an appropriate designation for logos: signatures. Generally, they appear at the bottom or bottom right of a page—precisely where you'd *sign* off on a letter. Television networks do a similar thing by superimposing their ID or logotype at the lower right of the screen, and it's the last thing you see when a station "signs off" the air. In advertising, logos work to "sign" the work—the same way that an artist might, to reinforce who's bringing you the message and to brand the product. It's the last opportunity the advertiser has to remind you who they are. Many consumers are brand-loyal, so it's crucial to communicate who's bringing you the message or whose product it is. If you don't, it's clearly a missed opportunity.

But logotypes can do much more. First, companies, large and small, employ a logo as a symbol, a graphic sign that unifies all of their communications. A logo identifies them. It implies quality. It differentiates them from their competitors. It officially puts them on the map of commerce and respectability. It may guarantee customers that they're getting the real deal. So, ideally, a logo or trademark *should* be consistent, appropriate, unique, clear, positive, memorable, as well as simple.

Keep several things in mind when creating a logo. It's important to make it suitable for *legible* reproduction. Often, logos are a balancing act

Figure 12-16
Compare the two Seattle Sonics' logos. How are they similar? How are they different from one another? When you deconstruct them, note what changes the designers made to update the team logo. Jack Anderson went into detail about the rationale for the redesign: "The recently unveiled Sonics identity is a return to fundamentals on and off the court. These elements include pride, respect, and hard work, all ingredients that past teams incorporated and shared with the city. The logo emphasizes the renewal of passion, commitment, responsibility, and respect for the game on both the fans' and players' parts." Does the new logo help reflect that? Art Directors: Jack Anderson and Mark Popich; designers: Jack Anderson, Mark Popich, Andrew Wicklund and Elmer del Cruz. Courtesy of Hornall Anderson Design Works.

between art and type. Sometimes that can be a perfect solution when the graphic and type reflect one another, as in Paul Black's simple logo for Aquastar pools and spas (see Figure 12–17). Sometimes, the graphic conveys the idea or place, such as this example for Tekno Sushi (see Figure 12–18).

Figure 12-17
This logo for AquaStar Pools and Spas really does a good job of saying both "water" and "star." How? The crisp sans serif type is easy to see and easy to read, and it is clean and legible at diminutive scales. Paul Black, art director/ designer/illustrator for Squires & Co., Dallas, Texas. Courtesy of Squires & Company.

Figure 12-18
Tekno Sushi, a sushi bar in Dallas, hired Howard Weliver Design to create a fresh and appropriate logotype for their business. They wanted something that communicated quickly and distinctly "high tech" and "sushi bar." Weliver delivered. Howard Weliver, art director, designer, illustrator. Courtesy of Howard Weliver Design.

Figure 12-19
Focus on just the leaves in this logo for the Ecumenical Center. Can you see the dove? Probably not. Focus on the dove, can you see the leaves at the same time. Probably not. How does this relate to Gestalt? Bradford Lawton was the art director and Jody Laney conceived the design for this striking trademark. Courtesy of Bradford Lawton Design Group.

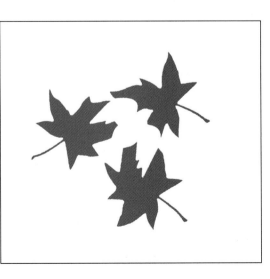

NIKE uses a "swoosh" symbol—period. (What other entirely graphic logos can you bring to mind?) Of course the logo can be entirely type, such as the logo solutions for Federal Express and Coca-Cola. On the other hand, a corporation may use type the configuration of which concurrently signifies something more, such as McDonald's "golden arches." Be wary, however, because typography can hold back a logo design if it's too frail or unreadable, particularly when presented in formats the size of a postage stamp.

Typographic legibility is central to effective logo design. When you connect shape with type, as noted with McDonald's, you might have the perfect solution. The Federal Express logo uses negative space in a most interesting way. Sometimes, too, graphics hatch a separate graphic via negative space. Look at the memorable logo created by Bradford Lawton and Jody Laney for the Ecumenical Center (see Figure 12–19). Does this logo surface anything you learned about visual communication theory in the first chapter of this book?

Make the logo adaptable enough to fit all the company's materials. It should be able to reproduce large or small and still communicate, *without* losing its design subtleties. It should impart the image, idea, and voice of the client. Ideally, it won't become outdated, but most logos do go through facelifts. It should also be suitable for wherever it will go: on letterhead, signage, vehicles, newspaper ads, outdoor posters, and so forth.

One of the world's most prestigious design firms is Pentagram, with studios in New York, San Francisco, Austin, and London. Their work includes identity and packaging materials, editorial, installations, exhibitions, and interactive media. They have created corporate identity materials for Citigroup, United, Star Alliance, Pantone, Muzak, and Scribner's Publishing—to name a handful of their clientele. For Scribner's they updated the logotype neatly. Scribner has an illustrious history as one of America's leading publishers: founded in 1846 by Charles Scribner, the company has published the likes of Ernest Hemingway, Edith Wharton, and F. Scott Fitzgerald. In 1995, Pentagram was commissioned to

modernize the existing Scribner logo. The company has long used the image of a lamp and fire as its symbol. It suggests that books provide illumination (see Figure 12–20).

Research, good communication with the client, and creativity are essential to problem-solving when it comes to identity. Logos are minimal in design and have to communicate at a glance—even when miniaturized. They are also what we *associate* with many of the most successful products, services, and corporations in the world.

Letterheads: Making an Impression

Often the letterhead is the initial contact the receiver of a message has with the sender. In fact, it might be the only connection between an organization and its clients, which places quite a weight on it to create a favorable impression and leave an apt image of the sender. The letterhead should have character but not be obtrusive, clever, or pretentious. It should be simple, yet not simplistic.

Typically, letterheads will be the first serious test of a logo's legibility. If it cannot be read here, it will likely fail. Typically, too, a letterhead is created and configured along with various related materials: envelopes, business cards, invoices, billing forms, and other smaller materials.

Letterhead designers suggest that the most effective executions are obtained by skillfully accentuating the *name* of the firm, product, or logotype in relation to the less important elements. Make sure that you consider presentation when designing letterheads, too. Should the letterhead make a formal or informal entrance? For example, the former might suggest tradition, solemnity, or heritage; the latter implies informality and a more playful, inventive, or modern look.

In a traditional design, symmetry tends to be the regimen. Type, graphics, and other components (rules, symbols, dingbats) are centered up on the page or envelope. Conversely, the modern layout may utilize *asymmetric* arrangements. Type may be set left or right on a strong vertical axis and the layout's components counterbalanced. Simplicity should reign, no matter the approach you use (see Figure 12–21).

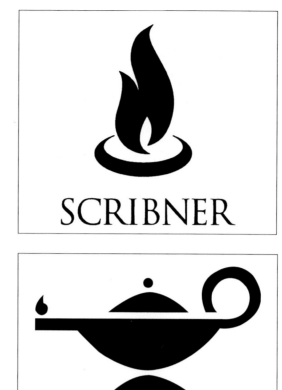

Color is also an important consideration and may be applied in a variety of ways in the letterhead: in the graphics, type, or even in the paper stock. Speaking of paper, in addition to many color options, you'll have a wide range of finishes or surfaces to choose from, including parchment, pebble, linen, woven, leather, and more.

Don't forget your margins. Side margins may be used to rack up your logo, graphics, and type lines (names, addresses, phone/fax/net numbers, or other information). Some organizations provide a masthead or long list of officers or other personnel on the letterhead. Any of these components might be racked to either side (or both), and/or run on the top or bottom of the page. In addition, don't forget the other function of the page, the letter itself. The advice is obvious: you don't want to leave space the size of a matchbook for the letter's message. Finally, some designers and clients like subsequent pages to have some minor design details built into them, rather than using blank pages for longer letters or messages.

Special printing choices can add a unique touch to the letterhead, too. They include engraving, embossing, blind embossing, hot stamping, die

Figure 12-20
Woody Pirtle offers insight to the Scribner logo redesign. "We modernized the existing logo, introducing a fresh, contemporary tone. The new symbol features the image of a torch, suggesting the heritage of the brand and Scribner's ethos concerning the illuminating quality of books." Compare the earlier version (top) to Pirtle's logo (bottom). Which do you prefer or think is more contemporary? Why? Partner/ art director/illustrator/ designer, Woody Pirtle. From GALE GROUP WEBSITE, by Pentagram Design for Charles Scribner's Sons. Reprinted by permission of The Gale Group.

cutting, and thermography (see chapter 9 for particulars on each of these processes). If you do opt to use them, follow the Bauhaus lead, form follows function. For example, take the case of the letterhead of Red Spider, the branding strategy agency (see Figure 12–22). Some designers like the 3-D effect of embossing, or they may prefer a *blind embossment*, which has Braille-like presence on the page with its uninked raised imprint. A linen texture may add to the formal sensibility of the letterhead design. Die cuts might imply something graphically, too. None of these examples was random or applied arbitrarily; each was a thoughtful and defendable creative solution (see Figure 12–23).

The Envelope: Making an entrance

Though little more than a sheath, the envelope does more than enclose and protect its contents. Envelopes are also all about *presentation*. They, too, are packaging, and people who take their messages very seriously, understand the value of a well-crafted envelope. Think for a moment how you react to mail you receive. What really stands off one piece of mail from the others you receive? How? Why?

Like the letterhead and materials they bear, envelopes imply a great deal about the sender. An envelope's external message is shaped by its color, format, size, type, graphics, seal, contour, paper (or other material), and its texture.

Figure 12-21

Compare the traditional layout (top) for Big Island Candies to the more modern K2 layout (bottom). Traditional layout in letterheads employ symmetrical balance and suggest heritage, reliability, and an established reputation—which is a very fitting image for Big Island Candies. Courtesy of Big Island Candies and Hornall Anderson Design Works. The image of K2 is an enviable one, and much different from that of Big Island. K2's products are celebrated not just for craftsmanship and performance, but for their blend of state-of-the-art construction and graphic flair. This asymmetric, colorful stationery is an appropriate face for K2. Big Island Candies: art direction: Kathy Saito and Jack Anderson; design, Kathy Saito, Mary Chin Hutchison, Sonja Max, and Alan Copeland; photography: JaneArmstrong. K2 Skis Stationery: art direction: Jack Anderson; design, Andrew Smith, Henry Yiu, Ed Lee. K2 brochure: Jack Anderson, art direction; design, Andrew Smith, Tiffany Scheiblauer, Andrew Wicklund, Mike Hone, Elmer DelaCruz, Sonja Max. Courtesy of K2 and Hornall Anderson Design Works.

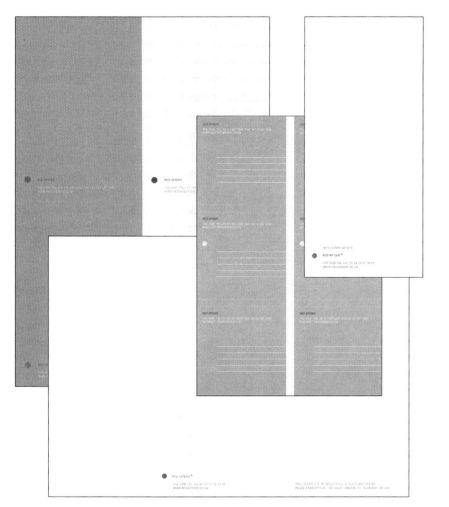

Figure 12-22
Red Spider—featured earlier—prides itself as a virtual company and invented a most unique and appropriate logo: a small, circular die cut hole, as the graphic device on its letterhead, cards, and other materials. Courtesy of Red Spider.

Figure 12-23
Funk/Levis & Associates created the handsome letterhead, business card, and other identification materials for *i*Horses—a virtual company specializing in products for equestrians. The dramatic logo presentation is used in a wide variety of applications. Design and illustration by Alex Wijnen. Courtesy of Funk/Levis & Associates.

Envelopes may be minimal or elaborate, simple and utilitarian, or quite sophisticated and refined. They may be personal or impersonal. How we respond to them is affected largely by their design. What paper was used? Size? Format? Color? Type? Graphics?

Envelopes are classified by size. There is a wide range of standard sizes, but printers can produce whatever designers can dream up. They may also be classified by the way they close. There are self-adhesive flaps, gummed flaps, flaps with metal clasps for added security, and button and string tie-down flaps, which were initially designed for heavier envelopes meant to be used over and over again. Today, the latter might also be used to make a grand entrance for the sender (see Figure 12–24). There are even more elaborate envelopes whose designs are protected by patents.

Figure 12-24

Em Dash Design (San Francisco) created these minimal but formal identity materials for W Hotels. The elegance and formality of the hotel is reflected in the clean, symmetrical layouts. Note refined tie and button envelope (bottom). Art direction: Frank Kofsuske; design: Mark Blaisdell, Satoko Furuta, and Frank Kofsuske. Courtesy of Starwood Hotels & Resorts Worldwide, Inc.

When selecting an envelope, you have to first consider the audience. Equally important, reflect upon the purpose of the mailing, the size and bulk of the material to be inserted, and *how* the envelope will be stuffed. Mass mailing is a different matter. An envelope whose contents are to be hand-stuffed should be one-fourth of an inch wider and one-fourth-to-three-eighths of an inch longer than its contents. On the other hand, if a printing plant or mailing firm plans on machine-stuffing the envelopes, the packaging must be compatible with the insertion system.

The graphics and typography of envelopes should be mated up to the design of the letterhead and smaller auxiliary materials. It's crucial to maintain continuity among identity materials. Finally, always consult the postal authorities and share your envelope's prototype design with them—*before* printing. Postage rates are affected by envelope dimensions and proportions, as well as by weight.

The Business Card: Trump Suits

The logo normally drives the business card, another identity piece. Business cards are like letterheads. Everything noted earlier about formality, paper texture, color, type, design principles, graphics, continuity, and image apply here. The copy and type should identify, locate, and depict. That is, the card's elements should emphasize the name of the person and/or firm, suggest the nature of the business or service, and provide the address, fax, website, and e-mail and phone numbers, or whatever is deemed essential information. It should be a proper match to the audience as well.

Business cards are also about identity and tend to be image-driven. San serif faces, because of their legibility, usually provide clean, dependable readability, which is important when using small point sizes. Type selection is significant; all the key data should be easily readable. But today, *other* senses can be factored into a business card's design (see Figure 12–25).

There are several standard sizes for cards. The generally accepted business card format is often identified as a #88. Physically, it's a cardstock

whose dimensions are 2 × 3½ inches. Resist the temptation to be different by using an unusual size. Odd-sized cards are often tossed, and won't fit the standard desktop file systems for business cards. Sometimes, though, a designer might specifically select a larger format—that can be diecut to fit within a Rollidex™. Other more common options are selecting stock that's 4 × 3½ inches, so that it can be folded in half to provide the same format, but with *four* sides. This may be a good strategy to accommodate clients who're looking to include sports schedules, rates, a litany of staff, or other important elements unique to their situation.

Be careful not to position lines of type too close to the edge of the card: normally, no closer than one-quarter of an inch. The logo should dominate the card (see Figure 12–26). Obviously, all the printing and paper options noted earlier are available for the business card as well.

Figure 12-25
Peel Interactive Media—whose graphic is a partially peeled orange—uses a scratch-and-sniff card with orange scent. It also employs color and sans serif typography. Notice the simple presentation of stacked type on the flip (lower) side of the Peel business card. Art direction and design by Kevyn Smith. Courtesy of Peel Interactive Media.

Figure 12-26
Chemeketa Community College student, Kimberly Krueger, designed this logo to represent the weaving together of cultures and people. It was designed to go on the college's Multicultural Center materials—cards, letterhead, and signage. Graphically, it suggests "from distinct roots we can all grow and live together." The client, the Multicultural Center on the Chemeketa Community College campus, wanted an identity that would represent both a gathering place for all people to feel welcome, as well as a spirit of multicultural inclusiveness. Design by Kimberly Krueger as an "in class" project for Professor Christine Linder, director of the graphic arts program.

Collateral: Supplemental Media

Sadly, collateral materials are considered as the orphans of graphic design. Briefly, they may be defined as secondary or supplemental media that reinforce or run parallel to a public relations or advertising campaign. Collateral materials are important advertising, branding, and public relations tools and may bolster a company's

image, presence, or identity. Technically, however, they are separate media.

Precisely what constitutes collateral varies depending upon who you ask. Typically, they consist of brochures, direct marketing materials, point of purchase pieces (POP), calendars, catalogs, pamphlets, CD and DVD materials, media kits, press kits, guerilla advertising, and miscellaneous company literature. Again, collateral is a "catch-all" category and although most of these formats follow the same design guidelines as other media, many have specific physical differences and design dynamics. In general, designing collateral materials is an exciting and challenging facet of graphic communication. Brochures are a good case in point.

Brochures: Unfolding Opportunity

Brochures carry a number of aliases: handbill, flyer, booklet, pamphlet, folder, or view book. Some design competitions or awards shows designate a "miscellaneous company literature" euphemism for them. Brochures allow considerable flexibility via their wide array of available formats. They might be as simple as the three-panel/two-fold format you find in your mail or under your windshield wiper. On the other hand, they may be as complex and sophisticated as an elaborate CD fold-out design, or, on a much grander scale, their format may be adapted for something as large as an exhibit or installation consisting of a series of huge, hinged panels. Sometimes, their formats and construction are more magazine-like, as in the case of automotive view books (see Figure 12–27). Brochures are also a common element of

Figure 12-27
Automobile companies tend to pull out all the stops when it comes to promoting their cars with brochures. So what if you're hyping the "ultimate" sports car, for example, a BMW Z-8? For starters, the simple opening panel offers an extreme close-up of the Z-8's ignition: the engine start button. Turn the page and you're told, "Don't forget to breathe." Appropriate. A two-panel spread of the 394 horsepower machine almost rocketing off the enameled five-color layout. Seriously, here's a car that looks like it's going 180 mph parked. The next two-page spread takes you inside the BMW, where—like the crisp, understated copy and design—minimalism reigns. The "view book" brochure format here is more like a magazine than a traditional "fold out" brochure, with a 9 1/2-inch-square format that's saddle stitched. It offers a design that's fitting for one of the best-designed automobiles in the world. The print materials, unfortunately, did not come with bibs to catch the reader's drool. Examples courtesy of BMW. ©2003 BMW of North America, LLC, used with permission. The BMW name and logo are registered trademarks.

direct mail materials, press kits, and even advertising. And, of course, you never know where a gatefold might show up in advertising, magazines, annual reports, or other publication materials. Not all, but most brochures have this in common: panels that *fold*.

Brochures are also good at demonstration. The panels make them unique, too, because they help tell a story—panel by panel. 5D Studio of Malibu *told* a story in the most minimal way (no words) by creating a brochure for Vecta chairs; in fact, it was a flip book. The art, when flipped, created a mini-movie showing how the chairs neatly stacked (see Figure 12–28). How's that for expanding the medium?

Functionally, brochures should be persuasive in concept and by design. They can motivate quickly, which makes them a favorite medium for agencies doing *pro bono* work, because using them may sensitize readers about a social issue. Or it may enlist supporters to a cause. They may exhort the voting records of candidates, hawk the benefits of the latest SUV, entice you to attend a university, show you the new features of an interactive video game, or make a case for you to support the YMCA. Actually, SamataMason used the *brochure* format for the Chicago YMCA's *annual report*! (See Figure 12–29.)

Indeed, brochures may be the most malleable of media. Surprisingly, though, they're also perhaps the least written about. If you take a quick tour through stacks of design books, you'd be hard-pressed to find much if anything written about them. But their range and various formats make them an invaluable communications tool when it comes to creative problem-solving.

To understand the nuances of the brochure and to make the most of its potential, you must first understand its parts: front, inside, and back panels.

Basically, the front panel functions like a cover or a poster. Because it is the hook, the art normally dominates to get the reader inside. The front panel may suggest a theme, project an image, establish a motif, or make a proposition. Normally, it uses tight artwork that is closely cropped (one element should dominate) and a short header, title, or claim. It might also include a logo, and, more rarely, a terse amount of copy.

It may replace art with a color or texture field or a hard-hitting headline. Some more sophisticated brochures don't employ art on the cover itself, but reveal it through a die-cut window.

Think of the brochure cover as a mini-outdoor board. It has to communicate quickly and often hit a moving target, so its components need to be terse, clear, and reinforce one another. If any word can be removed from the headline without harming the message, eliminate it. Crop and work tightly with art to help keep it minimal as well.

A brochure designed to promote the Primax "Commander" pen, was configured so that all its panels had a consistent look, two-thirds art and one-third reversed copy, with some variation from left to right. If sales and increased vending contracts are a measure of a brochure's fruition, this one succeeded (see Figure 12–30). What's more, the identical format was used for Primax print advertising and *larger* illuminated panels for signage in hotels, trade shows, and along conveyance systems in airports—words and all. The format even was employed for outdoor display, with the copy being replaced with terse headlines.

Typically, artwork and copy share space within the inside panels. When you're planning inner pages, it is important to properly sequence and transition the materials and copy on the pages. One common way to accomplish this is by defining a pattern and sticking with it for design and continuity purposes, as in the Primax examples. Often, however, designers relate panels to one another by bridging strategies.

If the interior of the brochure is copy-heavy, try to break it up with rebus elements, dropped initial letters, crossing headers, reverse blocks, thumbnail photos, bullets, rules, and other graphic devices to explode the gray of the publication. You might also consider employing pull-quotes, decks, and even extra leading. Try not to overload the panels. Shoehorning is especially counterproductive in brochure design.

Don't forget the *show and tell* nature of brochures, which is to say, tell your story visually. Don't waste the readers' time trying to say something that cannot be explained without writing a treatise on it. Plan your publication to be streamlined and void of excess baggage; the information should be memorable, clear, clean,

Figure 12-28
Jane Kobayaski, art director of 5D Studio, decided to stretch the brochure medium. Here's yet another non-folding brochure design. "Two years ago, we produced a flipbook to promote the introduction of the Vecta Kart chair. This year, Vecta introduced a new stacking version of the chair called the Kart Stacker, so we decided to produce a 'sequel' flipbook." The brochure also boasts an unusual perfectly bound, screw-post closure/binding, die-cut cover, and flip book which was run black and white cover to back. Jane Kobayaski, art director; Geoff Ledet, designer; David Ritch, photographer; and Thai Tran, illustrator. Courtesy of 5D Studio.

readable, and user-friendly. Speaking of readability, be sure to use comfortable inner margins throughout the panels. Margins should be consistent. Irregular margins look unprofessional and give the publication a sloppy look. Good design is about attention to detail.

Finally, still another inner panel strategy is to insert smaller, inside pages within the brochure format. The smaller pages make the design more interesting and playful. Inset panels are easily accomplished by using smaller formatted paper. If insightfully designed, inset panels can provide readers wonderful compositional shifts via the visual changes the turned pages create. Experiment with plotting inset page compositions if you plan to use this option for your brochure.

The closing panel may serve any number of functions, but normally it brings the brochure to closure. In direct mail and other instances, the back panel often serves as the *mailer* component, so leave ample space for addressing. Include a return address in the upper left corner and room

Figure 12-29
This brochure is also an annual report. Pat Samata designed this brochure for the Chicago YMCA. The striking cover artwork is surprinted with copy explaining how the Chicago YMCA brought Protestant and Catholics together from Cork and Belfast, Ireland YMCAs to broaden their visions and sensitivity through their "Bridge of Hope" program. The insides accordion fold out to six panels. Here are two of the large (6″ × 12″) format's panels: the chairman and president's letters and the board leadership page. Courtesy of SamataMason.

Figure 12-30
This Primax "Commander" layout relies on ground thirds for its structure. A format was sought for the brochure that could be easily adapted for magazine advertising, identity panels, and outdoor media. The client wanted the fountain pen to be the "hero" of the ad, and the horizontal format was a logical way to present the product. William Ryan: art direction, design, styling, and copy; Louis Squillace: photography.

for a stamp or postal indicia in the upper right. The back of the right panel may also reinforce or summarize the message. Often it's used for logistics, too: maps provide directions to the client's business. Finally, it may work as a response panel, for example, as an order, donation, membership, or subscription blank.

Planning Brochure Design

Adjustments in brochure design are common because of a brochure's panel-by-panel nature, but careful *planning* will help minimize them. In any case, begin by planning. Work out the basics in your initial blueprint:

1. Write up the purpose in twenty-five words or less.

2. Identify the audience in a sentence or less. Is there also a secondary target?

3. Outline the essential information to be included.

4. List the benefits or points of the information.

5. Establish a timetable for execution and distribution.

Clearly understand the purpose of the brochure. What is it supposed to accomplish? Is it to demonstrate stackable chairs? Motivate you to become a vendor for Primax fountain pens? Display Funk/Lewis & Associates logo samples? (See Figure 12–31.) Take a Holland America cruise to the Caribbean? (See Figure 12–32.) Support the YMCA? Your brochure should have a specific function.

Like all media, brochures should be carefully targeted. Audience shapes your voice, look, attitude, and use of color, type, and design. Know the audience as clearly as you understand your purpose. Enough said.

The distribution method and life expectancy of your brochure should also play a part it the design planning. Will it be mailed? Placed in an information or "take one" rack. Handed out on a street corner? Will the backside be a poster? Will it be used to simply announce a concert or rally? Or will its use be more long term? For example, will it be used year-round to market fountain pens, stackable chairs, cruise tours, or BMWs?

Production and printing costs also need to be assessed. How much money do you have for design? Photography? Printing? How many pieces are you planning on printing? Your budget will largely decide how much color you can use or if you can afford an illustrator. It will also determine the quality of paper stock you use, and the brochure's format and folding options.

As this preliminary visualization progresses, a form for the brochure may begin to take shape in your mind's eye. Form follows function. What will the physical size be? Shape? Folding possibilities are almost endless. This is the time to begin building a crude dummy. At this stage, some designers prefer to work in miniature. Others might rather experiment using its real size. In either case, settle on a format and begin experimenting. Then try a few other formats. Which folding patterns and configurations most appeal to you and match your budget?

Keep things simple. Remember panels interrelate. When you unfold them, their spatial

Figure 12-31

Brochures need not be predictable; they can be personalized and customized for presentation reasons. In this instance, Funk/Levis & Associates used a sleek format (8¾" X 3½") and a riveted, overlapped binding for their logo and identity sampler. It's also very functional and can fit in a standard-sized envelope. Design by Chris Berner. Courtesy of Funk/Levis & Associates.

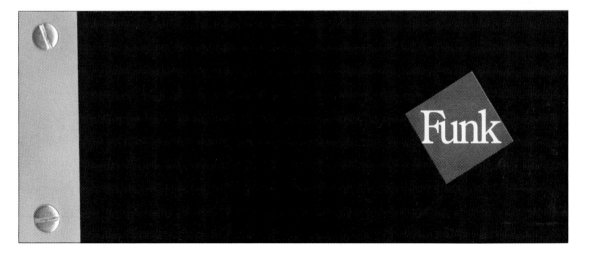

dynamic and relationships with the other pages or panels also *change*. Panels should work both individually and in relationship to the other panels. Remember, too, most folding brochures have two sides. You'll quickly discover that the front panel isn't at the far left in your layout. When you begin testing your rough layouts, you'll begin to discern the logistics and relationships between panels. How will the back panel relate? How do you maintain continuity with the inner ones? How do they work together to tell your story, communicate your message, or motivate the user? Will one side end up being a poster? How will it fold and work together as a whole?

Michael Blum, a printing instructor noted, "Approximately 35-to-40 percent of the labor cost of the average printing job is in finishing." Finishing for brochures might include die cuts, pockets, perforating, embossing, and other printing specialties, but it will almost certainly involve scoring and folding.

Modern equipment is capable of producing an extensive assortment of folds. All of them, however, are creased either parallel or at a right angle. *Parallel folds* are used for letters where two folds are scored to fit the letter into the envelope. The same fold, when the sheet is held

horizontally, becomes a standard six-panel (also called regular) fold. An accordion fold, is another parallel creasing. It, too, is a popular format. The most basic parallel fold is a single fold, halving a page and configuring a four-page format. Of course, with wider paper (or narrower folds) you can make additional creases to create eight, ten,

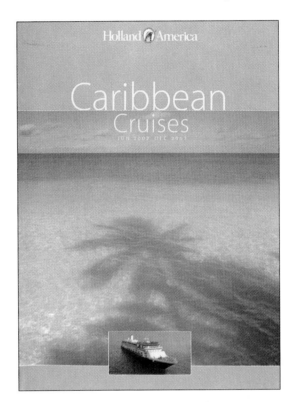

Figure 12-32
Hornall Anderson Design Works employed a magazine format for this Holland American Lines Inc. brochure for its Caribbean Cruises. Note the magazine cover and table of contents look of these elegant marketing publication. It makes a strong case to head to the Caribbean tomorrow! How is color used? Art direction: John Hornall and Julie Lock; design: John Hornall, Julie Lock, Jana Wilson Esser, Mary Hermes, Mary Chin Hutchison and Jana Nishi; photography: stock work; copy: Pamela Mason Davey. Courtesy of Hornall Anderson Design Works.

or more panels in the brochure. T-folds and "map folds" are two other choices you might utilize. Experiment with different folding arrangements when testing your dummies (see Figure 12–33).

Folding machines can handle signatures of many pages to create larger brochures, booklets, and publications of sixteen, twenty, twenty-four, or more pages.

There are many other options for folding, depending upon what equipment is accessible to you. Find out what options printers have at hand before you settle on a design. When you're investigating formats and getting bids, the printer's options may spark new or unique approaches to folding you hadn't considered.

Once you decide upon the folding arrangement and page size, begin designing the layout. This should include setting the margins, "speccing" the type, choosing and scaling art. Settle on an overall brochure design, and flesh out a prototype. Begin by folding several sheets (real size) into the panel arrangement you'll use. Then scan and drop in the art or sample images. Choose and apply your stylebook. At this point, you'll begin to see precisely how various elements relate to one another—even if they're still tentative. Play with the brochure layout. By experimenting and seeing how panels, art, and copy relate to one another, you'll quickly discover what works and what doesn't. If you have finished copy at this point, apply the stylebook and flow it into the design. You might discover you have serious problems: too many words or not enough art are common surprises. In these instances, you'll likely need to make adjustments, rethink panel relationships, or even decide you have to "write to fit" certain sections.

Brochure design is difficult and demands a great deal of planning because of its many options and because it is such a complex medium—but the payoffs may be substantial. At the very least, brochure design will teach you valuable lessons about visual storytelling that you can apply to other media, including moving imagery, and CD and AV material design.

CD and AV Materials: Designing for Sound and Motion

The sheer creativity of music is remarkable. However, the periphery of that industry and its products are almost as extraordinary. Concert

Figure 12-33
When designing brochures, consider the many possibilities for your publication presented by various types of folds. Several alternative formats are illustrated:
1. Vertical parallel fold;
2. Horizontal;
3. Book fold;
4. Short fold vertical;
5. Short fold horizontal;
6. Tent fold;
7. Gate fold;
8. Z- or concertina fold.
Of course, this list is incomplete; brochures may use map folds, T-folds, double (left and right) door folds and much more.

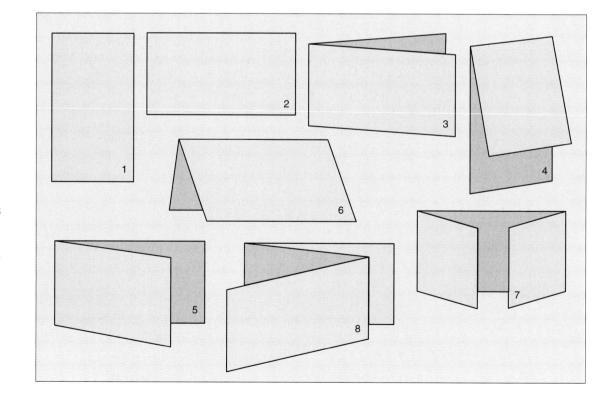

tickets. Posters. Point of Purchase (POP) materials. Box sets, and, of course, the CD (or DVD) cover, insides, and packaging design. CD design merges the artistry of the music with design, photography, and illustrations. Art directors invent visual components for a non-visual medium.

There are many pioneers in this unique area of design. Jim Flora worked in the 1940s and 1950s, first for Columbia and then RCA Victor, designing jazz albums for jazz legends like Benny Goodman. Reid Miles' art direction and design put Blue Note's album covers on the design map. Miles' tight modular form, duotones, black and white photography, and sans serif type are timeless (see Figure 12–34). In fact, much of that style is imitated today by Blue Note and others. In 1961, the album cover of Dave Brubeck's *Time Further Out* (a follow up to Time Out) used a Joan Miró painting on its cover. In fact, in the liner notes, Brubeck thanked the painter for his "inspiration" (see Figure 12–35).

Designing CD and AV materials begins with understanding the intricacies of brochure design. Nearly all CD and DVD materials use some kind of *folding* format. Deconstruct one of your CD covers and liner notes. What did you discover? At the very least, it has a front and back, spine, and two inside panels. Brochure *deja vu*.

Most designers love to work with this format. Along with the cover, spine and back, there are usually additional responsibilities. The interior liner notes are often fashioned in a brochure format—and, of course, there is the CD itself to design. Sometimes peripheral materials—posters, caps, or POP displays—are also part of the design project.

Start by establishing a theme, normally suggested by the CD title, liner notes, and the musician's input, and build upon it. Like brochures, CD design relies on continuity between panels. When you design for this genre of materials, strive to connect the visual elements to the voice and content of the music—and follow all the tenets of brochure design strategy. Basically, DVD and CD formats are identical; so, too, are their design and layout strategies.

Figure 12-34
The purity and form of Reid Miles album cover design has never been surpassed. This 1963 cover of Donald Byrd's *A New Perspective* literally practices what the album title suggests. By the way, if you've not heard this music, give it a listen. The personnel and the work are stellar. Cover art and album cover design by Reid Miles. Donald Byrd, *A New Perspective* CD cover – Blue Note 84124. Courtesy of Blue Note Records.

Figure 12-35
Columbia was another follower of the design paths blazed by the jazz music album architects, notably those at Blue Note, Riverside, Prestige, and Savoy. In this instance, the artwork for Brubeck's *Time Further Out* was literally art—a Joan Miró painting. Columbia used this direction as well as the influences of Blue Note, more or less, as matrixes for albums created by many of their artists, including Dave Brubeck, Charlie Mingus, Miles Davis, and others. Art direction: Tony Sellari; design: Ken Fredette; packaging manager: Hope Chasin; cover painting: Joan Miró, 1925. ©2003 Successio Miro/Artists Rights Society (ARS), New York/ADAGP, Paris. Courtesy of Columbia Records.

Catalogs

Catalogs are yet another interesting breed of collateral material. They're a unique combination of magazine, advertising, direct mail, identity, and often, fashion itself.

Many catalogs, however, disguise the standard catalog look by adopting a magazine format. They may offer a magazine-like cover and often an editor's page, interesting features, interviews, product review or narrative, and a table of contents page. The latter typically will list departments. For example, in the Cascade catalog: bags and clothing, camping, rafts, and rescue/safety. Catalogs for museums, travel agencies, exhibitions, design firms, colleges, and universities are

often quite sophisticated and—at a glance—almost indistinguishable from magazines.

Cascade Outfitter is an international, white water gear outfitter. They sell rafts, tents, cooking and camping gear, outdoor wear, kayaks, paddles, life vests, dry boxes, and river footwear, among other things. They're based in Boise, ID. Actually, though, Cascade Outfitters is a virtual company, offering both mail and Internet order options. Their catalogs offer an array of covetous gear for their audience.

In this instance, the cover of the *Cascade Outfitters* mail order catalog is a compelling photograph of an oarsman being completely inundated by a wave at the bottom of a treacherous drop on the Payette River (see Figure 12–36). That's a page-turner. Once inside the magazine, the "editor" relates a blow-by-blow recounting of the river run and cover photo. The rest of the publication's feature images document the Idaho river trip. Interspersed between those images are mostly knockout photographs of white water gear. It's a well-planned and executed formula that pays off in terms of reader interest and sales. An order form is provided in the back of the catalog—a common tactic—for those opting not to order by phone or Web.

In some respects, catalogs have a leg up on traditional advertising and other forms of direct marketing. Their targeting is precise. Generally,

people who receive catalogs are members, previous clientele, or otherwise individuals predisposed to the content. Plus, the presentation in catalogs tends to be alluring and mated up to the passions of their readers.

Like advertising, though, catalogs must be credible and persuasive. Largely, catalogs provide readers an interesting backdrop or situation, the audience can relate to. Content is important, too, but presentation and demonstration rule. Finally, perhaps more than any other facet of collateral, catalogs must be well conceived and *visually* driven.

Media Kits, Press Kits, and Info Kits: PR Multimedia

Actually, professionals often use the terms, *media kits* and press kits, interchangeably. Sometimes, catalogs and media kits are one and the same (see Figure 12–37). No matter their moniker, their function generally is to act as a kind of a compendium. Movie companies, publishers, magazines, and recording corporations use them for a variety of reasons. In some instances, they're used to promote a film, book, CD, or the company itself. The materials are also used by media planners or media buyers for their demographic, psychographic, or circulation data. The kits may also provide entertainment writers, reporters, or freelancers with background infor-

Figure 12-36

Cascade Outfitters is a pioneer in white water mail order and direct mail. They began as a humble, smalltown company that quickly realized they could extend their limited customer base by becoming *virtual*. The cover of this Cascade Outfitter catalog captures the explosive nature and adrenaline rush of running a class IV-V drop on the south fork of the Payette River in Idaho. Inside, the design mixes action and product photography. The cover art snares the reader, and successive images inside extend the theme. Eric Evans shot the action and studio (knockout) photos. Courtesy of Cascade Outfitters and Eric Evans Photography.

mation for a new film or recording. They may also provide background for a report on an organization, candidate, public service group, or anyone else utilizing a "press kit."

Typically, media or press kits employ a "pocket" folder format, but, as with brochures, designers often take great liberties with their size, configuration, and parts. The average media kit (if there is such a thing) might contain an overview of the company, photography, business card, letterhead, "handouts" (press releases), a fact sheet, schedules, product sample, or profiles of key players in the company, film, or musical group.

Typically, *magazine media kits* are also constructed with pockets. This collateral hybrid normally contains sample magazine issues, a reader profile, audience spending statistics, circulation information, competitor magazine comparisons, market share numbers, and advertising rates. *Seventeen*, for example, offers a media kit with neatly tabbed sections for its handsome, spiral overview booklet. It's packaged in a sturdy, folding wrap with a sunken embossment on the topmost fold of its cover.

To be sure, the media kit is a *sales* and/or public relations tool. Most magazines, for example, use media kits to promote or recruit advertising in their publications. They provide media buyers, prospective clients, and others a quick overview of the magazine: its demographics, psychographics, circulation numbers, and other information. This is invaluable information to media buyers because they can make a fairly quick assessment about how good a match that magazine (or other media) might be for their company's advertising.

Newspapers and other publications may utilize the "handouts" in media kits because they are ready-made stories, complete with photographs, pre-written reports or feature stories, and other "packaging" materials (see Figure 12–38). Often, especially when a publication is short-staffed, media or press kits seem like a great arrangement. Their audience, for example, is likely interested in an upcoming film—the report of which is available, start-to-finish on the reporter or editor's desk. It's a win/win situation. The paper or magazine or reporter gets a well-crafted story and accompanying photography. The recording, film, or publishing company gets free publicity. Media kits are normally slicked up to present a publication, company, or agency's best side.

Because media/press kits often use a variety of formats, there is no specific formula for their design (see Figure 12–39). In other words, apply the various graphic strategies you've learned in this and other chapters for the respective design formats you might adopt.

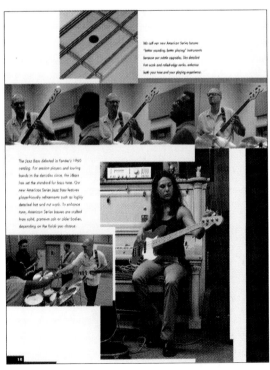

Figure 12-37
There's not a facet of the music industry or music genre that Fender guitars have not penetrated. Their Telecaster and Stratocaster guitars are legendary. This view book cover (left) speaks to the classic "American" instrument. The interior page design (right) uses modular design, a mix of tight and medium shots in color, and a woman playing one of their guitars. Fender currently has a new marketing push directed at getting their guitars into the hands of young women. Courtesy of Fender Musical Instruments Corp.

Figure 12-38
These media kit images come from Disney.Pixar's delightful film, *Monsters, Inc.* Top-to-bottom: Billy Crystal and John Goodman—who provide voices for Mike Wazowski and Sulley, respectively. A surprised Sulley—alarmed to find a human child (Boo) in monster world. Finally, Sulley (left) and scare assistant Mike Wazowski (right) wide-eyed at how much trouble has been unleashed when Boo gets loose. Artwork courtesy of Pete Doctor and Disney.Pixar. © Disney Enterprises, Inc./Pixar Animation Studios.

Figure 12-39
This Disney.Pixar's *Monsters, Inc.* media kit is a great example of functional design. It includes glossy still frames (carefully sealed in plastic) from the film, contact information, an on-line URL, and a 37-page booklet. The latter is a thorough compendium of the film, with a complete listing of its credits, background, production notes, character sketches, and personal biographies of the cast. The *Monsters Inc.* media kit comes in a handsome heavy-weight folder, complete with die-cut pockets and a large, full-color die-cut of Sulley. Artwork courtesy of Pete Doctor and Disney.Pixar. © Disney Enterprises, Inc./Pixar Animation Studios.

Books and Pamphlets

Books, pamphlets, and related materials are yet a different matter. These media are treated briefly here as, once again, the basic tenets of good design, typography, and other layout strategies apply.

Typical components in their normal arrangement within a book include—from front to back—the following sections or divisions: cover, title page, copyright information, dedication, preface, acknowledgements, contents, introduction, chapters and text, appendix, glossary, bibliography, index.

Normally, most of the book components noted above begin on *right-hand* pages, except copyright information, which often includes the printer's imprimatur. Copyright pages normally appear on the backside of the title page. This content order may be used as a guide for book and pamphlet logistics.

Parallel structure is immensely important to book design. When Kit Hinrichs designed this text, for example, he created a template of sorts by using the advertising chapter as the text's *prototype* chapter (see Figure 12–40). The Delmar Learning production staff and designers used it as a model from which to shape the remainder of the book. The cover is a separate, albeit related, issue. Designers normally provide a client several options for a range of a book's parts, including cover studies (see Figure 12–41).

Hinrichs' opening chapter architecture, handling of art, typography, color, graphic elements, page logistics, header/text/caption specifications, and other details served as the model for the rest of the chapters. The book's cover, table of contents pages, index, glossary, and several other elements—although designed *separately*—shared many of the stylebook specifics from his sample chapter design. Designers may opt to include a colophon at the front or conclusion of the book; a colophon briefly describes the publication's typography and perhaps a handful of other technical or design aspects.

Finally, stylebooks and continuity are just as important to book design as they are to identity, packaging, branding materials, annual reports, letterheads, brochures, catalogs, press kits, and every other medium.

Figure 12-40

Compare these book page designs for opening chapter spreads of *Graphic Communication Today, 4th Edition*. Kit Hinrich's prototype design (top left), which used real "in progress" art and writing for the advertising chapter, is almost identical to the completed chapter (top right). Courtesy of Kit Hinrichs, Pentagram, Delmar Learning, and the authors.

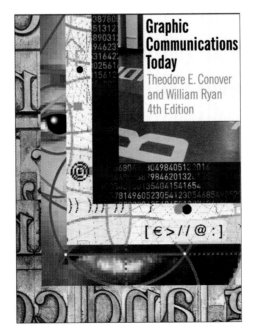

Figure 12-41

These are four original "cover studies" for *Graphic Communications Today, 4th Edition*, designed by Kit Hinrichs with designer Julio Martinez. Compare them to one another and to the finished cover of your text. Which one do you prefer? Why?

Figure 12-42
Jack Anderson—co-founder of Hornall Anderson Design Works, an internationally recognized design firm—has always focused on designing experiences that define the spirit, soul, and value of each project. Over the course of twenty years, Jack has been featured in numerous articles and books, and he and Hornall Anderson Design Works have received countless awards in a variety of design industry competitions. He is active in American Institute of Graphic Arts, New York Art Directors Club, Society for Typographic Arts, and Western Art Directors Club. His roster of clients is diverse, ranging from highly recognizable companies, such as the Seattle Sonics, Holland America, K2 Skis, Microsoft, Weyerhaeuser, and Jack in the Box to a plethora of esoteric clients, such as OneWorld Challenge, KAZI, Widmer Brothers, and Tokyo-based Okamoto Corporation. Courtesy of Hornall Anderson Design Works.

Delivery: Getting the Business

The best ideas you can imagine won't become realities if you can't convince your client, creative director, editor, or audience of their value. Presentation is perhaps the single most neglected aspect of visual communication education. It involves careful analyses of your audience and work and how to present or frame it in its best light. Other essential elements of presentation include research, planning, performance, voice, intuition, meticulous preparation, and good listening and communication skills. Jack Anderson, along with being a principal and art director at Hornall Anderson Design Works, is an accomplished presenter of creative ideas. Anderson's statement below is edited from a protracted conversation with the author (January-May, 2003) for an article (in progress) on effective presentation, "The Wind-up: Pitching Under Pressure." He provides a most lucid window into the process of presentation.

There are fine lines between presenting, sharing, and selling. The determining factor often lies in the "visual acuity" of your audience—their ability to "see" things or understand how concepts can be fleshed out. Some clients are able to look at rough thumbnails and immediately understand the journey. Others need to view and choose from very finished work. Until you understand how your audience digests information, you need to know when to lead and when to get out of the way, letting the work itself steer the client through the process.

Being able to read our audience before sitting down with them is key to holding their undivided attention. Some are more concerned with our rationale and ability to build consensus than the final outcome. Others simply want results. The question is which approach will be most persuasive? Should we present formally, providing several options to demonstrate our strategy and ideas? Is it more advantageous to keep the meeting casual, using two-way communication in an open venue? Or, should our approach be more one-sided or sales-centric with the goal of convincing our audience to see things through our eyes? Experience has taught us the importance of being flexible and tailoring the presentation to the client. What resonates with

one group might have the opposite effect with the next one.

We make a concerted effort early on to establish rapport and create a trusting environment for our clients and prospects. Ideation beats hard-sell tactics every time (see Figure 12-43). When a relationship is comfortable, parties see each other more as equals. Gaining trust and giving the client ownership in the work will engage them and may make the journey to a creative solution truly magical.

Regardless of how formal or informal a presentation, there is a structure—a linear thought process. For example, if our audience is larger or more varied in their opinions, background, or experiences, we might present a series of different concepts from a single strategy. At the opposite end of the spectrum is a "sell" mode, which is typically used in a more formal environment—when the audience wants or needs to be convinced. When opinions differ or when trying to move from one paradigm to another, we may find ourselves "selling" our recommendations with enthusiasm to the group in an effort to gain consensus.

As you prepare your presentation, consider these variables:

- *Is this a new relationship or a familiar relationship?*
- *Is your audience an individual or a committee?*
- *Is the meeting venue in your environment or theirs?*
- *What is their understanding of and experience with the subject matter?*
- *Do they have high or low visual acuity?*
- *Should the process be evolutionary (building on existing ideas or materials) or revolutionary (shifting paradigms)?*
- *Have they worked with other design/branding firms?*
- *Should you present digitally or with traditional "analog" materials?*
- *Who is the right team to present? Consider personality, roles, chemistry, etc.*
- *Will you be the first reviewed or last reviewed in an RFQ situation?*

We pitch a new client differently from one we already have. New business prospects typically want to know how we work. It's important to

demonstrate our experience within their type of business by showing case studies, as well as walking through the process of how we think. Expressing our enthusiasm and passion for what we can offer emphasizes our communication skills. It's crucial to do your homework on clients. Learn about their business, culture, and history—and their current and future states to prove you truly understand them and their needs. Our protracted relationship with the Seattle Sonics has helped us understand their needs, challenges, and audience (see Figure 12-44).

Next, we develop a design brief to help clarify the purpose of the project and the target audience. Our methods have run the gamut—from rudimentary sketches jotted down on the back of a napkin to constructing three-dimensional comps. In one case, we actually created an elaborate movie for the CEO of one of our biggest clients. The important thing to remember is that each situation is different and should be crafted to fit the goals and needs of the client.

The media we use are as diverse as our clients. Models, renderings, sketches, dimensional comps, and electronic Flash pieces are some of the more commonly used vehicles for connecting with our prospects and clients. Fresh perspective and intuitive design can also link the design team and client to the project. One technique we often use during this process is an attitude board, a visual montage that represents the flavor, feel, color

palette, and theme we plan to use; this can help move us forward to the actual design phase by providing an "atmosphere" (see Figure 12-45). It allows us to put pictures to words and helps the client share our vision. The attitude board has proven to be great for consensus building, particularly in a group environment. From here, concept sketches, thumbnails, and other tools are helpful in leading the client through the creative process. Next, we move to colored schematics, which clarify the concept; then we evolve the ideas to finished comps. By the end of the process, we've created a script of sorts to tie the design rationale to the project's objectives. This is invaluable in situations where a representative has to take these ideas back to a senior decision-maker in the company.

It's important to streamline and refine your presentation. Use different team members to present their part in the project, they are probably best suited to explain their area of expertise or their facet of the creative process competently and enthusiastically (see Figure 12-46). This helps demonstrate the team dynamic and the process of the solution itself. So that clients can view work in progress, we have often used our electronic "work space," as well as daily conference calls and sometimes video conferencing. We may also display our ideas by hanging rough sketches on a wall to serve as a backdrop for our presentations. Sometimes you

Figure 12-43

Holland America Line, Inc., a cruise touring company, has partnered with Hornall Anderson Design Works for the past 17 years to create a global literature program that communicated that the cruise line provided quality and a "unique guest experience." The best ideation comes from research and evaluation. HADW created a user-friendly view book, deftly tailored to the cruise sales cycle; at the same time, it connects emotionally with their audience. The look, copy, tone, and overall styling were redeveloped to underscore the Holland America brand. Color, inviting photography, and generous use of white space make these materials memorable and inviting. Art direction: John Hornall and Julie Lock; design: John Hornall, Julie Lock, Jana Wilson Esser, Mary Hermes, Mary Chin Hutchison, and Jana Nishi; photography: stock work; copy: Pamela Mason Davey. Courtesy of Hornall Anderson Design Works.

need to be more creative in the presentation process. For example, once we transported several 4 × 8-foot pieces of black Fome-Cor to a meeting, where we transformed the client's cafeteria into our "virtual office."

Regardless of the audience, presentation medium, or venue, there is an overall misconception that we're in the business of art. We're not. Designers are problem solvers whose solutions benefit clients. And, it's our responsibility to clearly and concisely present those solutions.

In summary, the best marketing, identity and media plans, advertising, research, and creative materials aren't worth the paper they're printed on, unless the work can be sold to the client. Having to listen to agencies *brag* about themselves is as tiring as it is boring, particularly after you've listened to a few pitches. Focus on the

Figure 12-44
Recently, the Seattle Sonics basketball franchise was feeling a backlash of things: a less than strong showing in the NBA, reduced ticket sales, and waning fan interest. The mission was to create a brochure (and peripheral materials) targeting season ticket holders to generate a renewed excitement for the Sonics. This oversized brochure was spawned from fan research, respecting the game, having a clear idea of the problem, and connecting emotionally to the audience. The partnership between team and fans, passion, and renewal are reflected here. Art direction: Jack Anderson and Mark Popich; design: Jack Anderson, Mark Popich, Andrew Wicklund, and Elmer dela Cruz; photography: Alex Hayden and Jeff Reinking; copy: Mark Popich and Andrew Wicklund—WONGDOODY. Courtesy of Hornall Anderson Design Works.

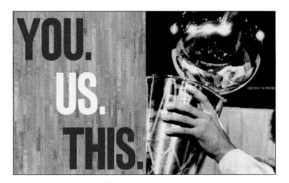

client instead of yourself. That alone will increase their interest tenfold. Presentations should be honest, direct, confident, and succinct. They should also be well-rehearsed; in fact, the more practiced and refined they are, the more natural your delivery will be. Practice builds confidence and helps ensure fluid presentation. Identity, packaging, branding, collateral, and all of marketing communications are based on image, so don't forget your own in the process of molding someone else's. Where you present is also important. Your own space imparts an image about you, too, so make sure your presentation area is an asset—not a handicap. If you're presenting on their turf, be familiar with it. Graphic communication is a visual business, so make the visual part of your pitch memorable and fresh and allow for flexibility. Present your research and strategy succinctly without murdering the client with "case studies." As Jack Anderson pointed out, there is no silver bullet in presentation, and typically, you pitch different clients differently. That said, the above suggestions should be constants in making presentations.

Graphics in Action

1. Bring your favorite product packaging to class. What is it that you most like about it? How do design principles figure into its solution? Color? Typography? Who is the audience and why is its graphic solution relevant to that audience? Product category?

2. The historic, former Latchstring Inn of Savoy, SD—initially, a humble and rustic lodge frequented largely by hunters and fishermen—has been replaced by an upscale facility, the Bear Claw Inn, used by affluent tourists. Bear Claw Inn is located in Spearfish Canyon in the northern Black Hills. The area features steep limestone cliffs, lush forests, and the creek from which the canyon takes its name. It is idyllic and easily one of the most beautiful canyons in the world. Your mission is to design a mix of hospitality materials that fuse its modern face with its past and the beauty of the environment itself. Here are a handful of possible components you might wish to include in your "hospitality package" for the new owners: a logo; main signage incorporating your logo; a color scheme for the rooms; restau-

rant menu; match pack design; and directional signage for rooms, spa, lounge, restaurant, and scenic deck. You may add, subtract, or adjust items from this list.

3. Select an interesting local "bed and breakfast" and create an innovative DO NOT DISTURB sign for its clientele. Make your solution unique and custom-tailored to the establishment or the guests it tends to attract.

4. Ghirardelli Chocolates has decided to add a completely different product to its line. ZOOM is basically a delicious Ghirardelli chocolate bar that features three other ingredients: crushed peanuts, ginseng, and gingko biloba. Along with being delicious, the bar boasts a power boost and increased mental focus. The target audiences include young (male and female) amateur athletes—especially volleyball, basketball, crew, football, soccer, swimming, and track, as well as those involved in less organized sports, such as snowboarding, rafting, hiking, mountain biking, skiing, kayaking, climbing, and skateboarding. Create a package design for the new Ghirardelli ZOOM bar.

5. Given the above scenario, create a mix of peripheral materials for the ZOOM bar. Several supportive items that come to mind are hats and t-shirts, POP (point of purchase) displays, posters, and bumper stickers.

6. Christmas or spring break is right around the corner. Assume that you only have 1,000 to 1,200 dollars to spend and plan a trip to some place you've always wanted to visit. Then get on the Internet and find a handful or so of on-line brochures. Carefully, read and deconstruct their presentation and information. Which one did you choose? Why? Which ones have the best presentation? Worst? How do value and features seem to affect the graphic presentations of the on-line materials?

7. The editors at *Rolling Stone* have decided that they want to do something to reinforce its brand identity. Come up with a smart and creative marketing strategy that focuses on rejuvenating its identity. Publishers want more young people (ages 18 to 25) reading its publication, without alienating its existing audience. Carefully assess the current situation at this magazine and its circulation history, and then come up with a plan to shift its branding strategy. What did you decide to do? Use peers as your focus group to help shape and test your strategy.

Figure 12-45
When Hornall Anderson was working with Jamba Juice, attitude boards played a big part in capturing the personality, look, feel, and color of that design project. Media Relations Manager, Christina Arbini explains: "We mount cut outs from books and magazines to Fome-Cor pieces, which are then mounted in a visually aesthetic manner to the larger black board. We pay attention to color palette, illustration or photography style, and actual images for graphic motivation. All the components help tie together the proposed direction of the identity and branding project." Courtesy of Hornall Anderson Design Works.

8. Create a new logo for *Rolling Stone* magazine—one that clearly speaks to the new, younger audience that you are targeting. Remember, too, as in nearly all logo redesigns, that it's important to keep enough of the old nameplate to maintain its identity and presence in the marketplace. You have also been told that the editor and publishers want to see 5-6 logotype (or nameplate) treatments. Be sure to use color in some of the work.

9. Find a long-standing company or product, for example, Coca-Cola, Chrysler automotive, Kellogg's Cornflakes, John Deere, Budweiser, Quaker Oats, or some other established brand, and investigate its logo history. Create a logo time chart for one of them by collecting 4–8 different logotype versions and their date changes. Bring them to class. Try to figure out what affected their transformations.

10. You develop the next logotype version for the brand you selected in #9. How do you change it? How do type, color, or other design elements affect the makeover? How do you keep its long-standing identity intact?

11. A publisher has contacted you to help discover if there is room for a new magazine, targeted at young women who might be considering marriage and interested in all the aspects of planning a wedding. Break the class up into teams of 3-to-5 students to compete for this possible client. For starters, you've been asked to conduct focus groups to determine what it is that members of your audience like and dislike about existing publications in this category. Along with getting a pulse on their positive and negative reactions to bridal magazines, find out what content or features they think are missing. Try to discover, too, what new things they'd like to see or learn about. Again, use peers for your focus group. You might even consider creating a short survey and setting up a table somewhere on campus to query interested passers-by.

After you've accumulated and analyzed your data, establish your audience, evaluate the existing marketing opportunity, and create a planning document that assesses the situation and the attitude and needs of your audience.

Finally, if your research and projections suggest that there is a good opportunity in this area:
- Give the publication a name.
- Create a mission statement for the magazine.
- Explain how it will be different from existing publications, and what new features it will provide its readership.

Figure 12-46
In presentations where the media is mixed, it often helps to use different team members to pitch each medium's respective components. Bouillioun Aviation Services materials included brochures, logotype, assorted print materials, interior logo installation, and environmental design. Courtesy of Hornall Anderson Design Works.

- Build a prototype that consists of a cover, table of contents page(s), department sample(s), a feature treatment or two, and a new offering.

12. Find an older corporate or product nameplate whose design you feel is inappropriate or not contemporary enough for its audience. Deconstruct and assess it and, in a paragraph or two, explain why it needs a makeover. Redesign the logo.

13. Create a new letterhead, envelope, business card, signage, or some variation from that list, for a local professional sports team, corporation, or service.

14. Using the teams you'd assembled for assessing the new bridal magazine opportunity, present your targeting decisions, research methods and findings, analyses, recommendations, and your graphic design materials to the class. Invite someone to class who's familiar with marketing and publications, targeting, and graphic design to listen to the presentations. Have the reviewer critique presentations and select a winning team.

15. Create a brochure for one of the above clients using the background or case situations provided as background.

16. The local Rotary group has decided that it wants to take an active part in helping educate parents, teachers, and young people about the symptoms or warning signs of teen suicide. Working in small groups of 3 to 5 students, investigate this topic thoroughly and come up with defendable creative strategy and build an 8- to 12-page brochure that educates your audience about these problems. See if there are likely linkage groups who might wish to help sponsor the brochure. Know clearly from the start what your goals are, why they are valid, and how you can help achieve them through the creativity of this brochure.

17. Create a catalog for one of the following: White & Wong Travel Service (specializing in trips to southeast Asia); Louisville Slugger bats and sporting goods; Apple Macintosh computers; Coach (women's handbags); Prestige/Riverside (classic jazz albums now available in CD formats).

18. Develop a media kit for a local band or your favorite recording artist. What materials do you elect to include in it? Why? If so motivated, come up with a promotional concept to launch the new album of the band or artist.

13

*I believe advertising is the most
powerful art form on earth.*
—Mark Fenske,
Chiat/Day

◄ *Coca-Cola*, photography by William Ryan

I magine taking simple tools like typography, layout, photography, film and/or music and using them to connect with people. To move them. To get people to think differently. To get them to actually care about things they had never even thought about before. To even shape popular culture and trends. Now that's something. But that's what advertising can do.

—Tracy Wong, WongDoody

Previous page
In 1886 Dr. John Penberton first brewed the savory syrup we know as Coca-Cola. It was his partner, Frank Robinson, who decided their logotype should use calligraphy because of its "personal appeal." Although the logo's styling has been tweaked over the years, its graphic resemblance to the original remains clear. Charles Frazer and Charles Patti briefly outlined the advertising history of Coca-Cola in their book, *Advertising: A Decision-Making Approach*: "The first year's sales (Coca-Cola) were not overwhelming, averaging about 13 drinks per day. Pemberton sold 25 gallons of syrup and grossed $50. He spent $74.96 on advertising, promoting the 'delicious and refreshing' theme. By 1920 Coca-Cola's advertising budget had reached $2 million. In the 1930s, the firm innovated the six-pack carton. For years, it has employed consumer research in planning its creative strategy, practice that has led to numerous imaginative (and award winning) campaigns. The carbonated beverage was one of the first American products to go multinational." A good product, strong graphics, and inventive advertising can help identify and market a company. Today, it's brand name—Coca-Cola—is so omnipresent that "Coke" is synonymous with cola.

Advertising: Garden or Ghetto of Commerce?

We have a love-hate relationship with advertising. While there are waves of wonderful work—creative ads that entertain, inform, and persuade us in an engaging, candid, and emotive way—there are also oceans of trash. Ads that insult our intelligence. Ads that hard sell us with the volume cranked up to *ten*. Ads that send us running for the remote. Ads that are pretentiously hip, mindless, or predictable. Tracy Wong, partner, co-founder, and creative director at WongDoody, discusses some of the problems with contemporary advertising:

I have a confession to make: I hate advertising.

If you're in a crowded movie theater, I'm the guy in the back you hear hissing loudly while the ads are playing. Because I hate commercials. I'm the guy who cusses like a sailor when I see a billboard violating a pristine outfield wall. Because I hate outdoor ads. On the radio, on TV, on the Net, in a magazine, on a shopping cart, on a damned urinal cake.

I hate it. I hate it all. I hate being bombarded by crap, crap, crap!

Hey, I'm not alone. As a matter of fact, all of America hates advertising too. It's annoying. It's insulting. Everywhere you turn, you're being bombarded by the same garbage.

Every one of us has been conditioned to hate advertising. None of us asks to be advertised to. So if it insults our intelligence, interrupts what we're watching, or just pisses us off, it deserves to be hated.

So what gives? I'm in advertising. I've created ads for more than 18 years. If it weren't for advertising, I wouldn't be able to buy all of my fancy black clothes. How can I live with myself if I hate what I do? Well secretly, I love the lizards in those Bud ads. I love that Nike TV spot where Tiger Woods bounces a golf ball on the head of his golf club, and, I love those "Got Milk?" billboards—the ones with the big cookies on them (see Figure 13-2).

Why? Because they're not ads, they're wonderful communication. Their fresh ideas and simplicity engage us. They entertain us. They reward us for paying attention.

So—how do those ads do it? How do they rise above the crap? It's not easy. No other form of visual communication has the demands (selling something) and the handicaps (vying for your attention when you didn't ask for the interruption) advertising has. I believe creating a great ad is harder than most any creative endeavor. Certainly harder, I feel, than any other medium or visual area mentioned in this book (see Figure 13-3).

Take a movie, for instance. You're sitting in complete darkness and silence. The director can take as much time as he/she wants, up to three hours without interruptions. Add a little sex and some heads getting blown off, and voila: you are entertained and fulfilled.

A commercial is, in and of itself, an interruption, a full-blown annoyance. It has a mere thirty seconds—I repeat, thirty seconds—to persuade you to buy a product or service you didn't even care about thirty seconds ago. And who said anything about being in a mood to buy?

A painting occupies a stark white wall in a museum assuming your full and undivided attention. Artists can do or say whatever they want. Nothing to sell. No logo. No half-off coupon. No authorized dealer listings. On the

Figure 13-1
Tracy Wong has been appropriately heralded as one of the most creative minds in advertising today. He is co-founder, partner, and senior creative director of WongDoody, Seattle and Los Angeles. After graduating from the University of Oregon and the Art Center of Pasadena, he launched his career at Ogilvy & Mather, NYC. A few years later, he moved to Goodby, Berlin and Silverstein (San Francisco) to produce award-winning work for Honda, the NBA, and many other clients, including his amazing "Fresh Mex" campaign for Chevys. The Chevys concept was to produce the advertising the same day the TV spots aired, a most amazing feat. His work has received every major advertising award. Self-portrait and photo-manipulation by Tracy Wong. Courtesy of WONGDOODY, Inc.

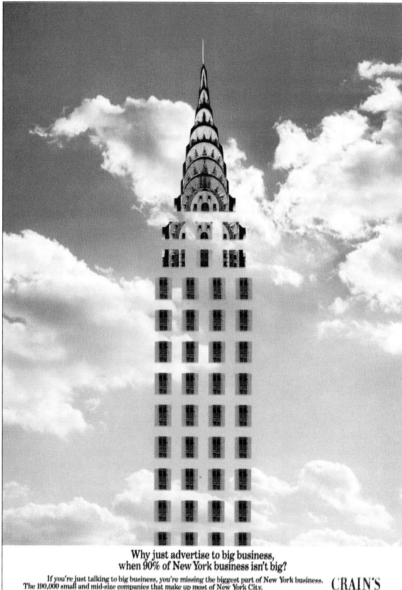

Why just advertise to big business, when 90% of New York business isn't big?

If you're just talking to big business, you're missing the biggest part of New York business. The 190,000 small and mid-size companies that make up most of New York City. So why not call Crain's at (212) 210-0257? Because unlike other business publications, we reach New York's biggest businesses. As well as its smallest. Not to mention a few sizes in between.

CRAIN'S NEW YORK BUSINESS

Figure 13-2
You know and love the long-lived advertising campaign—"Got Milk?" What you might not have noticed is that milk does not appear in any of these ads. Curious. Why? Well, the client and agency creative team felt everyone already knew the many nutritional benefits of milk. So why not *food* and *milk* for the ads? Jeff Manning, executive director of the California Milk Processor Board, said that Jeff Goodby felt that "milk is most important to us when we reach for it and find it is *gone*." The results? A magnificent campaign we all love and can identify with because of its charm, honesty, and fresh ideas. "Cookie Monster:" copywriter, Blake Daley; art director, Valerie Ang-Powell. Courtesy of Sesame Workshop 2003, Photo by John Barrett/California Milk Advisory Board.

Figure 13-3
A great visual metaphor and advertising idea may be as timeless as this Tracy Wong print ad for *Crain's New York Business*. The inference in the headline ("Why just advertise to big business, when 90% of New York business isn't big?") is demonstrated in the artwork—a meticulous knockout photograph of New York City's famed Chrysler Building—underscores the point effectively. Tracy Wong was then art director at Goldsmith Jefferey. Courtesy of WONGDOODY, Inc.

Figure 13-4
This compelling "Upon This Rock" two-page spread for K2 Skis put K2 back on the map. Tracy Wong offers this overview: "Over the previous number of ski seasons, K2 had wandered away from its rock 'n' roll, all-American extreme image. Plus, the ski market was flooded with marketing techno-hype by European competitors. Our solution was to create ads that would appeal to the emotional side of skiers and recapture the heart of consumers and retail shop kids. Hey, people ski for the fun of it, not for the high density polycarbonate foam. In just two ski seasons, this aggressive brand repositioning helped take K2 from #4 to #1 in U.S. sales." Art direction, Tracy Wong; copy, Craig Hoit; creative direction, Tracy Wong; production manager, Kathy Blakley; account manager, Pat Doody & Rene Huey; photographer, Larry Prosor. Courtesy of WONGDOODY, Inc.

Figure 13-5
Bare bones simplicity and a personal challenge in the United Way poster produced a dramatic increase in Christmas donations. The original poster was installed with a pencil and pledge sheet. Tracy Wong, creative director/art director, Ogilvy & Mather / NYC. Courtesy of WONGDOODY, Inc.

other hand, a magazine ad has mere seconds to stop, engage, and persuade you as you're flipping pages madly on the way to the feature you so dearly paid for. Good luck!

To top things off, I guarantee you most visual communicators, be they said filmmaker or painter—even a graphic designer or illustrator—look at us ad guys as the bottom of the creative food chain. We're the used car salesmen of visual communication in disguise. We're whores. Prostitutes of the arts. Just open your eyes and look all around you. All that crap, crap, crap you see? We did that. How can we even call ourselves "creative?"

Okay, so why, after all this rant, did I choose advertising? Hey, I'm on a mission.

A mission to do something interesting, fun, entertaining, thought-provoking, emotional—even (gulp) artistic (see Figure 13-4).

Imagine taking simple tools like typography, layout, photography, film and/or music and using them to connect with people. To move them. To get people to think differently. To get them to actually care about things they had never even thought about before. To even shape popular culture and trends. Now that's something. But that's what advertising can do. Even if the original intent is to sell pale yellow watered-down swill packaged in brown bottles.

Long ago, in a galaxy far, far away, when I was just a lowly art director fresh out of college at the prestigious firm of Ogilvy & Mather/NY, I did a print campaign for the United Way. The ads consisted of a series of posters hanging next to the elevator doors at the agency asking for Christmas donations. Attached to the top of the poster was a pencil hanging from a string daring people to make a choice, selfish or not. The ads were disarming and forced people to think. That year, office donations were the highest ever (see Figure 13-5).

More recently, I worked on an advertising campaign for the Seattle Super Sonics of the National Basketball Association. The strategy was to tell consumers that Sonics games were to be broadcast on live TV versus pay-per-view. Additionally, our aim was to raise the image of the players at a time when society began looking at pro athletes as multimillion dollar, pot-

smoking, gun-carrying, spouse-beating crybabies. Our charge was also to make them likeable.

The TV idea was to bring the concept of "The Sonics Are Coming To Your Home" to life by having actual players show up at people's homes unannounced and have them interact with unsuspecting fans. The campaign was a complete success and won every conceivable award in advertising including four Clios, the Oscars of our business. But the excitement, the real rush, came from the random comments we heard from people in Seattle. The elderly mother of our editor said, "I love Gary Payton because he likes old people." Our spot with NBA All-Star Gary Payton featured him playing Monopoly, watching

QVC, and dancing with residents at a retirement home. My wife's aunt, who knows nothing about pro hoops declared, "That Sam Perkins is so nice and so good with kids." Sam's spot featured him playing video games and Nerf hoop with little boys (see Figure 13-6). The stories go on and on. Clearly, we completely reshaped people's perceptions. In some cases a full 180 degrees.

Powerful stuff.

Well, that's the power of advertising. When it's good, no one thinks of it as advertising (see Figure 13-7). Why? Because it's funny, engaging, and sometimes challenging. It respects your intelligence. It respects your time. It's fresh and full of life. Finally, it has the ability to silence its

The Sonics are coming to your home.

SAM: Just Knock on the door?
CREW GUY: Just knock on the door.

Sam on Capitol Hill

The surprised family welcomes Sam in.

MOM: Oh my goodness!
SAM: Wassup?
MOM: Nice to meet you
DAD: Say hi to Big Smooth!

Cut to Sam in the backyard shooting hoops with the young boys.

SAM: Oh, they ran a play on you! Where you at, man? Gimme a high five! Okay, a little low five, then!

Cut to Sam in the boy's bedroom having a pillow fight when Mom comes in.

MOM: Okay, time to go to bed. Sam, stop that! In the bed, now!

Figure 13-6

WongDoody had the task of trying to explode fans' notions of the professional basketball player being a spoiled, aloof, self-centered millionaire. Rather than opting for the predictable slam-dunk thing, Tracy Wong executed an open-ended, basically non-scripted campaign where members of the Seattle SuperSonics showed up at the homes of various fans—unannounced. And the video rolled. The work was shot on "crappy video," but the idea wasn't to produce a slick, seamless TV spot with cinematic quality. Instead, Tracy Wong wanted to capture the slice of life interaction of the NBA players with Seattle families. The result was an immense success; in fact, Wong suggested in an interview with *one.a magazine* that it was the "most successful advertising we've ever done as an agency." Art direction, Frank Clark; copy, Dean Saling; agency production, Joyce Schmidtbauer; director, Tony Ober; creative director, Tracy Wong. Courtesy of WONGDOODY, Inc.

Figure 13-7

In many ways, Alaska Airlines is the ideal client. It's the airline most everyone wants to fly. In this instance, WongDoody used the concept of a museum exhibit and combined that idea with the long lines and waiting that we all resent at airports. The ad campaign, "Late Passengerassic Age," is as funny as it is fresh; we can identify with it. Creative director, Tracy Wong offers this backgrounding: "Over the past three years, Alaska Airlines has become the leader in passenger-based technology with innovations such as Web reservations and self check-in machines at the airport. This campaign, which ran in publications such as *Business Week* and *Fast Company* was created to promote this very fact to business travelers and investors." Combined with Alaska's on-going effort to provide the best possible flying experience, the airline has been voted the #1 Domestic Airline by the readers of *Condé Nast Traveler* five out of the past six years. This campaign was art directed by Pam Fujimoto, and Tracy Wong provided creative direction. Dean Saling penned the copy and the ads were produced by Kris Latta. Bob Peterson created this surreal photography, and Steven Frestedt managed the account. Courtesy of WONGDOODY, Inc.

greatest dissenter, me, that jerk in the back of the theater who just stopped hissing during a really great commercial.

Advertising truly drives our media, but it can also drive us *crazy*. Concurrently, as Tracy Wong so clearly points out, most of us disdain it. At its worst, it repels us. At its best, it's memorable, fresh, entertaining, and epitomizes some of the best visual communication *anywhere*.

Ultimately, however, advertising determines which magazines will succeed, what television programs will be aired, or how many pages your newspaper will print each day. At the same time, advertising tends to drive the look and feel of all design in a myriad of ways: innovative use of typography, photographic styles, color, or new layout approaches—to name a few of its influences. Remarkably, too, advertising shapes and mirrors our culture. Finally, advertising reflects the cutting edge of graphic design in all of its manifestations, from magazines to multimedia, video, newspaper, Web, outdoor, and more.

Ad agencies also tend to attract brilliant, skilled, and talented creative people, and in doing so, really stretch the boundaries of design and all of its principles. Advertising's range, media, and creative possibilities are as attractive to young designers as some of its salaries.

Because advertising is a powerful and persuasive medium, many designers look to it for inspiration. Ads may provide layout insights for everything from magazine pages to brochures (often an advertising medium), websites, and newspaper design. Graphics publications such as *Communication Arts*, *Print*, *Graphis*, and *one.a magazine* showcase inspired ads and even provide professional forums for the most talented copywriters, creative directors, and art directors in the world. For example, check out this minimal but striking ad WongDoody produced for Adidas, whose logo is imbedded in the ad's design (see Figure 13-8).

Of course, the creation of an ad is only a small part of the advertising process. While this chapter doesn't pretend to be a compendium on advertising and its creative process, it should provide you a grounding in ad design and offer you a window into the "creative" process of that profession.

Design and Advertising

Advertising differs from most other communication in three ways.

1. The communicator (client) pays to have the message circulated.

2. Compared to other media, advertising has more control over the message. The client and agency specify when and where the ad will appear.

3. The message and its size, content, art, design, and voice are determined by the client and the creators of the work.

While the client always has the final word, ads are usually created by an agency team (typically, a creative director, copywriter, and art director). Sometimes, however, ads are created *in-house.* "In-house" refers to the client creating the work—*without* the direction of an ad agency or anyone outside their doors. In the case of newspaper advertising, the work is often shepherded through a sales representative to members of the paper's creative services staff. Sales or account executives act as the conduit between the client and the creative team.

Clearly, advertising is *persuasive communication.* So are public relations communications, business communications, and marketing, identity, and branding materials. Because typography, art, and design cannot be separated from the ad's message, the most effective advertising messages cannot be created without understanding how these elements shape and affect the intended communication. The message should be fresh and have impact—like this powerful ad for Singapore CableVision (see Figure 13-9).

A quick overview of the creative process will help you appreciate its importance.

Developing a Creative Strategy: The Advertising Concept

Concept is central to an ad's success. Sending the *wrong* message is self-defeating; in fact, it may actually kill the sales of a product. No matter how well-crafted the writing or arresting the artwork, if the advertisement misses or confuses the audience, projects the wrong image, or communicates the wrong message, it has failed. Heaven help the client whose audience remembers the *wrong* message.

Research, clear marketing goals, and connecting to an audience emotionally usually make for effective *creative strategy.* In the real world, the client, advertising planner, and researchers evolve creative and media strategies, which are then passed on to the creative team. Planners select the medium or combination of media to be used (newspaper, magazine, TV, Web, outdoor) to help establish the content, context, and voice of the advertising. Essentially, most such strategies address these very important items:

1. **Target:** who is the audience? Is there a dual or secondary audience?

2. **Concept:** what is the big idea, theme, or basic message you're trying to get across? If you cannot put that in a single sentence or two, you're doomed.

3. **Benefits:** what is the most important feature (or features) of the product? Some advertisers list secondary benefits. The product's benefits are often tied to the concept.

4. **Rationale:** in a paragraph, defend your concept or "big idea." Better have concrete evidence and information to back it up. Most great ads begin with great research.

5. **What is the honest, emotive connection?** Although marketing is central to advertising, it better not get in the way of stopping and talking to the audience in a fresh and meaningful way.

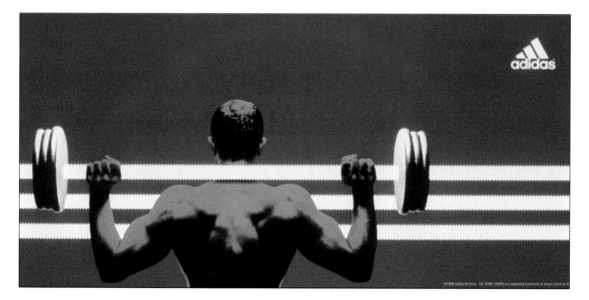

Figure 13-8

Adidas "Stripes" is a unique ad campaign that does as good a job of branding as it does engaging the consumer via its minimal design. The original assignment began as a nationwide retailer co-op advertising program which was to include magazine, newspaper, outdoor media, in-store signage and radio. The "three stripes" campaign quickly evolved to become part of a North American branding effort. The charge was to find a simple and graphic way to convey the Adidas brand across a multitude of sports. The campaign helped separate the German shoe manufacturer from a pack of would-be competitors to take over the number two position behind Nike. Art direction, Pam Fujimoto; copy, Michael McCullough; creative direction, Tracy Wong; production manager, Angie Schraw; account manager, Mindee Nodvin; photography, Steve Bonini. Courtesy of WONGDOODY, Inc.

Figure 13-9
It's likely when your eyes first alit on this ad you associated this image with the Eiffel Tower, or at least an illustration of it. That was the intent of the creative team who conceived and executed this amazing visual metaphor. And an appropriate one, indeed, given this poster is hawking the French Open for Singapore CableVision. The persuasive punch of this work hits hard and communicates "French Open" instantaneously. The Eiffel tower look-alike/tennis racket handle is brilliant. Dentsu Young & Rubicom, Singapore: Patrick Low, art director; Mark Fong, copywriter; Patrick Low and Mark Fong, creative directors; (Shutter Bug) Hom, photographer. Courtesy of Dentsu, Young & Rubicam-Singapore.

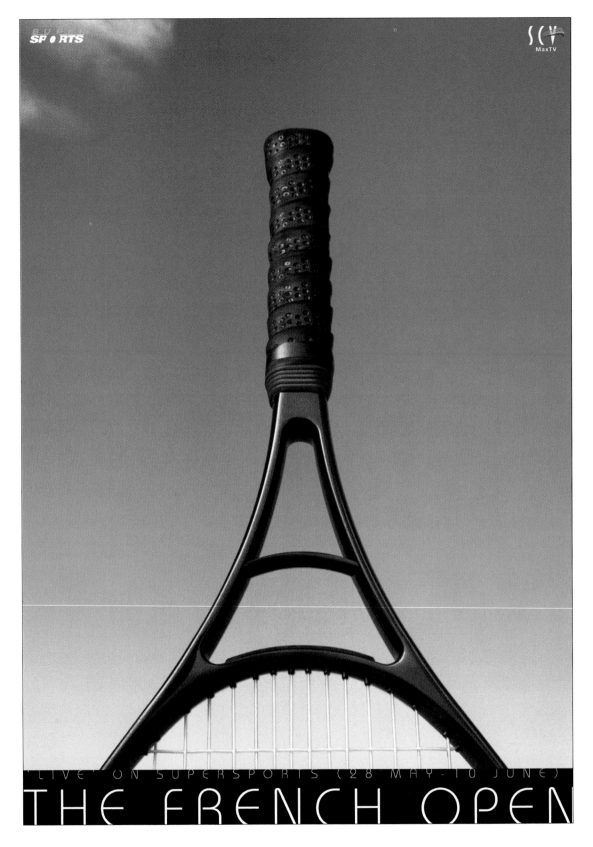

These two Giro bicycle helmets ads created by Crispin, Porter & Bogusky sell product features in inventive and memorable ways (see Figure 13-10).

6. Intended reaction: what is the audience supposed to do after they receive your message? Buy the product? Vote for a candidate? Become more informed? Take a test drive? Make a phone call or take advantage of a promotion? Know the mission from the onset.

Having good information at your fingertips is the smartest way to start. That translates into doing your homework, doing the sleuthing and research—and understanding *who* the audience is and *how* to talk to them.

Research

Research is imperative to the creative process. How can you sell something you know nothing about? Investigate the product as thoroughly as you can. The Internet is only a *starting* place. Interview the audience and current users. Try to surface new information about the product (or new uses for it), and certainly, where possible, try it yourself. A little research can produce a smart and unusual solution for a product. Seek out something that edifies or amazes *you* about the product—or how to sell it. Become as immersed and excited about it as your client. Strive to learn more about the product than anyone else knows. You might discover a new use or situation for a product. Maybe an interesting fact about its audience, history, development, uses, evolution, or benefits—or—an entertaining or really relevant way to communicate to your audience. Avoid *ad speak*—both the written and graphic versions. Predictability is also lethal.

In your research, be sure to check out the *competitors*. Discover all of *their* strengths and weaknesses—then work from the client's strengths. Some advertisers position the product against its competitors' weaknesses. Finally, after you've completed your research, make sure you keep your advertising communication personal. It's easy to forget that all communications are *one-to-one* propositions, especially when you're steeped in statistics, focus groups, demographics, and other research information.

Positioning

You've done the research and have some insights into the product. Now you need to decide how you want to *position* your product. Positioning involves balancing the *function of the product* and defining its *audience*. A classic example of *positioning* is how David Ogilvy positioned Dove as a "beauty bar" (with one-quarter moisturizing

Figure 13-10

The creative strategy for these two ads is to blend function and form for Giro bicycle helmets. "*Breathe*" (left) is really a double-entendre because it relates to the lung configuration of the helmets, but it also refers to the special venting in the helmet design for the cyclist's comfort. "*Beauty*" (right) refers, of course, to the helmet's design, and the tiger swallowtail butterfly analogy to the lightness of the headgear. These ads are also wonderful examples of using the product *as art*. Tony Calcao art directed these simple but arresting print ads for Crispin Porter & Bogusky (Miami). The text is executed with calligraphy, and the writing is as minimal and effective as the gently lighted knockout photography. Rob Strasbert, copywriter; Alex Bogusky, creative director; Mark Laita, photographer. Courtesy of Crispin Porter & Bogusky.

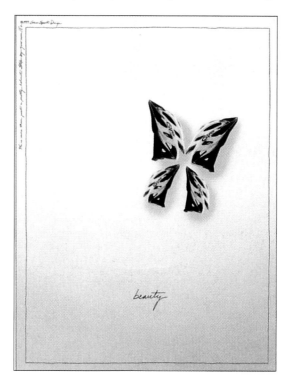

lotion) for women with dry skin, as opposed, for example, to a hand soap for male blue-collar workers. You've already seen the dazzlingly beautiful work Crispin Porter & Bogusky (Miami) did for Giro headgear. Compare that positioning with Bell helmets' positioning. The point is clear: research, positioning, and content shape creative solutions (see Figure 13-11).

There are a lot of great positioning strategies—some of them simple, others very risky. Leo Burnett did a magnificent job of positioning Marlboro cigarettes as the masculine cigarette choice by adopting a "rugged individual campaign." Print advertising and outdoor boards used wonderful photographic compositions and rich color to portray their spokesman—a gritty cowboy. The positioning was accomplished via *association*—and what's more, Burnett did it without words. An inherent irony is that the cigarette brand was initially targeted at women!

Stroh Brewing Company noted that their bottles were "steam-cleaned" (nearly all are). BMW positions itself as "the ultimate driving machine." Bayer aspirin helps prevent heart attacks. The fact is that any kind of aspirin will thin your blood and help reduce the risk of heart attacks. But because these companies made the initial claims, they owned the "concept."

In his book, *Ogilvy on Advertising* (Crown Publishers, Inc. New York/1983), Ogilvy underscores these lessons on positioning. "In Norway, the SAAB car had no measurable profile. We positioned it as a car for *winter*. Three years later it was voted the *best* car for Norwegian winters." Today, SAAB is still perceived as a great automobile for snowy climes. More recently, Rob Siltanen, then of Chiat/Day, separated Nissan advertising from the glut of *terrible* car advertising that barrages us by focusing on *what it felt like to drive the automobile*, rather than emphasizing the car itself or its features. A truly fresh series of ads that did an amazing job of branding Nissan. Indeed, several of the ads are included in the "best in advertising" and are in the the Museum of Modern Art's permanent collection. Among these pieces are the now famous Barbie and Ken and "Dogs love trucks" Nissan ads. Albeit risky, Siltanen's insightful and creative positioning helped establish Nissan as a "top-of-mind" product—and concurrently did a magnificent job of branding Nissan.

Figure 13-11

Contrast the creative strategy for Bell Helmets to their competitor's (Giro) in the two ads shared earlier in this chapter. How are the strategies different from one another? The research suggested the ads should demonstrate that the helmets were rugged, safe, smart. So, what's a crash-test dummy doing with a Bell helmet? The tag line reads: "Courage for your head." It underscores the minimal copy: "The sleek Forza 2 Pro with 14 vents and Half Nelson retention system. Way to go, Smarty." Goodby, Silverstein and Partners: Jeremy Postaer, art director; Brad Roseberry, copywriter; Heimo/stock, photographers. Courtesy of Gooby, Silverstein and Partners. © Heimo Photography/Bell Helmets.

One of the most brilliant positioning strategies was developed by the Ammirati & Puris advertising agency for BMW of America. The campaign ran in early 1980s when the stock market and economy were seriously on the skids. Tom Thomas and Anthony Angotti comment from their "Gold on Gold" essay from *The One Show Annual, Volume 5*, 1983: "We'd solved the problem several months earlier with an ad that said BMWs performed better, in terms of resale value, than 318 stocks on the New York Stock Exchange. The strategy was simple. A BMW is almost indecent fun to drive. Positioning it as a great investment allows you to tell yourself, your spouse, or whoever controls you through guilt, that you're being prudent rather than self-indulgent when you buy one (BMW)" (see Figure 13-12).

Recently, Sims Snowboards wanted to separate themselves from their competitors through their advertising. They wanted to be edgy. To stand out from all the predictable ads that imitated one another in this market: cliff-jumping, boarders flying through the air, and other action-oriented visuals. The result was a brilliant strategy conceived by Hammerquist & Soffel that consisted of creating artwork that brought to mind a photographic icon, "Tiananmen Square." The ad campaign, targeted at 13- to 30-year-olds, speaks to young snowboarders and shows a lot of attitude. Visually, the uneven borders and borrowed newspaper format give the ad an editorial look. It also adds credibility through the documentary look of its layout. The partially ripped caption reads, "In a courageous act of solidarity, a snowboarder stands up for freedom." Snowboarders, of course, are notorious for wanting to run untouched, wild areas. Great strategy (see Figure 13-13).

Finally, Doyle Dane Bernbach based their ad campaign on the fact that their client, Avis, wasn't the most popular car rental company. In fact, Avis was number two, but *tried harder*. Though risky, the result was one of the most effective ad campaigns ever conceived, due to its bold positioning and *positive* attitude.

Image

Image establishes the identification and association of a product. Ideally, it differentiates its *brand* from all the competitors in a given category. Brand gets its name from the marks fixed to livestock; branding shows ownership. In advertising, it relates to market share as well. Logos also help *brand* products. Image and brand are intertwined.

In many cases, image is literally about personalizing or personifying the product. Branding—at its best—results in *top-of-mind* advertising; i.e., the public equates a specific company or manufacturer with *that* benefit, industry or product. Volvo, for instance, is associated with automotive safety. Nike is thought to have the *best* athletic shoes and gear. Coke is associated with cola. Marlboro with cigarettes. Kleenex with tissues. McDonald's with hamburgers. Leatherman with pocket tools (see Figure 13-14).

Image encompasses not just a product's advertising, but its look, attitude, packaging, use of color—its *essence*. Image advertising is best accomplished visually. Marlboro, for instance, has used a cowboy and its western motif for over fifty

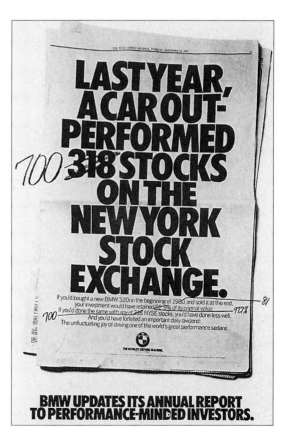

Figure 13-12
By the time this ad ran, the stock market was in even worse shape and BMW resale values had climbed higher. Thomas and Angotti didn't want to lose a great positioning strategy and creative concept, so they simply wrote over the old ad and delivered it to the production house. "So... we set a new headline (*changed 318 to 700*), defaced the mechanical with a grease pencil, and sent it off to the engraver's. The result is shown—maybe the first time in history someone committed an act of public graffiti in full view of millions and walked away with an award instead of a misdemeanor." *Carpe diem.* Courtesy of Tom Thomas, Anthony Angotti, BMW of America, and The One Club. © BMW of North America, LLC, used with permission. The BMW name and logo are registered trademarks.

Figure 13-13
"Tiananmen Square" is
the moniker of this ad for
Sims Snowboards.
Clearly, its composition is
based on the
photographic icon we all
know from the
Tiananmen Square
incident in China several
years ago. In this case, the
protester has a snowboard
under his arm, and the
tanks are replaced with
snow cats, or tractors that
move and groom the
mountain ski runs. The
creative director wanted
Sims ads to contrast the
predictable "guys jumping
off mountains" ads.
There's an earnest protest,
too, against machines
grooming the slopes.
Target? This ad campaign
is aimed at 13-30-year-
olds, and ran in
snowboard magazines.
The newspaper border
further contributes to its
documentary feel and
gives the ad the look of
editorial content; note
Sims Snowboards looking
like a partially torn
header for a story below
(lower right, exactly
where most logos appear).
Hammerquist & Soffel,
an ad agency in Seattle
did this remarkable job of
positioning and branding.
There is nothing
pretentious here, or
anything that smacks of
the typical "ad speak"
and "crap" here. The art
directors for this Sims
work were Bob Peterson
and Mike Proctor. Ian
Cohen and Grant Holland
crafted the copywriting,
and Bob Peterson did a
most extraordinary job
shooting and piecing the
art together digitally.
Creative direction by Fred
Hammerquist. Courtesy
of Hammerquist & Saffel.

years. Leo Burnett's image for Marlboro has worn like iron. Largely, too, all that has been accomplished *without words*. Much of Nike's advertising has also relied soley on its art and design.

A hard-working image puts a face or personality on the brand, and leaves a big impression through its visual power, emotional connections, and memorability.

Advertising Elements

Most print advertising contains four elements: art, headline, copy, and logotype. Some advertising professionals might add a fifth one, the tag, which is a terse line of copy often used with the logo to reinforce brand or an ad's "big idea." Nike's tag, "Just do it," has become synonymous with Nike itself. Volvo's image—*safety*—integrates its positioning of being the safest car in the world with its tag line, "Volvo for Life." But there's more than just safety implied here; the tag uses double entendre. It underscores its audience's loyalty to the Volvo brand.

While most ads share these components, not all advertising uses all four (or five) elements. *Image*

advertising, for example, may eliminate one or more of them—running only art and the product's logotype, or art (containing the logo on the product) and header. Good examples of this approach include print ads from GAP, Tommy Hilfiger, Obsession, Nike, and a lot of blue jeans and cosmetic advertising.

The Graphic Element: Artwork

It's no surprise that artwork—usually photography—dominates advertising. The fact is we are visually predisposed, and photos carry the weight and power of most print ads, but perhaps photography's greatest strength in advertising is its inherent credibility. We tend to believe what we see, even amid the hyperbole of advertising and even in this age of digital manipulation. But make no mistake: to be effective, art must also possess a *great idea*, as well as be visually arresting, employ appropriate camera angles, and structure its composition deftly.

Speaking of photography, if you're planning on working the creative side of advertising, be sure to take some kind of photography course, even

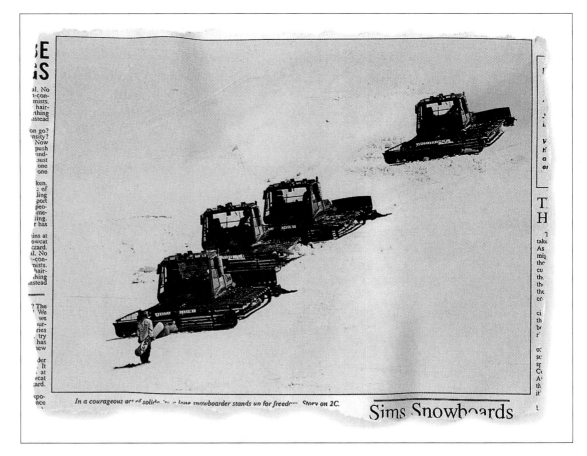

In a courageous act of solid... ...a lone snowboarder stands up for freedom. Story on 2C.

Sims Snowboards

one self-taught. At the very least, you'll need to share a common vocabulary with the photographer or art director, and understand the medium's possibilities and limitations.

Keep the art simple. Most photography fails because it's too busy. Generally, keep subjects to a minimum, and try to neutralize backgrounds with selective focus, tight crops, blocking, or framing or by using knockout imagery. Knockouts are especially effective in outdoor ads.

Art is what we see first and usually what leaves the most indelible impression upon us. Generally, visual elements receive the lion's share of the ad's space. Make even better use of that area by creating unforgettable imagery. Stir the curiosity of your audience.

Clearly, art may be used for numerous purposes. Focusing on the product is the most frequently used approach, closely followed by showing the product being used. Both ploys can underscore a need or desire for the product that hadn't been felt before.

Artwork can also reinforce a headline designed to flag the audience. This strategy is especially critical in outdoor media, where time and situation demand a near instantaneous communication. Goodby, Silverstein & Partners flagged the audience and integrated the product/client—*The Wall Street Journal*—into the headline. In effect, the newspaper's nameplate became an essential part of the ad (see Figure 13-15).

Identification and credibility are two important factors to remember when conceiving the visual idea for the ad. Don't dismiss the audience's intelligence. Mark Fenske has worked with Fred Hammerquist, Wieden & Kennedy, Cole & Weber, The Bomb Factory (an agency he founded), and TBWA/Chiat/Day. Recently in an interview with *one.a magazine*, he made this observation: "For years, clients have believed that the average person in the US has an 8th grade education, and that you have to talk down to them. I won't argue about formal educational levels, but I believe every person in America has a Ph.D. in watching TV." The average person possesses a great *crap detector*. Don't think of advertising as getting up on a box and barking your way into an audience's heart, brain-

washing, or driving a point home with a bazooka. Think of advertising as a personal interaction, a conversation, an honest proposition. Think of yourself, too, as the recipient of the message. Would you believe it—buy it?

Credibility refers to the believability of the ad and its contents. However, even hyperbole and incongruity can be credible if what the ad's addressing is something the audience can identify with—no matter how overstated or over the top the content is. The most important thing is *does it connect with the audience?* For example, Chiat/Day used a talking chihuahua (the visual metaphor for the audience, males 18–22) in their award-winning "*Yo quiero Taco Bell?*" TV spots. No one in their right mind *believes* dogs can talk, but the concept works. The dog shared the same interests and hip nature of the target, and shared the same insatiable appetite—in this case, for Taco Bell. The early campaign advertisements are classic. The work still entertains and stands up years later. Finally, the "*Yo quiero Taco Bell?*" also did a fantastic job of *branding* the client.

Quite often art can be used much more effectively than words to demonstrate features of a product or how it functions. Cutaway techniques

Figure 13-14
When it comes to pocket tools, Leatherman rules. Just ask their loyal customers. Sasquatch Advertising based this award-winning campaign on amazing testimonials from Leatherman owners. This ad is a great example of good research, humor, and top-of-mind advertising. "The hook snagged 175 pounds of twisting, writhing lawyer," reads the headline. The story is from a fisherman and his lawyer brother—*who was accidentally hooked*—while the two of them were landing *three* huge salmon, including a 35-pound Chinook that somehow managed to hook Todd. Leatherman saves the day. The testimonial ends, "Todd's no worse for wear. As for the salmon, let's just say he's caught his last fisherman." Memorable advertising, concept, writing, and illustration for Leatherman—the "go-anywhere, do-anything tool." Jack Unruh, illustration; Greg Eiden, copy; Tim Parker, art direction; Greg Eiden and Tim Parker, creative direction; Ken Chitwood, account supervisor. Courtesy of Sasquatch Advertising and Leatherman.

or greatly magnified illustrations of product details—often with the product in challenging situations—can help emphasize a point, feature, or message of the ad.

Your imagery can also *demonstrate* the happy result of using the product—literally and/or symbolically. A happy fisherman landing a four-pound bass with your client's lure shows results and is enticing to that audience. Using rich blues for the typography and offering a sea of white space in the Virgin Island Tourism ad symbolizes the emotion and freedom that your client wants its audience to feel. It also complements the photo of a couple lazing on a gleaming white beach framed by turquoise water. Always work for good visual metaphors.

Speaking of visual metaphors, here is an ad that "signs" a powerful message—one loaded with irony. Crispin Porter & Bogusky's "truth" campaign is one of the most memorable and successful anti-tobacco ad campaigns ever conceived. Their newspaper ad signs out "Chewing Tobacco Please." Its artwork clearly demonstrates the point here (see Figure 13-16).The art and copy drive home a serious point in an emotive manner.

It's important that the audience also connect emotionally with your ad. This approach may convince an audience who hadn't previously felt a need for the product. Again, while working as creative director for the Nissan Automotive account at Chiat/Day, Rob Siltanen based his campaigns on what it *felt like to drive a Nissan*—instead of following a safer, more predictable path of hyping the vehicles' engine, suspension, economy, or styling. How many car ads have you seen using predictable visual tactics? Cars

winding through tight curves or cars scattering leaves in their wake? Siltanen's work is perhaps the best ever conceived for this product category—by a mile.

Imagery can also flag the audience and connect them to reality. A photograph of a raging blizzard can remind you of the need for all sorts of items—snow tires, candles, Yahtzee, milk, or thermo-underwear—particularly if a storm has been forecasted around the time the ad appears. Relevance rules.

Headlines

The headline is the single most important typographic element in an advertisement. Its primary function is to hook the audience. Concurrently, it should tie the artwork and the copy together.

Generally, a good header attracts attention, while stating or implying a benefit. It should also flag the audience. Headlines may set the premise, bring news about a brand or product feature, reflect or reinforce the art (without being simplistic or obvious), and have good recall. If the headline is memorable enough to stick in the audience's head, it will likely do a great job of branding that product too.

Typically, the good headlines you read are generated from a mix of things: research, creative strategy, intuition, honesty, inspiration—*and* perspiration. Creatives often go through *hundreds* of ideas and initial headlines before they find the "big idea." Ogilvy points out in *Ogilvy on Advertising*, that Aldous Huxley, who began his writing career as a copywriter, noted that it was much easier to write ten good sonnets than it was to come up with one great headline.

Figure 13-15

This poster for *The Wall Street Journal* is one from an ad campaign entitled, "Adventures in Capitalism." Minimalism is central to effective outdoor or poster advertising. Here the design components are type, texture, color, and edging. How do each of these contribute to the sense of *image* in this ad? Of course, killer copy and a concept with attitude don't hurt the ad, either. Goodby, Silverstein and Partners: Eric King and Valerie Ang-Powell, art directors; Harold Einstein and Jim Haven, writers; Jeff Goodby and Rich Silverstein, creative directors; Hunter Freeman, photographer. Reprinted by permission of *The Wall Street Journal*, ©2003 Dow Jones & Company, Inc. All Rights Reserved Worldwide.

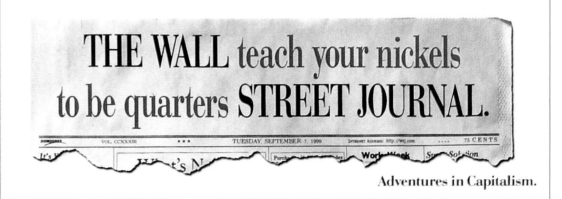

If the headline doesn't stop the reader, the ad will likely never be read. If it misses the intended audience—it fails. P.T. Barnum had another way of looking at it: if you don't get them in the tent, they won't see the show.

How long should the header be? Although there are great short and long headlines, usually shorter is better. While not all advertising gurus even support the use of outdoor advertising, its minimal nature make it a compact, quick-hitting format. It demands terse, clear, evocative headlines because it's the most stripped down ad medium of all, using art and a headline, basically. Additionally, an outdoor ad has to hit a moving target. So the art should be large and isolated—be simple without being simplistic—and the headline concise. The "Got Milk?"

outdoor boards are great examples of these points: knock-out art and a two-word header (see Figure 13-17).

Sometimes the art can be left out. The Martin Agency team of Jelly Helm and Raymond McKinney conceived this headline for Bernie's Tattooing: "Pictures developed while you wait." With a headline that compelling, who needs art? They didn't.

Establish the right voice and tone in your headline, and remember that all communication—particularly advertising—is a one-to-one proposition. Notice how the VW ads speak in a succinct, wry fashion. Volkswagen has run some amazingly effective heads with just two words: "Nobody's Perfect" and "Think Small" (see Figure 13-18).

Figure 13-16

This public service ad for the hard-working and much-acclaimed Florida Anti-Tobacco Pilot Program uses a double header that is central to the ad's truth concept. The header, CHEWING TOBACCO PLEASE, is expressed both in type and art. The art illustrates sign language. The copy reads: "How to ask for chewing tobacco after the doctors remove your tongue. If you chew tobacco you could get oral cancer. And lose your lip. Your tongue. Your cheek. Or your throat. And ultimately, your life." In this case, the tie between header, art, and copy is well-braided and delivers a very serious message in an honest and unflinching way. Crispin Porter & Bogusky (Miami) has produced many hard-hitting messages for the *truth* campaign; this ad was produced by Tony Calcao, art director; Stefani Zellmer Rao, copywriter; and Alex Bogusky, creative director. Courtesy of Crispin Porter & Bogusky.

Think about the tremendously successful Absolut campaign—a "big idea" in terms of concept, art, and headline, the latter generally consisting of two words. "Absolut" and whatever follows it to suggest or reinforce the artwork. Graphically, the campaign has great legs; TBWA/Chiat/Day has used this concept for years, and it's still interesting. It is also immediately recognizable and its *gestalt*-inspired shape is in the configuration of their product—its bottle (see Figure 13-19).

However, longer headers may be effective too. Ogilvy wrote one of the most famous headlines ever for Roll's Royce: "At 60 miles an hour the loudest noise to this new Rolls Royce comes from the electric clock." How about Colin Nissan's header for Rugged Mt. Ski Lodge of New Hampshire? "Our weekday lift tickets are just $19. Ironically, the same price for the Tic-Tacs at other mountains." Or Denzil Strickland's header for as unlikely a client as a cattle company. This headline was penned for Twin Eagles Cattle Company: "Modern cattle breeding is part science. Part tender loving care. And part watching where you step." Strickland follows that up with great copy for another ad; it reads: "At Twin Eagles, we provide a peaceful, tranquil environment for our cattle. We think it helps the breeding process. We don't know if that makes us sensitive or not, but when it comes to cattle, we sure are passionate."

So how long is really long in headline writing? John Robertson wrote a 45-word headline for an honored print ad, for Taylor Guitar (see Figure 13-20).

There are numerous header variations and choices. *Benefit* headlines stress advantages, but the best of them *don't* boast; instead, they simply point up product strengths or advantages—often with a touch of humor like the above examples. The average person can spot *ad speak* a mile away—*superlatives* or a message that's insincere, artificial, or pontificated. We resent all of the above.

Talk about honesty woven well with truth—in this case facts we all know—consider the powerful headline Ninel Pompushko wrote for the Holocaust Memorial Museum. "IN THE

UNITED STATES IT'S HARD TO FIND A JEW WHO IS UNAFFECTED BY THE HOLO-CAUST." Stretched barbed wire separates the top head from its refrain: "IN POLAND IT'S HARD TO FIND A JEW." Powerful words for a simple but honest and emotional message.

Promise headlines offer a reward for the use of the product or adoption of the idea. If you go this direction, make sure you provide proof that the promise will be kept in your copy. The "*how to*" header is closely related to the promise head. Two great ones for Altoids mints are "Freeze." and "Numb and Number." If you opt to employ a *question* headline, that is, one that poses a question, make sure the query is relevant and won't evoke a "so what?" response.

Most creative directors and clients dislike *blind* openers, headlines that don't flag the reader or that don't relate in any way to the art. But regardless of what kind of header you use, make sure it's compelling or jarring enough to ensure that your audience will read on. It's also effective if the headline can establish a meaningful emotional connection to the audience, which is precisely what the compelling ads created by the Carmichael Lynch Agency (Minneapolis) do for the Porsche Boxster S series (see Figure 13-21).

ABSOLUT KYOTO.

Figure 13-19 (above)
TBWA/Chiat/Day has produced over 1,000 Absolut ads (talk about a campaign that has *legs*) that basically do the same thing: the art is configured to resemble Absolut's bottle, which is followed by two words. ABSOLUT and one other word or phase directly related to the art. ABSOLUT KYOTO: here the koi (fish) are grouped in the shape of the bottle in a Shintu reflection pond. Courtesy of TBWA Chiat Day.

Figure 13-20
Generally, shorter is better when it comes to headers, but there are always situations that require them to be a bit more long-winded. "In one pair of hands, a piece of fine wood can become a living room coffee table. In another pair of hands, that piece of wood can become the sweetest sounding guitar. This is for everyone who has no desire to play the coffee table." Note, too, how the copy speaks back to the headline: "Some trees become pencils. Some become paper that becomes guitar magazines. Some become shoe trees. Some trees become Taylor guitars. Some trees have all the luck." John Vitro, art director; John Robertson, writer; John Vitro and John Robertson, creative directors; Art Wolfe and Marshal Harrington, photographers—for Franklin Storrza Ad Agency (San Diego). Courtesy of Taylor Guitars.

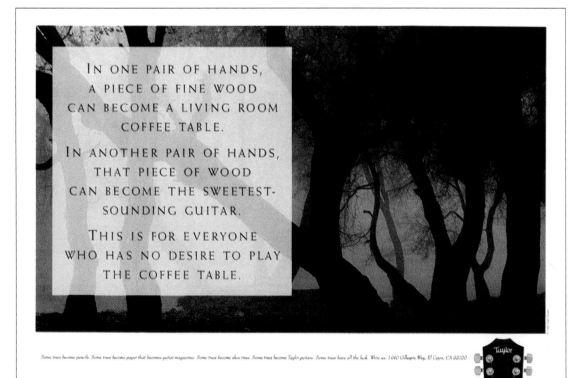

IN ONE PAIR OF HANDS, A PIECE OF FINE WOOD CAN BECOME A LIVING ROOM COFFEE TABLE.

IN ANOTHER PAIR OF HANDS, THAT PIECE OF WOOD CAN BECOME THE SWEETEST-SOUNDING GUITAR.

THIS IS FOR EVERYONE WHO HAS NO DESIRE TO PLAY THE COFFEE TABLE.

Headlines also require meticulous grooming by the designer or art director. That means precise kerning, leading adjustments, and paying particular attention to the header's line breaks. It's a good idea to break the lines of the header the same way a poet breaks lines within a poem. Generally, that means avoiding prepositions at line breaks and paying attention to meter, rhythm, phrasing, and the natural flow of the words. Since we're on the subject of type, remember that typography has its own voice, and needs to speak to the audience as much as the words do in the headline. A stencil typeface face looks good on the sides of tanks and prison shirts or would work well for an army surplus store's ad, but it probably wouldn't be a smart call for bridal fashions. Finally, *don't hyphenate headlines*.

Body Copy: The Ad's Text

When most people refer to *copy*, they mean the message or guts of the ad: the block of text that follows the headline. While there are distinguishing characteristics between the headline and copy block, technically and logistically, both are copy. For that matter, so is the tag. To be sure, they all need to flow together, speak in the same voice, and pull the same direction to effectively and efficiently deliver the advertising message. Speaking of voice, notice the subtle differences and reflected personalities of the *dialogue copy*

Figure 13-21

Carmichael Lynch Agency (Minneapolis) employs headers here that reflect and fuse with the art, although you might not notice that at first glance because the writing is so informal, matter-of-fact and loaded with dry humor. Compare these two ads: "What a dog feels when the leash breaks" and "The new Boxer S. When you buy one, we suggest you pick it up on a Friday." Notice how the use of blurred imagery, diagonal lines, ess-curves, and use of space help suggest motion in these designs and images. For "Leash Breaks:" Hans Hans, art director; Sheldon Clay, writer; Jud Smith, creative director; Georg Fishcher, photographer. For "Boxter S:" Chris Lange and Hans Hans, art direction; Michael Hart and Sheldon Clay, writer; Jud Smith, creative director; Georg Fishcher, photographer. Photography by Georg Fisher/Porsche Cars North America.

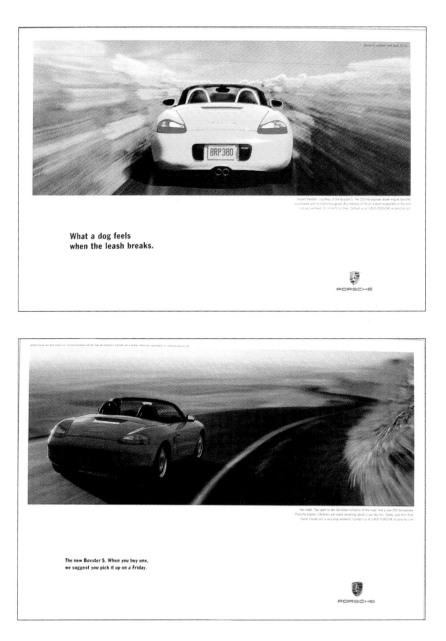

written by Elizabeth Ryan for Bed Bath and Beyond (see Figure 13-22).

Copy is composed of words. Great copy uses words that stop you in your tracks. Words that hold your attention. Text should speak concretely and clearly; the copy should entertain, inform, and motivate you. Words reflect the consumer's point of view rather than the seller's. Writing in the second person helps connect to the audience and maintain a personal exchange.

This is not a book on writing, but the following are some helpful (albeit succinct) points about writing good copy:

- **There are no formulas.** If you're using one, you won't be a very successful or happy copywriter.

- **The *lead* is even more important to advertising than it is to editorial writing.** Typically, more is at stake. For one thing, someone is *paying* for the message. For another, the space you have to make your pitch or tell your story is very limited, so your communication has to be terse, clear, and connect emotionally with the audience—who is constantly barraged by not just advertising, but media of every kind. Greg Eiden demonstrates how to craft a memorable and appropriate lead for this Leatherman print ad, where the tool saves the day—this time in Rwanda, Africa. "The truck died on the Rhino Trail. AAA (motor service) was probably out of the question." So, for an advertisement to

Figure 13-22
These are two finished roughs from a larger campaign for Bed Bath & Beyond. The work shares two anomalies: no headlines and copy that reveals distinct voices in a brief dialogue within the ads between inanimate objects. Elizabeth Ryan created fun but surreal conversations that reveal the personalities and functions of Bed Bath & Beyond objects, which just happen to be chatting with one another. Top: The expensive corkscrew speaking to a cheaper more utilitarian opener: "I'd rather get lost among forks than allow a chard of cork to tarnish the sublime tannin of a vintage merlot" (set in an antique roman italic typeface). The response from the opener (set in Courier, a typewriter face): "I can belch the alphabet backwards." Below: two candles—a large red, beeswax, scented candle and a simple, 20-for-a-buck birthday candle— exchange words. Expensive candle, type set in elegant Garamond: "Flickering upon yellow pages, I illuminate Hemingway and Poe, while hints of honeyed jasmine press heavy on your eyelids." The birthday candle's response? "You're old." Strong concepts, a good mix of art and type, and brilliant writing. The tag reads "this and that." Elizabeth Ryan, concept and writing; Josh Rosen, art direction and illustration. Courtesy of Bed Bath Beyond.

be successful, *everything* has to work, and the three most critical components are the art, headline, and lead sentence of the body copy.

- **Do your research.** How can you bring new, relevant, or fresh information about a product—much less convince someone to buy or try it—if you don't know anything about it? Know the product or service thoroughly. What are its assets and shortcomings? What are its new uses or special applications? Get as many facts about its background and history as you can. Collect customer testimonies about it. Whenever possible *use it* so you understand it firsthand. Some of the best copy and headline ideas come out of research. Sasquatch Advertising created a playful print campaign for Leatherman, based upon compelling stories they collected from loyal Leatherman users. In

one ad, Joe Craig and his wife had moored their boat in Lisianski Inlet, Alaska and were getting ready to turn in when they felt a violent crashing lurch. The body copy opens: "Suddenly our 26' boat was anchored to 40 tons of blubber" (see Figure 13-23). Sasquatch Advertising conceived and assembled this campaign based totally from its research.

- **Know your audience—*cold*.** In addition to secondhand research, interact with your audience. Know them firsthand. Hang out with them, talk to them, get a real sense of who they are and have a grasp of their motivations. Speak in their voice. Generally, communicate informally. You can't speak convincingly if you don't have a common understanding and frame of reference between yourself and the audience. Not a superficial understanding, a

Figure 13-23

The hero of this whale of a story is Leatherman of course. Its serrated blade allowed Joe Craig to quickly cut the anchor line before his craft was turned into a submarine. The Leatherman examples in this chapter are part of the same campaign and demonstrate how great concepts, writing, and art can unify a campaign and underscore features of the product (Leatherman tools) and customer loyalty—in fresh, fun, and memorable ways. There are also strong emotional ties within these stories. Jack Unruh so loved the concept, product, and ad campaign that he agreed to do the illustrations for considerably less than his standard art fees. Jack Unruh, illustration; Greg Eiden, copy; Tim Parker, art direction; Greg Eiden and Tim Parker, creative direction; Ken Chitwood, account supervisor. Courtesy of Sasquatch Advertising and Leatherman.

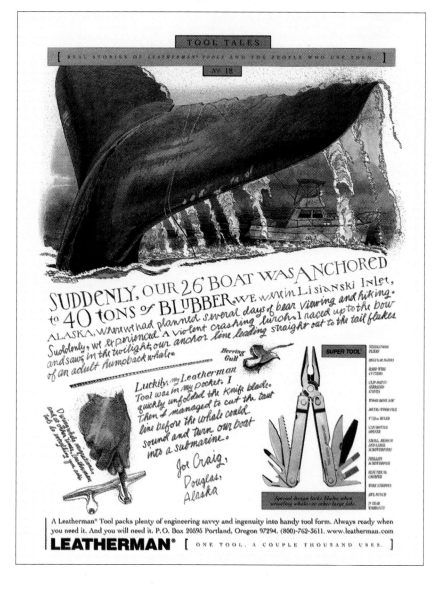

real one that covers all the bases. Along with the demographics and psychographics, know their needs, motivations, and how they think and live.

- **Use transitions where warranted to smooth out the bumps** between paragraphs, different points, or temporal fluctuations in your copy. If you're featuring multiple benefits, you might wish to use a call-out, or multi-panel format, to avoid multiple transitions in the writing. John Deere law mowers called attention to numerous features on its product to persuade consumers to buy it (see Figure 13-24).
- **Be a ruthless editor.** If the words you're using aren't contributing anything to the content, attitude, or impact of the ad's copy, purge them. Good copywriters aspire to whittle messages down to as few words as possible. The great ones are on a quest to conceive advertising that doesn't use *any words* at all. To that end, strip superfluous verbiage. The fewer words you use, the less you have to worry about transitions. Not to mention edits.
- **Write concretely!** Be explicit with your language. Watch your verbs especially closely. Be as exacting with them as possible.

- **Write in active voice.**
- **Write convincingly.** One thing for sure: you aren't going to bore anyone into buying anything. One of the best ways to be persuasive with your writing is to think *visually*.
- **The concept or "big idea" is everything.** To that end, make sure you do extensive brainstorming after you've completed your research. Study the best work out there in publications such as *Communication Arts*, *one.a magazine*, *CMYK*, *Ad Critic*, *Adweek*, *Graphis*, and *Print*. Just don't *process* that work. Deconstruct it. Imagine how and where the creative team might've gotten their ideas, why they used the strategy they did, and study how all the ad's parts—copy, art, headlines and other components—work together.
- **Speak in a normal voice.** Most successful copywriting utilizes the correct tone, voice, and feeling for the product and audience. Adjust accordingly.
- **Be honest.** The best copywriters are those who *don't* emulate others. That's one of the reasons that their copy is fresh, inimitable, and unique. Use language as artists would use their brushes. Be colorful, arresting, specific, and write in exciting, bold strokes.

Figure 13-24
Print ads with multiple benefits, selling points, or features often work better in the ad if a "call out" layout format is employed. This format also makes the copywriter's job easier because it reduces the need for contstant transitional shifts. Hal Riney & Partners / Heartland (Chicago) opted to use that tactic for this John Deere lawn mower print ad—a machine with many, many reasons for you to buy it! Ron Randle, art director; Patrick Hanson, writer; Jonathan Harries, creative director; Glen Gyssler, photographer. Courtesy of John Deere Commerical & Consumer Equipment.

- **Strive to bring a surprise**—an unexpected twist or perspective—that is going to stop your audience and direct them all the way through your copy, from your initial concept through the art, headline, copy body, and tag.

The Tag

The *tag* or tagline is the last line of copy in an ad. It's usually separate from the copy block itself, and often integrated into or below the logotype. The tag is critical to branding and often spawned from initial brainstorming sessions for an ad campaign—from an extensive headline list. An excellent tag, if it's strong and flexible enough, can outlive the actual campaign. For Blaupunkt car stereos, the tag, "Experience it," underscores the entirety of the ad—its art, copy, style, and attitude (see Figure 13-25).

Some common tags include: "Just do it"—Nike; "Can you hear me now?"—Verizon; "Don't leave home without it"—American Express; "The Ultimate Driving Machine"—BMW; "Because so much is riding on your tires"—Michelin; "Got Milk?"—Milk Board. In the latter case, copywriter Harry Cocciolo and art director Sean Ehringer of Goodby, Silverstein and Partners of San Francisco, created a tag that also turned out to be the header and copy of the ad. One-stop shopping. The "Got Milk?" campaign still turns heads.

Good tags have a number of things in common. They're terse. They sum up what a company wants you to think about its product. They promote product identity and branding. They're used in all the product's advertising. They are memorable and meant to be top of mind. They help maintain continuity in an ad campaign. They afford the advertiser one more opportunity to remind the audience about the product, and to reinforce brand image or positioning.

Logotype: Brand Awareness and Reinforcing Identity

The logotype or "signature" of the ad is the aegis or trademark of the client. Most logos are graphic rather than verbal, although some incorporate a slogan or tag along with the ad's signature. For example, Coca-Cola's scriptive type and the word "Classic" on its can or bottle. Logotypes are the heart of a company's identity, image, and brand. The logo or some variation of it may constitute a huge part of the product's packaging. Again, Coca-Cola comes immediately to mind or Mercedes Benz.

Logos aren't referred to as *signatures* for no reason. Typically, they're located at the bottom of the ad. Among other things, a logo needs to be distinctive, legible, memorable, and long-lived. Sometimes it is the logo—*period*—that carries the ad.

Usually, if a company does opt to change its logo, the new version has a clear connection to its predecessor. Remember that the logo is tightly braided to a company's brand and public recognition. So, it doesn't make sense to erase what has taken years and a lot of money to establish.

Figure 13-25
Greg Desmond, who art-directed and conceived this ad for Blaupunkt auto radios and auto stereos, made these comments about it. "Designed to be transit or metro posters and easily replicated by web barrier, I went back to German design roots that make this product great." Blaupunkt manufactures precision auto stereo and CD sound systems that produce a sound that's pristine at any volume. The precise measurement of sound within the cabin of your car creates not simply music, but an *experience*. That's precisely what Desmond was attempting to capture here with the art. Note how the brand name sandwich the copy and tag. Planning, Alan Boltz and Sean Jecko; copy, Ravi Costa; art direction, Greg Desmond. Reprinted by permission of Blaupunkt USA.

Outdoor Advertising: "Markets In Motion"

Clearly, outdoor is the oldest and most stripped down form of advertising media. Outdoor boards by themselves (this discounts bus and train signage, posters, and other forms of the medium) account for over $9 billion dollars a year alone. Many advertisers (David Ogilvy and Tracy Wong among them) dislike outdoor ads; they think they are invasive and compromise the landscape or environment. Savignac suggested you make them a "visual scandal"—i.e., *really* make them stand out. Nonetheless, outdoor advertising does offer special advantages. For example, it can target with great precision: it can zero in on a Hispanic audience via boards in Hispanic neighborhoods, or sell lodging, rent-a-car services, or airline promotions via signage in and around airports. Outdoor may also appear around the docks on the Sandy River and as a point-of-purchase display. Sasquatch Advertising created this clever poster for Jack's Snack–n-Tackle shop (see Figure 13-26).

Some of the most ingenious and memorable advertising has used this brazen medium. The minimal nature of outdoor media makes it an art director's dream. Outdoor media is especially important to this book because of its strong visual nature. An effective billboard typically has three elements: art, a succinct headline, and a clear identification of the sponsor—the logotype. Sometimes these elements are combined in a variety of ways.

Although *boards* are being focused upon in this section, *posters* are also considered outdoor media, and although smaller, they will succeed or fail based on the same principles.

Outdoor boards or posters are especially *challenging* to advertisers for four reasons:

1. A billboard has to hit a moving target. People may be streaking past on the highway at 65 mph or have a bus tail or other mobile signage quickly cross their vision. So the board must deliver its message fast—and clearly. Ad professionals suggest the billboard has 8 seconds *or less* to deliver its message.

2. Outdoor advertising has a huge presence. When you create outdoor designs, remember that not only is the audience in motion, but

Leaded

Unleaded

And just plain lead.

JACK'S SNACK -N- TACKLE
On the Sandy River in Troutdale, Oregon

Figure 13-26
This rebus design has a knockout photo of a paper coffee cup marked "2 shots" with "LEADED" below it; the second cup has decaf checked — it's designated "UNLEADED"; finally, a large lead sinker sits below the two coffee cups, along with the inscription: " AND JUST PLAIN LEAD." The concept is humorous and clearly communicates the idea that Jack's offers great gourmet coffee and fishing supplies. Media planning, Ken Chitwood; creative direction, Greg Eiden and Tim Parker; art direction, Ted Pate; copy, Greg Eiden; production, Kristen Holder; photography, Dave Emmite. Courtesy of Sasquatch Advertising and Jack's Snack-n-Tackle Shop. (See Figure 5-36 to compare this ad to others for Jack's Snack-n-Tackle.)

they're generally a considerable distance from the message. So, when you critique the outdoor ads you create, do so 12 to 17 feet away, if they're presented on a standard-sized sheet of paper. Better yet, walk briskly past them at that distance during your review.

3. Outdoor has intense competition. In commercially zoned areas, boards often stand shoulder to shoulder as they vie for attention. Plus, outdoor boards are buried amid the visual clutter of the street—store fronts, signs, marquees, traffic, and other visual obstacles.

4. There is a sizeable resistance to outdoor boards because opponents point out that they pollute our visual environment.

There are two major versions of billboards: painted boards and poster panels. Painted boards are more costly, but quite colorful and resilient to the elements. Your author began his advertising experience at an outdoor signage company in Chicago, All-Sign Corporation, washing brushes and helping journeymen by painting "fill" areas on large painted boards. Poster panels are mass-produced on laminated sheets (mostly with self-adhesive backs) and then applied to the board's panels. Billboards and signs come in all shapes and sizes; indeed, some are kinetic, unusually shaped, or electronic, and some may even utilize video or other moving imagery.

Advertisers list several advantages of billboards as an advertising medium. They include:

1. **Reach.** Billboards provide an advertiser excellent range at a reasonable price. Research has indicated that a well-placed board can reach 86.7 percent of the adults in an area. Illuminated boards work 24 hours a day, seven days a week. How's that for reach?

2. **Impact.** Outdoor signage is *larger than life.* Most boards are at least 12 by 24 feet, so an effective "big idea" on a medium of that stature is bound to have memorable impact. Boards are especially appropriate and effective in image campaigns. To truly appreciate the impact of outdoor ads, take a walk or drive through our larger cities. Their impact and arresting power are dramatic. Major League Baseball's Authentic Sportswear used inter-city rivalry for their "Wash Separately" board. Its impression on the Big Apple was huge in more ways than one (see Figure 13-27).

3. **Targeting.** As noted earlier, billboards may be strategically placed *at* or *near* the service or where the product can be obtained. Outdoor advertising along or within an airport, hyping a rental car company, Immodium, cell phones, or an airline, takes advantage of this kind of targeting. Boards can also be rotated to keep the message fresh and reinforcing. Billboards and bus tails and other moving signage reach most automobile riders between the ages of 18 and 24—the group most advertisers are looking to reach.

4. **Reinforcement.** Media planners like to use outdoor to reinforce other ad media to amplify the message to the audience. Others also like to use it to launch a product or campaign because of its reinforcement and impact power. Repetition is one of the requirements for making an impression on an audience (see Figure 13-28).

5. **Flexibility.** Normally, when we say "outdoor," we think of billboards. But outdoor media consist of a wide array of signage: bus sides and tails, posters, kinetic boards that revolve or have an array of moving panels,

Figure 13-27
How better to communicate with the baseball audience of New York (or many other places for that matter)? This outdoor ad for Major League Baseball's "Authentic" sportswear juxtaposes baseball jerseys for the Yankees and Mets with the header, "Wash separately." A great example of marrying art and headline. Ad courtesy of The Lord Group (New York): Steve Makransky, art director; Patrick Sullivan, writer; Tony Kobylinski and Jim Ritterhoff, creative directors; Dan Engongoro, photographer. Used with permission of Major League Baseball.

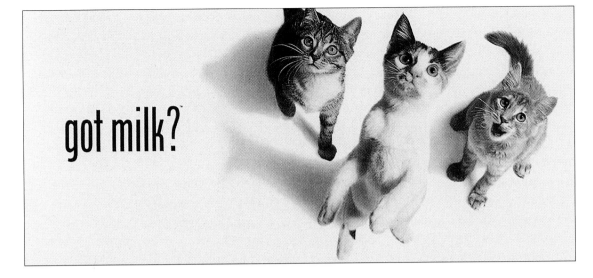

Figure 13-28
This billboard for the California Milk Processor Board is the perfect model for outdoor advertising. It has minimal elements. It uses knockout photography. The art is mated up to the headline. It's simple. The headline consists of two words. It makes one point. It uses large art. It uses sans serif type. It reinforces hundreds of other "Got milk?" ads we've all seen, including a few in this chapter. It has great impact. And—it's memorable and honest. Goodby, Silverstein and Partners are responsible for this fine work. © Hunter Freeman Photography/California Milk Advisory Board.

"slide" boards that use huge sheets of transparency (slide) film and are illuminated by bright white light behind them, electronic signage, and LED boards with moving imagery. They may be as small as the size of a standard-sized sheet of paper or as massive as some of the outdoor displays in Times Square. Some boards use sophisticated lighting techniques, reflective panels, or other things to snag your attention.

Everything you learn about design principles, type, color, art, headlines, and other facets of graphic communication apply to outdoor media. But given its unique characteristics, there are some important points to consider before setting out to create an outdoor billboard:

- Outdoor ads have three basic elements—art, header, logo.
- The headline should be limited to ten words—fewer are even better.
- Large illustrations get attention (see Figure 13-29).
- Remember, this is a *minimal* and very *visual* medium. So make sure you isolate the art via tight artwork: Spartan cropping, framing, and knockout photography.
- Use bold colors.
- Unify your elements. Make sure everything is cohesive—that the art, type, color, and design are compatible with one another.
- Tie the art to the headline. Each should reflect, amplify, or otherwise relate to the other, *without being simplistic*.

- Make one point. Keep it simple. Remember: the concept, art, head, design must communicate in a matter of seconds.
- Use type wisely. Type speaks to an audience beyond the words it uses. Also, legibility rules. So make the type seeable. Sans serifs, old style romans, and square serifs have the best visibility—in that order.
- Emphasize the sponsor. This is a medium where it's crucial to make the logo large. The board for *The Wall Street Journal*, featured earlier in this chapter, is a great example of calling attention to the client.

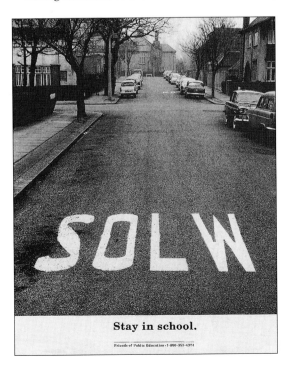

Figure 13-29
This poster underscores most of what's been hashed over in this chapter—particularly in the poster and outdoor sections. Large, powerful art is coupled up to the headline (three words), followed by a simple logo for Friends of Public Education. There's no missing the message: "Stay in School." Fallon McElligott created this poster advertisement for Friends of Public Education. The artwork and its painted message connect emphatically—like a baseball bat to the knees. Courtesy of Fallon McElligott and Friends of Public Education. Courtesy of Fallon Agency, Minneapolis, Minnesota.

The One Club

The One Club has been on a mission to nurture and honor exceptional creative work in advertising since 1975. It is a non-profit agency with offices and a gallery in New York City. Each year, The One Club for Art and Copy sponsors THE ONE SHOW—perhaps the single most important international creative advertising competition. The show and banquet bring the finest creative talents in advertising together each May to recognize the year's best work in all facets of advertising media. The creators of the best work are awarded gold, silver, and bronze "pencils." The exhibition and awards show also recognize and display the finest student advertising.

Through its publications, exhibitions, gallery shows, and awards competitions, The One Club seeks to inform and educate the public, students, and advertising professionals "about the intrinsic values of creative standards in advertising." Its magazine, *one.a magazine*, continues to showcase the most exciting new work, provide overviews of great advertising from the past, and assemble essays, forums and interviews with the best creative minds in advertising (see Figure 13-30).

In addition, The One Club has demonstrated a commitment to the next generation of advertising creative directors, art directors, writers, and designers. It provides scholarships, portfolio reviews, on-going gallery exhibitions, student competitions, and an annual exhibition of the best international student advertising. Student work is also displayed in "The Future," a special section in *one.a magazine*.

In 1995, The One Club established an education department to "build liaisons with educational advertising programs across the country." Over the years—along with its annual student competition—it has offered opportunities to students through its juried, invitational on-site "Young Creatives Competition," traveling exhibitions, internships, and its special scholarship program. There are student rates available for membership as well as for ONE SHOW annuals, and subscriptions to *one.a magazine*.

Television Spots: Art, Storyboard, Copy, Action

Television figures significantly into today's advertising media mix, but the TV landscape has

Figure 13-30
This recent cover (note its distinguished die-cut) and a feature on Sony and Lowe & Partners/SMS give you a sense of the style and content of The One Club's *one.a magazine*. The publication offers a window into the creative world of advertising via its features, essays, interviews, and forums on issues of the profession that range from ethics to technology. Like The One Club itself, the magazine educates, informs, debates, and shares exciting new work *and* revisits advertising heroes and great work from the past. Reprinted with permission of The One Club/*one.a* magazine.

changed dramatically over the past decade. Syndication, satellite and cable television, infomercials, reality TV, "buying" channels like QVC, and the plethora of specialized networks have made the media planner's job more complicated in many respects.

The major advantage of television advertising lies in its ability to inform and entertain us via its unique palette of sight, sound, and motion. Its presence is ubiquitous. TV is able to reach mass audiences and leave its imprint upon us culturally. Wieden + Kennedy is widely celebrated for its creativity and powerful TV spots. The Nike campaigns are all extraordinary: many Michael Jordan, Lebron James, and Tiger Woods ("Golf's Not Hard" and "Hackeysack") spots come to mind. The Nike list of work alone is as extraordinary as it is varied and extensive. But the agency has done equally brilliant work for other clients, including Miller Brewing, particularly its long-established Miller High Life brand.

Perhaps the most unusual and fun television advertising campaign to come down the pike in a long, long time is Wieden + Kennedy's Miller High Life work. It's a brilliant example of what you can do with a parity product targeted mostly at an older, blue-collar audience. The ads, however, are so fresh and honest that younger, more affluent consumers are buying into the advertising and the beer, too. Jeff Williams, Jeff ling, Susan Hoffman, and Jeff Selis of W+K teamed up with director Errol Morris and radical.media to create these retro-surreal TV spots. The ads, which are a mix of 15- and 30-second spots, have a documentary/stream of consciousness style and a "no frills" look and feel (see Figure 13-31).

Of course, like any advertising medium, TV has its drawbacks as well. The cost of a quality TV spot are steep, and the costs to place it nationally are even steeper. According to Vanden Berg and Katz, it costs $350,000 for a 30-second national spot in prime time on a major network. Plus, television spots aren't retrievable like print ads, nor do they have the extended reality or flexibility of outdoor media. Once TV spots have been aired, they're in the ozone—gone. Their formats—typically, 15-, 30-, and 60-seconds—add to their fleeting quality. That's a relatively

Figure 13-31
Each TV spot in the Miller High Life campaign features the Miller High Life man pondering the modern—often yuppified—world from his unique perspective. The situations within each spot provide a window into a simple life, but one fraught with important decisions. The examples are wonderful: A man with *very* greasy hands eating a donut:
• "The powdered sugar on this donut puts a semi-protective barrier between your fingerprint and your nutrition."
• A man worrying over taking the *last* remaining deviled egg "…if you make a light choice here, maybe you will have room for just one more."
• A man duct-taping the refrigerator closed to keep his Miller High Life beer cold: "The High Life man knows that if the pharaohs had duct tape, the sphinx would still have a nose. We salute you duct tape."
• Other scenarios? Our hero lamenting soccer's ever-increasing popularity, or being horrified that a neighbor can't park a boat trailer in tow, or noting the similarities in the spelling of BEER and BEEF while frying a hamburger on a grill. Like Wong's "Sonics" spots, the ads look homemade. They're simple, arresting, and cut through the "crap" out there.
This spot (entitled "SUV") involves the Miller High Life man sizing up a neighbor's SUV. Script follows: (Open on various shots of a man looking at his neighbor's SUV.) Anncr. (VO): "Leather seats. Automatic transmission. Nowadays, you'll hear people call this a truck. Well, a man knows a station wagon when he sees one. This *car* will only see off-road action if the driver backs over a flower bed. If this vehicular masquerade represents the High Life to which men are called, we should trade in our trousers for skirts right now."
LOGO: Miller High Life
Wieden + Kennedy advertising is responsible for this excellent work for Miller High Life. Jeff Williams, art director; Jeff Kling, writer; Susan Hoffman, creative director; Jeff Selis, producer; Errol Morris director; @radical.media, production company.
© Miller Brewing Company. Used with permission.

short span of time to communicate clearly and memorably to an audience armed with remote controls, mute buttons, and perhaps a hundred cable channels at their fingertips. Spots also have a short amount of time to tell a story, impart product benefits, establish brand, persuade, project image, and convince someone to buy or try a product.

Viewers have little time to absorb the spot, and the ad itself has mere seconds to communicate, so it's important to keep the material uncomplicated. Tell a simple story. Sell a single benefit. Make one direct point. As Tracy Wong pointed out earlier, there's tons of "crap" out there. The audience resents the blitz of terrible TV advertising, so your spot needs to be fresh, engaging, and entertaining.

Briefly, TV advertising copy needs to be short, informal, and personal. Ann Maxwell suggests in her book, *How to Produce Creative Advertising*, that there are six standard, commonly used formats for television: vignette, endorsement, demonstration, case history, comparison, and product as hero.

The research and writing discussed earlier for print copy applies to TV as well. However, TV spots may employ music, motion, narration,

ambient sound, special effects, dialogue, sophisticated editing, and more. A *storyboard* is normally used to integrate those elements initially. Storyboards are important, too, for client presentation and production. Their mission is clear: to plot and tell a simple story (see Figure 13-32).

There's a jungle of TV spots out there, so it's imperative to stop an entertainment-minded audience. Largely, that's why viewers are there, to be entertained: watch sporting events, soaps, sitcoms, movies, and their favorite programs—not commercials. So, be different, convincing, arresting. The entertainment factor is also why many smart advertisers create TV advertising that *amuses* or *diverts* us. If an ad entertains you while it's selling, you're less likely to hit the remote. Clearly, you aren't going to sell anything if your ad is predictable, insulting, or screaming ad speak. Effective TV spots stop, entertain and engage us. Wieden + Kennedy's famous Nike TV spot ("Hackeysack") featured Tiger Woods bouncing a golf ball on his club head, and finally smacking it like a baseball with his golf club for about 200 yards. Awe-inspiring idea, concept, and execution. Who could turn away from watching that?

Figure 13-32
Here are two "related" storyboard panels and two actual frames from the "Doe" spot for JanSport. Compare them. Again, the purpose of a storyboard is to quickly impart a sense of the narrative, establish shot angles, and composition and work as a tool to present a concept or ad campaign to a client. Often the presenters *act* out the storyboards in a meeting anyway, doing the dialogue, sound effects, and so forth. Courtesy of DDB Seattle and JanSport.

Treatment "Doe," JanSport

What does a copywriter do when a TV spot has *no words*? What a job, huh? Actually, the work includes more than concepting, as the treatment for JanSport's "Doe" spot demonstrates. Additionally, this *treatment*—the working or initial script for this TV spot—was invaluable at the presentation. The creative team literally acted out the treatment after it was explained and presented to JanSport. Copywriter Elizabeth Ryan's treatment follows:

Open on a narrow street with foot traffic and mopeds. Maybe it's an open-air market, with cobblestones and old posters peeling off the brick walls. People of all ages go about their business. The street bustles. This is where the city meets. It's late morning, the light is rich and golden. Colors pop. The turquoises, reds, and yellows are vibrant and rich. There's a sense of fantasy, a pregnant moment. Something is about to happen.

A boy walks through the crowd. He's about 22 years old, dressed in a T-shirt and jeans. He's walked this street hundreds of times before. He puts his headphones in his ears, and the music starts. As "Do Re Mi" plays, each verse of the song shifts the feeling and action of the spot.

The music begins. We don't hear the lyrics, but we all know the tune.

"Doe, a deer, a female deer": Across the street, we see a beautiful girl wearing a Bambi T-shirt walk through the crowd. She's about 20 years old, dressed in vintage clothes. She's right at the cusp of womanhood. When nobody's watching, she still behaves like a girl, but she's just exploring what it means to be a woman. She doesn't spend a lot of money on her clothes, but she wears them well. She seems vulnerable, a little off balance. The boy turns his head to watch her. It's a moment of epiphany. He's never seen someone so beautiful.

"Ray, a drop of golden sun": "Doe" steps out from under an awning and she's struck by a beam of light. Perhaps she stumbles, and turns her face away. Or shields her eyes with her hand.

"Me, a name I call myself": Cut to the boy as he turns and looks at himself in a store window. He smoothes his hair, adjusts his shirt. He doesn't care if people see him; he's abruptly self-conscious, but still confident. We can feel his urgency.

"Far, a long long way to run": Cut to a pan of the street. Doe isn't there. She's disappeared into the crowd. This is where the spot picks up, and tension builds. The boy starts running. As he runs through the street, we're struck with visual clues alluding to Doe. Has he just lost his soul mate? Maybe there's a palm reader or an old couple, or a poster of a couple kissing. The boy isn't aware of the signals; he runs past them, concentrating on finding Doe, but the audience notices.

"Sew, a needle pulling thread": Cut to boy running past a tailor's shop. An old woman is sewing a bridal gown in the window.

"La, a note to follow so": Cut to the boy running past a coffee shop. It's an old café, filled with regulars sipping their cappuccinos. The neon sign in the window reads "Lattes," but only the "La" is illuminated. It blinks.

"Tea, a drink with jam and bread": Cut to Doe, sitting at a table in the open air café. She's eating a pan dulce; a bit of jam is on her chin. She looks at him directly, not coy at all. We're left with the question: has she been waiting for him all along? Who has been pursuing whom?

"And that brings us back to Doe": The boy walks up to her and smiles. Doe smiles back. We know something is starting, but we're left not knowing the outcome. There's a sexy tension, and a sense of mystery.

Cut to a close-up of the boy's pack, and the JanSport logo.

That's a *lot* of copy for a 30-second TV spot without any dialogue, voice over, or other words. Another challenge is extending one *good* idea and building a *campaign* from it.

Examine the great work. Usually, it connects and holds us because we can identify with it. We can hook our own reality and experience to it—no matter how exaggerated or outrageous the content. The best ads also have the ability to tell a simple story; one with a clear beginning, middle, and end. The Tiger Woods example fulfills that model. We enjoy narrative form. It dominates our reading, cinema, TV programming, and it speaks to our rich oral tradition. Narrative also happens to dominate TV spots. A good TV ad should be able to be summed up in a sentence or two. Simplicity is central to advertising's success, particularly in the case of TV ads.

Like all of the other ad media we've discussed, TV spots are also type-dependent. The main typographical points to keep in mind are legibility and contrast. Actually, both are related. The audience won't be able to read the superimposed messages if the type is too frail, or if there's not enough contrast between the words and the background—particularly a moving one. Sans serif and old-style roman typefaces have excellent legibility qualities. It isn't by accident that art directors run reverse type in black letterbox formats or run reverse type atop strips of black below the image or on separate frames.

Supers (superimposed type) play several other important roles: first, they help extend the message, allowing for more information to be used in a very word-limited format. Roy Paul Nelson, author of *The Design of Advertising* and *Publication Design*, recommends—on average—that you not exceed five spoken words per second in the TV spot. The point is that superimposed type allows you to insert additional information, *subtitled* text along with the spot's dialogue, narration, or voiceover. Secondly, they help reinforce the message. Finally, "supers" continue to communicate, even if the TV is muted, because we're compulsive readers.

Recall is crucial to television advertising. We've all seen spots we enjoy, but every time they're aired—despite having seen them multiple times—we've no idea who is sponsoring the ad. Not a good omen, particularly if branding is important to the client.

Because of their visual preoccupation, students and ad novices sometimes forget how important *sound* is within a TV spot. If I'm selling you a Weber grill, think how much more impact the image of the grilled steak will have if you can hear it sizzling. The sound you hear on the average television commercial is layered with a wide variety of audio input from many sources. They include, but are not limited to, ambient sound, dialogue, narration, special effects, voiceovers, and music beds. All of these components provide credibility, life, and *elan* to ads. In a recent spot for Jansport's Euphonic Pack, DDB Seattle produced an engaging boy meets girl/boy loses girl/ boy finds girl scenario, using a song from *The Sound of Music*, "Do-Re-Mi," as its hook (see Figure 13-33). The story, though simple, is presented as a tender visual mosaic that is mysterious, engaging, and somewhat hypnotic. The ad is meant to connect to the audience emotionally. "It's about the incredible synchronicity when you're in love, when you're listening to music," the copy writer, Elizabeth Ryan, said, "how things just fall into place." The Euphonic Pack is designed not just to carry your stuff, it's designed to carry you musically, too.

Shoot and crop tightly. Televisions are small comparatively speaking, and people sit a ways back from them. So in order to have visual impact, much of the TV commercial spot uses close-up shots.

We use humor as an icebreaker in both informal and formal situations. Research shows that humor is above average in recall. Think of your five favorite TV commercials. How many of them provide a good laugh? Humor can be very effective where appropriate and help underscore the message of the ad. Along with improving recall, humor is effective at predisposing an audience to a product, message, candidate, service, or idea. Good speakers often open a lecture or presentation with a joke or amusing story. It warms up and relaxes the audience.

Storyboards are used for the scripting, production, and presentation of a TV spot. Actually, they're used for all moving imagery: TV shows, animation, documentary, films, and even some Web design. Although there are many different storyboard formats, most have a designated area

for visuals—a series of panels illustrating key scenes or camera shots within the spot—and a separate area for the words. This space may contain everything from the script itself to details regarding direction, camera angle, shot selection, special effects, tags, music and other sound notations, as well as where supers will appear and what they'll say.

Often, the word part of the storyboard is broken into two columns: one for direction and the other for scripting and actual dialogue. A storyboard format is easily constructed on the computer using your design software. You can scan photos or illustrate them by hand.

Your author teaches storyboarding with comic books. Comics are excellent examples of how to tell a story visually. They use tight cropping for impact, employ a distant perspective to offer the reader an overview, and medium shots to show interaction between characters—all on the same page. Comic book panels can really take us inside characters, too, via dialogue, stream of consciousness, narration—even share their thoughts. Storyboards are usually somewhere between 6 to 20 panels in length.

Like TV spots, comics provide—via words of course—sound effects, dialogue, and narration; and they impart the suggestion of motion through a sophisticated sequencing of panels. A few creative and art directors prefer to act out the ad's script or record it on audio tape for presentation purposes, instead of using a storyboard for TV spots. Photography is also a common way to *show what you mean* in a storyboard. Others use animatics—a videotape of stills, dialogue, narration, and music. Basically, it's a video version of a storyboard. *Whichever* method you choose, the crucial thing is capturing the magic, movement, voice, and essence of the spot.

The Advertising Campaign

Advertising campaigns are very different from one-shot ads. An advertising campaign in its most fundamental form is a series of ads that communicate or underscore one basic message. They must be cohesive in order for the ads to reinforce one another and function not just singly, but *together* over the long haul (see

Figure 13-33
JanSport's much acclaimed "Doe" spot is sophisticated and layered with interesting graphic metaphors that mesh with the spot's music. In fact, DDB opted to produce *two* nearly identical ads—a 30- and a 45-second version. The music for the JanSport spot— "Do-Re-Mi"—is intricately tied to the footage. The song was produced by Tomandandy Music (NY) and performed by DeVrae McCants and Desiree Gordon, a great match for the ad's young audience. "Do-Re-Mi" fuels the story line and ad's sensibility. Despite its techno-pop style, the sound has a haunting quality that syncs up perfectly with the beautiful imagery of director Anthony Atanasio and Jess Hall. The TV spot's blend of story, music, surrealism, and backpacks has won both JanSport and DDB Seattle a great deal of attention from the likes of *The New York Times*, *Ad Critic*, and *Adweek*. Executive creative director, Fred Hammerquist; copy, Elizabeth Ryan; art direction, Monica Taylor; production, Niki Polyocan; account direction/supervision, David Eiben and Anne Nielsen; planning, John Kerr. Film production—Naked Project, NYC: director, Anthony Atanasio; producer, Sergio Gullco; director of photography, Jess Hall. Sound: music produced by Tomandandy and performed by DeVrae McCants and Desiree Gordon. Courtesy of JanSport and DDB Seattle.

Figure 13-34). Campaigns require intensive research, smart positioning, brainstorming, creative strategy, media selection, and most importantly, a great idea.

Concept aside, continuity is the single most important quality of advertising campaigns. That means that there be strident similarities in each of the ads to hold them all together. A single ad within a campaign communicates and persuades on its own, but it should also tie to all the other ads. Often designers adopt a parallel structure for the layouts to help imprint the advertising's continuity. There are a lot of visual tools in the arsenal, including size, format, shape, color, typography, spatial arrangements, photographic style, the voice and tone of the headlines, and copy. Typically, each ad in a campaign will use a combination of some or all of those elements.

As the military analogy might imply, *campaigns* strike repeatedly as a series or sequence of separate engagements conceived to achieve a specific end over the long haul. The overall effect is collective in nature. The trick is to make each ad somehow different from the others, while still communicating the same basic message in a fresh and arresting way. No easy feat.

Repetition is a crucial facet of advertising. The best advertising campaigns repeat, remind, and reinforce the message by keeping ad presentations and content fresh. Campaigns that are especially given to longevity and messages that can be represented effectively are said to have *legs*. That's a particularly good thing for branding. Long-lived examples include Marlboro, Absolut, Swatch, Altoids, and some of the Volkswagen campaigns.

Although many advertising campaigns focus on using a single medium— for example, Absolut relies mostly on magazine ads—other products employ a variety of media. BMW, for instance, uses print campaigns in both newspapers and magazines, outdoor media, television, brochures, and on the Web. BMW's approach is to use a *multimedia* campaign.

Repetition is important to effectively communicate advertising messages. Campaigns, particularly multimedia campaigns, are a crucial part of establishing top-of-mind associations with the audience and in branding a product.

Presentation: Pitching the "Big Idea"
Advertising is the art of integrating your research, brainstorming, media planning, creative strategy, and shaping the "big idea" through brilliant writing and artwork. Ultimately, however, advertising depends upon successfully selling that work through effective *presentation*. In fact, advertising is largely presentation. Crafting words and art into an *ad*, *TV spot*, or *campaign* is presentation. If you work at a larger advertising shop, you'll likely be competing with other creative teams from your agency, pitching your ideas to the senior creative director, which is also presentation. Finally, you'll be presenting one or more ideas to the client, and vying against other agencies presenting work in the hopes of acquiring that account. This Wieden + Kennedy

Figure 13-34
The Flower Market is a floral chain that prides itself in selling fresh flowers at budget prices. The owner, however, wanted an ad campaign that didn't look or speak like typical florist advertising: something fun with a little attitude to catch the attention of its audience. Orion Design created these irreverent newspaper ads. Although small (roughly two columns by two and one-half inches), they stood out dramatically and did a remarkable job of selling flowers. There's no mistaking that these pieces go together and are part of the same campaign. In terms of longevity, this campaign has "legs;" to date, more than 150 ads have been produced using this voice and format. Art direction and copy, William Ryan; design and layout, Jan Ryan. Courtesy of Orion Design and The Flower Market.

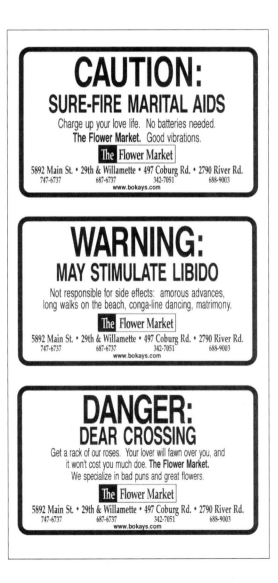

ad for Alta Vista must have been a memorable presentation; its finished ads certainly are (see Figure 13-35).

Rob Siltanen is as gifted a presenter as he is a creative director and writer. He offers insights into this process and shares his own approach to presentation:

Some wonder why major league baseball relievers are paid so much to pitch the final inning of a game. The reason, of course, is if the reliever doesn't get the job done, everybody else's time and effort over the eight prior innings are completely wasted.

In the advertising game, I believe the presentation of work is the equivalent to stepping on the mound in the ninth inning. If you don't deliver here, you may as well flush your brilliant strategy, ingenious concepts, and the weeks it took to come up with the work down the toilet.

In baseball, you must be able to close. In advertising, you must be able to present.

I can't tell you how many times people have told me, "Man, we had the greatest concept and that idiot client (or creative director) didn't buy it." That client (or CD) may very well have been as dumb as a sack of hammers and that concept might have been as innovative as Apple's "1984" commercial, but maybe it wasn't presented well.

I hate to be the one to say it, but creating the work is just half the job—and no matter how remarkable it is, it is meaningless unless you can complete the other half of the mission, which is: sell it. For me, putting together a great presentation requires nearly as much effort and artistry as it does to come up with the great concept itself (see Figure 13-36).

In my early years at Chiat/Day, when I worked as creative director on the Nissan account, I would spend several hours before each and every client meeting writing down the reasons why a certain ad was great. I would write down why the ad spoke to the audience and why and how it separated itself from its competition. I would anticipate questions that the client might have for me, and prepare a list of answers. I would outline our complete thought process and explain why that ad or campaign provided the best direction. This approach, which I continue to employ today, not only gave me great confidence when I walked into the meeting, it made it easy for the clients to appreciate the flow of logic to reach the same conclusions I did.

When walking a client through a storyboard, I try to push my energy level into high gear to bring the concept to life. I prefer storyboards that

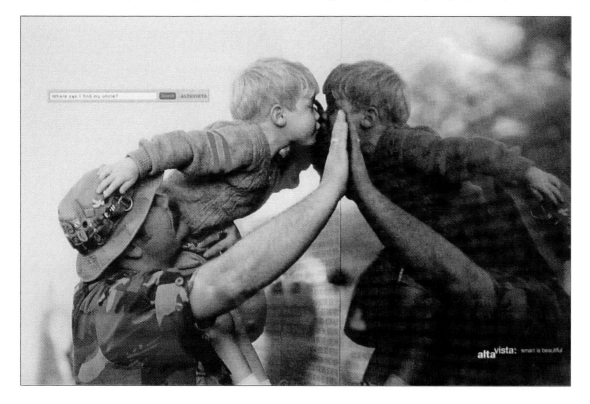

Figure 13-35
Honesty. Memorability. Power. Beauty. Four components that are constants in any Wieden + Kennedy ad you encounter—no matter the medium or the client. This print ad does all that and packs an emotional wallop to boot. Monica Taylor visualized and shaped this ad for Alta Vista. Jim Riswold crafted the words. An undersized header that is boxed together with an Alta Vista logo as a mortise atop the art reads: "Where can I find my uncle?" The artwork answers in a whisper: "At the Vietnam Memorial." A boy, sitting on the left shoulder of his father, kisses the name of his uncle. The symmetry and subtle photographic composition direct and hold our vision. Powerful. Quiet. True. Creative directors, Rob Palmer and Bob Moore; photography, Seny Norasingh. Reproduced with permission of Alta Vista Company. All rights reserved.

Figure 13-36
Nissan Automotive teamed up with Chiat/Day and creative director Rob Siltanen to produce some of the most compelling and memorable TV spots ever created. Instead of the predictable blowing leaves and ad speak about auto benefits, Siltanen and Nissan imparted what it felt like to experience driving and owning a Nissan automobile. Their tag line—"Enjoy the Ride"—spoke for both Nissan's fine products and television commercials. For Nissan's truck lineup, Siltanen came up with the famous line: "Dogs love trucks." The ads set a new precedent for television advertising and did one of the best branding jobs ever accomplished. The emotional power, engaging nature, and entertainment value of the ads have yet to be surpassed. As a matter of fact, several of the Nissan spots are in the permanent collection of the Museum of Modern Art. Courtesy of Nissan and Robert Siltanen.

are very simple, and try to keep the number of frames to the minimum required to tell the story. As a presenter, you play the role of creator, actor, director, sound effects person, and narrator. In effect, you're putting on a one-person play. Often I will begin with the storyboard to provide a setup then toss it aside—literally acting out the action—and return to the board to conclude the spot. A commercial is all about action and drama. The words, sound effects, and music you hear play a huge part making the pictures you see come alive.

Print presentation, however, is a different animal. Most clients don't think they're capable of creating and executing a television ad, but some believe creating a print ad is fully within their range of talents. After all, they've been writing since the age of five and who hasn't taken a photograph? It is for these reasons that doing your homework prior to a print presentation is hugely important. You didn't just stumble upon a font choice. You chose it for its unique expression. You didn't just place the logo in a particular place because it "looked good." You placed it there to provide balance. This kind of preparation demonstrates that you're the authority and that you gave the creation of the ad extensive consideration. With print, I try to make the comps as tight as possible. Sometimes, to show the breakthrough nature of an ad, we'll mock it up and place it into the actual publication or use Photoshop to show how the ad will appear in its magazine environment.

Typically during a creative presentation, we like to show three ideas for each assignment, presenting the recommended idea last.

Like the baseball reliever, a presenter can never take back a pitch. Once it's thrown, it's over. So practice, practice, practice—and go into the meeting with confidence, enthusiasm, and an orchestrated game plan. It will take some additional time and effort on your part, but you'll come up with a lot more victories.

Presentation is often forgotten amid all the other important facets of advertising education—media planning, research, marketing, copywriting, layout and design, campaign strategy, account management, and portfolio. Ultimately, however, it is presentation that determines who

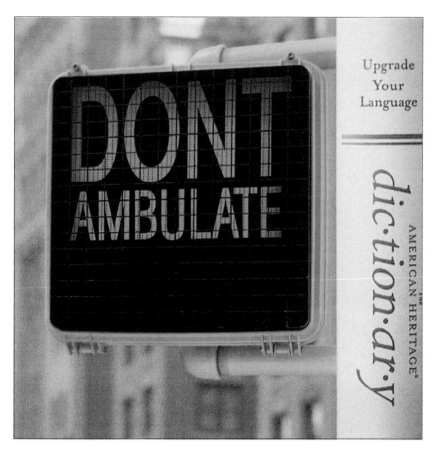

Figure 13-37

The *American Heritage Dictionary* bookends the right side of this print ad and provides its logo as well via the spine of the book. Most of the research that spawned these ads consisted of tearing out ads of competitors like *The New Yorker* and *Harper's* to determine what the agency (Mullen/ Wenham) *didn't* want to do. This campaign launches the first *color* edition of any dictionary. The humor employed by taking everyday objects (much of it signage) and doing a word shift on them is fun and memorable. The color helps separate the work from competitors in a functional way: color ads for a color dictionary. Art direction, Paul Laffy; copy, Brian Hayes; photography, Dan Nourie. © Houghton Mifflin Company and Mullen. All rights reserved.

gets the account. Your layouts and job interviews also require meticulous preparation and presentation. That said, what follows is advice to go along with Rob Siltanen's insights on this subject:

- Show up early. Get set up and comfortable with the surroundings and people there.
- Understand your mission and purpose for the presentation; although that may *seem* obvious it's not. *Everything else* should underscore, fulfill, and support that purpose.
- Presentations ought not be marathons. If the client suggests the meeting be a specific length, don't go over that time limitation.
- Be succinct. You should be able to break down specific presentation elements clearly and address them logically as relevant and definable pieces of your pitch; for example, background, research, audience, and so forth.
- Plan the presentation in segments. Along with helping you better organize and plan the pitch, having smaller components is easier to digest for both you and the client.
- Rehearse. Strive to make your delivery seamless. As Rob Siltanen noted, that will build your confidence and dramatically increase the

likelihood of your success. It will also relax you and allow you to pace the presentation adroitly.

- Anticipate client concerns. Have team members ask penetrating questions *during rehearsals*. Playing devil's advocate and taking pot shots during a rehearsal will make you "combat tested."
- Be flexible. A client may interrupt, ask a question, get a clarification, or react to what you're presenting. Again, prepare for interruptions and questions and answer their inquiries, but stay on track. Don't stray from your basic outline or ramble.
- Know your immediate audience as well as you can. Be familiar with their backgrounds, interests, and experience. Dress for the audience and situation.
- Maintain eye contact with the audience members. Don't *omit* anyone in your presentation. We've all been at meetings when a speaker doesn't look at us or engage everyone. That alienates those left out.
- Be persuasive. Bring enthusiasm, energy, and creativity to the presentation.

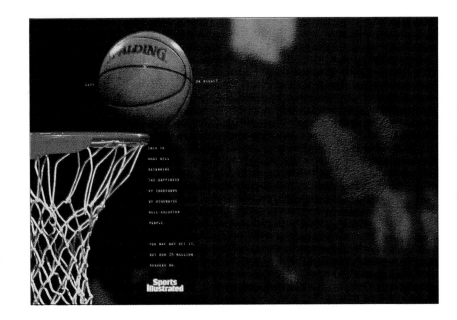

- Know the environment where you will be presenting. Have spare slide projectors, bulbs, tapes, etc. It's also good idea to have an A/V person you can rely on for any technical problems. This portion of your pitch should be as well rehearsed as the oral presentation.

- Have a strong opening. Use engaging transitions between presentation segments to bridge your delivery. If this is a group effort, show camaraderie and teamwork. Passing sections of the presentation smoothly to a partner helps with transitions.

- Have a clear, memorable close. Often it helps if your closing somehow ties to your opening remarks to bring the pitch full circle.

- Invite questions after the conclusion.
Presentations are a key element of the persuasive process.

Now that you've received an overview of advertising, you may be wondering how to begin preparing for a career working in the graphic or creative sides of this profession. You begin by slowly but surely creating and accumulating work for your portfolio.

Portfolios: Preparing Your Book —Showing Your Best Side

A brief section addressing portfolios and various paths to a career on the creative side of advertising may prove helpful to you. There are easily as many different stories about how students broke into advertising as there are creative professionals. Monica Taylor and Jonathon Graham elected to attend Virgina Commonwealth University's (VCU) Ad center graduate program (see Figure 13-39).

Traditional advertising education at research universities and colleges—Syracuse University, Kansas University, the University of Illinois, University of Texas-Austin, the University of Oregon, University of Florida, NYU, University of Tennessee, University of Georgia, and the University of Colorado, for example—provide strong overall advertising programs. Finishing schools tend to be more creatively oriented and are focused on helping students improve their conceptual, writing, design, presentation, art, and executional skills. Ultimately, students enroll in these programs to produce killer portfolios; basically, that's their mission. Some of those schools include The Art Center of Pasadena, VCU's Ad Center, The Creative Circus, The School of Visual Arts, Miami Ad School, Brainco, and The Portfolio Center.

Finishing schools are one option for students to create a strong book. Internships are another logical way to improve a portfolio *and* to break into the advertising profession. The catch-22 is that interns are selected based upon the quality of their portfolios. In fact, internships are important components in the curricula of both traditional advertising programs and ad finishing schools. Many students combine these two options. Either way, if you're looking for a creative agency position, it's your portfolio that lands you the internship or entry position.

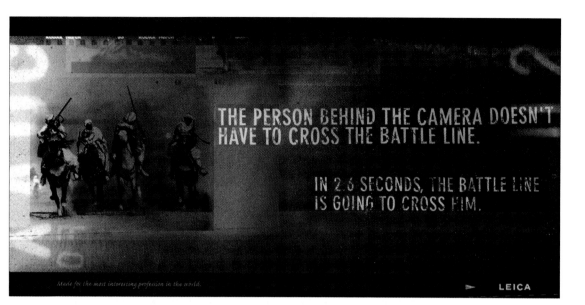

Figure 13-39
This work came from the portfolio of Monica Taylor (now an art director at DDB Seattle); she is a graduate of VCU's Ad Center graduate program. This ad from her campaign has impact and credibility for Leica cameras. Great art direction and compelling copy: "The person behind the camera doesn't have to cross the battle line. In 2.6 seconds, the battle line is going to cross him." The duotone art effect and stressed type presentation adds to the edgy copy. Clever concept, copy, and art. Kudos to Monica Taylor, art direction; Jonathon Graham, copywriting; Coz Cotzias, professor— Virginia Commonwealth University Ad Center, Richmond, VA. Courtesy of Leica Camera, Inc.

Briefly, a *portfolio* is a comped-up collection of your creative work. It should showcase only your best work. Make sure you include a broad range of clients. Ideally, your product list should be diversified and targeted differently so you can demonstrate how you speak to a variety of audiences. Normally, it's best to team up with another person to produce a book—writer and art director (or designer), or writer, planner, and art director. The writing should be appropriate to the audience and solution, and it should be terse, concrete, personal, and connect emotionally. Art directors should demonstrate their grasp of typog-raphy, color, design, and art strengths (illustration, photography, lithography, painting). Conceptually, the work should be stellar for both writers and art directors. Executions should be meticulously comped. Creative directors look for smart creative strategies in portfolio work, along with great writing, striking but appropriate use of typogra-phy and artwork, as well as deft executions.

A great book begins with interesting content: an unusual grouping of clients or services. Selecting a guitar store as your client is a little unusual, but electing to advertise it in this fashion is really unusual and a great solution (see Figure 13-40).

Figure 13-40
Rock on! John Branscombe's tongue-in-cheek rathskeller concert photograph of the Rolling Scones was recently featured as a first place entry in *CMYK* for magazine ads. This campaign was created for Guitar Center. Its copy reads: "Are you sure you're playing the right instrument?" Wonderful concept, photography, writing, and execution. Christian Osmers and Nicoletta Nelson, art direction; Dave Ciano and Nicoletta Nelson, copywriting; Johnscombe, photography; Jim Lemaitre, professor— Academy of Art College, San Francisco. Courtesy of Guitar Center, Inc.

Creative directors and art directors have likely seen several thousand, student snowboard, condom, sports car, and athletic shoe ads. The point is simple. For starters, choose a client list that's different, whimsical, or curious—or maybe include a client to explode a few notions about your range. If you're male, consider doing ads for a female audience, such as Tampax, Dior handbags, Kitchenaid Mixmasters, or Clinique products; if you're female, think about possibly advertising Craftsman power tools, Topps baseball cards, Giant mountain bikes, or pork rinds. You get the idea.

For the most part, print still dominates portfolios (see Figure 13-41). However, posters, outdoor work, and storyboards may find their way into a book. If you have a reel (executed TV, interactive, radio, or Web advertising) it usually is presented via an attached tape, CD-ROM, or DVD that is designed into the portfolio.

Many creative juniors still prefer to put their work in a zippered or buckle-down 14˝ × 17˝ leather case. These days, however, some feel that the velvet-lined, leather portfolio is a bit pretentious. Today, "books" are often less formally presented. Students tend to be more "hands on" and commonly fabricate their own books. "Mini-books" are especially prevalent because it's rela-

tively easy to produce numerous copies cheaply. They also tend to be more personal and inviting because of their size or presentation options (see Figure 13-42). Of course, there is a pragmatic value as well; a student can mail out twenty or more books without spending a fortune. Although the work should always be well executed and professionally presented, writers' portfolios tend to be less dressed out. It isn't unusual, for example, for a writer to adopt a 7˝ × 5˝ format (or thereabouts) and give it a simple spiral binding. Art directors are likely to have more elaborate mini-books with a strong graphic orientation—constructions that demonstrate their artistic prowess and visual inventiveness (see Figure 13-43). While websites, sheaths of slides, and CD-ROM or DVD portfolios are becoming more common, most art directors and creative directors prefer traditional portfolios or mini-books.

Advice to Aspiring Advertising Creatives

Finally, what follows are a handful of Curtis Clarkson's *steps* from his "12-Step Program for Juniors" looking to break into advertising. He is the editor-in-chief at *CMYK* (www.cmykmag.com) magazine. The full list is likely available to you with a subscription; here are five guidelines:

Figure 13-41
Forsooth, followeth directions "lest ye incur great wrath." Students from Miami Ad Schools (Miami Beach, FL and Minneapolis, MN) created this wonderful ad from an award-winning campaign. The client is Shakespeare in the Park. Signage with an Elizabethan twist makes for a very humorous and compelling print advertising campaign. The photography is produced in black and white; the only color in the ad is on the ticket/logo inscribed with a mug shot of Shakespeare and a "Shakespeare in the Park" moniker. The type in the ad reads: "*Romeo and Juliet*, *Hamlet*, and *Othello*—July 15th – 17th—Eisenhower Park." Mark Infusio and Kamal Collins, art direction; Adam Kanzer, copy; Scott Cirlin, photography; Steve Driggs, professor—Miami Ad School. Reprinted with permission of *CMYK* magazine.

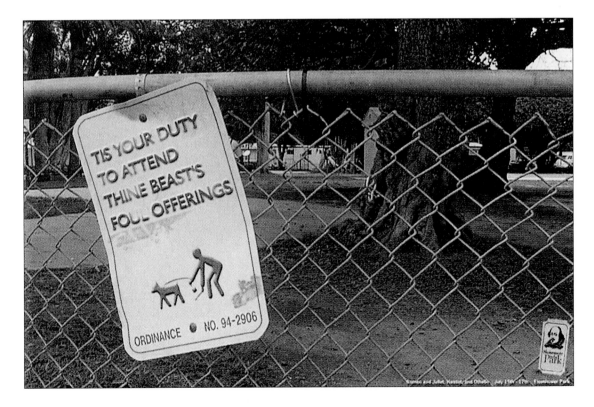

- Be honest with yourself. Is advertising really what you want to do with your life? Your buddies might think you're funny, but that doesn't necessarily make you a copywriter. On the other hand, if you find yourself gazing wantonly at print ads or sitting through *Dawson's Creek* for the commercials, then you may have yourself the makings of a career in advertising. For the promising art director or copywriter, advertising is a way of life. An ad education can be expensive, time-consuming, and extremely challenging. If you're doing it just to get out of going into Dad's insurance business, perhaps you should reconsider. Who knows? You might look good in a Fireman's Fund hat.

- Become a professional student. Those who succeed in this business never stop learning about it and about themselves in relation to it. Study others. Don't copy their work; just absorb it. Invest in your craft. No, not shag portfolio cases. Get the books, the annuals. Collect classic ads. Build a scrapbook of textures or matchbook covers or candy wrappers. Hey, it's not like studying spread sheets. This is advertising; learning can be as entertaining as it is enlightening.

- Be patient and practice. Not everyone discovers his or her talents in the first semester. Or the fourth. One day it could just hit you, and suddenly you'll get it. I've heard stories. With an encouraging instructor, little sleep, and a lot of work, anything is possible. Don't stop believing. Hold on to that feeling.

- Develop a good handshake. Enough with this wet fish crap. Shake hands with your potential employers. Good and firm. And look them in the eye while you do it. Hey, this is your foot-in-the-door we're talking about here. Great work gets you in, but personality gets you invited back. Think of an interview as a date. Be thoughtful and attentive, complimentary to a degree. Follow up with a thank-you note. No guerrilla tactics. If they truly like your work—and you—they'll let you know.

- Give back. This is so important. You might some day be in a position to influence others. A co-worker or a hopeful might be looking for advice. You might be asked to teach or give a talk. Do it. Be honored. Hey, nobody has all the answers, but if you can somehow get through to someone and in the process make him or her a better creative and/or a better person, then it's all worth it. And you'll be a better person for it, too. And when you review students' books, tell them exactly why something doesn't work for you.

Figure 13-42

Portfolios come in all sizes. Their formats offer student art directors and copywriters an opportunity to make an unusual and innovative entrance with their work. Presentation isn't everything in advertising, but great advertising is about memorable delivery. Matthew Graff (art) and Jonathon Clements (copy) opted to go *small* in this 6″ × 6″ spiral-bound format, using color as a hook for their product, the Leatherman Juice tool. William Ryan, professor, University of Oregon.

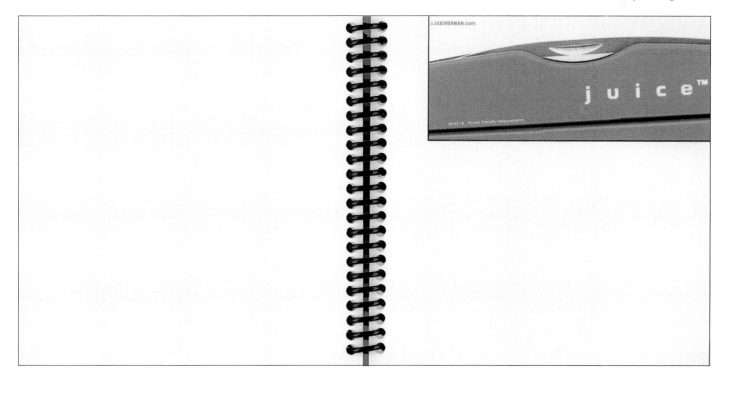

Figure 13-43
Returning to the Shakespeare theme, Jessica Cohoon put a "new spin on old plays" for the internationally celebrated Oregon Shakespeare Festival. She adopted a fun *TV Guide* format to succinctly advertise "The Tempest." The coffee stain atop the layout isolates the copy within the design and echoes the logo of the client. The copy reads: "Shakespeare leads us out to sea without a dinghy in this comedy-adventure. A royal tour is foiled when a family of castaways conjures a man-made storm that threatens the tiny ship and its crew. Scandal unfolds and the skipper is nowhere to be found." As in *TV Guide* film entries, "The Tempest" also has a date—(1611). So, did the writers of *Gilligan's Island* rip off the bard? Smart concept, writing, and design. Concept and copy, Jessica Cohoon; art direction, Jessica Cohoon and Cyrus Coulter. Courtesy of Jessica Cohoon and the Oregon Shakespeare Festival

Specifically, if you're planning on working as an art director, Hal Curtis has some great advice. He works as creative director at Wieden + Kennedy and has produced brilliant work there, notably on the Nike account. What follows is the close of a column he did recently for *Communication Arts* magazine (September/October 2002) entitled, "A Note to Student Art Directors." The column was initiated in no small part by Curtis' observation of the lack of fine art backgrounds and the limited executional skills that he sees in the portfolios of recent students. His advice is as timely as it is timeless:

I'm not an educator, but my guess is that the drop in the executional proficiency of today's entry-level art director is due to some horrible collision of the computer and the curriculum.

The computer because it teaches art directors how to be lazy.

The curriculum because it focuses on making ads, not art.

Here are a few ideas. You've probably heard most of them before. That's probably because they are important.

1. *Learn how to draw. I never trust an art director who can't draw. I know there are those rare examples of great art directors who can't draw, but it still drives me crazy. Drawing is simply an understanding of how lines and shapes fit together to communicate an object. If you can draw, you can probably lay out a page. Or compose a television frame. Or do all sorts of other art director things.*

2. *Develop a passion for typography. Good type is rapidly becoming a lost art and that's sad. If you don't know what a ligature is or you've never heard of Jan Tschichold—go ask one of your instructors. I hope they know. And hand letter a couple of alphabets while you're at it.*

3. *Understand value and how it behaves.*

4. *Become a closet editor. Other than music, it's the single most effective way to impact a piece of film.*

5. *Make photography a hobby.*

6. *Use your hands. It's the quickest way to make your work distinct because no one uses them anymore. I will quit the business the day "hands on" becomes an item on a pull-down menu. The computer is a wonderful tool, but your brain and your hands are much, much better. And they're yours. Not everyone else's.*

7. *Look to anything but other advertising for inspiration. There's culture all around us. Pay attention.*

And may I also add that Communication Arts *is a wonderful publication. Influence it. Don't copy it.*

Although Hal Curtis speaks to students in "advertising schools," his references seem to be more targeted to advertising *finishing schools*.

tupid idiot, can't you do anything right
now why I even waste my time with you,
a total waste and you'll never amount to a
hing, I wish I never had you, you jerk, stupid
hy can't you be smart like everybody else's k
hy did I have to be stuck with you, you'll end
eing a bum you are so stupid and worthless,
an't you ever do what you're told, you ne
sten, you must be retarded or something Wi
nat idiotic expression off your stupid little fa
ve told you a thousand times what are you d
nd dumb, and while your at it why don't you l
few pounds ow could y
e so ugly, why top
ke such a moron,
fe, why don't you
lon't you ever liste
uch a m on, get so
ne you l such a tra
hat from r crappy fr
unch of losers, look at
stupid brat, your
id idiot, can't y

Words can burn.

**If this is what you're hearing,
or if this is what you're saying,
put out the fire.**

**Talk to someone
who can help.**

1-800-555-TALK

Help is waiting.

**The National Committee for
Prevention of Child Abuse**

Figure 13-44
One of the interesting things about this ad campaign is that it targeted both the children being emotionally, verbally, or physically abused—and those responsible for the abuse. This award-winning ad specifically targets kids who are verbally abused. Its scant copy reads: "If this is what you're hearing, or if this is what you're saying, put out the fire. Talk to someone who can help." (Followed by a 1-800 number.) The artwork consists of reversed-out type bearing the hurtful words that these children are bombarded with daily: "you're worthless… you'll never amount to anything… I wish I never had you," etc. The finished art was crumpled, scuffed with sandpaper, and ultimately holes were burnt into the piece and on some of its edges to work as a strong visual metaphor for child abuse. It is perfectly matched to the simple header: "Words can burn." Art direction and design, Andrews Jenkins; copy, Andrews Jenkins and Dylan Coulter; creative direction, Andrews Jenkins and William Ryan.

Nonetheless, his message is as important to traditional ad programs as it is to finishing schools.

Graphics in Action

1. Carefully scan a newspaper and select an ad that you feel is poorly executed. Redesign it. Type up a short review that details why you don't like it and your rationale for changing it; then present your new design.

2. Compare the ads for Giro bicycle helmets with the Bell Helmet ad. How are the creative strategies different from one another? In what ways are they similar? How are each of these products *positioned*? Discuss the positioning strategy of both helmets.

3. Select a print advertising campaign that you think is hot. Bring 3 or 4 sample ads from that campaign to class for discussion. Speculate what the creative strategy was for these ads. Bring both the ads and your typed up creative strategy to class. Discuss.

4. Using the above scenario, deconstruct the above advertising campaign and discuss the positioning of the product or service. Discuss audience, *positioning*, type, benefits, and other nuances you can read into the print ad creative strategy.

5. Your client is the Blueberry Growers' Association. Research blueberries and prepare a one-page list of new things that you learn about

blueberries. Select two or three of those items and build ad campaign concepts from them, along with a tag for each.

6. Image is largely about personalizing or personifying a product. Select 2-3 advertising examples and analyze them, noting the product's image, positioning, and target audience. Discuss how those ads effectively communicate to the audience on a personal basis.

7. Using one of the above products, build a new creative strategy—one that uses a completely different *audience*: positioning, image, and target. This is not an arbitrary exercise, your changes must be both realistic and defendable.

8. Select a series of magazine ads from an advertising campaign, the concept, art, and headlines of which you really admire. Then, conceive the *next* ad for that campaign. You are responsible for the new concept, headline, and art. Obviously, continuity is crucial here, so adopt a similar photo style, layout strategy, and use of color. Also, make sure the voice and tone of your headline *and* type mesh with those features of the original campaign.

9. The Hershey Chocolate people want your agency to design three *different* print (magazine) ads in full-color. But here is the hitch: they are considering *separately targeting* several audiences—for the moment, anyway—and want you to come up with a creative strategy and a prototype ad for each of the following audiences and magazines respectively.

- Young women (ages 16 to 22). Think *VOGUE* or *ELLE*.
- Young, active men who are interested in edgy sports and possibly looking for a quick energy fix. The ads would likely be placed in the likes of *Paddler*, *Climber*, or *Mountain Bike* magazines. Think of this as a "positioning" shift. Here, Hershey's is positioning itself as being an *alternative* to "energy" bars.
- Boy's (Cubscouts, ages 8 to 11) involved with scouting activities, who basically don't need any reason in particular to indulge themselves in candy of any kind. The ads would appear in *Boy's Life*, an official BSA publication.

10. Prepare a three-piece magazine ad campaign for Makita Power Tools. You decide which three specific tools you wish to advertise; make sure the three tools are different. Your choices might include a power-sander, drill, circular saw, edger, jigsaw, or other Makita power tools of your choice.

Here is the kicker: Makita, who feels they are missing out on a large audience segment, has decided to target women, ages 20 to 45. Prepare a creative strategy; write 1 or 2 sentences for each of the following: target, concept, rationale, and intended reaction.

11. Create a three-piece *outdoor* campaign for Makita, targeting the same audience (see above question). Make sure you maintain continuity with art style, color, type, layout strategies, and so forth.

12. Kentucky Fried Chicken is launching a new product, Twister. It is essentially a crispy chicken/tortilla crossbreed. It's described as featuring "two of the Colonel's Extra Crispy Strips, topped with shredded iceberg lettuce, fresh tomatoes, and a splash of pepper mayonnaise sauce ... served hot on a soft tortilla wrap." Basically, the rest of the details for this advertising are fairly loose. They want you to create a 30-second TV spot.

They expect the spot to:

• increase traffic into KFC franchises to buy this new product;

• steep awareness of Twister and KFC; and

• "generate excitement" over Twister.

Prepare a brief creative strategy and a storyboard for your sample spot. You are targeting younger people, male and female, 15-25.

13. Singapore Airlines has opted to improve its American presence and market share by increasing flights from Los Angeles, San Francisco, Portland, and Seattle to Southeast and East Asia. Destinations include Bangkok, Jakarta, Hanoi, Manila, Bejing, Hong Kong, Kuala Lumpur, and Seoul. Research Singapore Air and come up with a creative strategy and media plan.

14. Using the above scenario, create an updated logo and tag for Singapore Air, and/or a three-piece print or outdoor campaign.

15. The volleyball women's team needs additional funds to get them to an interstate tournament. Unfortunately, the athletic department has no extra money and has suggested that students raise the money. Come up with a poster campaign that involves both the school and local community.

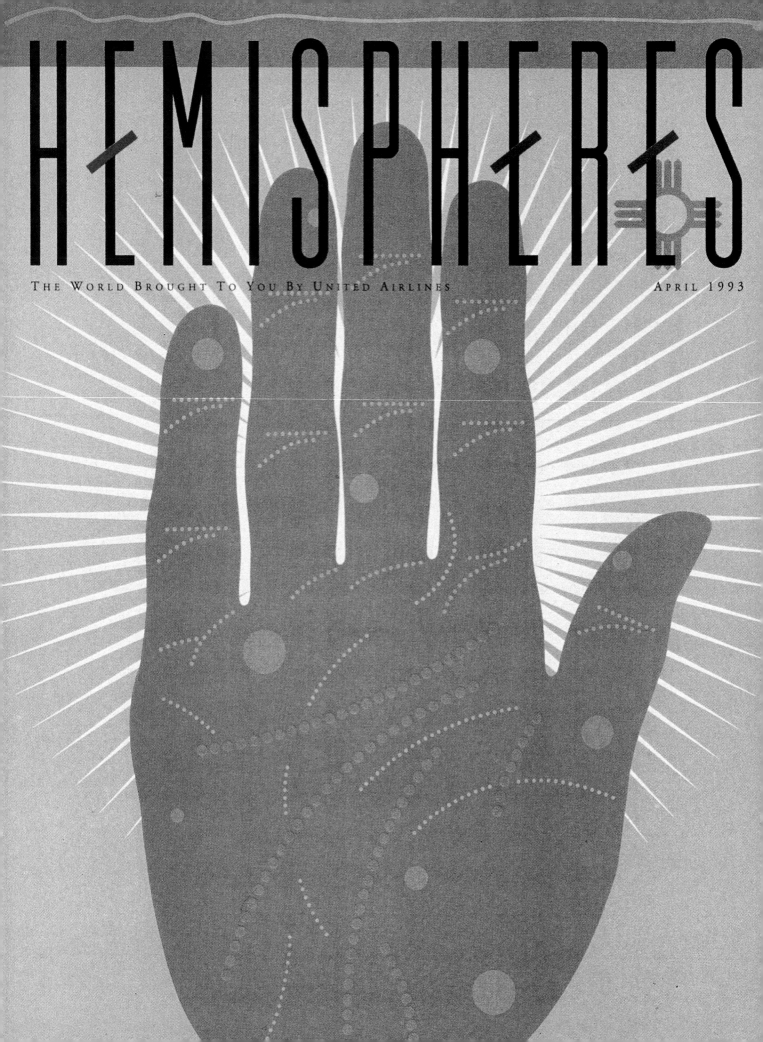

HEMISPHERES

The World Brought To You By United Airlines

April 1993

14

*Content and audience drive
magazine design.*
—Kit Hinrichs,
Pentagram Design

◄ *Hemispheres* cover illustration and design,
Michael Manwaring

As the bastard offspring of the book and newspaper, upstart brother to the literary journal, and poor cousin to the poster, the magazine lacked a unique visual format; as a consequence it became an ideal medium for graphic exploration.

—William Owen, Modern Magazine Design

Kit Hinrichs: Telling Stories Visually

Kit Hinrichs has been drawing since he could pick up a pencil. His vision and creativity were spawned from a love of drawing and illustration; those skills have steeped his gifts to synthesize, interpret, and visualize. Truly, he has a special interest and place in his heart for students of design, which, in no small part, contributed to his willingness to help design the book you hold in your hands. His teaching connections are almost as impressive as his design career. He has taught graphic communication and design at the School of Visual Arts (New York City) and the California College of Arts and Crafts (San Francisco). In addition, he's lectured at the Art Center College of Design (Pasadena) and at the Stanford Design Conference, American Institute of Graphic Arts (AIGA) National Conferences, and numerous other design associations and universities across the country. Kit Hinrich's accumulated design experience incorporates a wide range of projects. At Pentagram, he leads a graphic design team with expertise in magazine, corporate communications and promotion, packaging, editorial, and exhibition design. He speaks here about the special dynamics of magazine covers and offers aspiring magazine designers sage advice:

I've often wondered why I love editorial design and how having experienced the creation of a magazine has influenced everything I design; from identity programs to promotions, from way finding (logistical) systems to annual reports. Magazine design encompasses all the elements of good visual communication, and they're certainly the most fun.

Actually, magazine design has always fascinated me—largely because it's about storytelling, which I've always loved. We all enjoy having stories told to us. However, I think as a right-brain person and a designer, so I'm a visual storyteller rather than a verbal one. From my perspective, storytelling is about appropriately employing good typography, analysis, strategic thinking, interpretation, pacing, imagery, structure, and color (see Figure 14-3).

If one were to analyze the pieces of the whole, you'd soon discover that many specific areas of design are intrinsic to magazines. A cover, for example, often has to work as a mini-poster. Like a good poster, it has to attract you from a distance, communicate quickly, and define itself from things around it (see Figure 14-4).

Certainly some of the most iconographic covers that have influenced my career were those created for Esquire *magazine by George Lois. The cover of Andy Warhol drowning in a Campbell's soup can, for example, comes to mind. George was one of the best advertising art directors ever; he brought strong, emotionally-driven concepts that are required for high impact advertising and applied them to editorial design. Advertising is like that: the best of it deals with concepts that use images to transmit information quickly, efficiently. Advertising is about storytelling, too, but it has to communicate quickly—on the fly—like magazine covers (see chapter's opening art).*

Other editorial designers and art directors whose work I find inspiring include Willy Fleckhouse, Fred Woodward, Gail Towey, Paula Scher, and D. J. Stout. Mid-way through college, I spent a year in Germany, suspended in another culture, and discovered Willy Fleckhouse who was art director at Twen, *a German magazine published in Munich. His work taught me brand new*

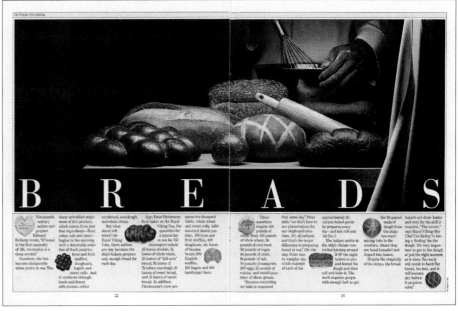

things about photography and cropping, pacing, scale, and ways of shooting. Clearly, Fred Woodward is one of the most imaginative art directors working today. He has an uncanny ability to reach into his knowledge of typography, art, and design history to come up with some of the most memorable layouts ever put to page. Texas Monthly, Rolling Stone, and GQ are among his list of successes. Gael Towey's sense of color and her overall vision are wonderful. As creative director at Martha Stewart Living, she developed a "look" and personality for not only a magazine but an entire company. Leo Leonni fled Fascist Italy, like many European designers who left their homes because of political and cultural oppression, and brought his vision to America. His covers at Fortune magazine are classic. I'm fortunate to work with both D. J. Stout and Paula Scher, two of my partners at Pentagram. D. J., who began his own legacy at Texas Monthly after Fred Woodward left, brings a strong storytelling approach to magazines. He also has a "take-no-prisoners" approach to covers. Paula's distinctive imagery and ability to reinvent herself graphically make her one of the leading designers in all disciplines today. Each of those designers understands how to integrate personality into whatever it is they're creating.

The personality of a magazine is most uniquely defined by its cover— first, through the logotype (see Figure 14-5). Like any good brand

Figure 14-1

This *SKALD* cover and two-page spread ("Breads") were designed by Kit Hinrichs nearly twenty years ago. Both of these award-winning designs are as stunning today as they were then. The cover is simple, clean, and crafted for its audience: affluent travelers who are members of the Royal Viking Lines *SKALD* Club and prospective Royal Viking cruisers. The nameplate— an elegant modern roman face—dominates the cover, sans cover blurbs. The "Breads" layout is a lesson in and of itself on understanding content, audience, and storytelling. Hinrichs' *bridging* strategies are simple but multiple. How many can you identify? *SKALD* cover design by Kit Hinrichs; art direction by Terri Driscoll; cover photo by Comstock. "Breads" spread: design direction by Kit Hinrichs; art direction by Karen Berndt; photography by Terry Herrerman. Courtesy of *SKALD* magazine/Kit Hinrichs.

Figure 14-2

Kit Hinrichs is the senior principal at Pentagram Design, San Francisco. His work has been honored and published widely. Several of his pieces are part of the permanent collection of the Museum of Modern Art. He is co-author of four books, *Vegetables*, *Stars & Stripes*, *Typewise*, and *Long May She Wave*. Kit is an American Institute of Graphic Arts (AIGA) fellow, past executive board member of AIGA, and member of the Alliance Graphique Internationale. Currently, he is a trustee of the Art Center College of Design and serves on the Accessions Design and Architecture committee at the San Francisco Museum of Modern Art. Courtesy of Kit Hinrichs.

mark, it must capture the feel of the publication, and it must be able to work with different subjects over a long period of time. Of course, it also has to be distinctive, but not so much as to make it difficult to work with other typography. I'd suggest looking at GQ, Vogue, and Wired as good examples of magazine logotypes.

Cover formats—the true physical structure of a cover—are also important elements of a magazine's identity. National Geographic, for instance, has its distinctive border, format, and nameplate (see Figure 14-6). Certainly, the distinctiveness and style of the imagery is essential to the look of the cover. Do you use only illustration (like The New Yorker) or bleed environmental photography (Arizona Highways)? Will the imagery be used for "concept" covers, which deal metaphorically with inside stories or perhaps an entire theme issue (Esquire)? Or will the cover's visual strategy use non-specific images like you'd find on Bride's or fashion magazine covers? In those instances, the covers mostly relate to the overall context of the magazine: using the cover blurbs to carry unique copy points. Some magazines don't subscribe to a rigid cover stylebook for the art, and let each cover represent a different perspective with each issue; they never discipline themselves to a dedicated position. The point of this isn't about which direction you choose, it's about choosing one and sticking with it.

As students of design, it's essential that you have a deep sense of your culture. Not just the music, art, media, literature, and other facets of

Figure 14-3

Both of these two-page *SKALD* spreads make up the first half of an eight-page feature on "China." They're also wonderful examples of visual storytelling via the seamless integration of artwork, typography (and a Chinese ideograph), thumbnail art, design, and color. Hinrichs designs at two levels here. The first is for scanners to take in the highlights of William Montalbano's story: inset thumbnail photo of the Great Wall and caption inset within larger image of the Chinese wilderness, and captions and artwork of the Shangj and Zhou dynasties spaced between the two columns of copy. The second level structures the guts or text of the story around the art, captions, and inlaid thumbnails to make a strong, inviting, and easy-to-read design package. The two spreads have logical connections. Their page structures, type, art, and designs relate immediately for the reader throughout the story. Design direction by Kit Hinrichs; art direction by Karen Berndt; photography by John Bryson, Hirojo Kubota, and Magnum Photos. Courtesy of *SKALD* magazine/Kit Hinrichs.

your 20-something culture—but the larger culture in which you live. That includes having a knowledge and appreciation of fine and graphic art history. After all, we stand on the shoulders of giants. It also includes understanding typography, its emotional value, and history; it's crucial to be able to read and understand how type works. Type is essential to storytelling. Too many young designers are consumed with imitating or using the freshest, hottest styles, and pay no heed to content. As designers, your job is to understand the story, the content, *first, and transmit it— make it accessible to your audience. Content and audience drive design. The fact is that to be able to tell a story well, graphically, you have to read, analyze, and understand it before you ever pick up a pencil or turn on a computer. Finally, work hard.*

Kit Hinrichs' introduction underscores the importance of having a grounding in culture at large, as well as in art and design history, and realizing that content shapes design and that you must use the appropriate voice in your graphic storytelling. This chapter is targeted at those in visual communication whose aspirations are focused on a career in magazine design and production.

Magazine Design: A Brief History

Creativity consists of observing, learning, and changing existing methods to adapt to new circumstances—a spiral pattern of subtly changed repetitions. It is a struggle between subconscious ideas and intellectual analysis, and between the conventional and the unconventional. It is, however, impossible to struggle in a historical vacuum. Push against nothing and you fall.

—William Owen

Understanding the rich graphic legacy of magazines over the years will help provide you with insights into designing them. The first magazines were literary or political in nature. Born of the industrial revolution, they marked a clear break from book and newspaper design, they tended to be independent and unusual. One of their most distinguishing characteristics was their strong visual orientation, perhaps because of their connection to the art scene, and their editors' fascination with poster design. Magazines were also expensive and targeted at the affluent and those immersed in the art and literary scenes.

Graphically, magazine illustration had its initial "golden age," the last thirty years of the nineteenth century. Along with the printing press, lithography, posters, packaging, and advertising,

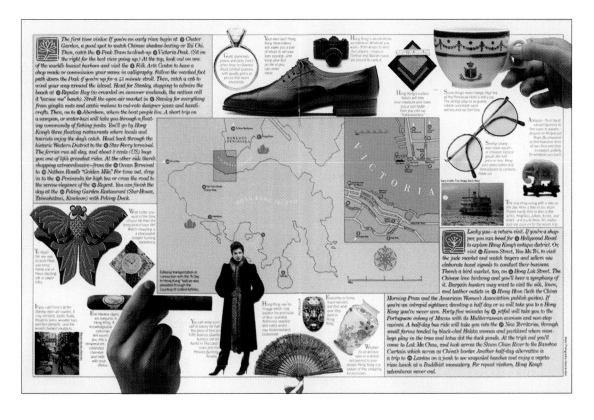

Figure 14-4

This Kit Hinrichs' playful two-page rebus layout incorporates coded maps of Hong Kong, its various districts (complete with information on what to see and do there), and useful information on the shopping treasures available on the island. The art is a wonderful mix of maps, photography, knockouts, illustration, engravings, and contoured type that is meticulously fitted to the graphics. It is, along with being a masterful piece of magazine page design, an elegant and engaging poster. Hinrichs is responsible for the art direction and design. Courtesy of *SKALD* magazine/Kit Hinrichs.

Figure 14-5

@*issue:* magazine is a "journal of business and design," an interesting and appropriate marriage for a subsidized publication targeted at business leaders, corporate communicators, design and business students, and the design and printing community. One of the magazine's missions is to educate students and others about how design impacts business success *and* communication. Michael Schwab illustrated this minimal but brilliant cover: its concept, metaphor, color, neutral background, and simplicity make for riveting art. The name, image, and sensibility of the communication are wedded in @*issue:*'s unusual nameplate. It was published initially for Potlatch, which has now merged into Sappi Paper, N. A. This magazine is an interesting example, too, of designers largely sharing the ideas for the editorial content of the publication, a trend that has recently made inroads in magazines. Courtesy of @*issue:* magazine. Kit Henrichs, design director; Maria Wenzel, designer; Michael Schwab, cover illustration.

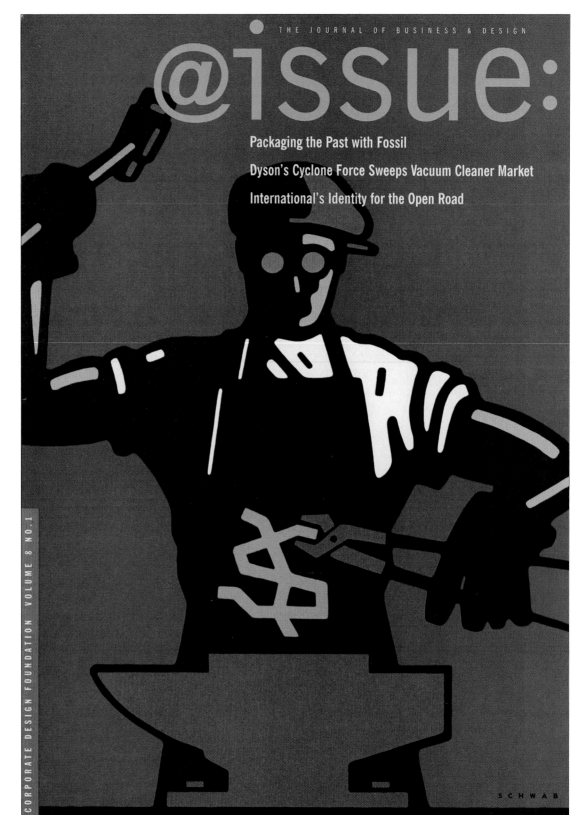

THE JOURNAL OF BUSINESS & DESIGN

@issue:

Packaging the Past with Fossil

Dyson's Cyclone Force Sweeps Vacuum Cleaner Market

International's Identity for the Open Road

CORPORATE DESIGN FOUNDATION VOLUME 8 NO. 1

SCHWAB

magazines were democratizing media. In France, smaller art magazines were making use of two-color, sheet-fed presses. Lithography and posters popularized specific art styles, often the very movements that were being rejected by the academy. Specialized magazines—*Paris Illustré*, *Le Rire*, *Figaro Illustré* (and others similar to them)—published illustrations from Toulouse Lautrec and other artists. *La Vie Moderne* recruited and published art from many of the impressionists, including Manet, Renoir, Pissarro, Sisley, Monet, and Degas, who took up the camera and later made photography contributions as well. The art publications contributed two other things that strongly influenced the future of magazines. First, they ran not just art, but features on popular culture. Secondly, their covers defied convention, often integrating type and illustration into an arresting and resonant poster format—such as this striking *Jugend* two-color cover (see Figure 14-7). Finally, these same publications' playful experimentation with typography influenced nameplate structure.

Magazine design continued to be affected by the art scene. Notably, the modern movement and its various factions—art nouveau, constructivism, Bauhaus, de Stijl, futurism, dadaism, and the Swiss school—all had a considerable impact on magazine design. Most of these beautiful early magazines were humble enterprises that were more focused on experimentation and quality than slick production. Indeed, their audiences were very narrow and small (see Figure 14-8). However, artists and designers from these factions contributed not only radical stylistic influences, they accounted for a revolution in publication design, page structure, and typography. Much of the invention and experimentation in typography and layout from this period are still affecting magazine design today.

In 1930, Henry Luce founded *Fortune* magazine—a business magazine launched in the midst of the Great Depression. However, like many Luce projects, it was a success, mostly because of his insistence on wedding stunning artwork with words. Often the *Fortune* cover art was a blend of Euro-modernism and American industrialism. Indeed, the illustrators, artists,

Figure 14-6
National Geographic, an international icon and tradition, has always used a standard cover format. The design has established product recognition through the years via its familiar bright yellow frame. Note the excellent legibility of the reverse type. Balance, unity, proportion, and emphasis are clearly evident in the cover's design. Connie Phelps, design editor; William Albert Allard, photography. Reprinted with permission of *National Geographic*.

Figure 14-7
The arrangement of space, typography and the use of two-color lithography in this handsome *Jugend* cover (1899) give it a strong poster-like appearance. Hans Christiansen also integrated the rounded, fluid type forms in the nameplate to repeat the graceful arched necks of the swans and the curved lines within the art. Many of the first magazines were directly connected to specific art movements—*Jugend* was the German version of art nouveau. Incidentally, both Germany and Austria are flush with living classic examples of this design style in furniture, glass, and architecture from this period.

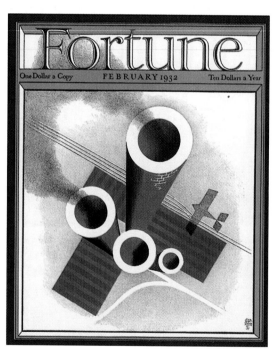

lithographers, and designers read like a who's
who from the art world (see Figures 14-9). Also,
at this time, magazines established the position of
"art editor" or "art director."

Many European designers and graphic artists
immigrating to America—some fleeing political
or cultural oppression—landed in magazine
design. Erté, long associated with art deco,
designed covers and fashion layouts for *Harper's
Bazaar* magazine. Agha, another Russian, was
brought to America by Condé Nast to work as
an art director for a number of publications,

including *Vogue*, *Vanity Fair*, and *House &
Garden*. Alexey Brodovitch joined Erté at
Harper's Bazaar; he became a design legend
whose tenure there ran from the 1934-1958. He
was also one of the major players in the "New
York School" of design in the 1940s and 50s.

While the impact of European modernists
cannot be denied, their rigid and often theoretical
approaches to design were sometimes too iron-
handed. American designers tended to be more
flexible and pragmatic, borrowing from many of
the typographical lessons of the de Stijl and
applying Bauhaus notions of organization, they
charted new directions.

In addition, the end of World War II marked an
important shift. New York City had replaced
Paris as the cultural center of the planet. It was at
this time and from this fermentation that the
New York School was born. Early pioneers
included Paul Rand (an early associate of adver-
tising guru Bill Bernbach) and Bradbury
Thompson. Rand went on to become editorial
designer at *Apparel Arts* and *Esquire* while still
in his twenties. His use of asymmetry and
minimal design were quite influential. Thompson
began his career in the Midwest as a designer,
typographer, and technician at several print
houses. He was not just a production wizard; his
deep understanding of process was applied to a
wide variety of design solutions. One of his most
widely applauded projects was *Westvaco Inspira-
tions*, a promotional magazine targeted at art
directors. It was basically a sampler of printing
papers, but its presentation of type, design, and
art was and still is amazing. Although run in
four-color, the publication had a minimal budget.
Despite those limitations, Thompson's ingenuity
and use of color and space made the project one
that young designers still study today (see Figure
14-10). Among other charges, Thompson worked
as an art director and senior designer at *Made-
moiselle*.

This period was truly a renaissance in
magazine (and graphic) design, and the innova-
tors and heroes were many. There is not nearly
room enough to discuss them all, but it would be
remiss to not make specific mention of Alexander
Liberman, Henry Wolf, and George Lois.

Liberman took on the reins of art direction at *Vogue* in 1943, but his finest work came later when he teamed up with Priscilla Park and photographer Irving Penn.

Henry Wolf had a passion, gift, and creative insight for concept covers. Some of this might have stemmed from his "other career." Like Rand and Lois, he began his graphic career in advertising. Wolf served as art director at *Esquire* (1952-1958), *Harper's Bazaar* (1958-1961), and *Show* (1961-1964). His book, *Visual Thinking*, offers a glimpse into how he worked and thought. The chapters entitled "Strange Perspective," "Unexpected Combinations," and "Roundabout Ways of Telling a Story" sum up Wolf's unorthodox methods.

George Lois' concept covers for *Esquire* and other publications have yet to be bettered. He loved visual metaphors and clever graphic puns.

In the 1960s media critics forecasted the demise of the magazine. They were only partially correct—primarily in two respects. First, the large general interest, pictorial magazines targeted at mass audiences were becoming dinosaurs. Many of the biggest had been folding. Television, among other things, replaced some of the need for them. Advertising also took its toll, and many advertisers and clients sought a tighter market niche. Targeting audience segments was becoming much more important to both magazines *and* advertisers. Secondly, magazine

layouts became more predictable and less visual. The use of typography also became more rigid, due to many publications adopting the International Typographic Style. To be sure there were exceptions, but the age of look-alike covers and more conservative magazine design had arrived.

One of those exceptions was Herb Lubalin, who was a typographic genius, as well as a brilliant designer. His design and art direction for *Eros*, *U&lc*, and *Avant Garde* are legendary. By the end of the 1960s, the letterpress and hot type were dying. The letterpress would soon be replaced by phototype. International Typeface Corporation (ITC) and companies such as Compugraphic were among the leaders in phototypesetting equipment. However, personal computers and "desktop" publishing would make phototypesetting extinct 15-to-20 years later. Lubalin—along with typographer Aaron Burns and phototype experimenter Edward Rondthaler—founded ITC in 1970 and dominated not only the phototypesetting industry, but type design itself. Phillip B. Meggs points out in his book, *A History of Graphic Design*, "Following the examples of Univers and Helvetica, ITC fonts had large x-heights and short ascenders and descenders; these became the prevailing characteristics of fonts designed during the 1970s and 1980s."

Some of the other important figures in design in the latter part of the twentieth century

Figure 14-10
Bradbury Thompson was a true anomaly. His technical background and practical experience with camera work, type, and the halftone process, brought special insights to his design gift. These two pages from *Westvaco Inspirations* demonstrate that true genius. Perhaps what is most striking about the work is Thompson's ability to make brilliant statements with average imagery. Courtesy of MeadWestvaco Corporation.

Figure 14-11

ESPN (The Magazine) was initially designed by WBMG, Walter Bernhard and Milton Glaser's offices in New York City. The magazine's cover is large, bold, and unmistakable; its nameplate, run in a gold metallic ink in this issue, also happens to be the ESPN network logo. Ben Wallace poses here as the fearsome, working-class, get-the-job-done rebounder he is. The cover is clean, dynamic, and always packs a lot of attitude. It's a fitting stance and an appropriate window into the rest of the book. How does the type work with the *content* of the cover? Design director, Peter Yates; art director, Henry Lee; director of photography, Nik Kleinberg; cover photography, Blake Little. Reprinted with permission of *ESPN* magazine.

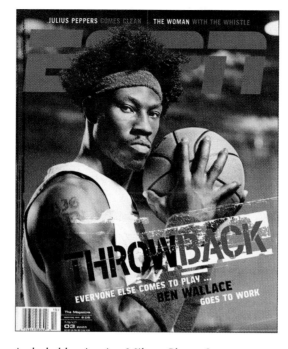

Figure 14-12

Emigre began as a working experiment, probably the truly first Apple Macintosh "desktop" magazine. It served as a kind of counter-culture publication for many years that pushed the use and notion of digitized type. It is celebrated for its experimental approaches to design—from complex, layered pages to out-and-out post-modern designs. Today, the back issues are collector's items, and the magazine continues to push the boundaries of type, design, and technology. This cover is *Emigre*, No. 36, fall issue, 1995. Copyright Emigre, Inc. Designed by Anne Burdick. Reprinted with permission of Emigre, Inc.

included luminaries: Milton Glaser, Seymour Chwast, Walter Bernhard, Willy Fleckhouse, Rudy VanderLans, Zusana Licko, Fred Woodward, Paula Scher, D. J. Stout, David Carson, Connie Phelps, and Kit Hinrichs. Glaser and Chwast founded Push Pin Studios (1954-1974) and launched *Push Pin Graphic* magazine as a vehicle to spread their vision. Its impact and their fresh approach to design were felt

worldwide. Much later (1983), Glaser and Bernhard would team up to focus mostly on magazine design and redesign in their WBMG offices in New York City; clients included *Money*, *ESPN*, *Time*, *Brill's Content*, *Adweek*, and *The Nation* (see Figure 14-11).

As art director for *Twen*, German designer Willy Fleckhouse brought a fresh and bold vision to editorial design. *Twen* raised the bar and served as a model from afar (Germany) for many contemporary designers. VanderLans and Licko were two other Europeans, who, like Lubalin, would have a significant impact upon type design. Frustrated over the limited typefaces available on the early Apple Macintosh computers, they invented their own, using Licko's computer programming background and FontEditor, a public domain character generator software. Their design ideas and typefaces were used in their magazine, *Emigre* (see Figure 14-12). Fred Woodward served as art director at *Texas Monthly* and *Rolling Stone*. He currently serves as graphics editor at *GQ*. His design is chameleon-like, often adopting other artistic influences (Bauhaus, retro, de Stijl, art nouveau, constructivism, 1960s psychedelia, and many others) or inventing new styles or combinations to fit the design problem, content, or sensibility of the story (see Sidebar and Figure 14-13).

The design range of Paula Scher is simply amazing; her knowledge and understanding of the history of graphic arts is reflected in her work. That gift and her sensitivity to *telling the story* graphically are second to none. Another gifted storyteller is D. J. Stout; his accolades for great design are well-documented through his art direction at *Texas Monthly* and Pentagram Design. Like Woodward and Scher, he has an intuitive bent for sizing up the sensibility of a story or message and arriving at a solution that is as original and discerning as it is appropriate, regardless of the medium.

David Carson created not only a new vision for magazines—*Beach Culture*, *Surfer*, and *Raygun*—but a swirl of controversy over his complex, exploded, post-modern style. Often the result of his experimentation and design was that the content was rendered unreadable, or nearly so. In direct contrast to Carson is Connie Phelps,

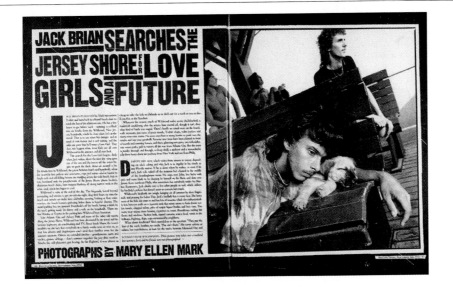

Fred Woodward/*Rolling Stone*

Fred Woodward is a living legend in magazine design, typography, and art direction. He's served as art director at two of the best-designed publications in the world—*Texas Monthly* and *Rolling Stone*. Later he was appointed as creative director of Wenner Media, overseeing *Rolling Stone*, *Men's Journal*, *US*, and numerous book and other publication projects. At this writing, Woodward serves as creative director at *GQ* publications.

Under Woodward's instinctive and insightful direction, *Rolling Stone* amassed more design and art direction awards than any other publication. He is also renowned for motivating and bringing out the best work from his creative staff and freelancers. He delegates with precise direction, a charge he takes seriously.

The power of his style stems from its remarkable *invisibility*. He possesses an uncanny ability to synthesize content and translate it into meaningful graphic style and storytelling. Perhaps Fred Woodward, more than any living designer, is best at drawing intuitively from art and graphic design history as well as from the bits and pieces of his past and from our collective simple reality. The result is breathtaking work that wows the average reader and the entire graphic arts world. He is chameleon-like and different from all his peers. In a world of signature designers, specialists, and many who mimic trendy styles or effuse style sans substance, Woodward shines uniquely. His design gift and prolific output earned him a place in the Art Directors Hall of Fame—the youngest person to have received that honor.

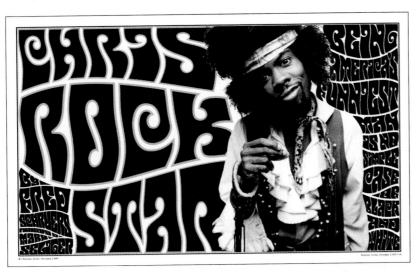

who works at *National Geographic* as design editor. Notice how she makes a powerful entrance in the compelling feature, "Meerkats – Stand Tall," with the photography and subtle crafting of type (see Figure 14-14). Her work and recent redesign of that publication is featured later in this chapter.

Last but certainly not least is Kit Hinrichs, whose magazine and other design work has graced pages throughout this text. In fact, he designed the book in your hands. To really understand design—or any discipline for that matter—it's essential you have a knowledge of its history, pushes, pulls, and possibilities. Studying the work of these masters and other talented designers is a grand start.

Big and Small Magazines Are Basically the Same

When you mention magazines, most people visualize one of the more popular publications, *Reader's Digest* (12.5 million readers), *TV Guide* (10 million), and *National Geographic* (8 million), with their impressive circulation figures.

Longtime standouts that come to mind include *Time, Sports Illustrated, Family Circle, Newsweek, Vogue, Rolling Stone,* and *Better Homes and Gardens,* or newcomer successes such as *Maxim, Wired, Wallpaper, ESPN, Elle, GQ* or *Premiere.* Most readers are familiar with *National Geographic* and its stunning photography, or *Scientific American,* with its neatly ordered layouts and its precise, detailed charts, and insightful information-graphics.

What they may not realize is that there are thousands of other magazines with specialized markets—magazines that are equally important to their readers. Magazines that rival their larger counterparts in terms of design, photography, and reportage: publications such as *DoubleTake, Paddler, Yes!, SOMA, Transworld Skateboarding,* and *Adbusters.* Complimentary magazines are a sub-category within this group. *Ruralite,* for example, is published by an eclectic co-op and distributed to all of its members.

In addition, some regional magazines maintain national and even international audiences— magazines that are as amazingly beautiful as they

Figure 14-14
National Geographic, long known for its compelling photography and ability to take us to exotic places, has received, in the past twenty years or so, equal acclaim for its meticulous design. Connie Phelps is the person whose vision has largely shaped its architecture, typography, and beautiful presentation. This spread, "Meerkats Stand Tall," uses type wisely: the deck or introduction mirrors the upright meerkat, and the header works seamlessly with the art. Connie Phelps, design director; David Whitmore, design editor; Mattias Klum, photographer; story, Tim Clutton-Brock. Reprinted with permission of *National Geographic.*

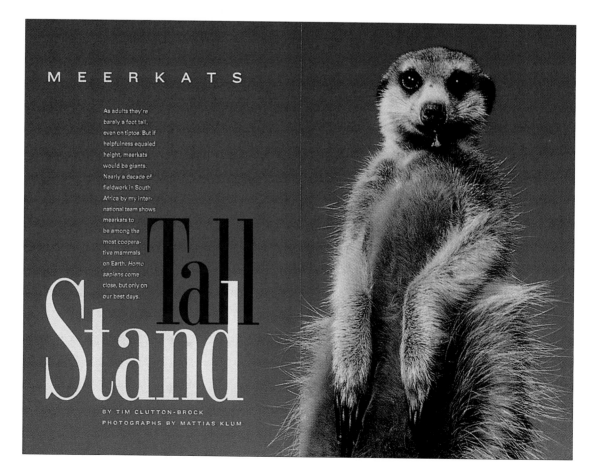

are thoughtful and influential. *Texas Monthly*, *The New Yorker*, *Chicago*, and *Arizona Highways* are wonderful examples of this genre of publication (see Figure 14-15).

There is yet another tier of magazines that falls under the general category of "trade publications." In fact, some magazine conglomerates specialize in nothing but trade books. International publisher Advanstar successfully cranks out more than fifty titles with such publications as *Urology Time*s, *GPS* (Global Positioning System) *World*, *American Salon*, *Physician's Management*, and *Pest Control*. There are also many corporate magazines you'll never find on coffee tables. Finally, many small publications target very specialized audiences. For example, *Fresh Cup* is a successful book focusing on just about any aspect of the coffee business you can imagine. Another interesting example is *@issue:*—a beautifully designed journal on the business of graphic design. It is complimentary, subsidized by Sappi Fine Paper of North America, and targeted at designers, art directors, printers, creative directors, and graphics people involved with publications.

What do all these magazines hold in common? Graphically, they work from the same basic

design principles and typographic tenets you've been studying. Indeed, the small rural electric association's quarterly can be just as attractive as larger publications and equally as effective communicating with its audience.

Of all the areas of printed communication, probably none is more interesting, challenging, and rewarding than magazines. Deadlines are demanding, but unlike newspapers whose turnaround time is overnight, magazine deadlines are more protracted. They are often planned months (sometimes a year) in advance. Generally, though, magazines are more meticulously designed and handsome by comparison as a result of their more luxurious deadlines and planning opportunities. On the other hand, *Metropoli*—a weekly magazine published by Madrid's *El Mundo* newspaper and art directed by Rodrigo Sanchez—continues to create smashing covers and magazine spreads week after week, year after year, despite the cramped turnaround time (see Figure 14-16). Other strong newspaper magazine components include *The New York Times Magazine*, *Pagina/12* (Buenos Aires), *The Seattle Times' Ticket*, *La Luna* (another *El Mundo* publication), *The Boston Globe Magazine*, *Clarin* (Buenos Aires), *The Independent's Sunday*

Figure 14-15
Texas Monthly, a local publication with an international reputation, has been a hotbed for magazine design. (There must be something in the water in Austin.) Fred Woodward and D. J. Stout set the bar at *Texas Monthly* for art direction. Here, D. J. Stout marries type and photography to content. "The Soul of East Texas" appeared in *Texas Monthly*; the story is a photo essay by Keith Carter with accompanying text by Prudence Mackintosh. Carter's duotone images are absolutely haunting. D. J. Stout's use of classic roman type in the headers, and the photograph of the worshipper looking into the opening left-hand page make for a direct, simple design that is befitting the content of this sensitive piece. Art direction and design, D. J. Stout; photography, Keith Carter; text, Prudence Mackintosh. Reprinted with permission of *Texas Monthly*.

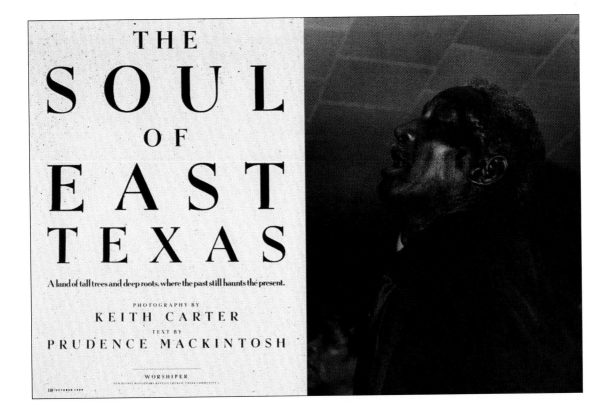

Figure 14-16

Frida. The *Metropoli* cover type, *frida, la atormentada biografía de una pintora diferente* (the tormented biography of a different painter), arches the illustration and meshes stylistically with the art. Frida Kahlo married Diego Rivera very young and their lives together were tumultuous. Her paintings incorporate the environment and backgrounds symbolically. Many of her paintings were self-portraits that were both haunting and revealing. Art direction and design, Rodrigo Sanchez, illustration by Raul Arias. Reprinted with permission of *El Mundo*/Unidad Editorial S.A.

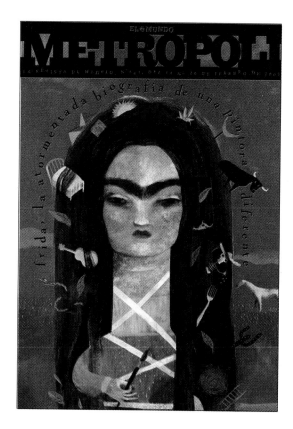

Review (London), *The Philadelphia Inquirer Magazine*, and *The Chicago Tribune's Sunday Magazine.*

It might surprise some to learn, too, that comparatively speaking magazines typically have *much* smaller staffs than their newspaper counterparts. Many magazines support an art director or graphics person whose main charge is the responsibility for all of the creative aspects of producing the magazine. The art director makes all the graphic decisions, and normally has production experience as well.

Although our concerns focus upon layout, artwork, type, and design, we cannot separate these facets of magazine production from editorial planning. Editors of larger magazines assemble editorial and art staffs months prior to a specific issue to entertain story, design, and photography possibilities. Together, they share ideas, select stories, budget space, and decide upon art and design direction. This activity may play out between two or three people at smaller magazines and many more at large publications—but the intent, planning, and function of the process is the same.

Basic Magazine Terminology

The following list contains basic terms anyone engaged in magazine editing, design, or production should understand.

Bleed: Art that extends beyond the page's borders. Note: when you do bleed a photograph or line art, make sure you run it at least 1/4 inch beyond all the outside edges of the page. If you don't, you stand a chance of a strip of white space appearing on your bleed edge if the page trim is off a bit. Don't put critical art components on the edge of any bleed.

Break of the book: The sequence and allocation of space for departments, articles, features, and other material printed in the magazine (see Figure 14-17).

Contents page: The page (or pages) that list, tease, and provide logistics for all the features, departments and other material in the book.

Cover: Includes not only the front page but the other three pages making up the outside wrap of the magazine as well. Note: the cover is usually printed separately on a different cover stock and designed as a separate entity as well.

Crossover: Artwork (or type for that matter) that straddles two pages is referred to as a crossover. They are an added cost. If you do use them, don't barely cross the page; bridge the pages purposefully. Be careful when you do use crossovers that you don't position type or important art elements in the gutter or on the crease.

Folio: Page numbers, date, and name of the magazine that appear on the pages—usually on the bottom of the publication's pages.

Front of book: An area, often at the front of the magazine, where short articles appear, or several unrelated pieces run on the same page. When these terms are placed in the back of the magazine, they are referred to as the back of the book.

Gutter: The margin of the page at the point of binding, or the *inside* margin. The term "gutter" is sometimes used when referring to the margins between text columns.

Logo: The magazine's nameplate, which often appears on the contents page, masthead, and so on, in addition to the cover.

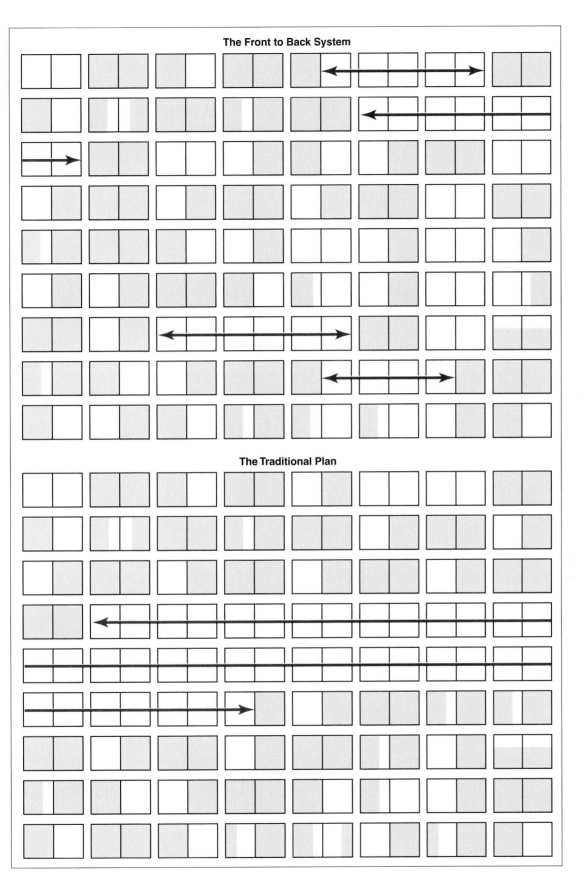

The Front to Back System

The Traditional Plan

Figure 14-17
The *break of the book* is an invaluable planning strategy that reveals where all the elements of a magazine's logistics are at any time. The break of the book is updated as stories evolve and as photography, editing, design, and even advertising are plugged into an issue. Most large magazines have several of these spread out on a wall or board concurrently because the staff is planning several magazine editions months ahead. Typically, the grid/page system runs front-to-back—cover to cover. The shaded areas shown here indicate ad placement. The break of the book keeps everyone current regarding the evolution of a particular issue.

Masthead: Area of the magazine that details all the staff, mailing, advertising, subscription, and other information. A masthead is not to be confused with a publication's nameplate or logo.

Perfect binding: Binding method that uses a flexible adhesive to hold cut and folded signatures together. The cover is wrapped and crimped while the adhesive is still wet (see Figure 9-50).

Saddle stitch: Binding that stacks signatures and then staples the middle fold of the pages (see Figure 9-50).

Self cover: Magazine cover printed on the same paper stock as the rest of the book.

Sidestitch: Binding in which staples are driven through stacked signatures of the magazine (see Figure 9-50).

Signature: A large, standard-sized sheet of paper stock that is printed on both sides, folded and trimmed to make up a section of a publication. For example, eight pages might be printed on each side and run as an sixteen-page signature, eight pages on each side of a sheet would be a 16-page signature, and so on.

Good Design Reflects Content

In any medium, but particularly in magazines, visual form and verbal content are inseparable. That is why it's essential that the editorial staff understand the visual aspects of their work. Likewise, it is precisely why visual people should be aware of the content, principal characters, and other details of the story—so they can better communicate its essence. It's imperative that everyone is on the same page. Your job as an art director, designer, photojournalist, illustrator, or other visual specialist is, again, *to tell stories visually* (see Figure 14-18).

Ideally, the art staff is intimately familiar with story content. That begins by making certain everyone involved with the story, including the photographer, designer, or illustrator assigned that piece, has read it (when possible) or seen existing treatments or outlines. For the photographer, a shooting script is also a good idea.

Articles that are well written but suffer from poor design won't get the readership they deserve. While compelling art cannot save poor writing, it should help tell the story and attract readers.

However, if the art and design are inappropriate or irrelevant to the story (no matter how beautiful or well-executed), they'll have failed—or worse yet, been misleading. The best stories are evolved carefully and shepherded start to finish by both sound art and editorial principals.

This "maestro" partnership creates a marriage between content and design. The editor's charge is to help keep the design relevant and within the limits of its function. The art director plots the overall graphic direction and assigns a photographer or illustrator to the piece. The photographer's charge is to make images that are memorable and tell the story. The designer weaves all the elements together in the layout to tell the story through its type, color, design features, and artwork (see Figure 14-19).

Long-Range Decisions

In designing or redesigning a magazine, there are several long-range decisions that should be determined early. These include the following:

- *Mission*: Determine exactly why the book is being published, and what the editors hope to accomplish by sending it out into the world. What do you suppose the mission of *Rolling Stone* is? *Wired*?

- *Personality*: Magazines, like people, are unique and have their own character, quirks, accouterments, and sensibility. Everything that's visual —from their type to their format, photography, and graphic attitude—should suggest that personality. What sort of image do you want the magazine to project? Is it dignified and reserved, informal and playful, or edgy? Loud? Counter culture? Thoughtful and copy-heavy? *SKALD* magazine's personality is playful but informative; its image is an elegant one. How would you characterize the personality of *Vogue*?

- *Audience*: Who makes up your readership? What sort of person do you expect to read the publication? Are they more word or imagery driven? Age, social and economic group, gender, culture? A college professor likely has different interests and reading habits than a rock musician or computer programmer. How are those readers different? Similar? How do you want to accommodate them? Voice? How do

Figure 14-18
The three spreads of
"America in Black and
White" from *FLUX*
magazine do a great job
of visual storytelling. The
feature piece contrasts
two stridently different
groups of patriots.
Women in Black silently
protest the war in Iraq
and violence in all forms.
People in White are pro-
Bush and in support of
the United States'
involvement in the
Middle East. This
photo essay does a great
job of comparing and
contrasting these two
groups and their stand on
war. (from top to bottom)
Luis Salazar shot this
compelling image of
children demonstrating
their support of American
troops in Iraq. The peal of
a hand-rung bell cues the
demonstrators from the
Women in Black group to
begin their 30-minute vigil
of silence. Horns, singing,
cheers, and a blur of flags
loudly announce the
arrival of the other group.
Tight shots, framing,
inventive cropping, and
dramatic use of space give
Salazar's imagery power.
Photography by Luis
Salazar; layout and design
by Jessica Weit; art
direction, Laura
Chamberlain; story by
Meg Hemphill and Josiah
Mankofsky.

Figure 14-19

"Come Together", a *FLUX* feature on intercultural and interracial dating among students on university campuses, uses the opening spread to tell the story visually. Kim Nguyen's powerful photograph uses a university gate to frame the couple; the o-shape is suggestive of unity. Beneath the bridged artwork is a statement by each person. The title of the story clearly flags the reader to suggest its content. An opening deck provides an overview of the story, along with statistics on intercultural/ interracial dating. A tight photograph of two hands is screened back behind the type and deck (upper left). Writers Calley Anderson and Kathleen Holt worked closely with photographer Kim Nguyen, designer Nann Alleman, and the story's art director and designer, Matt Lowery. The opening spread reflects their cooperative effort. Courtesy of *FLUX* magazine.

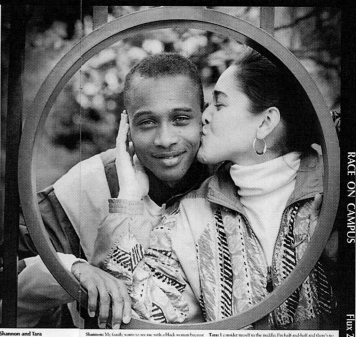

you want to talk to them? What are their interests, philosophies, and attitudes? How do they live?

- *Formula*: This refers to their philosophical mix. What kinds of information, articles, reviews, features, profiles will be included in *each* issue, and *how* will those components be presented.

- *Advertising*: Most magazines carry advertising, which in turn determines the size of the book. The more money ads generate, the more room there is for editorial material. Establishing a clear audience niche is important not just to a magazine's content; it's extraordinarily important to the publication's advertisers. Advertising also may determine the break of the book. Today, for example, many magazines have adopted the strategy of *not* running adjacent table of contents pages, that is, two-page spreads? Why do you suppose? The reason is simple. *Money*. If a publication splits its contents pages, it can likely charge more money for a page next to a contents page, because it gets plenty of traffic. Most ads run to the *left* of the single contents page. Why? Some magazines have even adopted the practice of running more single-page feature openers for the same reason—the bottom line. Designers resent that policy. Kit Hinrichs comments:

"Today so many publications have become advertising vehicles in search of an idea that ad sales often rule their editorial look and structure. Consequently, double-page table of contents have become a rarity. Why have a spread and no ads, when you can sell an ad opposite two separate *single* page table of contents pages? Ultimately, it is my opinion that an engaged readership is the real key to ad sales and higher rates."

- *Frequency*: The difference between the deadlines and timeliness of content, planning, design, staffing, and advertising will be substantial between a weekly, for example, and a quarterly publication.

- *Design and typographic determinations*: These include basic format: the page size, margins, number of columns per page, use of color, photography, nameplate, and the graphic stylebook. At the time of this writing, *Popular Science* magazine only uses two display faces—Futura and Celeste—for its feature openers but allows a tremendous amount of variation in typographic details—weight, size, style, leading, alignment, width—and how they're applied. Its smart type and design strategies were conceived by art director Dirk Barnett (see Figure 14-20).

IN HIS LAB FAR FROM THE SCENE OF A CRIME, SKIP PALENIK FORGES UNBREAKABLE CHAINS OF

EVIDENCE FROM DUST & DETRITUS. LET'S WATCH THE MASTER AT WORK. **BY GORDON GRICE**
PHOTOGRAPH BY JAMES LABOUNTY

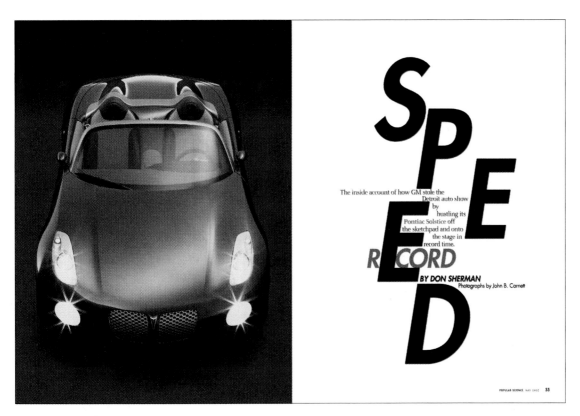

The inside account of how GM stole the Detroit auto show by hustling its Pontiac Solstice off the sketchpad and onto the stage in record time.

BY DON SHERMAN
Photographs by John B. Carnett

Figure 14-20

These *Popular Science* spreads received awards and recognition for their use of type, art, and overall design. Notice how different the handling of the type is in each instance; in fact, the average reader probably wouldn't realize the header stylebook employs the same two typefaces in the spreads. (Top) "Crime Seen," a clever play on words, is a story about Skip Palenik whose skills in forensic science provide convincing and convicting evidence in important cases. (Bottom) "Speed," uses the same typography but applies it in an appropriate but dramatically different fashion. Minimal and efficient use of typography by Dirk Barnett, who served as art director, design director, and designer for both of these layouts. James Labounty shot the photography for "Crime Seen." James B. Carnett was photographer for "Speed." Courtesy of *Popular Science*.

• *Editorial style*: Standard guidelines are used for consistency: spelling, grammar, punctuation, capitalization, and so on. Usually, magazines adopt the *AP Stylebook* or guidelines very similar to it. Many stylebooks also include all the physical aspects of the magazine. Staff members and freelancers are expected to adhere to the guidelines.

Stylebook: Cover and Typography Choices

The stylebook addresses all typographic components of the magazine: text, captions, pull quotes, crossing heads, by-lines and so on. It also takes into account all other design features, including the cover, photography, table of contents, design, keylines, column width, margins, and advertising placement.

In a nutshell, *the physical appearance of the magazine should reflect the editorial content and appeal to the audience for which it is intended.*

There are two basic philosophies for typographic headers. The first is to adopt one or two families of type for all headlines or titles; the second is to exploit a wide array of faces, selecting each header based upon the attitude, feeling, or image the art director wishes to impart about the content of a particular story. *Time*, *U.S. News and World Report*, and *Esquire*, for example, adopt the former approach. So, too, did *FLUX* magazine in its most recent issue, but in a most creative fashion (see Figure 14-21). On the other hand, *Rolling Stone*, *Seventeen*, *National Geographic*, and *Raygun* vary their feature headlines considerably. Witness the tremendous variety of type in all the *Rolling Stone* and *National Geographic* openers in this chapter.

Cover policy includes not just the nameplate and its related components, but how art, cover lines (or blurbs), and type will be treated. Not just what art will be run on the cover but how it will be presented. *SKALD* magazine mandated that the cover art would be fully bled, tightly cropped head shots. (Note examples in this chapter.) *The New Yorker* has always used illustration for its covers. *Time* varies its covers—illustration, photography, info-graphics, concept, or all-type covers; but always rimmed with *Time*'s signature red border. *Communication Arts*, a magazine which showcases the finest photography, illustration, interactive, design, and other visual media, is targeted at art and creative directors and people involved with graphic arts (see Figure 14-22).

A magazine's success is closely tied to the ability of its producers to isolate the target audience and create a product that will appeal to

Figure 14-21
Although typeface is consistent for headers in the *FLUX* stylebook, variations abound. Art director, Emily Cooke adjusts the type's color, size, and playful interaction between words within the headline slightly differently in each story. Compare the header treatment of this *FLUX* story, "The Dry Divide," to another story from that same issue, "Winds of Change." (See Figure 8-43.) Art direction, Emily Cooke; design, Russell Weller; photography, Karen Kanes; story by Lila Marie Thomas. Courtesy of *FLUX* magazine.

that audience. Thoughtful, appropriate design can help ensure that goal.

A magazine devoted to sports shouldn't look like a financial publication. Its appearance should radiate sports: big headlines, dynamic photography, energetic visual direction, color, vital pacing. It should be a brisk read and experience. A magazine targeted at thirty-something businesswomen should wear a different typographic "suit" than one appealing to counterculture snowboarders. These stylistic differences need to be clear and carefully considered in the initial planning stages when you are shaping the look of the book.

Visualization in Magazine Design

Visualization—the construction of mental imagery—is central to the magazine's appearance. It figures as the starting place of the book's graphic evolution.

One caution: it isn't enough that the magazine's appearance suggest, for example, "fashion." It must be stated uniquely, freshly, appropriately. The color, type, art, and other graphic nuances should stand *that* particular fashion magazine apart from all the other publications within its category or genre.

Scientific American is considered one of the world's best-designed magazines. It speaks to its audience clearly, smartly, distinctly. Its newsstand aura is considerably different than *Thrasher*, *ESPN*, *Premiere*, *Home and Garden*, or *GQ*. *Scientific American* might not appear compelling to someone interested in four-wheeling, fashion, or gardening, but its cover and overall design is a great match for those interested in the world of science.

Assistant Art Director at *Scientific American*, Mark Clemens articulates the function of design, "*Scientific American* deals with hard science and difficult subject matter, so it is imperative to keep the book looking clean, distinct and smart. The objective is to give readers a broad range of knowledge within the sciences." Very often that means employing illustration to demonstrate complex written information. "Portrait of a Volcano" is a great case in point (see Figure 14-24).

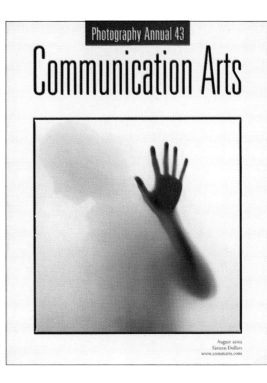

Figure 14-22
Communication Arts uses a clean, minimal but inviting cover design. The white space appropriately frames the art in the same fashion that a mat on a painting would frame the art. This is *Communication Arts Photography Annual 43*. Cover photograph by Damon Winter from a *Dallas Morning News* essay on the five senses; photo-editor at the newspaper is Anne Farrar. Patrick Coyne is editor and designer and Mark Eastman is associate editor at *Communication Arts*. © 2002 Damon Winter/*The Dallas Morning News*.

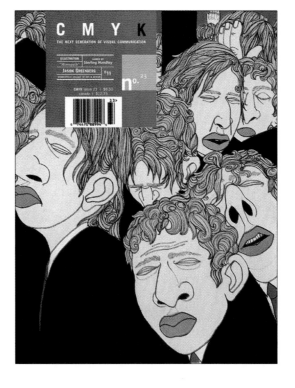

Figure 14-23
This *CMYK* logo is one of the more unusual magazine nameplates you'll likely come across. The publication showcases student work in advertising, illustration, photography, logotypes, websites, and editorial design. *CMYK*'s logo speaks to its audience. Art direction, Genevieve Astrelli; illustration by Jason Greenberg. Courtesy of *CMYK*. Reprinted with permission of *CMYK* magazine.

Figure 14-24

Mt. Etna is perhaps the most devastating and notorious volcano in the world. Author Tom Pfeiffer provides an informative and interesting overview of the volcano's 500,000-year history in *Scientific American*'s "Portrait of a Volcano." To bring Pfeiffer's words to life, scientific illustrator David Fierstein evolved these marvelous illustrations to help tell Mt. Etna's story graphically. Note the two earlier illustrations he created and their meticulous detail, and compare them to the finished *Scientific American* layout. Notice, too, how the black background adds drama and structure to the page. Illustration, David Fierstein; art direction, Ed Bell; design, Jana Brenning; story by Tom Pfeiffer. You might also wish to visit Tom Pfeiffer's website on volcanoes at www.decade-volcano.net. *Scientific American* © 2003 David Fierstein

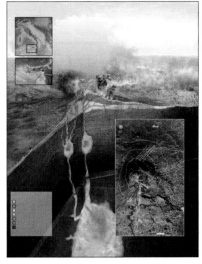

As you might imagine, the research, preparation, and coordination of all aspects of telling Mt. Etna's story were considerable. After the research, planning, and writing have been settled upon and the story's design direction had been chosen, it should not be altered. In order to establish the story's graphic identification and maintain its continuity, the design parts should reinforce one another. The visualization and presentation of the story should be consistent from start to finish. If there are jumps, keep the story's stylistic nuances consistent.

Maintain visualization throughout the book. Again, continuity is important—not just within a given story—but throughout the magazine. So is consistency. Regular readers should be able to spot your cover and nameplate immediately, even in a sea of other magazines on the racks of a newsstand. Finally, as the planning progresses, don't forget one magazine designer's admonition, "If you're dull, you're dead." *Scientific American*'s cover design, for example, is clean, direct, simple and appealing to its well-educated and distinguished readership—but one thing it is *not* is dull.

The Four Fs of Magazine Design

One way to approach a magazine's structure is to consider the "four Fs" of magazine design—function, formula, format, and frames.

Function

The *function* part of this method is obvious, but it will be helpful to jot down the missions the magazine should accomplish. Will it be an internal magazine, meant for the members of an organization or employees of a company or its members? *Ruralite* magazine is targeted at members of a utility company, but because of its broad geographic coverage, it has multiple editions. Or will it be external, aimed at specialized audience? Specific in terms of interests (*Climbing* magazine, for example) or specific in terms of culture, gender, career, avocation, science? Will it be aimed at those traveling at 25,000 feet—passengers for an airline, as United's *Hemisphere* magazine is? Will it be a "how to" publication, such as *How* or *This Old House*, or a publication that thrives on the latest cultural trends, interviews, political stories, profiles, the music scene and reviews, such as *Premiere* or *Rolling Stone*? Will it be a magazine that relies on stunning layouts featuring great photography, such as *National Geographic* or *DoubleTake*? Or will it, like *Texas Monthly*, have a local slant and content that has broader appeal? All these functions relate to the magazine's readership; all these functions affect the physical form of the publication.

Formula

The *formula* is the unique and relatively stable combination of the magazine's various elements—articles, departments, reviews, interviews, even cartoons—that make up each issue. These formula elements include the type of articles to be used: fiction, uplifting essays, interpretive pieces, photo essays, investigative reporting, humor, interviews, reviews, or whatever.

The formula also includes the kind of artwork that will be utilized—illustrations, information graphics, and photography or other art. It encompasses items such as the departments that will be a regular part of each issue, as well as editorial or special interest columns, poetry, cartoons and jokes, fillers, and other front or back of book miscellaneous items. Efforts should be made to produce content that has balance, consistency, and variety.

Sometimes, too, it's good to add a surprise or two to the magazine. Eric Pike really captured the content in his *Martha Stewart Living* piece on pewter—and concurrently brought the book variety by using a duotone approach in the full-color magazine (see Figure 14-25).

The formula may even adopt a consistent lineup of stories. Roy Paul Nelson made an analogy to a baseball manager arranging his batting order to editors establishing their lineup of stories and book parts in *Publication Design*. It's a fitting comparison.

Once the function of the magazine is defined and the formula developed, the designer can focus upon typographic concerns, along with the format and frames of the publication.

Figure 14-25
Normally when you think of *Martha Stewart Living* magazine, Gael Towey's unmistakable palettes of color and impeccable grids with generous use of white space come to mind. But not here. "For this article, in our November 1997 issue, we chose to produce a story on collecting pewter objects as a companion to a colonial Thanksgiving feature. Polaroid 8 × 10″ sepia process was used to capture the patina of this metal." Eric A. Pike, designer/design director; Suzanne Charlé, writer; Jose Picayo, photographer; Fritz Karch, stylist; Gael Towey, creative director. Reprinted with permission of Martha Stewart Living Omnimedia, Inc.

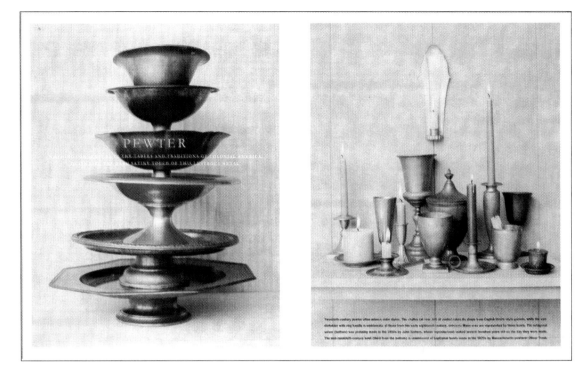

Format

The *format* includes the basic size and shape of the magazine plus the typographic constants and physical features that remain basically the same from one issue to the next. These constants include the cover design, masthead, interior logos, book break (space allocation), placement of regular features (departments, columns, and so on), folio line style, and techniques for handling *jumps*. ("Jumps" are the continuation of articles from one part of the book to the other.)

Magazines adopt a format, a basic design pattern or template, incorporate it within the stylebook, and stick to it. Compare the *National Geographic* interior logo and page design shifts from a recent redesign to the magazine's other department or page changes (see Figure 14-26). Consider the following when configuring magazine format:

1. The press capacity of the printer who produces the magazine and the most efficient way to use paper so you have a minimum of waste. For *one.a magazine*, published by the One Club of New York City, the format involves a *large* 10½ × 15½-inch page size and a distinctive die-cut cover. It's targeted at a very sophisticated audience: the most creative members of the international advertising community. So, its design and format should be equally creative.

one.a magazine's format/formula also includes interviews, reviews, and forums that contrast opinions of leading advertising creatives, along with many standing components such as its "Chatter" department and its die-cut cover (see Figures 14-27 and 9-47).

2. Ease of handling and mailing. How will the publication be delivered to the reader? Mailing it in an envelope could be a factor in determining its size. Some publications, such as *The Smithsonian* and others, use "wraps" on their covers for mailing or subscription purposes. Others, like *Look Japan* and *one.a magazine* wrap their publications in a plastic sheath. How the publication is delivered and used may also affect its format.

3. Contents also affect the magazine's format. Large photo layouts require elbow room, so a larger page size may prove essential to publications with extensive and dynamic art—*ESPN*, for instance.

Magazines generally determine format classifications by page size:

Miniature: 4½″ × 6″
Pocket: 6″ × 9″
Normal Format: 8½″ × 11″
Pictorial: 10½″ × 13″
Sunday Supplement: 11″ × 13″

Figure 14-26
National Geographic recently changed the interior logos and type, and added the yellow tab in the redesign of its front and back departments. Connie Phelps rearranged these components to "reflect a more conventional structure that readers can navigate easily." Compare these *Behind the Scenes* designs to other redesigned front and back components from that magazine (Figure 14-45 and Figure 14-46). Connie Phelps, design editor; Alexandra Boulat, photographer. Reprinted with permission of *National Geographic*.

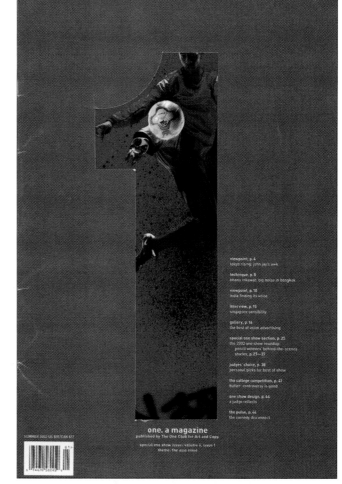

Figure 14-27
Two of the many interesting regular features of *one.a magazine* are (left) its regular "Chatter" department, a panel of the top art and creative directors addressing interesting and often controversial questions in a design format that is reminiscent of an online chat room and (right) its large format, die-cut cover. In some instances, it employs metallic ink covers. Cover advertising from Wieden + Kennedy, Tokyo for NIKE: "Free Yourself! Play like no one else"; creative direction by John Jay and Sumiko Sata. *one.a magazine* editor, Warren Berger; designer, Edwin Laguerre; editorial director, Mary Warlick; managing editor, Tiffany Meyers. Reprinted with permission of The One Club/*one.a magazine*.

There are variations to the standard sizes, and not all magazines fall into these categories. Most do, however, or come very close because of the standard paper sizes utilized by printers.

The most common magazine size today is the basic 8½″ × 11″, or thereabouts. A publication's size is determined mostly by efficiency, costs, function, and use. From a graphic point of view, the basic page provides enough room to showcase art and allow flexibility for interesting layouts.

Frames

Magazine *frames* are the outer page margins, the white space between columns of type and pages, and the white space used to literally "frame" the various elements such as headers, titles, crossing heads, bylines, and art (see Figure 14-28).

The outside and inner margins are important to your read. If you don't believe that, remove a justified column of type from a magazine and with a scissors cut the edges as close as you can to the line endings without cutting them. Then try to read it. As you may recall, *progressive margins* are designed to increase in size as they progress around the page. The inside margin (or gutter) is the smallest. On right-hand pages the margins increase clockwise, and counterclockwise on left-hand pages. *Regular margins*, however, are more common, and, as the name suggests, have identical margin measurement. However, many publications use *fat inside* margins, especially thicker magazines, to allow for the space lost through the binding in the crease of the book. In fact, many design programs have a page default set-up employing fat inside margins. Of course, there are infinite variations, and some designers like to use a deeper margin at the bottom of a page to provide more visual support for the page's content. Again, there is no rule carved in stone here.

Another white space decision concerns the space between columns. Allot a minimum of 1 pica of space here. Less will crowd the page and hurt the read. Generally speaking, the fewer columns you have, the more you can increase space between them without destroying the unity of the text area. Ragged type helps margin widths.

There is a tendency for those new at design to crowd elements. Don't be afraid to use plenty of white space. Set a minimum of 1 pica of space between art and text, copy and crossing heads, copy and pull quotes, and so on. While you can cheat with header and some display type, keep text columns within your margin "halo" all around the page—without fail.

Magazine Design: Assembling the Parts into a Whole

Planning the *break of the book* is a logical starting place for designing a magazine. Generally, there is a pre-ordained pattern established for the book's content. The break determines the sequencing of the all the magazine's parts. It's also used as a sort of working jigsaw puzzle that can at any instant reveal where the progress of the stories and their design are for the editor, art director, or anyone on staff. Some publications—*Scientific American*, for example—have various editions posted concurrently because they provide a long term overview and are useful in plotting future issues of a magazine. *Breaks* are also updated regularly as stories and art arrive and are designed.

Figure 14-28

Understanding the value of margins and how to integrate space within your frame is central to effective, reader-friendly design, particularly on a page as important as the table of contents. Notice how Kit Hinrichs and Maria Wenzel use the outer margins to hold the page together without the use of a single rule or line. White space works almost invisibly in this subtle and well-balanced layout. The art director and designer have integrated white space, color, typography, and art to hold this page together. Deconstruct how they've used each of the design principles in this *@issue:* opening page. Art direction, Kit Hinrichs; design, Maria Wenzel and Kit Hinrichs.

While there are certainly variations on *how* to break the book, there are two basic philosophies. The *traditional approach* is the more Prussian of the two; it locks in the standing components of the book (table of contents, columns, front and back of the book pieces, masthead, reviews, and advertising) at the beginning and end of the publication. The features and "fresh" materials are placed in the middle of the book. Generally, a feature or the strongest piece opens this "reserved" section. This has been an established method for *National Geographic*, *Smithsonian*, and many other publications. The *front to back system* is the other common approach. Under this arrangement, features and new articles are jockeyed around the publication along with the magazine's other parts, save the table of contents which is normally reserved up front. Mind you, magazines may take liberties or combine these approaches.

The Cover

Clearly, the cover is the most important component of the magazine. It's what readers see first and last and it serves as an identifier of the book. You tend to remember which issue a particular story appeared by way of cover recall. Additionally, covers function as a window into the interior of the publication, while concurrently imparting a message about the magazine's personality, image, mission, voice, and contents. That's a tremendous amount to communicate almost instantaneously, which is precisely what covers are expected to do because the audience is often moving past the publication at a newsstand, bookshop, or airport magazine rack. To be sure, the cover is the hook, and as such, it often determines how many copies are sold.

Most all covers share these basic elements: art, nameplate, date/folio line, cover lines or blurbs, price/UPC scan. Art dominates and, given the roles of the other components, typography is also a critical consideration. Together, the art and type should:

- Provide a unique identification of the magazine.
- Act as a window into the publication (see Figure 14-29).
- Communicate some sense of its contents, which is generally accomplished via its cover lines and art.
- Connect visually to its audience.
- Tease or lure the reader inside the book.

Critics have lamented the "formula" magazine cover. Their concerns are defendable. A quick inventory of any news rack would reveal the cloning syndrome common to magazine covers today. Most feature tight portrait shots of celebrities paved with row after row of cover lines. Some magazines—notably teen publications—more closely resemble table of contents' pages given the extraordinary amount of type shoehorned into the cover.

In a recent article in *PopCult* Magazine, "The Decline of Western Magazine Design," Coury Turczyn articulated his case convincingly, "Today, the art of the magazine cover has been vanquished by celebrity worship and bad taste. Designers are simply fulfilling the dictates of their industry, not unlike the paint person on an auto

 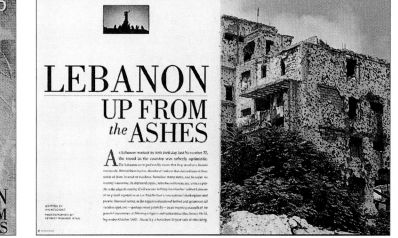

Figure 14-29

One approach to cover design is to select a lead article and feature it on the cover. In this example the superbly designed *Aramco World* used the same typeface and stylistic treatment on the cover as it did for the article's opener. Note the flush right lineup of the cover lines and feature headlines, as well as how the designer used space. Design of *Aramco World* by the Hill Group. Reprinted with permission of Saudi Aramco World, Houston, Texas.

assembly line. Innovation, creative expression, or even cleverness has been mostly abandoned. Artistic considerations are limited to how much retouching the celebrity head shot requires in Photoshop and how many headlines can be crammed in before the cover looks too 'busy.' The result: a world in which it's difficult to tell the difference between *Playboy* and *Harper's Bazaar* without cracking them open." The challenge to break out of that jungle of predictability is a formidable one.

Cover Typography

Most magazine covers are governed graphically by a stylebook. The typography that shapes the nameplate should be distinctive, appropriate, consistent, and large enough to flag its audience. Obviously, too, the logo should be decidedly different from its competing publications. Despite the simian inclinations these days, aping a nameplate is still a mortal sin in the commandments of design. Shaping the trademark of the publication is important, but plagiarism isn't an option. The following are some general suggestions for designing a nameplate:

- Select a typeface for the nameplate that's distinctive and matches the sensibility of the publication and the image you wish to project.
- Make sure it has good legibility. Generally, outline type has terrible legibility. Remember the nameplate or logo has to establish recognition and have good reach or projection. It has to hit a moving target. WIRED magazine has a distinct nameplate with instant recognition, so do *W*, *Rolling Stone*, *ESPN*, and *Harper's Bazaar*.
- It should be long-lived. You can't establish recognition if you're changing your logo or nameplate every other month.
- Try to configure a logo that makes a statement—one relevant to its audience (see Figure 14-30).

Kit Hinrichs offers sage advice for comparing different magazine nameplates for a cover design. "When evaluating a variety of different sample nameplates for a magazine, use the same artwork with the various logos. The reason may not seem so obvious. If you change the image *and* logo, you split your focus and confuse the decision-making process. The opposite is true when evaluating image directions and format. Pick a single nameplate and use it consistently for the entire stage of the process. It's a simple, clear way to make good decisions."

Like the nameplate, the other typography you place on the cover should also have excellent legibility. If you opt to surprint, make sure the cover lines contrast well against their backgrounds. *Surprinting*, you'll recall, is running type atop artwork. That brings up another point. Many art directors despise surprinting. On the surface, it seems inane that an editor would pay a photographer serious money for cover art only to bury it with type. However, publications whose sales at the newsstand are substantial often have to run cover lines in order to compete. That said, if you must use surprinting do so tastefully and keep the type off crucial areas of the artwork. Note the use of type atop art on the previous examples in this chapter.

In designing blurbs it's important to realize the cover is the book's store window. In effect, it acts as a poster or billboard to advertise and, hopefully, sell what the magazine has to offer each issue. Blurbs should be written and designed

Figure 14-30
Again, *@issue:* has a modernity, simplicity, and double entendre on its name and nameplate that *works*. The logotype is relevant to all audience factions: business leaders, the design and business community, and business and design students. Why? What is it about the title, design nuances, and typeface that make it successful? Look more closely at Woody Pirtle's wonderful illustration. Does Gestalt come to mind? Illustration, Woody Pirtle; editor, Delphine Hirasuna; design, Kit Hinrichs and Amy Chan; art direction, Kit Hinrichs. Courtesy of *@issue:* magazine.

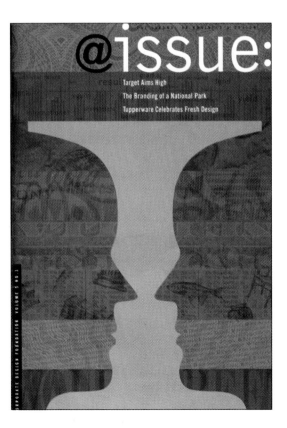

much like the copy on billboards—short and to the point, so that the message can be taken in at a glance. Milton Glaser suggested that a poster's message should communicate in five seconds or less. Magazine blurbs should be equally succinct. Their content should also relate closely to article titles. Since we're on the subject of cover lines, keep them concordant with how they're used inside the publication—in the table of contents and the feature itself. Readers become infuriated when they cannot locate an article hyped on the cover because of title or descriptor inconsistencies. It's also not a bad idea to place a page number alongside the cover lines to help direct the reader. User-friendly design is good design.

Another possible cover component is the slash. A *slash* is a bold diagonal rule usually run in the upper right-hand corner of a cover. It attracts attention and may point up a late-breaking bit of information about an important story inside the magazine. As a rule, they're run in color with bold type inset. If you use a slash, do so appropriately; it isn't just another cover line. Its purpose and information should be urgent, important, or especially timely to a story within the book.

Cover Art

Cover art may appear as typography, illustration, or photography. *Reader's Digest* is one example of a magazine that runs the table of contents on its cover. *Context*, DuPont's corporate magazine, uses its back cover as a table of contents page. *Metropoli* (an *El Mundo* magazine art-directed by Rodrigo Sanchez) often employs typographic illustration for its covers (see Figure 14-31).

Clearly, though, artwork dominates magazine covers. *The New Yorker* is one of the few remaining magazines using illustration exclusively for its cover art. *Metropoli* is another magazine whose stylebook specifies cover illustration; its illustrative solutions are as distinctive as they are refreshing. It's sad, though, that more magazines don't feature illustrated covers because the power and potential of illustration is limitless; so, too, are its many different styles.

Photography's power lies in its credibility. In fact, we trust it so much that we often confuse it with truth, forgetting that photographs are *images* of reality and not the real thing. Its highly graphic or representational nature is what makes it such a persuasive medium. It also has the ability to capture the moment, the essence of an event, story, or person.

Larger magazines hire out freelance photographers for most of their cover imagery, but a handful of magazines keep shooters on staff. Art directors or photo editors work closely with photographers when planning feature stories and cover art, often providing them shooting scripts with detailed expectations. They also insist upon hundreds or more frames of film from which to choose a cover. *National Geographic* magazine's covers are selected from literary *thousands* of frames of film. Compositionally, most cover photos are shot relatively tight, have neutralized backgrounds, capture a great expression, and are visually compelling.

Bleeding art is a common cover strategy. It might be bled in a wide variety of ways. Typically, though cover bleeds tend to be fully bled. Full bleeds increase the total area of the art, and lend more impact to the artwork. Cover borders may suggest a formal framing of the art. *Communication Arts*, *Time*, and *National Geo-*

Figure 14-31
Rodrigo Sanchez has a typographic gift for concept magazine covers. There are additional examples of his insightful work throughout this book. For type to work by itself as the art element of a cover, the idea behind it must be smart. Here Sanchez features typography for an issue of *Metropoli* that features two new films, *Chicago* and Scorsese's *Gangs of New York*. Notice how the *Metropoli* cover offers a flip-flop design that uses typography to suggest the skyline of the two cities. The concept and use of type is as creative as it is simple and brilliant. Art direction and design by Rodrigo Sanchez. Reprinted with permission of *El Mundo*/Unidad Editorial S.A.

Figure 14-32
Art director Dirk Barnett
uses a meticulously
groomed sans serif type
for *Worth* magazine's
clean nameplate, which is
run in a silver metallic ink.
Above the logo he notes,
in an understated manner,
that this is a "Special
Bonus Issue." The content
is clearly and cleanly
noted at the bottom of the
cover: "Wealth on the
Web: Where to find it,
how to spend it" and
strongly contrasted—
white type on the
thousand-dollar, navy blue
suit. The concept photo
for the cover consists of a
well-heeled man reaching
into his suit coat pocket;
his cufflink is a computer
"@" key. This intelligent
cover is able to
communicate a
tremendous amount about
the issue and get in all the
essentials—in a minimal
way. Barnett has worked
at a number of important
magazines on the graphic
side, including *Mirabella,
Men's Journal,
Entertainment Weekly,*
and *Golf & Leisure.* He
currently serves as the art
director at *Popular
Science*—and designs
books as well. Art
direction, Dirk Barnett;
cover photography,
Fredrik Brodén; design
director, Deanna Lowe.
Courtesy of *Worth*
magazine.

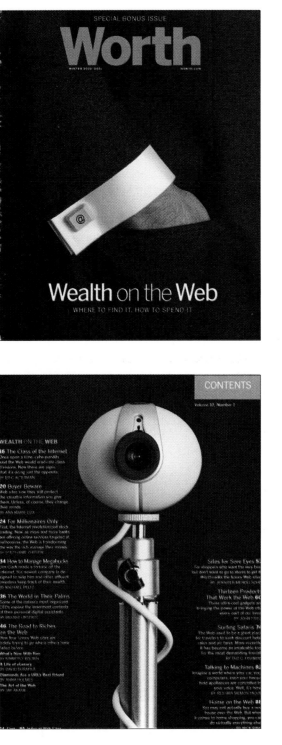

Figure 14-33
This *Worth* table of contents page is unusual and modern
but functional. It's actually the contents page for the
"Wealth on the Web" section of the book. Stylistically,
how does it work with the *Worth* cover? A single piece of
art (which will open the feature) on a black background
anchors the contents' page, and is framed by reversed
type. Each entry provides a header, description of the
article, by-line, and a page number reference. Smart, user-
friendly design. Art direction, Dirk Barnett; photography,
Jonathan Kantor; design director, Deanna Lowe; story,
John Fried. Courtesy of *Worth* magazine.

graphic are three magazines that employ borders.
Whichever strategy or medium you select for the
art, make sure your cover design and its *footprint*
remain consistent from issue to issue. For
example, compare *SKALD, @issue:,* and
National Geographic covers in this book.

Most mainstream magazines run covers sepa-
rately on heavier paper stock. To save costs,
however, some publications may choose to run
self-covers, that is, covers run on the same paper
as the rest of the publication. Other variations
include special cover wraps, usually an additional
plain brown wrapper cover; sometimes these may
not be attached to the cover per se, but slipped as
a sheath around the magazine cover for mailing
purposes.

When designing your cover, first browse
through an assortment of magazines and note
how designers have used typography, nameplates,
blurbs, and artwork to make an effective,
cohesive cover that works hard to capture your
attention and convince you to pick it up or buy
it. Consider these questions to help guide your
evaluations:

1. Does the cover clearly identify the maga-
zine? The logo or nameplate should be distinc-
tive, legible, and large enough to communicate at
a distance.

2. Is the personality of the nameplate a good
match to the audience? Along with being func-
tional (large, legible, and dark enough), it should
be appropriate to the readership.

3. Does it attract attention? The art, name-
plate, and coverlines need to work together *and*
be noticed. When designing magazine covers,
think of them as posters.

4. Is there a strong component to draw you
inside? There should be. Make sure, too, cover
lines and inside titles match up so an interested
reader isn't sent on a wild goose chase. You may
also want to use a page number reference in the
piece featured on the cover.

5. Does the cover design have strong continuity
from issue to issue? The nameplate, other type
treatment, art style, and presentation should be
consistent.

6. Make sure the cover contains all essential
information: nameplate, date/folio lines, price,
and so forth. Notice how art director Dirk

Barnett's handsome cover for *Worth* magazine works. He made sure it carried *all* the essential information: a clean nameplate with an important notation above it ("Special Bonus Issue") and two simple cover lines to connect to the brilliant "concept" cover (see Figure 14-32).

Table of Contents

The table of contents page is perhaps second only to the cover in terms of its importance to the book. Why does it receive such a high volume of traffic? It's an invaluable logistical tool to the reader because it provides a detailed mapping of all the magazine's parts: departments, letters page, columns, standing articles, preview page, and reviews—as well as all the new articles, photo essays, features, and other components (see Figure 14-33).

A good table of contents page works like a good menu. First, it's well organized. A fine menu is fractured into its essential parts: appetizers, wine list, luncheon menu, standing entrées, and specials. Likewise, break out your table of contents page with the same organizational care: departments, front of book, columns, features. Use references—page numbers work fine—on both story entries and any artwork that appears in this section. Like the entrées on the menu,

your magazine's entrées (columns, departments, reviews, features) should be fleshed out. Art directors should provide entrée details; for example, by-lines or credits and a short content descriptor for each story. Again, good design is functional and reader-friendly. To that end, build orderly, clean table of contents pages to effectively and efficiently route the reader through the book.

How much art should be on a table of contents page? It all depends. Visually, the table of contents should reflect the book. If it's strong graphically, there should be a generous serving of art there. If the magazine is word-driven, use less art. Notice how Kit Hinrichs employs his rebus signature to the *SKALD* table of contents page (see Figure 14-34). Many contents pages also provide cover notes, and borrow other style cues from the cover.

What else might you find in a good table of contents? This area of the book is also a logical place to position the publication's masthead, a letter from the editor, or an introductory comment on a theme issue, or to preview art or stories for the next issue. Many magazines also like to reserve a spot on the table of contents page for the cover art—usually a thumbnail image of the cover—along with a short

Figure 14-34
At first glance, what's unusual to you about this table of contents page (right) for *SKALD* magazine? What dominates? How is its format different from most table of contents pages you've encountered? Specifically, how does it connect to the other parts of the magazine you've seen in this chapter and to Kit Hinrichs' design style? Compare this *SKALD* magazine cover (left) with the first example used in the third chapter (see Figure 3-43 and 3-45). Again, there are no cover lines save the nameplate and date/folio line. The stylebook calls for tight *photography* of people or animals—*no celebrities here please*—that's squared up on the page. It makes for a clean and dramatic entrance; and the point, too, is that it demonstrates *SKALD'S* cover footprint or parallel structure. Art direction and design, Kit Hinrichs; photography from Comstock. Courtesy of *SKALD* magazine/Kit Hinrichs.

paragraph and photographer's credit. The masthead—not to be confused with the book's logo or nameplate—is a must for all publications. Among other things, it should provide a hierarchical listing of the magazine's staff, the magazine's address, and whatever other information the publication deems necessary for submission and advertising purposes.

Feature Stories

Feature articles are the main draw of the magazine. They are the principal reason that readers are there, and features take up the lion's share of the planning, time, energy, money, design, and artwork of the publication.

Recently, a *Media Post Monitor* report conducted by Erdos & Morgan found that magazines are considered to be the most "personal" and "relevant" medium today. One of the likely reasons for that sentiment is the nature of magazines themselves. They tend to be a very personal medium and have distinctive personalities. Why? Well, the best magazine designers speak graphically to their audiences in a befitting and clear voice. In addition, the editorial content of those publications is neatly tailored to their readers, and its presentation is equally appropriate and compelling.

Designing features begins with careful planning on all fronts. For starters, it is crucial

Figure 14-35

This feature from @*issue:* is simple in its design, but speaks to the content visually. Kit Hinrichs opens the five-page feature on the Restoration Hardware company. The art, a custom hammer and nails, straddle the opening pages. A beautifully written deck also bridges the pages and speaks to *what* the Restoration Hardware chain is all about: providing original and remade retro hardware to baby-boomers who're refurbishing or updating vintage homes. They provide wooden hammers, pewter fixtures, art deco-inspired furniture, brass and glass doorknobs, and a million other nostalgic items that connect to the past. It's a playful layout, characteristic of Hinrich's rich rebus design penchant. Kit Hinrichs, art direction; Amy Chan, designer; Delphine Kirasuna, editor; Steven Underwood, still life photography; John Blaustein, interior photography. Courtesy of @*issue:* magazine.

you understand the mission of the magazine, its audience, and the content of the story you are about tell. The maestro concept discussed earlier applies particularly to feature design. In order to fuse word, image, and design, it's important that the editor, writer, photographer, and designer be "on the same page." Each needs to understand the gist and point of the story. As a designer, you ought to be able to sum up a story in a single paragraph. Film producers suggest that a screenwriter be able to present a scenario in twenty-five words or less! Maestro team members should read and discuss the story, and each write a one-to-two paragraph description or summary of the feature. Compare notes. You'll discover quickly if everyone's read and understands the story. Who are the principals? What is the tone of the story? What needs to be *shown*? How? Why? (See Figure 14-35.)

Decide *which* tools you're going to use to tell the story, and how you're going to use them. Will the art be driven by photography? Illustration? Type? If you opt to use photography, do you use color or black and white? Does the story have a documentary flavor? Is it somber? Light? Put yourself in the readers' shoes. What needs or questions would they likely have? How do you answer them? Is a sidebar appropriate to background the audience? In a recent *FLUX* question

and answer feature with the Dalai Lama, it was decided that a sidebar ("Roof of the World") addressing the recent Sino-Tibetan relationship would provide readers with a brief history and a context to better understand the interview (see Figure 14-36). Would illustration be a good way to synthesize, interpret or summarize a complex feature? Would a tight portrait shot work best for an interview piece on the lead singer of Sygur Røs, or perhaps some kind of environmental portrait in Iceland? What will the style and feel of the photography be? How will color figure into the design equation? What type will best impart the mood of the story or align it with the content? Will the structure and grid of the layout be formal? Playful? Edgy? These are all questions you need to ask yourself. The point here, too, is that nothing you integrate into the pages should be selected arbitrarily; every tool and design piece should relate to the story and *how* you tell it.

Think of the feature designs as posters or mini-covers, too. Normally, art is a logical starting place and the best way to showcase or open a feature, and it's the best way to attract attention. Review the chapters on photography, illustration, and typography for specific direction on approaching any of these areas, or for detailed information on how to work with photographers and illustrators.

Figure 14-36
Sidebars can be extremely important, not only to the content of a story, but also as an *á la carte* serving to a story to inform and provide background for the readers. In this instance, *FLUX* writer Michele Osterhoudt provides a brief but thorough overview of China's oppressive policy toward Tibet: destroyed monasteries, nuclear dumping, and other travesties. Art direction and design, Kellee Weinhold; photography, Kareen Messerschmidt; story, Liesl Messerschmidt. Courtesy of *FLUX* magazine.

Briefly, use photography to tell the story, capture personality, and to put readers in interesting places they'd want to visit. If you have strong art—something you always strive for—run it large, as Keith Carter's powerful image for another *Texas Monthly* opener, "The Soul of East Texas" (see Figure 14-15). One excellent image is more valuable than a hundred good ones. David Doubilet's jaw-dropping photograph drives home that point (see Figure 14-37).

Bleeds, knockouts, crossovers, and concept openers are four common approaches to utilizing photography. When running supporting photos, grouping them with a cluster caption is an effective organizational strategy. Most editors like to use captions on all photography, regardless of size or logistics. Two-page opening photography is often captioned on the following page, sometimes combined with a caption for an image on that page. Don't forget the credits for the photographer or illustrator; generally, they're run along with the author's byline or run singly on each image. If the same photographer is responsible for the imagery throughout the story, it's easiest to use one credit at the start of the story rather than designating every single frame;

if the images were shot by multiple photographers a photo-by-photo credit citation is used. Photo credits may also be included in the cutline or positioned on the margin of the photograph. Don't use photographs redundantly. If you have two or three great photos of essentially the same thing, pick *one*.

Today, unfortunately, illustration is underused in feature stories and articles. Its range in terms of media, style, voice, and application is enormous. Publications such as *Atlantic Monthly*, *Rolling Stone*, *Texas Monthly* and *The New Yorker* often elect to use caricatures. Other publications build a stylebook that earmarks illustration for all fiction run in their publications. Illustration is a most remarkable medium, and it does a marvelous job of synthesis, interpretation, and working metaphorically in editorial design. It would be most encouraging to see it undergo another renaissance, one comparable to the great magazine illustration of the 1920s and 1950s. *Print*, *Communication Arts*, *one.a magazine*, *CMYK*, *Graphics* and other publications showcase contemporary illustrators and feature illustration on their covers regularly. Indeed, *Communication Arts* produces an *Illus-*

Figure 14-37
Like many *National Geographic* features, powerful photographs usually drive the opening spreads. In this article, the magnificent photography of David Doubilet is the reader-stopper. *National Geographic* did a feature on Doubilet's unique, underwater photography he'd shot over the years for the publication. "Light in the Deep: Selections from the Work of David Doubilet" celebrates the photographer's work. This feature opens with a two-page Doubilet photograph of a stingray in the Grand Cayman islands. Photography, David Doubilet; design editor, Connie Phelps; designer, Robert Gray. Reprinted with permission of *National Geographic*.

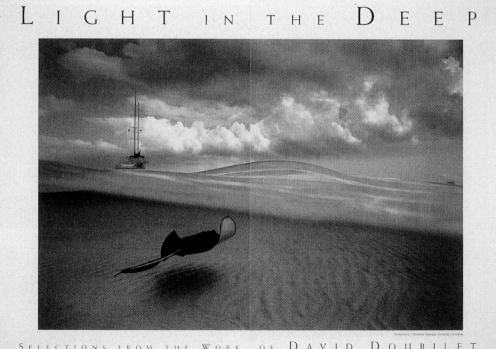

tration Annual, and Society for News Design has a "best of illustration" category in its annual.

Typography is another integral part of all feature design, but sometimes it functions as the art or shares the stage with the artwork. Type should connect with the art, editorial content, and all of the typographical devices used in storytelling: dropped initial letters, captions, text, headers, by-lines, pull quotes, decks, sidebars, crossing heads, and the like. Typography should provide your feature with a voice and special presence. It's a major part of imparting the story's personality, mood, and point of view.

Essentials of Page Layout

Clearly, analyzing and understanding the story are essential to effective visual storytelling. Grids are the base or blueprint upon which all magazine layouts are built; that includes features. Design principles provide the guidance, grids and the architecture for your layouts. Art, headers, decks, text, credits, and supplementary type (captions, dropped initial letters, pull quotes) are the guts or main components of magazine features. Emphasis is central to the success of any layout, only *one* element should dominate—usually the artwork. The following points are practical steps to help you create functional layouts that are pragmatic, harmonious, and compelling:

1. Know the mission of the magazine and details of the story intimately. Know the content, main characters, locale, slant, voice, and audience of the story. Decide what you want to show and tell.

2. Use a grid to square up the elements of a page in a logical and interesting fashion. Either (or both) of your axes—vertical and horizontal—may be used to align the components of your page design. Type should be aligned. Other components (captions, decks, art) should ride the their respective vertical and/or horizontal axis. Keep the pages clean and simple.

3. Distribute the feature's components throughout the layout. Don't bunch them up. Arrange the parts to maintain the layout's balance and to help break up the gray of the page. How was that accomplished in the previous figures?

4. Keep the elements from fighting one another. One should dominate. A common pitfall of novice designers is undersizing the art and typographic openers; that practice creates timid, boring layouts. It's also important to arrange the layout's parts together so they gel. Use powerful photography powerfully to tell the story. Perhaps *National Geographic* magazine has accomplished that objective the most consistently of any magazine over the years. Their photographers and art and design staff (led by Connie Phelps) have affirmed that legacy (see Figure 14-38).

5. Continuity rules in magazine design. Be consistent with layouts. Make sure the art, type, style, and structure all work together. They should speak in the same tone and voice throughout the story. *Everything*—from column structure to the art style, from color palettes to typographic stylebook—should be consistent.

6. Consistency is a virtue, but monotony is a vice. It's important to maintain your basic structure but vary the arrangement of the art and other page components to avoid predictable layouts. Again, the content, design goals, and the

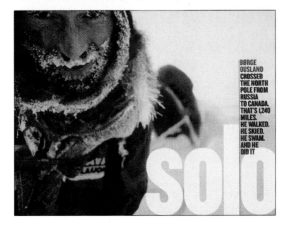

Figure 14-38
There is no mistaking what's supposed to be dominant in each of these opening spreads from *National Geographic* magazine. Truly, this publications is blessed by having the finest photographers in the world and an equally gifted and professional staff of art directors, typographers, illustrations editors, and an insightful design director in Connie Phelps. Note how the art, type, headers, decks, and other elements *tell the story visually*. In "Indonesia: Living Dangerously," the color from Alexandra Boulat's powerful photograph is married to the type. But notice how the letters in the headline are carefully adjusted so they abut and run above and below the baseline to add to the tension of the story. Again, content rules. Typography is *wedded* to the artwork. Credits for Indonesia: Robert Gray, design editor; Connie Phelps, design director; Alexandra Boulat, photography. "Solo" is a compelling photo essay on Børge Ousland, who crossed over the North Pole via Russia to Canada—1,240 frigid miles that he accumulated by walking, skiing, and *swimming*. Credits for "Solo:" Robert Gray, design editor; Connie Phelps, design director; Borge Ousland, photography. Reprinted with permission of *National Geographic*.

audience should shape design. Form does follow function. Compare the various magazine designs presented in this chapter to their respective audiences.

7. **Avoid piling large artwork atop smaller art.** This leads to a couple of problems: first, visually, you tend to crush the smaller art; secondly, you'll likely overload one area of the layout. On the other hand, if you're working with a number of supportive images, consider grouping them.

8. **Keep pages dynamic and graphically interesting.** Feature designs have to be *alive* to be effective. You won't bore people into reading or interacting with an article. Your pages (art, type, and structure within them) need a strong presentation. Make a statement—one that's synonymous with or reflective of the content. Remember the various approaches to design Fred Woodward employed and how he allowed the content to help shape the design solutions?

9. **Headlines are critical to features.** Like a good ad, a story header should be terse, appropriate, compelling, memorable, and understandable. If you use a *blind* one, make sure a good subhead or deck helps convey the gist of the story. Remember your role as a storyteller. Good headers draw the reader, communicate the substance of the story, and relate to the art. Be consistent with headers; a headline should be identical throughout the magazine.

10. **Decks, pull quotes, and crossing heads are equally invaluable.** They can provide compelling summations, powerful quotes, or mark transitions. They're multi-functional. They serve an editorial function and help flesh out the story, and they're capable of teasing a reader into a story. Graphically, typographic elements break up the gray of the page. Better yet, strive to integrate the layout's design ploys into the pull quotes or other graphic components of the story to make it visually *seamless*.

11. **White (or other neutral) space provides a restful place for your eyes.** Good use of white space stands off art, type, or other components. It brings dignity, framing, attention, and dimension to your work, opens the page, and helps make a strong presentation.

12. **Crop for impact.** Ideally, the photographer's composition is solid and doesn't require cropping, but when cropping is required, be ethical but ruthless with your pruning. Clearly, you do not want to mislead a reader through misrepresentation. On the other hand, photography is a subtractive medium and as an art director, your charge is to eliminate anything superfluous.

13. **Position artwork logically.** Careful arrangement of the layout elements themselves may provide a natural sequencing through the page, but artwork may also provide its own line of sight to the reader. Avoid plotting images with people looking off the page. One of your charges as a graphic communicator is to steer the visual traffic through your pages efficiently.

14. **Bleeding the art can add variety to layouts and give the photography or illustration more impact.** In a sense, bleeding may suggest "this art or idea is so important, so large, it won't all fit on the page." You also needn't always run art fully bled (off all four sides of the page). You also can bleed art off one, two, or three sides of the page.

15. *Bridging* **is perhaps the single most important strategy for maintaining continuity in a two-page spread.** Bridging, you'll recall, is straddling adjacent pages with one or more layout parts. The most common bridging components include artwork, header, deck, rules, keylines, and color or tint blocks. Feature spread openers—or adjoining pages, for that matter—must clearly connect; it's imperative the reader understands the pages are wed. If the pages don't appear to go together, you've failed and likely lost some readers as well. When crossing the gutter with artwork, make sure you don't place important pictorial elements (eyes, mouth, or an essential part of the composition) on the crease.

16. **Color is a powerful tool in your design kit.** It may provide invaluable continuity; for example, consistent color treatment within a story with rules, dropped initial letters, borders, pull quotes, or other elements. Along with maintaining the unity of the story, color provides important logistical cues to readers. Color has emotional, psychological, and cultural meaning; use

it wisely. In the case of the *FLUX* Dalai Lama story, cardinal red and saffron yellow—colors associated with Buddhism—were used throughout the article. Notice how Rodrigo Sanchez uses color subtly to wed a two-page La Revista layout (see Figure 14-39).

17. Establish clear entry points for the reader. Thumbnail photographs or dropped initial letters are good strategies for marking clear starting points or transitions for readers.

18. Design at two levels when plotting pages. Kit Hinrichs designs each story for two audiences. The first is for scanners. The average reader follows this reading pattern: art, headline, deck, pull quote, caption, body text. Strong art and clear headlines reinforce that sequence. Compelling decks and pull quotes, useful captions, and crossing heads will provide the scanner the gist of the story. Secondly—at a deeper level—you establish a graphic consistency for the story long term. That includes things such as pacing, how you use color, sidebar inserts, showing transitions, and policing the story for graphic continuity.

19. Endmarks may not seem like much, but readers like and use them. An *endmark* is a bullet or custom graphic that indicates the feature has ended, but readers often use them in other ways. You've likely had the experience where you're considering reading a story, so you search out its endmark to assess its length and decide if you want to read it or not. Most magazines design their own custom ending mark.

20. Great magazine design lies in the details. Following these suggestions will help you shape the story you're telling. Remarkably, if you truly understand the feature and its voice, each story you design will be as different graphically as its content.

In plotting the architecture for your magazine, remember that today's readers are constantly exposed to very sophisticated visual messages. To be effective in an increasingly competitive market, magazines must be attractive, concise, and speak clearly to their respective audiences. The trend is toward simpler layouts that use larger but fewer pieces of art, shorter but bolder headers, and larger and more dynamic type (see Figure 14-40). Stories are getting shorter, too. *Rolling Stone* is a recent casualty to that formula, unfortunately. That said, don't choose style over content. You're charge as a designer is to tell the story—graphically, appropriately, memorably.

Figure 14-39
Blue connects this two-page *La Revista* magazine layout on Naomi Campbell. The rich blues of the African butterflies in her hair are echoed in the type to the left, opposite the artwork. Rodrigo Sanchez, art director; Maria Gonzolez and Amparo Redondo, designers; Carmelo Caderot, design director. Reprinted with permission of *El Mundo*/Unidad Editorial S.A.

Figure 14-40

"Frontier justice is alive and well," according to this fascinating story on Texas posses and U.S. Deputy Marshall Parnell McNamara. D. J. Stout's pulled out all the stops in this compelling design for "The Last Posse" in Texas Monthly. Laura Wilson's tough photography meshes perfectly with Stout's big page presentations and befitting type in these award-winning layouts. The art direction and design are powerful, direct, and pack a visual wallop—a great example of how insightful graphic presentation tells a story, and makes it as interesting to Texans as someone who happened upon it in Toledo, Ohio. D. J. Stout, art direction; D. J. Stout and Nancy McMillen, design; Laura Wilson, photography; Gary Cartwright, writer.

Front and Back of the Book, Departments, Columns

Compared to their magazine counterparts—cover, table of contents, and features—front and back of book components are a lot less glamorous. *Front and back of book* refers to odds and ends of the magazine: typically, departments, columns, reviews, updates, letters page, editor's page, and so on. They take up considerably less space, budget, and planning, but to many readers they are the most important sections of the magazine. Many readers skip the cover and the more alluring sections of the publication and bolt directly to a column, department, or the music review section.

Too often these book sections aren't given the graphic attention and planning they deserve. As odd it is may seem, these magazine parts are precisely where many editorial designers begin the task of shaping a magazine's look and sensibility. The fact is that these components are every bit as important in the overall design scheme. Too often, though, they are the graphic ghetto of the magazine. Your challenge is make them handsome, functional, and inviting.

Another reason they're important is that they help establish the continuity. Why? Well, the designer's main charge is to link all of the book parts graphically. There are a number of ways to accomplish that end. Sometimes they are directly related to a publication's nameplate. Most of these different sections have interior logos, and the designer will use the same graphic treatment on each of them. Notice the design consistencies in Connie Phelps' front and back of book designs for *National Geographic* shown earlier in this chapter (see Figure 14-26). Shared type, color, tabs, and other design nuances also associate them. Another common tactic is to adopt a separate stylebook for these sections to clearly segregate them from the features and fresh articles.

The Relationship Between Advertising and Editorial Design

Advertising pages within a magazine are budgeted and designated in the master plan—the break of the book. Again, there are two basic approaches. The traditional formula anchors standing book components, such as table of contents, columns, and departments, and sandwiches the advertising throughout the front and back sections only. The feature well is deemed "untouchable" and is void of ads, except perhaps for the very beginning or end of that section. In contrast, the front-to-back break of the book scheme typically locks down a few magazine parts—the table of contents and department sections—and then intersperses advertising and features and other book parts throughout the publication. In the latter instance and in the case of jump pages, advertising often shares the very same page with the book's content. In these cases, the policy usually is to reserve full columns for each but not mix ads and editorial material within the same column. Some magazines, however, opt to pyramid advertising within the page.

As a designer, it's important for you to stand off the editorial material clearly from the ads within the publication. This is probably most critical with one-page openers. Basically, use strong magazine design strategies to ensure that features won't be confused with advertising. Remember, occasionally advertisers like to use "editorial" layouts. Some magazines won't accept them, and those that do generally demand the advertising be tagged as such. Another ticklish but less common problem is the unintentional juxtaposition between adjacent editorial and advertising pieces. For example, accidentally running an airline ad immediately across from the "Tragedy of Flight 270" story. Have good antennae and be sensitive to such possibilities. This weird or random collation may also work another way where a magazine appears to endorse a product. For instance, an Ocean Spray cranberry ad is unintentionally aligned with a story on the healthful benefits of the cranberry. On the other hand, some magazines may not have a problem with the latter. In fact, many magazines deliberately seek out specific advertisers for a theme issue; a recent *Paddler* magazine focused on women involved in white water sports. Advertisers responded in kind with their targeting.

Magazine Redesign

As odd as it might seem, advertising often has a great bearing on magazine redesign. Indeed, it in and of itself may be the impetus for a magazine opting to take the plunge to revise itself graphically.

However, there are a number of reasons why a magazine may choose to refit itself. Usually, economics is involved. Perhaps the most common rationale is that the publication has decided to change its editorial formula. Format and technology may initiate the change, too. Magazines may slightly adjust their dimensions *physically* and consequently require a makeover. Audiences change, too. Like everything else on the planet, magazines are affected by time. Style, taste, attitudes, technology, and interests may shift significantly over a relatively brief period of time. Some magazines are especially sensitive to trends and fickle interests.

Changing the image of the publication is another fairly common motivation for a redesign. Remember, too, a change in personnel, whether on the art or editorial side, may suggest transition. New art directors or designers may want to put their mark on the book. A new editor-in-chief may have different tastes or editorial motives. The great majority of the time, however, there are real editorial changes occurring, and they are the impetus for the redesign. In any case, if you are considering a makeover, it's essential to be functional: redesign to the mission, content, and audience of the publication.

The New Yorker is arguably the most sophisticated magazine on the planet, yet it continues to stand by most of its traditions, formula, and visual footprint. It blends illustration, cartoons, fiction, reviews, poetry, satire, non-fiction, politics, art, and local gossip, with all those charming pen-and-ink thumbnails. It is a barometer of Western civilization and concurrently an intimate window into the cultural swirl that is New York City. It recently underwent a redesign. David Remnick decided he wanted a "change" shortly after he assumed his duties as the new editor-in-chief. Its graphic reconstruction was subtle but effective (see Figure 14-41).

Sarah Mangerson, a designer at *The New Yorker*, is a fine arts and journalism graduate from the University of Oregon and a former designer at *Mirabella*. She suggested that function and aesthetics fueled the makeover. "The idea of the redesign was to modernize the magazine and add elegance to the book—without losing its spontaneous, playful, scattered feeling. *The New Yorker* loves 'surprises' in each issue—a huge photo to open a story, an edgy illustration, a splash of color, a giant cartoon. The redesign made the publication crisp, clean, and easier to follow. That helped draw more attention to the surprises, I think. The rules across the top of the page signal the start of a new article, or a rule across a photo denotes a showcase, as does the ragged type. The redesign's stylebook is more rigid than the old one. There is really no messing with it. NY Irvin type is used more consistently

Figure 14-41

When redesigning a publication with the history and power of *The New Yorker* or *National Geographic*, it's imperative to maintain its look, brand, and sensibility. Redesign changes to *The New Yorker*'s contents page and "Goings on about Town" are subtle. Simplicity and user-friendly design improve the table of contents page; notice how the red from the contents page is carried over to the "Goings" section and the grander use of photography in this section. Caroline Mailhot, art director; Sarah Mangerson, assistant art director; David Remnick, editor-in-chief. Courtesy of *The New Yorker*.

throughout the issue—the signature *New Yorker* typeface—which I really like. Our art director, Caroline Mailhot, told me NY Irvin was actually designed by the first art director of the magazine in 1925. Anyway, it's used for all the headlines and bylines in the departments and feature well. It is a nice match for the Caslon text; captions are run in Caslon italic. The redesign is all about consistency. Photography became more of a real option, too (see Figure 14-42). In all, the magazine was able to maintain its unmistakable style, yet tidy itself up and become more 'user-friendly.'"

Two years later, however, Caroline Mailhot felt the new modular system was a bit too confining. Mangerson continues, "While 'the grid' and not breaking columns made the magazine look very clean, we found the 2000 redesign was limiting in some aspects—for example, art and cartoons were sometimes too big or too small, and layouts started looking a little ordinary. Breaking columns gives us more flexibility with the sizes and placement of the art, so we're also now floating spots on the page to break the text, and give *The New Yorker* back some of the playfulness that it had before the 2000 redesign."

To be sure, redesigning a magazine with the mystique and tradition of *The New Yorker* is a delicate proposition. In no small way, that is the challenge of redesign: to freshen up the look of the book and fix what's broken—*without losing the look and integrity of the magazine.*

But magazine redesign is more than "messing with type, covers, and a stylebook." The possible repercussions are huge. To many readers, a magazine's design is a sacred cow; it is what they've known and loved—and they don't want it fiddled with. Concurrently, the reality is that a publication's audience changes: part of it grows older with the magazine, and part of its readership are recent converts. Therein lies the conundrum. In addition, an established magazine has created an identity and brand for itself. Its aegis is a proven connection to audience loyalty. However, magazines are also living entities, and like other media, they need graphic reconstruction to stay current and to keep their appearance from looking stale or antiquated.

Like *The New Yorker*, *National Geographic* magazine has a long-standing and unique presence in the world of publications. Actually, it is also the "Journal of Record" for many significant achievements, scientific discoveries, and world events. Its following is as broad as it is loyal. It's used as a reference tool in learning institutions, and its back issues are saved by

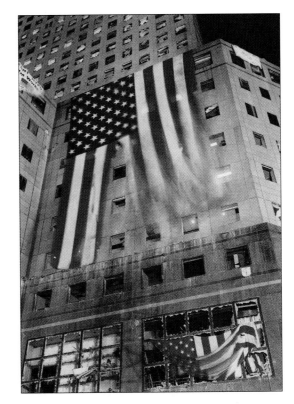

Figure 14-42
David Remnick's Showcase piece, "Witness," shares this moving image of the buildings in the Financial Center that rimmed the World Trade Center. Photographer Joel Meyerowitz, who is more known for his New York City street photography and beautiful color work of Cape Cod, documented the ruins of the 9-11 tragedy. He said it was important for all of us to know "what these ruins look like...because eventually something new will be here." Photographer, Joel Meyerowitz; writer/editor-in-chief, David Remnick; art director, Caroline Mailhot; assistant art director, Sarah Mangerson. © Photo by Joel Meyerowitz Photography. Originally published in *The New Yorker*. Reprinted by permission. All rights reserved.

millions of readers (sometimes for generations). *National Geographic* magazine, with its immediately recognizable bright, chrome yellow border, is the product most immediately associated with the *National Geographic* Society (NGS). Consequently, the magazine is the wellspring for the branding of all other NGS products.

Clearly, *National Geographic* is the epitome of practicing the *maestro concept*. It also has the luxury of possessing a talented and deep staff of visual communicators, and the budget and circulation for its meticulous printing, which still is, by the way, run on rotogravure presses. Gravaure is notorious for delivering, crisp, meticulous photographic reproduction.

The strength of the brand of *National Geographic* is largely due to the unusual heritage of the magazine. Its considerable resources allow the creation of rich, comprehensive story packages whose defining components are world-class photography, cartography, and illustration—all supported by extensive research from experts worldwide, and thorough, in-depth writing.

The design challenge is to strike a balance that preserves the visual integrity of the subject matter while concurrently integrating contemporary design conventions seamlessly. Connie Phelps has worked on the art side of *National Geographic* for the past twenty-five years and oversees the magazine's graphic side as design editor. Her vision and touch shape the look and design of the magazine. *National Geographic*'s design and graphic presentation must speak to readers whose ages cover a wide range. The evolution of the face and structure of the magazine is fascinating. Connie Phelps, who orchestrated its most recent redesign, provides an interesting graphic overview of the publication (see Figure 14-43).

Over the years, design for National Geographic *has been more evolutionary than revolutionary. The very first cover in 1888 is just a terra-cotta wrapper with the original seal of the Society in the center (see Figure 14-44a). Editor Gilbert H. Grosvenor recalled that in April 1899 he carried that month's issue to the post office himself (about 1,000 copies at that time). In 1904 the new format features the title and table of contents printed in brown ink on a yellow paper stock (see Figure 14-44b). There remain some faint traces of the art nouveau detailing. This format endures until 1910. Grosvenor engaged the Matthews-Northrup Works of Buffalo, a leading engraver and printer, to assist with yet another cover redesign, the sixth in 21 years. Robert Weir Crouch, an English-born Canadian decorative artist in the prime of his creative powers, had already contributed designs to such leading magazines as* Harper's, Scribner's, *and* The Century.

A border of oak leaves and acorns, emerging from the bottom center and rising up on either side, represents the origins and sturdy growth of the Society. At the top, it meets a garland of laurel leaves and berries, a traditional symbol of achievement and honor in the arts of civilization. Inset at the cardinal points are the earth's four hemispheres, representing the all-embracing nature of the Society's work and suggesting that the contents are bound only by "the world and all that is in it." A frame bordered in a buff color resembles a kind of window on the world.

The new cover, first gracing the February 1910 issue, was so successful that it remained intact with only minor modification for nearly fifty years (see Figure 14-44c). It formed the basis for the cover design and Society trademarks of today.

The July 1943 issue has the very first photograph on its cover, an image of a flag to support the war effort (see Figure 14-44d). In 1966, the oak and laurel leaves start to disappear in stages and by 1979 they are gone completely, leaving only one hemisphere (see Figure 14-44e).

It's important to also understand what initiates a redesign. The editor of National Geographic *magazine is always looking for ways to make it more accessible and relevant to our readers. One of the hallmarks of this magazine is its ability to*

Figure 14-43

Connie Phelps began her career at *National Geographic* as an "entry level" layout artist; that was over 25 years ago. Her background (majors in fine arts and architecture from the University of Maryland, and living for three years in Japan, Taiwan, and Hong Kong) were useful to her work. However, she aspired to oversee the design side of the publication and returned to school to study journalism and photography—while continuing to work at the publication. Today she is senior editor and design director at *National Geographic*, leading a team of 3 design editors and 5 designers. She is also design consultant to art directors globally, successfully launching the magazine in 25 countries. In addition, to the magazine, Phelps has been involved with many projects, publications and exhibitions. The American Society of Editors has honored Connie Phelps and *National Geographic* with its coveted "General Excellence" award twice in the last ten years. (As of this printing, *National Geographic* is a finalist in General Excellence and Photography, should they receive the coveted award, it would mark the third time in 10 years that it would receive the General Excellence award.) Connie Phelps also has an affinity for adventure and fishing.

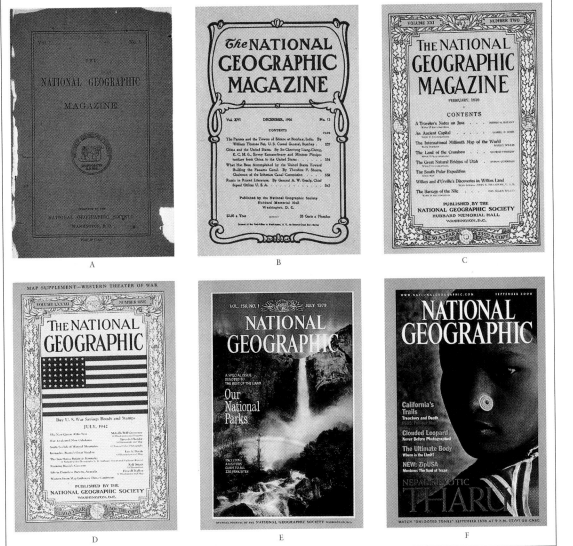

Figure 14-44
National Geographic has evolved from very humble beginnings—a terra cotta wrapper—to its most recent redesign, a bold but formal publication that reflects its content, sophistication, and editorial stature. Reprinted with permission of *National Geographic*.

present a complete, comprehensive story package, and to devote many pages to achieve that goal. The redesign responded to the editors' request that we find ways to create more entry points for the reader throughout the magazine, to ensure that we aren't losing any readers who may not be as inclined to devote lengthy reading time. Through the introduction of call-outs, smaller boxed items, and a more dynamic department structure, the design captures the attention of both the browser and the committed reader.

In September 2000 my design team launched the most recent redesign, which included a bolder, fresher, and more impactful cover (see Figure 14-44f). The typographic clarity and more familiar typography explain rather than label the magazine content for readers. The logo itself is larger and moved up to expose more of the pho-tography. We disposed of the cartouche—the last vestige of the old, archaic look. It only showed one quarter of the world anyway. Then we redesigned and elevated the departments to more closely match the recently evolved feature design and created more immediate, accessible sections allowing the reader additional entry points for browsing and a more interactive experience with our website.

Magazines that haven't been in business very long and haven't established significant reputa-tions can afford to throw caution to the wind and be more in vogue. But at National Geo-graphic—because our audience is so large, the ages of our readers are so varied, and children use the magazine for school projects—we must be deliberate and discreet in any changes we make.

Some of the issues and challenges we've faced include the following:

- *newsstand initiatives and their effect on cover design and philosophy;*
- *treatment of photography, the extremely judicious use of cropping or any other "manipulation;"*
- *the balance of storytelling space given to photography relative to all-type elements;*
- *our extensive caption blocks, a signature of NGM, carry more information than the average magazine's captions, posing specific design challenges;*
- *the actual physical size of the magazine;*
- *a need to create stronger guideposts throughout the magazine that direct the reader to other NGS media (especially the website);*
- *gravure printing and its impact on type size, color usage, ink spread, and density.*

The mission behind the redesign entailed many significant goals. For one, the Society was developing new platforms, and we needed a new architecture to be able to tie into and multipurpose our efforts. Our Departments section was becoming more important as our readers had less leisure time to spend on reading magazines.

Surveys (from Media Dynamics, Inc.) told us that typical readers spend only 20 minutes a day reading magazines, and we wanted to give our readers clear, useful choices to get more information about the stories we publish.

Our reordered front and back departments now reflect a more conventional structure that readers can navigate easily. Corner tabs in the magazine's signature yellow clearly identify editorial pages. These were also employed on the contents page (see Figure 14-45). A combination of bold sans serif, classic serif, and proprietary fonts make up the typographic family, and small over-line heads define story categories.

We restructured our "Geographica" and "On Assignment" sections, and our departments now offer a flexibility in the presentation of editorial content that is extremely popular with readers (see Figure 14-46). These sections now open on full spreads, giving them greater visual presence at both the front and back of the magazine and are also more attractive to selling ads because they are more feature-like. We will hold the line as long as we can to keep ads out of the editorial well. We are unique in that way.

Figure 14-45
National Geographic establishes continuity via the type, page structures, and something as simple as a yellow corner tab. Along with maintaining unity, the tabs work well to flag the reader. Compare the old and new magazine parts to discover how Phelps and her staff executed unity and continuity strategies. Design editor, Connie Phelps; table of contents page designer, Joe McNally; photographers: (top left) Alexandra Avakian, (top right) Peter Essick, (bottom left) Tim Laman, (bottom left center) Cary Wolinsky; (bottom right center) Diane Cook & Len Jenshel, (bottom right) Flip Nicklin. Reprinted with permission of *National Geographic.*

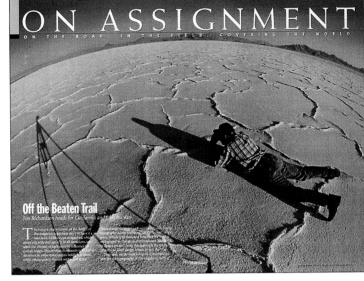

Figure 14-46
Designers appreciate the
value of flexibility with all
their tools and design
options. Typographic
range is important, and so
is having the elasticity to
really open up and use a
generous amount of space
in a section where
powerful photography
screams for more room,
as in this *National
Geographic* "On
Assignment" section.
Opening up the format
and the front/back of the
book makes some of those
sections more feature-like,
as in this example of Jim
Richardson's photography
bridging pages. Design
editor, Connie Phelps;
photographers: Jim
Richardson, Suriyeh
Kabiri (top photo of
Alexander Avakian),
Alexandra Avakian
(bottom photo).
Reprinted with permission
of *National Geographic*.

Finally, In the 25 years I have worked for the
National Geographic, *I feel truly fortunate to
have met such incredible people with such
amazing stories to tell. One of my favorite pho-
tographers, Steve McCurry, had taken a photo-
graph which is perhaps the most famous
photograph ever published in* National Geo-
graphic *magazine (see chapter one opening and
Figure 14-47). You've seen it: it's the face of the
young Afghan girl, a refugee with haunting eyes.
It is an image that sears the heart and graced our
cover in June of 1985. In her eyes you can read
the tragedy of a land drained by war. Her eyes
demanded a response. Her photograph inspired
people all over the world to volunteer in refugee
camps or do aid work in Afghanistan. It speaks
to the power of a single image and reach of a
magazine like* National Geographic.

Guidelines to Magazine Redesign

Connie Phelps' last comments on the power of a
magazine also underscore another point when it
comes to redesign. While the starting points are
quite similar in magazine design and redesign, an
existing magazine—such as *National
Geographic*—has an identity as well as a preex-
isting legacy: an important stake in reader per-
ception. On the other hand, a different magazine
may have more interest in reinventing itself, or
creating a new image.

In any case, when redesigning a magazine, it's
essential to know the history, problems, shifts,
and intended refocus of the publication. Today

research and reader surveys (such as the ones
alluded to by Connie Phelps) often shape the
content, features, and visual direction of the pub-
lication. The following list includes some of the
important questions to consider:

1. What parts of the current editorial formula
—stories, departments, article length, photogra-
phy, illustration, covers, point of view, voice—
do readers like? Dislike?

2. Who is the audience? Has it shifted? Is it
dying out or leaving? If it has changed, what is
the pattern and why the transformation? If read-
ers are leaving, it's critical to find out why.

3. How do the various magazine components—
cover, departments, reviews, features, art—stack
up? In other words, what appears to be work-
ing? What's not effective? What does the audi-
ence want to see or expect of the magazine?

4. Specifically, what are editorial changes going
to be? Are editors reinventing their image, mis-
sion, direction, or formula? What old parts of the
book are going away, and what will replace them?

5. What has the advertising history been?
Assessing those patterns may provide invaluable
information about the audience and the overall
effectiveness of the editorial formula. If nothing
else, advertisers are very astute about audiences,
as well as their behavior and needs.

These are difficult but essential questions. But,
again, they underscore the first commandment of
both design and redesign: function, audience, and
editorial content steer the look and architecture
of a magazine.

Figure 14-47

Seventeen years after Steve McCurry made the famous *National Geographic* photograph of the "Afghan girl" at a refugee camp in Pakistan, he returned and found her again. "A Life Revealed" is a heart-breaking feature recently run in *National Geographic* that reconnects readers to Sharbat Gula and provides a window into the shattered world of Afghanistan. "Time and hardship have erased her youth. Her skin looks like leather. The geometry of her jaw has softened. The eyes still glare." The horror of war she experienced as a young girl 17 years ago from the Soviet bombing returned via American forces purging Bin Laden's Al Queda training camps and overturning the Taliban regime there. This two-page spread uses isolation, white space, and symmetry to tell a simple but sad story. The designers used a black border around all of the pages of this feature—an appropriate graphic touch. Note contrasting images of Sharat with her one-year-old daughter, Alia (left) and Sharbat's shy image (right) from 1984. Photography, Steve McCurry; design editor, Connie Phelps; story, Cathy Newman. Reprinted with permission of *National Geographic*.

One Approach to Magazine Redesign

After you've carefully assessed the magazine's mission, formula, and audience and answered the above questions, you're probably ready to overhaul the publication editorially and graphically.

1. *Precisely, what is the editorial mission and formula?* Write a brief manifesto for the magazine to further clarify its philosophy, significance, niche, and purpose. What will the magazine contain? What components will make up the front and back of the book? In every case, try a variety of solutions. Initial design options are an inherent part of the redesign process. How many features will the magazine average per issue? If you don't understand what the content or the parts of the book will be, how can you design anything? When CMYK magazine decided to restructure itself, it began with a mission plan and specific goals. Genevieve Astrelli reflects their shift. "Greater newsstand and website presence was our goal. Greater circulation and readership were where we wanted to go. Backed by product innovations and a carefully selected marketing communications mix, we needed to give our readers more value and our advertisers

something to salivate over." Thumbnail sketches of CMYK covers (see Figure 14-48) contrast with the finished comps from *Popular Science*.

2. *Who's the audience and how are you positioning the magazine to that readership?* You don't build anything in a vacuum. Also, you don't design for awards, style, or the art director's ego. You design *content for your audience*. Astrelli continues: "Despite the many attractions *CMYK* held for its audience—school profiles, portfolio tips, and a successful student-to-employer matchmaking service—it didn't always speak to critical-eyed professionals. First and foremost, *CMYK* needed to be a design magazine the students and professionals could relate to. Reflect forward-thinking design and the sophistication of our reader base."

3. *Establish the break of the book.* What are you building and where is it going? Organize like parts. Departments, columns, and other front-and-back-of-the-book sections should be plotted. Think of the break of the book as your structural master plan. It clearly outlines the long-term design blueprint, so it better be functional for your content, audience, advertising, and needs because you'll be living with it for a

long time. What about advertising logistics? Demarcations? Or the relationship of departments to features to advertising? How do you adjust the pacing? Put yourself in the shoes of the reader and walk yourself through the book. Genevieve Astrelli also addresses some of these points: "Unzip and peek inside. You'll find within *CMYK* countless examples of visual stimulation: spruced-up versions of, naturally, cyan, magenta, yellow and black (CMY and K) placed throughout the magazine to both unify and visually distinguish among sections of editorial content, judge profiles, and student work. The new, eye-friendly table of contents. The purposeful placement of ads. The thumbnail images, typographic icons, and other snaps and buttons that hold the magazine together. All in all, you'll see a more youthful look." Clearly plot your design plan. That begins with the cover and contents pages, but continues throughout the book (see Figure 14-49). Think about pacing. When you build it, think *function* and how the reader will literally move through the pages. Pacing the parts is equally important. Don't give up all the best pieces at once, especially at the front of the book. Arrange the book's parts strategically and spread the strongest work out.

4. *Build a typographic stylebook.* Now that you know what your mission is, who your audience is, and what the break of the book will be, get specific. Typography articulates the voice, tone, sensibility, and credibility of your magazine. Moreover, it is the primary factor in establishing and maintaining continuity. Be specific: spec out detailed guidelines—typeface, sizes, leading, line arrangement, and column widths—for text, headlines, decks, by-lines, folio lines, pull quotes, dropped initial letters, and captions, as well as how and where they apply. Again, when you're assembling the stylebook, remember the audience—who you're talking to. How will you handle headlines? Will the approach be rigid with specific typefaces, sizes, leading, and such spelled out? Or will the headline philosophy be looser, where the type choices and treatment are tailored to each story individually?

5. *Create the magazine's nameplate.* Review your type chapters. In brief, the nameplate should be legible, unique, and tailored to the audience

Figure 14-48
This page is one of many pages of thumbnail designs sketched up by *CMYK* art director Genevieve Astrelli. "We wanted to appeal to the design sensibilities of our most important readers: aspiring creatives." Good design involves evolving many ideas, hard work, and experimentation. Reprinted with permission of *CMYK* magazine.

and magazine's image, and it should *project* the way a poster would. If you're looking to freshen up the nameplate, normally you don't *lose* the look of the original, especially if it has a strong identity. After you've selected a nameplate, craft interior logos for the table of contents, masthead, departments and other front-and-back-of-the-book parts. Do you borrow anything from the nameplate for the interior logos? Some publications do, but the more important issue is that the various interior logos all relate closely. Remember, typographical continuity maintains unity and helps keep the book organized.

6. *Build a prototype.* In the process, create a clear statement or stylebook specific to the cover; it should be the yardstick from which you construct all your covers. While the art director of *CMYK* liked the creativity of the original covers, she felt they underachieved and needed to be more functional. They opted to build a completely new cover—nameplate and all (see Figure 14-50). "None of the old covers gave you a real inkling of what was inside. We moved the fresh and bright new line of student creations out to the window display of *CMYK*'s cover and have wrapped it around the shapely mannequin that is the cover design. And its nameplate now instantly and colorfully defines the magazine." The best covers function as a window into the interior of the magazine, while concurrently projecting the maga-

Figure 14-49
The new *CMYK* table of contents page (right) really makes the older version bland by comparison. Appropriately, the change is as logical as it is graphic. This is a visually oriented magazine targeted at a sophisticated audience that is visually predisposed. Note how the cover (see Figure 14-50) and contents page relate. Art direction and redesign by Genevieve Astrelli. Reprinted with permission of *CMYK* magazine.

zine's personality, image, voice, and *contents*. Next, build the table of contents page. Establish a grid or structure for it. What will it contain besides the book's overview and general mapping? Masthead? Cover information? Editorial comments?

7. *Create an experimental (in-progress) prototype.* Using content that would be typical of the real book's departments, columns, and features, create layouts for a handful of front-and back-of-book sections and two or three feature pieces. Make sure to employ all of the type specifications in creating all of these, along with your plan for handling artwork. The art should be representative not only of each type of media (illustration, photography, concept artwork) your book will use, but how it would be used (color, black-and-white, duotone), as well as presented (crops, bleeds, borders, keylines, and so forth). The object here is to create something as close to the real book as possible, using your stylebook, manifesto, art guidelines, and all your design tools.

When *Popular Science* went through its redesign, it wanted fresh, powerful openers for its readers, not stodgy or predictable design, but

presentations that were much like science itself: exciting, enlightening, and full of surprises. A recent *Popular Science* feature, "FlyOrama," does all that and more, and it's representative of the new architecture of the magazine. Indeed, Barnett's redesign, typography, and layouts are receiving awards from The Society of Publication Designers, The Type Director's Club, American Photography, as well as National Magazine Awards Type Club (see Figure 14-51).

8. *Presentation, feedback, and refinement come next.* Typically, the final step is to present the working redesign prototype(s) (or even magazine parts) to editors, focus groups, publishers, editorial boards, or some combination thereof. Then it's reviewed, adjusted, refined, comped up, and presented again.

9. *Introducing the revised magazine design.* Very often you build several versions of the redesign and present each one separately. When you do that, make sure that the contents—headlines, art, and other basic elements—are consistent. That makes for a more level design playing field, as Kit Hinrichs noted earlier. Actually, since

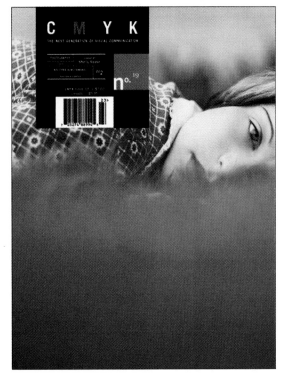

Figure 14-50
The audience and
magazine mission very
much determined the
makeover for the *CYMK*
cover. While playful, the
older cover didn't relate
nearly as well to its hip
and "upcoming" audience
of young creative talent.
Astrelli and her art staff
reinvented the look of the
cover and the entire book.
The new cover (right)
showcases fully bled
student work; the
photograph, *Sara*, was
made by Boushra
Almutawakel. The smart
and understated
nameplate is tidy,
different, and unique. The
nameplate format is
echoed in the magazine's
table of contents page as
well. Art direction and
redesign by Genevieve
Astrelli. Photography by
Boushra Almutawakel;
instructor, Ray Ellis—
Portfolio Center.
Reprinted with permission
of *CMYK* magazine.

we're on this point, *presentation* is extremely
important. You've put in a sizeable chunk of
time, thought, planning, effort, blood, sweat,
and tears. The last thing you want to do is stumble through your delivery. You should plan your
pitch and be well rehearsed. Be prepared to provide clear rationales for everything you've done
from the redesign's obvious changes to type
selections, art treatment, page structure, use of
color, cover design—everything. Editors and others want to understand the reasons and thinking
behind the revisions. Part of your job is to educate or explain to them the reasoning behind the
design changes. Obviously, too, the materials
themselves—printouts, slides, boards, whatever—should be meticulous. As odd or unfair as it
might seem to you, the quality of your presentation is probably at least as important as the
redesign itself (see Figure 14-52).

10. *Launch or evolve the new design.* Often, after
most the redesign elements are approved, the magazine *evolves* into its new reality over several
months, rather than all at once. It may continue
to be tweaked and adjusted as it is slowly unveiled
—sometimes due to input from readers, consultants, and others. In a sense, this is where you test
drive the book. Kick the tires of its design. You
see how it handles and make sure everything
works precisely the way you'd anticipated. Fine
tuning and alterations are a part of the process.

Magazines: A Post Script or Parting Shot

One of Webster's definitions of "magazine" is 'a
room in which powder and other explosives are
kept.' That's an interesting association, especially
given the charged nature of magazine design
today—dynamic layouts, explosive color, and
typography that connects with us on an
emotional level. But like graphic communicators
in other media, the role of the magazine designer
or art director is first and foremost to communicate content. When they can accomplish that feat
appropriately in an explosive or compelling way,
so much the better.

As Kit Hinrichs noted at the opening of this
chapter, magazine design epitomizes the art of
visual storytelling. In addition, magazine design
has remarkable connections to other media—
literally and figuratively. In that sense, and as its
etymology suggests, the magazine is a *storehouse*
of things. Covers and feature openers have to
work like posters to hit moving audiences—both
those traveling past a rack of publications in a
bookstore or newsstand and readers flipping
through the pages of the magazine.

Magazines have influenced other media, too;
television has created "magazine" shows like "60
Minutes," "Frontline," and "Entertainment
Tonight." Some magazines have spawned their
own television shows and spin-offs, or vice versa:
National Geographic, This Old House, Martha

Figure 14-51

The redesign and new architecture of *Popular Science* are as arresting and powerful as they are functional. Dirk Barnett comments on this feature, "FlyOrama," and its design. "Initially, we had some fantastic photos of the machine used to record the speed of insect flight. However, we decided to go with an illustration that did a better job of showing *what* the story was about—wing beats per second and the fly's motion. When it came to the type, the big O was irresistible and connects nicely to the insect." Note some of the other design details: the rounded corners of the black background mesh with the O in "FlyOrama" and the mix of motion and wire frame body of the fly in Stephen Roundtree's fabulous illustration. Design direction, Dirk Barnett; art direction; Hylah Hill; design, Dirk Barnett and Hylah Hill; illustration, Stephen Roundtree. Courtesy of *Popular Science*.

Stewart, and *Nickelodeon* come to mind. Today magazines have a symbiotic relationship with advertising. In fact, many magazines are busy branding themselves or marketing their sister publications or even products and other media. Most larger magazines have websites or some Internet presence. As demonstrated in this chapter, some trade magazines are public relations and marketing entities. Finally, magazines have intricate communication marketing programs.

The message is that the graphic possibilities, formats, media, and even the very function of magazines today are tremendous. William Owen sums it up best in his fine book, *Modern Magazine Design*: "The intellectual purview of the magazine has become so wide, and printing technology so sophisticated, that the form of its visual presentation is under no general technical or aesthetic constraint other than those determined by its familiar bound paper package." Today even paper is no longer a "constraint" because of media fusion and the expanded roles of the magazine.

At the same time, there are invaluable lessons to be learned from fine and graphic art history, and from the many past and present masters of magazine design.

Graphics in Action

1. Study the last 3 to 6 issues of your favorite magazine. Dissect the covers and write up a stylebook that you think is befitting its cover designs. Using the covers and your brief cover stylebook as your guide, create the publication's next cover.

2. Find a magazine feature that you feel does a poor job of design. Analyze it and write up a critique listing its shortcomings. Be specific.

3. Using this chapter as a guide, study the problem areas of the magazine feature layout in #2 and completely redesign the article. You may use different type, find different artwork, or even add a few components to the layout, such as decks, crossing heads, dropped initial letters, color, information boxes, sidebars, or other items. Try to use about the same amount of copy as the original. If you're adding materials or running art larger, you may have up to two additional pages of space. You might even wish to shoot your own photography.

4. Closely examine Kit Hinrichs' table of contents page for *SKALD* magazine (Figure 14-32). What did you learn about it when you were asked to deconstruct it? There are several unusual things about its design. First, although it's a standard-sized magazine page format, it has *seven* columns. Second, look closely and you'll see that its struc-

Figure 14-52
Here are but three of
many comps tried by Dirk
Barnett for this front of
book / department design
formula. "After many
different versions—
including one that riffed
off the periodic table of
elements (left)—we came
back to a very simple
approach with the words
'What's New?' on a four-
color page, big, in black
atop of a simple gray rule
(right). It provides an
immediate read, and gives
most of the power to the
photo." Presentation
plays a huge part in
redesign. It includes being
well-rehearsed and to
anticipate questions a
creative director or
committee might have for
you about type, design,
and a rationale and
explanation for your
changes. The prototype
pages you share should be
meticulously groomed.
Normally, too—even if
you're projecting slides or
using a Power Point
presentation of the work
—the sample pages are
mounted on foam core
board, and passed around
the room. Art and design
direction, Dirk Barnett;
designers, Dirk Barnett
and Neil Russo;
photographer, Tom
Schierlitz.

ture is completely vertical—*not horizontal* like most table of content grids. Third, it features the cover as it main art. Finally, it uses nine pieces of art in its layout, which vary from illustration to knockout art to photography. Using the Hinrichs example, select a contents page from a magazine you regularly read and apply as many of Hinrichs' design ploys as you can. What did you learn?

5. Select a magazine that appeals to a special interest audience and analyze its design and typography. Several examples that come to mind are *Four Wheeler*, *Modern Bride*, *American Iron*, *Cuisine*, *Architectural Lighting*, and *Soap Opera Digest*. Choose one of these or another magazine. Then try to determine how the design, typography, stylebook, art treatment, cover, and formula were selected and crafted to appeal to its audience. If there are design shortcomings, analyze them, and discuss strategies to correct them.

6. Given all you've learned from your study in #5, plan your own new magazine to compete with the ones in the market you examined. How will your publication be different from the others? What is its mission? Format? Formula? What will you call it?

Then prepare a 2-to-3 page business plan for the magazine, and design a sample cover and table of contents page as well.

7. Find a magazine cover or feature that you think would have done better with an illustration than the photography it used. Be prepared to make specific suggestions and discuss your reasoning. Think about the rationale Dirk Barnett adopted to use illustration over really good photography for his "FlyOrama" feature for *Popular Science* (Figure 14-51).

8. Select an area in which you're interested. Basketball? Snowboarding? Retrofashion? Film? Cheerleading? Do some research and find out what publications exist for that area. Check them out. What is the function or mission of each one? What are their formulas? Formats? Who are their advertisers? What's their circulation? How do they differ from one another? Write a report comparatively assessing their missions, formats, formulas, design styles, audiences, and advertising.

9. Nissan Automotive has asked you to create a magazine for them that is targeted at college students. Form teams of students and come up with a mission statement, column or department ideas, an overview of its general content, and several sample feature concepts for this magazine.

10. Take the next step for the Nissan project in #9. Again, as a team, develop an 8-page prototype which features a cover, 2-page table of contents spread, a department or column page, and a 4-page feature design. Greek in the text, but write up real headlines, cover lines, decks, and the table of contents, etc.

11. Select three distinctly different magazines. Get on the Internet and examine the website versions of the magazines. Is there good continuity in their respective designs—that is, between the print and online versions of the magazine? How are they similar? Different? How do they employ design and *usability* differently for their respective media? Prepare a brief report addressing all of these questions and any other relevant comparisons and contrasts between components of *each magazine* you've selected. Bring your report and pages to class for discussion.

There's almost no media experience sweeter... than poring over a good newspaper. In the quiet morning, with a cup of coffee—so long as you haven't turned on the TV, listened to the radio, or checked in online—it's as comfortable and personal as information gets.

—Jon Katz,
WIRED magazine, 1994

◀ *Bacon, Eggs, Coffee, and Newspaper: William Ryan*

The American newspaper is fascinating in its functions. Before it ends up in the trash, it gets wrapped around rubbish, used to line bird cages or wash windows, rolled up for a weapon against flies, or spread overhead as an umbrella. Children rip it up to make papier-mâché, put it under clay putty and paint boxes, fold it into airplanes and paper hats. It's a gift wrap, padding for parcels, a drop cloth, tinder, and a wrapper for hot peanuts at the game. There is something appealing about the pattern and the texture, and also something symbolic.

—*Kevin G. Barnhurst,* Seeing the Newspaper

Newspapers Today:
Function, Form and Formats

Kevin Barnhurst's overview of the other functions of newspapers is as wonderful as it is ironic. Of course, newspapers also bring us information. In fact, most readers begin each day easing into their routines via a ritual involving coffee, breakfast, and a newspaper. The newspaper is a marvelous compendium of our collective daily lives. It provides information from every corner of the globe, and news from just around the corner—on just about any subject you can imagine: politics, war, sports, business, arts, editorials, advertising, entertainment, weather, and comics. Every day, editors, reporters, visual journalists, and advertising staff scramble to meet deadlines and our informational needs. While it lacks the immediacy of some media, newspaper reportage tends to be more complete, and it's easily retrievable. Its words, imagery, and presentation influence our decisions and shape our attitudes.

These days there are some futurists who view the newspaper as a dinosaur and its process (ink on paper) also as a thing of the past. Electronic slates, e-books, on-line sites, and other technology have been predicted to replace the newspaper. To date, none of those things have eliminated the newspaper as a valuable medium and source of information in our lives. On the other hand, newspapers are fusing with other media; some provide weekly magazine and other topical sections or offer updated stories and other features online.

Although technology has dramatically altered and streamlined the process of acquiring information and editing, designing and producing newspapers, it hasn't changed the product significantly. Nor has it changed our appreciation and dependence on newspapers to inform, entertain, and keep us current on the ever-changing history of our shrinking planet. The newspaper reportage of the 9-11 terrorist attacks drives home that point dramatically. All of us can recall vividly where we were and what we were doing when we heard the report of the first hijacked jet slamming into the south tower of the World Trade Center (see Figure 15-1). Newspapers were there—helping us understand the event by providing useful information to their readers as well as sharing it with other media.

Indeed, the tragic events of 9-11 underscore how invaluable newspapers are to us. Despite the barrage of television coverage, it was newspapers that provided the most comprehensive information of the terrorist attacks. In fact, even newspaper overruns couldn't meet reader demand, and publishers and editors opted to print special sections and editions to meet readers' needs and keep the information flow in-depth and current.

The coverage of the tragedy varied considerably. Newspaper design tactics and formal interpretations spoke to different facets of the terrorist attacks. New information was constantly breaking; in fact, reporters fed an on-going torrent of jumbled information to their editors.

Previous page
Many of us begin our day with the morning newspaper, a cup of coffee, and breakfast. It's a near sacred ritual that provides us comfort, news, sports, entertainment, advertising, weather forecasts, comics, and crossword puzzles. The newspaper is an invaluable tool that connects us to the world and to our communities.

Photographers and videographers captured and shared a flood of visual images: the planes hitting the towers, raw emotional reactions of those witnessing this horror on the streets below, the courageous acts of firemen, police, volunteers and countless others—and of course the eventual collapse of the World Trade Center. At the forefront was *The New York Times* (see Figure 15-2). Its headline and deck were larger than usual but terse. The photographs were arranged into a vertical ground thirds column of art. The presentation was equally terse.

The New York Times, along with other publications, presented readers with thoughtful and thorough information graphics to establish a sense of place and the scope of the catastrophe. Info-graphics, such as "Reclaiming Lower Manhattan" and "Employees in the Twin Towers," answered many questions and offered readers significant information other media did not. Society for News Design reviewers awarded this work gold medals for its graphic chronicling and depth. "The graphic editors at *The Times* made clarity out of calamity. The work was done under stress and personal hardship but stands on its own merits," judges said. Despite the challenges, the judges saw this as communication at its best (see Figure 15-3).

Of course, this was an event with enormous global implications. Journalists from newspapers from all over the world—along with other media —delivered reportage. *Die Welt*, a German newspaper and one of the largest publications in Europe, ran an entire page of photos (see Figure 15-4).

Not only were the styles, strategies, and accompanying designs stridently contrasting, the formats and media exhibited the range of the newspapers' possibilities. Most of this array was largely possible through the use of computers and the sophisticated technology that drive our media. Consider the nearly bled, wrap-around cover of the *Asbury Park Press* and the *Chicago Sun-Times* poster (see Figure 15-5), the more traditional presentation of *The New York Times*, or the countless newspaper on-line editions covering the unfolding changes of this story.

Traditional newspaper pages, online reports, video streaming, posters, magazine formats were also used (see Figure 15-6).

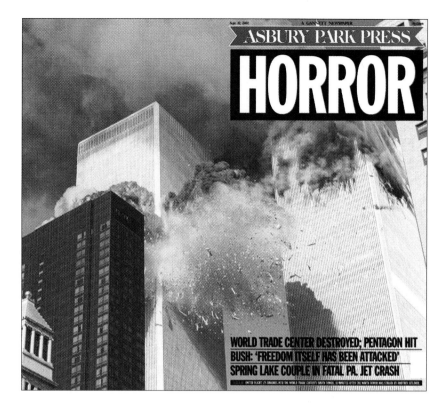

Figure 15-1

The *Asbury Park Press* makes a most unusual design statement by running a horizontal frame of film across the front and back pages of the newspaper. The strategy is appropriate. Clearly, this double-truck spread reflects the magnitude of the event in its presentation, use of space, type, and minimal design. Reprinted with permission of the *Asbury Park Press*.

Figure 15-2

For *The New York Times*, the amount of space allotted for artwork in this issue is unusual. However, despite the generous area provided the photography, the newspaper remains true to its objective and Spartan style. Note the strong traditional vertical styling and that it runs four separate pieces on the front page. Even the headline defers locality: "U.S. ATTACKED." Its presentation, in typical fashion, is sober, direct, and neatly organized. Design Director Tom Bodkin walks the fine tightrope between maintaining *The New York Times*' objective decorum and delivering a very emotional kick in the guts. Copyright © 2001 by The New York Times Co. Reprinted with permission.

Figure 15-3

Imagine the wealth of information these *New York Times* illustrations provided the nation. Content drives design. These comments from the *SND Annual* sum it up well. "The graphics were tightly edited but richly detailed. Each graphic offered layered information with smart contextual ideas, a depth of reporting, high technical proficiency, and an economy of color and design simplicity." Those responsible for these and all the other excellent info-graphics are noted below: Graphics Editors Hannah Fairfield, Mike Grondahl, Bill Marsh, Frank O'Connell, Sarah Slobin, Hugh K. Truslow, and Archie Tse; Maps manager, Baden Copeland; Deputy Graphics Director, Steve Duenes; Researcher, Karen Freeman; Illustration, Dan Foley. Copyright © 2001 by The New York Times Co. Reprinted with permission.

Figure 15-4

How did the foreign press play the terrorist attacks in its newspapers? *Die Welt*, which is Germany's premiere newspaper in much the same way that *The New York Times* is America's newspaper of record, ran this visually arresting page. The dominant image of the south tower collapsing loads up the right side of the page. Above, the top five images show the second plane crashing into the tower in sequence. On the left are peopled photos of the chaos, rescues and devastation. Reprinted with permission of *Die Welt*, Germany.

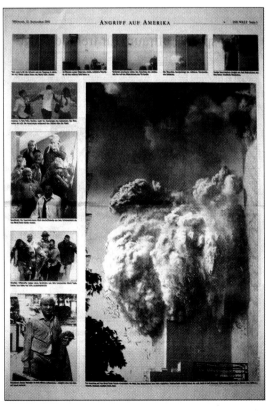

Newspapers and Technology

Digital technology, media symbiosis, and graphic communication were invaluable in telling the unfolding horror of the attack on the World Trade Center. Clearly, today's technology has a huge impact on newspapers everywhere. Dave Gray, Executive Director of the Society for News Design (SND), addresses a number of items: technology and the Web's touch on the newspaper industry, newspaper design, and the industry's current demand for visual communicators.

The Web and desktop technology are probably influencing newspaper design the most, since that's all the newspapers seem to know about. Very few newspaper editors and publishers are even aware of trends in product design, architecture, graphic design in magazines and design in general. The problem is there is very little other than surface decoration (shadowed lettering, cute little buttons, etc.) that can be brought back and forth between the internet and print. Reading patterns are probably very different, as the expectation of the reading experience is different when you sit down with a newspaper than when you sit down with a computer.

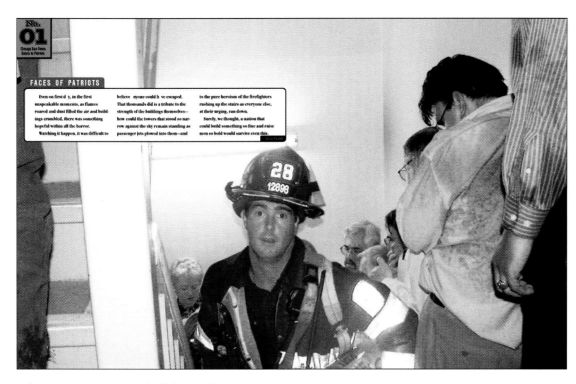

Figure 15-5
The *Chicago Sun-Times* went in a completely different direction from other newspapers, and in so doing, expanded the newspaper medium. From their documentation of the firemen, volunteers, policemen, the *Chicago Sun-Times* produced a series of amazing posters of the World Trade Center attack. The images and poster-spreads celebrated the heroism, humanitarianism, and compassion of people risking their lives to save total strangers. Reprinted with permission of the *Chicago Sun-Times*.

So, are newspapers in bad shape? Gray is optimistic:

I've become bullish on newspapers after traveling around the country this year speaking at state press associations. Small community newspapers will continue to thrive, I believe. The national newspapers will also survive and probably adapt because they have the where-withal and the best and brightest working on solving their problems. The larger metros may also survive because they have enough cash to buy time to figure it all out. The medium-sized metros currently losing circulation and staff and cutting content may disappear in the future because they are too large to be nimble and change quickly enough and are driven by the bottom line. Ink on paper will survive, but content, size and process will change. My best guess now is that more and more newspapers will become compact in size and content, trying to find a niche like the small community newspapers already have.

There is still a strong need for newspaper designers. At the same time, different publications and other new media are clamoring for visual communicators, too, making their demand even greater. Indeed, the visual world in which we live is becoming more graphically oriented each day. So, how are newspapers dealing with that glaring need? Dave Gray, again:

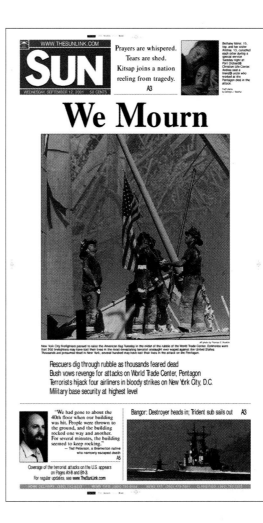

Figure 15-6
Contrast the Bremerton, Washington *SUN*'s approach to that of the other newspapers covering 9-11. It is very personal. Tom Franklin's image of the firemen's patriotism in the midst of chaos is powerful yet understated. The editors and graphics staff opted not to show the planes' impact on the towers. To be sure, those were images all of us had seen countless times on our television sets. Indeed, they'd been well imbedded into the American and world psyche. The headlines ring true. The words, "We Mourn," provide a sentiment that is as simple and direct as it is honest. It also localizes the outpouring of feelings for something that happened all the way across the continent. Reprinted with permission of *The Sun*, Bremerton, Washington.

The SND on-line job bank has about 100 jobs available at any given time. Yes, newspapers want to hire designers, but there is a shortage of them. Editors and publishers don't know enough to look to design and art schools instead of journalism schools, where graphics education is limited at best. The principles of journalism are far easier for a designer to learn, than design is for a journalist to learn. Some designers and artists respond to the deadlines and the newsroom atmosphere, but many don't. Art and design at a newspaper is like a M.A.S.H. unit is to a real hospital. You have to love that kind of work. Too many Gen-Xers won't make that kind of sacrifice. And the design schools don't

Figure 15-7
David Gray was a co-founder, nine-year treasurer and executive board member of the Society for News Design (SND) prior to becoming its Executive Director in 1996. He has worked as a designer, graphic editor, managing editor, and editor at various newspapers. His work has appeared in *Graphics* and other publications. He has written for *DESIGN, The Journal of SND*, the *ASNE BULLETIN, News Photographer, Wirewatch, Editor and Publisher*, and other journalism magazines. Gray was the Gannett Journalist-in-Residence at Colorado State University in 1986; has lectured and taught extensively; and conducted training sessions for the Rhode Island School of Design (RISD), API, NESNE, New England Newspaper Association, Institute for Graphic Communication, Pratt Center for Computer Graphics, and SND. He is currently an adjunct faculty member at the Rhode Island School of Design. Courtesy of David Gray.

really teach anything about newspapers as part of a "publication design" curriculum. Newspapers are just part of the day-to-day background and are hardly glamorous enough to fill a portfolio.

Gray's insights are encouraging. But what's equally promising is that newspapers offer other design opportunities that extend well beyond the boundaries of traditional newspaper page design. Most papers today need designers for their advertising, special sections, and Web and interactive components. Dailies offer weekend entertainment tabs and larger newspapers have magazine supplements (see Figure 15-8). What's more, newspapers don't exist in a vacuum. They are strongly affected by the push, pull, and fusion of other media, and as noted above and in the examples

from the 9-11 tragedy, newspapers have a variety of formats and media available to them.

But make no mistake, the digital age has significantly changed how news is collected and how papers are published. What was once held in great suspicion by the newspaper industry is now embraced as necessary. Digitization, high-powered computers, and stalwart servers have changed newspaper reportage forever. Sophisticated and very powerful software, the likes of PageMaker, Quark XPress, Illustrator, InDesign, and Photoshop, have made pagination and electronic design nearly seamless. Video screens, scanners, and powerful software have streamlined the process of marrying word and image in publications. Today's visual journalist makes graphic decisions as well as editorial ones in the process of telling us stories. Newspaper designers may also find themselves using sophisticated software to create other media. For example, the *San Francisco Chronicle* elected to celebrate Barry Bonds' home run record by creating a sophisticated poster that used a separate piece of art for each of his 73 homers (see Figure 15-9).

However, it isn't as if newspapers aren't experiencing serious problems. Perhaps of all the media, the newspaper faces the single greatest challenge today. For starters, they are hemorrhaging — losing audience share and advertising in unprecedented numbers. Additionally, some designers and visual communication experts believe that we are riding the cusp of change and that the newspaper may soon be reinventing itself.

Concurrently, the opportunities for young visual communicators in newspapers have never been better. Newspapers have become more and more visually oriented, with increased use of photography, color, illustration, information graphics, bold typography, and other graphic devices. Electronic publishing, digital technology, the Web, and powerful design programs have made it possible to produce beautifully-crafted pages and on-line sites with sharper imagery and more saturated color. So, both the trends of more visual newspapers and burgeoning technology could help initiate a renaissance in newspaper design. Surely, the tools and need are there. Of course, technology doesn't create or direct new

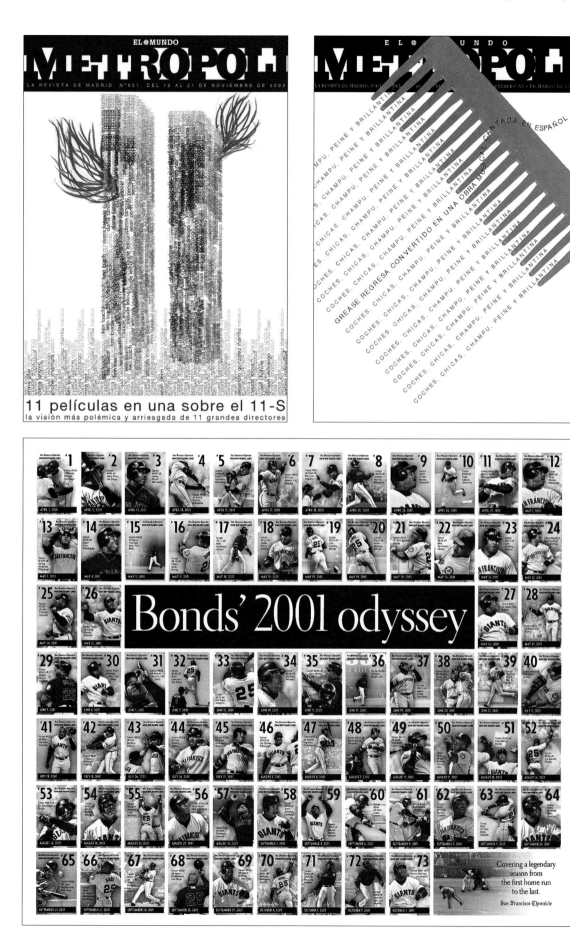

Figure 15-8
Examine these two *La Luna* and *La Revista* magazine supplements for *El Mundo* newspaper of Madrid, Spain. These covers demonstrate the power that illustration and the magazine genre have in newspapers today. How are they different from one another in terms of voice, tone, and personality? Left: September 11th (the movie) uses type to create its illustration! Right: How has Sanchez integrated type into the *Grease* artwork? Covers art-directed and designed by Rodrigo Sanchez. Reprinted with permission of *El Mundo*/Unidad Editorial S.A.

Figure 15-9
Among other media design peripherals, newspapers sometimes opt to create posters. Matt Petty, *San Francisco Chronicle* designer, reflects on this one: "This was a special poster we did to mark the monumental 73 home run season Barry Bonds had in 2001. Each picture marked one of his home runs: either hitting it, rounding the bases, or celebrating afterwards." It is a stunning design—both in terms of its concept and its execution. Design, Matt Petty; photography, *San Francisco Chronicle* staff and Associated Press photographers; creative direction, Nanette Bisher. Reprinted with permission of the *San Francisco Chronicle*.

explorations in design. *People do*, and the new ranks of newspaper design pioneers are likely reading this book.

However, before proceeding, it is important to recognize that knowledge of newspaper design isn't just for journalists or graphic designers aspiring for careers in that industry. Understanding the many facets of newspapers and newspaper design may also prove valuable for those who work in the following areas:

- Advertising designers and creative service specialists produce many of the ads we read in newspapers. They may also help produce newspaper supplements or special sections or work on incoming spec work in newspaper "creative services" departments. In addition, many advertising professionals deal with print media or with "shoppers"—tabloid format advertising publications. A few years ago, there were a handful of these publications. Today, they're everywhere.

- Dave Gray notes, "Walk through any public space and see all the free alternative papers up for grabs. The metro should have taken on more of an alternative role and snatched up all the advertising in the 1980s but in some cases turned it down. Many more newspapers will probably become free, supported by ads only."

Indeed, free publications such as the *Willamette Week* (Portland, Oregon) and the *Chicago Reader* have brought respectability and excellent reportage and design to this genre of the newspaper, including investigative reporting and elaborate election coverage. *Willamette Week*'s Shawna McKeown reflects: "*Willamette Week*'s voters' guides are easily our most ambitious efforts of the year. Before each election, the editorial staff conducts countless candidate interviews. Months are spent researching and analyzing ballot measures. Issues are thoroughly and vigorously debated. Candidates are selected. Finally, the reporting, analysis, and opinion are distilled down to a 15,000-word story that brings order to the world and helps our readers make a difference." But how is this invaluable information designed and packaged? (See Figure 15-10.)

- Many public relations people speak the language of the newspaper industry with media professionals. In fact, the public relations area creates a wide array of media— newsletters, annual reports, brochures, websites, corporate magazines, film and video, and—you guessed it—newspapers.

- There is a growing need for Web designers and Web masters at newspapers today. The Web is surely the fastest-growing facet of today's media, and the newspaper industry—despite a symbiotic love-hate relationship—realized its potential. Web applications vary from full-blown on-line newspaper sites, such as the *Los Angeles Times*, to URLs cited in the paper for everything from links to additional background on a given story, to reader surveys, advertising, polls, and complaint lines—just to name a few. All large newspapers and most medium-sized ones use the Internet these days. Undoubtedly, the Web and other electronic media will continue to grow as important facets of the newspaper.

Visual Journalism

No matter the format, size, or audience of a newspaper, design and effective visual communication are central to the continuation of newspapers as a viable medium—one that's relevant to younger readers and advertisers alike.

Figure 15-10

Willamette Week is a popular tabloid in the Northwest, and its covers are always a surprise. Shawna McKeown talks about this voter's guide cover: "We debated several cover subject possibilities for the May 8, 2002, election issue. Local celebrities and a dominatrix were just two of the possibilities, but in the end art director Anne Reeser found the perfect image: our very unsexy but irresistibly patriotic poster boy for democracy was the talk of the town that week. Papers disappeared from boxes at record rates." The stars and stripes touches and red, white, and blue nameplate treatment, and artwork make a very serious subject—elections—fun. The cover blurb reads: "It may not be sexy, but our voter's guide has all the flesh you need for the May 21 elections." Art direction, Anne Reeser. Reprinted with permission of *Willamette Week*.

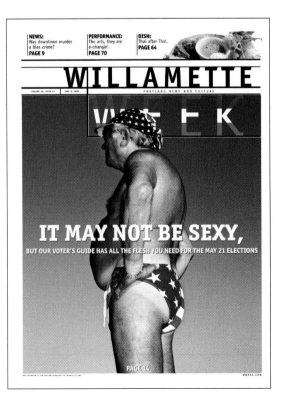

Deborah Goeken is the managing editor of the *Rocky Mountain News*. She's well aware of the importance of visual journalism. Indeed, the *Rocky Mountain News* has received two Pulitzer awards for breaking news photography in the past several years. In a recent interview with Steve Miller for SND's *Design Journal*, Deborah Goeken assessed her view of evolution of visual journalism: "Advances in technology have helped make photography more immediate, nearly instantaneous in fact. In a way, I think the constant video footage has made the power of still photos even more evident, showing that the ability to study a photo and to understand its nuances make it very powerful. And graphics are now an integral part of our presentation of the news—and most often one of the best ways to help readers understand complicated concepts." The pages from the *Rocky Mountain News* walk the talk; the photographs are powerful and tell a difficult story, and their layouts and presentation are equally potent—without getting in the way (see Figure 15-11).

However, not all newspapers subscribe to such articulate visual storytelling. In fact, many media scholars would suggest that the newspaper industry, perhaps more than any medium, tends to be most resistant to change. Unfortunately, a large part of that hesitancy includes a lack of appreciation of the importance of visual journalism. In large part, the design shifts being initiated today are efforts to break away from traditional thinking and to make newspapers more visual, inviting, and reader-friendly to contemporary audiences.

Shallow thinking and stubborn publisher attitudes aside, newspaper design may be more encumbered by economics than aesthetics. Indeed, all too often publishers view redesign as a necessary evil and more as window-dressing to help improve sales, rather than the structural overhaul to improve function and communication and to meet the needs and sensibilies of its ever-changing audience.

But the myopic inclination of some publishers and editors to see the visual aspects of journalism as window dressing is changing. David Yarnold, editor at the *San Jose Mercury News*, fully understands the power of photography and effective graphic communication. The *Mercury News* reflects Yarnold's thinking and commitment to visual journalism. Indeed, it is one of the most celebrated newspapers in the country—period—for its bold use of photography and design. David Yarnold was asked recently about the future of visual communication. "It's a brilliant future," he said. "We've just started to explore the relationships between text, visuals, and on-line and broadcast media. The whole on-line thing got off to a false start, but the integration is starting to happen. But it's going to demand an even greater degree of sophistication, and that's

Figure 15-11
These are a series of pages from the *Rocky Mountain News* coverage of wildfires that raged through Colorado in the summer of 2002. The photographs won the Pulitzer Prize for breaking news photography. "During the height of the fire season, we switched out the main front-page photo two or three times a night, we perfected double-truck photo spreads until the last possible moment and sometimes a little bit beyond the last possible moment," Jonathon Berlin, assistant design director, reflects in SND's *Design Journal*. Accolades to the *Rocky Mountain News* and its fine visual team led by Janet Reeves, director of photography; Randall Roberts, presentation director; and Kathy Bogan, design director. Reprinted with permission of the *Rocky Mountain News*.

an incredibly challenging idea. How will SND judge convergence? Who gets the top jobs of the future; what skills do they need? I think the answer is that the best journalists win. Story-telling is our pulse—and the people who know that best will lead." Denis Finley, Managing Editor at *The Virginian-Pilot*, concurs with Yarnold—with a minimalist twist: "I love what Pegie Stark Adam and Nigel Holmes teach at The Poynter Institute: 'Every mark you make must have a meaning. If you don't give it one, somebody else will.' Those are words for visual journalists to live by." In the case of Dale Earnhardt's tragic crash, Finley's *Virginian-Pilot* tells a sad but meaningful story to its readers with a minimum of art (see Figure 15-12).

With the lead of newspaper professionals, such as David Yarnold, Pegie Stark Adam, Dave Gray, Tim Harrower, Denis Finley, Mario Garcia, Deborah Goeken, and Rodrigo Sanchez, other visionaries, and SND, the visual future of news-papers should be bright, indeed.

Figure 15-12
In this example, *The Virginian-Pilot* dedicates its entire "Sports" page to racing legend, Dale Earnhardt, and his fatal crash. Ironically, the headline, reads: "He raced to live." To the left, his statistics—victories and top finishes—are stacked to note his sizeable list of racing achievements. A simple but appropriate knockout photograph of his car (#3) anchors the bottom of the layout. Below the retrospective on Earnhardt are reference paragraphs directing readers to related stories inside: "Reminisces," "About the Crash," and "Pilot Online." Design, Buddy Moore; photo editor, Bill Kelley; sports copy editor, Mike Flanagan; sports editor, Chic Riebel; deputy managing editor/ presentation, Denis Finley. Copyright © *The Virginian-Pilot*. Reprinted with permission.

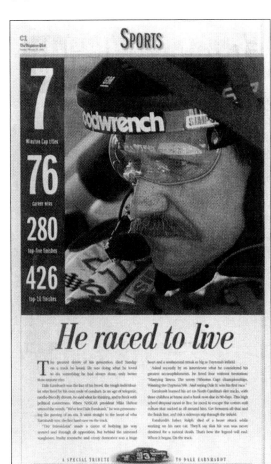

The Development of Newspaper Design

The remainder of this chapter will trace the development of newspaper design through hot type, computers, and the Internet. In addition, it will examine newspaper design and redesign in the light of present trends and share some of the work of today's gifted graphic editors, art directors, and page designers.

The Colonial Era Format

The first newspaper designer in America was a renegade Englishman who fled his country one jump ahead of the sheriff. Only one issue of his paper was printed before it was promptly sup-pressed. Benjamin Harris arrived in Boston some-time in 1690. The single issue of his publication, *Public Occurrences, Both Foreign and Domestic*, appeared on September 25, 1690. Fourteen years passed before another newspaper was produced in what is now the United States. The *Boston News-Letter* was issued by John Campbell, the postmaster. It was more successful than Harris' paper and continued publication for 72 years.

As you might expect, these early newspapers adopted a format similar to that of the early British newspapers; it was the closest model the colonists had at hand. Both papers noted above were the first of what might be called the "Colonial Era" of American newspaper design. They were simple, small, and made little effort to display what we would consider real news. However, they did have several distinctive typo-graphic characteristics that some designers still endorse today.

Public Occurrences used a four-page format, roughly 7½ x 11⅜ inches. It was set in 12-point type. The columns were about 17 picas wide. The newspaper utilized a two-column layout. The columns were separated by white space rather than column rules. Two three-line, dropped initial letters appeared on the first page. They were the only attempt to add typographic or graphic variety to the body copy. The *Boston News-Letter* followed a similar pattern.

Colonial newspapers were produced by printers rather than journalists or publishers. At that, most of them were book and general com-mercial printers first and newspaper producers second. They used the same typefaces for both

Society for News Design

The call for better newspaper design is nothing new. In fact, in the 1970s and 1980s, with the advent of computers, pagination, and color offset presses, editors began rethinking the graphic structure and image of newspapers. In 1979, a group of newspaper designers organized the Society for News Design with 22 North American members.

Today, the membership and reach of the Society for News Design is international, serving nearly 3,000 members in more than 52 countries. Membership includes publishers, editors, designers, artists, photographers, managers, students, illustrators, and journalism and design faculty who design newspapers, magazines, and websites. The organization is dedicated to improving news presentation and design throughout the media.

It showcases the finest in newspaper and newspaper magazine design and provides traveling design and photography workshops throughout the country all year long. SND also has special membership rates for students and holds yearly international newspaper design competitions featured in its annual, *The Best of Newspaper Design* (see Figure 15-13).

The value of the Society for News Design cannot be overstated, not only to the newspaper industry and its members, but to the next wave of editors, photojournalists, designers, reporters, graphic editors, illustrators, and visual journalists. SND also provides student and minority programs for mentoring and scholarships. Its on-going "Quick Course" programs offer traveling, international workshops for professionals and students alike in newspaper design, new media, advertising design, editing, and information graphics. The Society for News Design's full-color, 250–275 page annual, *The Best of Newspaper Design*, is more than worth the organization's membership fees in and of itself. In addition, members receive SND's quarterly magazine, *Design Journal*, and its monthly newsletter, *Update* (see Figure 15-14).

If you're planning a career in newspapers or any aspect of editorial design, your education should include acquiring a membership in the Society for News Design (www.snd.org).

Figure 15-13

This spread from the SND annual showcases *The Virginian-Pilot* as one of several featured among the "best designed newspapers" in the world. Judges strongly consider "design as well as content" in their deliberations over literally thousands of entries from around the world. SND's annual, *The Best of Newspaper Design*, is available to all Society of News Design members. Courtesy of Society of Newspaper Design and *The Virginian-Pilot*. Copyright © *The Virginian-Pilot*. Reprinted with permission.

Figure 15-14

This page is the opener for a three-page feature, "When Sports Sing," in the "Showcase" section of SND's newsletter, *Update*. John Adams shares his five-step plan the *Sun-Sentinel* employed for its annual football sections. *Update* is published eight times a year. Courtesy of Society for News Design.

their newspaper printing and book work. Consequently, newspapers closely resembled book page formats (see Figure 15-15). They were set in large type on wide columns, and the columns were usually separated by white space. A handful of printers used vertical (or column) rules between columns.

Ironically enough, some of the design changes in recent years have actually borrowed from the Colonial newspaper. These include larger body type, wider columns, and the use of white space to separate columns rather than column rules.

During the more than 200 years that elapsed between the Colonial format and today's design structures, newspapers went through some wrenching changes in appearance. Designers of newspapers—regardless of whether the newspaper is a metropolitan daily, a weekly, a corporate publication, or a university or high school weekly—will find it worthwhile to trace these changes to understand how newspapers evolved graphically.

Figure 15-15
John Peter Zenger's *New York Weekly Journal* is representative of the Colonial era newspaper format. Note how the *Journal's* layout is more reminiscent of a book page than a newspaper page.

The Traditional Format

The traditional format dominated newspaper design for nearly a century. However, as newspapers proliferated, competition began to shape the business. There was an increasing effort to be first with the news, to obtain the largest circulation, to gain the most advertising, and to make the most money (see Figure 15-16).

The large margins of the Colonial newspapers were reduced to fit more news and advertisements on the pages. Body copy was set in smaller type so more material could be fitted on the page. In the 1800s, eye-fatiguing 6-point body type was the norm.

Column widths were reduced until the 13-pica column became the standard. Instead of ample white space between columns, they were closer and vertical rules were employed. Making maximum use of every pica of space was the rule, so it's no surprise how jammed the pages looked and read. Sadly, some of this same "shoe horn" mentality affects newspapers today.

Increased street sales and general interest in the news led to bolder typographic play with the headlines, particularly during the Mexican War (1846-1848). There had been only an occasional headline on stories before the 1840s. Most, however, were one to four lines, and all headers were restricted to a single column.

The Mexican War seems to have been the event that truly triggered the expanded use of headlines. Additional lines were added with short dashes between each unit. These areas became known as decks. The short dashes were and are referred to by some as jim dashes. Later, during the Civil War, it was not uncommon for a newspaper to print a headline with up to twelve decks employing as many as six different typefaces or styles.

There was good reason for restricting headlines to single columns rather than employing multicolumn heads, which we would likely do if a big news story broke today. Some of the larger newspapers were printed on the Hoe type-revolving cylinder press. The type was locked in place on the huge rotating cylinders with the help of wedge-shaped column rules anchored in the

curved bed of the cylinder. Most column rules were made of brass, so printers were reluctant to cut them. Dave Gray also pointed out that his understanding "…was that it was impossible to run heads or anything else across two or more columns because the press couldn't be locked, and one-column rules were part of the press cylinder lockup system." Technology limited design.

There were, of course, design aesthetics unique to this era. Printers believed that to "break the column rule"—that is, to spread a layout over two or more columns—disfigured a page. *The New York Herald* ran two-column headlines in 1887, but it left the rule between the columns intact and divided the header on either side of the rule, as improbable as that might seem. Meanwhile, the rule ran right through the headline!

When decks of more than one line were composed, the practice was to center each line. This led to the headline pattern called the *inverted pyramid*, in which each succeeding line is smaller than its predecessor line and all are centered to give the appearance of an upside-down pyramid.

The single-line header or one-line deck became known as a *cross line* or *bar line*. If the line filled the column width, it was referred to as a *full line*. Although fast disappearing, a few newspaper designers still use those terms today.

Other traditional headline patterns were developed. A head in which the first line is a full line and each succeeding line is indented (usually an em) and justified became known as a *hanging indent*. *The Wall Street Journal* uses a hanging indent in its head schedule.

A head in which the top line was set flush left, the middle line centered, and the third line flush right with all the lines as nearly equal in length as possible was called a *step head*. Step heads could be two, three, or more deep, but all used a step-down pattern. As a matter of fact, these still exist today. *The New York Times* clings to this style to this day, as do a number of smaller newspapers (see Figure 15-17).

During the heyday of "yellow journalism," which started in the 1890s, more and more multicolumn headlines appeared. In addition, headlines became larger and bolder. The single-line *banner head* that stretched across the width of the newspaper page made its first appearance around this time.

All these typographic and stylistic innovations became part of the evolution of newspaper design. Tabloids borrowed many of those changes.

Figure 15-16

The traditional format emerged in the middle 1880s and dominated newspaper design in the United States for a century. This is Joseph Pulitzer's famous *World*, published in New York City.

Figure 15-17

Typical traditional headline formats were widely adopted between 1880 and the early 1900s; they're still used today in some newspapers. The top all-caps lines are bar lines followed by two-, three-, and four-line inverted pyramids except for the third deck in "LAUNCHING A VESSEL," which is a hanging indent. Decks are separated here by jim dashes. The heads are separated by Oxford cutoff rules.

The Tabloid Format is Born

In the 1920s two cousins, Joseph Medill Patterson and Robert McCormick, both members of the family that owned the *Chicago Tribune*, started a half-sheet newspaper. The *tabloid* (or "tab") was born. Tabloid newspapers—papers with small pages usually half the size of the broadsheet—had been tried before but none had succeeded in this country. However, the time was right for a smaller newspaper to be successful— one tightly written, loaded with photographs, art and snappy headlines. It was targeted at the urban subway rider. And successful it was. Soon tabloids were springing up in most major American cities.

As a result of the flashy design, the tabloid was tagged a "sensational" journal. In any case, the tabloid page size has many assets as a valid design form and deserves a solid place in the communication spectrum. Indeed, many newspaper "futurists" are predicting that many newspapers will eventually adopt this format. Recently, the *Chicago Tribune* invented a separate tabloid publication, *Red Eye*, to attract young professionals using public transportation. The *Sun-Times* followed suit with a second tab, *Red Streak*. While obviously still a long way from tabloid size, broadsheet newspapers are shrinking; most traditional newspapers have adopted a 50-inch web press size, or page dimensions of roughly 12½ x 22 inches.

Today, there are a number of important newspapers that have maintained their tabloid formats. They include the *Chicago Sun-Times*, *Newsday*, the *Philadelphia Daily News*, and the *Rocky Mountain News*.

Characteristics of the Traditional Format

Narrow columns, along with rigid and precise headline patterns, became trademarks of the traditional newspaper format. Some newspapers continue to use this approach or some variation of it. In addition, designers are adopting traditional design traits today where they are appropriate to their overall design philosophy. Generally, the traditional format is characterized by the following:

- Column rules separating narrow columns. Often narrow margins can make the column rule even more crammed. Dave Gray pointed out that in metal lock up days, these rules "were turned over to form a black rule for death notices."
- Headlines with a number of decks, all separated by jim dashes.
- Nameplates often embellished with "ears" or type material on either side at the top of the page. These often contain weather, edition logo, promotional material, slogans, and so forth.
- Cutoff rules separating unrelated units such as stories, photos, and cutlines.
- Rules above and below the folio lines, the full-width lines under the nameplate giving the volume and issue number, date, city of publication, and similar information.
- Banner heads, sometimes used every day regardless of the importance of the news, which would be followed by readouts or decks.
- Boxes, bullets, ornaments, dingbats, and other embellishments—used liberally.
- Many headlines set in all-capital letters, particularly the top decks in the head.
- Types from several families often used in the head schedule.

In addition, the design plans of the front and inside pages of traditional newspapers usually follow definite preconceived patterns. These patterns are discussed in the following chapter.

As with all design, though, it is difficult to categorically classify the styles of newspapers within clear-cut time and design periods. Most papers share a variety of different affectations, design nuances and sometimes even formats (see Figure 15-18).

Some publications changed slowly. Others changed little or not at all, but the traditional approach to newspaper design began to come under scrutiny in the late 1930s and early 1940s with the emergence of what might be call the "functional" design philosophy.

Functional Design

The *functional design* philosophy is based on the concept that if an element does not serve a specific purpose, it should be eliminated, and if

another element can do the job better, then it should be used (see Figure 15-19).

John E. Allen led the revolt against the traditional, highly formalized style of newspaper design. His editorship of the *Linotype News* was regarded as the nation's typographic laboratory, and his authorship of three books on newspaper design lent authority to his recommendations. Allen's campaign began in 1929 with what he called "streamlined" headlines. There were heads set flush left or ragged right.

In arguing for the change and for abandoning the complex head configurations, Allen made these points:

1. The traditional headline form is difficult to write, and often it is unnecessary to use inaccurate or inappropriate words because of the rigid unit count. (Of course, today the degree of difficulty factor would be moot.)

2. All-CAPS lines are difficult to read compared with lines set lowercase.

3. Flush left heads allow more white space to flow into the page, consequently lending headers more breathing room.

4. Traditional head forms may be more difficult to read and (even with today's more streamlined technology) take more time to set.

These points made sense to enough designers, and newspapers adopted the "functional" style. It was based upon the idea that the purpose of typography and graphic design is to make the contents understandable and inviting. The *Detroit Free Press*, long a widely recognized leader in newspaper design, is one of the most functionally designed newspapers in the country. Their art and design staffs have consistently set the design standard over the years (see Figure 15-20).

Designers examined each element of the newspaper page and evaluated its effective communication value. They proceeded from the thesis that if a functional newspaper were to be designed, the first step was to define its function—a logical starting point.

The functions of most newspapers can be summarized as informing, interpreting, persuading, and entertaining. The design and layout of any newspaper should help it achieve four specific goals.

Figure 15-18

Although *The New York Times* utilizes a "traditional" format, it is by no means boring or antiquated. It uses a tight stylebook that should reflect it being the newspaper of record, but it continually serves up layouts and page designs that surprise and engage its readers. Fred Norgaard, art direction. Courtesy of *The New York Times*. Copyright © 2001 by The New York Times Co. Reprinted with permission.

Figure 15-19

This special page on the homeless appeared recently in the *Los Angeles Times/Orange County Edition*. It demonstrates the Bauhaus philosophy that form follows function. The powerful images by Mark Boster dominate the page and lock your attention to his subjects and to the page. Captions, credits, an understated header, and an interactive "IF YOU WANT TO HELP" list on the far left are all given a lot of space to make for an inviting and efficient read. Photography and interviews, Mark Boster; design, Kirk Christ; art direction, Kris Onuigbo; Director of Photography, Colin Crawford. Courtesy of the *Los Angeles Times*.

The Goals of Functional Design

1. Attract the reader and increase readability.

2. Better organize and sort the content so the reader knows at a glance which information is the most important and what each part of the newspaper contains.

3. Create an attractive and interesting package of pages.

4. Establish clear recognition so the paper can be readily identified.

A number of innovations in design were adopted in the late 1930s and early 1940s to help accomplish these goals. After the adoption of the flush left headline form with fewer (if any) decks, other efforts were made to allow light into the pages and explode the gray of copy-heavy layouts. White space was used more freely. Nameplates were simplified. Often "ears" were dropped or cleaned up. Graphic and typographic elements in the nameplate area were eliminated in favor of more white space.

The top, and in some instances the bottom, rule on the folio line was eliminated. Vertical column rules were dropped in favor of increased white space between columns. A pica of white space between columns was considered minimum for effective separation. Collin Andrew kept many of these concepts in mind when designing a *Gazette* special sports page on the U.S. Women's

Open: generous use of white space, dropped initial letter, ragged lines (flush left) of text, simple and understated logo, and hard-working decks (see Figure 15-21).

Cutoff rules and the odd jim dashes were scrapped in favor of white space, although some newspapers continued to use cutoff rules if they were thought to be more effective in designing story and art demarcations.

The new design movement favored fewer banner headers and more variety in layout. The optical attraction of the upper left corner of the page was utilized by placing stories or photos there rather than subordinating them to the traditional lead story in the upper right corner. The logistical shift not only improved functionality, it spoke to basic design principles and took eye movement into consideration.

Shorter nameplates were another design change. Designers frequently used skyline heads and stories, placed above the nameplate and extending across the width of the page. In fact, usual, full-width nameplates were resized in varying widths so they could be shifted around the page to accommodate larger artwork, blasting heads or to simply provide more flexibility in page layout for variety or a change of pace.

Other functional innovations for the newspaper front page included better overall

Figure 15-20
Functional newspaper design reigns at the *Detroit Free Press*. SND judges awarded these elegant and engaging pages "special recognition." Highlights of their review: "The work reflects his (Kyle Keener's) thoughtful, planning, attention to detail, and clever conceptual imagery. The *Detroit Free Press* used a tabloid format for these sensitive pages in its paper's special Sunday section, 'Summer Dreams.'" Kyle Keener (deputy photo director) shot these touching images and Karolyn Cannata-Winge designed this section. Unfortunately, there is not room to show all the spreads. Keener should make a book of these images and have Cannata-Winge design it. Reprinted with permission of the *Detroit Free Press*.

content display via indexing or highlighting inside features to attract readers to the inside of the publication. More photos were used and often run larger to give them increased impact. Photographs were cropped closely and enlarged. More attention was paid to the bottom half of the page—the area below the fold—to achieve a better balance and to present a livelier look from top to bottom. The number of jumped stories was reduced because research revealed that a story loses as much as 80 percent of its audience when it is continued to inside pages.

A horizontal thrust was introduced with the use of more multicolumn heads and bigger photographs. This helped break up the dull repetition in more traditional, vertical layouts of column after column and *tombstone headlines*, all lined up left-to-right together across the top of a page. Captions were shortened and rules, boxes, and ornaments simplified or even stripped away altogether.

Not all newspapers adopted the entire array of functional design ploys. However, more papers did take on a more modern format—one that reflected what had come to be accepted as a basic tenet of good newspaper design.

Perhaps one of the least noted concepts of functionality is that the newspaper's look should reflect its editorial philosophy and that its design and content should be tailored with its audience in mind. *The New York Times*, still Spartan and traditional in its basic graphic presentation, continues to win awards for its adherence to that philosophy. Though a tad more flamboyant, the Canadian newspaper, the *National Post*, also maintains traditional styling.

The Optimum Format Arrives

In 1937 the *Los Angeles Times* restyled its format by adopting functional design. That same year it received the coveted Ayer award for "outstanding newspaper design." Twenty-eight years later, *The Courier-Journal* of Louisville, Kentucky, and its companion newspaper, *The Louisville Times*, became the first metropolitan newspapers to usher in the *optimum design* era. *The Courier-Journal* cut its columns per page from eight to six and widened the columns from 11 to 15 picas.

In the 1960s some newspapers began to appear with a "downstyle" headline arrangement. The *downstyle head*, you'll recall, is composed in all lowercase letters except for the first word, acronyns and proper nouns. This approach further simplified header arrangements by making them more readable and user-friendly (see Figure 15-22).

In 1965, daily newspaper circulation in the United States was 60,358,000. Ten years later, the population had grown by more than 23,000,000 while newspaper circulation remained virtually unchanged. During that decade, circulation of all the general circulation newspapers in the country only increased by 115,040.

Editors and publishers recognized that something was amiss. Population increases were not reflected in their circulation numbers. This caused them to take a closer look at their product and its graphic presentation. They decided changes should be considered to improve newspaper design in order to make it more relevant and attractive to younger readers.

Following the lead of Louisville's *Courier-Journal* and others, many newspapers adopted two basic changes. The size of the body type was increased from the standard 8 points to 9 and

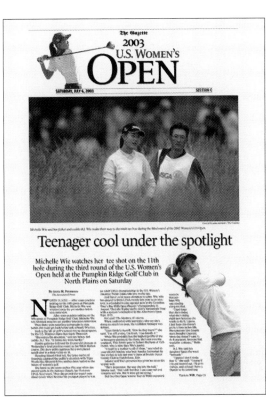

Figure 15-21
Photography dominates this sports page layout. Collin Andrew's use of space and knockout photography of Michelle Lie (both top left and bottom right) make this page inviting and user-friendly. Notice how he sequences your vision into the section titles and logo as well as the text. It's worth noting, too, that Collin Andrew shot this imagery of Lie at the U.S. Women's Open at Pumpkin Ridge and completely designed the opening page's layout. Photography and design courtesy of Colin Andrew and the *Gazette*.

even 9½. Columns were widened to approximate the optimum line length for reading ease and speed. This meant changing from the cramped 10½- or 11- pica columns to more comfortable 14- or 15-pica columns.

By the middle of the 1970s, the majority of newspapers had switched to the six-column format for at least their front and section pages. Some newspapers went to five-column pages, and virtually all of them increased the white space between columns. Dave Gray and others have suggested that the momentum for this change was the result of an advertising column width standard proposed by the American Newspaper's Association—today's Newspaper Association of America. However, some newspapers shifted the column formula by employing five-column front pages with six columns within the newspaper's inner section pages to accommodate advertising guidelines.

Another pioneer in newspaper design was Edmund C. Arnold, who succeeded Allen as editor of the *Linotype News* and who has been long recognized as one of America's authorities on newspaper design. Arnold urged that designers strive to make newspapers more readable. "There are many advantages to the op format," he wrote in *Modern Newspaper Design*. Arnold stressed function and optimum line length and other design basics that improved the read-ability of newspapers as well as reader comfort levels.

However, even though the optimum format made newspaper reading easier and more pleasant, circulation remained static. Conse-quently, the non-believers regressed, and many newspapers shrunk their columns back to a narrow 12 picas and reduced the body type back to 8 point. The intent and rationale of the optimum format had been lost on them.

The Redesigning Era

Newspaper design today is in a state of flux. The optimum format is with us in spirit if not in actuality. At the same time, editors and designers are probing ways to make newspapers more visually exciting. They are struggling to keep up with the rapid changes in the life-styles, culture, and interests of their readers—and potential audience. As noted earlier, new technology and the digital age are also shaping many facets of the content, form, and format of the newspaper. That said, some publishers are favoring whatever changes save money in an ever-shrinking market. One such move, and it is a major one, is the scramble of many broadsheet newspapers to move to the 50-inch press. Along with many graphic editors, Gray laments that many "drive by" editors and publishers make this "bottom line" move "without really considering the real impact on content, design, and cost."

Importance of Marrying Design and Content

There is, however, a growing realization of the importance of blending design and content to develop the most effective communication package. Some modern-day pioneers have who have worked long and hard to that end are Leland 'Buck' Ryan and Drs. Mario Garcia and Pegie Stark Adam. Ryan, who is director of the School of Journalism and Telecommunication at the University of Kentucky at this writing,

Figure 15-22
The Hartford Courant is a leader in newspaper design. Like the *Detroit Free Press, San Jose Mercury News, Chicago Sun-Times, La Gaceta, The Plain Dealer, Clarin, The Boston Globe, El Mundo, Die Zeit, The Virginia Pilot, The New York Times, Le Devoir,* and other newspapers with consistently strong architecture, the *Courant* takes risks and mixes surprise with logic to tell stories in memorable ways. *The Hartford Courant* still largely uses the optimum design for its page structure, but its stylebook is flexible and often accommodates other approaches to design— but always relating content and context to design. In this sports section, the newspaper delivers a clever design that emphasizes verticality. All headers are run downstyle, save the main head which defers to "small caps." Reprinted with permission of *The Hartford Courant.*

created the "maestro" concept, a team approach to newspaper stories that shapes every aspect of the story by putting the editor, reporter, photographer, and designer together from the start. Consequently, the designer knows the story intimately and clarifies his needs and vision to the others. The result is smart writing, design, and photography to communicate the story.

Mario Garcia, longtime director of the graphics area of the Poynter Institute for Media Study, is another visual crusader: "Improvement in content and emphasis on clear writing and editing, combined with effective graphic innovation should be present" before circulation declines can be reversed. His *WED* concept (Writing-Editing-Design) embraces visual thinking through the marriage of words and images.

The Poynter Institute for Media Studies has also conducted a legacy of on-going design research. It utilizes, among other things, eye-tracking technology that establishes how the human eye processes newspaper page designs, color, size, typography, photography, and other page components. SND, too, has recognized the art and science of newspaper page architecture while concurrently raising the bar on that medium's role in visual storytelling. While most newspaper designers will tell you they have a long way to go, the Poynter Institute, SND, and many colleges and universities continue to provide important research for the field and apply what they've learned through their educational programs. University journalism programs such as those at Syracuse, Michigan State, Temple, Texas, Kansas, Missouri, Northwestern, Oregon, Florida, North Carolina, and other fine colleges and universities are providing important research and challenging curricula for their students to prepare them for careers in journalism. They also offer students hands-on experience and internships.

The Total Design Concept

Concurrently, new technology is opening doors to the future for newspaper editors and designers. Mechanical constraints of the past have largely disappeared, allowing the designer to apply what has been called the *total design concept*. Instead of being restricted by a page that is divided into columns and vertically oriented, the designer now sees the page as a blank canvas upon which to create an effective and appropriate design that speaks to the reader—one that tells the story through words, photographs, and design. *El Mundo* newspaper and its magazines epitomize total design. In fact, Rodrigo Sanchez (who opened Chapter 5) literally reinvents *Metropoli* on a weekly basis, stretching the newspaper magazine's visual possibilities, content, and form (see Figure 15-23).

Figure 15-23

What do newspaper design, Bjork, a Spanish talk show host, and the Incredible Hulk have in common? Well, not much to Rodrigo Sanchez. Notice how his *Metropoli* covers become chameleon-like: marrying content and concept to design—without losing the identity of the publication. They exude *total design*. Reprinted with permission of *El Mundo*/Unidad Editorial S.A.

The Modular or Mondrian Format

Today the design question has become not how to fill columns but how to marry content and form to create an effective page that is reader-friendly, compelling, and aesthetically pleasing—a page that meshes form and content. Some designers have retained the basic vertical approach, which has withstood the test of time. However, a more functional design strategy that most papers employ is the Mondrian or modular format. This grid approach to design perhaps made the single most important contribution to modern page layout (see Figure 15-24). Oddly enough, its inspiration was gleaned from the paintings of Piet Mondrian, an important Dutch painter and the co-founder of the *de Stijl* movement—another prime example of how fine art has influenced a graphic arts counterpart. Another variation of Mondrian, modular, or grid design is Swiss design, which utilizes the grid but without lines to demarcate elements within the rectangular space.

Mondrian painted mostly in the early twentieth century. By 1917, he was concentrating most of his efforts on the use of primary colors—red, yellow, and blue—combined with black and white. His work investigated some of the more formal essences of design and design principles by limiting his content to lines, squares, rectangles, and color.

Typical of Mondrian's art were simple compositions employing vertical and horizontal lines at 90 degree angles forming intersections, squares, and many rectangles. Mondrian, who lived until 1944, has been an important influence on contemporary art and architecture, as well as on the modular approach to layout of newspapers, magazines, websites, brochures, advertising, and just about every other medium.

The Mondrian, International Typographic Style, and Swiss design discussed in Chapter 2 were adopted by newspaper designers (see Figure 15-25). Characteristics of this philosophy include the following:

- Use of a precisely drawn grid.
- Adoption of sans serif type—largely used for display type because of its great legibility and tendency to offer variety to page texture.
- More type set ragged right.
- Additional use of white space.
- More of an emphasis on function, using design principles as guidance.
- Combining the work of the reporter, visual communicator, and editor to present information in as clear a manner as possible.

The use of the grid, advocated by this movement, has become standard practice in publication design, particularly in newspapers and magazines. In the modular approach to newspaper design, the page is made up of a series of rectangles. Each spatial unit or module contains a separate element: photo, side bar, headline section, body text, and so forth. Sometimes these are combined into a single unit. Using this strategy, stories are easily packaged, unified, and fitted within the page.

Mondrian formats are as hard-working and efficient as they are popular in the design of publications and websites. Designers who have adopted the Mondrian or modular plan have these suggestions for structuring layouts:

- **Begin your newspaper designs by sketching out thumbnail grids made up of various combinations of rectangles.** Try to avoid multiple patterns of square shapes, as they may appear more predictable and less interesting. Keep in mind all of the various design principles.

Figure 15-24

This painting is a good example of Piet Mondrian's modular style during his *de Stijl* period, which was strongly influenced by the Bauhaus. Mondrian's work is especially relevant because it influenced editorial design and underscored the importance of grid design. Private collection, photo of Mondrian painting courtesy of Sidney Janis Gallery of New York.

Remember you'll need an emphasis or a dominant module, good balance, interesting proportions, good sequencing to move the eye of the reader, and, of course, unity. Select the sketch that is most effective with your art for that particular page.

- Flip sketches, or even hold them up to a mirror for additional grid perspectives and layout possibilities.
- Remember, only one module should dominate the page. Most often, this space carries the artwork and (the great majority of the time) the lead story. This module should be placed above the fold within a broadsheet design, usually the upper left or upper right—important real estate in the page's logistics, due to optical center and normal eye flow.

- Normally, each module should be self-contained with a rule to define and unify it. However, the rule shouldn't be too heavy-handed. Usually, a hairline, half-point, or 1-point rule works just fine; typically, four points is the maximum. Some designers use color, but black is standard for keylines. Fairly generous white space, 18 to 24 points worth, may be used instead of rules.
- The page should be thought of as packages of information. Modules usually contain a head and art, or they may consist of art and cutline only. Elements should be arranged to transmit the story or information as clearly as possible.
- Crop visuals tightly and appropriately to give impact and more power to the imagery. Although illustration is being used more in

Figure 15-25
Several outline layouts here demonstrate variations of a three-column grid. The modular approach to newspaper and most magazine, advertising, and other publication design grew out of the work of Piet Mondrian, the philosophy of the International Typographic Style, and Swiss design.

newspapers these days—typically in arts, entertainment, magazine sections, accent pages, and their ilk—photography still dominates. Remember, too, we are visually predisposed and a picture is worth at least a thousand words, so powerful photographs should be run large and prominently placed on the page.

- **Give the art, headlines, and other page elements breathing room, use white space generously, and avoid cramming elements together.** Notice how the design staff of *The Hartford Courant* constructed the beautiful modular layout for "Photographer's Eye" (see Figure 15-26).

Not all newspaper designers advocate modular design, but it is amazing how often you find the grid's footprint throughout media design. The corporate art director of *The New York Times* Company, Lou Silverstein, comments on modular design in Chapter 17. Some publications—*The Wall Street Journal* is a good example—still prefer vertical layout structures. That said, when deconstructed, most layouts (all publication layout and design, not just newspapers) reveal some kind of grid or modular structure as their basic underpinning. To see this for yourself, get four different newspapers and quickly create thumbnail renditions of each of them. Do the same thing with a few website and magazine pages. You'll likely discover skeletal forms of the grid in each instance.

Today, electronic publication (or what used to be referred to as "desktop") gives designers tremendous layout freedom. Even modular structures can be customized with software tools that weave or "wrap" text around implanted graphics to establish a rebus look to page or page module (see Figure 16-). Art and typography can also be easily manipulated in minutes or less to achieve some stunning page arrangements and architectural possibilities.

Before establishing a layout or design strategy for a newspaper, however, it is important to analyze the publication's image, mission, and audience.

How to Analyze a Publication

Most newspapers—certainly the metros and larger publications—analyze their product on a regular basis. In fact, many hold regular daily or weekly meetings to discuss and assess their editorial and graphic progress.

Graphically, one of the major design concerns is typography. Does it reveal an appropriate image of the publication? For instance, does the entire issue help identify the newspaper as a conservative publication for a conservative community? Do the main type components—headline, color, graphics, text, deck, and cutlines—work cohesively? Does the type suggest the newspaper is devoted to health care and medical interests or to the manufacture of heavy equipment? Clearly, the appearance of the newspaper should reinforce its purpose, speak to the audience, and reflect publication image. The University of South Carolina's *The Gamecock* newspaper recently overhauled its design and typography; its changes are as functional as they are aesthetic and current (see Figure 15-27).

Figure 15-26
Modular design is clearly evident in this *Hartford Courant* "Photographer's Eye" page. Deconstruct this layout by sketching it. Its bare-bones structure could almost serve as an outline for a Mondrian painting. Photography by Marc Yves Regis I. Courtesy of the *Hartford Courant*. Reprinted with permission of *The Hartford Courant*.

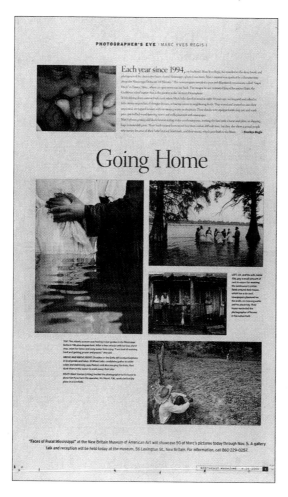

There are two basic approaches to type selection: the first one is to opt for type that is basic, invisible, and utilitarian; the second is to build a typographic stylebook that employs faces with distinctive personalities to match the paper's overall style, audience, and image.

The analysis should also examine whether the various design elements (heads, body, pull quotes, decks, interior logos, rules, artwork, etc.) and their arrangement help tell the story. Is the flow of the copy interrupted or confusing? Does the layout increase readability? Would readers be attracted to the story? Would they be inclined to pass up a story because its layout is uninspired or boring? If you were a subscriber would you want to invest your time reading this newspaper?

Basically, the entire package should do a smart job of "sorting" and organizing the contents on the page so the reader can locate topical matter easily. The reader should also sense the hierarchy of the page intuitively and understand the relative importance of its stories or parts by how the page contents are arranged. Note the remarkable sequence and organization of *The Virginian-Pilot* spread on Michael Jordan (see Figure 15-28).

Once an overall impression has been established, each of the typographic elements should be examined and carefully evaluated:

1. Body type. Is it legible and readable? Roman faces tend to have the highest readability and bring inherent texture to the page. In newspaper design, however, it's better to avoid using modern romans because hairline serifs don't reproduce well on newsprint. The size of the type should be checked to make sure it's large enough for easy reading. Remember, too, that faces with larger x-heights tend to have better readability. Line length should not be too short as it will tire the eye. On the other hand, especially long lines cause tracking problems. Leading should also be examined. A good rule of thumb is to autolead text, or add 1 to 2 points to the type size for body copy leading.

Figure 15-27

What a difference a year makes. *The Gamecock* (student newspaper of the University of South Carolina), is a great "before and after" example of insightful and functional design. Its typography, spatial arrangements and photo treatments are clearly different from one another. The graphic makeover is as aesthetically pleasing as it is inviting, functional, and user-friendly. The redesign team consisted of Dave Horn and Martha Wright; Victoria Bennett, Brandon Larrabee, Mary Hartney, Kyle Almoond, and Mackenzie Clements served as creative consultants. Reprinted with permission of *The Gamecock*, University of South Carolina.

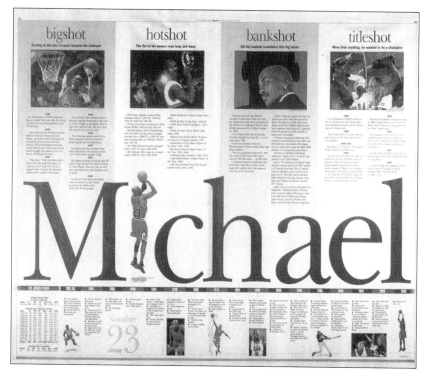

Figure 15-28
The directional cues, organization, and modular (albeit uneven) breakout of this double-truck layout from *The Virginian-Pilot* is risky, appropriate, and stunning. It is as flamboyant yet grounded as its content: Michael Jordan. From its bold header (with Mike being the "I" in the header and the basketball the dot on the "I") to its rebus timeline, it is classic. The writing and copyediting ("bigshot," "hotshot," "bankshot," and "titleshot") are a perfect blend of great design and clever storytelling. Design, Courtney Murphy Price; sports editor, Chic Riebel; photo editor, Bill Kelly III; sports editor, Tom White. Copyright © 2001. *The Virginian-Pilot.* Reprinted with permission.

2. Headlines. Is the header type attractive? Does it reflect the tone and image of the publication? (See Figure 15-29.) Is the type appropriate for the feature content? Bold types are common for headlines, but be careful the counters of the letters are crisp and not given to clotting. Remember that often bolding isn't required because you're already running the type at large point sizes. The head type should be clear and legible and have fairly good unit count. If more than one headline family is used in the stylebook, the faces should harmonize, but one should dominate. Groom the headlines— certainly the ones over 20 points—by kerning, or at least by tracking them tightly. Don't autolead headlines. One of the most common typographical headline errors is leading the lines too generously; because the type is so much larger, it normally does not require the same leading ratio as does text. Avoid hyphenating words in the headlines or other display type at all costs.

3. Typographic color. Have ornaments, dingbats, bull's eyes, and other visual banality been avoided? If typographic garnishing has been employed, it should enhance the layout and relate to the story, not detract from it. Think simplicity and function first if you're tempted to use any dingbats.

4. Newspaper constants. Do the standing heads, departments and column heads, and the masthead harmonize with the overall feel and effect of the layout? The constants should be alive—not static. Concurrently, these standardized type treatments should not be altered to suit content or the whims of someone, and they should fit comfortably with the other type in the newspaper. Employing these guidelines consistently helps the continuity of the paper. Notice how *The Hartford Courant* maintains design unity in its various section pages through the use of color, typography, page structure, and various anomalies (see Figure 15-30). Features in entertainment, cuisine, travel, and arts sections may allow for a lot more freedom with type selection, but typically, the section mainstays (front page, sports, editorial, business, metro, and the like) follow the stylebook religiously.

5. Photos and cutlines. Are the photos and other artwork cropped properly for emphasis and impact? Art should help communicate the story (see Figure 15-31). Cutline (or caption) style should be consistent throughout the publication. Captions should be set in a typeface and style that harmonizes with the other typography yet provides contrast. One common and effective ploy is to use an italicized version of the text face for cutlines. Set captions the proper width— generally not to exceed 18 picas. Some designers prefer to break captions beneath wider art into columns that approximate ideal line length. Indented captions with ample leading may help brighten a page.

6. Front page layout. Are the basic design principles employed appropriately? Is optical center used to help achieve better balance and sequencing? Remember, the front-page design should emphasize the most important story, but normally more than one strong element is needed to enliven the page. However, the page shouldn't be overloaded to the point where it becomes an unwieldy conglomeration.

Are there strong elements in the "hot spots"— the four corners of the page? Unless there is a planned vertical thrust to the page, a strong horizontal treatment generally works best. Again, that's a more workable reading and designing

arrangement for most modular layouts. White space should be ample and well-planned. Think function and readability. The best writing in the world will lose a significant chunk of readership if it's jammed too tightly into a page.

7. Inside page layout. Some inside pages don't carry advertising or serve as common "jump" pages; inside pages may even carry features. An SND award-winning "inside page" from the *Detroit Free Press* celebrates "Everyday Inventions" in memorable and inviting ways (see Figure 15-32). However, when advertising is employed, is there a consistent pattern evident for advertisement placement? Ads should not be arranged haphazardly on a page, and the pattern adapted should be used consistently throughout the newspaper. Advertisements should be placed so they do not destroy reasonable editorial display; that is, they should be kept as low on the page as possible. Is there an

Figure 15-29
Typographically, you don't tiptoe into a heavy story—certainly not one as tragic as the 2002 Colorado wildfires. The use of type here reflects the emotion, power, and urgency of this story. So, too, does Dennis Schroeder's powerful photography. Janet Reeves, director of photography; Dennis Schroeder, photography; Randall Roberts, presentation director; Kathy Bogan, design directory; Jonathon Berlin, assistant design director. Courtesy of Jonathon Berlin and the *Rocky Mountain News*. Reprinted with permission of the *Rocky Mountain News*.

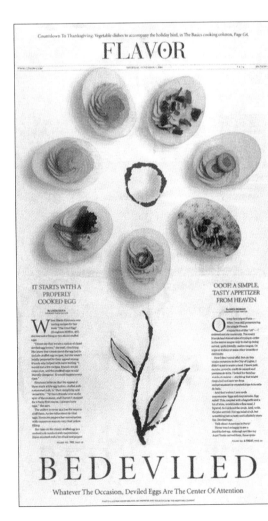

Figure 15-30
You can tell at a glance that these section pages from the beautifully designed *Hartford Courant* have continuity. While both pages are minimal and show restraint, the travel page (left) uses color and asymmetry to grab and hold the reader in "An Autumn Epiphany," while the cuisine page (right) employs symmetry and whimsy. Both are arresting, simple, and sophisticated. Can you find other differences and similarities between the pages' construction and presentation? "Autumn": Josue Evilla, designer; Mike Mirko, photographer; JoEllen Black, photo editor. "Bedeviled": Chris Moore, designer; Josue Evilla, illustrator; Michael McAndrews, photographer. Reprinted with permission of *The Hartford Courant*.

Figure 15-31

Unfortunately, *The Oregonian* (Portland, OR) doesn't receive the attention that it deserves for its remarkable design, photography, editing, and reportage. Patty Reksten led the maestro team that shaped this powerful story on autism, "This is how we live." Moyota Nakamura's photo tells the story visually. Julie Sullivan's words are riveting. Randy Cox lays down type and a sophisticated layout, and gets out of the way. Patty Reksten, photo editor; Randy Cox, art direction and typography; Moyota Nakamura, photography; Julie Sullivan, story. Courtesy of *The Oregonian*. Reprinted with permission of *The Oregonian*.

Figure 15-32

The *Detroit Free Press* treats this inside page royally. Although it presents a single feature, "Everyday Inventions," the design uses the "four corners" principle deftly. The layout celebrates "Black History Month," specifically the inventions of African-Americans— simple but invaluable inventions: the fountain pen, golf tee, scoop, traffic light, wrench, and more. Amy Etmans, news designer; Diane Weiss, picture editor; Steve Dorsey, design and graphics director/designer; Eric Seals, photographer; Jessica Trevino, gallery page coordinator. Reprinted with permission of the *Detroit Free Press*.

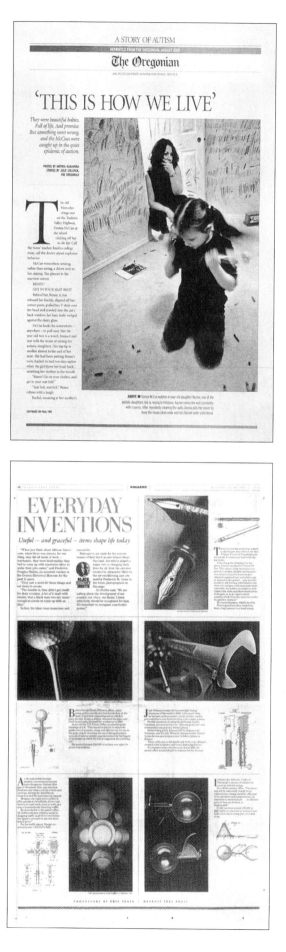

editorial stopper—a story or art or a combination thereof—on each inside page?

Once each part of the newspaper's anatomy has been analyzed and improvements noted, the suggested changes should be scrutinized to ensure they mesh with the rest of the publication in order to maintain its unity and style.

Graphics in Action

1. Select a daily newspaper—ideally, one you don't often see or read—and study its typography and design. See how many examples you can identify that illustrate applications and principles of newspaper design. For example, black letter type used for the nameplate; stylebook contrasts between text, cutline, headline, and other display typography; four corners' usage; modular or Mondrian structure; or creating balance on the page with art and text blocks.

2. Deconstruct a metro front page by outlining and blocking out the page's modules and art. Then, from that sketch, make a Mondrian-like page painting. Display them in class and compare to several real Mondrian paintings. Be sure to use primary colors where the artwork of the newspaper page appeared.

3. Build a prototype of your own newspaper's front page; that is, one *you* invent. But before you start, compose a brief statement of two or three paragraphs that details the intent of the publication, its image, mission. Finally, clearly define the audience. Then, specify and select all your type, and do most everything else from scanning in your art to plotting a grid for your pages. Keep the type selections to a minimum; three faces tops—of course you can vary them in terms of size, weight, styles, and so forth. "Greek in" the text. (Use the suggestions from the "How to Analyze a Publication" in this chapter as a guide.)

4. Plan the "ideal" sports or entertainment section of your school newspaper. Remember your audience! Select the format and page size, types for headers and features, departments, and all the design elements that you believe should be incorporated in such a publication. Don't forget the photography and be sure to play the imagery you select appropriately. Make a strong graphic statement.

5. Body type (text) makes up the lion's share of most publications, including newspapers. Part of your mission as a designer is to break up the sea of gray (especially in longer stories) in an appropriate way that encourages readers to enter the story and engages them in a meaningful way. Using a tabloid format, create several rough layouts for an inside film review page. Assume you have only one piece of (5″ × 7″) art. The main objective here is to use a minimum of typefaces (no more than three) in interesting ways to help break up the page. (Employ type size, leading, weight, indents, crossing headers, rules, alignment, gradations, dropped initial letters, and the like as your primary tools.)

After you've presented your roughs in class and listened to critiques, decide which graphic strategy has the most potential and build a prototype page for the following class meeting.

6. Assume you are designing a front page that focuses on an important local story—the homeless in your community. Your editor and art director want you to dedicate the entire page to open the story. In other words, this is the primary content of the front tabloid page. (In fact, the editors are hoping to construct a three-part series focusing on different aspects of this social issue.) However, they also want you to design an "at a glance" box that tersely but adequately tells the story using type alone, and they want you to come up with a relevant sidebar related to some aspect of the story.

Given the above charge, break up into teams of three. One of you should act as the designer, another the researcher, another the photographer. You may make your own photographs or use those you find for your pages. (Perhaps you can work with the school's photojournalism or photography students. If you use another person's art for your layouts, be sure to credit them.) Again, remember that you're designing for a tabloid format.

7. Using your local or closest daily broadsheet paper as a working model, select a recent front page and convert it to a tabloid format. In the process you'll quickly discover that not all the imagery and information will fit the smaller page size, so along with converting the design format, you'll have to be an editor of sorts, too, deciding what information and photography to keep and what to omit. Try to at least "tease" or mention some of items that you have decided not to run on the page; these may appear in your sky-box or teaser lines atop the page, or in a left- or right-hand column. Scan photos and try to use as many of the existing headers, decks, cutlines, and other elements as you can.

Be prepared to discuss your experience: what you learned, how you determined what to keep or toss, how tabloid page reconfigurations helped or hindered the design process, etc.

8. Your editor has decided to launch a special Saturday arts & entertainment supplement dubbed *Weekend Ticket* and wants it to have a magazine look and wear a tabloid format. It's targeted not only at the regular audience, but also at tourists and weekend visitors. She's asked you to build four prototype pages for it: the cover, a film review page, a feature page on the local sports team, and a standing page hawking cultural offerings: city museums, art galleries, the planetarium, concert series, and so forth.

9. Design a small newspaper for an organization to which you belong (your fraternity or sorority, marching band, or intramural sports at your school) or design a company or corporate newspaper for a firm with which you're acquainted. Build, as a working model or prototype, the following: front page, sports page, business page.

10. The Portland Science Center, Atlanta Art Museum, or Denver Dance Troupe (choose one) has asked you to create a small tabloid newspaper targeted at urban youngsters who are needy and come from broken homes. Target? Kids 8-13. The idea is to acquaint young people with this area (science, art, or dance) and to present that area in an interesting way that they can relate to. The client would like you to come up with something that's engaging and interactive. Create a front page for the paper. Along with the page design, of course, you'll be creating a nameplate, short teaser box or table of contents, and folio lines. How will you use color? Type? Photography? Other art?

Redesigning The Wall Street
Journal *reminded us that all
redesigns—whether for big or
small newspapers—need to
begin with a realization that
traditions are to be respected.*
 —Dr. Mario Garcia
 Design magazine

◄ Ollie delivers *The Wall Street Journal*, Eric Evans

Be impactful. Make a difference to readers every day. I can't imagine a greater challenge. I work with so many talented visual journalists that there are days when I look at the full range of sections on the wall, and I just smile.

—David Yarnold, Editor, San Jose Mercury News

Figure 16-1

The power of this *Hartford Courant* page design lies in its simplicity, planning, and presentation. The paper broke this important story on a political scandal. Bill Leukhardt and Edmund Mahoney wrote the story with the help of seven other writers and reporters. How's that for team work? Indgrid Muller was responsible for the front page's fresh layout. A strong deck set flush right (upper left) breaks down the story and forms a bookend on the former mayor's mug shot. The story is neatly sequenced and packaged. Reprinted with permission of *The Hartford Courant.*

Previous page

Newspapers continue to deliver the news and meet our expectations daily. They offer a dependable and credible window into our world—near and far. *The Wall Street Journal* is *the* financial newspaper of record. In redesigning it, Dr. Mario Garcia clearly realized its legacy in terms of content, context, and design: "Enhancing a product to suit the needs of contemporary readers does not imply abandoning those elements which have made the newspaper viable and contributed to its excellence." Photography by Eric Evans; canine modeling, Ollie. Courtesy of Eric Evans Photography.

Developing a Design Philosophy

In many ways, the *San Jose Mercury News* and a score of other well-designed newspapers really set the bar for visual storytelling. Editor David Yarnold thoroughly understands the power of images and graphic design; he's worked as a photographer, picture editor, and as a news editor. He encourages risk-taking and trying new and unusual approaches to design. "Giving readers great information in a really boring way is like giving a dog a coconut. It's not very satisfying," Yarnold pointed out in a recent interview with

Design Journal. He's not only committed to great visual journalism but great journalism, period. His design philosophy includes taking advantage of all your resources and challenging staffers to tell stories in truly memorable ways every day.

In the best of all worlds, editors would share Yarnold's design philosophy, and newspaper design would not be looked upon as a token stepchild, an afterthought, mere window dressing, or as some kind of Prussian stylebook that arbitrarily filters the paper's contents and monitors the publication's graphic "dress code." Instead, editors, designers, writers, and photographers would be sharing their work, intent to best shape and tell each story, using the "maestro" concept. For example, the *Hartford Courant* used nine reporters to investigate and assemble the background for a story on a mayor whose shocking behavior brought about a scandal that affected him, his family, city, and state. Note, too, the *Courant's* visual journalists used art, graphics, type, and design to help tell this story (see Figure 16-1).

Today newspapers, like all media, are becoming more and more visually oriented. Unfortunately, most of the journalism and communications programs don't offer an emphasis or program in visual journalism. College and university journalism curricula remain word driven. Students are forced to cobble their own curriculum together, often raiding fine arts departments to get more hands-on experience in photography, graphic design, typography, and illustration and to acquire more experience (and sometimes an initial grounding) in graphically oriented software programs. This scenario is sad and especially ironic at a time when media have become more dependent on graphic presentation and therefore need more visual journalists and designers—and at a time when media are fusing.

Many professional newspaper designers would suggest that inequity also exists in the newspaper profession. Many photojournalists, designers, illustrators, and other graphics people feel like second-class citizens in a medium that is dominated by "word journalists." The good news is that kind of attitude is changing. Organizations such as Society for News Design (SND), The Poynter Institute for Media Study, and the National Press Photographers Association underscore the importance of visual journalism. Talented designers, educators, and many editors also preach the gospel of graphic communication.

Ideally, design would be adroitly wedded to both word and image and appropriately presented to the audience. Presentation is everything, especially in today's fast-paced and very visually astute world. That's the starting place for adopting a design philosophy. However, it's important to stretch our appreciation of as many approaches to design as possible, including looking outside our immediate resources and ideas. Today SND and many newspapers provide excellent visual models for others to learn from. In addition, SND offers on-going workshops and seminars to improve journalists' skills and design philosophies. More editors are coming from design or photography backgrounds, too, and are more sensitive to the graphic needs of newspapers.

Outside influences may be found close to home or very far away. The vision of Kris Viesselman, Senior Art Director at *The Orange County Register*, connects to international newspaper and magazine design: "We can learn a lot from many papers from Spain, Argentina, and Mexico (see Figure 16-2). Their work tends to be more aggressive and experimental in the way they use color, size, contrast of elements, and photography. These same papers often use information graphics aggressively. Some German and Scandinavian papers use edgier illustration and more extreme photo cropping than most American papers would employ. Many European papers also have a keen respect for clean, elegant typography and consistency throughout inside pages."

Figure 16-2

Both of these two-page spreads are reminiscent of magazine feature design, and they live up to David Yarnold's tenet: "Be impactful." What are the different ways these pages impact you? Keith Richard's face reflects the creases time has worn on him in this (top) *La Luna* layout. Rodrigo Sanchez, art direction and design; Francisco Dorado and Chano del Rio, designers; Carmelo Caderot, design director. "Momias" (mummies) is another powerful *El Mundo—La Revista* design (bottom). Simple and minimal are best; indeed, they often are inspiring and eye-stopping approaches to design. Rodrigo Sanchez, art direction and design; Maria Gonzolez and Amparo Redondo, designers; Carmelo Caderot, design director. Reprinted with permission of El Mundo/Unidad Editorial, S.A.

In addition, design philosophy might marry idea, form, art, type, line, illustration, and color to the concept and content of the article itself. Design philosophy also might be defined as your beliefs and attitudes toward all aspects of graphic design and how you apply those tenets in creating newspaper or special section pages for your audience. It would include such things as typography preferences and application; how you play and use photography and illustration, color, info-graphics or info-lists; and the use of lines, rules, tint blocks, and ultimately, the stylebook that you create for the publication. Of course, it would also include the application of your taste, graphic judgement, and aesthetic instincts.

Design isn't a cacophony of photo manipulation and design software tricks. It is purposeful and planned, not sleight of hand or a software dazzle. Kris Viesselman underscores that point: "In my experience as an art director and a university instructor, I've run across so many

students soon to graduate, who know all the technical tricks but are weak in conceptualizing and critical thinking. They're inclined to use all of the bells and whistles but lose track of the message. It seems that no matter what medium people choose, these same skills are important." Content drives design. Form follows function (see Figure 16-3).

While books, classes, and workshops can help, they are not the answer in and of themselves. That said, you can learn a lot by poring over *Communication Arts*, *Print*, *Graphics*, *CMYK*, and SND's *The Best of Newspaper Design* annuals. Like anything as complex as acquiring a well-grounded philosophy, it requires time, experience, commitment, and education.

Clyde Bentley, University of Missouri journalism professor, adds these insights about how you might think about the newspaper in shaping your design philosophy: "Remember that a newspaper is more than images and more than words. It is even more than the combination of the two. In the minds of many readers, the newspaper is an organic creature with a distinct personality, both a temper and a sense of humor, a recognizable haircut and a place at the table. There is good evidence to show we don't so much need newspapers as we rely upon them to give us the counsel, information, and friendship that we probably should be getting from our family and neighbors. I think if more designers would anthropomorphize their newspapers, they would have more success with their readers. The closest design analogy I can think of is a cartoon character. It's just a drawing, but many artists refer to their characters as real people. They know how they should react—how they will react—in any given situation."

The fact is that effective storytelling is a blend of imagery, word, typography, and design. In addition, the best newspaper work happens when the story's photographer, writer, editor, designer, and illustrator work together—through planning, by updating one another, and by sharing ideas and control over the story.

One constant in newspaper design is that graphic solutions for an endless stream of stories never cease. What's more, there are an infinite number of ways to design a story; that in itself may be viewed as a blessing or a curse.

Figure 16-3

The Orange County Register's most recent redesign was done in-house. The principals involved with the makeover included designers, editors, reporters, photographers, and market researchers. Note the heavy use of art on the upper part of the page and the clean modules. Together, Neil Pinchin, Kris Viesselman, Peter Nguyen and redesign team leader, Brenda Shoun did the hands-on redesign work. Jim Parkinson created the new nameplate. Reprinted with permission of *The Orange County Register*.

Kris Viesselman

Kris Viesselman works as the senior art director at *The Orange County Register*, where she leads a team of more than 30 visual journalists. Their team has won numerous awards from the SND and *Print* magazine's *Regional Design Annual*.

When I was in college, studying to be an art teacher, a friend of mine asked me to help out for 'one night' at the college paper. I think I did a small illustration that evening. But suddenly I found that I was back there several nights a week. Over the next few years, I wrote stories, created graphics, and designed pages for our weekly paper. And, before I knew it, in addition to my art major, I had picked up a minor in Mass Communication-Print Journalism and a second minor in Spanish. Aside from journalism and publication design classes, students interested in newspaper design should consider course work in writing, a second language, public speaking, and typing. Also, any drawing classes are very helpful. Sketching is the foundation for developing concepts and communicating them to others.

During my final year of study, I had a short internship at a large daily newspaper. The work I did there had me hooked. I loved the dynamic, unpredictable nature of the work. Every day meant new stories and thus fresh design challenges

Nearly seventeen years have passed since that first night. My work has allowed me to work with amazing people and provide a service that can be entertaining, informative, and helpful. What we do, specifically, is make information more accessible and easier to understand.

Newspaper design is a strange medium in which to work because at once it can be so temporary—after all, people wrap fish and line bird cages with our work—yet, what we do can serve as a significant account of history.

Effective design can't be separated from content. Visual elements should never be decoration. All design should be integral to storytelling. Use of white space, photography, and typography should all be considered in terms of the whole package so that each piece supports the others (see Figure 16-5).

Well said. Kris Viesselman possesses a Spartan design philosophy; she and *The Orange County Register* art staff apply the same approach to redesign, too.

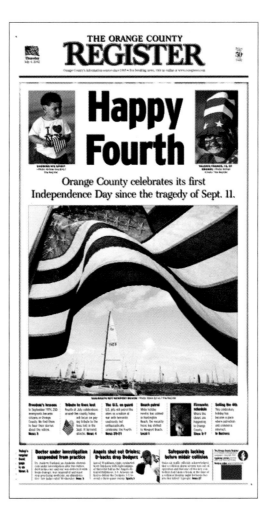

Figure 16-4

Kris Viesselman has spent more than 15 years in newspaper design and has previously worked as an artist, designer and art director at *The Sacramento Bee* and *Los Angeles Time*s, where she was part of three Pulitzer-winning efforts. In addition to her newspaper work, Viesselman teaches publication design and graphics classes at California State University, Fullerton. She has also been a regular speaker at international news design conferences and has worked as a design consultant in the United States and abroad.

Figure 16-5

This Fourth of July layout from *The Orange County Register*, explodes off the page. Its red, white, and blue patriotism is appropriate. It celebrates the "first Independence Day since the tragedy of Sept. 11." Its basic symmetry, vibrant color, potent photography, and simple message ("Happy Fourth") communicate clearly and quickly. It's a real eyeful, and its mini-table of contents below the large art directs readers quickly to important stories and relevant information throughout the newspaper. Graphics and art by *The Orange County Register* art and photography staff. Courtesy of *The Orange County Register*. Reprinted with permission of *The Orange County Register*.

Redesign: Age, Audience, Architecture, and Process

The first step to any newspaper redesign is to research the publication. The normal newspaper redesign process involves both formal and informal research. Surely, the most valuable input comes from the readers themselves. Viesselman reflects on the *Register's* recent make over: "Our readers were essential to our mission. They were heavily involved throughout the process, from early surveying to viewing prototypes in focus groups. The color-coding, for instance, was completely reader-driven. What was somewhat surprising was the level of passion some readers have about changes you make to the newspaper. Certain things are extremely important to certain readers, and when you change those things, there is often a very strong reaction—either positive or negative."

Redesign teams conduct focus groups, examine surveys, and customer service responses. Along with focus groups, *The Orange County Register* used professional phone surveys, paper questionnaires, even personal interviews at public events. Demographics and psychographics are evaluated. In addition, a professional designer is hired or a design team is assembled to carefully process all of this information before they turn on a computer or begin conceiving a new look for the publication.

To be successful a newspaper and its various sections must have three qualities:

1. It must contain the information people want and need.

2. It must attract the audience.

3. It must be interesting.

Appropriate and well-tailored design can help achieve all of the above. Note how this *Orange County Register* entertainment cover (*Show Weekend*) fulfills all three. Graphic communication begins here long before words do (see Figure 16-6).

Figure 16-6

Show Weekend (an entertainment guide for *The Orange County Register*) uses its cover to flag readers on a review feature for the film, *The Blair Witch Project*. What is it about the design, color, type, and illustration that make this layout edgy and representative of the film? Martin Gee, design and illustration; Kris Viesselman, senior team leader. Reprinted with permission of *The Orange County Register*.

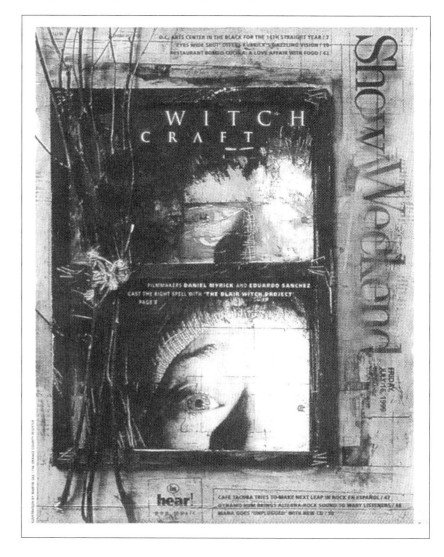

It is also a good idea to post your redesign ideas to share the direction of your work with colleagues and invite reactions and feedback. This will help the flow or evolution of your design. The posting process also helps give the entire staff a sense of ownership. Sergio Romero, redesign project leader for Argentina's *El Tribuno*, chalked up the success of his redesign to the staff's involvement: "People showed a very positive attitude and looked on the project as their own. They accepted the challenge of creating new ways of working and modifying the paper's production processes, and they did it with optimism."

However, before specific design strategies are cobbled together to recraft a newspaper, a few general guidelines should be reviewed:

- Typography and graphics can tell the reader a lot about the publication that's being produced. They can say, "This is a hard-hitting, crusading publication." They can infer, "This is a dignified and conservative publication devoted to accuracy and thoroughness." They can suggest, "This newspaper offers a light, breezy approach to all the activities it is attempting to cover." Or, they might imply, "This is a counter-culture publication with a shoestring budget."

- Remember that typography and graphics can provide instantaneous identification for a pub-

lication. Identity is as important to newspapers as it is to advertising or any product. Note the distinctive, bare bones approach Cleveland's *The Plain Dealer*, David Kordalski, and Shayne Bowman took on its "Friday" entertainment prototype section (see Figure 16-7).

- Typography and graphics can help readers spot the various departments, sections, or other publication contents. They may assist the reader to sort out the stories and prioritize the material—that is, clearly understand which stories are most important and which are minor pieces.

Don't forget the body type. Although body typefaces are sometimes downplayed or selected without much deliberation, designers must remember that text type is at the core of communication. Alan Jacobson, principal of Brass Tacks Design of Norfolk, VA, drives that point home—with some tongue-in-cheek humor: "When a redesign is launched, readers care most about body-type legibility. Unless you moved the crossword puzzle."

Redesigns aren't spawned in a vacuum. They are based on shifting realities. Nothing is static. Needs, growth, and resources of the newspaper and its audience change, and it's important for the newspaper to change, too. Indeed, audience is perhaps the most important part of the redesign dynamic.

Figure 16-7
Cleveland's *The Plain Dealer* has long been known as a progressive newspaper—in terms of its strong writing and editorial content and its design. A recent redesign of the publication included simplifying and amplifying the power of its "Friday" weekender section. These prototype "Friday" layouts feature minimal typography, simple design strategy, and "if you got it, flaunt it" photography. Shayne Bowman's designs are particularly arresting here in the "Got My Mojo Working" salute to Muddy Waters and the Blues. Art direction and AME, David Kordalski; design, Shayne Bowman. © 2001 *The Plain Dealer*. All rights reserved. Reprinted with permission.

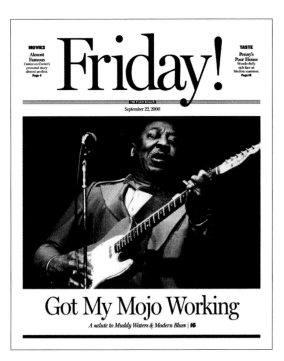

The Redesign Plan

Once the research, format studies, and resource reviews have been completed, a plan and timetable can be created. Many designers follow a step-by-step outline that looks something like this:

1. Complete the research and assess the needs of readers and the newspaper.

2. Put together a cross-disciplinary team to insure the most democratic input.

3. Survey the readers through questionnaires, focus groups, and informal inquiries at coffee shops, malls, and the like. Watch readers process the paper. Get honest assessments about what they most like and dislike and find out what new things they'd like to see in the paper.

4. Build a list of specific goals along with a rationale for each one.

5. Establish a realistic timetable that addresses each of the goals. Often newspapers do redesigns in phases—one section or mission at a time.

6. Specify how and by whom all decisions will be made.

7. Produce an initial prototype.

8. Post the on-going prototype in a central area, so all can see it. Solicit feedback from as broad an in-house and reader audience as you can.

9. Build the stylebook at the same time the design is being evolved.

10. Evaluate and refine the prototype.

11. Alert readership of the upcoming redesign.

12. Produce a final prototype to be used as a guide in creating actual pages.

13. Put the new design into action, evaluate it, get reader reactions (this includes assembling additional staff to cover the incoming phone calls).

14. Promote the change in design in a positive manner through paper and other media. Many publications, such *The Boston Globe*, *The Orange County Register*, and *The Plain Dealer*, printed a readers' guide or orientation section for their respective redesigns.

15. Make necessary alterations.

16. After tweaking and making adjustments, continue the redesign throughout the newspaper sections.

17. Maintain the new design, continue the evaluation, and make final refinements.

Redesign as a Problem-Solution Process
Setting Clear Goals

There isn't much point in jumping into a redesign process without first deciding what it's supposed to accomplish. Goals need to be established and set, no matter the size of the publication (see Figure 16-8). These goals vary considerably from one newspaper to another. Publications often face different problems or have dissimilar missions.

For example, recently *The Orange County Register* embarked on a redesign in an effort to better serve its audience, appeal to the newspaper's shifting demographics, and better compete with other media. It also wanted to try to reach additional readers via new sections, reorganized content, typography overhauls, and its bolder graphic approach. Remarkably, not only did they execute the makeover in-house, the staff opted to approach the changes gradually by tackling the redesign progress one section at a time.

In another instance, judges from the Inland Daily Press Association critiqued several newspapers for overloading their front pages with too many stories. They ruled that the effect caused too much clutter and decreased readability. These same jurors berated the "skyboxes" atop the front pages, claiming that "the most annoying design element on many newspapers is promotions found at the top of the front page in dark, ugly boxes and in color." Essentially, they suggested the upper page teasers pulled the readers' eyes "away from stories that are less graphically appealing but which should be read nevertheless."

On the other hand, when the *Orlando Sentinel* was redesigned, more stories and visual items were packed into the opening page. The nameplate was boldly underlined with a color rule and topped off with colorful rebus skyboxes, hawking the more visual stories in the newspaper. In this case, its makeover and research paid off. In the first four months following its redesign, sales were up 13.5 percent from the previous year. Many consider skyboxes "stoppers" and visual cues to get a reader into the paper.

Yet another mandate for redesign is articulated by José Manuel Fernandes, Editor-in-Chief for

Público, the most influential and popular newspaper in Portugal. "What do we do with our favorite shirt when we no longer feel comfortable with it?" he asked, referring to the fact that despite its increased success and circulation, *Público*'s ten-year-old design was beginning to show its age.

Fernandes noted how the paper needed to cater to its long-standing readership as well as *Público*'s younger scanners, "That was our two-pronged challenge: catering to the ten-minute reader and also to the one-hour reader." Along with adopting stronger section openers, new weekend front-page design (with a table of contents built into it), and more flexibility in its overall look, it uses an "integrated editing and layout system (based on Adobe's InDesign)."

Although there are a few common goals among the above redesigns, each publication had to meet its specific (and complex) agenda of needs. They accomplished their missions not to win awards (although they received many) but to serve their readers and solve existing problems.

Study after study has shown that readers prefer well-organized newspapers. They like to find information easily, and they like to find columns, sections, and other paper features (crossword puzzles, TV listings, stock market reports, weather pages) in the same spot issue after issue. A basic objective of any redesign project is to organize content to reach this end consistently.

Goals should include adherence to the general guidelines for good design, including making the newspaper more visually attractive while building a consistent design theme throughout and designing with simplicity and restraint. Restated: the design should never overwhelm the message.

The New York Times is a newspaper that is recognized almost as much for its design as it is its content. Although its front page and news section tend to be conservative and traditional in terms of their design, the newspaper has initiated remarkably innovative design within. Its inside sections and magazine components are strikingly attractive (see Figure 16-9).

Figure 16-8

The *Times-Leader* of Wilkes Barre, Pennsylvania proves that a newspaper needn't be a major daily to execute a smashing redesign. Presentation director Joe Kitka and designer Deborah Withey came up with a mix of old and new design strategies for their overhaul of the newspaper. These pages use older typefaces and the paper's reclaimed "diamond" graphic to mix contemporary and earlier elements. Older readers loved the retooling borrowed from the past, and the open, reader-friendly pages. Younger readers liked the contemporary look of the newspaper and its retro design features. The paper also opted to run photography larger and tighter. The result was a win/win situation. Reprinted with permission of the *Times-Leader*.

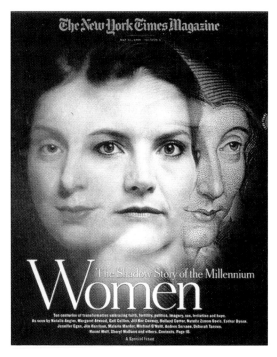

Figure 16-9
The New York Times'
inside, magazine and book
review sections offer
arresting designs and
stunning photography and
illustration. (Left)
Powerful photography,
especially powerful sports
photography, should be
run large. Note symmetri-
cal design, and simple grid.
Wayne Kamidoi, designer;
G. Paul Burnett, photogra-
pher; Joe Zeff, illustrator.
(Middle) "Beyond Primary
Colors: Bold New Ice
Creams" makes a colorful
analogy between ice cream
color and paint. Nicki
Kalish, art director;
Kiyoshi Togashi, photogra-
pher. (Right) "Women:
The Shadowy Story of the
Millennium" fuses an
etching, painting, and pho-
tography change to suggest
a sense of the story and
history via the art. Janet
Froelich, art director; Joele
Cuyler, project art director;
Kathy Ryan, photo editor;
Ignacio, designer; Sarah
Harbutt, project photo
editor. Copyright 1999 by
The New York Times Co.
Reprinted with permission.

Although some regard *The New York Times'*
opening page static and out-dated, it exemplifies
the basic premise of effective design: it truly
reflects its editorial philosophy and appeal to the
well-read audiences it has long attracted and
continues to inform. *The New York Times* is
after all regarded as the newspaper of record. In
addition to its front face and structure, *The New
York Times* continues to impress SND and other
award's judges with its surprising yet tasteful
page design.

Simpler Is Better

Perhaps there is no stronger voice to sing the
praises of simplicity in newspaper design than Dr.
Mario Garcia. His research work at The Poynter
Institute for Media Studies and his extensive
international design experience is well known.
Indeed, he has worked on nearly 500 newspaper
design and redesign projects in more than 35
different countries.

At a recent lecture at the Consello da Cultura
Galego in Santiago de Compostela, Spain, he
preached the gospel of simplicity for today's
newspaper design.

In endorsing a minimalist approach to
newspaper architecture, Garcia reviewed the
bandwagon newspaper design evolution of the
late 1980s and 1990s. Among other things, it
included the overuse of color and information

graphics, oversized photographs, and newspapers
whose pages were log-jammed with as many
visual elements as could be stuffed into their
pages. Somewhere along the way, technology and
the latest trends seemed to become more
important than clean design. Seemingly, design
had become in no small part a science of
excesses.

His rationale for returning to simpler, cleaner
design includes the need for today's communica-
tions—particularly newspapers—to be more
functional and efficient. His reasoning also
endorses better page organization and a more
logical flow of information. He maintains that
stripping excesses away improves the contrast
and readability of the page, while concurrently
improving navigation. The *San Francisco
Chronicle* adopts that design philosophy as
reflected in this simple but arresting solution for
its all-California World Series preview page (see
Figure 16-10).

Garcia's minimalism and "less is more"
approach, like the simple lines and near chrome-
less body of a 1955 Chevrolet two-door coupe,
are classic. The essence of communication is
clarity and simplicity.

Newspaper Redesign: A Mini Case History

When *The Plain Dealer* of Cleveland underwent
its recent redesign, the day prior to the

newspaper's coming out party, it included a special four-page section entitled, "My city, my new paper." Readers received a thorough preview of all the changes.

The Plain Dealer redesign connected to its readers. The paper had dedicated a complete section detailing the changes, rationale, and a discussion of each transformation—down to minute details. This offered readers good information, ownership, and a clearer understanding of the process and the reasons the design of the paper had been updated.

So why the graphic overhaul?

Newspapers work in a daily state of flux. In addition to the constant whirlwind of breaking stories, emergencies, deadlines, and distribution, there is an ebb and flow of new graphic ideas, features, and even entire sections being added to the publication. Attrition is normal, too; eventually, stylebooks and design plottings may become compromised.

Sometimes, the grind of this normal evolution produces an interesting mix of old and new. *The Plain Dealer* put it this way: "Envision a grand old home. Over time and through several occupants, the house has undergone countless additions and remodels—so many, in fact, that the integrity of its original design barely shows. The rooms are a hodge-podge of decorating styles. The traffic pattern is unwieldy, the kitchen is out of date. It may be tolerable, even charming in spots, but it is not even close to its potential, in either form or function. A complete restoration is in order, and common sense dictates tackling the structure first, then the decoration." Compare, for example, *The Plain Dealer* makeover of a sports page featuring "Browns vs Titans" (see Figure 16-11).

However, like the process and challenges of all newspaper redesign, altering a familiar publication is loaded with difficult decisions. *The Plain Dealer*'s makeover was based upon building a new newspaper structure that had better continuity. Specifically, the newspaper employed new section flags or logos, improved indexing, more related story boxes, key words to help identify the nature of the story, Internet linkages, new typography that was balanced—that is, it was selected for both improved readability and

Figure 16-10

Less is more. Sometimes newspaper pages communicate like posters, stopping scanners in their tracks. Sometimes, too, a newspaper page is inventive enough to make a reader want to pin it up. What better way to communicate an in-state, Interstate World Series? Matt Petty, designer; Nanette Bisher, creative director for the *San Francisco Chronicle*. Reprinted with permission of the *San Francisco Chronicle*.

aesthetic reasons. Finally, the redesign took advantage of one of the many *Plain Dealer* strengths, its award-winning photojournalists and illustrators, by anchoring every section page with large artwork.

All of the redesign was based upon good research, putting the audience first, and, making appropriate design decisions to communicate succinctly and clearly.

Making Design Decisions

After you've established your goals and clarified priorities, the design or redesign of a publication can proceed. Research and reader findings should be assimilated and woven into the design changes list, and the decision-making process can be organized along general and specific lines. First, examine the suggestions made for the overall design and compare them to your goals. Then, begin examining the specifics, such as the front page architecture and the areas to be reworked. Next, build a general page architecture you feel

Figure 16-11

The Plain Dealer of Cleveland recently adopted a new design. These are before and after examples of a sports "Browns vs. Titans" overview page. How is the makeover page more reader-friendly? It's text is larger, white space is more abundant (knock-out photography also increases white space here), and the page is better organized. These and other changes dramatically improved presentation and usability. Staci Andrews, sports designer; David Kordalski, AME/visuals; Mike Starkey, deputy sports editor. © 2001 *The Plain Dealer*. All rights reserved. Reprinted with permission.

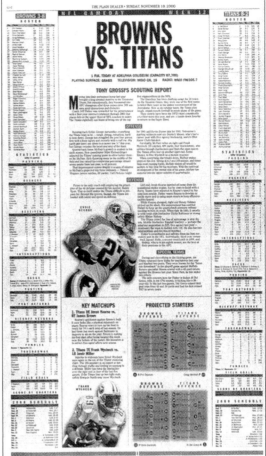

accomplishes all that you need to do and apply it to the section pages and the inside pages of your design. *The Register-Guard* is a great model for design continuity that runs throughout the paper and all of its sections (see Figure16-12). Note how well the pages mesh graphically.

Objectives for Good Design/Redesign

Designers generally agree on these objectives for good design and redesign:

1. Organization, continuity, and clarity come first.

2. The design should communicate clearly and efficiently.

3. Legibility and contrast are crucial for good navigation and an easy read. This applies to everything from page design to typography, from consistent logistics to using artwork effectively.

4. The design should create a special identity for the newspaper.

5. Prioritizing the page via sound logistics and appropriate use of proportion will help you arrange the stories in a clean and logical way.

Remember, too, the stories and their importance and relevance to the reader direct much of the context of the design.

6. The design should communicate in a recognizable and consistent fashion.

7. Consistency is important to readers. Your design logistics should reflect that.

8. Accomplish your goals and meet reader needs with economy. That means that the design has to be flexible, too, in order to accommodate the hectic pace and ebb and flow of news stories. In a newsroom, stories that didn't exist a few minutes earlier can suddenly explode into reality, so your design has to be able to handle sudden changes.

Achieving Effective Design

Effective design can often be achieved by translating the above objectives into these six steps:

1. Keep it clean and simple.

2. Square off type masses into modules.

3. Give the page layouts enough white space; the stories need to breathe so readers don't feel claustrophobic processing the page.

4. Make sure your lead story and photography dominate the layout.

5. Examine how you've used the four corners of the page.

6. Avoid redundancy in content; that includes the photography, artwork, and display type.

Although some designers disdain modernism and modular arrangements, the grid dominates newspaper page design. Indeed, no matter how fixed designers may be in avoiding a grid design, they'll inadvertently put modules into the page design one way or another.

Modular design basically consists of arranging stories in separate rectangular modules throughout the page. Type should be squared off so that each column of type fills (or nearly fills) the column space allotted. Square off the tops and bottoms of the columns within the each module. Type shouldn't be allowed to zigzag across the pages. The modules (or rectangles) should be arranged appropriately so stories fit logically in terms of their placement, size, and importance. The vertical and horizontal modules should be arranged in an appropriate and pleasing way. The mission is to create reader-friendly pages.

Pages and the stories within them need breathing room. White space used effectively can brighten a page; it is not wasted space but a crucial design element. It can help the reader by isolating and emphasizing elements and revealing where one story ends and another begins. Avoid crowded, jammed-together pages; they deflect readers. Think of white space as an inviting island in a sea of type, and direct your readers there for the great art you've framed off, as in these instances in the *Rocky Mountain News* and *Metropoli*: two different problems, two very different solutions using white space (see Figure16-13).

Any element on the page that does not help the reader should be considered an ornament. If that item isn't helping communicate the story or serving a specific function, eliminate it.

Although not as prominent in newspaper design these days, the "four corners" concept of newspaper design may provide contact and turning points for readers as they scan the page. The four corners are known as "hot spots." Designers may want to plot a strong element in some or all of these areas to help the eye sequence or move through the page or to help balance it. Reexamine *The Orange County Register*'s "Happy Fourth" front page to note how its art staff worked this concept for good sequence and balance (see Figure 16-5).

Figure 16-12
The recent redesign of *The Register-Guard* (Eugene, Oregon) emphasizes bold use of photography, sophisticated type, grid design, and the smart use of color. The front, "Entrée," and sports pages shown here exemplify smart design philosophy. Redesign coordinator, Carl Davas; graphic director, Rob Romig.
(Left) Opening page: Rob Romig, design; Nicole DeVito, photography. (Center) "Entrée:" Rob Romig, design; Nicole DeVito, photography. (Right) Sports: Rob Romig, design; Paul Carter and Carl Devaz, photography. Reprinted with permission of *The Register-Guard*.

Figure 16-13

Using white space inventively and functionally is important in all design, but particularly in newspapers where stories and graphic components are often jammed into the page. Compare and contrast the ways that the *Rocky Mountain News* and *Metropoli* employed white space as a major design strategy in these opening pages. The *Rocky Mountain News* design staff used white both figuratively and literally on this front page reporting a freak snow storm in the Denver area. Rodrigo Sanchez served as designer, art director, and illustrator for the *Metropoli* cover, using it literally as a blank canvas for "Tisiano en El Prado." courtesy of the *Rocky Mountain News* and *Metropoli*.

When making design decisions, carefully apply the basic principles of design, and factor in the legibility, clarity, readability, simplicity, and suitability of the type. Your page's design blueprint should also be flexible enough to accommodate sudden changes. That versatility should also translate into a chameleon-like quality of design to help avoid a rigid, day-after-day sameness. One of the strengths of modular design, though, is its invisibility to the average reader.

Also, remember that nothing lasts forever. The editors of *Público* realized that its paper, no matter how successful, had aged graphically. Their "old shirt / new shirt" analogy is a fitting one, which is to say that all publications should reevaluate their look and style—their designs. Changes should be made as conditions and situations warrant, but only after serious evaluation, research, and planning—and only after clear goals and expectations are in place.

Finally, it is important to keep the lines of communication open to both your staff and readers, and to solicit feedback. The ultimate decisions, however, should be in the hands of the person in charge of the redesign or the art director.

After design changes and objectives have been agreed upon and initial layout directions probed, it is time to see how the alterations will look on the finished page. You're ready to build your prototype. The prototype is a "dummy" page created on the computer. A handful of designers still use pasteups, and sketches are often employed as initial starting points, but, clearly, the computer is today's standard design tool.

It's sensible to build your stylebook at the same time you reshape the architecture of your redesign. In creating the new prototype, it's wise to use real stories and photography that were being used in the old design when creating the dummy. If headline style changes are part of the master plan, use real headlines, perhaps even reworking/rewording them. Doing this provides a fair comparison, one grounded in reality, and it offers a quick, at-a-glance "before" and "after" perspective. A good example of this comparative process is demonstrated in *The Plain Dealer*'s before and after "Browns vs. Titans" sports page (see Figure 16-11).

The best prototypes are working models of actual pages and content. Typically, during the design or redesign process, many prototypes are constructed and discussed before a final one is adopted.

Newspaper Redesign and Typography
Text and Content:
The Guts of the Newspaper

The tendency in most newspaper redesigns is to begin with the front page and spend most of the time and effort with this small part of the whole package. While the front page's importance is obvious and cannot be overlooked, the rest of the publication and its parts warrant the same kind of serious planning.

One such component is the paper's typography. Since "reading the newspaper" is the basic objective, perhaps an early examination of what is read most—its text or body type—is a logical starting place for stylebook considerations.

The criteria for selecting a proper body type are legibility and readability. Again, legibility refers to visibility—the visual perception of type. Headlines and other display type are more about legibility than readability. Readability simply refers to the facility of the read. Size, leading, x-height, width, weight, column length, style, and the typeface itself all affect readability and legibility.

Clearly, serif (or roman) type is preferred for newspaper body copy. Serifs better join (or appear to connect) letters. When we read, we read groups of words at a time, so some typographers surmise that serifs (especially walking serifs) appear to connect letters within a word, which facilitates readability. In fact, serifs often physically attach letters to one another when kerned (see Figure 16-14). In addition, we are more familiar with serif type; it's what is used in most elementary primers and children's books for good reason—readability.

Many designers feel old-style and transitional roman faces have better readability and personality than the other serif sub-groups. X-height is also an important factor in readability. Generally, old-style faces have the best legibility and transitional serifs have the largest x-heights. So, it isn't by accident that newspaper text faces are almost exclusively one of the former.

Downstyle (capitalizing only words at the beginning of a sentence, proper nouns, and acronyms) makes for a better and easier read in text and headlines. Lowercase letters better shape words; this shaping is lost when type is set all uppercase. There is also inherent coding with uppercase letters: capital letters normally suggest a proper noun or beginning of a sentence. In large doses, text type set all uppercase slows reading speed, retards word recognition, and takes up to 30 percent or more space.

Believe it or not, one of the most frequent comments received when a new design has been launched concerns the text type. When *The Charleston Gazette* was redesigned, the body type was increased from 9 to 9.5 points. Don Marsh, the editor of this West Virginia paper, reported in *Editor & Publisher*, "Although we've given up 5 to 7 percent of our news space by using larger type, with our readers the change was the most popular aspect of our redesign." When *The Register-Guard* went through a recent redesign, phones rang off the wall from irate readers who complained about the smaller point size in the TV guide section.

When your author redesigned the Iowa Veterans of Foreign Wars' statewide newspaper, *The Voice*, and was mandated to run text smaller—from the recommended 10- to 8-point type—it caused a deluge of complaints. The following issue ran at the larger point size. The lesson is obvious: smaller type may allow for additional information to be run, but if people

Figure 16-14
Serifs help suggest a juncture between letters in words, and some feel they do a better job of grouping letters within a word, making it easier for us to read, because we read groups of words at a time. Look closely at the walking serifs in this kerned example.

Lance Armstrong has earned
his place among the Tour de France elite.

can't read it or have to strain their eyes to decipher it, the message is wasted.

Check text faces you're considering for their readability and reproduction qualities. The face you use for your body copy should have a clean and open cut. When type is printed at high speeds with thin ink on rough, absorbent newsprint paper, the letter configurations may break, spread, or distort.

The type's structure should be strong and bold enough to avoid a gray look. Also, there should be sufficient contrast between the thick and thin strokes to bring good visual texture to the page so it doesn't look monotonal. On the other hand, avoid modern romans because their thin strokes are often too frail and don't reproduce well on newsprint.

Typefaces selected for newspaper text should have good x-heights and be well-proportioned. The x-height should be ample enough to give full body but not so large that it dwarfs the ascenders and descenders of the letters. The extra care you take in selecting an appropriate and very readable text face will pay dividends in reader reaction.

Again, most newspapers choose old-style or transitional romans for their body typefaces. There are many roman variations and faces such as Times, Palatino, Caslon, Century, Baskerville, Garamond, Goudy, and Times-Roman, which are tried and true. Some newer faces on the block that are popular include Miller, Walbaum, Minion, Slimbach, Granjon, Gulliver, Myriad, Nimrod, and Charter. Of course, the Font Bureau, Adobe, the Poynter faces, and other type houses are great sources of typography.

Nameplates, Headlines, and Other Display Type Applications

First impressions are hard to change, and the initial reader assessment of a newspaper is gleaned from its front page and the design elements it contains. These include the *nameplate* (also called the *flag* or sometimes the *logo*) and any embellishments in the nameplate area. It also includes the headlines, cutlines (captions), standing heads such as those for skyboxes, weather, index boxes, and "briefer" boxes (often

a column that presents brief or terse summaries of the day's main stories).

Nameplates

The nameplate is the publication's trademark. It should be legible, unique, attractive, and appropriate. As a general rule, designers suggest it should contrast but be in harmony with the other type on the page.

Many newspapers choose a black letter type for their nameplates because of image, since many publications are time-honored, respected institutions. This type group is the oldest, so it (and its codings) are closely associated with truth, tradition, and longevity. Black letter faces also happen to contrast well with nearly all headline type.

On the other hand, tabloids appealing to a younger, on-the-go audience, such as *Red Streak*'s 18- to 34-year-old commuter audience, might opt for a bold, urgent-looking logo. Again, readers, image and content shape design (see Figure 16-15).

Stylebooks

When planning a newspaper, one of the primary steps in working with type is to adopt a stylebook. Among other things, a style guide regulates typography. Technically, a stylebook also may include non-graphic things: correct usage, grammar, spelling preferences, capitalization, punctuation, and so on. Most stylebooks also include graphic guidelines as well. Some newspapers have a stylebook strictly employed for usage and the like as well as a separate stylebook or typography or graphics manual for type and artwork. In any case, designers tend to refer to the latter as a stylebook anyway (see Figure 16-16).

Today, design software simplifies even the most complex headline schedule or stylebook by offering its users a style sheet to establish and govern type, which can list all of the sizes and styles of type to be used in a newspaper—or any publication, for that matter. The range of faces, type sizes, alignment and styles for headers in a paper is referred to as a head schedule. This provides a designer or the daily layout people a

tool that literally and consistently prescribes headline type; concurrently, the schedule maintains unity in the header type throughout the publication.

Display type is usually any editorial typography—excluding captions and text—that appears on a page. Notably this would include: heads, decks, kickers, sidelines, crossing heads, dropped initial letters, pull quotes (or "pullouts"), and subheads. Most designers select faces that contrast the text type.

Sans serifs have better legibility than their roman counterparts, so they serve well as display type (for headlines, pull-quotes, briefers, subheads, crossing heads, decks, and the like). Also numerals are more legible in sans serif.

It is no secret that today's media are fusing. Traditional boundaries are changing or even merging—aesthetically, structurally, technically, and in many other ways.

Media borrow regularly from one another; in many instances, for example, newspapers offer readers websites for story backgrounds, links to additional information, advertising, exchanges with writers and editors, or even a readers' forum. In addition, many media adopt features and design strategies from their counterparts. Newspapers are no exceptions.

Today some newspaper sections and their designs more closely resemble magazines than they do newspapers. In general, newspapers have become more pictorial and have adopted many typographical strategies that we might consider nuances of magazine design: decks, cover teases, feature pieces, pull quotes, crossing heads, decorative initial letters, and endmarks—to name a few. In addition, photography has become more dominant. Indeed, arts and entertainment, travel, cuisine and many special sections sometimes employ a single, large photographic image that dominates the page.

Although most of this graphic sophistication is more likely to land in a newspaper's magazine section or in more feature-oriented areas, it does manifest itself on front pages too. Teasers atop the page function similarly to magazine cover blurbs. Some papers have borrowed a mini-table of contents feature and placed it on the front page.

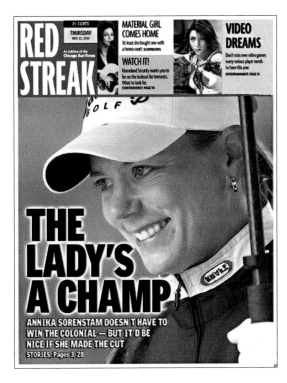

Figure 16-15
Red Streak often runs type large and bold. Its covers are good lessons in poster design. This cover celebrates the prowess of golfing sensation Annika Sorenstam. Note how she is looking into the cover lines. The cover type has been outlined (white behind black type and vice-versa on the smaller deck below) to ensure good contrast and legibility. Courtesy of the *Chicago Sun-Times*, *Red Streak*, and Robb Montgomery. Reprinted with permission of the *Chicago Sun-Times*.

Fumble!
That's the nemesis of the Huskies

Figure 16-16
A stylebook maintains consistency in type and other areas throughout the newspaper. Here, precise specifications are spelled out for handling a reverse kicker head.

Firefighters trapped below Clay Hill Ridge

■ Thirty-mile-an-hour winds and a second fire started by campers have encircled a group of 35 firefighters outside Agness, OR.

By JOHN OLIVER
TRIBUNE STAFF WRITER

Figure 16-17
To help today's busy reader, many newspapers employ a short paragraph as a subhead in lieu of a standard deck. This head treatment is commonly referred to as a "brief," "briefer," or "nut graf." Some credit *The Oregonian* for inventing this type of head/summary treatment.

Figure 16-18
Pullouts or pull quotes are multifunctional. They help break up the gray of a page. Pull quotes may be used to take up space if a story or layout is running short. Finally, they also tend to stop readers, who—after reading the pullout (or a crossing head)—often opt to read the story because of the compelling nature of the quote. This is a strategy newspaper designers borrowed from magazine design.

Louis Hastings could not remember precisely when the idea occurred to him to murder the entire town of McCarthy, Alaska— but he set out to complete that mission mid-morning on March 1, 1983. By two o'clock that afternoon six lay dead in the snow.

Iraq Remains Indignant Despite U.S. Bomb Threats

Associated Press

Figure 16-20
This downstyle head uses a hairline and two-point rule with the all-CAPS credit line.

137 feared dead in Indonesian disco fire

REUTERS NEWS AGENCY

▲ **Figure 16-19**
Typical flush left header with all words capitalized. Note treatment of source line (Associated Press) with one-point rules above and below.

Figure 16-21
Head with kicker. Kickers are usually underscored.

Tiger attack!

Woods comes on strong in final round with an eagle and three birdies to overtake Singh and Garcia

Figure 16-22
Reverse kicker. The kicker is set larger than its following line and may also use other faces, styles, or even color.

Fashion
Runways reveal new fall colors

Figure 16-23
Some publications use a lighter version of the type employed in the top deck for contrast purposes.

Afghan farmers return to growing drug crops
U.N. experts say government's eradication program a "dismal failure"

Newspapers may have very elaborate graphic manuals or stylebooks that are virtual textbooks of design. These stylebooks can—in one fell swoop—designate specific type choices for everything typographical, from text to headers. For the small newspaper, a simple style sheet can be created that includes samples of all the typography specifications for headers, subheads, decks, pull quotes, captions, and other publication features. Better yet, this stylebook or style sheet can be easily set up on a software design program.

Headlines

The headline is multi-functional. It should flag the reader and make the page look attractive. It may also establish an identity and personality for the page. You should use header type to accomplish these tasks. There is no silver bullet font for heads, but most any roman (old style, transitional, or modern), slab serif, or sans serif face will work well. Some publications prefer to go with a sans serif to contrast with the roman text face and use sans serifs for their legibility and boldness. Other newspapers lean toward elegant moderns—the likes of a Bodoni, for example. It is important to maintain a pleasant harmony—or strident contrast—between the header and text type. The header type should also have good legibility, personality, range in size and style, and good unit count. It should also be appropriate for both the image of the publication as well as the audience.

Incidentally, because headers are run at larger point sizes, they generally don't require bolding. In addition, some heads require tighter leading than text, and careful grooming via kerning and tracking adjustments.

Jump Lines

Jump lines may seem less important typographically, but they're crucial in "continued" stories to direct readers smoothly and logically to the rest of the piece. *Jumps* are stories continued on another page. *Jump continuation* lines instruct readers where to find the rest of the story, while *jump pickups* flag the reader to the remainder of

> Please turn to **AFGHANS**, page 13A
>
> **AFGHANS** continued from page one

the story (see Figure 16-24). Make sure your style and wording is consistent when using jump lines. They should also be clear, specific, friendly, and informative. *Never land a jumped story on an orphan.* An orphan, remember, is a short line at the end of a paragraph. Many newspapers like to use a common page for jumped stories, often the back page of the section. It's simpler to handle as a page design, and it's reader-friendly.

The Front Page: Making an Entrance

The front page of a newspaper is the first thing a reader sees over breakfast. It's the poster page looking out at passers-by from the publication's vending machines. In addition, it sets the tone and style for the rest of the publication, and it reflects the editorial or "news" philosophy of the publication.

Generally, newspapers employ a more conservative approach for this page's layout. After all, news is serious business and newspapers take themselves and their missions very seriously. It isn't by accident that many editors adopt black letter nameplates, justified columns, meticulously kerned headlines, and make other sober design choices for this component of their newspapers. Front page presentation tends to be restrained, deliberate, and hierarchical. Editors spend a good deal of time and deliberation deciding which stories earn front page status, and where they should go on the page. In a sense, it's much akin to a baseball team's manager and coaches selecting a batting order. Selecting the graphic components for the page works similarly and is generally affected by the "story stack." *The Register-Guard* prides itself on its content, design, photography, and production, as well as its reputation for covering local, regional, national, and international news (see Figure 16-25).

Figure 16-24

A jump continuation line tells readers where to find the rest of a story inside the paper. For example, "Please turn to AFGHANS, page 13-A" (top). A jump pickup steers the reader to the continued story deeper into the paper: "AFGHANS, continued from page one" (bottom). Some publications may even adopt a stylebook policy of running the jump pickup as a headline on the jump page.

Objectives of Front Page Design

The front page is expected to accomplish a litany of objectives:

- **Identification:** The page should develop its own unique look via its nameplate, structure, typography, and voice. Readers should know the newspaper at a glance. Think of it as the publication's cover.

- **Order and Present News:** Again, the front page selects and orders the news. The editorial staff decides which story is most important and then establishes the hierarchy of the other stories that will appear on the front page.

- **Work as a Poster:** Often, the front page has to hit a moving target from its vending machine, news rack, or newsstand location, so it must function like a poster. If a newspaper sells or depends upon an inordinate amount of "rack" sales, it tends to be more visual. If it's a broadsheet, the paper tries to keep the lead artwork above the fold.

- **Attract and Sequence Readers:** Newspapers also use skyboxes or "boxcars" and skylines atop the page as teases to attract attention and to steer readership into the newspaper (see Figure 16-26). Some differentiate between the terms *skybox* and *skyline*; the former being boxed art by itself, the latter being art and a line or two of copy. Most designers use the term "skybox"—period, no matter if boxed art is accompanied by words or not.

- **Present News in Brief:** Briefer or digest columns are used as front page elements by many newspapers. Normally these entries are one to two-paragraph summaries or updates of other important (often on-going) stories.

- **Establish a Strong Visual Hook:** Every front page should have a dominant piece of artwork—usually a photograph connected with the lead or another of the page's stories. Sometimes a "stand alone" photograph will be used if it's especially strong or relevant to the community.

In addition, a front page may also contain a number of other parts, such as a standing calendar for the week, weather information, briefer or digest column, index, "inside" tease, skyboxes, previews, and other page components.

Constructing a front page is basically no more difficult than designing any page, but it has more parts. In a sense, the additional standing elements (skyboxes, weather, briefer columns, indexes, and the like) are good things because their page geography is consistent, and they provide a working matrix. It's easy to update weather, indexes, digests, or rework skyboxes. However, front page design is more challenging for several reasons. The front page is the newspaper's showcase page, so it should be fresh, interesting, and flexible. Deadlines also tend to be more demanding. Finally, front page designs are more stressful to design because stories are always breaking or are changing. A murder, factory explosion, hostage situation, or other late-breaking story may force a staff to tear a page apart at the last minute.

Guidelines for Planning the Front Page

The following guidelines are helpful when you're building and placing elements within a front page:

Figure 16-25

This front page from *The Sunday Register-Guard* features its most recent redesign. This issue opens with a story about local doctors, nurses, and support people volunteering their time in rural Barillas, Guatemala. Other stories sharing the front page are on guerrilla attacks on U.S. troops in Iraq and national unemployment. How would you characterize the news philosophy of this newspaper? Rob Romig, graphics editor; Paul Carter, assistant graphics editor; Thomas Boyd, photographer; Carl Davaz, deputy managing editor; Jim Parkinson, revamp of nameplate. Reprinted with permission of *The Register-Guard*.

1. Study other newspapers, especially those that have been recognized for their outstanding design. Society for News Design's *The Best of Newspaper Design* and *Communication Arts* both showcase the finest newspaper design in the world. Try to analyze what makes these designs special by deconstructing their parts; note what stops and holds you.

2. Build a nameplate by experimenting with different typefaces, kerning, rules, color, and gradation. Don't forget the supporting cast of parts: dateline, slogan, price, folio lines, etc.

3. Create a "skyline" or "skybox" for the nameplate. Most newspapers integrate them atop front and section pages to tease important stories. Will a floating flag (a smaller version of the nameplate) be used? Sometimes newspaper designers build several sizes of a nameplate in specific column widths. However, if you "float" the flag, be careful it doesn't get lost in the mix of other page elements. Your publication's identity is crucial.

4. Visualize your work, and use your computer to build thumbnail and quick sketch versions of your design ideas. Select the best elements from each one to streamline and evolve the page arrangement you like best. Try to keep lead photographs above the crease of the page.

5. Try to position the strongest elements within your hot spots. Normally, the major stories or photos are strategically placed. Tradition once dictated that the lead story be put in the upper right corner; today, the lead story is often placed elsewhere.

6. Avoid "tombstoning" or butting your heads. Tombstones are two or more heads that are placed side by side atop a page. Usually, too, the type treatments or "type specs" are identical. They may confuse the reader. At the very least, tombstones blur a story's importance and bring a monotonous look to a page. Although tombstone headers are still not considered a good design ploy, some papers do use them.

7. Check each design module and element to make sure it's functional. If it's not, consider eliminating it.

8. Make sure the page exhibits the attributes of basic design principles—balance, proportion, sequence, emphasis, and unity.

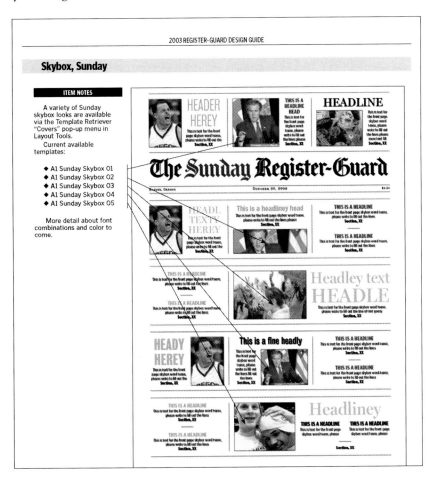

Figure 16-26

This page from the style guide for *The Register-Guard* addresses how the publication handles skyboxes. It shows five possible ways to present the skybox section of the newspaper. Courtesy of *The Register-Guard*. Reprinted with permission of *The Register-Guard*.

Apply the basic design principles appropriately. Use the things you've learned using optical center, four corners, and white space to help achieve better balance, proportion, and sequencing. The front-page design should emphasize the most important story, but normally other visual elements are needed to enliven a broadsheet page. Tabloids have fewer elements and tend to be more visually oriented (see Figure 16-27). Indeed, sometimes they more closely resemble magazine covers than newspapers. Grids and good organization are important for the front page's unity. Long term, a consistent architecture should be planned for this page for continuity purposes. Strike a smart balance between art and words, and regardless of the word-to-art ratio, don't overload the page with too much information.

Keep the page reader-friendly, inviting, and easy to process. Design this page and all the other pages of the newspaper for scanners and deep readers. White space should be ample and well planned. Function and readability are at the heart of successful front page design (see Figure 16-28).

Inside Pages

Newspapers continue to evolve and are changing their structures and design approaches as you read this book. Since the introduction of the optimum format, the look of inside pages has been in a state of flux. When the broadsheet (full-size newspaper) was changed from eight to six columns and the tabloid from five to four, the placement of advertising switched from several basic patterns to

Figure 16-27
Willamette Week is not only a tabloid, it is one of the growing number of free tabs that Dave Gray alluded to in the previous chapter. This newspaper has a strong following not only in Portland, but throughout the Northwest. Along with its strong investigative reportage and features, the newspaper offers well-researched and objective overviews of the political scene. Shawna McKeown comments on the front-page design, "Illustrator Mark Zingarelli created a comic panel that perfectly captured the apathy of our electorate while alluding to how overwhelming the responsibility of voting can be in Oregon." The challenging issue is credited with bringing a significant increase in voter turnout. Art direction, Ann Reeser; illustration, Mark Zingarelli. Reprinted with permission of *Willamette Week*.

confusion and sometimes chaos. It was possible to find reading matter set in as many as four or five different widths on one page. The widespread adoption of the 50-inch web press created narrower broadsheet pages and consequently newspapers adjusted their column widths and arrangements. Various column widths are still very much the case on front pages and opening section pages; however ads almost never appear there. The result is a hodgepodge that defies comfortable reading and the basic tenets of legibility.

Today, however, most papers have adopted the Standard Advertising Unit (SAU). The SAU was devised by the American Newspapers Publishers Association in an attempt to bring standardization and order out of the madness caused from using various column widths.

The SAU system starts with a 2$\frac{1}{16}$-inch column with $\frac{1}{8}$-inch gutters between columns. Note the substitution of inches for points, picas, and agate lines. The full-page width contains six columns for advertisements. The ANPA suggests that only inches and fractions of inches be used to measure advertisements. It also recommends fifty-seven modular sizes for national advertisements but leaves size decision for local ads up to the individual newspapers.

The new system has helped designers produce more attractive inside pages and aided the cause of newspaper advertising sales as well.

Ad Placement

There are several standard patterns for placing advertisements on a page. A designer should adopt one of them and use it throughout the publication—except, perhaps, for special sections. However, if a special section includes more than one page, the same pattern should be extended throughout its pages.

The most common basic patterns include:

- **Pyramid:** In this configuration, the advertisements are constructed like varying sizes of building blocks from the base of the largest ad in the lower right-hand corner of the page. This leaves the hot spot or optical center—the upper left corner—open for editorial material. This is actually a half-pyramid and is sometimes called that.

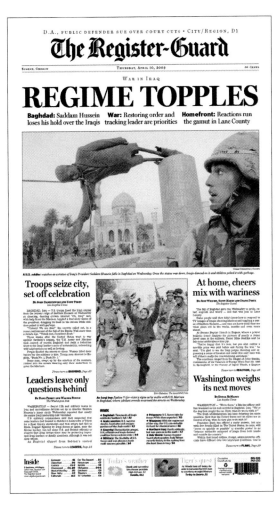

- **Well or double pyramid:** For this layout, ads are placed on the inside and outside columns, and across the bottom of the page. This forms a sort of well that can be filled with stories and photos.
- **Magazine:** In this pattern, some columns are filled with advertisements and others are completely reserved for editorial content. This arrangement works well with modular layout and pagination.
- **Modular:** Advertisements are clustered to fill or form rectangular modules on the page. Again, this approach works well with pagination equipment (see Figure 16-29).

Regardless of the pattern adopted, there are a few points to remember when planning inside pages. Top-of-the-page areas—premium layout real estate—should be kept open for the display of editorial material. Advertisements that are placed too high on the page can choke editorial space. There should be enough room above the

Figure 16-29
Shown here are some of the more popular inside page arrangements for placement of advertisements. The key to attractive inside pages is to adopt a consistent pattern and keep the top of the page, especially the upper left-hand corner, open as much as possible for editorial display.

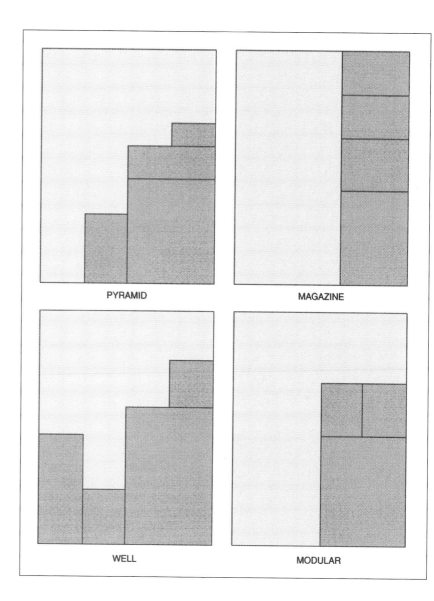

ads for at least a headline and arm or body type, which should be able to run as deep as the head. If the remaining space is too small, the ads should be adjusted accordingly, if that is possible.

In an ideal world, designers should try to provide one "stopper" for each inside page. The attention-getter might be an illustration, a stand-alone photo, or a strong story and headline. Some editors try to have some art on every inside page, although that can prove difficult. When editorial art is placed on a page, it shouldn't be placed side by side with advertising.

Extreme care should be taken to balance editorial and ad content so they do not conflict. A story about an airline crash, for example, should not be placed on the same page with an airline advertisement. If you make that mistake,

your readers and advertisers will let you know about it.

The best-designed inside pages avoid tomb-stoning and package stories in multi-column modules.

Editorial and Section Pages
The editorial and section pages are considered special newspaper turf. Editorial pages are the heart of the newspaper, a forum between the editors and their public. Section pages make clear demarcations within a tabloid and are separate entities in broadsheet papers—in a sense they work as covers. Both should reflect the interests and content of their respective areas while preserving the flavor and continuity of the entire publication. Most newspaper's section pages share similar design architecture with the front

page, along with many typographical nuances, stylebook features, and the like. In any case, insightful use of design principles, color, typography, grids, space, and artwork apply across the board — no matter if you're designing a front page, magazine section, sports layout, or travel or editorial pages.

The Design of the Editorial Page

Oddly enough, editorial pages tend to look like clones of one another: conservative, gray, uninspired, and predictable. They don't have to be that way. While they ought not look like the Sunday comics section, they can go a long way to improve their aesthetics and architecture, while maintaining their sober function.

The editorial page should be distinctly different from all the other pages. Readers need to understand that it is an opinion page, a forum where ideas and perspectives may clash. Newspaper editorial pages tend to be understated, conservative, and copy-heavy. Most run black ink only. Like most front and section opening pages, they don't carry advertising. Compared to the rest of the paper, these pages tend to be much more formal.

A few newspapers have eliminated the editorial page. Clearly, though, most editors would point out that an important part of their responsibility includes taking a stand on political, social, and local issues that are important to their readers.

Insightful designers and graphics editors can make the editorial page a more dynamic part of the publication. Some strategies that might help improve its graphic appeal include:

- Eliminate column rules to open up the column spacing.
- Improve the texture and "color" of the page by using editorial cartoons, charts, maps, information graphics, and even photography where these ploys are appropriate and helpful in making an argument, statement, or an editorial point.
- To help break up the gray, copy-heavy page, consider using high-contrast photography or well-rendered line art for portraits of the writers of the standing columns. Lack of artwork can make editorial pages appear monotonous, stiff, and reader-unfriendly.

- Set the body type in a larger point size.
- Try using larger headlines but in a lighter weight than the main heads.
- Employ pull-quotes, crossing heads, dropped initial letters, and decks for longer pieces, to open them up and to increase reader traffic through the page.

The editorial page can help a publication shape its distinctive personality, and it can be an attractive graphic component that can increase reader interest. Instead of writing it off as a lackluster clone, give it a look that matches its voice and importance.

Section Pages

Section pages present a special challenge to the editor and designer. On the one hand, each section opener needs to be in harmony with the complete newspaper. At the same time, each should reflect its own purpose, content, and personality. Today, the most common newspaper sections include "Business," "Sports," "Arts and Entertainment," "Living," "Metro," "Travel," and "Food" or "Entrée" pages.

Features One of the interesting evolutionary aspects of newspapers is a symbiotic one: the influence of the magazine. Newspapers have borrowed the magazine's sexier design and packaging and even the magazine section itself. This change has been influenced in no small part by stunning design work from Europe and South and Central America. Indeed, there are many wonderful examples shared throughout this book. Among the newspapers that have made significant design innovations are *El Mundo* (Spain), *Die Zeit* (Germany), *Correio Braziliense* (Brazil), The *National Post* (Canada), *Público* (Portugal), *Palabra* (Mexico), *The Independent* (England), *Taipei Times* (Taiwan) and *Die Welt* (Germany).

However, American newspapers are also doing some pretty remarkable feature work. The *San Francisco Chronicle* mixed design with reportage and research methodology with photography in this remarkable feature spread on the peace rally in San Francisco. The black-and-white treatment gives the work a kind of documentary flavor (see Figure 16-30).

Newspapers are putting more money, effort, and experimentation into features and section page design. Today's trend is to adopt some magazine design techniques while maintaining the general design philosophy of the newspaper (see Figure 16-31). There exists a concurrent harkening back to design nuances of the 1930s, 1940s, 1950s, along with borrowing some of that period's typography. This retro direction often meshes with the magazine and international influences noted above.

Special sections and specialty publications allow newspaper ad staffs to help advertisers zero in on their prospects. For instance, a special fall Outdoor section, featuring autumn recreational sports provides an excellent vehicle for advertisers such as local and chain sporting goods outlets, boat dealerships, REI, gun shops, camping supply vendors, and others targeting hunters, fishermen, hikers, and campers. Sports preview, fashion, remodeling, computer technolo-

gy, extreme sports, and back-to-school inserts are a handful of other special section examples. If it's a good idea—one that will attract a significant audience—advertising will follow.

Advertising drives the newspaper. As advertising goes, so goes the page count. Newspapers use both features and section pages to play to audience needs and interests as well as to their advertisers. Design figures strongly into making these newspaper components successful.

Food Back in the stone age, food pages were incorporated with the stereo-typed women's section. Today many men and younger people are cooking enthusiasts, so gender implications and—thankfully—the predictable feminine typographic treatment are also things of the past.

Our culinary pallets have also become much more sophisticated in recent years, and a food or entrée section can supply readers with everything from recipes to thematic offerings: Thai cuisine,

Figure 16-30

This black-and-white, double truck spread from the *San Francisco Chronicle* is a terrific example of a news graphic. The deck of this feature ("Counting Crowds") sets up the story beautifully. "The world from above looks different than it does from street level, as these actual aerial photos of last Sunday's San Francisco anti-war march show." Nanette Bisher, creative director of the newspaper, explained the layout and their methodology, "We hired a firm to do a scientific count of a peace rally. Organizers and the San Francisco Police Department had estimated the crowd at 250,000-300,000. Our count—a literal head-by-head count from aerial images shot at the apex of the rally on 7 x-7-inch negatives, which were blown up to conference table-size prints of the entire parade/rally route—showed there were actually more like 50,000 people." Both this layout and the actual assemblage of the large format photos used a grid. Notice how the typography is integrated with the imagery, almost like girders. The type helps support the art—and vice versa. Reprinted with permission of the *San Francisco Chronicle*.

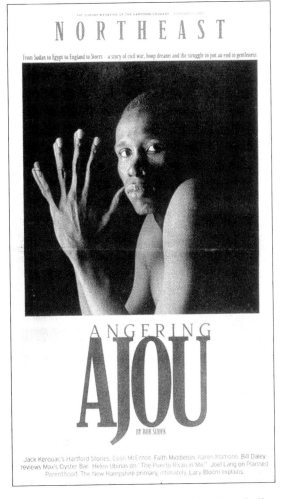

Figure 16-31
From better (left) to best (right) department: one of the most beautiful and functional newspaper designs in the world is *The Hartford Courant*. A format shift and a complete reworking of the typography for its *Northeast Sunday* magazine pay dividends, especially when coupled up with subtle color treatment here. Christian Drury, AME, design; Joseph Hilliman, art director; Thomas McGuire, AME/ photography; Jay Clendenin, photographer; Bruce Moyer, photo editor; Suzette Moyer, designer. Reprinted with permission of *The Hartford Courant*.

desserts, restaurant reviews, wine-tasting, vegetarian fare, sushi, health foods, and the like (see Figure 16-32).

Today, photography departments spend a sizeable chunk of time setting up and shooting images for the Entrée pages. This genre of photography requires careful lighting, meticulous color-balancing, and well-conceived styling for whatever is being photographed: fruit, vegetables, beverages, finished dishes. In many instances, the food is even hand-painted to enhance its color.

Many readers take these pages very seriously, so recipes or preparation and grilling instructions should be presented clearly, succinctly, and accurately. It is also helpful if the recipes and other "collectibles" are presented in a scale that makes them easy to clip, file, and use.

Sports Clearly, sports pages are worlds unto themselves, and sports staffs operate as virtually separate entities on many newspapers. Some have their own head schedules set in type of their own choosing, regardless of whether it harmonizes with the rest of the newspaper. Thankfully, however, that kind of ad hoc graphic independence is fading fast. The *San Francisco Chronicle* used bobble head dolls for a playful layout of its annual Major League Baseball special preview section (see Figure 16-33).

If anything, the appeal of the sports page has increased. Today, sports such as soccer, bicycle racing, golf, auto racing, and tennis have nearly

as much of a following as the National Football League, National Basketball Association, National Hockey League, and Major League Baseball. College sports are practically an industry in and of themselves, and women's sports are gaining in popularity. High school sports, too, are an essential component of the contemporary newspaper, regardless of its size. This area is also a logical link to younger audiences—something very important to newspapers.

But interest in sports extends even farther as more and more people participate in recreational sports: everything from running to baseball and fishing to rafting. The recent explosion of alternative and extreme sports, such as skiing, kayaking, skateboarding, snowboarding, and rock-climbing, has also had a huge impact on young and older audiences alike, as well as both males and females.

Compared to their section counterparts, sports page designs should be more dynamic. Indeed,

Figure 16-32
Food and Entrée pages are important components of today's newspapers; their design strategies have tremendous range. (Left) A play on words—"Chips Reign"—and playful art and design make for this national "features" award-winning layout. *The New Orleans Times-Picayune* art staff used whimsy and the perfect mix of photography and illustration in this poster-inspired layout. Note how the lower right chocolate chip crashes into the copy. Beth Aguillard, designer; Ellis Lucia, photographer; Jean McLintosh, art director; Dale Curry, editor; George Berke, design director; Kenneth Harrison, illustrator. © 2003 The Times-Picayune Publishing Company. All rights reserved. Used with permission of *The Times-Picayune*. On the other hand, the section's styling may be downright seductive (if you happen to fancy asparagus, anyway). "Spear this" uses sophisticated photo-illustration via a full bleed for this feature on the equally sophisticated asparagus. It is from the *Detroit Free Press* food section. Susan Tusa, photographer; Andrew Johnston, photo editor; Bryan Erickson, designer/deputy design director—features. Reprinted with permission of the *Detroit Free Press*.

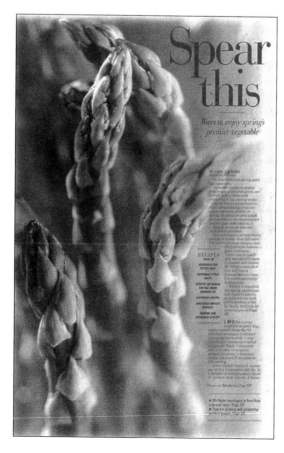

their presentation and layouts should bring the same kind of energy and excitement to the page as sports bring to their fans.

Some newspapers produce separate sections on a regular basis, targeting participation sports such as bicycling, hiking, boating, and running marathons. Papers also produce special sports sections for a wide variety of reasons: to launch a university's football season, present an overview of the World Series, or feature the upcoming women's high school basketball championships, for example.

The typography of sports pages should reflect the vibrant action-packed activities they record. At the same time, they should maintain continuity with the rest of the paper. A bolder posture of the same type as used in the entire newspaper might offer more life to the sports page. Splashing features into the page, magazine-style, may also offer more variety. Generally speaking, though, typography (from the sports interior logo, to head schedule, text, and cutlines) should follow the publication's stylebook to help unify the entire newspaper.

Sports news often includes much statistical matter, box scores, standings, schedules, and event summaries. The trend is to set this material in agate (5½ point) or condensed sans serif type and group it for all sports in a separate page or part of a page. This practice helps the orderly organization of sports information and enables the editor to set the type in the optimum line width for agate. The typographic appeal of the statistical matter may be improved with distinctive headings for each topic. Small graphics to identify each sport may also be incorporated within the headers or rule dividers.

Arts and Entertainment A quick examination of other media points up the snowballing popularity of arts and entertainment. The array of entrées for this feature-oriented section is a marvelous smorgasbord that can satisfy any taste. Content may include theatre and play reviews, music, gallery exhibitions, interviews, film, television fare, personality pieces about artists, dance, comic books, concerts, opera, collectibles, popular culture, and detailed schedules for most of the above.

Many larger and middle-sized newspapers create "events" calendars to list and feature the wide array of happenings in the cultural and entertainment world.

Larger and nearly all medium-sized newspapers offer a weekend or Sunday Arts and Entertainment (A&E) component, often along with a Friday or Saturday "what's happening" type of section to alert readers about local and regional cultural events. These sections also provide a wide draw from just about every part of the community: from the higher cultural world who follow art, opera, and classical music to the average reader who likes to take in rock or blues concerts, monster truck demolitions, or the latest film. Packaging and thematic strategies are especially functional and appropriate for much of A&E page design.

Travel As Marshall McLuhan suggested, we live in a global village. The world has become smaller place, and people have more leisure time on their hands and many have acquired some international experience. Their travel might be pragmatic, spawned by business dealings or conferences, or; it might be motivated by an upcoming week or two of vacation time or an exchange or sister cities programs. It's also quite common for students today to protract their education and cultural understanding by studying abroad. Whatever the reasons, our interests in travel and other cultures have never been so widespread and enthusiastic.

Though usually weekly and reserved for Sunday readers, travel sections have become a staple for today's newspaper. This section is normally feature-driven and offers (albeit more abbreviated) magazine-like articles, such as "Discovering Cuba," or "Ten Secret Beaches in Southeast Asia." *The Boston Globe*, a highly esteemed newspaper for both its content and design, produces dazzling layouts for its travel section.

Smart section editors often plan "theme" packages in advance and woo advertisers well ahead of the publication date. Travel sections also run regular columns and standing information on global weather, lowest airfare prices, monetary exchange rates, cheapest tourist destinations, and the like.

Figure 16-33
The *San Francisco Chronicle* is fortunate to have two serious World Series contenders in its backyard: the Oakland Athletics and the San Francisco Giants. While the preview focuses on local teams, it provides an overview of both leagues and also pits other inter-city rivalries—the Mets and Yankees and the Dodgers and Angels. Knockout, rebus pieces, and generous white space make this layout clean and inviting. Matt Petty, design and illustration; Nanette Bisher, creative director. Reprinted with permission of the *San Francisco Chronicle*.

Photography figures as prominently in these pages as type and layout. Designers sometimes take more liberties with display type in travel sections and also tend to run larger photos and good supportive art as well (see Figure 16-38) Often, sidebars are also used to discuss travel arrangements, cultural interests, food, or historical overviews. Take a quick tour of the best-designed newspaper pages and sections; you're sure to find a number of travel examples among them.

Business It is not by accident that *The Wall Street Journal* has the largest daily circulation in the United States. Business news is big business. However, it is more than business news that has made *The Wall Street Journal* a success. It features excellent writing, accurate editing, broadened coverage, and an impeccable reputation for financial newsgathering. Note the earlier discussion of *The Wall Street Journal* and Mario Garcia's recent redesign.

Figure 16-34

Prior to serving as a design editor at the *Chicago Sun-Times* and *Red Streak*, Robb Montgomery worked in features design at the *Chicago Tribune*. Montgomery has been honored with top awards from the Society for News Design, Pictures of the Year competition, the Illinois Press Association, the Florida Press Club, and The Society of Professional Journalists . He also teaches a graduate class in visual editing at the Medill School of Journalism at Northwestern University. His talents, however, aren't limited to the visual realm; Montgomery is a songwriter, record producer, and operates a website at kidvibe.com. Reprinted with permission of the *Chicago Sun-Times*.

Figure 16-35

This front page from the *Chicago Sun-Times* shows the impact of the magazine-like tab format when great photography is coupled with bold type and design on a story that had not only Chicago, but the entire country talking. "Say It Ain't So-Sa" is a marvelous headline that helps tell the story and the hopes of die-hard Chicago Cubs fans. Compare its design to that of the *Red Streak*. Courtesy of the *Red Streak* and *Chicago Sun-Times*. Reprinted with permission of the *Chicago Sun-Times*.

Robb Montgomery and *Red Streak*

Robb Montgomery is the News Design Editor for the *Chicago Sun-Times* and the Executive Art Director of *Red Streak*, a youth-oriented daily edition of the *Chicago Sun-Times*. (See Figure 16-29.) It competes head-to-head with the *Chicago Tribune*'s tabloid, *Red Eye*, for the coveted market of young commuters, ages 18-34. Montgomery designs and edits the front page for both papers and is the visuals editor for special newsroom projects. The *Red Streak* hit the streets in October 2002. Robb Montgomery is also one of the visual editors involved in the 2003 redesign of the *Chicago Sun-Times* (see Figure 16-35). He offers a background and design discussion of *Red Streak*'s launch:

Red Streak was built from scratch in 23 days. The planning, design, staffing, and creation of an entirely new newspaper was completed in less time than some publishers take to decide which restaurant will cater the company party.

The Chicago Sun-Times *drafted four senior editors from its newsroom and recruited 15 bright young journalists from the company's suburban Chicago newsrooms and gave them the mission to create a newspaper that they would read. The pace was furious; there were dozens of problems to solve and decisions to be*

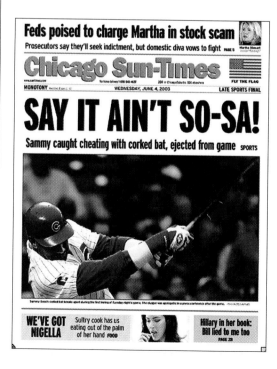

made. Ordering computers, pulling desks out of basement storage, and deciding on a name. Should we have a sex advice column? How about two?

We got e-mail and voice mail messages from the vice-presidents of marketing and circulation asking for the new paper's logo before we even settled on a name. At the end of the first day's brainstorming session, my bosses said they wanted the paper to have a color double truck appear every day. I still couldn't get logos for the staff and we didn't have enough copies of Quark Xpress, but I said, 'Sure, we'll design a rockin' color center spread everyday.' People in our makeshift newsroom didn't even know each other's last names yet, but somehow we gelled as a team and started pumping out pages and taping them up to the wall.

Looking back, I can honestly comment that the spirit of any new publication is defined by the process by which it was conceived. The Chicago Tribune *spent 16 months and millions of dollars methodically planning, analyzing demographic data, and revising every element of* Red Eye *(Tribune's* tab*) based on private focus-group research. By contrast, the Sun-Times' effort was a manic-driven project headed by a small group of editors and reporters who were given the freedom to follow their instincts about what would appeal to younger readers. The* Tribune *had kept their plans a secret, and we had three weeks to meet them in the streets (see Figure 16-36).*

Media watchers were attracted to this classic David vs. Goliath showdown between the well-funded Red Eye *and the scrappy little* Red Streak *effort. Without consultants, focus groups, or even a proper prototype,* Red Streak *became an instant hit with Chicago readers, and media pundits went on record saying that they preferred* Red Streak *over* Red Eye. *Most felt that it was more genuine and ambitious in its packaging approach.*

Red Streak *is more like a magazine than a newspaper: modular ad stacks, lots of color, and page after page of layouts with eye-popping visuals. The headlines and cutlines are more*

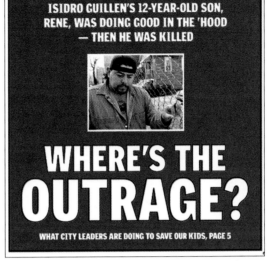

playful and often pithy and biting. They are written in the language of young adults. The combination of story selection and visual editing with an attitude gives the publication a strong personality.

Red Streak*'s news digests are a signature element of the paper. A typical 'Deadline: Chicago' two-page spread features 26 stories and nine photos on two tabloid pages. And it looks good. It scans well and reads well because the information is prioritized, the headlines are to the point, and the copy is crafted to match the news hole. We use the same Deadline format in the Sports, Entertainment, Business, and Nation/World sections. Younger readers are more accustomed to a visual assault of headlines, images, boxes, windows, cutouts, and screens. They already get most of their news on-line and from cable TV. The pages of* Red Streak *have an elevated sense of visual agitation that would likely appear uncomfortably out of place if used for a mainstream newspaper (see Figure 16-37).*

Finally, the front page is newsy, spirited, and refuses to be ignored—all key ingredients for a youth-oriented commuter read that relies on single-copy sales.

Figure 16-37
This beautifully-designed inside *Red Streak* page on Tampa Bay receiver, Joe Jurevicius, uses information graphics, rebus photography, and type (note the strong deck and two pull quotes). At first glance, it might be easily mistaken as a sports feature opener for a magazine. Courtesy of *Red Streak* and *Chicago Sun-Times.* Reprinted with permission of the *Chicago Sun-Times.*

Figure 16-36
Red Streak covers pull no punches. They're designed to grab your eyes and hold them. These two *Streak* covers are representative of the strong covers Montgomery helps his staff craft for the newspaper's young audience. (Left) Piecing together the visual components for "FREE!" was a "challenge." In addition to having photographs of all seven freed American POWs, *Red Streak* had a dramatic lead image of Shoshana Johnson being rushed into a helicopter in Iraq outside Tikrit that they wanted to run big. The solution? Eliminate the "refers" at the top of the page and replace them with thumbnail photos of the other six American soldiers. (Right) On the other hand, outraged citizens and the newspaper are looking to city leaders to find out what they're going to do to stop the spate of senseless killings of innocent children. This bold red cover reflects the rage of the father of a 12-year-old boy (Isidro Guillen) who'd been shot to death—and the rage of an entire community. Courtesy of the *Red Streak* and *Chicago Sun-Times.* Reprinted with permission of the *Chicago Sun-Times.*

Figure 16-38
The Boston Globe is easily one of most beautifully designed papers in the world. These two travel pages demonstrate the power of photography and its ability to capture the essence of place—something obviously important to readers of a travel section. The impact of these layouts begins with the imagery and continues through simple logistics, design, and effective use of typography. The person responsible for these compelling page layouts is Keith A. Webb, art director and designer at *The Boston Globe*. Photo by Adam Wolfitt/Corbis. Reprinted with permission of *The Boston Globe*.

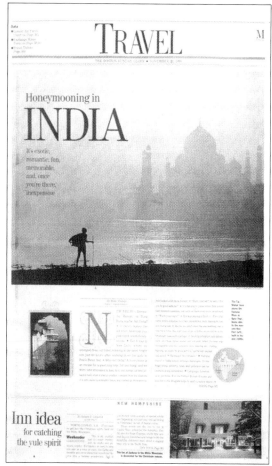

Newspapers everywhere are realizing the reader appeal of the business section. There was a time when business news was presented in staid, conservative—even dull—reporting and layouts. In addition, the average person today has sizeable investments in retirement plans and sheltered investment programs. As the interest in business news has grown, business pages have become more lively. Publishers are slowly realizing effective visual communication should apply to all sections of the newspaper (see Figure 16-39).

Business sections are also logical places to integrate maps, fever and pie charts, histograms, and information graphics for business articles. Of course, the business section is also normally the home for the New York Stock Exchange, NASDAQ, Standard and Poor, and Dow Jones trading reports, along with Mutual Fund quotes. Newspapers also employ graphics for market analysis. Financial columns also often appear in this newspaper section.

Future of Newspaper Design

When asked what is the single most important thing that shapes newspaper redesign today, David Gray responded: "Quest for the bigger bottom line. Since 'design' at many American papers is a 'luxury' and not seen as part of the editorial process, that's the first place staff is cut or allowed to decline by attrition because the jobs aren't filled. And not too many people (designers) are looking to fill them, since the pay and hours are still bad compared to dot.coms."

Often editors, and publishers in particular, see redesign as more of a way to sell more newspapers than to improve the communication dynamic of their publication. Too often, too, that is a publisher's yardstick for the success of the graphic overhaul: are circulation and newsstand numbers up? On the other hand, the future of any newspaper is closely tied to how well it understands and fulfills the needs of its audience and how well every aspect of the publication connects to its readers. Boundaries need to be pushed and formats stretched (see Figure 16-40).

In terms of format, newspapers are in a phase of appraising and changing every aspect of their publication formats. First, most broadsheet newspapers are considering a 50-inch web press for both cost and material savings or have already adopted the trimmed down configuration. Clearly, the broadsheet format will remain a newspaper mainstay. That said, there appears to be quite a bit of experimentation with the tabloid format, including some papers switching back to broadsheet after testing the tab waters. Most newspapers, however, use tabloid formats for special sections, supplements, or their magazine editions at the very least.

Recently, the Friday entertainment tab section, *Free Time*, of the *Minneapolis Star Tribune* ping-ponged its way from broadsheet to tabloid to broadsheet. However, not only did art director Denise M. Reagan, features design director Rhonda Prast, and design director Anders Ramberg have to shoulder the task of redesigning *Free Time* within its original format, they also were assigned the task of merging it with another section, *Variety*:

"Necessity is the mother of invention," Reagan said. "Or in this case, reinvention. The Star Tribune's *Friday entertainment tabloid, called* Free Time, *had to be reformatted as a broadsheet section. Two years after its introduction, traditional readers had never warmed to the tab format, and declining readership for the section was leading to decreased advertising. Also, its undesirable placement in the paper (usually stuffed inside the classifieds) made it hard for readers to find."*

The makeover is as beautiful as it is pragmatic. The opening pages feature strong art—sometimes one huge photo but more often a large image with a strong supporting cast of photographs and illustration. Often the designers employ playful rebus layouts, occasionally more formal symmetric arrangements as in on the *Variety* "ART" page. The typography is simple but handsome. The nameplate/section logos are crafted from Bodega San Serif and contrast the Franklin Gothic Demi employed for headers. Walbaum and Walbaum Italic serve as alternate headline type and deck heads, respectively. The text face is Utopia.

Variety appears seven days a week; on Fridays, a weekender version, *Variety/Free Time*, is published. In addition, there are special designated pages for "Travel and Arts," "OnStage," "Home and Garden," and "Movies."

But in the future, will newspapers be more visual? Well, if you look at the evolution of newspapers, one thing is fairly clear and consistent. Over the years, they've become more and more visually driven and sophisticated. Of course, David Gray's earlier reference to Lockwood suggests that publishers make the final call and that the bottom line is the bottom line, which is to say that most publishers endorse design not for aesthetic, functional, or visual reasons; they sign off on a redesign for economic motives.

Nonetheless, papers have continued to be more graphically oriented. *The Minneapolis Star Tribune's Variety* is a good indicator for the future. Other wonderful examples of strong visual styling and sophisticated graphics in newspapers: *El Mundo* (Madrid, Spain); *The Hartford Courant*; *Chicago Tribune*; *The Boston Globe*;

Figure 16-40

When Robb Montgomery wanted to celebrate the patriotism Americans showed after 9/11, he opted to run posters for the *Chicago Sun-Times*. He honored the firemen of New York City, thousands of volunteers who participated in rescue efforts, and others. These are but two posters from a larger series executed by Montgomery and the writers, photographers, and designers of the *Chicago Sun-Times*. At top is a poster of McKayla Skye Montgomery "who took her first breaths at 9:44 a.m., precisely the same time thousands took their last." Actor Robin Williams, shown here at a San Francisco blood center on September 11, was just one of 176,406 people nationwide who donated blood during the first three days after the terrorist attacks. Art direction, Robb Montgomerey; design, staff; copy, Debra Pickett. Courtesy of the *Chicago Sun-Times*.

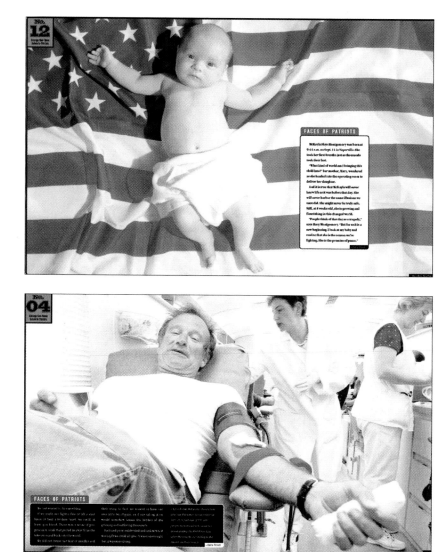

Helsingborgs Dagblad (Helsingborg, Sweden); *National Post* (Don Mills/Toronto, Canada); *The Seattle Times*; *St. Petersburg Times*; *The Straits Times* (Singapore); *Le Devoir* (Montreal, Canada); *Die Welt* (Berlin, Germany); *Taipei Times* (Taipei, Taiwan); *The Star Ledger* (Newark, NJ); *The Oregonian* (Portland, OR); *The Sydney Morning Herald* (Sydney, Australia); *The Tribune* (San Luis Obispo, CA); *The Sun News* (Myrtle Beach, SC); *Sunday Herald* (Glasglow, Scotland); *Die Zeit* (Hamburg, Germany); *Ottawa Citizen* (Ottawa, Canada); *Grand Forks Herald* (Grand Forks, ND); *Correio Brazilliense* (Brasilia, Brazil); *Svenska Dagbladet* (Stockholm, Sweden); *Reforma* (Mexico City, Mexico); *The Spokesman-Review* (Spokane, WA); *The Times* (Northwest Indiana); *The New York Times*; *The Washington Post*; *Detroit Free Press*; *The Free Lance-Star* (Fredricksburg, VA);

The Plain Dealer (Cleveland, OH); *El Norte* (Monterrey, Mexico); *The Orange County Register*; *The Charlotte Observer* (Charlotte, NC); *La Voz del Interior* (Córdoba, Argentina); *Asbury Park Press* (Neptune, NJ); *Metropoli, La Revista*, and *La Luna* (Madrid, Spain); *The Baltimore Sun*; *Orlando Sentinel*; *The San Diego Union-Tribune*; *El País* (Madrid, Spain); *Houston Chronicle*; *Newsday* (Melville, NY); *Star Tribune* (Minneapolis, MN); *The New York Times Magazine*; *Clarin* (Buenos Aires, Argentina); and the *San Jose Mercury News*.

The list could go on and on.

What's especially interesting and encouraging is that all of the newspapers above have gone through many redesigns and likely will see additional visual overhauls to come. What's more, because they serve varying audiences and cultures in different places, they are different visually

from one another. The spectrum of newspapers today is vibrant, and the role of design and redesign in newspapers will only become more important as media converge and design issues become more challenging, and as technology provides more powerful tools for the designer.

Graphics in Action

1. Find a recently redesigned newspaper. Bring it to class and compare the "before" and "after" versions of it. Which changes do you like? Dislike? Break up into 3- to 5-person teams and try to establish a rationale as to why it was made over.

2. Select a newspaper whose nameplate you do not like. Assume the newspaper is on a mission to attract more young readers and redesign the nameplate. Be prepared to discuss your rationale. Remember, you don't want to lose existing readership.

3. You've just been asked to assess the graphic needs of the school newspaper. It's in dire need of an overhaul. In fact, its design is antiquated enough to affect its credibility and its readership is horribly low. Put together a brief 8-10 question survey and ask readers at your school to cite what they like and don't like about the paper and what new components they'd like to see. Bring the list to class and discuss it.

4. Using the above in-class session as your starting point, develop a prototype for the school newspaper. Create several typography combinations for the paper's text and display type. Bring the best 3-5 groupings you have to class and pick the one you favor. Present each to the class briefly without telling them your preference. See which ones they choose.

5. After the typography discussion (see above), build a brief stylebook for type (text and display type) and bring it to class.

6. Using your new stylebook, design two sample section pages of the school newspaper—for example, front and sports section pages. If you can, borrow the actual stories and their accompanying artwork from a real paper (or art that you borrow that is appropriate for the stories' content). Compare the two.

7. The editor of your local newspaper wants to "open up" the design and look of its editorial section. You've been told that the pages should be "fresh and vibrant," but not lose the pages' sober quality. Come up with a list of 10-15 specific suggestions to accomplish this task, and present them to your professor—who will serve as editor. (If the professor can bring in an editor and designer from the local paper and serve with them as the advisory panel, better yet!)

8. Using the feedback you received from the above presentation and dialogue, design a prototype editorial page (or two) on your computer. Use important stories that are current—along with artwork—for the page(s) content.

9. Obtain a copy of a newspaper with which you are not real familiar. Assume that you have inherited the ownership of this paper. Since your background and interests are graphic, you take a long, hard look at the paper. How would you improve the front page? Don't forget that it is a profitable business and you do not want to take a chance on the new design adversely affecting reader acceptance and thus circulation and advertising.

10. Statistics reveal that the average age of newspaper readers keeps increasing, and young people seldom read newspapers beyond the "comics" pages. In an attempt to remedy this problem, your newspaper chain has decided to invent a "young readers' page." Being the art director of the flagship publication of your media chain, you've been asked to create a small 4- to 6-page mock-up of this tabloid section.

Remember, you are targeting 12- to 18-year-old (middle to high school) students. What will you put in it? Do you move existing components from their current homes in the paper to this section? What new things do you create? How do you establish a viable and credible connection to this audience? How might you involve them in this mission? What are some of the inherent dangers and opportunities involved with such an endeavor? What will you call the section?

After you've discussed this problem and answered all the questions, create an opening page for this young peoples' section. Also, have a list of the various components, columns, features, and other items that it will carry. After you have critiqued the opener, design the other prototypes pages, applying the class review.

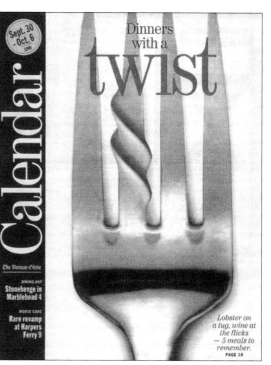

Figure 16-41

Arts and entertainment sections continue to improve via redesign. Perhaps *La Luna* and *La Revista* are the most celebrated publications for their pure design—newspapers or otherwise. (Left) Sanchez's *La Revista* opening spread on Clint Eastwood speaks to the overwhelming presence of the actor by its design and tight cropping. Rodrigo Sanchez, art director; Maria Gonzolez and Amparo Redondo, designers; Carmelo Caderot, design director; Alain Deplantier, photographer. Reprinted with permission of *El Mundo*/Unidad Editorial, S.A. (Above) The power of this *Boston Globe* layout, "Dinner with a twist," lies in its concept and brilliant visual metaphor on the fork tine. Photo manipulation makes the *Globe's* A&E Calendar page a real stopper. Reprinted with permission of *The Boston Globe*. (Bottom left) *Ticket*, the A&E section for *The Seattle Times*, embraces interesting photography that is raised to great heights via Jeff Neumann's intuitive handling of typography in this layout; it's raining type. Truly, this is a high wire act with type and deserving of its silver medal for SND for entertainment features. Reprinted with permission of *The Seattle Times*.

11. Your medium-sized daily has opted to broaden its reach and content. One of the suggestions is for the paper to create sections for travel and food. Another is that they redesign the existing arts and entertainment section. Using a smaller daily newspaper from your region, accomplish the above tasks.

12. Redesign an inside page of a newspaper. Examine the pattern of advertisement placement. If the pyramid or well is used, redesign to magazine or modular. Redesign the editorial content to make its display more effective.

13. During a redesign summary meeting, you learn that your editor has decided to launch a magazine section for the newspaper's Sunday edition. He's asked you to produce 5-6 sample pages, including a cover, table of contents page, arts review page, and sample a 2-page feature. Format-wise, he wants a publication that can easily be inserted into the folded broadsheet. This could turn out to be your regular assignment, art director for the magazine section, so go for it!

14. Create an "alternative sports" special section for your local paper. Focus on non-traditional sports that have a big following in your area. Possibilities include wake boarding, kayaking, body surfing, skateboarding, skiing, surfboarding, rock-climbing, sky-diving, back-packing, rafting, snowboarding, and windsailing. You choose the "alternative sport" focus for the section, but make photography a dominant element throughout the pages.

As you might guess, the editor wants the page to be different, but maintaining continuity with the rest of the paper is crucial. Which is to say: this section should reflect the edginess that is associated with these sports and be appropriate to the audience, but maintain graphic connections to the rest of the paper.

Another concern of the editor is that this section be self-sufficient. Where will the advertising to support these pages come from? Create a list of likely prospects. Try to go beyond the obvious: gear and athletic stores.

15. Rodrigo Sanchez is on vacation and you have been charged with designing this week's cover of *Metropoli*. Select a hot "arts and entertainment" subject and create a Sanchez-inspired cover.

A Hitchhiker's Guide to the Information Highway and Cyberspace: A Brief History and Overview

Designing for New Media

Multimedia

The Future of the Web, Interactive Formats, and Multimedia

Graphics in Action

The Web is the ultimate customer-empowering environment. He or she who clicks the mouse gets to decide everything. It is so easy to go elsewhere; all the competitors in the world are but a mouse click away.
—Jakob Nielsen,
Designing Web Usability

◄ *The Web, Jan Ryan*

E ven though we navigate daily through a perceptual world of three spatial dimensions and reason occasionally about higher dimensional arenas with mathematical ease, the world portrayed on our information displays is caught up in the two-dimensionality of the endless flatlands of paper and video screen. All communications between readers of an image and the makers of an image must now take place on a two-dimensional surface. Escaping this flatland is the essential task of envisioning information—for all the interesting worlds (physical, biological, imaginary, human) that we seek to understand are inevitably and happily multivariate in nature. Not flatlands.

—*Edward R. Tufte*, Envisioning Information

A Hitchhiker's Guide to the Information Highway and Cyberspace: A Brief History and Overview

Tufte's fine book is a wonderful starting place for all of us when it comes to new media design and *envisioning information*. His charges as a professor at Yale University are as fascinating as his books: he teaches graphic design, political economy, and statistics. His research and writings are especially insightful to the architecture of Web and interactive media—and to the design of new media, much of which is capable of *layering* information in new and exciting ways, some of which actually *simulates three-dimensionality*. Today interactive designers, who work with converging media and ever-changing technology stress usability and multiple access in their design.

At last count there were nearly seventy thousand informal and global networks surging through telephone lines, cables, and wireless communication systems. The Internet can access just about anything: traditional media (newspapers, magazines, newsletters, film, and business communications); music; libraries and immense databases; special interest and political groups; personal interactivity via interactive games, chat rooms, and e-mail; and a jungle of advertising and e-commerce (see Figure 17-1). Despite the massive flow of information, the hodgepodge of uses and users, and the amazing variety of media unleashed on the Internet, it functions well—computer errors, freezes, and protracted download time aside. Furthermore, it does so with a minimal amount of governance or regulation—at least for the moment.

Its public and anarchic nature seem especially odd and somewhat ironic because the original prototype of the Internet was developed by the Rand Corporation for the United States military, which wanted a secret and sophisticated communication system that could survive a nuclear attack. During its experimental stages, the government allowed access (via *public* telephone lines) to private users, primarily scientists and university researchers. Then, in 1982, the National Science Foundation refined the system and made it accessible to computer research labs and the gurus of high technology. It didn't take long—roughly ten years—for digital pioneers to transmit not just words but graphics, photography, sound, and video.

Today, the Internet's chameleon-like technology adapts to CD-ROM, DVD, cell phones, and other evolving formats as well. The rest, as they say, is history. However, the "Net's" evolution continues to snowball, and its integration with other media has blurred the margins of media and changed our thinking about "mass media." On the one hand, the "Net" can be a very

Previous page
The Web, interactive, and multimedia stretch our notions of media, and epitomize media convergence and the changing nature not just of media but the technologies that drive them. In his foreword to *multiMEDIA: from Wagner to Virtual Reality*, William Gibson noted: "Multimedia, in my view, is not an invention but an ongoing discovery of how the mind and the universe it imagines (or vice versa, depending) fit together and interact. Multimedia is where we have always been going." Artwork by Jan Ryan.

Figure 17-1
These two pages are representative of the Arctic Cat: Firecat website. It has received a variety of awards and much attention for its innovation and storytelling, from snowmobile enthusiasts and Web designers alike. It underscores the importance of simple, logical design (www.articcat.com/hot). Periscope Site Design used strong photography, color, simplicity, and function to drive its design. Andy Gugel, graphic and interface designer, summed up its success, "The day that the Firecat launched, we were blown away to find that traffic to the Arctic Cat site had increased more than 1,500 percent... in less than 2 hours." The writing is crisp and engaging, and the design blends photography, illustration, and a smart menu to tell the story of the concept, creation, and features of Firecat. Courtesy of Artic Cat and Periscope Site Design.

personal, one-to-one medium, allowing instantaneous interaction. Two great examples of this sort of site are: 2bMe (www.2bme.com)–a very personal and sensitive website created for teens with "appearance-related side effects" due to cancer treatment; and the North West Rafters Association site that offers ongoing information to members and visitors on everything from river flow/temperature/hazards and weather data to political and ecological news and trip reports (see Figure 17-2).

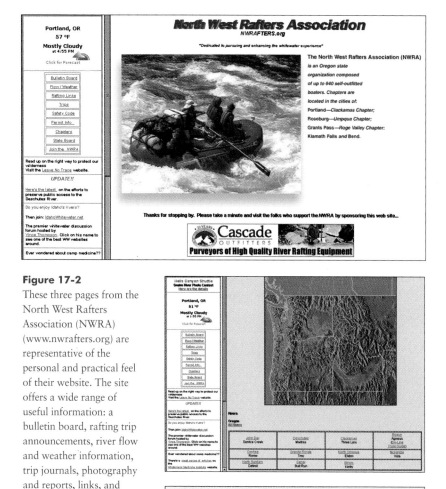

Figure 17-2

These three pages from the North West Rafters Association (NWRA) (www.nwrafters.org) are representative of the personal and practical feel of their website. The site offers a wide range of useful information: a bulletin board, rafting trip announcements, river flow and weather information, trip journals, photography and reports, links, and safety and permit updates. Here are pages offering drainage maps and river flow data, a photo-journal excerpt, and information on the Deschutes River. Design and webmaster, Kerry Walsh; photography by Matt Kramer. Courtesy of the North West Rafters Association.

At the same time, the Internet can reach millions of people simultaneously. It entertains us, connects us to loved ones, provides up-to-the-minute details on breaking news stories, and it's an invaluable research tool. In addition, the Web provides endless e-business and marketing opportunities. Because it is such a complex cultural reflection of us (sort of an electronic *zeitgeist*), the Internet epitomizes symbiotic media relationships. Today, globalization (along with media convergence) challenges designers everywhere to create messages that can work across cultures or specifically target a culture on the opposite side of the world from where it was created (see Figure 17-3).

Perhaps more than anything else, however, the Internet has profoundly affected how we communicate, both en masse and individually: how we do business, process information, and carry on with our daily lives. In addition, it has significantly dissolved traditional media boundaries—even media identities. Indeed, all major publications and corporations have an interactive or Internet presence. It has also extended and underscored the importance and possibilities of branding. *ELLEgirl*, a leading fashion magazine for young women, and its sister publication, *ELLE*, have developed a strong online presence. Alexis Mersel, editor at *ELLEgirl.com*, points up the importance of market presence and brand through the Internet: "Many forms of media have used the Internet for brand expansion or enhancement, so they look at it positively. For instance, *ELLEgirl* magazine extends its brand and user base through its website: more eyes equal bigger audience equals stronger brand equals more advertising." *The Chicago Sun-Times* created *Red Streak* to compete with *The Chicago Tribune*'s *Red Eye* tabloid; both targeted the young urban commuter. *Red Streak*'s website is a great interactive complement to the newspaper and its branding (see Figure 17-4).

Initially, though, not all media were quite so embracing of the Internet. Many media felt threatened by interactivity and the Web, as well as the changes they'd created. That shouldn't be

surprising because initially, all new media rock the boats of older media. When radio emerged, some claimed it would replace newspapers; pundits also predicted the end of radio and film when television became a reality. To be sure, though, the Internet has dramatically changed the media landscape. For example, many traditional newsletters and annual reports have shed their former print versions and donned electronic formats instead. Part of the angst is in reaction to the unique blend of words, sound, motion, film, links, and the *interactivity* of the Internet—and—its instantaneous nature. Clearly, too, some of the media migration to the Web is driven by simple economics. Electronic annual reports, newsletters, catalogs, and other media often don't cost as much as their printed counterparts, and it often takes less time to create them. Many large catalog brands (J. CREW, REI, and Delia's, for example) save printing and mailing costs by distributing fewer catalogs due to their strong Internet presence, e-mail newsletters, and the preference of many customers to order online. For example, J. CREW used the "Net" to make shopping easier for existing customers and to reach a new generation of shoppers (see Figure 17-5). Timeliness is yet another advantage. If Cascade Outfitters is closing out last year's raft models or overstocked camping gear, it can mass-post sales almost instantly to its wired customers.

Indeed, Web and interactive media are flexible and multi-faceted. In addition, the Internet can provide information on anything in a matter of seconds. The result has been a stampede by other media to establish some kind of presence on the "Net," if for no other reason than to hedge their bets—but that can be positive. Like media transitions of the past, however, the crossover for many media is often as clumsy as it is predictable. For the less visionary, a typical response might be to simply rubberstamp a print version of its publication, advertising, or message on the Web without really considering the medium's options, its interactive nature, or how people use it. That is *not* the case, however with these handsome, user-friendly pages from the *Rocky Mountain News'* website (see Figure 17-6).

Figure 17-3
Here are three sample website pages from agencies whose clients are truly global in nature. Their work involves not just interactive media but packaging design, hospitality and identity materials, annual reports and myriad other collateral publications. (Top) Red Spider is a virtual company located in the UK whose primary focus is in branding. (Middle) SamataMason is located in the Chicago area, and (bottom) Immortal Studios in Singapore. All are global players whose fine design work is recognized worldwide. Courtesy of Red Spider, SamataMason, and Immortal Design.

Figure 17-4
How does *Red Streak*'s website design relate to its print version graphically? (See *Red Streak* examples in the previous chapter). What have the designers done to tailor it to its young Chicago commuter audience? Note how color and voice speak to its brand and identity. Artwork courtesy of Robb Montgomery and the Chicago *Red Streak*.

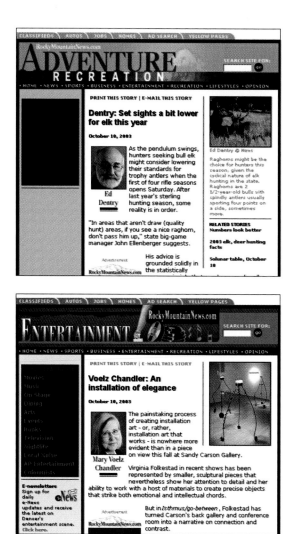

Figure 17-6 ▲

The *Rocky Mountain News* is a wonderful example of a newspaper that utilizes its online counterpart appropriately. Everything—from the strong sans serif typography to the indexes, use of color, shorter, snappier writing, and usability—speaks to the medium and the audience. It is a great example of how to take a newspaper and restructure it using the interactive nuances of a website. Note the structural similarities between the entertainment and adventure/recreation sections of the online newspaper. Courtesy of Jonathon Berlin and the *Rocky Mountain News*.

Figure 17-5 ▲

J. CREW's quality, fashion, and memorable catalogs are sustained and continued online. Their shopping site is inviting, stylish, informative, clean, and easy to use. Form and function are key. The use of generous white space and knockout photography suggest the same sophistication and allure as their print catalogs. You'd be hard-pressed to find a cleaner, more inviting website—regardless of its content or mission. Courtesy of J. CREW.

Communication Arts

Communication Arts has been showcasing the best creative work in graphic arts for more than forty years. It has pioneered the field of graphic communications and is a permanent part of the library of nearly every advertising firm, design studio, and website agency in the country. Its features, columns, departments, reviews, and annuals are as relevant as they are timely. Editor Patrick Coyne contributes this historical overview of interactive media and *Communication Arts* (see Figure 17-7).

Communication Arts, *the largest trade journal in visual communications, was launched in 1959 as a sideline business by two creative communicators who wanted to continue experimenting with printing technology. In the mid 1950s, Dick Coyne and Bob Blanchard ran a design firm, owned a typography shop, and wanted to set up a color separation and litho stripping facility. They were one of the first design firms to bypass standard mechanicals and assemble jobs directly in film.*

They reasoned a magazine could take up the slack when these facilities weren't being used by the design business. At the time there wasn't a true national design magazine on the subject. Their goal was to showcase quality work from around the country, presenting as much in color as possible.

Prior to Communication Art's first issue, all magazines and newspapers were printed on letterpress. Offset lithography was just beginning to become popular, but only for small and short-run jobs. With a finer screen and less expensive preparation, Coyne and Blanchard found that offset lithography offered designers greater freedom. One of the biggest obstacles was how to reproduce work originally printed on letterpress that used special inks and colored paper. Their solution was to create four-color screen tints in 10

percent increments and then print master sheets showing all the possible combinations. That made Communication Arts *possible (see Figure 17-8).*

The first issue debuted in August 1959. Among a number of innovations, it was the first magazine in the United States printed by offset lithography. Most of the ads came in as letterpress plates. Proofs were printed on a repro press and then line shots made to convert the ads to film. It was also perfect bound. Since there were no commercial perfect binders available, issues were bound by hand in an experiment under an arrangement with Stanford University Press. "Most of the issues were fine," Dick Coyne said, "but I wouldn't have recommended that anyone pull too hard on the pages."

After a gradual start, Communication Arts *began an annual juried competition to generate income and editorial content. Within a few years, it grew in size and stature to become one of the most respected competitions in the industry and was eventually segmented into four different annuals: graphic design, advertising, photography, and illustration. Through the 1960s and 1970s,* Communication Arts *documented the increasing sophistication of visual communications as some firms grew into large identity/branding organizations with international offices while other practitioners became specialists in packaging, annual reports, and signage. Paid circulation increased to 50,000.*

The magazine's evolution continued to parallel the fundamental changes in the industry itself. In the 1980s, the desktop publishing revolution began and computers were incorporated into design offices. Communication Arts *made the conversion, and like the profession, it absorbed the role of the typesetter. Typographic procedures were established the hard way, by trial and error. The whole process left many with a renewed respect for their former typesetter's skills and a better understanding of their fees.*

Figure 17-7

Patrick Coyne is editor and designer of *Communication Arts* (*CA*). In addition to overseeing the layout and content of the magazine, Coyne writes feature stories and the editor's column. He has also guest lectured at numerous creative clubs and universities. Prior to joining *CA* in 1986, Coyne was a principal in the multi-discipline, San Francisco-based design firm of Patrick Coyne Stephanie Steyer Design Office. After graduating from California College of Arts and Crafts, Coyne worked for Michael Mabry Design and SBG Partners. Reprinted with permission of Communication Arts/© Coyne & Blanchard, Inc. All Rights Reserved.

Figure 17-8

These covers represent a mini-history of *Communication Arts* magazine reflecting its style and design evolution and how technology reshaped the covers. (Top left) Lloyd Pierce designed the inaugural cover of *Communication Arts* (August, 1959), which featured mechanical-color screen tints. The original *CA* logo was designed by Freeman Craw and is closely related to his Craw Clarendon Condensed. (Top right) "Not qualified" had been the explanation for the lack of minority participation in the visual arts. Bill Tara, a contributor to *CA* in the 1960s, created Tutor/Art, training Los Angeles inner-city high school students so they could prepare portfolios for art school acceptance. The story was included in this 1968 issue. William Arbogast, photographer. Reprinted with permission of *Communication Arts*/© Coyne & Blanchard, Inc. All Rights Reserved. (Bottom left) The 1991 cover, "Frog Spurn," is one from a set of fifteen illustrations for *Bizarre Birds & Beasts*, published by Dial Books/USA and Pavillon Books/UK, with an environmental theme, written and illustrated by London-based James Marsh. This was an extremely popular cover, and was reproduced as a poster. Courtesy of James Marsh. (Bottom right) January/ February 1996 photograph by David Gaz. The image, from a feature on his work, illustrated a *Communications Week International* article, art directed by Karen Verlander, about the expanding capabilities of telephone companies-investments in film, television, bioresearch and multimedia. Courtesy of *Communication Arts*. © David Gaz.

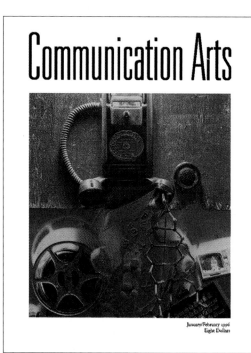

As the visual communications field grew in size and scope, the technology revolution continued to accelerate. By late 1993, nearly one in three U.S. households contained a personal computer, and approximately 23 million adults used a home computer every day. A majority of people used a computer at the workplace. Designers and clients began producing educational and corporate communication materials that were never printed but delivered on disk or CD-ROM. Now viewers could interact with the content by deciding what information to see and in what order. Then, on September 12, 1994, Netscape

released the beta version of its *Navigator Web browser. Now viewers could see images and text combined with a reasonable amount of visual sophistication from any computer connected to the Internet.*

Soon after, the Web began its explosive growth. Almost every company and institution realized they wanted a website, and demand quickly outpaced the small supply of capable Web designers. Many traditional print-based designers added Web design to their skill set and joined the Internet boom. By the end of 1995, 16 million people were using the Internet. By 1999 that number had reached 120 million. In 2002, 580 million people used the Internet.

Seeing the need for visual communicators to both explore and expand this new medium, Communication Arts *launched its own website and a fifth competition, the* Interactive Design Annual, *in 1995. The impetus for the* Interactive Annual *actually came about during the 1994 Design Annual judging. All nine judges spent 30 minutes huddled around one computer to view the* three *interactive entries received that year. There were still 14,000 print entries to judge in less than three days. If more interactive entries were received in the future, the whole system could collapse.*

The Interactive Design Annual *has since grown to become the benchmark for interactive media and receives over 2,000 entries a year. Paid circulation for the magazine has grown to 70,000 readers (see Figure 17-9).*

Today, almost two-thirds of the graphic design firms and advertising agencies are involved in interactive media design and nearly all visual communicators are online. Communication Art's *modest initial website has grown into a three-site network which includes Design Interact, an information resource for creators of interactive media; Creative Hotlist, a customizable online application for connecting talent, companies, and services; and Communication Arts, a streamlined, online interface for Communication Arts magazine. The network now attracts over 200,000 distinct monthly*

visitors and has become a primary destination for visual communicators online.

Technology is an integral part of visual communications and new forms of media continue to expand the role of its practitioners. As the leading journal to the trade, Communication Arts *will add coverage and content as it documents this exciting and rapidly evolving field.*

Figure 17-9

Communication Arts also offers a variety of online components. (Top) *Commarts* is the online interface for *Communication Arts* magazine. Users can find a complete index of articles, search for firms profiled, or subscribe to the magazine. (Middle) *Design Interact* is a content-heavy site directed toward information architects, designers, and programmers, providing comprehensive coverage of the people, processes, and tools in interactive media (www.designinteract.com). (Bottom) *Creative Hotlist* is the largest jobs and careers site for creative professionals. Users can find or post jobs specific to the industry and customized by location, experience or category. Target: graphic designers, art directors, creative directors, commercial photographers, illustrators, and students of the trade (www.creativehotlist.com). Reprinted with permission of Communication Arts/© Coyne & Blanchard, Inc. All Rights Reserved.

Designing for New Media

There is a great deal of confusion about terminology regarding *new media*. The moniker, "new media," is limiting because what's new today will likely be antiquated, inappropriate, or even meaningless tomorrow. For example, fifteen years ago, the term "desktop publishing" meant something. It was a revolutionary approach to design whereby personal computers streamlined the planning, assemblage, and execution of a publication. Today, it's little more than an interesting choice of words because all or nearly all publications and other design work are created on computers. For our purposes, we'll think of new media as a convergence of media, technology, culture, and ways of shaping communication content.

The terms "Web" and "Internet" are used interchangeably. Whatever you call it, it's important to never forget that the medium is fluid and *interactive* and that it employs *multimedia*. The Internet is driven by its technology and accepts and transmits literally all media. *Interactive* is anything that engages the user in some way, whether it be through a promotion, a toll-free number, call to action, a chat room, video game, or website that one has to navigate. Kevyn Smith, creative director at Peel Interactive, feels that any "engagement with content is interactive." For this chapter, it might be better to qualify interactive as the mix of graphics, text, video, sound, illustration, photography, animation and other media— as in a website, video game, or DVD.

This chapter will address the visual aspects of the Internet and interactive media first, and multimedia later—in no small part through the eyes and experience of several interactive designers, a webmaster, animators, and even a director.

Web & Interactive Media Design: Aesthetic Similarities

One thing that should be reassuring to you is that *all media*—magazine, film, photography, newspaper, or Web page design—essentially abide by the same design principles, composition, and graphic strategy. The design principles applied are identical—or nearly so—and so, too, are many structural considerations. A review of the design chapter might prove helpful to you. Suffice it to say, though, that Web pages or interactive frames should be appropriately *balanced*; have an *emphasis*; *sequence* a user efficiently through their space; provide *unity* and *continuity* between parts; and establish interesting proportions. In fact, often proportions are fixed within Web page design as parallel structure to establish a clear graphic footprint and *integrate* the pages of site, video game, DVD, or interactive advertising pages (see Figure 17-10).

Actually, you can learn a tremendous amount by examination and deconstruction. Spend a half-hour or so visiting five to six websites you frequent or are at least familiar with; then, using a search engine, select another half-dozen or so you've never seen. Ideally, choose ones whose content will be interesting to you. Keep a running list of what you like and dislike about the content, presentation, structure, type, usability, color, and media employed by each, *keeping their respective audiences in mind*. What you'll likely discover is that the ones you favor speak to you clearly and simply. They integrate content with design. They're informative and easy to read. They're user-friendly, easy to navigate, and work relatively quickly. They're also fresh and visually stimulating.

Figure 17-10

This *CA* interactive winner uses multimedia in a compelling way through film. The overview summed it up perfectly. "To attract a younger audience to the brand, BMW created a high-bred cinema/ad campaign. A series of short films, by acclaimed directors, focuses on the well-engineered vehicles by taking viewers on high-speed car chases." It is a remarkable blend of entertainment and commerce. Compare these BMW pieces to the Hummer website (Figure 17-51) design and other automotive sites. Fallon ad agency and its creative director; Will Uronis/Tim Stevenson, art direction; Keith Butters/Michael Ma, interface designers/developers; Shane Hutton, copy.

Then take a run through a gallery of the best-designed websites and award-winning interactive materials. If you don't have examples at hand, visit *Communication Arts* (www.commarts.com) and seek out their Interactive annuals as well as their regular issues featuring Web and interactive work. It's very likely that jurors selected their winners for basically the same reasons you chose your favorite sites.

The American Institute of Graphic Arts (AIGA) provides other valuable resources. Its fine online publications include *Loop: AIGA Journal of Interactive Design Education* (www.aiga.org/content.cfm?ContentID=282) and *Boxes and Arrows* (www.boxesandarrows.com/archives/002585.php). The latter is where "many of the serious new practitioners 'hang,'" according to Clement Mok, celebrated graphic designer and AIGA president.

While basic graphic design concepts are only a part of the mix, they are crucial to building effective interactive media. One of the first instincts of a novice designer is to overload a site with bells, whistles, and media, with little concern for content, function, and usability. But there is another crucial consideration; Hillman Curtis— principal and chief creative officer of the New York City digital design firm, hillmancurtis.com, underscores that it is "… important for designers to keep in mind that there is a currency on the Web, and that's time. It's your viewer's time, and that's something that has to be

respected. If you can keep that in mind, then all of these things that seem like limitations or hurdles toward your ultimate creativity are actually your allies in the fight for clear communication."

There are four design adages to *emphasize* at this junction, advice you've heard earlier via this book's pages. Design to your audience. Form follows function. Keep it simple. Content rules. In other words, always defer to substance over style, and direct it efficiently to the audience. The way these Hornall Anderson Design Works website pages employ grids and modular design is simple yet sophisticated; they exude sensitive and insightful design (see Figure 17-11).

Modular design or grids provide inherent organizational strengths. Many designers use them to frame or to formalize a site or interactive frame or

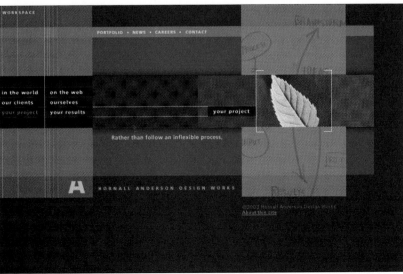

Figure 17-11
Grids provide a strong, functional design underpinning for these handsome Hornall Anderson Design Works website pages (www.hadw.com/). Their simplicity and clean design make them inviting, functional, and easy to use. They also prove that grids are as valuable to interactive and website design as they are to print media architecture. Courtesy of Hornall Anderson Design Works.

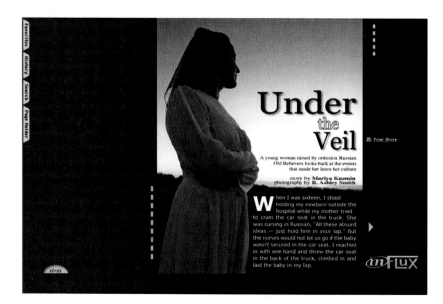

to build a menu. Use white space purposefully to isolate, to make a dramatic entrance, to organize, or to show what goes together on a page or within a frame. White space as a strategy is also invaluable to all the design principles: use it for emphasis, proportion, balance, unity, or for sequencing vision. Since we're talking about grids and divvying up space functionally, the following are a couple of things to keep in mind when using your grids or page's space. Roughly, content should make up half to three-fourths of the page or area used, and *generally* navigational components should not exceed a quarter of the space.

As with any design, organize elements, eliminating any unnecessary ones; maintain continuity; and strive to make each page look seamless. Finally, design with the user in mind. Why is the user there? To be entertained? To catch up on a club's activities? To do research? To shop? To monitor investments? To get information? The demographics and psychographics of your audience are as important with interactive as they are with advertising. However, there are still other things to consider. What platform are users likely using? How sophisticated are their computer skills? How familiar are they with the Internet? What browsers are they likely using? These are a few interactive-specific design questions. This online *FLUX* site, *inFLUX* (see Figure 17-12), integrated many of its magazine design nuances, but online art director Lisa Klepner added smart features to better immerse the user. Stories have geographical info-graphics, sound bites, historical backgrounds, photo galleries, links, and other items for the audience.

The Web has been referred to as a "great democratizing medium" or "equalizer" because literally *anyone* can create a website or homepage. But there is a down side to that freedom: graphic *anarchy*. In some cases, chaotic layouts or lack of composition may be intentional—a purposeful counterpoint to imposed structure. Most of the time, though, it's just bad *sight* or

Figure 17-12
InFLUX is an online magazine, and because its function is to inform, its structure is comprehensive but simple. Concurrently, it is related to but distinctive from its print version. Hypertext, clear navigation, and simplicity are central to its effectiveness (influx.uoregon.edu). Design and creative direction, Lisa Klepner; art direction, Justin Kistner. Courtesy of *inFLUX* online magazine.

site design. We've all had the experience of arriving at a website and having no idea where to begin, what to do, how to proceed, or what the point is. The content and structure is a mess, an assault on our eyes and intelligence, or it might be so busy and loaded with information that we're overwhelmed: we're clueless about the site's purpose, information, or usability. In such an instance, the site's organization and basic design principles have been tossed to the wind.

Web and Interactive Media Design: Aesthetic Differences

As a designer or visual journalist, you face special issues and problems unique to new media formats and their technologies. Kevyn Smith is a design pioneer in the field of interactive communication. He has served as an art director, creative director, and designer for various media.

Interestingly, too, much of his Web design work was created for *other* media: Starbucks, Warner Brothers, *National Geographic*, the New York Philharmonic, and The Smithsonian Institute, for example. Today, he works as the creative director at Peel Interactive, Seattle. Smith addresses some of the most important issues of Web design, and talks about multiple users and how to *think* interactive (see Figure 17-13).

Despite its quirks, Web and interactive design is a potent and flexible medium. Remarkably, it allows the end user an incredible array of interactive options. However, when you mention "interactive design," people aren't always sure what you mean. Interactive design, to me anyway, is anything in which the user has to engage to elicit a response or information. It can be something as simple as a kiosk, an MP3 player, a Sony Playstation game, a cell phone interface, a museum touch screen, handheld devices, or even a DVD movie menu. Those options speak to interactive media flexibility and design potential.

Our primary missions are to invent an environment that caters to multiple users, provide easily accessible jump points or learning paths to content, and offer simple but memorable design. Most importantly, we create something that is an experience and that adds value.

Every project we design starts with this question: "What does the user want from this site and how should we deliver it?" Different objec-

tives require different solutions. However, one thing they all share in common is user-centric design. If you provide multiple access through the same content, users will create their own experience and make their own paths through the site to the information they seek. Multiple options also accommodate a wide variety of learning styles.

When Amnesty International approached us to create a campaign against torture, we decided to include a test as well as case studies. The objective was to give users the opportunity to take a "Torture Test," receive a score, and have a chance to learn more about the test's answers (see Figure 17-14). We figured that there would be two main user groups: those who wanted to take the test and interact with it, and those who just wanted to acquire the information. Clearly, we didn't want to force users to take the test in order to access content. Our intent was to build a flexible site to accommodate different user patterns and learning styles. So the "torture test" was one level of information. In addition to that navigational path, we offered another route: pulldown menus across the top of the page that provided jump points to case studies, resources, and other information that was provided via the test. Providing several routes to the content made the site very user-centric offering different experiences.

Sometimes, you want to provide information to different audiences but at different content levels and depths. For example, when we created a site for the New York Philharmonic, the site was supposed to tell the life story of Andre Kostelanetz quickly, without alienating or losing the audience. The project was a Flash site, part of a series that focused upon the legendary conductor. When we realized the Philharmonic's depth of content, we wanted to offer more information to those willing to dig deeper. To accomplish the Philharmonic's objectives, we built the site to cater to two users: one who wants the information now and a different audience with the curiosity and time to explore the site thoroughly. This enabled both user groups to access information based upon their interest, needs, and time.

Consequently, we broke the site into five sections that spanned the life of Andre Kostelanetz. Whenever users enter any of these areas, they encounter music, an animation loop of five or so

Figure 17-13
Kevyn Smith must deal with "drop deadlines" often. Despite the stress and nonstop workload, he has received numerous industry awards from *Communication Arts*, *How*, *Critique*, The Seattle Show, and One Show Interactive. In addition, he is a contributing author of *Rich Media Studio*—a media instruction guide published by Friends of Education—and teaches digital design and convergence media at Seattle's School of Visual Concepts. Smith has worked with a wide array of clients, including REI, Starbucks, the Smithsonian Instititution, Microsoft, NASA, Amnesty International, and many Fortune 500 companies. Photography by Elizabeth Ryan.

Figure 17-14

Amnesty International users who took "The Torture Test" acquired new information, no matter how they chose to process the content. The Amnesty International site is a good example of giving users choices to learn on their own terms. It also succeeds in educating the audience about how torture may manifest itself in many different ways. Art direction and design by Kevyn Smith. Courtesy of Peel Interactive and Amnesty International.

photos, and a paragraph of text—everything you would need to get a peek into each period of the life of Kostelanetz. Each section was constructed similarly, so users became familiar with the design and organization of the information. The structure accommodated the target audience and fulfilled the Philharmonic's goal. More adventurous users could enter a gallery separate from the initial page. It was loaded with photos, interactive elements (such as a clickable music score), and audio interviews. At the same time, users are able to scroll over a wall of content and select whatever they want to view. We created a truly multi-sensory environment. If users activate an audio interview, they can listen, scroll, read, and view photos all at the same time. This is a good example of a truly interactive site, one complete with multiple levels to explore for even the most curious and sophisticated visitors (see Figure 17-15).

Usability is central to all facets of interactive design and should be employed at each phase of site development. Giving users the chance to get a glimpse of content before they dive into it makes good sense; sometimes it's important because of download time or the user's dial-up speeds, which was key in the Philharmonic's project because the gallery pages were content heavy. Offering users an overview allowed them to decide if they wanted to "explore more" or download additional content.

The Museum of Fine Arts (MFA) in Boston presented a difficult challenge. The museum had created an entire collection of poppy block-printed products with origins to a summer carpet from the Mughal Era of India; the carpet was found in their basement archives. In an effort to sell this collection online to current catalog subscribers, reach a younger audience, and tell the more romantic story behind the inspiration for the reproduction, the MFA utilized the Internet. Digital storytelling established a link between their printed catalog and the launch of new media initiatives. The Museum did an excellent job of promoting the site in its merchandising catalog, and the website was a huge success with their loyal patrons, as well as with new visitors to the MFA/Boston catalog site and the museum itself (see Figure 17-16). Indian raga music and

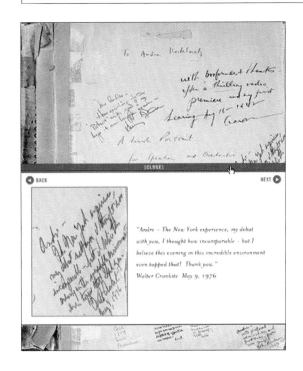

Figure 17-15
Kevyn Smith and Peel Interactive built an amazingly detailed site for the New York Philharmonic; one that featured a comprehensive overview of conductor Andre Kostelanetz's life, actual recordings of his music, and even images of his handwritten musical scores. The interactivity and multiple paths created for the site make it one users like to revisit. Courtesy of the New York Philharmonic and Peel Interactive.

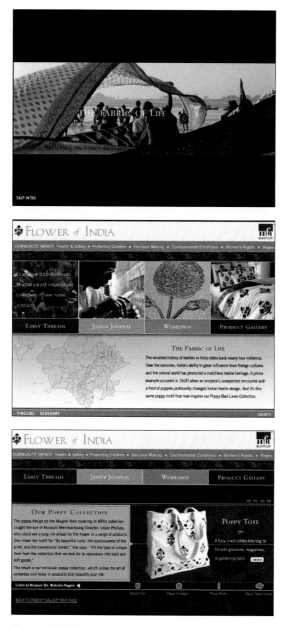

Figure 17-16

"The Flower of India" website created for the Museum of Fine Arts (MFA) of Boston marries aesthetics and function with commerce. Dissolves, music, photography, and intuitive interaction are the website's greatest design strengths. How does one measure the success of such a project? For the MFA, it was a sell-out of the entire inventory of "poppy block-print" cotton collection of products. In addition, the MFA received industry recognition as an innovative curatorial organization using unique methods of marketing products that contribute to education and outreach on a global scale. *The New York Times* also published a review praising the MFA, website, and product. Finally, the website's design received numerous awards. Creative direction, art direction and site design, Kevyn Smith. Courtesy of Kevyn Smith, Peel Interactive, and the Museum of Fine Arts (Boston).

ambient sound was employed to enhance the sense of being there. In addition, the opening used dissolves, beautiful photography from India of textile crafters, and poppy block-printing. The environment was intended to immerse users and deepen their experience with the site. From a navigation standpoint, the user interface was very fluid and intuitive; it offered users multiple choices and cues to access content.

Again, all of these interactive examples focus on usability, the most important facet of Web design. If you alienate your audience, or lose their attention, you've failed. All the fancy graphics and multimedia in the world can't help you if the site isn't user-centric, or "user-friendly." Remember, there are many different users online, and each has a different back-ground, need, interest, learning preference, and information being sought (see Figure 17-17). If you keep that in mind, you stand a much better chance of engaging people. Emphasize multiple-experience navigation and think interaction. More response equals more overall engagement.

Generally, the more users there are, the bigger and more interesting interactive media will be. With so many platforms to accommodate, inter-active design is never boring. At Peel, we pride ourselves in creating innovative interactive work, and in accommodating platforms such as DVD's, kiosks, and wireless applications. The finest interactive media balance design and usability. Finding the perfect combination is key to effective communication.

Technical and Other Considerations in Web and Interactive Design

Other important design considerations include, but aren't limited to, navigation, platforms, browsers, site architecture, plug-ins, file sizes, type, color, and content. Like all media, web design has its pros and cons. However, the advantages far outnumber the shortcomings.

Perhaps the single largest challenge in designing online is the nature of the medium itself. Technically, there are all kinds of worrisome inconsistencies. For starters, multiple platforms and browsers are available to users, and you have to be concerned how they will affect your site. Monitor screen size and resolu-

Figure 17-17

SmartKids (www.smartmuseum.uchicago.edu/smartkids) is a website built by Peel Interactive for the David and Alfred Smart Museum of Art at the University of Chicago. Everything about the site, from its use of type and color to its playful user-centric experience, speaks to children. Kevyn Smith talks about the main page: (Top) "Kids are used to navigating the four different sections of the site. They act as guides through the content, and we deliberately illustrated them to represent the audience—a diverse mix of race and culture." The second panel (bottom) is part of an interactive sequence from the "Artist Studio" portion of the site. Here children can actually explore the process of photography—from first taking a photo all the way to developing it in a darkroom. Art and creative direction, Kevyn Smith. Copyright, Smart Museum of Art, University of Chicago.

tion also vary and influence design decisions. Indeed, technology and user preferences are strange bedfellows. For example, while monitors continue to increase in size, there is also a trend evolving in the *opposite* direction. The Web is rapidly gravitating toward the use of smaller screens, due to the increasing popularity of cell phones and Personal Digital Assistant (PDA) devices. More and more users are accessing the Internet from their palm-held devices and cell phones. Web designers who want to stay ahead of the curve need to recognize this shift and learn how to design for smaller screens and whatever else is on the interactive horizon. Because of the tiny screen size, graphic display must take a back seat to content. Consequently, formats may vary in size from roughly a 25-inch monitor (or larger)

to a screen roughly the dimensions of a matchbook. However, there are even more technical issues.

File size and download times are two other elements unique to Web and interactive design. While designated lines and high-speed cable options shorten download time considerably and are becoming more common, most users don't have them at this writing. As more people adopt higher speed options, the less file size will be an issue. *Plug-ins* present yet another concern. Plug-ins are software programs available to users via a Web download, for example, Flash or QuickTime. They may prove to be a hindrance, because users might not have the latest plug-in and may not want an updated version, or even take the time to download them. Most users keep

whatever software or browser versions they have until they no longer work. Some plug-in downloads require a browser update, which translates into more time and hoops to jump. There are ways around this issue, but they are involved. What's more, the average user isn't a webmaster or interactive designer; they expect simple and direct usability and aren't willing to spend much time dealing with *any* kind of technical issue. So when designing an interactive

Figure 17-18

Dreaming America, Inc. is a forward-thinking company that specializes in creative site design and development. Their work for Bonfire Snowboarding is exemplary. The site (www.bonfiresnowboarding.com) provides everything. One of its features asks visitors to input information on their riding styles and clothing needs; then, the database surfaces appropriate products and the locator directs users to where they can find the products locally. Scott Benish, creative direction; Scott Benish/Josh Kneedler, interface and graphic design; Kim Markengard/ Scott Benish/Josh Kneedler, development. Copyright deepPlay.

site with Flash, for instance, a designer might wish to include an HTML mirror site for users who do not have or want the plug-in.

Of course an interactive site often incorporates many other media. A website can integrate video, sound, motion, photo collages, animation, links, and text—any or all of which may be interactive. The Web is the first real communications platform that offers users that kind of media smorgasbord—a buffet of choices that present information through experience and interactivity. Bonfire Snowboarding (www.bonfiresnowboarding.com) used a mix of media, including compressed video clips, catalogs, rider profiles, and a hot online radio station (Bonfire Radio), for its interactive website. If you opt not to spend time here, the navigation is simple and thorough for the huge database buried within. The site is as much about reflecting the culture of the brand as it is about entertainment and function (see Figure 17-18).

From a brand standpoint, the Web is a platform that reinforces identity and media presence in totally different ways from print or TV. Brand may be extended and presented in a personal way on the Internet. In terms of user experience, the medium is more active than most other media because its dynamic is more engaging. The Web tends to be more of a "lean in" medium compared to TV, which is a *cooler*, more "lean back" medium.

Another distinctive property of the Web is its nonlinear character. As the Amnesty International site demonstrated earlier, interactive has the ability to present information to the user in a variety of ways, using different approaches to the content, as well as different routes to *navigate* it. In addition, content can be interrelated, cross-referenced, and made accessible from various areas *within* the site; it can also provide links to *outside* the site. All of these strategies give users control over how they opt to find and digest the content, via multiple user experiences. How is this for giving users great information? (See Figure 17-19.)

To be sure, content also influences interactive design; it helps shape the site as well as the experience of the user. Remember, different users are

Figure 17-19

For hanlon brown design, the challenge of creating a website for the Rose Quarter (www.rosequarter.com/) of Portland, Oregon was a formidable one. The arena caters to a broad clientele, including the NBA's Portland Trailblazers. The design agency wanted to deliver a "robust, interactive website to capture a great deal of information about the arena and events." One nice interactive feature of the site allows fans seeking tickets to click on a section to see what the view from those seats will look like—a smart design feature. Creative direction and design by hanlon brown design. Courtesy of hanlon brown and the Rose Quarter.

interested in different content. Concurrently, however, the *same* user may be interested in a wide range of content. That said, it's important to realize that *content affects design*. For instance, you wouldn't build a newsletter site for *Imaginis.com Breast Health Newsletter* (newsletter@jhill.imakenews.net) the same way you'd design an e-commerce site for Red Envelope (www.redenvelope.com). Obviously, any e-newsletter is text heavy. For example, *The Onion* has several versions—all of them satirical—but its newsletter consists entirely of text with links to full stories and other features; consequently, readability, simple type, and regular updates are central to its success. Because words drive any e-newsletter, the writing style should be simple, succinct, and informal in tone.

In summary, Web designers have to account for user screen sizes, plug-ins, modem speeds, monitor resolutions, browsers, color, typography, and more. Fortunately, the World Wide Web Consortium and other groups monitor user and browser statistics and share their information regularly. Finally, given the complexity of Web design, most serious Web and interactive designers have technicians and coding specialists at their side to help construct the site.

Designing for E-Commerce (Karenina Susilo)

On the other hand, navigation and persuasion are paramount to e-commerce sites. Though important, aesthetics should defer to accessibility and simplicity. Clear organization, simple menus, and good searching features are essential components of merchandising. Karenina Susilo, an interactive designer who specializes in merchandising design for Yahoo! Shopping, offers insights to e-commerce design:

For the past couple of holiday seasons, I have tried my best to avoid going to the mall. Online shopping is the way to go: no crowds, no traffic, no parking nightmare. As a merchandising designer and interactive designer for Yahoo!Shopping, I know firsthand how convenient it is to shop online. However, with the massive amount of products available online, it's nice to get a bit of help to narrow down the choices. This is where merchandising design makes an impact.

Just like a shop's window display or a magazine cover, online merchandising design aims to stop shoppers and entice them to check out selected products— and ultimately to buy them. Effective merchandising pages also serve as guides to suggest what to buy amongst the

Figure 17-20

Karenina Susilo is a merchandising and interactive designer at Yahoo!Shopping—an online mall that contains thousands of merchants, from mom and pop operations to the likes of Nordstrom, Dell, Sony, and Walmart. Susilo began her career at *Mirabella* and her background is in magazine design; today her focus lies in marketing, merchandising design, and promotion. Photograph courtesy of Karenina Susilo.

millions of products for sale online. At Yahoo!Shopping, the content of merchandising pages may vary: they can promote the latest and greatest, hype what's hot this season, display sale items, or showcase a brand or products related to a specific gifting season.

As a merchandising designer, I am responsible for designing the theme and layout of the page. A shopping producer usually initiates the project and provides a project requirement document. Then I begin selecting colors, styles, artwork, and typography to fit the particular mood or theme of the page. I also examine competitor sites to check out their presentation strategies. From there I design several prototypes for the producers to choose from. After getting feedback from the producers and fellow designers, I modify the chosen prototype and present it for final approval. I still have to slice the prototype and code the page in html and prepare it for our in-house project management tool, which launches the page live.

When designing, I keep in mind the target users of the page. Designing for Mother's Day is definitely different from Back to School. The atmosphere of the page should welcome users to stay and browse the products. Getting users' interest is the first step to encouraging them to check out the products and purchase them (see Figure 17-21).

As a designer, I appreciate the freedom I have when designing. However, the job also comes with many challenges. One of the bigger ones is to weigh the client and the producer's needs with the design itself. Sometimes compromising and a bit of diplomacy are needed to make sure clients and producers' needs are balanced with aesthetics—the look or design of the page itself. Another challenge is the very quick turnaround. This is especially difficult because it limits the time I have to create the best design possible.

As online shopping continues to grow, the more important it is to make sure sites are functional and user-friendly. It's also important to keep the pages fresh graphically. To retain user loyalty, an effective online shopping site needs to provide interesting and useful content to help customers with their purchasing decisions. If merchandising pages are well maintained and keep the user in mind, they have all the potential to meet this goal.

Planning and Site Architecture: Plowing the Flatland

The reference, plowing the "flatland," again, relates to Edward R. Tufte's insights to envision-

Figure 17-21
The databases of merchandising design sites are gigantic; so, too, are the product offerings. Creating effective and efficient pages is incredibly challenging. The secret is to keep them simple, easy to use, and tightly organized—as evidenced in this woman's fashion page from Yahoo!Shopping. Karenina Susilo, merchandising and interactive design. Courtesy of Yahoo! Inc.

ing and presenting information. Architecture is largely plotting the various dimensions and graphic possibilities of your *space*, and how it will be layered, interrelated, assembled, and used.

Who, What, and How

All good design begins with research, planning, and thoughtful organization. It's imperative that you clearly understand and can answer the following before you begin to design a site:

1. Who are your *users*?

2. What is the *mission* or *purpose* of what you're doing?

3. What are the *main features* or pieces of the design?

4. What are the *secondary* parts of the site?

5. How will you organize them?

6. Specifically, how will the website persuade, tell the story, achieve the goals, sell or feature merchandise, present the news?

7. How will you accommodate the different traffic (users)?

8. What is the *desired outcome*? Make sure you understand your audience(s) and goals clearly and keep them in mind while plotting your site.

Architecture accommodates the needs and tastes of the client or owner. You can have the most beautiful home on the block, but without a solid foundation, it won't hold up. The same holds true for a website. Without a thoughtful blueprint, the site will collapse. Architecture is at the heart of good design, and good planning and a solid foundation will ensure a site's integrity, structure, and longevity, as demonstrated by this hip hanlon brown site for Hip Furniture (see Figure 17-22).

There is a logical process to follow. First, how big will it be and, again, who are the main users? How content-driven is it? What kind of site is it: portal, informational, newsletter, advertising, e-commerce? All of these elements factor into the structure of the site. Jon Sievert, concert photographer and founder of humblearchives.com, discussed his needs for a site that featured his collection of concert photography, "The purpose of humblearchives.com is to showcase my extensive collections of photographs of musicians to print buyers and potential leasees for reproduction in

Figure 17-22
When hanlon brown design took on Hip Furniture (www.ubhip.com) as a client, the firm wanted to develop a sleek, clean, sophisticated website, one that mirrored the furniture company's image and one that was easily updated with new products. These two site frames demonstrate the clean, inviting design. They also created a custom zip code tool to determine the online shoppers' delivery location. Pretty hip. Courtesy of hanlon brown design and Hip Furniture.

the media." He established both the audience and purpose of his site in one simple sentence.

The Site Map: Laying Out the Logistics

Once you've established the audience, content, and type of site you're constructing, you have enough information to lay down an initial *blueprint* or *site map*. This is a simple layout that clarifies the site's logistics. The maps may be simple pencil sketches like this one for Sievert's Humble Archive (www.humblearchive.com). Or it may be meticulously fleshed out. Usually, though, it is better to work loosely at this stage to avoid investing time and effort into something the client might not want (see Figure 17-23).

Like any building, you'll need separate plans for each level or page. This document may be used internally or presented to the client to help define the site and its nuances. Along with itemizing its basic characteristics and underpinnings, the site map will help plot user experience and the content placement. Humble Archives and Jon Sievert required something simple, user-friendly, handsome, and cross-indexed: "The images will need to be organized by musical idiom (blues, rock, acoustic, and so forth), and each layer or section of the site should list artists alphabetically. I needed sample images of different musicians for each musical genre to tease and link to their work. At the same time,

each selected artist should feature a large image, but have a single strip of thumbnail images of that artist that you could select to get a larger, more detailed image to see." The "Blues" opening page is a good example; it's simple, clean, and allows the visitor to sort through the artists via the scroll bar (see Figure 17-24).

For the most part, that was the starting place for planning the architecture and mapping of humblearchives.com. Its architecture was constructed so the imagery could be retrieved in a variety of ways: via thumbnail samples, name, genre, date, artist, and so forth. Visitors also could move through the site in other ways via optional paths: by reading about genres of music or specific musicians or by checking out Sievert's background, his book, *Concert Photography,* and other features (see Figure 17-26).

The User-Experience Model —Accommodating the User

User experience is another crucial facet of this process. It involves sketching a *user-experience model.* Because of the varied approaches and learning preferences of individuals, sites should be structured user-centrically to accommodate all the users. Concurrently, it is important to integrate content and theme into the site. Ideally, the structure should be intuitive, efficient, simple, and enjoyable for users. It should also be relevant to *why* they're there: information, entertainment, shopping, research, or whatever other purpose. Also, since you can't control how users will navigate the site, your parts or pages should be able to stand by themselves. Obviously, though, a single page must relate clearly to the whole; for example, randomly accessed pages should work

Figure 17-23

Pencil sketches were used initially to establish a working map or rough blueprint of the proposed architecture of humblearchives.com. The roughs here show variations and a general plotting of the site. At this stage, it's important that the client have input to help clarify functional and aesthetic issues. Again, most clients prefer to see "roughs" early in the process. Compare these blueprint sketches to the gray models and real pages. Design/ development/ blueprint sketches by William Ryan.

Figure 17-24

B. B. King is featured on the Blues page for humblearchives.com. The page is simple. Compare the page to the needs statement originally provided by Jon Sievert. A grid structure, sans serif type, bordered artwork, and a simple scroll bar keep the website clean and easy to look at and use. Art direction, William Ryan; creative direction and design, Jan Ryan; photography by Jon Sievert.

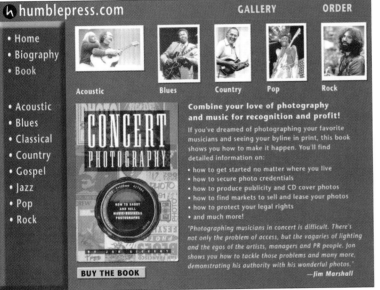

Figure 17-25

It was also important that the humblepress.com site have a separate page to display John Sievert's classic book on how to work as a photographer in the music industry. The *Concert Photography* page shows a parallel structure to the main page, music categories, and artists' pages. How are they similar? Art direction, William Ryan; creative direction and design, Jan Ryan; photography by Jon Sievert.

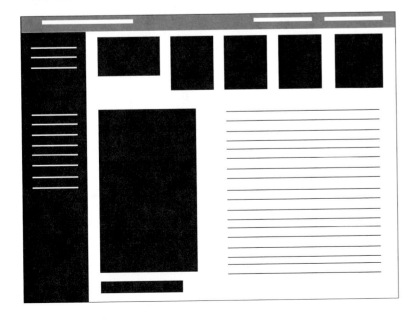

Figure 17-26

Gray models are the next logical step after pencil mappings or rough blueprints. Although stripped down, they speak to function, basic design, and usability issues. The outline approach allows both the designer and client to strip away the veneer and examine the "bones and muscle" of the site and how the space is used. Art direction, William Ryan; design and gray model renderings, Jan Ryan.

Interactive Technical Issues

It's unlikely your website will look and behave exactly the same way on every browser and operating system. However, you can help maintain a certain level of consistency if you do a little research to learn how your audience uses your site. If that isn't possible, do some digging to establish industry standards and learn more about the target, its online sophistication, as well as its technical limitations. Pay special attention to the following:

Browser and platform issues

It's unlikely that many of your visitors will be using 3.0-or-below browsers to experience your website, but would it be wise to use JavaScript that only works on IE 6.0 on Windows NT? Probably not. If at all possible, survey your audience to find out what platforms and browsers they're using and design for the lowest common denominator. Don't be seduced by bells and whistles that most of your visitors won't likely use anyway.

Load time

There's no quicker way to alienate a visitor than to deliver a bloated page that takes forever to download. Most of America is still tied to "dial up" connections. Design for them, or offer different versions of the site.

Monitor screen resolutions

Monitor resolution seems to be increasing, though slowly. The safest bet is to design fairly close to 800x600.

Testing issues and brower archives

If you're serious about building websites, it's imperative that you test them. It's probably just as important to keep old browser versions around for testing purposes as it is to acquire the latest ones. Generally, it's the super-users who're fixated on having the latest of everything. Most other users are content to keep their browsers as long as they work.

well on their own and relate to the rest of the site. Focus groups may be initiated during this stage—as well as experimentation with prototypes—to nail down a concept or sell an idea. Sometimes interactive designers augment or replace a user-experience model with a storyboard, particularly if it's going to be an animated site or if video or motion graphics are included. Storyboards are also helpful in explaining a site's interactivity. After you've determined how to provide a strong user experience and constructed a solid site map, you're ready for the next step: gray models.

The Gray Model: Plotting the Pathways and Arranging the Content

Gray models, or "site blueprints" as they are sometimes referred to, will help to flesh out a rough layout, different pathways for user experience, and arrange the content. Gray models get their name from the fact that they are monotonal—usually gray—for the same reason that blueprints are blue: to emphasize the structure and *architecture* of the site (see Figure 17-26). Full-color blueprints would likely prove distracting. Gray models stress function. They literally map the relationship between parts, pages, layers, and navigation and help explain your vision to the client. They're *not* aesthetically oriented. Internally, they'll reveal how much space is devoted to content, form, graphics, text, other media, and so forth. Essentially, this document is pretty much bare bones, an outline or skeleton of the site, and uses gray rectangles for photos, lines (or Greeking) for text examples, and boxes or other shapes to suggest additional site parts.

Staying on Track

After constructing a site map, user experience model, and a gray model, you're ready to move on to the fun part—designing; however, to ensure it stays fun, there are some tools you should implement to coordinate the project and to keep it on schedule. Typically, the design stage includes applying design principles, grids, and other aesthetic considerations noted earlier. If you're working with a client, establish a *timeline* and *deadlines* for the different phases of the design. It's also a good idea to create a spreadsheet and

"break of site" (much like the way a magazine art director would use a break of book) to keep track of where you are on any page or stage of the design (see Figure 17-27). Another helpful organizational tool is a *content matrix*: an outline of the project that clarifies what content the client is responsible for delivering to you and when it's done.

Making Sure It Works

Many clients or designers will specify that a *prototype*—a working miniature model of the site, be part of the process to illustrate the experience. Prototype models make the site come alive and help ensure that client expectations and needs are being met. Typically, it works in conjunction with the site map and user-experience model. Once all of this is clarified, a *functional spec* may be created to define just exactly how the site will work. Often, too, refinements and even more major changes evolve after this part of the process.

As you can see, the actual chronology of the steps may vary somewhat, if for no other reason than that they are all interrelated. Also, designers may rearrange the steps or the way they plan a project. Ultimately, you may also want to install some sort of tracking system to get a better sense of your audience and how they use the site.

Typography and color are other important interactive components. Although there are some obvious similarities to typography used in print, there are strident differences as well.

Typography: The Visual Embodiment of Language

It is surprising and disappointing not to find chapters or even a single index entry for "typography" in such illuminating texts on Web and interactive design as Jeffery Veen's *Hot Wired Style* or Jakob Nielsen's *Designing Web Usability*. While they do discuss "fonts" and provide some suggestions and minor discussions on typography, there isn't as much on type as there ought to be.

Type is a delicate but large part of Web and interactive design. Typography is the visual embodiment and separate reality of language. Indeed, it presents and shapes content; it *is* the text and a significant part of the multimedia experience. Regardless of the medium, voice, or audience, the function of type and text is to be read. It's also probably the most efficient and facile way to communicate. Educational,

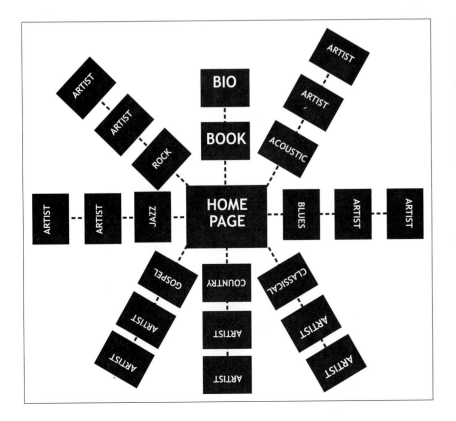

Figure 17-27

A site diagram or "break of site" provides a quick overview of the layout of the site. There are various models to show interconnectivity between site frames or pages. They may be linear, stacked, or layered. They may use a spider diagram, or they may be demonstrated in other ways. This abbreviated spider model of humbleachieves.com shows the site's organizational plotting at a glance. Diagram, Jan Ryan.

research, and news sites rely upon text to transmit enormous amounts of information.

It would make sense to review chapters three and four of this book, rather than to rehash all of the particulars of typography. There are, however, some important things to keep in mind about using type that are unique to the Web and interactive design. For starters, interactive media aren't static like their print counterparts: they move. They also have a myriad of complex technical issues that affect readability and legibility; things such as screen size, file compression, bit-mapped type (type composed of pixels), resolution, browsers, embedded type libraries that limit which faces a user may have access to, and the reading experience itself is different from print. Any work displayed on a TV screen or computer monitor, including video games, interactive media, and even film and video, are *projective*; the type is presented and illuminated from behind *electronically*. A magazine, newspaper, or catalog page (or even a billboard) is reflective; the light bounces off of it and into our eyes. Consequently, the print type is sharper and has significantly fewer variables.

Think about the type you've seen as credits on film, television, and websites; even the cleanest and sharpest of it isn't as crisp as newspaper headlines. Again, the type *moves* or pulses in film, Web, or interactive media, which adds to its *softened* acuity. The result is that readability and even legibility suffer; that said it should be pointed out that typographic definition and readability for websites and interactive media are improving (see Figure 17-28).

There are a variety of strategies or ways to use cyber type. Each has its pros and cons. Coding and embedding it within a document or site via HTML allows you to program a simple style sheet to help maintain continuity for text parts (headlines, bylines, and copy). While it can be helpful, HTML is still not the designer's greatest friend, especially when it comes to the creative use of typography. Text fields are typically

created in this manner. *Text fields* are scrollable text areas that can vary from a paragraph or two to literally limitless copy (see Figure 17-29). By the way, text fields should not be confused with *hypertext*. The latter is not copy in the usual sense, but a word, sentence, or paragraph of the copy or site that when clicked on takes the user elsewhere. Text fields may also keep the document interactive in the sense that a user can add to it, delete pieces, or respond to questions or participate in on-going forums.

However, there are obvious downsides to adjustable text. For example, even if the typography and text are carefully groomed, they can be altered or exploded in a second if the user's computer even defaults to a different typeface. Again, computers may vary tremendously in terms of available fonts. Users may resize their browsers, which can also foul up a basic layout. Or a simple edit or type specification alteration may increase or decrease point size or weight or other specs within the text and *reflow* the copy. An even more aggravating consequence may cause weird spacing between letters and words. An interactive and Web type technique that *appears* to give type better resolution is anti-aliasing. *Anti-aliasing* smooths out the pixilated edges of type or graphics by blending their color and background. Today, *aliased* typefaces may help readability, letterform, and letter and word spacing (see Figure 17-30). Often, too, a user may opt to specify a different face because they despise Courier, Times, or Helvetica. Of course, typefaces are structured differently from one another and take up different amounts of space.

Another approach to working with large amounts of type is to break it up into smaller chunks and keep it within the fixed frame or table cell of the page. In this case, the user toggles or clicks to the next section or page.

Creating PDF files (portable document formats) is another option to prevent users changing typefaces or other type specifications. When designers build or convert a layout to a PDF file, the file becomes a single entity. Its type is embedded and the graphics and other components are embedded as well. As a result, the PDF cannot be altered on the user's computer (see Figure 17-31). This is probably an ideal solution

Figure 17-28
In the case of interactive media and websites, legibility (how *visible* or *seeable* the text is) and readability (how easy it is to *read* the words) are closely intertwined. For websites, sans serif faces are the preferred type race for both legibility and readability. Clearly, faces whose architecture or letter configurations are evenly stroked will be more reader-friendly. Arial (sans serif) and Bodoni (modern roman) are contrasted here.

Figure 17-29
This text field from *inFLUX* may not be altered by the user. The type is fixed. Visitors to the site may not alter the typeface, leading, size, alignment, style, weight, or any other typographic specifications. This is a story about a government program that exterminates coyotes through M44 cyanide charges. The power of Kelly Berggren's type adds to the compelling photography of Kim Wallace. Art direction, Lisa Klepner. Courtesy of *inFLUX* online magazine.

if the creator is striving for a seamless, permanent document with near flawless typography that's been kerned and meticulously groomed—one the user can't mess with. The obvious limitation is that the user, while getting an aesthetically pleasing site, cannot alter or interact with it. However, users may interact via links; for example, Adobe Acrobat may allow for hyperlinks within a document. *SWF* files, exported from Flash, are fully interactive and animated equivalents of PDF files (in the sense that the source cannot be altered by users, and all graphics and text can be embedded).

Color can be problematic, too. Be careful not to fry the rods and cones of your readers' eyes by laying electric orange atop neon pink, for example, or concocting equally discordant and glaring color combinations. Type laced with vibrant color, especially when indiscriminately mixed, can be more than a bit overwhelming (see Figure 17-32). Again, remember that type is to be read and your mission is to eliminate as many barriers as possible to enhance communication. Readability rules in Web typedom. However, you may make allowances (in moderation) for the content, audiences, or voice of your messages.

Contrast is also important to readability. Charcoal gray type on a black background—or for that matter red, purple, or royal blue on black—make for terrible contrast and a difficult

Figure 17-30
Anti-aliased type helps smooth out the diagonal and curved edging of website type, but it also compromises the structure of the type due to its blurring effect. At actual screen sizes, the smearing is generally not noticed, but when enlarged, it's evident what the smoothing action does to the type.

read. One rule that applies equally to both print and interactive is that reversed type (white on black) is more difficult to read than black on white. Generally, the stronger the contrast and the more neutral the colors employed, the better. Black on white is still difficult to match for sheer readability. Black atop chrome yellow is another strong combination. That said, remember that there are occasions and situations to use reverses, especially if the text length isn't encyclopedic (see Figure 17-33).

Finally, beware of a handful of specific color issues with type. Blue, because of its shorter wavelength, is a tougher read. Blue also carries Web color coding, suggesting that a link or area within a site hasn't been visited. In contrast, red or purple is often used on link typography to cue users that they've "been there, seen that."

Color: Showing Your True Hues

Color is an essential tool in all design work; interactive is no exception. It is often used in marketing, branding, and identity, and we rely on color to help sort out our reality. Yellow warns us; red stops us; blue soothes us. In addition, we may associate specific colors with fashion or a product or company. For example, in our society black is considered timeless and elegant; it's used extensively in fashion advertising; "a diamond is forever" with jewelry in a field of black makes a statement. In contrast, Harley-Davidson uses black (with orange type) in its logo, and most Harley riders are ensconced in black: helmets, leathers, t-shirts, and boots. Color also has cultural meaning. In Western cultures, black is read as a symbol of death and mourning.

As was discussed in Chapter Six, colors affect space, mood, and vision in a variety of ways. All other things being equal, warm colors have more projection and tend to dominate a page or frame, while cooler ones recede. Contrast is important, too; a lighter area will dominate a larger dark one. Primary colors have more pop and muted ones tend to be subservient to solid, brighter colors, but you have to be careful with them because they have some associations. For

Figure 17-31
Typography is clearly a major component of Projean LoBue—an ad agency and site design-development firm. Imagine the time and work that went into creating these panels. This simple site (based mostly on rollovers) is essentially a word association game. The typography is crisp and minimal. You wouldn't want users fooling with this type.
Gary LoBue, Jr./Kevin Projean, creative direction, design, and production. Courtesy of Prejean LoBue.

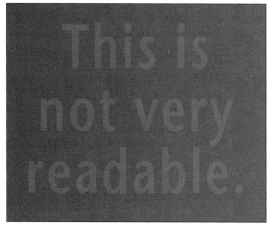

Figure 17-32
This typography/ background combination is a good example of what can happen to readability and legibility when bright colors lack contrast. Using hot, vibrant color—whether on type, backgrounds, or both—can be deadly for readability and your readers' retinas.

instance, we often associate children with primary colors—both are *loud*. In the SmartKids website, primary colors work well (see Figure 17-34). But primary colors may have a tendency to cheapen more sophisticated design because of their inherent *volume*. A fascinating website full of lessons about color and simplicity is McNett Country (www.act3i.com/mcnett), which meshes color, tones, and artwork with interviews, narration, and sound.

As noted earlier, color contrast is especially important with interactive design, particularly when used with type. In addition, there are existing color codes (links, for example) peculiar to Web design. Also, some of the same inherent interactive limitations apply to color. Monitors, for example, vary in both resolution and color presentation, and different browsers and platforms present color differently. Palettes vary, too; although PC and Mac palettes both contain 256 colors, the colors and their configuration are not identical. The default system in Windows, for example, mandates that the first and last ten colors are consistently configured; Macs only require that the first palette chip is white and the

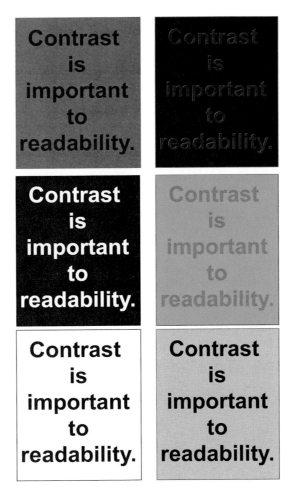

Figure 17-33

Compare the readability of these type and background combinations. Which one is most difficult to read for you? Easiest? Least stressful for your eyes?

Figure 17-34

Kevyn Smith and Peel Interactive use bright colors in an appropriate and exciting manner for SmartKids (www.smart-museum.uchicago.edu/smartkids). The colors blend with the site's playful nature and connect with its audience. The concept here—making kids "art detectives"—is particularly engaging for the users. How does the type relate to the audience? Does it borrow from another medium? Which one? Copyright, Smart Museum of Art, University of Chicago.

last black, which makes Mac system palettes appear deeper and flatter on a PC. Additionally, users may adjust or correct color on their monitors as well as their color palettes. Because of these and other variables, designers generally rely on the standard 216 Web colors that work with the lowest resolution of monitors. If you're working on an important print project, calibrate your monitor with the printer's monitor setting for the best results.

Compared to print, Web or interactive color use is more constrained, and typically colors are selected from a Web-safe palette (216 colors). Of course, the entire color spectrum can be used, but users with less than a million colors on their monitor won't get the intended chromatic effect. Muted or noticeably different colors will appear instead. So color usage is limited. On a Web page, like the printed page, background color is also specified. Web pages often make use of tiled background images. Coordinating colors between foreground and background imagery is an integral part of the design process. Given this limitation it is especially important that you understand how color affects contrast, spatial order, projection, and design. Visiting the Poynter Institute for Media Studies site on color may help you immensely (poynter.org/special/colorproject) (see Figure 17-35).

To ensure that color appears consistently on any operating system, most designers opt to use the palette of 216 Web-safe colors, which is fine for many needs including type and flat graphics. However, that limited palette is generally inadequate for most photographic images, gradated artwork, or in situations where subtle color variations have been employed. In these cases the images are usually saved as full color JPG images. This assumes that users will have 24-bit color displays for proper viewing.

Writing For the Web and Interactive Media: Cyberwriting

Like other media, the Web has its own very distinct writing style and guidelines. Clearly, screenwriting is as different from advertising copywriting as newspaper writing is different from writing for posters or outdoor boards. Cyberwriting is especially unique because of its odd dynamic, media mix, and the nature of its audience. It's often the *first thing* processed by browsers. Additionally, it's important to note that often Web and interactive designers become so fixed on platforms, sound, multimedia, color, usability, and all the technical aspects of Web and interactive design that the writing becomes a stepchild or a last minute consideration. Make no

Figure 17-35
Creative director Pegie Stark Adam, who is probably more celebrated for her newspaper design and painting work, designed this *Communication Arts* award-winner for The Poynter Institute for Media Studies. Reviewer Drue Miller probably summed up the site best: "The exercises are what won me over—they're not only fun and simple, but really effective at teaching the principles of color design." Art direction, information architecture, and site design: Pegie Stark Adam and Anne Conneen. Courtesy of Pegie Stark Adam/Anne Conneen. The Poynter Institute for Media Studies.

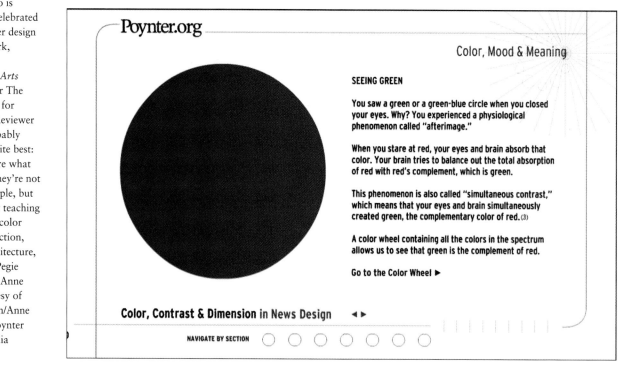

mistake: writing is a *crucial* component of the mix and an *invaluable piece of the whole.*

Guidelines for Effective Writing

First of all, to write effectively for the medium, you need to understand the nature of reading on the Web. According to research cited by Jakob Nielsen in *Designing Web Usability*, reading from a monitor is approximately "25 percent slower" than reading from print media. In addition, the audience tends to be younger, in a scanning mode, and in a hurry. Although this is not a text on writing for the Web, a list of writing guidelines is important to you; after all, words are one of your most significant tools.

1. **Words probably have the most to do in shaping the *content* and *usability* of the medium.** Users are looking for quick information, not encyclopedic treatises. If the writing is too lengthy, clever, dense, or cryptic, your audience will be gone, unless they've specifically visited your site for the textual content. Alexis Mersel, editor at *ELLEgirl*, underscores the importance of writing for the medium: "It's very important not to try to translate content directly from other media (i.e. print) online; always think of them as separate entities." However, several things that writing for any medium should hold in common are proper grammar, spelling, syntax, punctuation, and other basics sacred to using language properly.

2. **Organization is critical.** If you have different departments, components, or things to say to browsers, break them down, *clearly*, into separate entities. An excellent magazine table of contents page is an ideal model to consider, because it meticulously breaks out the architecture and content of the publication. Be ruthless in your organizational efforts, and in what information you opt to use. By the way, this organizational mandate applies to the *entire* project or site, not just writing.

3. **Establish your titles or sections first.** Clearly define the nature of the parts of the page, section, game, company, or whatever you're designing and writing for. Titles should be short. Single words work best, but try to keep the title under 30 characters if you can. Titles should not be repetitive. Although that advice sounds obvious, it isn't. If the pages or sections are different, they should be named *differently* from one another. We've all had the frustrating experience of seesawing back and forth between similarly named pages or sections of a site trying to find something. Titles should be clear. Readers don't have time to be puzzled, dead-ended, or misdirected.

4. **Headlines: think like an advertising copywriter creating outdoor boards.** You have to communicate quickly and hit a moving target. To that end, keep the headers terse, to the point, and lucid. The function of a good headline is not to tell the story, but to announce it in a clear and

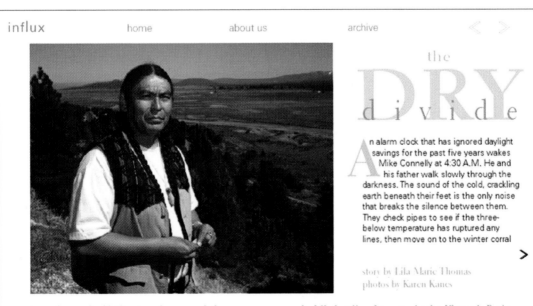

A rancher and a Native American search for common ground while battling for water in the Klamath Basin.

Figure 17-36

"The Dry Divide" is a double entendre headline. The story focuses upon a Native American and a rancher, both of whom are hoping to find a "common ground" for sharing water rights on the Klamath, a river threatened by years of drought. Russ Weller's use of color in the headline suggests the arid conditions. Art direction by Russ Weller and Emily Cook; photography by Karen Kanes; story by Lila Marie Thomas. Courtesy of *inFLUX* online magazine.

interesting manner. Write simply. Use verbs wisely; they are your silver bullets. Remember that the headlines should show or reflect content *and* context. Finally, *slash* any word that can be eliminated without affecting the meaning of the header.

5. Shorter is better. Write tersely and clearly. Web gurus the likes of Karenina Susilo of Yahoo, Kevyn Smith, and Jakob Nielsen all suggest that cybertext sections should be at least 50 to 60 percent shorter than how they'd appear in print.

6. Remember, too, a large chunk of your audience consists of scanners. To that end, many of the things you learned earlier in the design, typography, and newspaper and magazine design chapters apply here. Break up the text with dropped-initial letters, crossing heads, decks, captions, bulleted lists, color, sidebars, pull quotes, and the like. In that way, even if all of your message isn't read, scanners will get the gist of the copy, or better yet, some readers will be stopped by one of the above tactics and lured into the text.

7. Write from the heart; edit from the head. Hillman Curtis believes that writing should be alive and relate to the theme or concept of the site. While making observations on Web writing as an interactive juror for a recent *Communication Arts Interactive Annual*, he noted, "It's important to speak to someone's head through the heart, and not the other way around. It's going to be a stronger emotional message if you give attention to the theme and don't putter." To be sure, good advertising copywriters and creative directors understand the power of an emotive message. Clearly, you aren't going to bore someone into buying or reading anything. Your words should be sparse but have personality.

8. Try to keep your pages brief. A lot of the writing guidelines here underscore one very important message: shorter is better. Most users don't like to do a whole lot of scrolling, so try to keep pages screen size if possible. It's easier and more natural to a reader to break to the next page rather than scrolling down an existing one—and fresher, too. Also, relegate supplementary data or information to other pages. If you have to employ scrolling, keep it vertical. Generally, avoid horizontally scrolling. Many users don't even realize horizontal scrolling is an option.

9. Your voice should be clear, individual, and appropriate to your audience. Readers can immediately sniff out a marketing "come on" or superlative-speak. Credibility is essential to meaningful communication. Be honest, direct, succinct, and don't be afraid to use humor, where warranted.

Figure 17-37
"Troubled Waters" is another story about a river in trouble. In this instance, the initial letter is part of the headline. The story is introduced with a deck that both "briefs" the story for users and asks a provocative question to lure them into the feature. Note, too, the large, legible, easy-to-read type. Design, Arlene Juan; art direction, Emily Cook; photography, Thomas Patterson; story by Jennifer Snelling. Courtesy of *inFLUX* online magazine.

10. Edit not just to hone your word count but, more importantly, for clarity. A good editor consistently and sagely employs all of these guidelines. A proper edit will shape the content, context, attitude, and effectiveness of your message.

Usability: Comfort and Facility

Basically, usability relates to function, convenience, and the elimination of any barriers for your audience. *Usability* refers literally to how user-friendly a website or interactive medium is to its audience. It involves facets of design as simple as organization, legibility, readability, and good planning, as well as more technical aspects involving platforms, navigation, timeliness, and audience match.

Who are the users, what do they want, and what are the most appropriate and simple ways to connect with them? As Karenina Susilo of Yahoo points out, "Most users hate to wait for the page to download, so get rid of unnecessary big size images and files. It's better to make your site usable. So function overrides aesthetics, bells and whistles." Susilo, continues, "Today, 800x600 resolution is still the browser setting of most users. Therefore, be mindful when designing to make sure you cater to this large percentage of users." Also, will *all* the browsers work with your site or materials?

At a more technical level, debugging is imperative. All of us have had plenty of nightmarish experiences on the Internet: your browser doesn't work on a site, or links fail, or large areas of information are blocked out or go into some weird *mosaic* mode, or your computer freezes or crashes. Before you sign off and send anything you've created out into the ether, make sure you've got the bugs out.

Usability Considerations

Make sure the nomenclatures you use on the website are easily understood by your target audience. There's no point of using 'fun' and 'different' names or monikers if users have no idea what they mean. These are good smart starting points:

1. Assume nothing.

2. The user is *not* like you.

3. Know the content, intent, and audience as well as you can.

4. Test everything on different browsers, monitors, and platforms.

5. Employ focus groups where feasible and appropriate.

6. Listen to the feedback and your client, *and* take their input seriously.

Making PopSci.com More User-Friendly (Peter Noah)

Usability—how well a person is able to use a tool to accomplish a specific goal—is incredibly important when creating websites. Often, though, it's ignored. Consider the number of times you've regretted landing on a dysfunctional site while surfing or researching a topic. What if you had a dollar for all the times you've hit the back button, froze your computer, or ditched one site for a competitor's because it *was easier to use?* Peter Noah is the online producer for *Popular Science*, the Web companion to the 130-year-old magazine. He provides a thoughtful and candid discussion on usability and site design:

When I first started working as an online producer at Popular Science (www.PopSci.com) *it was clear that the old site experienced too much feature creep. Creep consists of the changes or additions made on a project after it's already begun. It is akin to changing horses midstream. The more that this happens, the more likely the project will fail. The site looked almost as if it had been created in a vacuum; navigation and design choices were not user-friendly. In fact, the creators might've been the only ones capable of navigating the site. Many fundamental usability rules were simply ignored.*

Luckily for me, the entire brand (magazine and site both) was on the cusp of a massive redesign. It was my goal to create a functional, user-friendly PopSci.com—*a redesign based upon simplicity and usability. Specifically, it was important that the site was accessible to an audience familiar with the magazine as well as one who had never even picked up an issue of* Popular Science. *My philosophy is that visitors should always be able to find the content that interests them, quickly and easily, as well as locate related content or have access to search for that content immediately.*

To that end, we focused the redesign on a few key issues:

Figure 17-38
Peter Noah is designer and the online producer for *Popular Science*, the Web companion to the 130-year-old magazine of the same name. His resume of online work includes Barnes & Noble.com (bn.com), Children's Television Workshop (ctw.org) and *Today's Homeowner Magazine*—now *This Old House* (thisoldhouse.com). Before journeying into the Web, Noah worked as a writer, contributing to publications ranging from the *Los Angeles Times* to *Urb Magazine*. A New York City transplant, Noah is always surfing the Web. Portrait by John B. Carnell.

A story is never more than two clicks away and digestible within one page. *Our users averaged one and one-half page views per visit. Therefore, it was imperative that any story be accessible within two pages or clicks or less. Clearly, too, it was crucial that the stories themselves had meaningful decks and headlines—much more so than their counterparts in print.*

Simplify the navigation bar. *The former PopSci.com had two primary navigational areas. The one on top was barely visible in its dark surroundings. The second area consisted of a long running column located on the left, which was so extensive it had to be grouped under four headers. The question was why? It was terribly confusing, and the average person was clueless as to which one was the primary navigational tool. In addition, many of the links didn't offer any cues as to what lay behind them. As it turned out, some of the links in one navigational bar simply cross-referenced pages linked to from the other bar.*

So we did the logical thing: we organized the content and came to the conclusion that it fell under seven primary subject areas. We planned a simple content list that any of our visitors could understand. In fact, 99 percent of the site could be organized within these categories. If it was an

aviation story, for example, it was an aviation story, and it didn't need to be further broken down into magazine categories that would have meant nothing to the first-time visitor. The new, simplified "nav" bar was inserted on every page—in precisely the same location.

Create template clarity. *After simplifying and limiting the navigational bar to one entity, we pared down the page types to three (excluding the home page). It was important that our readers have a consistent experience. An article page always looked like an article page, and the same needed to hold true for category index pages and search results. We wanted visitors to always find the primary content in the center of the screen, no matter which article they were reading. In addition, we sandwiched the article between art and related materials, inserting a bold image to the left, and placing related materials on the right, which is where the links, polls, and multimedia were positioned. We maintained parallel structures on the pages; that is, we established consistent proportions on these pages. The image widths would never exceed 315 pixels, and the pages would rarely scroll more than 1.5 times. The category index pages underwent a similar transformation: one featured story and a list of other stories. And we always provided a*

Figure 17-39
The former *Popular Science* site's main page (left) had a wide variety of problems: clutter, multiple navigation bars, and a dark environment that was neither user-centric nor inviting. Peter Noah's redesign mission was a formidable one. (Right) Grids and usability go hand in hand. Peter Noah comments: "We broke up the article page into very clear, distinct areas, keeping the design clean, with as little distraction as possible for the users." The optical center of the website layout is dominated by art. Artwork courtesy of designer Peter Noah and *Popular Science.* Courtesy of John B. Carnett/ *Popular Science* magazine.

search. In our case, we kept that feature on the top right throughout the site.

Make the home page obvious. *The old PopSci.com home page was a jumble of information. Nothing was emphasized, so equally sized areas competed for the viewer's attention. Feature stories were buried toward the bottom. And the page itself scrolled forever. It was unclear what was important, what wasn't. Not even a compass or clairvoyant could have helped you through this mess.*

So it was important we integrate a logical hierarchy into the redesigned page; the one we created couldn't be clearer. In effect, what we wanted to tell our visitors was simple and direct: check out this story if you've only time for a quick read. It's that important. However, if you're not interested in that feature, here's a sampling of other stories you'll find on this site. I believed that the secondary feature stories, arranged in a grid-like manner, worked especially well in illustrating the mix of content the site offered.

Ultimately, I believe we accomplished most of what we set out to achieve. The redesigned site was brighter, leaner, well organized, and most

importantly, much easier to navigate. However, some of my 'minimalist philosophy' caused problems we're now addressing for the next redesign:

Design over function? *We fixed the type size so users wouldn't be able to adjust it through their browser preferences. This was a choice made simply to maintain design integrity. However, at the same time, that decision ignored an incredibly important fact about some of our audience: many of them had trouble reading the small type.*

Where am I? *The Internet is an amazing mosaic, one replete with many roads, paths, and ways of accessing anything. Consequently, many of our visitors don't come to the site through the home page but via search engines or forwarded URLs, for example. Sometimes they enter through archives that aren't linked directly from the site. In these cases, the site offers little or no visual cues as to where they land within the overall architecture or hierarchy of the site.*

How do I subscribe? *The redesigned site offered a whopping total of two subscription links, one of which was invisible, because it was buried in a pulldown menu. How anything so obvious could be overlooked is beyond me. But*

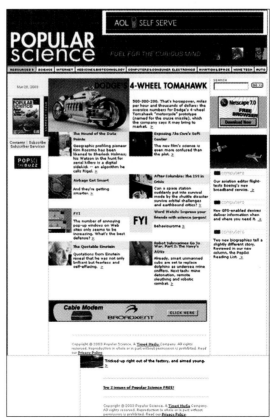

Figure 17-40
The *Popular Science* website redesign employs a clean, stripped-down grid that reads quickly and easily. Simplicity, logical readout, and associations are important to an online magazine's table of contents or main pages. Peter Noah underscores what they wanted: clarity and usability. "A single image, headline, and deck occupy most of the real estate; it's laid out on a page designed to fit within an 800 x 600 screen." Artwork courtesy of designer Peter Noah and *Popular Science.* Courtesy of John B. Carnett/ *Popular Science* magazine.

Peter Noah's Usability Checklist

Navigation

Persistent navigation that clearly identifies your site's categories and most important functions (search, contact us, and so forth), allows users to explore and enjoy your site efficiently. What's more, simple, intuitive navigation will increase the likelihood they will return. Always provide an obvious link back to the home page as part of your navigation strategy. Don't assume they'll realize the logo is a link to the home page. This underscores the "assume nothing" rule.

Take advantage of conventions

This is a general tip that covers a lot of what's already been discussed, but it's worth reiterating. Websites have been around long enough that users are likely to have specific expectations. Take advantage of them. Place primary navigation along the top of the page, secondary navigation along the left, search boxes top right or thereabouts, and branding on the upper left. Utilities such as links to access information and help pages are expected on the upper right.

Readability

Don't make the same mistake I did if you're building a site that features a lot of editorial content. Sure, light gray, nine-point text against a white background might look pretty, but ultimately it will only alienate people. Don't fix your font sizes; allow your visitors to adjust them as necessary through their browsers, and max maximize contrast. Try to adhere to conventions when choosing font colors for hyperlinks, visited links, etc., or at least be consistent within your own site.

Respect your audience's time

This may sound obvious, but it's a good idea to keep in mind when creating your website as it will spark usability issues as well as address a host of related concerns that you'll want to tackle. Assume your visitors have only a few minutes to spend with your website. What have you done to maximize the site's usefulness to them? Can they navigate through categories without having to return to the home page each time? Are images optimized and cropped as to minimize download time and maximize the information conveyed? Do your headlines, subheads, and captions convey the essence of a story without forcing readers to go through the first few paragraphs?

the fact is that we did miss it. But the Web's interactive capability quickly surfaced the problem: we received countless e-mails from folks asking how to subscribe to the magazine. I shudder to imagine how many subscription opportunities we lost as a result of that oversight. To correct the problem, we rotated subscription offers in all ad positions and added text links in key areas of every article page. Not surprisingly, subscriptions shot up. Interestingly enough, the most effective link was the one found at the bottom of every page. Go figure.

Pulldown menus aren't always a good idea. To anticipate growth in non-editorial categories, we created a pulldown menu on the navigation bar called "resources." The term "resources" says little about anything remotely interesting that might exist in this pulldown menu. Consequently, anything we placed here became instantly invisible. This didn't work at all.

I've yet to come across a site that gets it all right, regardless of its version history. The constraints of the medium change at a feverish rate. Trends die. Conventions morph. Technology changes. Sure, there are certain standards that should always be upheld, but how will they change when delivery methods, browsers, and platforms all change? For example, what will the Web look like when broadband connectivity becomes ubiquitous? What if browsing the Web on a cell phone becomes commonplace?

This is, perhaps, one of the most challenging and frustrating aspects to usability and design for websites. At the same time, it's the most thrilling. Few media have gone through so much evolution in so short a period, and I, for one, can't wait to see what's next.

The usability of Flying Dog Brewery's website is excellent (see Figure 17-41). It has excellent navigation, good branding, easy access, great readability (even though it uses edgy type), rich color, humor, and it's a quick and easy read. The message is that you can produce fresh, exciting, interactive design work using guidelines.

It cannot be overstated how crucial usability is to interactive and Web design. That point underscores how important it is to make user experience positive. The question is how accessible is your site? You want your site to be easy to

search, explore, and navigate. Think of the controls on your dashboard, or on the TV remote control, or the ESPN-TV scrolling scoreboard. While not all of these examples are "interactive," they still have usability issues. People still have to look at them and make sense of what they're communicating. A website's usability speaks to that same kind of intuitive, direct communication. Again, *usability* is central to every part of interactive design: planning, architecture, aesthetics, color, type—everything, including coding.

Coding—Circuitry and Language

There are a number of ways to think about interactive code. In one respect, it is analogous to the electrical plotting of a building's architecture. Code is the sunken circuitry that makes the site *go*. Indeed, programming is the basis of Web interactivity. Without the ability to receive and respond to user input (via keystrokes, mouse movements, and so forth), there would simply no interactivity, which is akin to having outlets, switches, and electric components without any of them actually being *wired*.

At its most basic, this interaction may simply involve clicking on a hyperlink within a page or using navigational buttons on the browser menu bar. Strictly speaking, code is language, and every part of the site or interactive media, from the content to the design, photography, sound, animation, illustration, and so forth, is dependent upon code. Basically, *code* is a systematic means of communicating information, graphics, and media through embedded commands—the explicit and methodical use of numbers, letters, and words. Michael Trezza is an interactive developer who is facile with code. It's his creative *medium*; in fact, you should think of developers as interactive artists:

In 2000, I bought a Macintosh and a friend turned me on to a program called Macromedia Flash. Think of Flash as Adobe Illustrator (a popular vector drawing application) beefed up with the ability to animate along a timeline, which is analogous to video editing. In fact, it is code that controls this monster program.

The code language I speak most fluently is Actionscript, the language of Flash. If you write code yourself, you probably know that Flash's

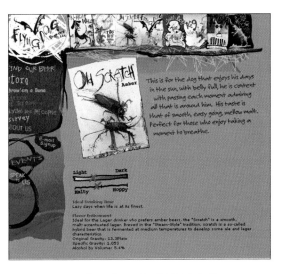

Figure 17-41
Flying Dog Brewery is a company with attitude; its products, advertising, packaging, and identity reflect that stance with their edgy design. Their website (www.flyingdogales.com/) maintains the same kind of pluck. The voice, type, simplicity, and wonderful Ralph Steadman illustrations impart an edginess in this site page for Old Scratch Amber ale. Courtesy of Flying Dog Brewery.

Actionscript is based on the ECMA-262 Standard, meaning it is nearly identical to JavaScript in syntax and structure. Both look, feel, flow, and handle data similarly. The following are a few examples illustrating the similarities and differences between the two languages.

Goal: to output a message to the screen using Actionscript and JavaScript.

> *Example 1: Actionscript*
> *function myFunction(argument){*
> *trace(argument);*
> *}*
> *myFunction("hello world");*

The above code, written in Actionscript will "trace" (output to the screen in the authoring environment) the text "hello world."

> *Example 2: JavaScript*
> *function myFunction(argument){*
> *alert(argument);*
> *}*
> *myFunction('hello world');*

The above function written in JavaScript will pop up an alert box containing the text, "hello world."

Here you can see a basic example of how similar they are structurally, and how they differ in syntax. Both commands print the "hello world" text to the screen by creating a function *(think of a function as an encapsulated set of steps used to perform a task) and then executing the function by calling its name, modified by the text we want the function to output. In essence, we tap myFunction on the shoulder and say "hello world", and since the only thing myFunction knows how to do is*

Figure 17-42
Michael Trezza is the lead Flash and site developer at axis360. Over the last several years, Trezza has developed award-winning interactive sites for Martini Racing (martiniracing.com), RallyTrack, (a virtual rally car component for the website), Dale Earnhardt, Inc. (daleearnhardtinc.com), Memory Hall (an interactive, living history of Earnhardt Racing), and Virtual Pit. Photography courtesy of Mike Trezza.

repeat what it just heard (represented by the place-holder word "argument"), it does just that, in its native language.

Though the syntax is relatively similar between the two languages, they differ greatly in their implementation. JavaScript must be run from within a Web browser, whereas Actionscript operates within its own proprietary software (the Flash player). Another side note is that the Actionscript trace command is not generally used to the same end as the JavaScript alert command because the output of trace will only be seen by the developer or author.

It took me a while to understand the power of code: it sculpts data, creates graphics, and orchestrates Flash animation. Initially, I was scared off by its cryptic nature, but once I got my feet wet, new worlds opened up to me.

Code is pretty simple in concept. You create a command, then execute it. The complexities of the commands are what seem so alien. Think of basic math—addition, subtraction, division, and multiplication. Let's try the following example:

$$4*8/2+(2*23-2)/234+92(-3)(-9)*(-23/4)$$

This math can be done at the fifth-grade level. Its organization, however, scares you because it does look daunting, despite its inherent simplicity. The same idea holds true for most code: mainly, it consists of the few commands within the language.

It wasn't until about a year ago that I took writing code a step further. I stumbled upon the power of object-oriented programming (OOP). Surely, this isn't the venue to explain OOP, and you'll find that most programmers cannot explain it well (myself included). But I will share an idea that code, like spoken language, is extensible (extendible or flexible) and allows you to create shortcuts or compress commands. What does your best friend call you? A nickname maybe? Let's say your name is Michael Trezza, and your friends call you Trezz. Basically, that's an abbreviated way to address someone. Simple idea. The same concept applies to code as well. If I constantly need to find out a certain bit of information I would create a "function" to do it, a shortcut.

EXAMPLE 1 : No function:

A = 10;

B = 5;

C = (a+b);

EXAMPLE 2 : Function:

A = 10;

B = 5;

function addNumbers(num1,num2){

C = (num1+num2);

}

addNumbers(a,b);

What has happened is you've created a "shortcut" for this operation. You can use that very same function to add any 2 numbers, in fact, and not only the 2 from the example.

You could write:

addNumbers(23,61);

And the program would output "84." This example demonstrates what is called extensibility (mentioned earlier). The idea behind extensibility is the ability to create "new words" that the program can understand, from existing words. You've created a new word (a nickname, a shortcut) called "addNumbers," and you've explained to the program what you mean when you say "addNumbers." You have "defined a function" by speaking the language!

These are simple examples, but they form the basis for writing code. It's simply input and output. You are organizing and orchestrating the flow of data in the correct directions. Code can be used to create moving graphics on the screen, pull data from a database, create charts of it, and build an immersive 3-D world using sound and motion. But no matter how complex or elementary, it is simply language.

Just as I use the English language to describe things when speaking to people, I can use code to describe those very same things when "speaking" to the computer. I can take data, funnel it into an algorithm, and come up with intense graphical representations of it that perhaps no one has seen before. That is what I hope to do every day— create something nobody has ever seen before.

I've actually taken this idea literally as an experiment. I built an application in which I can input a passage of text from a book or wherever and the application will render graphics based on the frequency of the letters. For example, if you have a string of text, "aabcddeee," the raw data from that string could be interpreted as:

A_frequency = 2;

B_frequency = 1;

C_frequency = 1;

D_frequency = 2;

E_frequency = 3;

With these numbers, I can place raw data into any output mechanism I create. In this case, I chose to duplicate a simple graphic onto the screen based on the frequency of the letter. And I colorized the graphic based on the letter's ASCII code. Every letter in a typeface or font is represented by a numerical value, so that the letter "a" when shown in the font Arial is still an "a" when shown in the font Times New Roman.

A little bit more abstractly, I speak to the computer in its own language and tell it in which way I want it to utilize the input that it is given. In return for learning its language, the computer will obey my commands, if I have communicated them correctly.

The possibilities for user control of text input, image motion, color, music and navigation are almost endless. At the core of these commonly accepted tasks—something as simple as a link or as complicated as a well-crafted animation—is the code. It is language and the substructure of commands that give the site its *juice*.

Lithyem: Deconstruction of a Website (Michael Trezzi)

The actual process of assembling a website is similar to constructing a building. What is its function or use? Who will use it? Will it need room for an addition? Begin with a simple idea. Michael Trezzi illustrates by deconstructing his site, Lithyem (www.lithyem.net):

Concept

From the outset, you need a concept. Start by asking yourself some familiar questions: What is the purpose of the site? Who are the users? Are they familiar with the Web? Why would they come to this site—information, recreation, news, shopping? Will the site need to be updated frequently, or is it a one-off?

Then you have aesthetics to consider. What kind of feeling do you want the site to convey to visitors? The initial response to the look and organization of a website has a huge impact on whether they stop or not or on how long they stay. The site should be user-friendly and efficient.

When I started working in interactive design, I bought a URL, www.lithyem.net, as a venue and

test bed for my ideas and interactive experiments. Its latest version is what I will deconstruct to explain my ideas on organization and interactivity.

The feelings I wanted to evoke were simplicity, cleanliness, and experimentation. After a lot of thought, I decided that I wanted Lithyem to be simple, ambitious, engaging, and creative. In this case, visitors would be other Flash designers (as I often post new techniques and code that I have experimented with) as well as clients looking for fresh work and who (hopefully) might get in touch with me. This left me halfway between an exploratory experience and one based upon need. Content would vary because the site would be updated often, usually daily in some way or another. Also, because the site is intended to be somewhat experimental and evolutionary, I allow myself to deviate from the interactive norms (for example, the use, look, and feel of buttons and scrollbars). But even in the heart of wild experimentation, it's important to be consistent, so any new standards or unconventional items that I create (for example, Windows OS buttons) will maintain the same continuity throughout the site. Getting to the experimental stages involves a lot of thinking and sketches. Simple pencil sketches help you think through development, function, and usability issues. It's like thinking out loud (see Figure 17-43). This image shows an early

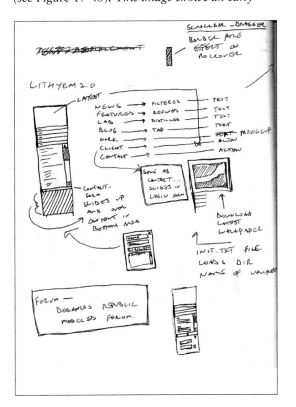

Figure 17-43
Working with a pencil and paper is the best way to think out of the box for many designers, art directors, illustrators, and developers. It frees you from the plastic world of the keyboard, mouse, monitor, and software programs.

sketch of www.lithyem.net, reflecting my thinking about how the site navigation should work. Because I had a lot of content and had to divide it into several categories, I chose a navigation-based interface—in other words, the navigation was most important.

Experiment

The experimental phase is an ongoing one. Everyday I find something that inspires me. Sometimes I discover a pattern in the limbs of a tree, and it sparks an idea about fractals. Or visit another website whose navigation I think I could be extended or improved upon. New ideas are spawned from almost anything: a particular shade of blue sky, an angle or perspective of something familiar that I've never seen before, even the sound the computer makes when it is "thinking." Recently, I was playing with words—magnet poetry on my girlfriend's refrigerator—and thought I could build a site around that idea! (See Figure 17-44). I thought, "How cool!" That could work as a great multi-user environment

where people could create fridge poetry for anybody to see it in real-time.

Another creative Lithyem addition occurred to me when I was thinking about recursion (see Figure 17-45). In this case, I used Flash to experiment with recursion—a logical succession of elements or motif—in which I was trying to emulate the growth patterns of tree limbs and recursive function.

The Lithyem site is really the result of endless experimentation. It is truly a blend of a hundred other ideas and projects I had built earlier: Flash XML parsers I'd developed; the PHP message board code; or the code that drives the motion of the navigation elements. Even the file structure of the backend of the site is a result of experimenting with the idea that its backend could mirror the front end in a way that allows me to update it effortlessly. For example, the backend structure of www.lithyem.net is an exact copy of the XML documents that drive it. The documents that govern the navigation of the site are structurally identical to what the user sees.

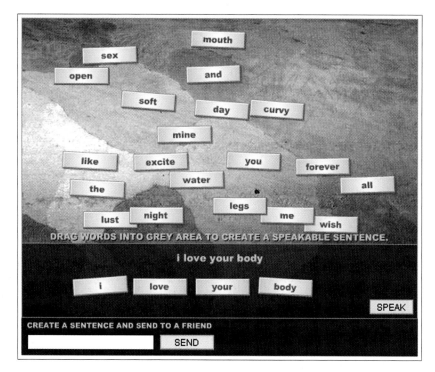

Figure 17-44
Michael Trezza took the "fridge poetry" concept to another level in his Lithyem website. Trezza explains: "Imagine. You could create poetry, and e-mail your poem to a friend, who can have the computer 'recite' the poem to them upon receipt." This strategy employs multimedia and in doing so steeps the user's personal experience. Concept, design, interface by Michael Trezza. Courtesy of Axis360/Mike Trezza.

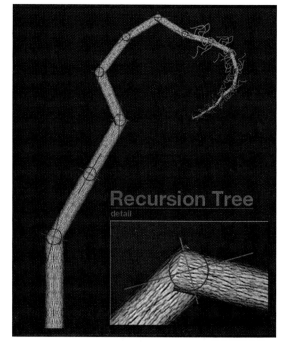

Figure 17-45
Trezza's work here functions on two different levels. There is both real and implied meaning, which is to say that the tree and nodes are literal but also metaphorical because the idea of *recursion* may be applied to the site design. The inference is organic. Courtesy of Axis360/Mike Trezza.

```
<?xml version="1.0" encoding="iso-8859-1" ?>
- <root>
  - <item>
      <title>ORGANISM Screensaver</title>
      <date>Mar 21, 2002</date>
      <desc>LITHYEM Organism screensaver. Amoeba-like behavioral pattern.</desc>
      <link target="content">system_content/downloads/organism</link>
      <img>system_images/downloads/organism.jpg</img>
    </item>
  + <item>
  + <item>
  + <item>
  + <item>
  </root>
```

Frontend Mirroring Backend.

Figure 17-46
Perspective is not just about looking at things from different angles; it's about configurations, how parts are interrelated, and the ability to see and *understand* things in a new way. It's like seeing with fresh eyes, as Michael Trezza's "mirror" approach to navigation demonstrates. Courtesy of Axis360/Mike Trezza.

The hierarchical nature and organization of data makes the website simple to navigate and use (see Figure 17-46). There is a lesson here which is that the breakdown of hierarchy—I would argue—is a flaw found in many websites. The consequence is that it leads to difficult navigation and poor information structure, which in turn frustrates you until you give up and quit browsing the site.

Design

The actual designing of the site is a culmination of the last two phases. I weave my concept and all the experimentation and play with them until I find a layout and structure that works. My personal aesthetics lean toward Swiss and German design. I tend to design in grids or cells; it's just a preference (see Figure 17-47).

In this case, I focused on the needs of the website and the experiments that I'd generated. Then I integrated them to make the site serve its audience properly while still being easy for me to update with new content. Function. For www.lithyem.net I chose a super-clean, monotone layout. The main draw or focus of the site is its content; I use the site to share new work as well as a test bed for my Flash/design experiments. The content or focus of the website led to the design—in its entirety.

Production

After I'm happy with the design, I begin building the site. This is the phase people spend most of their time. However, I would maintain that spending more time on the experimental phase would cut down production time significantly. At this point, I take the Flash modules I've built and start to skin them with the art from my designs.

Because I have a full-time job, I've little time to update or add new content to www.lithyem.net. Because of these constraints, I constructed the file structure simply so that I could make any changes quickly and intuitively (see Figure 17-48). This all works together in an effort to keep

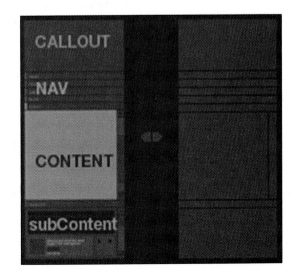

Figure 17-47
Grids are as functional in interactive and website design as they are in other media design. They offer inherent organizational benefits that serve the aesthetics of a design as much as its usability. Courtesy of Axis360/Mike Trezza.

Figure 17-48
Function and simplicity can
make for a two-edged sword,
but in this example, there is
great usability for the visitors
and developer alike. Trezza
clarifies, "The file structure and
basic content management
systems allow me to upload new
images and alter and create new
text content." A win-win
situation. Courtesy of
Axis360/Mike Trezza.

Figure 17-49
One control panel version of the
ever-changing Lithyem website.
Like its code, usability, and
aesthetics, it is simple and
functional. Courtesy of
Axis360/Mike Trezza.

the site fresh without overburdening me. After
all, new content helps to keep visitors coming
back; it's as simple as that.

Test

*Testing a website's architecture is never really
over. When you're debugging or checking a site,
use it differently each time. Shake up how you
experience the site. Maybe you click button B
before button A, and discover the site crashes.
It's imperative that you try every possible
sequence or combination. Assume nothing. Be
prepared for someone to drag the slider off the
page, shrink the window, accidentally press
control/alt-delete, or smear peanut butter on the
monitor and tell you that your site doesn't work
properly. The more complex the site, the more
soft spots it will likely have and the more
breakable pieces for the "right" user.*

*I have one friend who is a site's ultimate devil's
advocate. Every time I build something, he
examines it and shortly thereafter tells me what's
flawed: "I triple-clicked on the button and tried
to drag it onto the desktop, and the site froze
up." When I'm testing a site, this procedure isn't
one I generally think to try out. He has a knack
for wreaking havoc on machines and is the
ultimate beta tester. Remember, for every person
out there that does know how to use your site,
there will be ten others who won't. If you test
with them in mind, your work will be better
for it.*

*This was how www.lithyem.net was built (see
Figure 17-49). Lithyem is a playground for my
digital ideas—a place to explore the puzzles,
vision, and perspective—and it serves as a test
bed for projects that hopefully might help clients
communicate in a more compelling and effective
way or improve their business and bottom line.
If you are a developer or designer, I encourage
you to create a website, if only for yourself.
Figure out what you want to do with it and who
its audience will be. Then experiment and realize
that you can turn it into anything you can
imagine. Build a family tree that distant relatives
can help flesh out; create a recipe book and
encourage friends to add their best dishes; invent
a website that tracks and manages your fantasy
sports leagues. Build something!*

Multimedia

"Multimedia (may) blur the boundaries between life and art, the personal and the mediated, the real and the virtual. The implications of these tendencies we are only now beginning to grasp."

—Randall Packer and Ken Jordan, from "Overture"—*multiMEDIA*

As its name suggests, *multimedia* is a conglomerate of different media. Many also use *interactive* and *new media* interchangeably with multimedia. However, not all types of multimedia are interactive in the same way the Internet is. In fact, strictly speaking, many of our traditional media are multimedia. For instance, magazines integrate word, type, illustration, and photography—all different media. Film employs language, type, imagery, music, dialogue, ambient sound, and motion. You get the idea.

Convergence and Eclecticism —A Brief Overview

Multimedia has a long and interesting history. The backgrounds of those who've experimented with the area are as fascinating as they are varied; scientists, composers, artists, musicians, inventors, animators, and many others have worked in multimedia and influenced its evolution (see Figure 17-50).

Actually, it was Samuel Morse who first *wired* a nation and later the world with the telegraph (1844). His technology radically altered our notions of time, space, and communication. Many look to composer Richard Wagner, along with his engaging work and essay entitled "Artwork of the Future" (1849), as the pioneer who really underscored the importance of media integration. He attempted to immerse those who

Figure 17-50

One young artist testing the limits of multimedia is Salvadoran Luis Salazar. At this writing, he is assembling a marvelous experiment blending music, words, ambient sound, interviews, photography, and other media. The project showcases several of his documentary series on Hispanic culture in New York City: poets, the underground hip-hop scene, young Latino women working in the modeling industry, and street photography. These photographs are from three series (top to bottom): *NYC Hip-Hop en Español*, *La Bruja*, and *Street Work*. His media experimentation offers a most remarkable window into Hispanic culture. Media courtesy of Luis Salazar. © salazarluis.

attended his musical dramas by merging sound, poetry, lighting, dance, music, and visual arts into their theatrical experience. Marinetti (see Chapter Two) and the Futurists proclaimed cinema the "supreme art" in their manifesto; it married *new* technology (film) to word, theatre, and story-telling. Marcel Duchamp experimented with mixed media and common objects to encourage interaction and stretch the notion of *what* art could be.

In 1945, Vannevar Bush, an important intellectual and writer, suggested that a machine he called the *memex* could be built to store "information that could be retrieved through automated association." The memex never materialized, but his idea fascinated and influenced many scientists. Later, Ted Nelson first coined the term "hypertext," and suggested a nonlinear and interactive system as an alternative structure to creating, organizing, and retrieving information in his book, *Computer Lib–Dream Machines.*

Later, John Cage attempted to explode the boundaries of music by incorporating theatre, visual arts, and interaction to extend the experience of the audience. Over his lifetime he collaborated with many artists outside of music to create his work.

William S. Burroughs' writing often employed nonlinear structures that more closely tracked as our minds would track and associate to encourage more reader interaction. Ken Kesey, who taught a fiction class at the University of Oregon, employed one exercise that required students to write collaboratively: each would start a story and it would make the rounds with the other students inventing the direction of their parts in each story—"crazy quilt fiction."

In the 1960s, painter Robert Rauschenberg used mixed media in his artwork, first by integrating everything from newspapers to his own bedspread in his art (much like Duchamp's "readymades") and later by incorporating silkscreen on Plexiglas with electronic equipment in *Soundings* (1968). Actually, the latter was an experimental piece of art created by artists and scientists called EAT (Experiments in Art and Technology). Shortly thereafter, scientists and researchers at Stanford and the UCLA exchanged the first e-mail message.

Then, around 1974, the British launched several teletext systems—notably the British Broadcasting Corporation's (BBC) Ceefax system and Oracle, which was created by a group of independent broadcasters to compete with Ceefax; both were one-way systems (download only). However, five years later British Telecom (England's Post Office) unveiled the first two-way, interactive computer system which utilized telephone lines and cables. Bush and Nelson's ideas were becoming realities. The Web and multimedia were taking shape.

As noted earlier, the U.S. military and the Rand Corporation developed an early model of the Internet to establish a sophisticated communications system that could survive a nuclear attack. Finally, in 1989, a group of scientists at CERN—a particle facilities laboratory in Switzerland—constructed an in-house data sharing system. Tim Berners-Lee, a young English engineer working there, tagged the system the "World Wide Web." He followed Nelson's idea of linking information, and applied his concepts of "hypertext" and "hypermedia." The structure of a shared global information network was born, and by 1993 the "Web" was everywhere. In 1994, video broke through the primarily text-oriented Internet when several California computer scientists and multimedia experts employed their digital MBone (Multicast Backbone) system to videostream a twenty-minute segment of a live Rolling Stones concert. Since then, media fusion, technology, and integrated interactive formats have blossomed. In fact, today most all media have some sort of Internet or multimedia presence. The range and intent of websites and Internet messages are overwhelming.

The uses and applications of today's multimedia systems are staggering compared to their counterparts born just a few years ago. Graphic quality, memory, speed, and applications are much more sophisticated. The technological evolution keeps extending the possibilities of multimedia: DVDs, cable delivery, reception units (cell phones, palm pods, etc.), and wireless technology. We come to take all these changes and on-going improvements for granted, forgetting how much older multimedia formats pale by comparison. Today, anyone can use e-mail to

send messages, photography, sound, video, and music *anywhere*, as well as engage others in chat rooms. We can delve into huge databases, monitor up-to-the-minute news breaks, use sophisticated search engines, download music and films, participate in on-going art projects, or shop via e-commerce.

To be sure, the Internet still has its shortcomings and frustrations, but the sprawling system provides a truly democratized medium—one with little official control and regulation. At the same time, given their inherent media convergence, the Internet, Web formats, and interactive media allow a designer to integrate a wide range of media and multi-sensory components within a single format. Therein lies the challenge.

The earlier sections of this chapter are also about *multimedia*. Surely, the Internet, websites, e-commerce, corporate sites, e-mail, and online versions of other media are multimedia in the truest sense (see Figure 17-51). But there are many other multimedia offerings, which range from performance art to advertising; from online, role-playing offerings to video and computer games; from Multi-User-Dungeons or MUDs (collaborative writing sites) to interactive DVDs. Because of the wide variation in media design and formats, it's especially important to have specific goals, thorough planning, and a deep understanding of the media to be used.

It is critical to design for the final output at the onset of any project. Delivery media present different design possibilities and challenges. For example, vector animation played on the Web allows for interactivity and scalability (resizing based on monitor size). However, due to modem speed and bandwidth issues, such motion is likely to play best at around 12 frames per second on the Web. In contrast, animation created for video normally plays at 30 frames per second—actually, 29.97. Film runs at 24 frames per second. At the appropriate speed for the medium, the motion will be smooth, whether vector animation (such as a SWF file) or animation created from a series of bitmap images. Standard video, however, doesn't offer interactivity. In contrast, DVDs may allow for interactivity (more if using DVD-ROM features) and are an excellent and increasingly popular format due to

Figure 17-51

Modernista!/Identity One designed this powerful website for Hummer. Note its strong parallel structure, simplicity, and clean graphic footprint. Producer Beth Doty summed it up, "This site was created to fulfill the Hummer tagline and be 'like nothing else.' The site receives comments galore from visitors who say it's the best designed car site around." The Hummer website is content-heavy, informative, engaging, intuitive, and a delight to all the senses. (www.hummer.com). Gary Koepke/Lance Jensen, creative direction; Will Uronis/Tim Stevenson, art direction; Keith Butters/Michael Ma, interface designers/developers; Shane Hutton, copy.

the large amount of data they're capable of storing.

The main point is that each of these formats provides strengths and weaknesses and presents different design challenges. Simply replacing one medium with the next misses the point that media are *different*. Take advantage of the unique characteristics of a given medium. Finally, take the medium and format into consideration early—in the planning stages of a project.

Computer Animation

Clearly, moving imagery is one of the most interesting areas within multimedia. Due to the explosion of video and computer games, animation is one of the most fascinating and fast-

growing areas of multimedia. Animation may be created simply via flip books or the most basic computer animation systems, or it may be undertaken on a grand scale. *Toy Story*, for example, was the first full-length animated feature film that was produced start-to-finish using digitization and computer technology; it literally took several years to produce. Animation's popularity has created an acute need for animators in the film industry.

Although the concept of animation—a series of frames or cels moving in swift succession to produce the illusion of continuous motion—has not changed much, the technology that creates it has become much more seamless and is capable of expanding the viewer or user's sense of reality. There is some disagreement over who should be credited for first using flip books for animation purposes. Generally, Frenchman George Méliés (*A Trip to the Moon*, 1904) and Winsor McCay (*Gertie, The Trained Dinosaur*, 1914) are cited among the earliest pioneers. Actually, Méliés' part in *A Trip to the Moon* was for special effects. McCay created some cartoons, such as *Gertie*, as interactive elements in his stage shows. Two other important animators were Max Fleischer and Walt Disney. Fleischer appeared on the cartoon animation scene long before Hanna-Barbera, Warner Brothers, and even Disney. Some of his more celebrated characters included *Betty Boop*, *Bimbo the Dog*, *Bosco*, *Popeye*, and *Koko* (*Out of the Inkwell*), who appeared in cartoons which fused film and animation. His technical and artistic genius led to the first cartoon using sound (*Popeye*). Walt Disney, along with his brother Roy and illustrator Ub Iwerks, created his classic short, *Steamboat Willie* (1928). Of course, Disney's vision and ability to draw upon classic fairy tales and convert them to feature-length animations (*Snow White*, *Pinocchio*, *Cinderella*, and *Sleeping Beauty*) really put Disney Studios on the map. Eventually, he built an empire that crossed media: cartoons, books, feature films, comic books, television shows, and theme parks. Ultimately, Disney became a global corporation whose holdings include many studios and the ABC television network. Today, animated features are a respected part of the film industry.

Animation is also an important component of multimedia.

Directing Computer Animation —"Say what?" (Pete Docter)

One of the most esteemed talents in animation is Pete Docter. He works with Pixar and Disney as a writer, animator, and director. Some of his successes include Toy Story, Toy Story II, and Monsters, Inc. Docter addresses the complicated charges of being a director of animation.

Here's a question I get quite often: "How do you direct an animated film, since there are no real actors?"

Actually, directing animation is quite complex. Imagine you have a large square room, without windows or doors. Now picture a fifteen-foot long hot dog, suspended from the ceiling, with sixty ketchup bottles hovering over it. The bottles are rigged to dispense ketchup when hit by one of six hundred superballs, which are released from a trap-door in the ceiling when a small dog steps on a button hidden somewhere in the floor. Actually, this has nothing to do with directing animation, but it'd be quite a sight, wouldn't it?

Well, okay, forget that. To be honest, directing animated films is a bit like conducting a symphony orchestra. I know I went off base with the hot dog thing, but stick with me on this one. Because this is animation, instead of the usual ninety or so musicians, there are more than six hundred. Now imagine that each of them must be recorded individually at a separate time. What's more, the music they're playing is being written as the recording takes place. Sound complicated? Welcome to animation production!

Despite the complexity, animation has one very simple goal: to tell a story that moves the audience emotionally.

At Pixar, the director is the first person working on a project, and the last one to leave. For lack of a better description, the director is "the keeper of the vision," the person responsible for shaping the story and shepherding the hundreds of people who work on the film. But I'm getting ahead of myself. Let's start at the beginning.

First, the earth cooled. Next, oceans formed. Soon after this, I began working on Monsters, Inc. Well, maybe it wasn't that long ago, but it feels like it. Monsters, Inc. took five years to produce from its initial concept to the finished film itself.

As I recall, I first thought of Monsters as potential subject matter while in the shower. I pitched a basic outline to fellow Pixarians Jeff Pidgeon and Harley Jessup (after drying off and getting dressed). Curiously, the original idea dealt with an unhappy thirty-year-old man who is visited by monsters. Terrified at first, the man discovers that the monsters personify specific fears he never dealt with as a child. Eventually the fellow befriends them, and the monsters help him overcome his fears. As his anxieties fade, his friends also disappear, leaving our hero a sad but stronger, more courageous person.

Monsters seemed like a perfect subject. Like toys, monsters are something we were familiar with as kids. But in thinking it through, we all agreed that a film about monsters without their creators—children—was really missing half of the story. So the story became a tale about a monster who worked at a factory, scaring kids for a living. One day after returning from his frightening work, he accidentally brings a girl into the monster world: a forbidden act which he spends the rest of the film trying to correct. In the process, he becomes a surrogate parent and his life is turned upside-down. Here was a theme I could relate to, since my wife had given birth to our first child six months earlier.

We produced about fifty drawings to pitch this basic concept to our creative and business partners at Disney Feature Animation. Everyone liked the idea. The story was fresh, people could relate to it, and it was full of potential.

Mind you, it took around four or five months to arrive at this point. However, creating a working script took another three years. Now, I can almost hear you saying, "Three years? Geeze, they built the Empire State Building in a year and a half! What were you guys doing?" Well, before you blow a gasket, calm down a minute and let me explain. Creating a good story is the most difficult and most important aspect of any film. An audience will watch and be entertained by a great story, even if the animation stinks. But not even the most dazzling animation or special effect you can imagine will sustain a lousy story—and good stories don't come together overnight.

At Pixar we begin by writing a treatment (a basic outline of the story), followed by a script. Because animation is a visual medium, we move rather quickly into storyboarding. Many people—Alfred Hitchcock and Steven Spielberg, for example—use storyboards to previsualize the film's composition. For us, storyboards are almost more of an extension of the scripting process. We shoot these continuity drawings on video, edit them together with temporary dialogue (provided by us, the "Pixar Players"), and add music and sound effects. Then we sit back and watch the film as it will appear (in a sort of limited, abbreviated way) on the big screen.

It is now, watching the film on story reels for the first time, that we encounter our first major problem: the movie stinks. Parts of the film are confusing. Setups don't pay off. Other parts are just plain boring. Even though this happens in all our films, we're always surprised. Joe Ranft, our storyboarding guru at Pixar, says that's why they call it "stoREBOARDing." We reboard and reboard and reboard the film. Ultimately our story crew—usually eight people, but at times as many as seventeen—produce more than forty-six thousand drawings. Our editors create literally weeks worth of edited material. If there is any secret to what we do, it is this: if it's not right, we do it again—and again and again—until it is.

To make sure we're on track, we check in frequently with John Lasseter and Andrew Stanton, our executive producers. Less often, we have screenings of the film for our friends at Disney. When you work on the same story for years, you get awfully close to it, and it's easy to lose your objectivity. Showing the film to someone you trust provides two benefits: you instantly see it through their eyes ("Doh! Why didn't I see that before?"), and you get their reaction and insights: perceptions you might never have thought of yourself.

As the film slowly, painfully appears that it just might work after all, we cast the actors. Billy

Figure 17-52

Pete Docter has worked as an animator, writer, storyboard artist, animation supervisor, screenwriter, and director. He was also one of the first artists hired at Pixar. His interest in animation started in grade school; when he was eight, he completed his first animation, a flipbook. Many years later, he studied animation at California Institute of Arts (Valencia); there Docter produced numerous shorts, including the Student Academy award-winning short, *Next Door*. His work at Pixar and Disney has been heralded as some of the finest animation and screenwriting ever produced: *Toy Story*, (1995), *Geri's Game*, (1997), *A Bug's Life*, (1998), *Toy Story II*, (1999), and *Monsters Inc.*, (2001). Photograph courtesy of Pete Docter.

Figure 17-53
These drawings by Harley Jessup, Jeff Pidgeon, and Pete Docter were made very early in the process to pitch their story *Monsters, Inc.* to people at Pixar and Disney. Pete Docter comments on them, "Things are very low-tech at this point: I stand in front of the group and tell the story while paging through the drawings. The idea is to give a good approximation of what people will *feel* while watching the film. The story changed quite a bit from this first pitch to the final film, but everyone accepts and even anticipates that kind of evolution. You can see and hear this original treatment (done up a little fancier than we pitched it originally) on the *Monsters, Inc.* DVD under 'bonus material' in the 'Humans Only' section, under 'Story.'" It's interesting to note how even rough sketches capture the spirit of the animation and its characters' personalities. Artwork courtesy of Pete Docter, Disney, and Pixar.

Crystal, John Goodman, Steve Buscemi, and others arrive one at a time, bravely sitting in front of a microphone in a lonely gray recording studio, listening as I try to convey how this glorious scene—right now a series of hastily pinned-up scribbles—will play. They conjure up the sets, props, and even other characters in their minds as they create a performance using only their voice. I try to make sure what we're recording will blend with all the other actors and elements (most of which don't even exist yet) to create a believable, entertaining scene.

At this point, there are around two hundred people designing, building, painting, assembling, articulating, animating, lighting, and rendering individual parts of the movie. It's up to the director to make sure each person has the knowledge he or she needs in order to complete their task, because everyone works on isolated, specific elements which will only come together at the very end. For example, within our main character's apartment living room, there is a La-Z-boy reclining chair. Harley Jessup and David Hong prepare concept sketches. Paul Mica drafts the final designs in front, back, side, top, and bottom views. From these drawings, Dale Ruffolo builds the recliner within the computer. Dan McCoy creates the Naugahyde surface texture. Bryn Imagire paints imperfections, the chair's scratches, scuffs, and dirt. Every single thing *you* see on screen must be designed and built.

Animation is an exacting process. Each animator, for example, produces an average of three seconds of final footage per week. In the end, after a year of work, each animator creates a total of about two minutes of non-contiguous animation. This means we needed around fifty animators to finish the film. Here the director makes sure each scene meshes with the others around it, even though there are essentially fifty actors playing one role. The director tracks continuity and also makes sure each scene communicates the humor, tension, or fear that it is meant to convey.

Luckily, I have lots of help. On Monsters, co-directors David Silverman and Lee Unkrich focus on the story and the layout and editing, respectively. They are invaluable and essential partners in of the creation of the film. Additionally, each department has a leader whose charge is to maintain high quality and efficiency. Still, the director is the only person who knows how every individual element of the film will mesh into the final version—the film itself. And every time I miscalculate, it means more work for someone else.

There are many other areas of the film's production I haven't even mentioned: lighting, rendering, music, and sound effects. Making an animated feature is a huge job, and directing one is the most difficult thing I've ever done in my life. Of course, there are times when I wonder, "Is all this really worth it?"

It's at those times that I think back to myself as a fourth grader at Nine Mile Elementary School in Bloomington, Minnesota, drawing flip-books in the corners of my math text. As I ruffle through the pages, tiny scribbles—each a little different than the last—magically come to life. Even today, it makes my heart race just to think of it.

Pete Docter's words carry the same kind of energy, creativity, and imagination as his animation. His insights, which underscore the

Figure 17-54
One might think that something as seemingly insignificant as a chair wouldn't be important in an animated feature. Hardly. Pete Doctor explains: "Monster aesthetics are a bit different from ours, and we tried to design everything in a way monsters would find pleasing. Though these concepts are clever, eyeballs tend to catch the audience's attention. And nothing in the background should distract from the point of the shot: the characters." Concept drawings for Sullivan's chair by Glenn Kim and Ricky Nierva. These model packet drawings by Paul Mica—and dozens more like them—are given to the computer modelers to help them build Sullivan's chair. "To make objects more believable to the audience, we try to design in a sense of history. Sullivan has used this chair for years, and his spikes and sharp claws wear away at even the toughest fabric. Hence: duct tape. Sullivan sits in the chair during the movie, so it was important that the chair actually fit his oddly proportioned body." Artwork courtesy of Pete Docter, Disney, and Pixar.

details and emphasize the importance of the planning process in any kind of multimedia, provide motivation for anyone considering a career in this field.

Computer animation is not the sole domain of feature films the like of *Tron*, *Monsters, Inc.*, and *Finding Nemo*. Much of animation, though, is still aligned with film; *Star Wars* (which was shot digitally) and, more recently *Harry Potter* have raised the bar for multimedia work within the industry. In fact, many of today's films incorporate computer animation as special effects("fx")—often to the extent that we often cannot distinguish between what was filmed and what was animated or overlaid as a special effect.

However, there are many other applications for multimedia and computer animation. They include but aren't limited to "flying chrome graphic" 3-D animation; advertising; interactive video and computer games; motion rides;

websites; interactive educational materials; and TV and film opening and closing credits. While most of these applications don't require the resources and budgets of features such as *Matrix* or *Harry Potter*, they're still expensive and time-intensive. They also demand the same kind of attention, planning, direction, and meticulous attention to detail as feature films.

3-D Animation: Bringing Manatees Back to Life (Todd Kesterson)

Computer animation may also be employed for public service or pro bono projects. One wonderful example is the 3-D animation work that Todd Kesterson did for the endangered manatee. Kesterson began working with computer graphics prior to the introduction of Apple Macintosh, a few years shortly after the Jurassic Age. About that time, the Commodore Amiga opened the door of graphics and

Figure 17-55
Todd Kesterson has worked as an artist, multimedia designer, and computer animator for nearly twenty years. Some of the clients of his commercial work have included Busch, Nova, *National Geographic*, and PBS—to name a few. He is also a professor of multimedia design and an ecological activist—which reflects his educational background in design and biology. Photograph by Amy Ryan.

computer animation to the average person, making the world of desktop video and consumer-priced computer animation a reality. Today's students may find it difficult to believe that there was a time when powerful graphics and the 3-D options now available on the average PC or Mac were reserved only for a select few—those with access to Cray supercomputers.

For Todd Kesterson, this accessibility under-scores the importance of personal communica-tion—at a moderate cost. He strongly believes in the power of the individual artist, designer, or graphic communicator to use these tools to counter "mainstream" media: messages that are largely created and distributed by a corporate world. He speaks of the motivation and process in the creation of the "Manatees" animation, and he addresses a serious philosophical concern that is a "must read" for anyone contemplating a career in animation or any form of digital graphic communication:

I've spent much of my career working with multimedia, video, and 3-D imagery—as a pro-fessional animator and as an educator. What makes 3-D animation so rich—in part, at least— is that it's based on the concept of virtual space and includes aspects of so many other media components. To get your head into this space, it might be easiest to think of the computer world as a physical movie set, with props, actors, lights, and cameras. All of these pieces can be moved and manipulated to create a desired composition, and each element can be altered over time. What follows is a deconstruction of a 3-D computer animation project, from pre-production planning through final taping. It will give you an apprecia-tion of multimedia and a sense of the evolution

and process involved in creating computer animation.

Background *When I worked at Digital Artworks studio, a director representing Busch Entertain-ment—the parent company of Sea World— proposed an interesting multimedia project. Busch wanted to create a 3-D animation project to raise public awareness of the plight of the endangered manatee. These gentle creatures are often maimed or killed by reckless speed boaters in the inlets and freshwaters just off the Florida coast. The client wanted to alert the audience, both children and adults, of the deadly risks manatees faced and educate them about the animal's peaceful nature.*

Our charge was to create a computer-animated introduction to a multimedia presentation on manatees: to set the tone for the entire project, while accomplishing its educational objectives. The animation also needed to be accurate, credible, entertaining, and visually compelling. The idea was to feature a mother manatee and calf swimming together, and capture their "per-sonalities" through simple body motion.

In addition to the complex animation we had to create, we discovered several other interesting challenges. First of all, manatees aren't exactly meant to do action films; they spend most of their time floating around or grazing—not much to work with to create an essence of these creatures in just over two minutes of screen time for a "visual sound bite." Plus, we had to impart a sense of the underwater environment and needed to add realistic textures and water ripples to the scene. Added to that was the inherent "client factor." However, in this case, there were layers of people involved: the usual client

Figure 17-56
This is a reconstruction of the original storyboards, which use panels that are both motion studies and visual mappings for manatee movement. Storyboards and illustration by Todd Kesterson.

committee, scientific advisors, a producer, a director, and finally, our own studio staff. Understanding this hierarchy and insisting upon clear communication up front can help tremendously, but with so many cooks in the kitchen, contradictory feedback and frequent requests for changes were inevitable. Finally, as with most jobs, we were expected to complete this within a limited time frame and within the budget.

Process *During the pre-production phase, the client presented us with a concept and rough storyboards (see Figure 17-56). It was our task to interpret the storyboards and to modify them as necessary. As principal artist, I immediately headed to the library to learn all I could about manatees. Fortunately, I discovered a biological study with detailed illustrations of the manatee's swimming motion (see Figure 17-57). I was also able to locate video footage and photographs of manatees for both modeling purposes and animation reference.*

Modeling in the computer world involves modifying geometric "primitive" shapes—in this case, building manatees from scratch. The result is a wireframe model, a mathematically defined form in 3-D space with information about each vertex and connecting curve (see Figure 17-58). The model can be rotated, scaled, repositioned, and otherwise modified—either as a whole object or on an individual vertex basis. Once the wireframe was complete, the manatee model was "rigged" with a skeletal structure and controls to simulate swimming through its muscle and body movement.

It was also important to determine how much detail we could create in the manatee's form versus what we could add as texture maps or surface images. Manatees have a relatively simple structure (at least in their physical appearance). This allowed us to produce a rather uncomplicated body shape, creating more detail around the animal's head. Since the storyboards didn't demand extreme close-ups, we opted to add

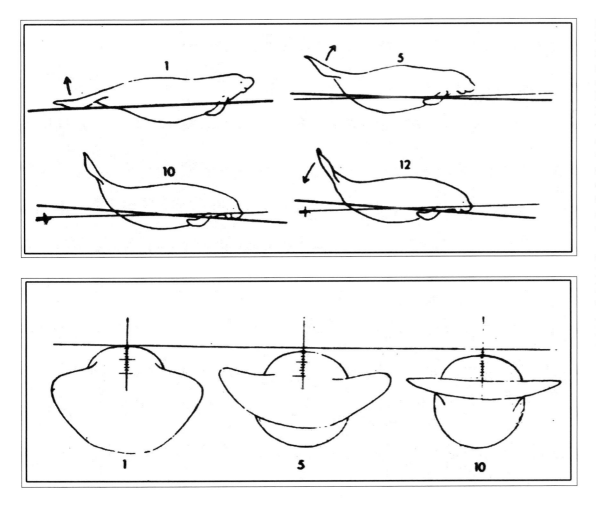

Figure 17-57
Research is an invaluable facet of storyboards and animation that you might not read much about in books on those subjects. However, it is precisely where you should start on any multimedia project. Great animation is a mix of vision, research, creativity, and the ability to tell a simple story in a compelling way. Courtesy of Todd Kesterson. "Ecology and behavior of the Manatee (Trichehus Manatus) in Florida" by Daniel S. Hartman, 1979, special publication - American Society of Mammalogists. Alliance Communications Group.

Figure 17-58
Wireframe designs, while appearing impersonal and almost alien, are created in computers to build an external architecture for a model—in this case a manatee. Courtesy of Todd Kesterson and Digital Artworks.

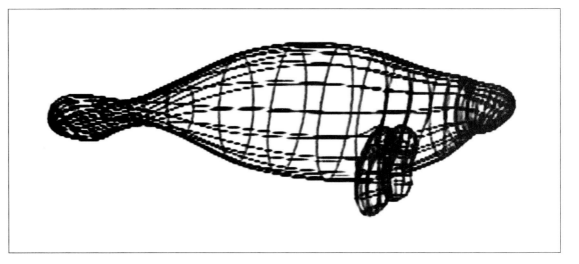

much of the detail in the form of textures rather than modeling. We needed to be extremely accurate with the manatee's texturing while at the same time maintain meticulous continuity throughout the scene's color scheme. That meant insuring that the texture of each form was considered in relationship to the entire scene, and from scene to scene throughout the animation. The same rule applies to all elements of design.

We also created models and textures for underwater vegetation and ground surfaces. These were simple executions compared to the main modeling, so I will skip further discussion of

them. The overall mood for the scene was established through the use of virtual lighting, some of which was created through textured water surfaces to simulate water ripple patterns seen from below (see Figure 17-59).

Animation was concentrated into three categories: model motion, light/effects motion, and camera motion. The manatees moved through virtual space while swimming. Although the basic swim motion is almost identical for the cow and calf, I varied their speed and timing to make the motion of each of them unique. The baby's personality was further enhanced by a graceful roll-

Figure 17-59
This close-up view of baby and mother (calf and cow) manatees demonstrates the power that texture, lighting, color, and backgrounds have upon the *credibility* of computer animation. This image could easily be mistaken for a color photograph. Courtesy of Todd Kesterson and Digital Artworks.

Figure 17-60
A simple, two-minute sequence of a pair of manatees swimming could easily take weeks to create and an equal amount of time dedicated to research, initial renderings, computer work, and literally thousands of frames of imagery. Courtesy of Todd Kesterson and Digital Artworks.

over. Meanwhile, the camera slowly moved throughout the animation to add more life to the scene. The water ripple effect cycles seamlessly, clearly establishing the underwater environment without drawing attention to itself.

After countless tests and changes, the project received final approval, allowing us to complete final rendering at full-image resolution and quality. Hundreds of individually rendered images comprising this final rendition were then recorded on BetacamSP professional video format (see Figure 17-60).

The final step involved creation of the soundtrack. Project One Audio viewed the animation and composed original music for this scene to suggest a peaceful underwater environment, complete with water sound effects. The soundtrack was recorded to synchronize with the animation.

Techno-Slavery and Doing the Right Thing

Today, however, there is an inherent danger working in multimedia. It comes in the guise of a new form of techno-slavery: the "data wrangler" or technician who merely answers to the machine, managing files or performing mundane tasks rather than actively participating in design and the critical evaluation of content. Avoid this situation at all costs.

As artists and designers, you should play a critical role in content development. Beware, though, because the promise of sexy new tools may only ensnare us in their trap, in terms of money, time, and artistic development. It's an ongoing balancing act. But to err on the side of

Todd Kesterson's 3-D Animation Process Checklist
- Researching / planning
- Storyboarding / creating color keys (conceptual art)
- Modeling (wireframe construction)
- Rigging (creating skeletal structure, controls for skin bulging, etc.)
- Texturing
- Adding motion (model, camera, lights)
- Creative effects
- Rendering
- Recording to video, film, or compressing for Web
- Audio recording and mixing

technique at the cost of creativity is to write your own pink slip. It's also a sure path to career dissatisfaction and to complacent participation in work that may not be in your best interest or the interests of society at large. So the "information age" is also the age of scrutiny, flexibility, and guerrilla survival tactics. It's filled with perils, but also with the promise to help shape the design and application of emerging technologies and new forms of communication.

As tools become more sophisticated and accessible, the power of the individual artist/designer to counter the corporate-controlled "mainstream" media increases and offers more opportunity. In a very large sense, the real power of these media is their inherent empowerment—that is, the ability of individuals to produce and dis-

tribute their own work. Granted, much of the world still lacks access to multimedia tools and the Web. But for those who do, the possibilities—and, in my opinion, the "responsibilities"—to use these tools in an effective way are endless. As individual creators, you can provide unique perspectives and fresh content, personally explore relationships to the community and the planet, and perhaps expand and share your artistic vision. Sure, it sounds idealistic, but it's possible. In fact, I left the world of commercial production and advertising in the hope of developing richer, more meaningful messages that I had a personal say in creating. The tools are in our hands, and the stories are waiting to be told.

Animation is a central component of much of multimedia. It's used extensively in films, advertising, websites, medical animation, educational materials, computer and video games, television, artwork, and other media.

Finally, "*Claymation*" is another path to animation that largely dismisses illustration or other two-dimensional rendering and relies instead on recording 3-D clay models one frame at a time. Perhaps more than any other studio, Will Vinton Productions has perfected the art of claymation. Their California Raisins work is still classic, as are many other projects they created, including Rob Siltanen's great "Toy" spot for Nissan Automotive.

Survival Skills For Professional and Student Animators

Like most website and interactive work, animation can be a rigorous and taxing undertaking. To help you maintain your sanity, health, eyes, and sense of humor, what follows is a list of survival skills conceived by Todd Kesterson and William Ryan.

1. Keep a sense of humor. Laugh at the insanity of the job, the industry, deadlines, content, or the questionable taste of some clients. Be willing to laugh at yourself, too. "It's only a movie," after all.

2. Develop a tolerance for criticism and constant, and sometimes arbitrary, feedback from clients and co-workers. While you're at it, grow a thick hide if you already don't have one, and be sure to leave your ego at the door. Concurrently, trust your own voice and vision and share them honestly and openly.

3. Ignore people who seem to think the rest of the world should live as they do. Often, they are miserable people with no life outside of work.

4. Never give all of your artistic energy to any job; reserve some for your own creative projects. Understand your own artistic vision and never stop working toward the fulfillment of that goal, regardless of what you're working on.

5. Be a ruthless editor. Good editing for animation—or any kind of moving imagery—begins before you've recorded a single frame. It's all about planning. It's all about understanding how to tell a simple story with a sequence of images whose point of view, camera angle, composition, and connection to the previous and subsequent frames helps tell the story in an interesting and original way.

6. Find a proper balance between your work and your personal life—one that works for you. Realize that the size, location, mission statement, and values of the company or client that you work for will all have a tremendous influence on your daily life.

7. Simple is better. Strip away extraneous elements that don't contribute to the sense, feeling, or mood of what you're creating. Presentation is everything; attend to details and mesh the voice, sensitivity, and intent with the *content*. Study *other* media for ideas, format, style, and design.

8. Be enough of a specialist to land a job and enough of a generalist so that you offer more than technical skills to a client or your employer. At the same time, be flexible and work to find or create your niche in your workplace or industry, *and* make "learning" your mantra.

9. Take advantage of slow or "down" times to build your skills, update your demo reel, and search out other job prospects. Always get copies of your work (in the highest quality format possible). Also, back up portfolio work.

10. Be a cultural sponge. As pointed out early and often in this text, it's crucial to connect to museums, galleries, design-oriented publications, and art books and to understand older and contemporary culture, as well as its push-pull effects. Know your roots and past legacy of fine and graphic arts as well as you do the current scene.

11. Study comic books, storyboards, film, and other animation; deconstruct them and notice how illustrators, animators, and filmmakers use

point of view in their work and how it affects communication. Point of view is a significant aspect of telling stories visually. You can never learn enough about using perspective, interesting camera angles, and viewpoint in animation or any kind of moving imagery.

12. Promote yourself and your art through competitions, film festivals, lectures, or other opportunities. People have to see your work before they can respond to it or offer you a job. Network regularly through tradeshows, workshops, and informational interviews and take full advantage of professional organizations connected to your field of expertise—on local, regional, national, and even international levels. Contacts often *do* lead to jobs. Good public relations is essential to the success of both individuals and agencies.

13. Follow through on your commitments. Deadlines are real. A missed deadline can cost you a client or your job.

14. Always track your hours. This will help you monitor your efficiency and help you estimate bids for other projects. Always add an "X" factor to every bid to account for unforeseen challenges that almost always arise.

15. Take daily walks. It's healthy for you physically, mentally, and emotionally. It's also a great time to think out a problem or break down a creative dilemma.

16. Be thorough and professional, but avoid perfectionist tendencies. Let the client do the nitpicking.

17. Know when to stop, particularly with "spec" work and rough cuts. Remember the law of diminishing returns: You'll spend the same amount of time/energy to achieve the last 10

percent of quality that you spent for the first 90 percent.

18. Don't underestimate your own worth. Avoid working for free or for ridiculously low wages, unless you realize real benefits, for example, internships, personal satisfaction, or unprecedented exposure. Of course, pro bono work is an exception here as well. Maintain a strong social awareness and conscience, and support social causes important to you.

19. Animation may be a representation of life, but it's a poor substitute for it. Step away from your monitor or drawing table long enough to give yourself a needed break.

20. Get a good chair and don't forget to look away from the monitor and blink your eyes once in awhile. You'll realize long and short term benefits as a result.

The Future of the Web, Interactive Formats, and Multimedia

Like time, design and technology are not static propositions. The future has seamless though often neglected connections to the past. Understanding earlier fine and graphic art history is not only good connective sinew to your graphic heritage, it provides you a grounding and grasp of the transformations that helped shape contemporary design. That background will also provide you with additional creative muscle to help shape the future. As part of the next generation of visual communicators, it's important that you bring that understanding and perspective to your vision and to your work.

Technology and its software, hardware, and specific production techniques are in continual flux (see Figure 17-61). Yet the connections

Figure 17-61
National Geographic photographer Cary Wolinsky used graphic designer Barbara Wolinsky (founder of Trillum Studios) to design this clean and very accommodating interactive site. It was built by Aurora and Quanta Productions in Portland, Maine and is now part of the Independent Photographers Network operated by Photo District News in New York. Cary Wolinsky noted, "The site serves two audiences. One group includes the casual browsers, students and people who want to buy prints. The other is made up of publishers who want a simple way to view and license my work. We are working on a new design to make the navigation a bit cleaner." The refinements in most interactive media are ongoing ventures. Artwork courtesy of Cary Wolinsky.

between old and new are relevant, regardless of whether we're talking the typewriter and its relationship to today's computer keyboard or the television monitor's kinship to the computer monitor. Indeed, the shortcomings of our old technology provide incentives and direction for new technology. Even the Internet and its facility for "links" to related information is nothing new; *The Bible* uses sophisticated and engaging linkages to scripture. Edward Mendelson provided readers of *The New York Times Book Review* an eloquent and insightful analogy between scriptoria and the Web in "The Word and the Web." Mendelson notes: "Medieval manuscripts of *The Bible* were the first books to be interconnected by a system of cross-references. Biblical cross-references, unlike most of the links on the World Wide Web, always point in both directions. A link from the Old Testament to the New is mirrored by a link from the New to the Old." Wonderful influences from the past are all around us; all of them point to the future.

Like technology, visual styles are constantly changing as well. Over the past twenty years or so, technology and our graphic tools have been radically transformed. Concurrently, the demand for skilled and well-educated visual communicators has snowballed. Not only are media becoming more visual, older media are morphing and borrowing from the new ones being spawned. The symbiosis is an intriguing one. Concurrently, the changes and responsibility for designers, illustrators, graphic editors, animators, photographers, filmmakers, and art and creative directors have also increased dramatically. Clearly, the future of media is a digitized one, and the visual charges of the new guard will be more demanding—technically, creatively, and graphically (see Figure 17-62). In a recent column in *Communication Arts* magazine, Patrick Coyne asked: "So who is going to be doing the (graphics and design) work in the future?" His answer is as interesting as his question: "Creatives with exemplary creative skills who understand the overall media landscape, are up-to-date on the latest production processes, have good networking skills, and are able to communicate the value of what they do to potential employers and/or

clients. Exposure to all the arts and culture in general is going to help give you more creative solutions. This is not a good field for operating in a vacuum."

Digitization has affected all media permanently —or until the next huge technological breakthrough. Some other future developments include:

- The Internet will become *larger* and more user-friendly.
- Dedicated phone and cable lines will become more common and cheaper to use, and many will be linked with other media.
- Computers will continue to increase in speed, memory, and functions available to their users. Jacob Neilsen suggests that the average hard drive will hold a terabyte of memory in the next five to ten years.
- Television and the Internet will continue to merge. Obviously, too, many television cable companies (whose names and designations are already shedding the "television" moniker) will have a stake in further blurring media boundaries.
- Bandwidth will continue to increase along with graphics, communication, and other needs.
- Wireless technology, which is already a reality, will extend communication possibilities and our availability to anyone seeking us out.
- Coding will be simpler and more intuitive.
- Plateless and more sophisticated digital production will become the norm.
- "Mobile" Web-enabled cell phones and PDA technology will become more powerful and common and will provide more functional options.
- Media will continue to converge.
- 3-D animation will persist in its gravitation toward photo-realism.
- Gaming and interactive entertainment will increase in popularity and become more *interactive.*

To be sure, the future will bring change and offer designers, other graphic communicators, and users a brave new world loaded with remarkable technical innovations and even additional "new media."

The above forecast is a conservative one. Jakob Nielsen, one of the world's most celebrated authorities on usability and the Internet, has a long list of rather interesting "long-term" predictions for the Web and interactive media in his book *Designing Web Usability*. These include—but certainly aren't limited to—the following:

- The real estate market will be severely affected because the computer and Internet will continue to extend autonomy to the average person, and we will have a rebirth of the cottage industry.
- Large corporations will become more fixed on "maintaining brand recognition while all real work is done by loosely coupled networks of virtual workgroups spread around the world."
- E-mail and the Internet will eventually eliminate the need for The Post Office, at least as we know it now.
- Because of the abundance of wireless PDAs, our privacy will become even more seriously compromised.
- Web pages will no longer be designed for a fixed screen size because of the onslaught of PDA technology, television-Internet symbiosis, and other monitor-size issues.
- Browsers will disappear as a "separate application category."

Nielsen's book is a compelling read and offers a lot more than supposition about the future; as its name implies, the text is a handbook on integrating design, navigation, content, and usability in the creation of websites.

While most readers likely won't recall this scenario, there was a time when personal computers didn't exist. More recently and *not* very long ago, the average computer didn't have enough memory to drive the simplest and most stripped down version of any of today's software, and monitor screens were roughly the size of a postcard. While you can quibble about many downsides of a free-enterprise system, today's marriage between commerce and technology dramatically increases the research and development of computers, peripheral products, and computer-related materials, thus expanding the role and possibilities of graphic communication.

Figure 17-62
The Society for New Design is well aware of our digitized world and has embraced technology, design change, and the future perhaps more than any other facet of the newspaper industry. The mix of media offered its membership—magazine, website, newsletter, and design annual—exemplifies their commitment to design and to the many challenges facing newspapers today. Courtesy of the Society for News Design.

However, do not underestimate the power of the mind and the #2 Ticonderoga pencil. As Aldous Huxley noted, truly seeing is more a process of the mind and our experience, not just our eyes. The greatest ideas and the finest artwork weren't created by technology; they were created by human beings. David Lance Goings is an important author (*A Constructed Roman Alphabet*), designer, historian, founder of St. Hieronymus Press, and sometimes contributor to *Communication Arts* (CA) magazine. This excerpt from his recent essay "A Brief History of Pre-Electronic Printing" in *Communication Arts* provides a fitting conclusion to this chapter: "Wise designers will become acquainted with their legacy, and remember above all that good work is independent of technology. Change is the heart of design." To that, Hal Curtis would add: "There's culture all around us. Pay attention."

Graphics in Action

1. Bring the address of your favorite website to class. Open it up and walk your classmates and instructor through some of the highlights and special features of the site. (Prepare your "walk-through" ahead of time and take no more than 5 minutes to present it.)

2. Surf the Web, looking for a badly designed corporate website. It does not matter what kind of site it is—e-commerce, portal, informational, newsletter, or advertising—as long as it isn't a personal site. Using this chapter's discussion of what makes an effective design—usability, navigation, voice, effective typography, interactivity, and so forth—write a full critique evaluating the website for each of the above.

3. Divide up into teams of 2-4 students and select a specific product category. (Bicycles, blue jeans, cell phones, computers, compact cars, and sunglasses are but a half-dozen examples.) Then search out the websites of 4 to 5 different brands within that product genre. (For example, bicycles might include Schwinn, Giant, Huffy, Specialized, Cannondale, or Burley.) Choose the website that would most likely convince you to purchase a product based upon the company's website, and the site that is the least compelling. Make sure that each person on the team of students chooses her/his best and worst sites. Each team should evaluate product categories different from those opted for by other teams. Each team member should prepare short written critiques of the different websites, citing their respective strengths and weaknesses.

4. Using publications such as *Wired*, *Communication Arts*, *Print*, *PC World*, *Mac User*, or *ID* magazine, research current Web and interactive trends. Find a trend that especially interests you (either pro or con) and prepare a 3- to 8-page report on it.

5. Working in a team of 2 to 4 students, *plan* a website for a local band. Before you even turn on a computer, research the band and its music, audience, and mission or goals and decide upon the *content* of the site. After you've made those assessments, draft several initial site maps, gray models, and a content matrix for the website. How will typography figure into the project? (See Planning and Site Architecture.) Bring your overview and plan to class and discuss.

6. Keeping audience, content, intent, and usability in mind, construct a website for the local band that you selected (in #5 above). What will it contain? How will you present band members, music, lyrics, background information, tour dates? Will it offer music (sound)? Animation? Shoot your own photography. Write your own notes and select your own stylebook for the use of type, color, and graphics. If you opt to use videostreaming or animation, create your own moving imagery.

A

Abstract expressionism A school of art that relies on a highly intuitive and emotive approach to nonrepresentation where the art and act of painting itself superceded content. Heroes of this 1950s movement included Jackson Pollock, Wilhelm de Kooning, and Mark Rothko.

Access To retrieve information from a storage device (internal memory, disk, tape). Access time is the time it takes to retrieve the stored data.

Accordion fold Two or more parallel folds with adjacent folds in opposite directions; a format that opens much like an accordion, usually a brochure.

Achromatic The absence of color; black, gray, or white.

Additive primaries Colors that when combined, produce white light.

Advertising campaign A series of ads that communicates or underscores the basic voice, style, and context of a series of ads; continuity is central to the success of the campaign and its components.

Agate Type or a unit of measurement that is 5½ points in size. Fourteen agate lines equal 1 inch.

Alignment The positioning of letters so all have a common baseline; it also refers to the even placement of lines of type or art.

Alphabet length The width of lowercase (usually) characters when lined up a through z.

Ampersand The symbol used for and (&).

Analogous color Two colors immediately adjacent to each other on the color wheel.

Animatic A rough videotape of stills, dialogue, narration, and music to suggest the content, voice, and style of a television, animation, film, or multimedia piece.

Animation A series of frames or cells moving in swift succession to produce the illusion of continuous motion.

Annual report A yearly financial accounting and overview of a company, business, or institution; the Securities and Exchange Commission (SEC) mandates that all publicly owned companies produce a yearly report detailing the financial state of the company.

Antialiasing The technique of smoothing out pixelated edges of type or graphics by blending color and background.

Antique A coarse, textured, and uneven paper finish.

Aqueous coating Water-based varnish used to clear-coat paper.

Art deco A ubiquitous decorative style of art of the 1920s and 1930s that was characterized by streamlined objects and diagonal lines, as well as strong geometric elements.

Art nouveau A decorative style of the late nineteenth century that often employed sinuous line and organic forms. It also incorporated features of Japanese art and often depicted simple scenes from everyday life.

Ascender Any lowercase letter stroke that runs above its x-height or mean line.

Asymmetry A more playful and sprawling approach to balance that employs counterbalance to achieve a visually pleasing design; elements are not centered up along an axis. Asymmetry tends to be informal.

Audience The group to whom your design or layout is targeted.

Auto-leading A default setting that most computer design software programs use; normally, 120% of the type's point size.

B

Back shop The production end or area of a printing company.

Backslanted posture Type that is slanted or raked backwards.

Balance Equalizing the weight on one side of a vertical axis with the weight on its opposite side.

Bank One line of a multiline headline.

Banner A large multicolumn headline, usually extending across the top of page 1 in a newspaper.

Bar chart A graphic way to present statistical information horizontally, using the left side as the baseline or starting place.

Bar line A single-line header or one-line deck, also known as a cross bar.

Baroque A flamboyant and often elaborately ornate design form that characterized the style of seventeenth- and early eighteenth-century Europe.

Base alignment The positioning of characters so the bottom of the x-height lines up evenly on a horizontal line; in phototypesetting this alignment is used for the even positioning of different type styles on a common line.

Baseline The imaginary line that anchors uppercase and other letters.

Bauhaus A German school that offered instruction in all the arts with the underlying idea that form follows function; the Bauhaus also believed that art should be functional. Bauhaus fostered the idea of applied arts.

Ben Day The regular pattern of dots or lines used to add tonal variation to line art.

Bézier curves Curved lines that are used in computer illustration for drawing and type rendering. These points set the shape of a curve.

bf The designation for setting type in boldface.

Big idea The main idea, concept, or strategy of any graphic message, especially in persuasive messages created for advertising, public relations, identity, or marketing communications.

Bilateral symmetry Another word for symmetrical balance.

Biological responses Inherent, unlearned physiological reactions.

Bit Binary digit. This is the single digit of a binary number; 10 is composed of two bits. Also the unit of information making up the digital or dot image of a character or graphic; small parts of a letter; just little dots.

Bitmap graphic A graphic image document formed by a series of dots, with a specific number of dots per inch. Also called a "paint-type" graphic.

Black Letter A very angular, complex, and dark typeface often seen on newspaper mastheads, also known as "grotesques." Black letter is the oldest race.

Bleed Artwork that is run beyond the perimeter of at least one side of the page.

Blind emboss The raised, uninked surface (embossment) on a piece of paper.

Block A group of words, characters, or digits forming a single unit in a computerized system.

Block letter A letterform without serifs (the finishing stroke at the end of a letter), in the sans-serif type group.

Blueline A photosensitive proofing page using blue emulsion on white paper; a generic term for rough page proofs a printer provides a client for correction purposes.

Blurb Copy written with a sales angle, usually in brief paragraphs, and typically on magazine covers; also referred to as coverlines.

Body copy The message or text of the ad; usually follows the headline.

Body type The text or copy; generally, type that is run at 7 to 12 points.

Boldface Characters of normal form but heavier strokes.

Bond paper A strong, durable paper stock that is commonly used for letterheads, envelopes, and business forms.

Book type style Slightly narrower version of a normal type style that is often used in book publication to save paper and ink.

Boot Turning on a computer.

Border A frame around the type, art, or complete layout in either plain lines or an ornamental design.

Bowl The interior part of a letter in a circle form such as in a b, c, d, or o.

Box A border or rule that frames type; also referred to as keyline.

Bracketed serif A serif (see below) connected to the character stem with a curved area at the connecting angle.

Bracketing Shooting a photograph at the metered setting and exposing several more frames that slightly over- and underexpose the same composition to ensure a good exposure.

Branding The process of establishing and maintaining the identity, image, and association of a product, service, or company; good branding may result in top-of-mind associations: Nike with athletic footwear; McDonald's with hamburgers; Coca-Cola with cola.

Break of the book The allocation plan or master plan for using editorial and advertising space in a magazine.

Break of site The page arrangement and levels of a site; a Web site's version of the magazine's break of book.

Bridging A unity or connective device used to unify two or more pages of a layout.

Brightness The reflectance value of a paper stock, or the measure of the amount of light that is reflected from the paper; brighter papers do a better job of reproducing photography and other artwork.

Briefer A short paragraph (or "nut graph") that summarizes the content of a story in a sentence or two; briefers normally appear atop or aside the beginning of a story to offer "at a glance" synopsis for the reader.

Broadsheet A standard-size newspaper page as contrasted to the small tabloid size.

Brownline A brown-line image on a white background.

Browser An informational search service that provides precise organizational maps to the Internet; a user's basic computer format connecting it to the Internet, for example, Netscape or Microsoft Internet Explorer.

Bulk The thickness or caliper of paper.

Bullet A round, solid ornament resembling a large period: •.

Byte A number of binary digits, or bits, needed to encode one character such as a letter, punctuation mark, number, or symbol.

C

CD-ROM An acronym (Compact Disk-Read Only Memory); a disc used to store digital data.

CMYK Cyan, magenta, yellow, and black.

Calendaring The process of smoothing paper by passing it through a series of rollers used to smooth, flatten, and sometimes coat a paper stock.

C&lc The symbols for setting type in which the first character of each word is capitals.

Camera-ready The completed image from which a printing plate is made.

Capitals Large characters, the original form of Latin characters.

Caption The term used in publication layout for the explanatory matter accompanying art; usually called a cutline in newspaper editing.

Card A printed circuit board; computer systems are made up of these boards.

Cardboard Also referred to as tag board, this stock is a heavier, stiffer version of index paper.

Caslon, William A type designer who lived in England in the early eighteenth century.

Catchline A line of display type between a picture and a cutline.

Cathode ray tube (CRT) An electronic tube used to project images on a screen; it is also called a visual display unit; a television picture tube.

Centered alignment Type is centered or set "neat center" in a column.

Channel noise Any problem or distraction inherent within or around the medium used; for example, bad TV reception, a newspaper photo that is out of registration, a Web site that freezes, or film that has slipped out of the projector's sprockets.

Chroma The intensity of a color.

Clip art Inexpensive camera-ready or digital line illustration available through graphics services companies.

Clipboard A temporary holding place for material, in the computer. You can temporarily store text, graphics, or a group selection on a clipboard for later use.

Cloning Pixel manipulation used in image processing to add or remove detail in a picture.

Cluster caption Combining a series of captions for several pieces of art and running them together in one large paragraph or cutline.

Coated stock A finished paper stock with a smooth and often glossy surface.

Cognitive theory An explanation of visual communication that asserts that perception involves a myriad of mental processes: interpretation, memory, comparison, salience, association, inventory, analysis, and recognition.

Collateral materials Secondary or supplementary media that reinforce or run parallel to a public relations or advertising campaign.

Colophon The data about design, type styles, and production of a book; usually found at the end of the book.

Color wheel An ordering system of color values established by Albert H. Munsell.

Column chart A graphic way to present statistical information vertically, using the left side as the baseline or starting place.

Combination Halftone and line on a single printing plate.

Communication The process of conveying and understanding information.

Communication mix A combination of media selected to sell and reinforce the advertising or marketing message; also referred to as media mix.

Complementary Colors positioned directly across from one another on the color wheel; also known as contrasting colors.

Complete communication Consists of five parts: sender, message, medium, receiver, and feedback or some way to indicate that the message was understood.

Composition The arrangement, organization, or grouping of an image's (or layout's) parts into a cohesive whole; establishing order in a photograph by using framing, selective focus, contrast, linear thinking, juxtaposition, and other compositional strategies.

Comprehensive A layout or mechanical that is shown to the client to simulate the final product; also know as "comp."

Computer graphics Any charts diagrams, drawings, and/or art composed on a computer.

Condensed type style A narrow and diminutive style of a family's type.

Constants The typographic and graphic elements in a publication that don't change from issue to issue.

Constructivism a. an explanation of visual communication initiated by Julian Hochberg that suggests we make visual sense of our world through ocular fixations on a pattern of shapes, or visually arranging a series of planes together. b. an abstract art movement that originated in Russia shortly after World War I that was characterized by the exploded arrangement of geometric shapes and planes; its nontraditional configurations influenced futurism, de Stijl, the Bauhaus, and other modernist art movements.

Content matrix An outline of the Web project that clarifies what content the client is responsible for delivering and when it is due.

Continuous-tone image A photograph that contains black and white with a full range of grays between them; a full-color photograph.

Contour type Wrapping text around, within, or aside the graphics within a layout or design; often called a rebus design.

Contract proof A color proof that printer and client agree is exactly how the printed product will appear.

Contrast Placing light elements atop dark ones or vice versa; two opposite elements or concepts in context: rich and poor, or life and death, for example.

Copy The text or information to be printed.

Copy block A segment of body type or reading matter in a layout.

Copy fitting Determining the area a certain amount of copy will occupy.

Counters An area of a letter that is enclosed; as enclosed areas of a lowercase e or o.

Cover stock A stiff, heavier paper stock that is normally used for the covers of pamphlets, book jackets, magazines, etc.

Creative strategy A formal rationale that articulates the audience, goal, analysis, and intended reaction of a communication; most all advertising and public relations messages are based upon marketing and creative strategies.

Crop To edit a photograph or graphic by removing parts of the artwork.

Credits Attribution paid to the writer, photographer, illustrator, and others responsible for the story or work.

Cropping L The two right angles used to frame art to determine where it should be cropped.

Cross bar Single-line header or one-line deck; also known as a bar line.

Crossing heads Terse headlines sunk into the story to break up space and show transitions of time and locale shifts within a story; crossing heads are usually set only slightly larger than the text, bolded, and given extra leading above and below their place in the text.

Crossover Artwork that bridges or straddles two pages.

Cubism A school of art that uses semi-abstract forms which suggested an essence rather than representing it, often by presenting several perspectives of the object simultaneously. Braque, Picasso, and Cézanne used cubism in much of their work.

Cuneiform The Phoenician phonetic writing system.

Cursive type A typeface that "mimics" handwriting, but whose letters are not joined.

Cut A piece of art ready for printing; originally referred to as a mounted engraving used in letterpress printing.

Cutline The descriptive or identifying information printed with art; a caption.

Cutoff rule The dividing rule between elements, usually used in newspaper format.

Cyan A vivid blue color used in process (full-color) printing.

Cyberspace The Internet region reached through computer browsers.

Cylinder press A printing press in which the form to be printed is flat and the impression is made on paper clamped on a cylinder that is rolled over the form.

Dots per inch (dpi) A measurement used for designating the resolution of artwork in printing.

DVD A digital video disk, a sophisticated digital storage format sharing the same dimensions and look as a CD; the DVD's greater storage capacity allows it to handle much larger messages and documents (feature films, for example), interactivity, multichannel audio, and other features.

Dadaism A school of art founded by Arp which adopted a philosophy that emphasized the absurdity of life and questioned what constituted art objects.

Daguerreotype An early photograph produced on a silver or silver-laced copperplate invented by Daguerre.

Dandy roll A roll used in the papermaking process that produces different types of finishes.

Dash A small horizontal rule in layouts; also a punctuation mark.

Database A collection of information that is organized and stored so that an application program can access individual items.

de Stijl Literally "the style." A Dutch art movement that adopted the very close association between fine and applied arts that the Bauhaus espoused; its rectangular forms and primary colors had a huge influence on editorial design and helped establish the grid as a basic design tool.

Deboss A recessed embossment.

Debugging Correcting errors in programs, especially Web sites and interactive materials.

Decisive moment photography A phrase coined by French photojournalist Henri Cartier-Bresson which espouses that there's a critical moment when the lighting, composition, expres-

sions, action, and essence of an event intersect, providing a precise moment that captures the "essence" of the action or event.

Deck A sentence or short paragraph used in conjunction with the headline (usually set below it) to tease or flesh out the story's content.

Demographics The social and economic characteristics of a selected group of people, including age, sex, education, and income.

Densitometer A device used by press operators to measure how much ink is being applied to a page.

Density The lightness or darkness (contrast) of a photo or image.

Descender Any lowercase letter stroke that runs below its baseline.

Design To conceive or plan a graphic message for a specific purpose or function that is conceived to be communicated to a specific audience.

Die cut A special printing method using a machine to punch a hole or pattern into paper.

Dingbat A typographic ornament.

Display type Generally, type that is run at 14 points or larger; typically, headlines, decks, pull quotes, and other nontext type is classified as display.

Doctor blade An arm on a gravure press that scrapes and cleans off the excess ink from the recessed wells on the plate.

Double pyramid The placement of advertisements on a page or facing pages to form a center "well" for editorial material.

Double truck A single advertisement that straddles or crosses two facing pages or newspaper layout.

Download To transfer data from one electronic device to another. You could download information from one computer to another with a modem, for instance, or you could download information from a hard disk to a floppy disk.

Downloadable fonts Fonts that you can buy separately and install so as to expand the variety of fonts available on your printer.

Downstyle Setting only proper nouns, acronyms, and the first letter of the first word in a sentence in uppercase; everything else is set in lowercase. The text for this book and the copy for most publications are set in downstyle.

Dropped initial letter A letter inserted into the first word of an opening or transitional paragraph in a publication which is set much larger and placed within, aside, or atop the copy bock.

Duotone A two-negative, two-color halftone made from a screened photograph.

E

E-business Browsing, interacting, or doing business electronically with a company or institution over the Internet.

E-mail Electronic messages sent and received electronically through computers.

Ear The editorial matter alongside the nameplate (the name of the publication) on page 1.

Ecological theory An explanation of visual communication espoused by James J. Gibson that suggests we rely on spatial cues and surface properties within the environment to make sense of what we see.

Em A unit of typographic measure that is the square of the type size in question; for example, an em at 12 points would be 12 points high and 12 points across. It is also referred to as a "mut."

Embossing A raised, Braille-like impression on paper, created by using convex and concave dies to elevate the paper's surface; it produces a third dimension on the page.

Emphasis Giving a single element (usually artwork) within a page or layout visual importance or significance; emphasis may be achieved by size, color, isolation, incongruity, and other methods.

En A unit of typographic measure that is one half the width of an em; at points, an en would be 6 points in width. It is also referred to as a "nut."

Enameled A process that uses enamel or some other chemical to give a smooth finish on the paper's surface.

Endmark A character or logo that literally marks the end of a story, chapter, or magazine article; this device is a carryover from the scribes and the pre-printing era.

Engraving A printing process that recesses, or engraves, type, a logo, or artwork onto a page.

Entry point An area a designer uses to attract vision to a spot on the page, often to steer our vision to the beginning of a story; common entry points include thumbnail photos, dropped initial letters, color blocks, or rebus elements.

Expressionism An emotive school of art that was distinguished by its raw, almost crude, primitive presentation. The style reflects the philosophy that life needed to be stripped bare and reduced to its essentials.

Extended A form of type in which the normal character structure is widened.

F

Face The style of a type, such as a bold face.

Families A specific typeface for example, Caslon and all of its styles and variations: Calson light, Caslon book, Caslon bold, Caslon italic, Caslon bold italic, etc.

Felt side The side of a paper that was away from the wire mesh during the manufacturing process.

Fever chart Also referred to as a line or rectilinear chart, using a singular plotted line with multiple points to show change along a timeline or some other constant.

Figure Dominant or featured element in a design.

File A collection of stored information with matching formats, the computer version of filing cabinets.

Flag Synonymous with nameplate; the name of the publication in a distinctive design.

Flatbed press Version of the letterpress that uses a sliding flatbed that accepts a sheet of paper as the bed slides back and forth beneath the impression cylinder.

Flexography printing A printing process that is water-based and is very similar to offset printing. The ink comes in contact with an engraved anilox cylinder that distributes the ink to another cylinder, which makes an impression on the paper. The plate is a flexible letterpress-type plate; hence the name.

Floating flag A flag set in narrow width and displayed in a position other than the top of a page.

Flush left alignment The left side of a type in a column is set neat or flush left, but its right side is ragged. Flush left is also referred to as ragged copy or ragged right.

Flush right alignment The right side of a type in a column is set neat or flush right, but its left side is ragged. Flush right is also referred to as ragged left.

Foil emboss A thin layer of metal or metallic pigment is fused atop the embossed or raised surface of the paper.

Folio line Originally a page number, but usually now the line giving date, volume, and number; or page number, name of publication, and date in small type on the inside pages.

Font All of the characters and numerals available to a specific family variation of a typeface at a given point size. Technically, computers and computer software use the term font incorrectly and interchangeably with typeface.

Footer One or more lines of text that appear at the bottom of every page, similar to folio lines or running feet.

Format The basic size and shape of a magazine or other medium, along with its typographic constants and physical features that basically remain the same from issue to issue.

Formula The mix of information, articles, reviews, features, profiles, and other information that will be included in each issue of a magazine.

Foundry type Printing type made of individual characters cast from molten metal.

Frames The outer page margins, the white space between columns of type and pages, and the white space used to literally frame the various elements of a magazine's content.

Framing Enclosing an element within a frame to set it off from its background or the rest of the composition.

Front of book The area often the front of the magazine where short articles appear, often several unrelated pieces running on the same page; also known as back of book, for obvious logistical reasons when small unrelated pieces are placed at the back of a magazine.

Full bleed Artwork or a graphic element that is run off all sides of the page.

Full color A term indicating four-color printing; also referred to as "process" color or CMYK (Cyan, Magenta, Yellow, Black).

Full line Cross bar that fills the entire column width.

Futurism A school of art linked to the writing community characterized by typographical anarchy.

G

Galley A three-sided metal tray used to hold type; the term also refers to long strips of printed photographic or cold type ready to be proofread and used to make paste-ups.

Galley proof The impression of type used for making corrections.

Gestalt philosophy A psychological explanation of visual communication based upon the analyses of visual stimuli, observation, and response that suggests that visual perception is derived by organizing graphic elements or pieces into groups. Its primary premise is the idea that the whole is different from the sum of its parts.

Gigabyte A thousand megabytes or one billion bytes.

Gothic A group, or race, of monotonal types that have no serifs; also called Sans Serif.

Grain The direction that fibers lie in a sheet of paper.

Gravure printing A process that prints from a recessed plate, also referred to as intaglio printing.

Gray model A bare bones site blueprint used to show content and to demonstrate its structure, depth, and logistics or user pathways.

Grid See Mondrian design.

Gridding A rectangle containing many smaller rectangles within it that is used by designers and photographers to plot and organize their respective space; the modules created demarcate stories or message parts from one another. In photography, grids are akin to framing.

Ground The background or subordinate areas within a design.

Ground thirds Breaking up the space within a layout into roughly one-third and two-thirds parts; the concept is related to the Greek golden mean or golden oblong.

Grotesk The European name for Gothic type.

Gutenberg, Johannes Refined a moveable type printing process that revolutionized European culture.

Gutter The margin of the page at the point of binding, or the inside page margin.

HTML(HyperText Markup Language) An acronym commonly used for the coding and sets of commands used to format an interactive document for the Internet.

Hairline The thinnest rule used in printing, or the thinnest stroke in a letterform.

Halftone A process that converts a continuous-tone image into a series of dots or lines so that it can be printed.

Halved imagery Breaking images or fields into halves; one-half foreground/one-half background.

Hanging indent A headline style in which the first line is full width and succeeding lines are indented the same amount from the left margin.

Hanging punctuation Punctuation set outside the margins of justified text. Some designers consider this to be aesthetically superior to setting punctuation within the line length.

Hard copy A printout of your design or text.

Hardware The actual equipment that makes up a computer system (see also Software).

Head An abbreviation for headline.

Header The headline of a story, feature, report, print ad, or a title or label.

Headline The title of an article, feature, advertisement, news story, or other message; the single most important typographic element in an ad.

Headline schedule A chart showing all the styles and sizes of headlines used by a publication.

Hieroglyphics A writing system that used pictographs to represent words, ideas, and sounds (phonograms).

High gloss A coated or varnished paper surface used to enhance the reflectance properties of the paper to ensure excellent reproduction of photographs and artwork.

Highlight The lightest portion of a halftone photograph; the area having the smallest dots or no dots at all.

Histogram A chart (step chart) whose columns touch; histograms measure two variables concurrently.

Horizontal bleed Artwork run off the left and right sides of a page.

Horizontal makeup An arrangement of story units across columns rather than vertically.

Hot metal Type, borders, and rules made of molten metal cast in molds.

Hot stamping A thermo-printing process that transfers a foil material to a paper's surface.

Hue The gradation of a color or the color seen.

Huxley-Lester model An explanation of visual communication that suggests that sight and thought are inseparable; specifically, too, that "the more we know, the more we see; and the more we see, the more we know."

Hypertext A word, sentence, or paragraph of the copy or site that when clicked, takes you elsewhere.

ISSN An acronym for International Standard Serial Number; an assigned registration number used for books.

Icon A small graphic image that identifies a tool, file, or command displayed on a computer screen.

Iconic sign A symbol that resembles what it signifies; for example, a photograph.

Imposition An arrangement of pages for printing so they will appear in proper order for folding.

Impression cylinder A printing press unit that presses paper on an inked form to make the print.

Impressionism A style or theory of painting popularized in late nineteenth-century France; technically, it often used separate daubs or strokes in primary unmixed color to simulate actual "reflected light." Degas, Renoir, Monet, and Manet were among the painters of this important movement.

In-house Work produced by a company or organization for itself; it is created without the direction or help of an ad agency, design, or other company.

Incongruity Presenting an element or subject out of its normal context; this ploy is often used to achieve an unusual, ironic, sarcastic, or humorous spin on a message.

Index stock Stiff, utilitarian paper.

Indexical sign A symbol that suggests some causal or other connection to something: smoke suggests fire; dark clouds suggest an approaching storm.

Info-graphic An illustration that visually integrates easily digested data in charts, graphs, and miniature storyboards; often they include pictographs or illustration to personalize or dramatize their presentation.

Initial The first letter in a word set in a larger or more decorative face, usually used at the beginning of an article, section, or paragraph; also known as dropped initial letter.

Ink-jet printing A method of placing characters on paper by spraying a mist of ink through tiny holes in the patterns of the characters.

Insert Reference lines inserted into the body of an article; also called a refer or sandwich.

Intaglio A printing method in which the image is carved into, or recessed, in the plate; also called gravure.

Integrals A color proof process that combines or integrates the color separations into one print; also known as a "match print."

Interactive A communication process that allows immediate, two-way (or more) communication between senders and receivers of messages.

Interface In media, common lines or boundaries shared by computer components or computer systems where two different systems mesh.

Internet The global network of high-speed telephone lines (and wireless technology) used to link, carry, and send computer messages and other information; also known as the Web or information highway.

Inverted pyramid A headline style in which each centered line is narrower than its predecessor; term is also used for a newswriting form.

Isolation Setting a design element apart from the other elements within a layout or composition.

Italics A typographic style first developed by Aldus Manutius that is not only pitched forward, but also smaller in stature and slightly cursive.

Jaggies The ragged edges of an image that are produced when a digital or circular line is scanned into a system. Jaggies are caused by lack of resolution; some say they resemble stair steps.

Jim dash A small rule usually used to separate decks in a headline or title.

Jump head A headline on the part of a story continued from another page.

Justified alignment Copy that is set flush left and right except for paragraph beginnings and endings.

Juxtaposition Featuring the main element of a design by facing it in the opposite direction from all the other components of a layout.

K

Kerning Grooming a small amount of type such as a headline or title by adjusting the space between individual letters in a word.

Keyline A line used to frame illustrations or photography; also referred to as a box or "boxing."

Kicker A headline that usually appears above or below the interior logo of a publication.

L

Laid effects A paper with a pattern of parallel lines giving it a ribbed appearance.

Laser printing A printing process that uses a tiny pinpoint of light that passes through a finely tuned optical system and projects on a light-sensitive drum.

Layout The arrangement of structure of a publication, Web site, ad, or other medium's basic components: type, copy, artwork, and other elements.

lc The abbreviation for lowercase.

Leading Line spacing or the amount of space designated between lines of type; leading gets its name from the strips of lead or lead alloys old-time printers inserted between lines of type.

Legibility The visibility of a typeface; sans serifs, for example, have better legibility than serif fans because of the consistent girth of their letterform.

Letterpress A relief method of printing; the process involves printing from an inked, raised surface, and the paper is impressed directly from plate (the racked type and art); also referred to as "hot type" printing.

Letterspace The space added to the normal spacing between the letters in a word.

Ligature Two or more characters joined to make a single unit.

Light An electromagnetic radiation within a fairly narrow wavelength.

Lightface Characters with strokes that have less weight than normal.

Line art A piece of art or a plate in black and white, not continuous tones.

Line conversion Continuous-tone art that is been converted to line art for printing.

Linen Paper A paper made from linen or having a finish resembling linen cloth.

Lines per inch (lpi) Rating of halftone screens. Lines per inch represent rows of halftone dots per linear inch. A 150-line screen would consist of 150 rows by 150 rows of halftone dots per inch.

Lithography A flat-surface printing method based on the principle that oil and water are mutually repellent.

Load time The time it takes for a Web page to completely appear on a screen and function.

Logo Abbreviation for logotype.

Logoform The Chinese pictorial writing system.

Logotype a. two or more letters on a single piece of type. b. a distinctive type arrangement and mix of type and art used for the name representing a publication, business, or organization.

Long grain The direction that the grain runs along the width of the press cylinder.

Lowercase The small letters of the alphabet.

M

Maestro concept A collective strategy invented by Buck Ryan for newspaper story-telling that features the editor, writer, designer, and photographer working together to plan how to best communicate the story.

Magaletter A more finished or refined newsletter that closely resembles a magazine.

Magenta Also called process red; it is a purplish red color and is used in process (or full) color printing.

Magnetic ink Ink that contains ferrous (iron) material that can be sensed magnetically.

Majuscule A term used by scribes for capital letters; an uppercase letter.

Makeup The art of arranging elements on a page for printing.

Margin The area (typically, white space) that surrounds the art and type.

Markup Instructions for a finished rough or comprehensive that are addressed to the printer or person in charge of producing or printing the message.

Mass communication The process of creating, delivering, and receiving messages and stories to large, disparate audiences through a variety of channels that range from books to the Internet.

Masthead The area of the magazine that details all the staff, mailing, advertising, subscription, and other publishing information.

Matrix (mat) The brass mold from which type is cast (or molded) in the hot metal process.

Mechanical A paste-up ready for plate-making.

Mechanical separation Copy prepared by a designer with each individual color in a separate section.

Media mix A combination of media chosen to sell and reinforce the advertising or marketing message; also referred to as communication mix.

Media planning The research and decision-making process of which channel or medium best communicates or most efficiently conveys the message to the target audience.

Megabyte (MB) One million bytes of information or 1,048,567 bytes.

Menu A list of commands that appears when you point to and click on the menu title in the menu bar of a Web site.

Menu bar The area at the top of a computer screen by which the user can access the actual pull-down menus.

Mercuries Sixteenth- and early seventeenth-century English news pamphlets.

Metallic ink Ink laced with metal flakes or chemicals to simulate a shiny metal finish.

Middletone Tonal values of a picture midway between the highlight and shadow. Sometimes called midtone.

Minimum line length The shortest width of lines of type for acceptable readability.

Miniscule The early lowercase letter forms developed by the scribes; a lowercase letter.

Minus leading Leading that is set at less than the typeface's specified point size.

Minus letter spacing Reducing the normal space between characters; a technique possible with photographic or electronic typesetting.

Miscellaneous A name given to a "catch-all" category of typography. Most of these faces are used in retail newspaper advertising; also known as novelty or display type.

Miter To cut a rule or border at a 45-degree angle for making corners on a box.

Mixing Combining more than one style or size of type on the same line.

Mnemonics Ancient memory-aiding devices; also used to refer to abbreviations of complex terms used in encoding computer instructions.

Mock-up A full-size, experimental layout for study and evaluation.

Modem A telecommunications device that translates computer signals into electronic signals that can be sent over a telephone line; a way to get information from one computer to another or from your computer to a print shop and so on.

Modern Roman A typeface that is distinguished by a more exaggerated contrast between thick and thin strokes, a precise geometry, and its straight, thin hairline serifs; the most elegant and formal of the roman subgroups.

Modular design See Mondrian design.

Modular format Design scheme based upon the grid-like paintings of Piet Mondrian. Also referred to as a grid or Mondrian format.

Moire A distracting pattern that results when a previously screened halftone is screened again and printed.

Mondrian design A set of guidelines that encourages a grid layout, asymmetrical and organized layouts, straightforward presentation, and rules, boxes, lines, and tint blocks to demarcate space. Also known as modular design, the grid, and Swiss design.

Monochromatic Color harmony that is constructed from different values of the same color.

Monospaced type A typeface where each character occupies the same amount of horizontal space.

Monotonal type strokes Lines that form a typeface's design that are uniform in girth and stroke; typically, sans serifs.

Monotypographic harmony Using only one family of type in a layout or document.

Montage A composite picture, usually made of two or more combined photographs.

Mortise An area cut out of a piece of art for the insertion of type or other art.

Mug shot A head-and-shoulders photograph of a person.

Multimedia The concurrent mix and use of a variety of media used in a single message.

N

Nameplate The name of a publication set in a distinctive type form, also called flag or logo.

New media The latest technological media applications; a convergence of media, technology, culture, and innovative ways of shaping communication content.

New realism A school of art that returned to strong representational imagery, often experiments in montage, multimedia, and assemblage.

New York School of Design This movement was centered in New York City and influenced graphic design from roughly the late 1940s to 1990. It relied heavily on geometric form, big type, and tightly cropped photography. Paul Rand, Bradbury Thompson, Herb Lubalin, George Lois, and Saul Bass produced some of the finest work of the New York School.

Newsprint Inexpensive paper with a rough, uneven, and pitted surface; newsprint is primarily used for mass-circulated newspapers and artists' drawing paper.

Nonpareil A term for 6-point type.

Normal type style The upright, medium-weighted version of a typeface we see most commonly.

Notch mortise A rectangle cut from a corner of a rectangular illustration.

Novelty A category of type that is usually ornamental in design and does not display any strong characteristics of one of the basic races or species.

O

Object-oriented graphic An illustration created in an object-oriented, or draw-type application. An object-oriented graphic is created with geometric elements. Also called a "draw-type" graphic.

Oblique Typography that is pitched forward.

OCR (optical character recognition) A device that electronically reads and encodes printed or typewritten material.

Offset A printing process in which the image is transferred from a printing plate to a rubber blanket to paper.

Old Style Roman An informal subgroup of type with shared characteristics which include leaning counters, a mild differentiation between its thick and thin strokes, and serifs that are often pinched, bracketed, tapered, or quirky. This serif subgroup has the most personality and funtionality of any type group.

Omniphasism Rick Williams's theory of visual communication that suggests we make visual sense of what we see by employing cognition, association, and intuition.

Op-art A short-lived school of art that reflected an antiestablishment culture that used optical illusion, strong repetitive lines, and other strategies that were visually stimulating.

Opacity The relative capacity of a paper stock to obstruct light from passing through it.

Opaque ink Ink that covers whatever is beneath it.

Optical center The area of a page that is located slightly left of center and about a third of the way down the layout or composition.

Optical weight A system of visual measure that suggests: dark elements weigh more than lighter ones; color weighs more than black and white; bright primary colors weigh more than their muted counterparts; irregularly shaped objects have more weight than shapes we're more accustomed to seeing; big things tend to weigh more than smaller ones; and that logistically, elements closer to a layout's vertical axis weigh less and those farther away weigh more.

Optimum format A format in which the width of the type columns is within the range of maximum readability.

Optimum line length The width of a line that is considered ideal for readability; normally, one and one-half times the lowercase alphabet or about 38-42 characters per line.

Ornament A decorative typographic device.

Orphan In typeset copy, a single word or a short line left at the bottom of a column or page (see Widow).

Outdoor advertising Usually associated with billboards, but also includes posters, bus signage, and other variations; also referred to as outdoor.

Outline A type design in which the letter is traced or outlined by lines on the outside of the strokes, and the inside of the letter is blank.

Overline A display type heading placed above a picture.

Overlays A sheet of transparent plastic or paper placed over a piece of art of a layout on which instructions are written and areas to be printed in color are drawn.

Overprint To print over an area that has already been printed.

Overset Body matter that exceeds the allotted space.

Oxford rule Parallel heavy and light lines.

P

PDA device A small, sophisticated technology (for example, cell phones and Palm Pilots) used to send and receive information.

PMS (Pantone Matching System) A full spectrum of color that uses various formulae mixing cyan, magenta, yellow, and black. The system is uniform and used the world over because of the consistency of the precise color blends, which are numbered in the PMS library.

POP Point-of-purchase materials.

Page description language (PDL) Software that describes an entire page, including all its elements. PostScript is a popular page description language for computer publishing.

Pagination The process of arranging and numbering the pages in a publication.

Paper weight How much one ream of paper weighs in a basic size.

Parallel field Two or more folds in the same direction.

Parallel fold Letters where two folds are scored to fit the brochure or publication in an envelope.

Parallel structure A basic footprint or design matrix that establishes a specific structure for a layout: locking down the design, type, art, and other graphic strategies in the respective layouts; a print advertising campaign normally uses parallel structure to maintain a cohesive identity for the advertising.

Paste-up The process of fixing type and other elements on a grid for plate making; pasteup is a mechanical.

Pebbling Embossing paper in its manufacture to create a ripple effect.

Perception Awareness of the elements in our environment through physical sensation; how we understand and filter what has been sensed visually using our experience, cognition, intuition, and powers of association.

Perfect binding A binding method that uses a flexible adhesive to hold the backs of trimmed pages together while they're ground to size and additional adhesive is applied.

Photocomposition Phototypesetting by film or paper.

Photoengraving A printing plate with a raised surface.

Photolithography An offset printing process that uses a plate made by a photographic process.

Phototypesetter A device that sets type by a photographic process; letter images are recorded on light-sensitive film or photographic paper that is then developed and printed.

Pi To mix type; individual metal characters that have been mixed up by accident.

Pica A standard, typographic unit of measure that is 12 points in width; there are 6 picas in an inch.

Pictograph A graphic that integrates one or more types of charts and illustration to personalize information.

Pie chart A circular chart whose parts are established by radii to illustrate an individual piece of information to the whole; a graphic way of showing one or numerous parts to a whole.

Pigment The dry powder that gives the ink its color.

Pixel (picture element) The smallest part of a graphic that can be controlled through a program. You could think of it as a building block used to construct type and images. The resolution of text and graphics on your screen depends on the density of your screen's pixels.

Planography A printing process that uses a plate with a flat surface; offset lithography is a planographic process.

Plans book A thorough advertising or public relations compilation that provides a client or agency with an overview of a communication problem; typically, it includes research, interview results, focus group studies, situation analysis, marketing plans, creative strategies, finished ads, or other communication materials and information.

Plate A printing surface.

Platen press A version of a letterpress in which paper is held on a flat surface and pressed against the printing surface or bed; also referred to as the "job press" and "clam" press.

Plug-in Specific software programs used in Web and interactive designs that needed to receive or read specially formatted messages; for example, Flash or QuickTime.

PMT (photomechanical transfer) A positive print that is ready for paste up.

Point The smallest unit of printing measure; approximately 1/12th of an inch. There are 12 points to a pica, and 72 points to an inch.

Pork chop A small headshot of a person, usually half a column wide.

Porosity The amount of air that can pass through a sheet of paper.

Portfolio A collection of a person's creative work.

Poster makeup An arrangement of a newspaper's front page that usually consists of large art and a few headlines to attract attention.

Positioning How a product is presented in terms of its benefits, function, and audience relationship. Volvo is an automobile which is positioned or singled out for its safety and customer loyalty, for example; even its tag reflects its positioning: "Volvo for life."

Postmodernism A school of art that rejected the "modern" art movements of the twentieth century, especially the grid system it used.

Posture The stance or pitch of type, roman (upright), oblique, and backslanted.

Prescreen A halftone positive print that can be combined with line copy in paste up, thus eliminating the need to strip in a screened negative with a line copy negative.

Press check To oversee a print job, adjust color if needed, and monitor the quality of a press run.

Primary color The colors red, yellow, and blue, which combine to make all other hues.

Primary optical center The spot where a reader's eye usually first lands on a page: the upper left quadrant.

Principles of design Fundamental concepts that apply to structuring a sound and appealing visual message: balance, proportion, sequence, emphasis (or contrast), and unity.

Printer's pairs A prearranged, calculated grouping of single pages found on a signature; specifically, determining where two-page spread pages will appear in the signature.

Pro bono Work provided a client or group usually public service in nature at no cost.

Process color Printing CMYK colors in combination to produce all colors; full color.

Production department The mechanical department of a printing plant.

Progressive margins Margins that get larger as they move around the sides of the page.

Projective light Illumination that is projected electronically as opposed to being reflected, as in the case of television or computer monitor imagery.

Proof A preliminary print of set type or a comprehensive, used to detect errors before the final printing.

Proportion The spatial relationship between one element in a layout or design to the rest of the composition, or the relationship of one part of a design to a single element within that design.

Prototype A working, in progress, model of a Web site or other medium.

Psychographics A set of qualitative research used to measure the lifestyle, values, habits, attitudes, and the like of a given audience.

Pull quote A quotation taken from the text of a feature or story that is enlarged and placed within the page design; also known as a pull out.

Pyramid An arrangement of advertisements on a page to form a stepped half pyramid.

Quad A unit of space in setting type.

Quad left, quad middle, quad right Commands that instruct a typesetting machine to put space in lines.

Quadrant makeup A plan for a page in which each quarter is given a strong design element.

R

RGB Red, green and blue.

Race A collection or group of typefaces that have several graphic characteristics in common with one another, but differ from one another in terms of x-height, width, stroke, and specific configuration.

Ragged right Type set justified at the left margin and unjustified (uneven) at the right margin.

Ragged left Type set justified at the right margin and unjustified (uneven) at the left margin.

RAM (Random Access Memory) The temporary memory inside the computer that allows stored text and graphics to be accessed.

Rationale In advertising or public relations, a paragraph that defends your campaign concept or big idea.

Readability How easily a typeface is read.

Readout The headline or unit of a headline between a banner head and the story; also used to refer to devices for breaking up body matter such as quotes (called quote-outs or pulled quotes) set in display type and embellished with typographic devices.

Ream Standard measure of paper; there are 500 sheets of paper to a ream.

Rebus A representation of words or syllables by pictures; in design, a strategy flows text around rebus artwork, that is, knockout photography or illustration.

Recto In book or pamphlet design, the odd-numbered, right-hand pages.

Recycled paper Coated paper with at least 10 percent post-consumer waste and at least 30 percent post-consumer waste for uncoated paper.

Register To line up color printing plates so the multiple impressions will create an accurate reproduction of the original.

Reflective light Illumination reflected from a medium into our eyes, as in a newspaper, magazine, or outdoor billboard.

Regular margins Margins sharing the same measurement.

Relief printing Printing from a raised surface; letterpress.

Renaissance Literally means rebirth; late fifteenth- and early sixteenth-century style of art and design marked by a strong rebirth of humanism through the revival of classic Greek and Roman style.

Repetition or repetitious forms Using various repetitions to echo a shape or configuration within a composition.

Repro (reproduction proof) The final image used for paste up and plate making.

Resolution The number of dots per inch (dpi) used to represent a character or graphic image. The higher the resolution, the more dots per inch and the clearer the image looks.

Retro A movement branched from postmodernism that revived older design styles and applied them using postmodern treatment of type, spatial arrangement, color, and slashing line angles.

Reverse White letters or lines on a dark background.

Reverse kicker A headline form in which the kicker is larger than the primary headlines.

Rivers Vertical strips of white space in areas of type created by excessive space between words; also called "rivers of white."

Rococo A French derivation of Baroque style that was even more dramatic, elaborate, intricate, and ornamental.

Roman a. a serif typeface, with letter strokes that vary from thick to hairline. b. in terms of posture, an upright letter with main strokes that are perpendicular to the base line.

ROP (run of press) Color or other matter that is not given a specific special position in the publication.

Rotary press A letterpress that uses a rotary impression cylinder and rotary-type bed as well, plus a web-fed or continuous roll of paper.

Rotogravure A high-speed, web-fed gravure printing process.

Rough A reproduction-sized layout whose elements are not finely finished.

Royalty-free graphics Artwork that is in the public domain and/or is available to the public without paying a royalty or service charge for its use.

Rule Straight line of varying widths typically used to demarcate design elements from one another.

Run-in head A headline that is part of the first line of the text.

Running foot A line at the bottom of a book page that indicates the book, chapter, or section title, and/or the page number.

S

SEC The Securities and Exchange Commission.

Saddle stitching A binding method that nests collated and trimmed pages atop one another, and staples (or stitching) are applied to the center (or spine) of the pages.

Sandwich A short notice placed within the body of an article.

Sans serif Typefaces without finishing strokes or serifs.

Scaling Sizing artwork to specific enlarged or reduced dimensions from its original size.

Scanner A hardware device that reads information from a photograph, image, or text, and converts it into a bitmap graphic.

Scoring Is accomplished by a machine that creases the paper where it's meant to be folded.

Screen A device, available in various densities, used to reduce continuous-tone art to a halftone plate.

Screen printing A process of printing that cuts and meshes a stencil into a fine, porous screen, usually made from silk or nylon, which is mounted to a frame. The ink or printing medium is then squeegeed onto the surface of the printing material used; also called silk-screen or screen process printing.

Scriptive type A typeface that "mimics" handwriting, but with letters that are joined.

Scroll To move a story or page up or down on a video display terminal screen for editing or reading purposes.

Search engine A computer program that searches Web sites to find and index information at the request of a user.

Secondary color A hue (color) produced by mixing two primary colors.

Section logo A typographic device used to identify a section of a publication.

Selective focus Shooting film or tape at a very wide aperture setting to blur the foreground and background, leaving a narrow area of focus on the main element of the photograph or film frame.

Self cover Magazine cover printed on the same paper stock as the rest of the book.

Semantic noise Any misinterpretation or misunderstanding of a word, words, or their context. In England, for example, an elevator is commonly called a lift; that reference may not be understood in the United States.

Semiotics A theory or explanation of visual communication that relies entirely upon the science of signs.

Sequence How the reader moves visually through a layout or composition.

Series All of the available sizes of a face within a family; series were important to "hot" type and phototypesetting, but not to digital type.

Serif a. the closing stroke on Roman or serif type. Serifs were copied from the letterform that Romans created by chisel or brush strokes; the finishing strokes that were used to clean the edges of their letters are called serifs. b. typefaces whose designs have adopted serifs in their design; they are characterized serifs and thick and thin letter strokes; also referred to as Romans.

Set solid Type set with no leading between the lines.

Shade Adding black to a color, or a color darkened by black.

Shaded Type that gives a gray instead of solid black imprint.

Shopper An advertising publication, usually tabloid-size and printed on newsprint.

Sidebar A supplementary story that provides additional or background information from a different perspective than a story along side it; for example, an interview with the Dalai Lama may offer a brief history of the political and religious relationship between China and Tibet.

Sideline An arrangement with short display lines to the left of the cutlines.

Side stitching A binding method that neatly arranges the folded and trimmed pages one on top of the other and then stitches them approximately a quarter-inch from the left edge.

Signature a. a single sheet of paper, both sides of which have been printed in a prearranged grouping of single pages. b. another name for a company's logotype, especially in advertising design.

Silhouette Art in which the background has been removed. Also called knockout or outline photography.

Sinkage A point below the top margin of a page where chapter openings or other material is set.

Site map A Web site blueprint detailing its architecture, layers, and logistics.

Skyline A headline or story at the top of the first page of a publication, above the nameplate. Also called skybox.

Slash A bold diagonal rule usually run in the upper right-hand corner of a magazine cover; used to call attention to late-breaking or special content.

Slug A unit of space, usually between lines of type and usually 6 or 12 points thick; a line of cast hot type; an identifying line on copy.

Small cap A capital letter for a font smaller than the regular capital.

Solid leading Setting the leading measurement the same as the type's point size; for example, 10-point type would have 10-point leading.

Sorts Characters that are obtainable but not ordinarily included in a font of type, such as mathematical signs and special punctuation and accent marks.

Source line A credit, normally the bottom line, for an information-graphic attributing the origin of the information.

Species A basic division of type; a race of type.

Spine The midpoint area between the front and back covers of a book or magazine; the center point of the outside cover.

Spiral binding Binding method using a plastic or wire spiral to hold the pages together.

Split complements Colors that are next to the complement hue in the color wheel.

Spot color One hue (color) in addition to black, usually in a headline, display line, border, or ornament.

Spot varnish A subtle, special printing nuance accomplished by applying varnish to a specific area or areas on a page.

Square Serif A typeface characterized by monotonal strokes and heavy, squared serifs; also called Egyptian, or Slab Serif.

Stacked leading Placing the baseline of an upper headline squarely atop the line of type that is directly below it; this is accomplished by setting the leading at approximately 70 percent of the type's point size.

Standard emboss Ink is applied to the raised surface or embossment on paper.

Standing head A column, forum, department, or review moniker that appears in every issue of a publication.

Stem A main typographic stroke that extends above the x-height or below the baseline of a letter.

Stepped head An arrangement of display type in which the top line is flush left, the middle line (if used) is centered, and the third line is flush right, and all the lines are less than full width to create a stair-step effect.

Stereotyping The process of casting a printing form from molten metal by using a mold (called a mat) or paper, usually in a curved form, to create a curved printing plate for a rotary press.

Stet A term meaning "do not change," used in proofreading.

Stock art Photographic or illustration that is sold to the public, usually for "one-time" rights only. Stock art may save an agency or publisher the expense of hiring a professional photographer or illustrator; the downside is that anyone has access to the artwork.

Storyboard A series of panels illustrating key scenes or camera shots within a script for a film, animation, TV spot, or other medium for moving imagery.

Straight matter Reading matter; body type; the text material in a book.

Streamer A banner headline.

Stripping Combining halftone and line negatives to create a comprehensive negative for printing plates that contain line and screened art.

Strokes The anatomical elements or lines used to form letter.

Stylebook A guide used to maintain design continuity and consistency in a publication, Web site, advertising, or other extended message; stylebooks typically speak to typography, photo style, page structure, logos, and design.

Subhead A short headline supplement used to flesh out a headline, especially a blind header. Often subheads are not complete sentences.

Sunken initial An initial letter inset in reading matter.

Supers Superimposed type placed atop of a film or video frame.

Surprinting Running type atop artwork.

Surrealism A school of art in which the artist searches the unconscious mind for content, often presenting a surprising mix of common objects thrust into an alien world. It was influenced by Dadaism and the theories of Sigmund Freud and made famous by Salvador Dali.

Swashbuckle A heavily embellished and ornate type style; it is usually italicized but given to long, flaring letter strokes. It is also know as Swash type.

Swipe file A collection of artwork borrowed from magazines, catalogs, and other publications used for artwork ideas, style, content, scale, etc. A swipe file is an "idea" or "for instance" file, not something whose contents you plagiarize.

Swiss design An even more stripped down version of Mondrian design, which establish a basic grid design without the use of lines or rules and popularized sans-serif typography; a stripped down race of type.

Swiss School See Swiss design.

Symmetry An approach to balance that aligns layout elements by centering them evenly (or nearly so), atop one another, so that if split vertically, the two sides basically mirror one another; also known as bilateral symmetry. Symmetry is a more formal approach to balance.

T

Tabloid A newspaper roughly half the dimensions of a broadsheet; usually between 11 x 15 to 11 x 17 inches in page size.

Tabular matter Statistics arranged in table or columnar form, such as stock market reports, financial statements, and so on.

Tack The intrinsic tendency of ink to stick to a page.

Tag, or tag line A line of copy that is normally placed beneath or near the logotype in an ad; a creative phrase or word that sums up a product or service's brand or image.

Target audience The intended recipients of a message or communication.

Terminal A device in a communications network or system where information can be entered, removed, or displayed for viewing and arranging.

Text The Black Letter race or species of type; also reading matter.

Text fields Scrollable text areas that appear in Web or interactive media that can vary from a paragraph or two to literally limitless copy.

Texture Graphically showing tactile surfaces in an image.

Text wrap To run text around an illustration in a page layout. Some programs have an automatic text-wrap feature that will shorten lines of text when a graphic is encountered; in other systems you need to change the length of lines to go around a graphic.

Themography A printing process that produces a raised surface of imagery or words by dusting the wet ink printed on a paper's surface with a resinous material.

Thumbnail An initial, rough sketch of a layout in its miniature form.

Tint Adding white to a color, or a color that is lightened by white.

Tint block An area on a printed page produced in a tint, usually with type or art surprinted on it.

Tombstone Identical side-by-side headlines that compete for attention.

Tone The luminosity or lightness or darkness of a color; also known as value.

Tracking The spacing program in some design software that allows letter and word space adjustments (from loose to very tight) in large groups of words.

Transitional Roman A serif face that possesses design characteristics of both old style and modern counterparts, along with having the largest x-height of the serifs, generally. It is also the most difficult of all the serif subgroups to identify.

Transparent ink Ink that allows a color beneath it to show through; most full-color printing uses transparent ink so the colors can fuse to create other colors.

Triad A combination or chord of three colors, each of which is at the point of a visualized equilateral triangle placed on the color wheel.

Typeface A specific family of typography; for example, Garamond, Caslon, Helvetica, and Lubalin.

Type specs Type specification; i.e., the selected size, weight, leading, line alignment, and other elements of your typographic guide or stylebook.

Type style One of a number of structural deviations within the letterform of a specific family of type; for example, italic, book, and condensed.

Typo An error in set type.

Typography The use and arrangement of elements for printing.

U

URL An Internet or Web site address for a computer or a document that consists of a communications protocol followed by a colon and two slashes (as http://), the identifier of a computer (as www.kayak.com), and usually a path through a directory to a file. Universal resource locator.

U&lc The designation for setting type in capital and lowercase letters where it is appropriate.

Unit A fraction of an em; in a 36-unit phototype-setting system, for instance, an em would have 36 units; more units allows more latitude in programming space between letters and words in designating character widths.

Unit count A method of determining whether display type will fit a given area.

Unity The overall cohesion and coherence of a layout's parts, especially as each separate element relates to the rest of the layout's parts.

Uppercase (UC) Capital letters.

Upright posture Type is run at a 90-degree vertical stance, perpendicular to the baseline; also referred to as Roman.

Usability A term that emphasizes ease of use in a Web site or in any interactive media.

User Any person using or performing an action in an interactive document, Web site, or interactive media.

User-centric An approach to Web site or interactive design that is focused on the user; being "user-friendly."

User-friendly A Web site or computer program that is easy to use and navigate.

V

Value The luminosity or lightness or darkness of a color; also known as tone.

Varnishing A printing method that applies a transparent coat of varnish to a page; also referred to as clear coat.

Vehicle The liquid that carries the pigment and bonds it to the paper.

Velox A black-and-white print of a halftone photograph.

Vernacular Design that adopted preexisting commercial and clip art and used it to fit content and context.

Verso The even-numbered, left-hand pages.

Vertical bleed Artwork run off the top and bottom of a layout.

Vertical justification Automatic adjustment of leading or the space between lines, in very small amounts so columns on a page can all be made the same depth.

Victorian A more stripped down and reserved version of design than its immediate predecessors (baroque and rococo) that was widely practiced in the latter half of the nineteenth century; named after Queen Victoria of England.

Video display terminal (VDT) A device and screen for arranging elements.

Vignette An illustration in which the margins appear to fade into the background or an oddly cropped photo as in the case of a circular or round crop.

Visual communication How we see; how communication works via basic communication models; and how theories of visual communication apply to a variety of audiences, messages, and situations.

Visual literacy Understanding the basic tenets of graphic communication (e.g., design principles, color, typography, and composition), and being able to apply them directly to at least one medium.

Voice The tone, attitude, grammar, and visual cues mated to a specific target audience.

Voiceover Narration that is spoken over the video portion of a TV spot, film, video, or animation.

Watermark A design, name, and/or logotype impressed on paper during manufacture.

Web A wide strip or roll of paper that travels through a press for printing.

Weight The density or darkness of comparative thickness in the strokes of a typeface.

Well The arrangement of advertisements on the right and left sides of a page so editorial matter can be placed between.

Widow A short line, usually just a word or two, at the end of a paragraph.

Width The amount of horizontal spacing of a letter; digital type can be adjusted by condensing or expanding its horizontal scale.

Wild art A standalone photograph; also known as a standalone.

Wire services Commercial news agencies that sell stories and visual imagery to newspapers, TV stations or networks, magazines, and other media who pay for the service.

Wire side The side of the paper that was on the wire mesh as it traveled through the manufacturing process.

Wireframe model A mathematically defined form in 3-D space with information about each vertex and connecting curve.

Wove A paper with a uniform, unlined surface and a soft, smooth finish.

WYSIWYG An acronym for "what you see is what you get."

X-height The height of a lowercase letter x, as measured from the baseline to the waistline or mean line in a specific typeface from its lowercase x.

Z

"Z" readout A visual pattern of the occidental eye; generally, we sequence a layout or composition starting at the upper left corner, move right, then make a diagonal sweep, ending with our vision exiting the lower right.

Zapping Editing out TV spots during the videotaping process.

Zines Self-published magazines that are produced using computer programs and published on the Internet.

Zipatone A transparent sheet containing dot or line patterns that provides a tonal effect similar to that provided by Ben Day.